Her Again

Her Again

BECOMING MERYL STREEP

Michael Schulman

HARPER LUXE

An Imprint of HarperCollinsPublishers

Photo Insert Credits (clockwise):

Pg. 1: Courtesy of the Bernardsville Public Library Local History Collection; Courtesy of C. Otis Sweezey; Courtesy of Michael Booth. Pg. 2: Photo by William Baker, Courtesy of William Ivey Long; Photo by Martha Swope/© Billy Rose Theatre Division, The New York Public Library for the Performing Arts; Photo by George E. Joseph/© Billy Rose Theatre Division, The New York Public Library for the Performing Arts. Pg. 3: Illustration © Paul Davis; Photofest; Irv Steinberg/Globe Photos, Inc. Pg. 4: Universal Pictures/Photofest © Universal Pictures; Photo by Mondadori Portfolio/Getty Images. Pg. 5: United Artists/Photofest © United Artists; Photo by Jack Mitchell/Getty Images. Pg. 6: Columbia Pictures/Photofest © Columbia Pictures; Columbia Pictures/Photofest © Columbia Pictures. Pg. 7: Photo by Graham Turner/Getty Images; Photo by Art Zelin/Getty Images. Pg. 8: Photo by ABC Photo Archives/ABC via Getty Images.

"We're Saving Ourselves for Yale"
Copyright © Renewed 1964, David McCord Lippincott
Copyright © 1946, David McCord Lippincott
Lyrics used by permission of the Lippincott family.

The Idiots Karamazov
Copyright © 1981 Christopher Durang and Albert Innaurato
Excerpts used by permission of the Authors.
"Surabaya Johnny" from *Happy End*
Text by Bertolt Brecht, Music by Kurt Weill.
English translation by Michael Feingold.
Copyright © 1972 by European American Music Corporation.
Copyright © renewed. All rights reserved. Used by permission.
Originally published in German in 1929 as "Surabaya-Johnny."
Copyright © 1929 by Bertolt-Brecht-Erben / Suhrkamp Verlag.
Used by permission of Liveright Publishing Corporation.

HarperCollins books may be purchased for educational, business, or sales promotional use. For information please e-mail the Special Markets Department at SPsales@harpercollins.com.

FIRST HARPERLUXE EDITION

ISBN: 978-0-06-246677-8

HarperLuxe™ is a trademark of HarperCollins Publishers.

Library of Congress Cataloging-in-Publication Data is available upon request.

16 17 18 19 20 ID/RRD 10 9 8 7 6 5 4 3 2 1

For Jaime

"Can I just say? There is no such thing as the *best* actress. There is no such thing as the greatest *living* actress. I am in a position where I have secret information, you know, that I know this to be true."

—MERYL STREEP, 2009

Contents

Her Again

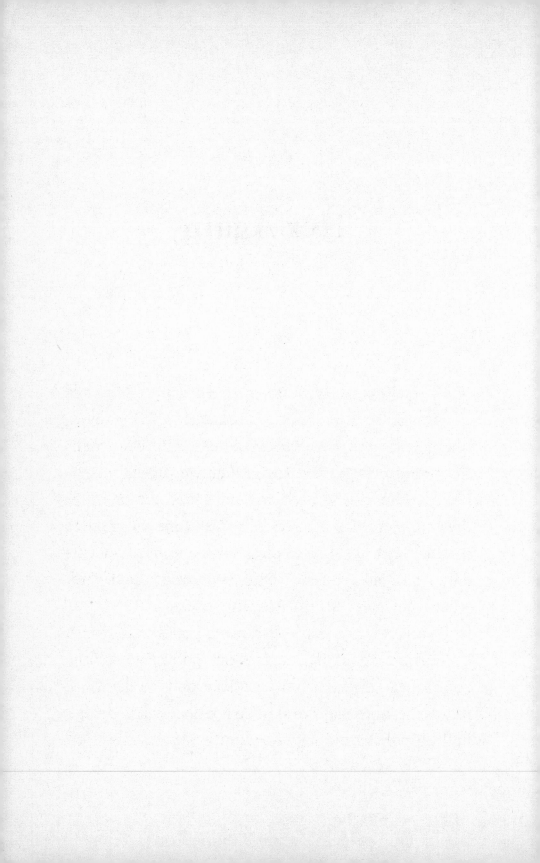

Prologue

Not all movie stars are created equal. If you were to trap all of Hollywood in amber and study it, like an ancient ecosystem buried beneath layers of sediment and rock, you'd discover a latticework of unspoken hierarchies, thwarted ambitions, and compromises dressed up as career moves. The best time and place to conduct such an archeological survey would undoubtedly be in late winter at 6801 Hollywood Boulevard, where they hand out the Academy Awards.

By now, of course, the Oscars are populated as much by movie stars as by hangers-on: publicists, stylists, red-carpet correspondents, stylists and publicists of red-carpet correspondents. The nominee is like a ship's hull supporting a small community of barnacles. Cut-

ting through hordes of photographers and flacks and assistants trying to stay out of the frame, she has endured months of luncheons and screenings and speculation. Now, a trusted handler will lead her through the thicket, into the hall where her fate lies in an envelope.

The 84th Academy Awards are no different. It's February 26, 2012, and the scene outside the Kodak Theatre is a pandemonium of a zillion micromanaged parts. Screaming spectators in bleachers wait on one side of a triumphal arch through which the contenders arrive in choreographed succession. Gelled television personalities await with questions: Are they nervous? Is it their first time here? And whom, in the unsettling parlance, are they wearing? There are established movie stars (Gwyneth Paltrow, in a white Tom Ford cape), newly minted starlets (Emma Stone, in a red Giambattista Valli neck bow bigger than her head). If you care to notice, there are men: Brad Pitt, Tom Hanks, George Clooney. For some reason, there's a nun.

Most of the attention, though, belongs to the women, and the ones nominated for Best Actress bear special scrutiny. There's Michelle Williams, pixie-like in a sleek red Louis Vuitton dress. Rooney Mara, a punk princess in her white Givenchy gown and forbidding black bangs. Viola Davis, in a lustrous green Vera Wang. And Glenn Close, nominated for *Albert Nobbs*,

looking slyly androgynous in a Zac Posen gown and matching tuxedo jacket.

But it's the fifth nominee who will give them all a run for their money, and when she arrives, like a monarch come to greet her subjects, her appearance projects victory.

Meryl Streep is in gold.

Specifically, she is wearing a Lanvin gold lamé gown, draped around her frame like a Greek goddess's toga. The accessories are just as sharp: dangling gold earrings, a mother-of-pearl minaudière, and Salvatore Ferragamo gold lizard sandals. As more than a few observers point out, she looks not unlike an Oscar herself. One fashion blog asks: "Do you agree that this is the best she has ever looked?" The implication: not bad for a sixty-three-year-old.

Most of all, the gold number says one thing: It's my year. But is it?

Consider the odds. Yes, she has won two Oscars already, but the last time was in 1983. And while she has been nominated a record-breaking seventeen times, she has also lost a record-breaking fourteen times, putting her firmly in Susan Lucci territory. Meryl Streep is accustomed to losing Oscars.

And consider the movie. No one thinks that *The Iron Lady*, in which she played a braying Margaret

Thatcher, is cinematic genius. While her performance has the trappings of Oscar bait—historical figure, age prosthetics, accent work—they're the same qualities that have pigeonholed her for decades. In his *New York Times* review, A. O. Scott put it this way: "Stiff legged and slow moving, behind a discreetly applied ton of geriatric makeup, Ms. Streep provides, once again, a technically flawless impersonation that also seems to reveal the inner essence of a well-known person." All nice words, but strung together they carry a whiff of fatigue.

As she drags her husband, Don Gummer, down the red carpet, an entertainment reporter sticks a microphone in her face.

"Do you ever get nervous on carpets like this, even though you're such a pro?"

"Yes, you should feel my heart—but you're not allowed to," she answers dryly.

"Do you have any good-luck charms on you?" the reporter persists.

"Yes," she says, a little impatiently. "I have shoes that Ferragamo made—because he made all of Margaret Thatcher's shoes."

Turning to the bleachers, she gives a little shimmy, and the crowd roars with delight. With that, she takes her husband's hand and heads inside.

They wouldn't be the Academy Awards if they weren't endless. Before she can find out if she's this year's Best Actress, a number of formalities will have to be endured. Billy Crystal will do his shtick. ("Nothing can take the sting out of the world's economic problems like watching millionaires present each other with golden statues.") Christopher Plummer, at eighty-two, will become the oldest person to be named Best Supporting Actor. ("When I emerged from my mother's womb I was already rehearsing my Academy speech.") Cirque du Soleil will perform an acrobatic tribute to the magic of cinema.

Finally, Colin Firth comes out to present the award for Best Actress. As he recites the names of the nominees, she takes deep, fortifying breaths, her gold earrings trembling above her shoulders. A short clip plays of Thatcher scolding an American dignitary ("Shall I be mother? Tea, Al?"), then Firth opens the envelope and grins.

"And the Oscar goes to Meryl Streep."

The Meryl Streep acceptance speech is an art form unto itself: at once spontaneous and scripted, humble and haughty, grateful and blasé. Of course, the fact that there are so many of them is part of the joke. Who but Meryl Streep has won so many prizes that

self-deprecating nonchalance has itself become a running gag? By now, it seems as if the title Greatest Living Actress has affixed itself to her about as long as Elizabeth II has been the queen of England. Superlatives stick to her like thumbtacks: she is a god among actors, able to disappear into any character, master any genre, and, Lord knows, nail any accent. Far from fading into the usual post-fifty obsolescence, she has defied Hollywood calculus and reached a career high. No other actress born before 1960 can even *get* a part unless Meryl passes on it first.

From her breakout roles in the late seventies, she was celebrated for the infinitely shaded brushstrokes of her characterizations. In the eighties, she was the globe-hopping heroine of dramatic epics like *Sophie's Choice* and *Out of Africa*. The nineties, she insists, were a lull. (She was Oscar-nominated four times.) The year she turned forty, she is keen to point out, she was offered the chance to play three different witches. In 2002, she starred in Spike Jonze's uncategorizable *Adaptation*. The movie seemed to liberate her from whatever momentary rut she had been in. Suddenly, she could do what she felt like and make it seem like a lark. When she won the Golden Globe the next year, she seemed almost puzzled. "Oh, I didn't have anything prepared,"

she said, running her fingers through sweat-covered bangs, "because it's been since, like, the *Pleistocene era* that I won anything."

By 2004, when she won an Emmy for Mike Nichols's television adaptation of *Angels in America*, her humility had melted into arch overconfidence ("There are some days when I myself think I'm overrated . . . but not today"). The hits—and the winking acceptance speeches—kept coming: a Golden Globe for *The Devil Wears Prada* ("I think I've worked with everybody in the room"), a SAG Award for *Doubt* ("I didn't even buy a dress!"). She soon mastered the art of jousting with her own hype, undermining her perceived superiority while putting it on luxurious display.

So when Colin Firth calls her name at the Kodak Theatre, it's a homecoming three decades in the making, a sign that the career rehabilitation that began with *Adaptation* has reached its zenith. When she hears the winner, she puts her hand to her mouth and shakes her head in disbelief. With the audience on its feet, she kisses Don twice, takes hold of her third Oscar, and resumes the time-honored tradition of cutting herself down to size.

"Oh, my God. Oh, *come on*," she begins, quieting the crowd. She laughs to herself. "When they called

my name, I had this feeling I could hear half of America going, 'Ohhh, no. Oh, come on—why? *Her. Again.*' You know?"

For a moment, she actually seems hurt by the idea that half of America is disappointed. Then she smirks.

"But . . . *whatever.*"

Having broken the tension with an impeccable fake-out, she proceeds to the business of gratitude.

"First, I'm going to thank Don," she says warmly. "Because when you thank your husband at the end of the speech, they play him out with the music, and I want him to know that everything I value most in our lives, you've given me." The camera cuts to Don, patting his heart.

"And now, secondly, my other partner. Thirty-seven years ago, my first play in New York City, I met the great hair stylist and makeup artist Roy Helland, and we worked together pretty continuously since the day we clapped eyes on each other. His first film with me was *Sophie's Choice*, and all the way up to tonight"—her voice cracks briefly—"when he won for his beautiful work in *The Iron Lady*, thirty years later." With Thatcheresque certitude, she underlines each word with a karate chop: "Every. Single. Movie. In. Between."

She shifts her tone again and continues, "I just want to thank Roy, but also I want to thank—because I really understand I'll never be up here again." (With that, she gives an almost imperceptible side-glance that says, *Well, we'll see . . .*) "I really want to thank all my colleagues, all my friends. I look out here and I see my life before my eyes: my old friends, my new friends."

Her voice softening, she goes for the big finish: "Really, this is such a great honor, but the thing that counts the most with me is the friendships and the love and the sheer joy we have shared making movies together. My friends, thank you, all of you, departed and here, for this, you know, inexplicably wonderful career."

On "departed," she looks skyward and raises a palm to the heavens—or, at least, to the lighting rig of the Kodak Theatre, where show-business ghosts lurk. Any number of ghosts could have been on her mind. Her mother, Mary Wolf, who died in 2001. Her father, Harry, who died two years later. Her directors: Karel Reisz, who cast her in *The French Lieutenant's Woman*; Alan J. Pakula, who made her the star of *Sophie's Choice*. Surely, she thought of Joseph Papp, the legendary theater producer, who plucked her from obscurity months after she finished drama school.

But at this moment, seeing her career come to yet another climax, it's hard to imagine that she didn't think back to its beginnings, and its beginnings were all wrapped up in John Cazale.

It's been thirty-four years since she saw him. Thirty-six years since they met, playing Angelo and Isabella in a Shakespeare in the Park production of *Measure for Measure*. Night after night in the sticky summer air, she would beg him to show mercy for her condemned brother: "Spare him, spare him! He's not prepared for death."

John Cazale was one of the great character actors of his generation, and one of the most chronically over-looked. Forever Fredo of the *Godfather* movies, he was her first deep love, and her first devastating loss. Had he lived past forty-two, his name might have become as familiar as De Niro or Pacino. But there was so much he hadn't been around to see. He hadn't seen Meryl win two Academy Awards by the time she was thirty-three. He hadn't seen her age into regal self-possession. He hadn't seen her play Joanna or Sophie or Karen or Lindy or Francesca or Miranda or Julia or Maggie.

John Cazale hadn't lived to see her onstage now, thanking her friends, all of them, for this "inexplicably wonderful career." After one last "thank you," she waves farewell and heads toward the wings, having

burnished her reputation once again. Meryl Streep, the Iron Lady of acting: indomitable, unsinkable, inevitable.

But it wasn't always so.

Forty-two years earlier, Meryl Streep was a pellucid Vassar student just discovering the lure of the stage. Her extraordinary talent was evident to all who knew her, but she didn't see much future in it. Although she possessed an idiosyncratic beauty, she never saw herself as an ingénue. Her insecurity worked in her favor: instead of shoehorning herself into traditionally feminine roles, she could make herself foreign, wacky, or plain, disappearing into lives far beyond her suburban New Jersey upbringing. Neither a classic beauty in the mold of Elizabeth Taylor nor a girl-next-door type like Debbie Reynolds, she was everything and nothing—a chameleon. One thing she knew she was not: a movie star.

What happened next was a series of breaks that every actress on earth dreams of, though few have the raw talent to seize them. By the end of the seventies, she had become the star student at the Yale School of Drama; headlined on Broadway and in Shakespeare in the Park; found and lost the love of her life, John Cazale; found the second love of her life, Don Gummer,

and married him; and starred in *Kramer vs. Kramer*, for which she would win her first Academy Award—all within ten dizzying years.

How did she get there? Where did she learn to do what she does? Can it even be learned? The questions don't exist in a bubble: the same decade that made Meryl Streep a star represented a heady, game-changing era in American film acting. But its biggest names were men: Al Pacino, Robert De Niro, Dustin Hoffman. Against her instincts, she joined the cast of *The Deer Hunter* to be with the ailing Cazale and broke into the *Godfather* clique. But it was the nuance and dramatic wit of her performances that earned her a place there. She excelled at the in-between states: ambivalence, denial, regret. Makeup and accents made her unrecognizable, and yet each performance had an inner discontent, a refusal to inhabit any one emotion without coloring it with the opposite emotion. Her interior life was dialectical.

"It's like church for me," she once said, before stumbling on the question of where she goes when she is acting. "It's like approaching the altar. I feel like the more you talk about whatever it is, something will go away. I mean, there's a lot of superstition in it. But I do know that I feel freer, less in control, more susceptible." Her immense craft was not without its detractors. In

1982, Pauline Kael, *The New Yorker*'s maverick film critic, wrote of her performance in *Sophie's Choice*, "She has, as usual, put thought and effort into her work. But something about her puzzles me: after I've seen her in a movie, I can't visualize her from the neck down."

The phrase stuck, as did the idea that Meryl Streep is "technical." But, as she is quick to explain, she works more from intuition than from any codified technique. While she is part of a generation raised on Method acting, rooted in the idea that an actor can project personal emotions and experiences onto a character, she has always been skeptical of its self-punishing demands. She is, among other things, a collage artist, her mind like an algorithm that can call up accents, gestures, inflections, and reassemble them into a character. Sometimes, she doesn't know from what or whom she has borrowed until she sees it up on the screen.

Coming of age during the ascendance of second-wave feminism, her discovery of acting was inextricable from the business of becoming a woman. During her cheerleading days at Bernards High School, she modeled herself on the girls she saw in women's magazines. Her world opened up in 1967 at Vassar College, which was then all-female. By the time she graduated, it had opened its dorms to men, and she had intuited her way

through her first major acting role, in August Strindberg's *Miss Julie*. A decade later, she starred in *Kramer vs. Kramer*, as a young mother who has the audacity to abandon her husband and child, only to reappear and demand custody. The film was, on one level, a reactionary slant against women's lib. But Streep insisted on making Joanna Kramer not a dragon lady but a complex woman with legitimate longings and doubts, and she nearly hijacked the movie in the process.

"Women," she has said, "are better at acting than men. Why? Because we have to be. If successfully convincing someone bigger than you are of something he doesn't want to know is a survival skill, this is how women have survived through the millennia. Pretending is not just play. Pretending is imagined possibility. Pretending or acting is a very valuable life skill, and we all do it all the time. We don't want to be caught doing it, but nevertheless it's part of the adaptation of our species. We change who we are to fit the exigencies of our time."

The years that changed Meryl Streep from winsome cheerleader to the unstoppable star of *The French Lieutenant's Woman* and *Sophie's Choice* had their own exigencies, ones that also transformed America, women, and the movies. The story of her rise is also the story of the men who tried to mold her, or love her, or place her

on a pedestal. Most of them failed. To become a star—never high on her list of priorities—she would do so on her own terms, letting nothing other than her talent and her otherworldly self-assurance clear her path. As she wrote to an ex-boyfriend her freshman year of college, "I have come to the brink of something very frightening and very wonderful."

Mary

On the first Saturday of November, the student body of Bernards High School gathered for a sacred rite. Homecoming: the ratification of a hard-fought teenage hierarchy. On a crisp green football field tucked behind a Methodist Church, the notoriously hopeless Bernards Mountaineers faced off against their rivals from Dunellen, a New Jersey borough not unlike their own. At halftime, the players cleared the field. Then it was time to crown the homecoming queen of 1966.

Everyone in school knew this year's winner, a blond, blue-eyed senior from 21 Old Fort Road. She was one of those girls who seemed to have it all together: smart, good-looking, with a boyfriend on the football team.

They had seen her on the cheerleading squad. And in the choir. And in the school plays—she always got the lead. As the bow-tied student-council president escorted her onto the field, the eyes of Bernardsville fell on her limpid, peculiar face.

She was beautiful. Everyone knew it except her. Alabaster skin. High cheekbones that seemed chiseled like statuary. Hooded eyes, set slightly close. Hair the color of cornsilk. A nose so long and forked it was practically an event.

She wasn't nearly pretty enough to be a movie star, she thought. Movie stars were girlish or voluptuous or demure. They were Audrey Hepburn or Ann-Margret or Jane Fonda. Movie stars were pretty. And no matter how many boys had fallen over one another for her affections, she wasn't pretty, she told herself. Not with that nose.

Pauline Kael would put it this way: "Streep has the clear-eyed blond handsomeness of a Valkyrie—the slight extra length of her nose gives her face a distinction that takes her out of the pretty class into real beauty." No matter that Kael would become her most vocal critic. She was right: Meryl Streep wasn't pretty. She was something else. Something more interesting, or at least harder to categorize. When she arched an eyebrow or twisted a lip, she could be anyone: an aris-

tocrat, a beggar, a lover, a clown. She could be Nordic or English or Slavic. For now, what she wanted to be was all-American.

Last year's homecoming queen, June Reeves, had returned from junior college to fulfill her final duty: placing a twinkling diadem on her successor's head. The newly crowned queen boarded a float bedecked with flowers, flanked by her homecoming court: Joann Bocchino, Ann Buonopane, Ann Miller, and Peggy Finn, all with flipped hair and corsages. As the float traversed the field, she waved to the crowd and smiled, flashing a white glove. She had worked hard to become the queen, primping and peroxiding and transforming herself into the person she was determined to be.

None of her subjects knew how miscast she felt. What they saw was a role she was playing, down to the last golden hair on her head. Even her giggle was a construction: she had practiced it, making it light and lithesome, the way the boys like. She wouldn't have called it acting, but that's what it was. With unwavering diligence, she had spent her high school years immersed in a role. Still, as good as she was at playing it, there would always be cracks in the façade. She didn't look like the women she saw in the magazines, not really. She had fooled these people, or most of them. The girls saw right through her.

Waving to the crowd, she stayed in character. It felt nice to be worshiped, but perhaps a little lonely. Up on that float, she was on her own plane, a few inches closer to the November sky than any of her supposed peers. If only June or Peggy or her best friend, Sue, could join her—but there was only one queen, and her job was to be the best. Perhaps for the first time, and certainly not for the last, Meryl Streep was learning that perfection could be a prison.

She was seventeen years old.

She would soon discover that transformation, not beauty, was her calling card. It had been with her from the beginning. Call it "the zone." Call it "church." It was a place she visited before she knew how to describe it, though she never really figured out how.

"I was six, placing my mother's half-slip over my head in preparation to play the Virgin Mary in our living room. As I swaddled my Betsy Wetsy doll, I felt quieted, holy, actually, and my transfigured face and very changed demeanor captured on Super-8 by my dad pulled my little brothers—Harry, four, playing Joseph, and Dana, two, a barnyard animal—into the trance. They were actually pulled into this little nativity scene by the intensity of my focus, in a way that

my usual technique for getting them to do what I want, yelling at them, never ever would have achieved."

That was six. This was nine:

"I remember taking my mother's eyebrow pencil and carefully drawing lines all over my face, replicating the wrinkles that I had memorized on the face of my grandmother, whom I adored. I made my mother take my picture, and I look at it now, of course, I look like myself now and my grandmother then. But I do really remember, in my bones, how it was possible on that day to feel her age. I stooped, I felt weighted down, but cheerful, you know. I felt like her."

The Virgin Mary was a natural first role: Meryl came from a long line of women named Mary. Her mother was Mary Wolf Wilkinson, whose mother was Mary Agnes, shortened to Mamie. When Mary Wolf's first daughter was born, in Summit, New Jersey, on June 22, 1949, she named the baby Mary Louise. But three Marys in one family was a lot, and before Mary Louise had learned to speak her name, her mother had taken to calling her Meryl.

She knew little of her ancestors growing up. Her mother's side was Quaker stock, stretching back to the Revolutionary War. There were stories of someone getting hanged in Philadelphia for horse thievery.

One grandmother busted up bars during the Temperance movement. Her grandfather Harry Rockafellow Wilkinson, known as "Harry Pop" to his grandchildren, was a joker and a gesticulator. When Meryl was little, her maternal grandparents still said "thee" and "thou."

Mary Wolf had a wide, warm face and a bright humor inherited from her father; years later, playing Julia Child, Meryl would draw on her mother's immense "joie de vivre." She was born in 1915, in Brooklyn. During World War II, she worked as an art director at Bell Labs, and later studied at the Art Students League in New York. Like most of her peers, Mary gave up her wartime work to be a full-time wife and mother: the kind of woman Betty Friedan wanted to galvanize with the 1963 publication of *The Feminine Mystique*. But Mary didn't suffer from the malaise Friedan observed in so many housewives, perhaps because she never abandoned her artistic pursuits. While she raised the kids, she worked in a studio on the back porch as a commercial artist, drawing illustrations for local publications and businesses. Had she been part of her daughter's generation, she might have gone out and had a career. As it was, she kept her finger in the pie, and the extra income didn't hurt.

Meryl's paternal side had none of the same ebullience. "Streep" was a German name, though for many

years she thought it was Dutch. Her father, Harry Streep, Jr., was an only child. (Harrys and Henrys were as plentiful in her family as Marys.) Nicknamed "Buddy," he was born in Newark in 1910 and went to Brown on a scholarship. After a year, the Depression hit and he was forced to leave. For three decades, he worked in the personnel department of Merck & Co. The job was mostly hiring and firing. Meryl noticed some melancholy in her father, possibly inherited from his mother, Helena, who had been institutionalized for clinical depression. Helena's husband, Harry William Streep, was a traveling salesman who left her alone with their son much of the time. As an older man, Meryl's father would watch his grandson, Henry Wolfe Gummer, in a high school production of *Death of a Salesman* and weep, saying, "That was my dad."

When Meryl visited her paternal grandparents' apartment, she could sense a pervading sadness. The shades were drawn so as to let in only a sliver of light— nothing like the warm Wilkinson house. Her grandmother reused absolutely everything. She would save pieces of tinfoil and wrap them into a ball, which she kept under the sink as it grew larger and larger, to Meryl's fascination.

In the postwar glow, a bright, suburban American dream was within reach for families like the Streeps.

They moved around central New Jersey as the family got bigger, first to Basking Ridge and then to Bernardsville. After Meryl, there was Harry Streep III, nicknamed "Third." Then there was another boy, Dana, a skinny jokester with freckles. Meryl's parents would bring her to her brothers' Little League games, but she was just as rambunctious and athletic as they were, maybe more so.

In Bernardsville, they lived on a tree-lined street on top of a small hill, just a short walk from the public high school. The town sat on New Jersey's "wealth belt," about forty-five miles west of New York City. In 1872, a new railroad line had transformed it from a tranquil collection of cottages to a bedroom community for affluent New Yorkers, who built summer homes far away from the city din. The tonier among them erected mansions on Bernardsville Mountain. The "mountain people," as some below called them, sent their children to boarding schools and trotted around on horses. In later years, they included Aristotle and Jacqueline Kennedy Onassis, who kept a ten-acre Bernardsville estate.

The railroad bisected the rest of the town: middle-class Protestants on one side; on the other, working-class Italians, many of whom made their living constructing the mountain people's homes. There were few local industries, save for Meadowbrook Inventions,

which made glitter. Aside from its equestrian upper crust, the town was like its many cousins along the Erie Lackawanna line: a place where everyone knew everyone, where bankers and insurance men took the train into the city every morning, leaving their wives and children in their leafy domestic idyll.

As members of Bernardsville's earthbound middle class, the Streeps were nothing like the mountain people. They didn't own horses or send their children to private academies. Unlike the Colonial-style houses popular in town, theirs was modern, with a Japanese screen in the family room and a piano where Mr. Streep would play in the evenings. Outside was a grassy yard where the Streep kids could while away summer afternoons.

Harry had high expectations for his children, whom he wanted on the straight and narrow—and in Bernardsville, the straight and narrow was pretty straight and pretty narrow. Mary had a lighter touch, and an irreverent wit. Aside from their birthdays, the siblings would get "special days," when they could do whatever they wanted. For a while, Meryl chose the zoo or the circus, but soon her special days were all about Broadway shows: *Oliver!*, *Kismet*, Ethel Merman in *Annie Get Your Gun*. Meryl adored musicals, which, as far as she knew, were the only kind of theater there was. At a

matinee of *Man of La Mancha*, she sat in the front row "shooting out sparks," as her mother would recall.

She was bossy with her little brothers, coercing them into imaginative games, whether they liked it or not. They were, after all, her only scene partners. Third acquiesced, later describing her as "pretty ghastly when she was young." But the other kids in the neighborhood weren't so easy to manipulate. "I didn't have what you'd call a happy childhood," she said in 1979. "For one thing, I thought no one liked me . . . Actually, I'd say I had pretty good evidence. The kids would chase me up into a tree and hit my legs with sticks until they bled. Besides that, I was ugly."

She wasn't hideous, but she certainly wasn't girlish. When she watched Annette Funicello developing curves on *The Mickey Mouse Club*, she saw a gamine cuteness that eluded her completely. With her cat-eye glasses and brown, neck-length perm, Meryl looked like a middle-aged secretary. Some of the kids at school thought she was a teacher.

When she was twelve, she got up at a school Christmas concert and sang a solo rendition of "O Holy Night" in French. The audience leaped to its feet, perhaps stunned to hear the neighborhood terror produce such a pure, high sound. It was the first time she felt the intoxication of applause. Among the surprised were

her parents. Where had Meryl been hiding her coloratura?

Someone told them to enroll her in singing lessons, so they did. Every Saturday morning, she would take the train into New York City to see Estelle Liebling. Miss Liebling, as her students addressed her, was a link to a vanished world. Her father had studied with Franz Liszt, and she was the last surviving pupil of the great Parisian voice teacher Mathilde Marchesi. Miss Liebling had sung Musetta at the Metropolitan Opera and toured two continents with John Philip Sousa. Now she was in her eighties, a chic matron in heels and crimson lipstick, imposing despite her petite frame. She knew everyone in the opera world, and she seemed to mint star sopranos as fast as the Met could take them.

With such a lofty teacher, there was nothing stopping the adolescent Meryl from becoming a world-famous soprano. Not that she was crazy about opera—she preferred the Beatles and Bob Dylan. But that voice was too good to waste. Weekend after weekend, she went to Miss Liebling's studio near Carnegie Hall, standing beside the piano as the octogenarian teacher ran her up and down scales and arpeggios. She taught Meryl about breathing. She taught her that breathing is three-dimensional, reminding her, "There's room in the back!"

As she waited outside Miss Liebling's studio for her 11:30 a.m. appointment, a glorious sound would echo from inside. It was the 10:30 student, Beverly Sills. A bubbly redhead in her early thirties, Sills had been coming to Estelle since she was seven years old. Meryl thought Beverly was good, but so was she. And nobody had ever heard of Beverly either.

Of course, that wasn't quite true: Sills had been singing with the New York City Opera since 1955, and was only a few short years from her breakout role, Cleopatra in Handel's *Giulio Cesare*. "Miss Liebling was very strict and formal with me," Sills wrote in her autobiography. "When she was at the piano, she never let me read music over her shoulder, and she got *very* annoyed the few times I showed up unprepared. One of Miss Liebling's favorite admonitions to me was 'Text! Text! Text!' which she said whenever she felt I was merely singing notes and not paying attention to the meaning of the lyrics. Miss Liebling wanted me to sing the way Olivier acts, to deliver what I was singing in such a way that my audience would respond emotionally."

Miss Liebling had another mantra: "Cover! Cover! Cover!" She was speaking of the passaggio, that tricky vocal stretch between the lower and upper register. For some singers, it was a minefield. Cover it, Miss Liebling told her charges, with certain vowels only: an "*ooh*" or

an "*aww*," never a wide-open "*ahh*." Make the transition seamless. For a gawky adolescent with braces and knotty brown hair, the idea must have held some extra appeal: cover the transition. Make it seamless.

In the fall of 1962, Meryl's parents brought her to City Center, the home of the New York City Opera. Sills was debuting as Milly Theale in Douglas Moore's *The Wings of the Dove*. It was the first opera Meryl had seen, and she was rapt. Until then, Beverly had been the nice lady whose lessons preceded her own. Now, watching her onstage, Meryl saw what all those drills on Saturday mornings were for—the glory that capped all the grueling hours of work.

She realized something else that night: she didn't have a voice like Beverly's, and she would never be an opera singer.

After four years, she quit her lessons with Miss Liebling. The reason wasn't just that she had given up her dreams of debuting at the Met. Meryl had come through the passaggio of puberty, and what lay on the other side was far more tempting than Verdi: she had discovered boys.

It was time for a metamorphosis.

At fourteen years old, Meryl Streep took off her braces. She ditched her glasses and started wearing

contacts. She doused her hair in lemon juice and per-oxide until it gleamed like gold. At night, she wore rollers—it was torturous, but she'd wake up with a perky flip. As Meryl primped for hours in the bathroom mirror, surely to the chagrin of her younger brothers, she discovered that beauty gave her status and strength. But, like most teenagers rushing head-long toward womanhood, she was barely conscious of what she was leaving behind.

"Empathy," she would say, "is at the heart of the actor's art. And in high school, another form of acting took hold of me. I wanted to learn how to be appealing. So I studied the character I imagined I wanted to be, that of the generically pretty high school girl." She emulated the women in *Mademoiselle* and *Seventeen* and *Vogue*, copying their eyelashes, their outfits, their lipstick. She ate an apple a day—and little else. She begged her mother to buy her brand-name clothes, and was refused. She fine-tuned her giggle.

She worked day and night, unaware that she had cast herself severely against type. She studied what boys liked, and what girls would accept, and memorized where the two overlapped: a "tricky negotiation." She found that she could mimic other people's behavior with faultless precision, like a Martian posing as an Earthling. "I worked harder on this characterization,

really, than anyone that I think I've ever done since," she recalled. Gone was the ugly duckling, the brassy little bully of Old Fort Road. By fifteen, that Meryl had disappeared. In her place was "the perfect *Seventeen* magazine knockout."

She was an excellent imposter.

News of the sixties seemed not to reach Bernardsville, even as the counterculture caught fire elsewhere. Sure, her friends listened to the Beatles and "Light My Fire," but transgression took the form of a beer, not a joint. The place looked like something out of *Bye Bye Birdie*. Girls wore A-line dresses down to the knees, with Peter Pan collars cinched with a small circle pin. Boys wore khakis and Madras jackets and parted their hair. The vice principal would come around with a ruler to measure their sideburns: too long and they'd be sent home.

Fun was a hamburger at the luncheonette in the center of town, or a movie at the local cinema. At the "Baby Dance," the freshmen dressed up in bonnets and diapers. The next year, it was the "Sweater Dance." After that, the Junior Prom, which was themed "In Days of Olde." It was a fitting motif. "We felt like we were in a little shell, that we were protected and everything would be safe there," said Debbie Bozack (née

Welsh), who, like Meryl, entered ninth grade in September, 1963, two months before the Kennedy assassination.

Debbie met Meryl in homeroom on one of the first days of class. At Debbie's old school, there were only five kids in her grade, and the crowded hallways at Bernards High terrified her. So did the prospect of changing for gym. Meryl, though, seemed confident and fearless. They had most of the same classes, so Debbie followed her around like a disciple.

As a newfound adherent to American teenage conformity, Meryl longed to join the cheerleading squad. So did Debbie. But Debbie couldn't do a cartwheel to save her life. Meryl, who was not only self-assured but athletic, was a pro. Some days, Debbie would follow Meryl home after school, where Meryl would try to teach her to do a cartwheel on the lawn. As Meryl guided her legs over her head, Debbie's hands would grate against the pebbles that came up after the rain. In the end, it was all for naught. Debbie didn't make the squad. Meryl, naturally, did.

On fall weekends, the student populace would converge at the football games. With the exception of the brainiacs and the greasers, everyone showed up. Everyone had a place. There were the twirlers. There was the color guard, where Debbie landed a spot. There

was the marching band, which was quite good, thanks in part to a precocious senior named John Geils, who within a few years would trade in his trumpet for a guitar and start the J. Geils Band.

But the cheerleaders, or "cheeries," stood apart from the rest. Not that they were mean, but they were close-knit, bonded by their good looks and popularity. With the letter "B" emblazoned on their outfits, they would chant, "Thunder, thunder, thunderation!" Meryl became best friends with her fellow cheery Sue Castrilli, who worked at the Dairy Queen. There wasn't much to do in Bernardsville, besides driving on a loop on the 202 between the DQ and the train station and then back again. When Sue was on duty, she would give her friends double dips.

In class, Meryl was attentive when it suited her. She had a knack for languages—the accents, at least. When she didn't care for the teacher, she got C's. She dreaded the geometry teacher, whom the kids called Fang. Even worse was biology. "Just remember Biology and the Biology exam and you'll never sleep again," one boy wrote in her sophomore yearbook. "I don't know what you'd do if I didn't tell you all the answers," wrote another.

As the sister of two brothers, she was comfortable around boys, maybe more so than she was around girls. She loved the guys who sat in the back row, because

they were funny; from them she picked up comedic lessons she wouldn't use until much later. For now, Meryl was content to be their audience, careful not to step out of character. At home, the dinner table was a clamorous exchange of ideas. But opinions, Meryl learned, didn't get you a second date—boys didn't like to be contradicted. Opinions, for now, took a backseat.

In the spring of 1964, when Meryl was a freshman, she met Mike Booth. She had gone on a date or two with his cousin, J. D. Mike was a sophomore with longish dark hair and a toothy grin. He wore Shetland sweaters with the sleeves cut off halfway—the closest Bernards High came to rebellion. His father thought he was a failure, and Mike proved the old man right by drinking and getting into fights. He had barely passed the ninth grade.

"Do you like it here at Bernards High?" Meryl said, when J. D. introduced them.

"I do now."

Mike thought that Meryl was swell. "Her eyes were extremely bright," he would recall. "Her smile was genuine. She didn't smirk or run with a pack, like a lot of girls. Yet there was a slight awkwardness about her, as though she was certain her dress didn't look right, or her shoes didn't fit, or she was just plain ugly."

Mike began walking her home from school—he didn't have a driver's license. During the summer, they'd go to his Aunt Lala's place for picnics and swim in the pond, or play baseball. On nights, they'd go to parties or the Bernardsville movie theater, rushing home to make Meryl's eleven o'clock curfew. Mike wrote her poems, and she gave him a volume of modern American and British poetry, a Christmas present from her father.

In the middle of the summer, Mike began football practice, and Meryl started practicing with the cheeries. They'd meet for lunch; Meryl would share one of her trademark peanut-butter-and-jelly sandwiches, which they washed down with a Tab and a leftover brownie or piece of cake, which Meryl joked was "aged like a fine cheese." Mike liked her self-deprecating humor, which she'd use to brush off anything that irked her. Sometimes she did impressions for him—he thought she was a "terrific mimic." When he asked if she liked to swim, she switched on a Jersey accent and said, "Duh, yeah," flexing her biceps and bragging, "I'm really quite atletik—for a girl."

On their walk to the community pool one day, they spotted a discarded ring glinting up from the side of the road. It was a promotional item from American Airlines, with a metallic eagle encircled with the words

JUNIOR PILOT. Mike put it on Meryl's finger. They were going steady.

Harry Streep didn't like the idea at all. At first, he limited Meryl to seeing Mike just once a week. Then it was every two weeks. Then he insisted that she go on dates with other boys, since she was too young to go steady with anyone. One day at the pool, Meryl won a race at a swim meet, and when she got out Mike gave her a kiss on the cheek. Word got back to Mr. Streep, who chastised his daughter for the public display of affection.

Finally, he cut her off from Mike entirely. They met secretly on a path through the woods between their houses, which were a mile apart. Mike handed her a love poem. Meryl's eyes were red from crying. She went home that night and warned her father: If you don't give me some freedom now, I'll be one of those girls who goes berserk once she leaves for college. He relented.

In her notes to Mike, Meryl daydreamed about their future together. After high school, they'd get married and move to a remote island where they'd join the Peace Corps and "civilize the natives." Then Meryl would go to Sarah Lawrence, or maybe Bard, while Mike got his law degree and became a part-time writer. He'd win the Pulitzer Prize. She'd accept the lead in a Broadway

play and immediately become rich and famous. They'd buy a villa on an island off of Nice—early-American style, of course—and throw parties twice a weekend.

Mr. Streep watched Mike with a wary eye. Nevertheless, Mike observed, "There was this constant joking and bantering that went back and forth between Meryl, her mother, and her brothers. They made fun of each other, but in a delightful sort of a way. I remember thinking, Jeez, these people really enjoy each other."

Mike and cheerleading may have dominated her time, but they didn't monopolize it. Bolstered by her father's sense of drive, she raced through high school in an extracurricular frenzy. Her freshman year, she was class treasurer. She did gymnastics and became the secretary of the French Club. She was the head of the announcers, who recited the lunch menu into the loudspeaker each morning. She drew art for the yearbook. She swam.

Meanwhile, she kept up her singing. She joined the choir, which performed in stately robes. One year at the Christmas concert, she scored a solo in Vivaldi's *Gloria*, performed at the Short Hills Mall. The 1965 edition of the *Bernardian* yearbook pictured her in a sweater and flipped hair, with the caption: "A voice worth noting."

But Meryl wasn't so sure of her vocal abilities. She confessed to Mike that she thought her voice was "sharp and shrill." He thought it was beautiful. When they approached her house, she would announce herself by wailing, "Ooooo-eee! Ooooo-eee!" Miss Liebling would have killed her.

"I'm going to strangle you, Meryl dear, if I hear that falsetto one more time!" her mother would call back, holding her ears.

It was in part her mania for activities that led Meryl to audition, her sophomore year, for *The Music Man*. She had seen Barbara Cook play Marian the Librarian on Broadway. Now she surprised half the school by winning the role for herself. Third, who was a freshman, played her lisping little brother, Winthrop. When it came time for the big show, she sang "Goodnight, My Someone" with a voice as light and high as a feather. She told Mike that he was the "someone."

Even her chemistry teacher took to calling her "Songbird." The next April, she played Daisy Mae in *Li'l Abner*, singing and dancing in fringed cutoffs. Days after the curtain went down, she was still glowing. "Almost every day for the past two months has been a 'Typical Day' in Dogpatch, so the song goes," the sixteen-year-old Meryl told the school newspaper, adding: "It's pretty hard to put this out of your mind so

quickly." The following year, she was Laurey in *Oklahoma!* Her best friend, Sue Castrilli, was in the cast. So was Third. Playing these dainty ingénues, she didn't think about the acting part. "I thought about the singing part," she said later, "the showing-off part, and the dancing part."

It was a way to feel loved, something she hadn't quite convinced herself she was. "I thought that if I looked pretty and did all the 'right things,' everyone would like me," she said of the teenage self she would later abandon. "I had only two friends in high school, and one of them was my cousin, so that didn't count. Then there's that whole awful kind of competition based on pubescent rivalry for boys. It made me terribly unhappy. My biggest decision every day used to be what clothes I should wear to school. It was ridiculous."

Some other part of her was trying to claw its way out. On afternoons after school, she'd come home and put on her parents' Barbra Streisand albums, imitating every breath, every swell. She found that she could express not only the emotions of the song but the other feelings she was having, the ones that didn't fit the character she was playing. Even as she mouthed along to the truism that "people who need people are the luckiest people in the world," its irony was apparent:

at school, she was surrounded by people, but she didn't feel lucky. She felt phony.

"Often success in one area precludes succeeding in the other," she would say. "And along with all of my exterior choices, I worked on my, what actors call, my interior adjustment. I adjusted my natural temperament, which tended—tends—to be slightly bossy, a little opinionated, loud (a little loud), full of pronouncements and high spirits. And I willfully cultivated softness, agreeableness, a breezy, natural sort of sweetness, even a shyness, if you will, which was very, very, very, very, *very* effective on the boys. But the girls didn't buy it. They didn't like me; they sniffed it out, the acting. And they were probably right. But I was committed. This was absolutely not a cynical exercise. This was a vestigial survival courtship skill I was developing."

Mike Booth didn't seem to notice. The "slight awkwardness" he had noticed when they met had disappeared, and in its place was "exuberance," he recalled. "Somehow she had become even prettier than the year before."

Meryl had taken up drawing and gave him her cartoons, most of which were at her own expense. She'd render herself with hairy arms and an elongated nose, still in her cheerleading outfit, or as a lifeguard with bulging muscles and a mustache. Her insecurities were

practically begging to be noticed, but Mike saw only talent, which he thought he had none of. At seventeen, he was a middling athlete and an even worse student.

In May, Mike took Meryl to the prom at Florham Park. With her white gloves and corsage, she was a "vision of smiling light," he thought. They had been dating for more than a year. That August, Mike brought her to see the Beatles at Shea Stadium. The band was barely audible above the screaming. Luckily, they knew all the songs by heart. Their favorite was "If I Fell," which they called "our song." It told them what they already knew: that love was more than just holding hands.

Pitted against the bigger, badder players across New Jersey, the Bernards High football team was accustomed to humiliating defeats. But the first game of the season in the fall of 1965, against Bound Brook, was different. Thanks to a magnificent fifty-yard run by a junior named Bruce Thomson (sprung loose by a key block from Mike Booth, the left guard), the Mountaineers pulled off a rare win. Mike eyed Meryl on the sidelines, screaming her head off in her red-and-white cheering uniform.

But Meryl's attentions were wandering. She had set her sights on Bruce Thomson, who had brought the Mountaineers their brief moment of glory. Bruce was

a sandy-haired, broad-shouldered hunk with an ego to match. His girlfriend was the captain of the color guard. She was a senior, like Mike, and had grown suspicious of Meryl. So had some of the other girls. Meryl was someone who got what she wanted. She wanted Bruce.

Mike was planning a road trip down south with a friend, a last hurrah before the wide world swept them up. The night before they left, he went to a dance and saw Meryl and Bruce in each other's arms. He could only blame himself. A couple weeks earlier, he had broken up with Meryl. He didn't want to be tied down, now that he had a fleeting chance at freedom. He had let Meryl slip away, maybe for good. A few months later, he enlisted in the U.S. Army as a Medical Corpsman.

In the fall of her senior year, Meryl was elected homecoming queen. No one was surprised. By then, she had built a coalition of wary admirers: the cheeries, the chorus girls, the boys who could make her giggle and glance. "Like, okay," Debbie recalled thinking, "we know Meryl will get it."

Her again.

There she was, at the big football game against Dunellen, the senior-class queen of Bernards High. Bruce Thomson had become her new beau, and they

looked good together: the homecoming queen and the football star, a high school power couple. From the float, she gazed down on her subjects: the twirlers, the color guard, the jocks, the class clowns from the back row, all arranged in a teenage taxonomy. The plan she had put in motion the day she tore off her old-lady glasses was complete. She had pulled it off, almost too well.

"I reached a point senior year when my adjustment felt like me," she would recall. "I had actually convinced myself that I was this person and she me: pretty, talented, but not stuck-up. You know, a girl who laughed a lot at every stupid thing every boy said and who lowered her eyes at the right moment and deferred, who learned to defer when the boys took over the conversation. I really remember this so clearly, and I could tell it was working. I was much less annoying to the guys than I had been. They liked me better and I liked that. This was conscious, but it was at the same time motivated and fully felt. This was real, real acting."

If only she could see beyond Bernardsville, past the proms and pompoms and tiaras and "Goodnight, My Someone"'s. At eighteen, she took her first plane ride. Passing over Bernardsville, she peered down and saw her whole life below: all the roads she knew, her school, her house. All of it fit in the space she could make with

two fingers. She realized how small her world had been.

In high school, there had only been one game to play, so she played it. The 1967 edition of the *Bernardian* yearbook revealed just how limited the options were. Beneath each coiffed, combed senior portrait, the descriptions of the graduates read like a generation's collective aspirations, a handbook for what young men and women were supposed to be. Between the genders was a bold, uncrossable line.

Just look at the boys, with their gelled hair and jackets:

"Handsome quarterback of our football team . . . big man in sports . . . likes to play pool . . . partial to blondes . . . usually seen with Barbara . . . Avid motorcycle fan . . . likes cars and working on them . . . fond of drag racing . . . enjoys U.S. History . . . whiz at math . . . future in music . . . future engineer . . . future mathematician . . . future architect . . . looking forward to a military career . . . most likely to succeed . . ."

Compare the girls, miniature Doris Days in pearl necklaces:

"Wants to be a nurse . . . captain of the cheeries . . . keeps the D.Q. swinging . . . a sparkling brunette . . . what beautiful eyes . . . Steve, Steve, Steve . . . loves to sew . . . Twirling is one of her merits . . . a whiz on

the sewing machine . . . Cute smile . . . loves short-hand . . . future as a secretary . . . Future nurse . . . giggles galore . . ."

Amid these future architects and future secretaries, the eye is barely drawn to Mary Louise Streep, who spent four years trying to ace conformity and succeeded. Beneath her lustrous portrait is a hard-won summation:

"Pretty blonde . . . vivacious cheerleader . . . our homecoming queen . . . Many talents . . . Where the boys are."

In the southwest corner of Vermont, Meryl Streep sat in front of a stern-looking administrator at the Bennington College admissions office. Her father was waiting outside.

"What books have you read over the summer?" the woman inquired.

Meryl blinked. Books? *Over the summer?* She was on the swim team, for crying out loud!

She thought back: there had been that rainy day at the library, when she read this one book cover to cover. Something about dreams, by Carl Jung.

But when she said the name of the author, the woman balked.

"Please!" she sniffed. "*Yung.*"

Meryl crumpled in her seat. That was the longest book anyone she knew had read over the summer—anyone on the swim team, at least—and this woman was giving her grief for mispronouncing the author's name?

She found her father outside. "Daddy, take me home." And he did.

So maybe she'd flubbed Bennington. There were other options. She was, in her estimation, "a nice girl, pretty, athletic, and I'd read maybe seven books in four years of high school. I read *The New Yorker* and *Seventeen* magazine, had a great vocabulary, and no understanding whatsoever of mathematics and science. I had a way of imitating people's speech that got me AP in French without really knowing any grammar. I was not what you would call a natural scholar."

Still, she knew she wanted something more than secretarial school, where Debbie and some other girls were headed. She liked languages, enough to fake a little French. Maybe she could be a United Nations interpreter?

The straight and narrow, it turned out, led to Poughkeepsie. In the fall of 1967, she made the ninety-minute trip from Bernardsville for her first term at Vassar College. And this time she knew how to pronounce "Carl Jung."

Julie

"Purity and wisdom" was the motto of Vassar College, though it had long disappeared from the school insignia. Founded in 1861, Vassar was the first of the Seven Sisters schools to be chartered as a college, with the goal of providing a liberal-arts education for young women equivalent to what Harvard or Yale offered young men.

By 1967, though, purity was seriously out of fashion, and the refined living of the all-female campus seemed like something from another century. The expectations were clear: Vassar women were to marry well and raise families, perhaps volunteer or pursue part-time careers if they had the time. Sarah Blanding, the president of Vassar in 1961, assured a luncheon audience that the school was "successful in preparing young women for

their part in creating happy homes, forward-looking communities, stalwart states, and neighborly nations."

Step one in creating a happy home: enter a happy partnership, preferably with a boy from the Ivy League. On weekends, the ladies of Vassar would pile onto buses bound for mixers at Princeton or Yale. (If you missed the bus, the bulletin boards were papered with signs for rides.) As the buses pulled onto the men's campus, boys in ties would crowd around, waiting to see the latest haul. If you were lucky, you'd dance with a Whiffenpoof, and if you were that kind of girl, you'd wake up the next morning in the Taft Hotel. Then it was back on the bus to Poughkeepsie.

A decade later, Meryl would star in a television version of *Uncommon Women and Others*, a play by her drama school classmate Wendy Wasserstein. Based on Wasserstein's experiences at Mount Holyoke, another Seven Sisters school, the play captured the vanishing world of midcentury women's liberal-arts education, one in which young ladies in headbands and pleated skirts are trained in "gracious living" by the matronly house mother, Mrs. Plumm. On Father-Daughter Weekend, they sing:

Though we have had our chances
For overnight romances

With the Harvard and the Dartmouth male,
And though we've had a bunch in
Tow from Princeton Junction,
We're saving ourselves for Yale.

Of course, not all the women of 1967 were there to earn an M.R.S. The year before, the newly formed National Organization for Women had released its statement of purpose, in which Betty Friedan called for "a fully equal partnership of the sexes," and the more progressive of the Vassar freshmen were of the same mind.

In *Uncommon Women*, a character describes her conflict between finding Mr. Right and the thornier demands of modern womanhood. "I suppose this isn't a very impressive sentiment," she says to a girlfriend, "but I really would like to meet my prince. Even a few princes. And I wouldn't give up being a person. I'd still remember all the Art History dates. I just don't know why suddenly I'm supposed to know what I want to do."

Meryl arrived on campus oblivious to the changing tides. "On entering Vassar, if you had asked me what feminism was, I would've thought it had something to do with having nice nails and clean hair," she said later.

She was entranced by the school's traditions, its pride—not the rah-rah stuff she'd known as a cheerleader, but the exalted nature of academe. A few days into her first semester, the students assembled for the convocation ceremony, signaling the end of orientation and the beginning of the fall term. It was held in late afternoon on the hills around Sunset Lake, a man-made pond where Vassar girls traditionally brought their dates. Now everyone wore white, and the entire faculty sat in robes on a platform. "A very aesthetically moving scene, right?" Meryl wrote in a letter to her old high school boyfriend Mike Booth. "No. But what really rocked me was just thinking how some of the greatest minds alive were sitting there in front of me. Little Meryl Streep, and they were actually prepared to meet *me* face to face in a seminar. Wow. It's enough to strip your ego to the bone."

She hit it off with her roommate, Liz, and they hung out in the campus coffee shop and played guitar. The repertoire: Eddie Floyd's "Knock on Wood," Simon and Garfunkel's "The Dangling Conversation," "In My Life" by the Beatles, "Hold On, I'm Comin'" by Sam and Dave, "Here, There and Everywhere" (Beatles again), some Otis Redding. Meryl doodled a picture of herself and Liz playing on a couch. Over Liz, she wrote: "sexy dark voice, Jewish, Brooklyn,

pot, beat, beads, nice, considerate." Over herself, she wrote: "Mary Louise Streep, 18 years and five months, medium to high wiggly voice, Wasp, Bernardsville, moderate, uncertain, JM"—for Johnny Mathis—"still affectionate, hook nose like Baez, heart of gold."

In reflective moments, she wrote to Mike. He was stationed in Germany, en route to Vietnam. Distance may have made it easier for Meryl to confide her anxieties, as well as her zeal. "I was really apprehensive about coming here," she wrote him, "but there are so many different people [that] I needn't have worried about being thrown amongst debutantes and greasy grimes. There are a lot of both groups here. Some belong to both categories, but there are tons of miscellanies like myself."

She took drama and English and, "just for the hell of it," introductory Italian. There were no boys around to dress up for, or to fight over with other girls. The spawning ground—"where the boys are"—was a bus ride away, and that was far enough that she could finally exhale. People were staying up all night smoking cigarettes and arguing about feminism and race and consciousness. Meryl read *Soul on Ice*, Eldridge Cleaver's account of being black and imprisoned in America—who even knew about the Black Panthers back in Bernardsville? She could wear the same turtle-

neck for weeks on end, put her hair up in a hasty bun, do Turkish dances in the dorms. No one cared. For once, female friendship was untainted by competition or envy.

"I made some very quick but lifelong and challenging friends," she said later. "And with their help, outside of any competition for boys, my brain woke up. I got up and I got outside myself and I found myself again. I didn't have to pretend. I could be goofy, vehement, aggressive, and slovenly and open and funny and tough, and my friends let me. I didn't wash my hair for three weeks once. They accepted me, like the Velveteen Rabbit. I became real instead of an imaginary stuffed bunny."

Not that boys were out of the picture. She began seeing a Yale junior named Bob Levin, the fullback of the football team—"my new thing at Yale," she'd call him. Her roommate had set them up on a blind date. She would cheer him on at football games, including an infamous Yale-versus-Harvard match that tied 29 to 29. (Tommy Lee Jones was a Crimson guard.) On weekends, she'd go to parties with Bob at DKE, where one of his fraternity brothers was George W. Bush. At the end of his senior year, Bush tried to tap Bob for his secret society, Skull and Bones, but Bob declined,

preferring the more informal Elihu Club. Meryl would be his dinner date at Elihu on Sunday evenings. She wouldn't say much, still unsure of a girl's place in the old boys' club.

Her taste in men hadn't changed much since high school, but her sense of their importance was eroding. At Vassar, there was an unspoken rule: if you made plans with a fellow student on the weekend—say, a concert at Skinner Hall—those plans would be immediately usurped if either girl landed a date. The boy took precedence. "I remember when I was, like, a sophomore that someone brought up that probably this was rude and weird and cruel, and that friends were as important as boys," Meryl recalled. "That was a new idea, completely new idea."

She had overpowering reactions to art, to books, to music. One weekend, she went up to Dartmouth to see Simon and Garfunkel. When Garfunkel sang "For Emily, Whenever I May Find Her," she was transfixed. The last line, especially—Garfunkel's wailing, searching declaration of love—moved her for reasons she struggled to articulate. It's an "understatement," she wrote to Mike, in a letter enclosed with a pressed orange maple leaf, "but somehow when he sang the words it was almost like the beautiful feeling you have

when someone first tells you the same thing. I can't understand how he can, after singing that song as many times as he has, still make it so earth rocking."

It was a lesson in performance. A lesson in emotional truth.

One night in her dorm, she sat in bed reading James Joyce's *A Portrait of the Artist as a Young Man*. When she got to the last page, she closed the book, the words still ringing in her ears: "Welcome, O life! I go to encounter for the millionth time the reality of experience and to forge in the smithy of my soul the uncreated conscience of my race."

Meryl thought she was having a "severe identity crisis." She went down the hall and asked a girl if she had a fever, just to feel another person's hand on her forehead. The book had confused her, but in a way that felt unbearably exciting. Everything else now seemed trivial: the inane dorm-hall chatter outside her door, her intellectualizing with Bob. She wanted something real, something that hit her in the face and shook her out of her constant preoccupation with herself. But what was "real"? What was Joyce trying to tell her? It was as if he was pushing her somewhere she wasn't ready to go, or wasn't willing.

She started writing a letter to Mike, so many miles away: "I tend now, however, perhaps because of dis-

tance (physical/spiritual?) to make you, 'Mike,' what I am searching to find, or something which you represent to me, something I value above all things. I wish so hard you were here always. I miss your presence or at least your word. James Joyce really has me flying around. His 'Portrait,' you know, some sort of autobiography, is so greatly personal. I see you there, me, everybody. There is so much I cannot understand in his work." She signed off in Italian: *Te aspetto e le tue parole come sempre.*

I await you and your words as always.

At two o'clock in the morning, Mike Booth was woken up in his barracks and told to report to the emergency room. The clamor of descending helicopters erased whatever was left of his sleep. The Vietcong had overrun a base down the coast, and now the medics hauled out bleeding soldiers one by one from the choppers.

The 91st Evacuation Hospital, in Tuy Hoa, usually treated Vietnamese civilians, but when something like this happened, they made an exception. Mike darted among the wounded GIs, cutting their fatigues off with scissors. Some of them needed tourniquets, badly—they might lose a limb, but it was their only chance of making it through the night. By daylight, nine Americans were dead.

Such a stupid war, Mike thought to himself. *It shouldn't be going on in the first place.*

Mike hadn't waited for the draft, or evaded it like some of his friends. He enlisted, hoping for a big adventure. Like a lot of people back home, he had his doubts about the war, but he decided that if he became a medic he'd have something to be proud of, no matter what. After three months of basic training and three months of medical training, he shipped out to Germany, where he worked in a dispensary and drove an ambulance.

Most guys were thrilled to be stationed in Germany, but Mike wanted to be where the action was. A friend of his had requested a transfer to Vietnam, and the Army was happy to oblige. After a beer-filled night, Mike decided to do the same. Within two or three weeks, he got his orders and flew to the air base in Guam.

Three times a day, Mike would go to the replacement center, as names and service numbers were called out like in a game of bingo. *Private So-and-So! You're going to Da Nang! Report to Officer So-and-So!* When someone got called to one of the "bad places," the other guys would turn their backs, as if he had a disease. Mike wound up in Tuy Hoa: right in the action. From the plane, he looked down on the Vietnam coastline: all lush jungles and winding beaches, as alien as a Martian landscape. He was finally getting his adventure.

He rode on the back of a truck to the hospital, vaguely aware that he was sniper bait. When he got to the barracks, he dropped his duffel bag on his new bed and went to meet the other men in the unit. Out back, he found twenty or thirty guys, blasting music on a tape deck and smoking dope like there was no tomorrow. Past the barbed wire were an artillery unit and a trucking unit and then sand and cactus as far as the eye could see.

The next day, he reported to the hospital, where there were more patients than beds. He began working twelve-hour shifts, six days a week. He saw traumatic amputations, gunshot wounds, fragmentation wounds, women, children, Vietnamese soldiers. Some had third-degree napalm burns all over their bodies. It was ghastly, but he considered himself lucky. Had he been sent to the front lines as a field medic, he would have been a walking target.

On days off, the guys rode in a truck down to a shantytown, where girls were available and you could get cartons of cigarettes stuffed with marijuana. Mike would wander off to the countryside and amble into Buddhist temples, where the monks would pour him tea. Sometimes, he and a buddy would rent motorcycles and ride them to the edge of town, jumping over ravines like aspiring Steve McQueens. Other days, he

would lie in the barracks, reading books from the camp library. "I felt like such a loser being in Vietnam," he recalled, "but I said, 'Well, I'm going to read. I'm going to develop my mind.' And so I read an awful lot of philosophy and existentialism: Dostoyevsky, Camus, Sartre. A lot of poetry—Baudelaire, Rilke, Rimbaud, Yeats. Books about Buddhism and Eastern philosophy."

He knew he was missing out: on college, on rock and roll, even on the antiwar protests that he read about in the paper. When he turned twenty, he got a letter from Meryl. She had just been down to Yale to hear the author William Manchester speak. "I'm not flunking here," she wrote. "It's not hard at all. The reading is fantastic. Read Joyce, 'Portrait of the Artist as a Young Man,' and also very very great is Richard Rubenstein 'After Auschwitz.' "

Back in Bernardsville, Mike had always talked to Meryl about books. But all this breathless rumination over Joyce and roommates and Simon and Garfunkel only made her—and home—seem farther away. "I felt," he recalled, "like I was on the other side of the world."

Those first two years at Vassar, she walked around campus in a liberated daze. But it wouldn't last. The all-female haven that had emancipated Meryl Streep

was under imminent threat. Like her, the school was having a severe identity crisis.

Across the country, single-sex education was falling out of favor. By 1967, nearly two-thirds of the Vassar student body came from coeducational public high schools like Meryl's, and the idea of giving up boys (whatever the benefits) was becoming harder to accept. Alan Simpson, the Oxford-educated historian who had become Vassar's president in 1964, was a firm believer in liberal-arts colleges for women. But applications were drying up. Unlike the other Seven Sisters schools, which were located close to their male counterparts, Vassar was relatively isolated, and it held less and less appeal for young women who wanted to interact with men seven days of the week.

In the fall of 1966, President Simpson formed the Committee on New Dimensions, which would plan for Vassar's future. At its first meeting, he noted that Hamilton was creating a college for women, and Wesleyan and Yale were likely to follow. Ideas were floated: maybe Vassar could create a coordinate men's college, or affiliate with an existing one nearby? The committee began to explore potential "dancing partners."

What the committee didn't know was that Simpson was considering a much more radical plan. In December, he met with Kingman Brewster, the president of

Yale, to discuss a possible merger between the two universities. Vassar would sell off its Poughkeepsie campus and relocate to New Haven. He kept the plan quiet, knowing it would be an academic bombshell.

But word got out, and news of an impending "royal marriage" drove Vassar's alumnae to near hysteria. "How unthinkable," one wrote to the alumnae magazine, "to change this quiet and beautiful atmosphere for a huge city complex with its pressures and tensions." Professors were similarly opposed, fearing they would be overshadowed or supplanted by their Yale counterparts. A headline in *Life* magazine echoed the growing sentiment: "How Dare They Do It?"

The undergraduates, though, were intrigued. Sure, they might lose their identity as Vassar students. But "saving ourselves for Yale" would now be a cinch, minus the three-hour round trip. Some took to singing "Boola Boola," the Yale fight song, on the quads. A survey in the spring of 1967 asked students: "Would the presence of men in class improve the quality of discussion?" and "Do you think that the absence of men in Vassar classes involves any important loss in perspective?" Sixty-eight percent said "yes" to both.

Like most everyone at Vassar, Meryl followed the fracas closely. Few students believed the Yale merger would really go through. The relocation would be

costly, and those pearl-clutching alumnae might write Vassar out of their wills, to the detriment of students on scholarships. But most of them liked the idea nonetheless, including Meryl.

"I really think they should move to New Haven if we are going to catch up, or maybe loosen up as much as, say, Antioch or even Swarthmore," she wrote to Mike. "It's really so unnatural, especially the social relationships. Hectic, frantic, rushed, etc etc. Now they have affiliations between certain colleges at Yale and houses here at Vassar. That sets up an easier way to have, you know, friends-lovers instead of weekend LOVER babies."

On November 12, 1967, President Simpson informed President Brewster that the Vassar-Yale study was dead. Burying his thwarted enthusiasm, he proclaimed: "Full speed ahead in Poughkeepsie!"

But how? The idea of creating a coordinate men's college still hovered. Then came a dramatic reversal: on May 30, 1968, the faculty voted 102 to 3 in favor of admitting men to Vassar. This option had received minimal scrutiny, but it now seemed like the least apocalyptic scenario. Had Simpson not pursued the Yale merger with such brio, the elders of Vassar might never have considered coeducation. On July 11th, as the students were enjoying the summer of '68, the board of

trustees approved the plan. Starting in autumn, 1970, Vassar would admit men for the first time since World War II.

"Vassar to Pursue Complete Coeducation; Method and Cost Under Consideration" ran the front-page headline in the *Miscellany News*, Vassar's student newspaper. As the fall semester began in 1968, the students were abuzz with excitement, angst, even droll curiosity. In a *Miscellany News* column titled "Vassar Men—Facing a Comic Doom," a student named Susan Casteras imagined life for the incoming males. How would a "6 ft. 2 brawny superman" fit into a "female-tailored bed"? Would the bathtubs have to be rescaled to fit more "Amazonian proportions"? "Meals, too would have to be replanned to avoid a starvation diet image. One delicate scoop of cottage cheese on two wilted lettuce leaves, one 3 inch square of meat, one wiggly slab of red jello, and a glass of ice tea (with or without the lemon) are not the stuff of which wonder-strong men are made."

As 1968 turned into 1969, the women of Vassar steeled themselves for the coming boy invasion. But men were far from the first thing on Meryl's mind. Now a sophomore, she was busy acquiring a "genuine sense of identity." And part of that identity was the ability to

become someone else. She was discovering acting, and the Drama Department was about to discover her.

Another metamorphosis.

Mike Booth had begun to dread coming home. He knew that everyone would look at him differently. It didn't matter that he was against the war, or that he'd been a medic: he'd be branded a "baby killer." Plus, he had gotten used to adventure. Tuy Hoa was starting to feel like where he belonged, if he belonged anywhere.

In late July, 1969, he was on a layover somewhere between Vietnam and home. He had stopped at Fort Lewis for a fresh uniform, an airplane voucher, and one last terrible Army haircut. The televisions in the airports were still playing footage of Neil Armstrong landing on the moon. But Mike didn't share the rest of the country's euphoria.

"It didn't mean anything for me, except I felt like the astronaut," he recalled. "After being in Vietnam for a year and a half, I was in an alien world. Except, instead of being in a spacesuit, I was encased in all my memories." *God,* he thought, *I wonder if I'll ever be what they call normal again.*

He hadn't told his family which day he was arriving, because he didn't want a welcome party. When his

mother saw him at the front door, she was overwhelmed. She sat him down and related all the town gossip: who was sick, who was pregnant, who was having money problems. Jet-lagged, Mike was on the verge of falling asleep when she said, "Oh, and one more thing."

"What's that?"

"Meryl's been calling here every day, wondering when you're coming home."

When she walked in the door, he was astonished. Two years had elapsed since they'd seen each other. Her look had become bohemian: hoop earrings, jeans, sandals, and a backless Indian-style blouse, her yellow hair now down to her waist.

Holy cow, he thought, *she's not a girl anymore.*

He told her about the hospital and Buddhist temples and riding motorcycles. She told him about Vassar and drama class and what books she was reading. He couldn't get over how beautiful she was, how confident and self-possessed. To his surprise, she acted like they had never broken up. They started seeing each other every few days, driving around Bernardsville to their old haunts. In the back of his mind, he kept thinking, *What the hell is she bothering with a guy like me for?*

It was as if nothing had changed. Except something had. In their letters, they had communicated their deepest longings. But in person, they felt distant. Mike

was restless, not sure what to do with himself. Most people were hesitant to ask him about Vietnam, and when they did, he didn't know quite what to say. The younger kids in town looked at him suspiciously. His elders—the men who had fought in World War II—would slap him on the back. But that didn't feel right either.

Meryl had changed, too. In conversation, she would casually mention the college guys she'd been seeing, like Bob Levin. Mike didn't understand why. He just knew that she was holding back, and so was he. After a while, he asked why she kept coming to see him, then telling him about her other boyfriends. She told him she didn't know what he was really thinking—he'd broken up with her before, and he had barely written to her when he was gone, despite all her letters. "I realized how cowardly I had been with her," he recalled, "because I wasn't going to come out and really let her know how I felt about her. She was kind of playing the same game with me that I was with her."

Mike needed to get out of town. It didn't matter where—his parents' house was too quiet, and Bernardsville was too small. Having missed the Summer of Love, he decided to hitchhike out to San Francisco. Maybe he could still get a taste of it, or at least another adventure. At the end of the summer, Meryl drove him

an hour down Route 22, to Easton, Pennsylvania. He gave her some things he'd gotten on a thirty-day leave in India: a silk brocade, an ivory carving of Shiva.

Before he got out of the car, she gave him a kiss and said, "Don't forget to write when you're out there."

"Sure," he said. But he knew that he wouldn't.

One day in drama class, Meryl delivered a Blanche DuBois monologue from *A Streetcar Named Desire*. A thickset man with a bushy mustache came rushing up from the back of the room. It was the teacher, Clint Atkinson.

"You're good! You're good!" he told the stunned young Blanche.

He handed her a script. "Read *Miss Julie*," he said.

She looked down at the words from August Strindberg's 1888 masterpiece. Sure, she had gotten the leads in the high school musicals. But this was no Marian the Librarian. Nothing in her experience seemed to match up with that of Strindberg's heroine, a tortured Swedish aristocrat. At least, not at first. But as Meryl read, Atkinson's eyes widened. He saw something in this lissome twenty-year-old, something that she had not yet seen in herself. He had found his Miss Julie.

He went to the head of the department, Evert Sprinchorn, and told him he wanted to do *Miss Julie*. Sprin-

chorn balked: "You can't do that!" Unlike Atkinson, who was a working director, Sprinchorn was an academic, and a Strindberg scholar at that. Atkinson was up for contract renewal, and Sprinchorn was certain he was trying to butter him up by suggesting a Strindberg play.

But he knew that it wouldn't work. For one thing, he told Atkinson, there are only three characters. To fulfill the student demand, they'd need something with at least five or six parts. Besides, the role was much too demanding. Miss Julie is a psychological minefield, a woman self-immolating from the pressures of her class and the fire in her heart. Playing games with her own authority, she seduces—or is seduced by—her father's servant, Jean. Miss Julie is a rebel, a lady, a lover, and a mess. And she has to carry the entire play. What undergrad could pull that off?

Atkinson pleaded: "Why don't you come to a reading tonight and see what you think?" Sprinchorn agreed. Hours later, he and Atkinson were sitting side by side in the student greenroom, watching Meryl Streep read the part of Miss Julie.

Within ten minutes, Sprinchorn leaned his head in to Atkinson's: "Go ahead with it."

Lights up on the kitchen of a Swedish country manor. It's a midsummer night, and Miss Julie is causing her

usual scandal at a dance nearby. Waiting in the wings to make her entrance, Meryl watched the two actors playing the valet and the cook, gossiping about the mistress of the house. ("Tonight she's wild again. Miss Julie's absolutely wild!") Her hands rested on her ruffled blue gown, with an opulent bow atop the bustle. Her lemon-colored hair was pinned up. It was the first serious play she had ever seen, and she was starring in it.

The student theater had once housed a riding academy, and when it rained some of the backstage rooms still smelled of the stables. In the lead-up to the play, Atkinson had asked a couple Vassar girls to go into New York to find lilacs for the set. Since it was not actually midsummer, but midwinter, they had failed. So he sprayed the theater with lilac scent, just enough to cover the whiff of horses. When Meryl heard her cue, she stepped into the light, a lilac dew settling on her brow.

Some of the drama majors, who had put in long hours at the shop, had balked at the casting. Meryl didn't appear to mind. "She just seemed much more mature than I was," said Judy Ringer (née Metskas), who played Christine, the cook. "I'm sure she was in many ways. But in terms of her acting style and her ability to access her emotions, she had much more ma-

turity than anybody else in that department. And who knows where that came from—I can't say."

On the surface, she seemed nonchalant. "I don't remember her having any particular investment in it," recalled Lee Devin, the young instructor who played Jean. Boys had yet to enroll at Vassar, and, as usual, the male roles were played by teachers or hired professionals. Onstage, Devin was her seducer, servant, and tormenter. Offstage, he tried to play professor, but she had no interest in intellectual banter. "My kind of curioso instructional pompous attitude was not for her," he said. "She just did the stuff."

But the play seemed to work a strange magic on her. "It was a very serious play, and I had no idea what I was doing, really none," she said later. "But oh, my God, it just was a place to tap into all sorts of feelings that I never had I guess admitted to myself, or felt like parading in front of a group of people."

It was as if Miss Julie's emotional landscape had unlocked Meryl's own, transforming it from black-and-white to Technicolor. Strindberg's heroine runs the psychological gamut: imperiousness, lust, entitlement, disgust, self-disgust, self-hatred, pleading, wailing, dreaming, panic—all before wandering back into the night in a suicidal trance, Jean's razor in hand. "She

is the first neurotic, with her inner self fighting, and eventually destroying, the outer shell of respectability," the *Poughkeepsie Journal* wrote in its rave on December 13, 1969. "A tall order for any actress . . . one that Miss Streep handles with surprising ease."

She was back in the zone, in the church, in the place she had visited as a child playing the Virgin Mary.

"How did you know how to do that?" her friends asked.

She had no clue.

Evert Sprinchorn had a theory about why the play so transmogrified its leading lady. "Meryl Streep, whether she knew it or not, identified with the character," he said. "Miss Julie sort of hates men. Well, there's an aspect of Meryl Streep—she's rebelling against male society."

"I loved my father," Miss Julie tells Jean, "but I took my mother's side because I didn't know the whole story. She had taught me to hate all men—you've heard how she hated men—and I swore to her that I'd never be a slave to any man." Strindberg wrote *Miss Julie* about a disappearing world, in which the old elite was falling apart in the wake of a new industrial class. Julie and Jean, according to the playwright, are "modern characters, living in a transitional era," one that throws aristocrat and servant into a deadly *danse macabre*.

In other words, it was not unlike the college campus where the play was being staged. It was December, 1969—the eve of a new decade, the eve of a new Vassar. Soon men would be in the classrooms, the dorms, even the bathrooms. Gone would be the demeaning weekend mixers, yes. But what else would be lost? Would the women of Vassar still talk in class when there were boys in the back row? Would they still leave their hair unwashed?

For those first male students to set foot on the Vassar campus, the world had gone topsy-turvy. Women were used to being in places they weren't wanted. Now men were the novelty. Men were the minority. Rarely had they encountered a world so unprepared for their existence. There were no urinals in the bathrooms. Flowery chintz drapes hung in the living room at Raymond House. (They mysteriously disappeared two days into the semester.) One aspiring bodybuilder practiced his five-hundred-pound dead lift in his dorm room, until a space was found for him in the basement. Jeff Silverman, of the class of 1972, transferred from an all-male school, dreaming of a hormonal adventure. "Being the only man—in class, at the dinner table, or just perambulating through the quad—was something we all had to get used to, just as we had to get used to seeing curlers in the morning and nightgowns at night, and

making no big deal of either," he recalled. "The rules had yet to be written. Proper etiquette was made up as we went along. At first no one knew what to say at 8 a.m. to the woman sitting next to you at breakfast. But we quickly learned that 'Pass the sugar, please' would do for a start."

The women, meanwhile, were adjusting to the sound of male footfalls in the dining rooms. For Meryl Streep, the change was acute. "The men came my junior and senior years," she recalled. "I lived in Davison and Main, and they moved in with us: demitasse, the dress code, the parietals disappeared. But so did some of the subtler eccentrics. They went underground, I think. I remember the first coed year when suddenly it seemed that the editorships of the literary magazine, the newspaper, the class presidencies, and the leadership of the then very important student political movements were all held by men. I think that was temporary deference to the guests. Egalitarianism did prevail. Vassar evolved. So did we. I think we were ready for them, the men, but I know I was personally grateful for the two-year hiatus from the sexual rat race."

In *Miss Julie*, Jean remembers growing up in a shack with seven siblings and a pig. From his window, he tells Miss Julie, he could see the wall of her father's garden,

with apple trees peeking out from the top. "That was the Garden of Eden for me, and there were many angry angels with flaming swords standing guard over it. But in spite of them, I and the other boys found a way to the Tree of Life. . . . I'll bet you despise me."

Miss Julie shrugs and says, "All boys steal apples."

Mike Booth was still restless. He had hitchhiked all the way to California. On the way back, he hiked through the Grand Canyon. For a time, he worked in a restaurant in North Carolina. Then he got a job driving a cement truck. Nothing stuck.

His mother had sent his high school transcript to a college-placement center, and every time he came back home she showered him with catalogs.

"Look! Hiram Scott College, out in Nebraska!"

"I don't think so, Mom."

One rainy night, President Nixon came to Morristown, near Bernardsville, to campaign for a gubernatorial candidate. Mike and a friend went to protest. When Nixon's motorcade arrived, he was up front, shouting, "One, two, three, four, we don't want your fucking war!" Nixon flashed a victory sign with his fingers and ducked inside the hotel. When he came out, a half hour later, the protesters were even angrier. Nixon went for

his limo, and the crowd surged forward, propelling Mike until he was five feet away from the president. He looked Nixon in the eye and chanted at the top of his lungs.

Once Nixon drove away, Mike heard someone say, "That's the guy!" Suddenly, three men in suits came over and threw him on the ground. They emptied his pockets, then hauled him inside to an empty office for an interrogation.

"Who are you working for—the Communist Party?" one of them asked.

Mike cackled. "Are you kidding? I'm a vet who just got home from the war, and I don't approve of the shit that's going on there."

They asked what he was doing at the protest.

"I was only trying to get his autograph," he snarled back. "I'm starting a local chapter of the Tricky Dick Fan Club."

The incident made the local papers. When reporters called the house, his mortified father said he had left for college in Colorado. Of course he hadn't. He was right there, even if he seemed worlds away. One week, he'd tell his parents he was going to hike the Appalachian Trail. The next, he wanted to go to Taiwan to study Chinese. All he knew was that he couldn't sit still.

Then he realized what was going on: he missed Vietnam. He missed the excitement. He missed the jungles. He missed riding into town on the back of a truck in the middle of a monsoon rain.

Meryl kept asking when he was going to visit Vassar, and finally he took the train to Poughkeepsie. He hung out with her college friends, who now included men. He drank wine—too much, probably. He was nervous. They talked poetry, and when Mike began extolling Ezra Pound, one of the guys shot back that Pound was an anti-Semite.

"I know that, but he's also a great poet!" Mike said, before pronouncing that "Ballad of the Goodly Fere" was one of the best poems ever written. But what did he know? He'd never been to college.

Before he left, Meryl told him that he should think about enrolling at Vassar, now that it was open to men.

But Mike knew it would never happen. "As a vet, I felt so out of place with all those privileged kids," he recalled. "Maybe I was insecure, but I knew Vassar wasn't the place for me."

The fall semester of her senior year, Meryl did the last thing someone bemoaning a crumbling matriarchy would do. She spent the term at all-male Dartmouth as part of a twelve-school exchange, one of sixty

women on a campus of nearly four thousand. It was the mirror image of Vassar.

When she got to campus in late 1970, she realized what she was in for. Like the men at Vassar, the women who had crash-landed in Hanover, New Hampshire, were a novelty, often an unwelcome one. "They really didn't want us here," she recalled. "There was an us-and-them feel to campus."

One day, Meryl and a girlfriend were studying in the corridor of Baker Library and had to use the bathroom, which was on the other end of the room. They could feel the eyes of male students on them, so they waited and waited, until they couldn't anymore. As they crossed the library, the boys started tapping their toes in rhythm with their footsteps. Then they started pounding their hands on the desks. "It was completely hostile," Meryl said.

Dartmouth's social scene was dominated by the fraternities on Webster Avenue. One night, Meryl's classmate Carol Dudley saw a desk careen out of a window. Moments later, two men in a drunken brawl rolled down three flights of stairs and out into the snow, wearing nothing but shorts. Meryl would balk at the women who would "bust into houses like cattle to the slaughter," disdainful of the rigid gender roles she had only recently learned to transcend at Vassar.

Academic life was similarly jarring. "I got straight A's. My eyes crossed when I got the printout," she would recall. "At Vassar they had a party in the English Department when the first A was given out in twenty years. At Dartmouth, it seemed to me, A's were conferred with ease and detachment. 'Ah,' I said to myself, 'that's the difference between the men's and women's colleges.' We made A's the old-fashioned way. We earned them. At the men's schools, they seemed to be lubricants in the law-school squeeze, and a fond alma mater was anxious to see her boys do well."

Even so, the counterculture was more visible at Dartmouth than it had been at Vassar. The boys wore their hair long—it looked like "Vassar from behind," Meryl recalled. Raggedy clothes were in, and "the social life was incredibly open," Dudley said, "because anybody could afford old T-shirts or whatever from the Army Navy store. Everybody had an old banger. And you could be totally cool without spending anything, other than drinks in the dorms, and the chip was either fifty cents or a dollar for a keg of beer."

In her isolation, Meryl took solace in the beauty of the Upper Valley. When she wasn't waitressing at the Hanover Inn, she would read on the shores of the Connecticut River, or go to Rollins Chapel to sing to herself. It was always empty. That was the way she liked it. She

tried out for a play, but lost the only female role to her best friend. She was the only woman in her dance class. In playwriting class, taught by the Trinidadian professor Errol Hill, she wrote feminist dramas: "highly symbolic, metaphorical, serious but funny" treatments of women's lib.

She may have taken some of her zeal from Gloria Steinem, who had delivered the commencement address at Vassar that spring. In a speech titled "Living the Revolution," Steinem told the class of 1970, "Men's hunting activities are forever being pointed to as proof of tribal superiority. But while they were out hunting, women built houses, tilled the fields, developed animal husbandry, and perfected language. Men, isolated from each other out there in the bush, often developed into creatures that were fleet of foot, but not very bright."

Meryl's thesis project at Dartmouth was on costume design. She spent hours on the linoleum floor of her dorm room in the Choates, sketching costumes from different periods of theatrical history: pantaloons and petticoats and corsets and bustles. By winter, she had a portfolio spanning the ages, apparitions of women she might have been, or could become.

Carol Dudley had noticed a difference between Vassar's educational style and Dartmouth's. "The women

at Vassar would tend to take notes seriously and regurgitate stuff," she recalled. "Whereas I found the men's thought to be much more freewheeling, that they had more ideas that were theirs and were willing to argue their turf." It wasn't that the men were smarter. They had been pushed to be vocal and argumentative in class, while the Seven Sisters schools still had the vestigial whiff of "gracious living."

Meryl noticed it, too. "I remember thinking, at Vassar, people would sit quietly and answer questions with judicial, thoughtful, ruminative answers," she said. At Dartmouth, no sooner did the professor start asking a question than five guys were trying to answer. "It was very inspiring. It was something I didn't have in me," she said. "The climate and the expectation were playing to the proactive."

As 1970 turned to 1971, Meryl packed her bags and headed back to Poughkeepsie. It hadn't been easy being so outnumbered by men, but those few months in Hanover had fortified her. In class, she mimicked the enterprise she had seen at Dartmouth. Before her professors even finished asking a question, she would thrust her hand up and say, "I don't even think that question is *valid*." It didn't matter that she had no idea what the question was. She had seen both sides of the

gender looking glass, and as any Alice in Wonderland knows, things only get curiouser and curiouser.

Professor Atkinson couldn't stop putting her in plays: Brecht's *The Good Woman of Setzuan*, Molière's *The Miser*. In March of her final term, she was in *The London Merchant*, George Lillo's tragedy from 1731. Atkinson chose the play in part because it offered a good role for Meryl: Sarah Millwood, a prostitute who coerces her lover to steal for her. He winds up murdering his uncle, and the couple is sent to the gallows.

Once again, the action onstage mirrored the gender war in the dorms. Disparaged as a "deceitful, cruel, bloody woman," Millwood unloads on the male sex: "Men of all degrees, and all professions, I have known, yet found no difference, but in their several capacities; all were alike wicked to the utmost of their power."

Meryl tapped into the rage she had displayed in *Miss Julie*. Maybe she was thinking of the Dartmouth boys who had pounded their fists on her way to the library bathroom. Or maybe the times had gotten to her. The previous April, President Nixon had authorized the invasion of Cambodia, and the escalation was hotly debated on campus. Meryl had gotten a taste of the antiwar movement at Yale, where she and Bob

Levin hung "We Won't Go!" signs as students heckled them from their dorm windows. But at Vassar she felt disillusioned by the rallies and the bonfires—they all seemed to be dominated by boys, who were still a minority. When Meryl saw them holding forth on the quad, they reminded her of Abbie Hoffman wannabes, performing for a swarm of adoring girls. It was theater, but not the good kind.

Whatever was driving her, it erupted like lava during her final speech in *The London Merchant*. "The audience was just cheering as if it was an operatic aria," said Evert Sprinchorn, who played the merchant Thorowgood. "When I read descriptions of nineteenth-century plays, it sometimes says, when there's a piece of bravura acting, 'The audience rose *at* her.' Well, when I was onstage with Meryl Streep I felt exactly that—the audiences rising at us."

The *Miscellany News* agreed: "Meryl Streep coos, connives, weeps and screams her character alive," it raved. "It is a roll [sic] with which Ms. Streep is familiar. Through her performances as 'Miss Julie,' Moliere's Frosine of 'The Miser' and now as Millwood, Ms. Streep is acquiring an image."

Despite the praise, Meryl kept wondering whether acting was a legitimate way to make a living; for a time, she couldn't decide whether to major in drama or eco-

nomics. But Atkinson believed in her, enough to bring her to New York before she had the chance to graduate. In April of 1971, she made her professional debut, in Atkinson's production of Tirso de Molina's *The Playboy of Seville*, an early Spanish dramatization of the seductions of Don Juan. Meryl played the peasant Tisbea, one of his conquests.

The play went up at the Cubiculo Theater, a subterranean seventy-five-seater nicknamed The Cube, on Fifty-first Street off Ninth Avenue. It wasn't the cleanest part of town, but it was New York. Atkinson had brought a handful of Vassar girls down on their spring break, the talented ones like Meryl who could hold their own against the pros.

Philip LeStrange was a New York actor playing Catalinon. He had acted with Meryl at Vassar, in *The Miser*, and she seemed to him like someone without a care in the world. Backstage, the girls would tally the laughs they were getting night to night—one of them even kept a chart, which she'd check off during the scenes. But Meryl wasn't counting. Meryl was watching. The same was true of *The Playboy of Seville*. "Even in production," LeStrange said, "she would be at a vantage point where she would be, again, watching."

What did she see? Among other things, she saw Mi-

chael Moriarty, the thirty-year-old actor playing the title role. Erratic, handsome, with a high forehead and intense eyes, Moriarty had a quavering, disassociated voice, like he was about to snap. He played Don Juan like a cool cat, almost bored to death.

He didn't make it through the three-week run. Midway through, he got cast in a Broadway show and quit. Unlike *The Playboy of Seville*, it was a paying gig. Atkinson scrambled for another Don Juan and found one, albeit with a completely different approach to the part. For Meryl, it was a glimpse at the winds of show business, and far from the last time she'd cross paths with Moriarty.

She returned to Vassar, still unsure what to do with her life. She knew she was good at acting; her friends in the second row at *Miss Julie* had told her so. But when she thought of her holiest moments onstage, her mind kept returning to Sondra Green's speech class.

Meryl had become one of Green's most beloved students at Vassar. She was one of five handpicked for Green's advanced class in "the fundamentals of speech." Green didn't like improvisations, but she was curious about what Meryl would do with the assignment she had in mind.

"I had never given it to anybody before and I never

gave it to anybody after," she recalled. "I told all the students I was going to go pick up my mail, and I would be back in five minutes, so they had that much time to prepare the improvisations I would assign to them. It doesn't matter what I told the other students. With Meryl, I told her to simply get up on the stage and that she would be taking her final curtain call after fifty years in the theater." Think of Helen Hayes, Green told her.

When she came back, she had Meryl stand onstage behind a curtain. She instructed the other students to applaud wildly and yell "Brava!" The curtain opened, revealing a girl of no more than twenty-one. But she carried herself like a woman of sixty years or more, someone who had taken countless curtain calls on countless stages.

She stepped forward, clasping her hands and bowing regally to her audience of five. Then she opened her arms and gave a speech.

"This is as much your curtain call as it is mine," she said grandly. "We have done this together, through all of these many wonderful years . . ."

Green was transported. So was Meryl, who was in tears.

"I'd never made myself cry before, even when I

wanted to, you know, to get something when I was younger," Meryl recalled, many years, and many curtain calls, later. "I was never able to do that, but this really killed me . . . It was just sort of a glimpse into an imaginative leap that I thought, Ooh, you know, you can thoroughly sort of lose yourself in this thing."

She had gone back into the church of make-believe—and discovered herself, fifty years in the future.

Mike Booth had finally found another adventure. His mother, in her unyielding quest to get him to move on with his life, had shown him a catalog for the University of the Americas, in Mexico. On the cover was a picture of two snowcapped volcanoes, Popocatepetl and Iztaccihuatl. It looked beautiful. It looked like a place where he could get away from the past.

Back home on break, he got a job at a shoe store in downtown Bernardsville. A few days after he started, Meryl walked in the door. In her scarf and long coat, she looked worldlier somehow. Her cheerleader skip had become a swagger.

They met up a couple times, just as friends. Mike no longer felt like the sad sack he'd been when he first came home. Now he was a swashbuckler, a globetrotter. And he had met a girl in Mexico. He made sure

to mention her to Meryl when they were back at his place.

"She's beautiful, and she's half-Mexican," he said, thinking back to the summer she'd bragged about her Ivy League suitors.

"Really?" Meryl said, perhaps with a flicker of regret. They had watched each other change over these breaks in Bernardsville, each time drifting further and further apart. Back in high school, their world had been so small and safe. Now they no longer made sense together. The boy she had once confided in about James Joyce had found a new chunk of the world to get lost in.

But she had found something, too, something just as entrancing and all her own. On one of their breaks, she had told him excitedly, "I finally did some acting at Vassar."

"No kidding."

Meryl said she'd been in a play called *Miss Julie*. She'd been covered in fake canary blood, and all her friends had come and laughed their heads off.

"Can I do a scene for you?"

Mike snapped to attention as Meryl transformed into Miss Julie at her most withering, after Jean has defiled her: "You lackey! You shoeshine boy! Stand up when I talk to you!"

In hindsight, Mike wondered whether she had chosen the scene for a reason. Was some of Miss Julie's

rage directed at him—latent anger or disappointment about the way things had worked out between them? As he watched, the source of her emotions didn't occur to him. He simply marveled. He hadn't seen her do any acting since Daisy Mae. Nothing like this.

Man, he thought, *has she come a long way.*

She graduated from Vassar on May 30, 1971. The commencement speaker was Eleanor Holmes Norton, the black feminist leader and future congresswoman. Still wondering whether she should apply to law school, Meryl returned to the Upper Valley. Some friends of hers had started a theater company in New Hampshire. She was all set to join them, until she found a better offer.

One day, she and her friend Peter Maeck, who had been in her playwriting class at Dartmouth, were flipping through the campus newspaper and saw an ad for a new summer-stock company called the Green Mountain Guild. It paid $48 a week—not bad. Peter and Meryl drove to Woodstock, Vermont, to audition. They both got in.

Its founder was Robert O'Neill-Butler, a theater professor who ran the company with his younger wife, Marj. O'Neill-Butler was grand and a bit tyrannical. The actors, who called him "O-B," could never quite

tell if he was British. Offstage, Meryl sang jazz standards she'd learned from her mother and played with O-B's six-month-old son, whom she nicknamed Crazy Legs.

They would travel from town to town, putting on plays in Stowe and Killington and Quechee, sleeping in lodges and bunkrooms, everyone crashing together commune-style. One night as they all went to bed, Maeck deadpanned, "So this is the theater." They all cracked up in the pitch-black.

Nothing felt serious, especially acting. In John Van Druten's *The Voice of the Turtle*, Meryl and Peter Maeck had to eat milk and cookies. In the middle of a scene, Meryl raced offstage, then walked calmly back on and said, "Sorry, I had a cookie stuck in my throat. Now, where were we?"

O-B assigned them *Affairs of State*, a hoary 1950 boulevard comedy. Peter Parnell, another Dartmouth friend, was playing a politician who falls in love with his secretary. Meryl played the secretary, a part Celeste Holm had originated on Broadway. Left to their own devices, the young actors found the script so old-fashioned that they secretly rewrote it as a campy genre parody, with Parnell imitating Cary Grant and Meryl doing mousy-secretary-turned-bombshell. When O-B showed up on opening night, he was aghast—but too late to stop them.

As the weather cooled, O-B transformed the summer-stock company into winter-stock. Meryl and three other actors moved into an old farmhouse in Woodstock with a mile-long driveway. When it snowed, which it did almost constantly, the place felt like a colonial homestead, something out of a fairy tale. "It was really quite idyllic," Maeck recalled. "We'd rehearse right in the house and cook for each other and have friends over. It was really quite the life."

They performed in ski lodges and barns and converted restaurants, storing their props on unused tray racks or whatever was at hand. The audiences were tired and sunburnt after a day on the slopes. Sometimes Meryl would hear snoring in the dark. She sold ads for the programs and wrote plays, which she didn't show to anyone. She starred in Shaw's *Candida* in a beautiful old barn, and her parents came from New Jersey to see it. On New Year's Eve, some Dartmouth friends drove up from Boston in two Volkswagen Beetles. The first day of 1972, they woke up bleary-eyed and happy.

But she was feeling restless. Fun as her little "dilettante group" was, she knew that better theater was being done elsewhere. She was ready to be a real actress, whatever that meant. On a day off, she and Maeck went down to New York so Meryl could audition for the National Shakespeare Company, a touring

troupe that operated the Cubiculo, where she'd done *The Playboy of Seville*. She thought the audition went well, but they rejected her, "which she just found crazy and unbelievable," Maeck said.

She figured if she was going to act—really act, not frolic around in ski lodges—she would have to study acting. She looked at applications for the two top drama schools in the country, Juilliard and Yale. The application fee for Yale was $15. For Juilliard it was $50, more than she was making in a week. Meryl wrote Juilliard a letter dripping with self-righteousness—something like, "This just shows what kind of cross-section of the population you get at your school."

That left Yale. Like most places, the drama school required two audition monologues, one modern and one classical. For modern, she picked an old standby: Blanche DuBois, *A Streetcar Named Desire*. For classical, something stately: Portia from *The Merchant of Venice*. "The quality of mercy is not strained; / It droppeth as the gentle rain from heaven . . ."

In that snow-covered farmhouse, she drilled her speeches. The thrill of it came in switching back and forth. One minute she was neurotic, sexually frustrated, sweating in the New Orleans heat. The next, she was brainy, cool, pontificating about the quality of mercy. The thrill of it was metamorphosis. That she could do.

From Woodstock, it was a straight shot down to New Haven. In late February, the spires of Yale were just beginning to thaw in the resurgent sun. Wearing a long dress, she was greeted there by Chuck Levin, a first-year acting student. He was the brother of Bob Levin, her Yalie ex-boyfriend. Meryl and Bob had broken up when he graduated and moved to North Carolina. They had talked vaguely about marriage (cohabitation wasn't an option), but once again Meryl's father had kept her on the straight and narrow. His ultimatum to Bob: "You want to provide for her? Pay for her last two years of school." That was the end of that.

At Yale, Chuck ushered her to a former fraternity building that had been taken over by the drama school. Up a musty flight of stairs was a rehearsal room with a small wooden stage. As Chuck waited outside, Meryl stood in front of a panel of professors. She showed them Venice. She showed them New Orleans.

Peter Maeck was staring out the window of the farmhouse when he saw Meryl's Nash Rambler huffing up the snowy driveway. She popped out of the car and climbed up the steps—she was practically strutting. She fixed her glowing eyes on him and smiled.

"I knocked 'em dead."

Constance

Sigourney Weaver. Christopher Durang. Wendy Wasserstein. Meryl Streep. The talents who converged at the Yale School of Drama between 1972 and 1975 would cement those years as the school's undisputed golden age. They would work together for decades, even as Broadway and blockbusters and Pulitzer Prizes catapulted their careers. For now, they were bright young actors and playwrights and eccentrics, sewing costumes and stumbling through Chekhov amid the ivied walls of Yale.

Sound nice? It was hell.

"I feel instinctively that a school, or a place that professes to be a school, should make an effort not to judge so arbitrarily," Sigourney Weaver would say. "It was all politics. I still don't know what they wanted from me.

I still think they probably had this Platonic ideal of a leading lady that I have never been able to live up to. And would never want to."

"The first year sent me into therapy," said Kate McGregor-Stewart, class of 1974. "I was struggling to prove my worth and still be allowed to be there, because a lot of people got cut at the end of the first year. I think we went from eighteen to twelve."

Linda Atkinson, class of 1975: "They didn't take your strong points and build on them from there. The point was to destruct all of that and then find something else to build up in you. Which is sort of stupid, right? You're sort of talented, and So-and-So says, 'Throw that out the window.'"

Wendy Wasserstein called it the Yale School of Trauma.

"When I was in drama school, I was scared," Meryl would recall. "It was the first time I realized this isn't something that is fun, that it had a dark side." Yale "was like boot camp, shaving your head. It made you humble. A lot of it was breaking your spirit, and out of your survival instinct you start gathering what's important."

None of this was apparent when she arrived in New Haven in the fall of 1972, having gotten in on a scholarship. She knew she loved acting and drawing

and nature, and she told her new classmates that her favorite place in the world was the Laurentian Mountains, north of Montreal. She had just turned twenty-three.

She moved into a three-story yellow Victorian house on Chapel Street, down the street from the Yale Repertory Theatre. The house had previously been used by Alcoholics Anonymous, and occasionally someone would peer through the windows, looking for a meeting. Now it was the kind of place where students could drift in and out, living there for a few months, or a semester, or a couple. The first night, the housemates gathered in the kitchen to discuss the house rules. Everyone would write their names on the food in the pantry, they decided. Meryl would share the first floor with a directing student named Barry Marshall, along with his wife and their corgi, called Little Dog.

On the second floor was William Ivey Long, a dandyish North Carolinian who had never been this far north. Having studied Renaissance and Baroque architecture at the College of William and Mary, he had recently dropped out of a doctoral program at Chapel Hill (thesis topic: Medici wedding festivals) to study stage design at Yale under the master teacher Ming Cho Lee. He had grabbed the last strip off a "roommate wanted" flyer and was still sleeping on a cot.

Later in the semester, they would get another house-
mate: a tall, patrician beauty named Susan Weaver, who
had decided at thirteen years old that a longer name
suited her and started calling herself Sigourney. Every-
one knew her father was Sylvester Weaver, the former
president of NBC, but you wouldn't guess it from her
chaotic fashion sense: hippie rags and motorcycle jack-
ets, selected from color-coded heaps laid around her
room like garbage piles. She looked like Athena dis-
guised as a bum. At Stanford, she had spent some time
living in a treehouse. When Christopher Durang met
her, she was wearing green pajama pants with pom-
poms, which she said was part of her "elf" costume.

Now in her second year, Sigourney still baffled the
faculty. They saw her as a leading lady. She saw her-
self as a comedienne. They harped on her appearance,
comparing her to an unmade bed. At one evaluation,
they told her she looked sullen in the hallways. "I'm
sullen in the hallways because I'm not getting cast in
anything!" she shot back. When she showed up to her
voice lesson the following day in a white blouse and
pearls, the instructor sneered, "You know, Sigourney,
you don't have to be loved by everybody." For her
next evaluation, she found a piece of muslin from the
costume department, drew on a giant bull's-eye, and

pinned it to her jacket—a symbol of her sartorial persecution. "Hit me," she said.

Disillusioned, she moved off campus to get some distance from the school, and wound up on the same floor as William Ivey Long. "Oh, you've got to come and see the Cabaret," she told him his first night in New Haven. "My friends are performing in it." Soon, he was sitting at a table with Chianti bottles and checkered tablecloth, watching the strangest performance he had ever seen in his life. It was performed by two second-year playwriting students: Albert Innaurato, who was dressed as the Mother Superior from *The Sound of Music*, and Christopher Durang, in a blue taffeta evening gown. After the show, an academic with a droopy mustache sat down and started pontificating on art and the theater. It was Michael Feingold, who would become the chief drama critic at *The Village Voice*.

"I didn't know what was happening," Long recalled. "I didn't understand the theater they were doing." He was ready to pack his bags and go home.

The next day, he was in his kitchen, staring at a "blond goddess" who called herself Meryl Streep. When she heard that Long was studying design, she asked, "Would you like to see my costume sketches?" Then she showed him her drawings, beautifully imag-

ined and rendered. *Oh, my God,* he thought. *She's an actress and she draws like a dream.* Now he was really ready to bolt.

"Every class at the drama school thinks that somebody was a mistake," said Walt Jones, a directing student in Meryl's class. "And I thought it was me." Of course, most of them were worrying the same thing. But who would admit it? Better to keep your eye on your classmates and try to figure out who didn't belong. Because if it wasn't one of them, then it might as well be you.

Drama schools are founded on a dangerous kind of calculus. Attract theatrical personalities, at an age when their ambition vastly outstrips their experience, and place them in a community so small and insular that the most valuable resources—attention, praise, parts—are in perpetually short supply. Still, the Yale School of Drama fed on its own special brand of crazy, and that was thanks to one man: Robert Brustein.

With his booming voice and ironclad ideals, Brustein presided over the drama school like it was his own private fiefdom. Having made his name as the combative drama critic for *The New Republic,* he believed in Artaud's gospel of "no more masterpieces": theater should be challenging, political, and blisteringly new.

He loathed the naturalistic dramas of Arthur Miller, extolled the epic theater of Bertolt Brecht. Between semesters, he summered in Martha's Vineyard, socializing with the likes of Lillian Hellman, William Styron, and Joseph Heller. His most famous book was *The Theatre of Revolt.*

Years before he became its dean, Brustein had attended the Yale Drama School as an actor. He found the training archaic. In phonetics lessons, the students were taught to widen their *a*'s and trill their *r*'s. They listened to recordings of John Gielgud and learned to recite their lines in a "mid-Atlantic accent," which Brustein concluded to be unsuitable for the stage, since nobody lives in the mid-Atlantic except fish. "It was all fans and flutterings and bowings and scrapings and Restoration plays," he said. He dropped out after a year.

So when Kingman Brewster, the president of Yale, asked him to take over the program in 1966, he balked. The Yale School of Drama, as far as he was concerned, was one of those "stagnant ponds" where theater went to die. If he did agree, he'd need license to make sweeping changes: new staff, new curriculum, new everything. "My plan was to transform the place from a graduate school, devoted to fulfilling requirements and granting MFA degrees, into a professional conserva-

tory, concerned with developing artists for the American stage," he wrote in *Making Scenes*, his memoir of the "turbulent years at Yale."

When Brustein arrived in New Haven the next term, he was "the liberal on a white horse," according to his first associate dean, Gordon Rogoff. The new Yale School of Drama wouldn't produce "personalities," the kind you see in the movies. It would mint repertory-theater professionals who could tackle anything from Aeschylus to Ionesco. "I wanted to develop an actor capable of playing any role ever written," Brustein wrote, "from the Greeks to the most experimental postmodernists." Imagine his dismay when a promising young actor from the class of 1970, Henry Winkler, went on to become the Fonz on *Happy Days*.

Intrinsic to his vision was establishing the Yale Repertory Theatre, a professional playhouse that would work in tandem with the school. Students would perform alongside hired actors, in bold, genre-busting productions that mocked bourgeois tastes. There was Brustein's production of *Macbeth*, in which the witches were extraterrestrials who beamed in on flying saucers. There was Molière's *Don Juan*, which began with a "blasphemous ritual sacrifice"—blasphemous, because the Yale Rep had made its home in the former Calvary

Baptist Church. "The middle-class burghers were in shock," Rogoff said.

When he got to Yale, Brustein vowed to run the school as a participatory democracy. But the turbulent years—radicalism, Black Power, sit-ins—transformed him, like Robespierre, into an autocrat. By 1969, the *Yale Daily News*, which had once applauded Brustein's "open, permissive approach to dissent," was decrying his "authoritarian, repressive policies" and calling for his resignation. Brustein was defiant. "I had tried to be a mellow, reasonable administrator and had presided over uprisings, disruptions, and cancellations," he wrote. "I no longer felt very avuncular."

By the time Meryl arrived, he had alienated almost everyone. Yale undergraduates thought he was shortchanging them by not allowing access to graduate classes. Audiences were confounded by his experimental programming. Graduate students were in constant rebellion. "You know the Sara Lee slogan in the TV commercials—'Everybody doesn't like something, but nobody doesn't like Sara Lee?' " one student told the *New York Times Magazine*. "Well, around here that might be paraphrased to read, 'Everybody doesn't like somebody, but nobody doesn't dislike Robert Brustein.' "

The newly assembled class of 1975 knew, to some extent, that they were entering a cult of personality. But here was the strange thing: when they got to campus for their first semester, Brustein was gone. Exhausted by eight years of turmoil, he had taken a year off to be a guest critic for *The London Observer.* In his place sprang a cadre of petty tyrants, who were about to make Meryl Streep's first year at Yale a torment.

On Wednesday, September 13th, Meryl walked down Chapel Street to attend her first day of classes. Of her thirty-nine classmates, nine were enrolled in the acting program: four men, five women.

The curriculum, according to the official Drama School bulletin, would consist of "a highly disciplined period of training, when all students are serving in an apprentice capacity. It is during this period that the development of their talent, expansion in outlook, and artistic contributions to the theatre are evaluated." If the evaluation went awry, students could, and would, be put on academic probation, the first step toward getting kicked out altogether.

Twice a week, they would gather in the University Theatre for Drama 1, "Introduction to Yale Theatre." It was taught by Howard Stein, whom Brustein had appointed acting dean. Stein was universally beloved; he

was Brustein's buffer, the smiling, encouraging good cop you could go to in a bind.

On Monday, Wednesday, and Friday mornings was Drama 128, "Voice Training," with instruction in "correct breathing, tone production, articulation, and corrective tutorial work." On Tuesdays and Thursdays was Drama 138, "Stage Movement," for training in "acrobatics, mime, and studies in the expressiveness of gesture and body composition." This was the domain of Moni Yakim and Carmen de Lavallade, a former prima ballerina who had joined the Rep in hopes of re-inventing herself as an actress.

Meryl enjoyed these classes, with their pragmatic focus. "The things that I honestly really think about now and rely on are physical things," she said later. In movement class, they learned about relaxation and strength. In voice, they read sonnets and learned that a thought is a breath and a breath is a thought. "In the singing class, where people were not singers, Betsy Parrish said, 'It doesn't matter, singing is expression, it's undiluted, unobstructed by your brain and all your neuroses. It's pure. It's music. It comes out from the middle of you.' I learned all those things. But acting, however, I don't know how people teach acting."

And yet acting was taught, in Drama 118—the course Meryl would come to dread. Every Tuesday,

Wednesday, and Thursday afternoon, the students would file into Vernon Hall, the converted frat house where she'd had her audition. In the basement was the Yale Cabaret, a lovingly disheveled black box where the drama students could let loose and stage their own work, no matter how thrown-together or bizarre. Directly above it was a wide studio with wood floors and weak sunlight, strewn with folding chairs and costume racks. This was where Drama 118 would meet, with the goal of "establishing an Ensemble work approach" and honing specialized skills such as "improvisation, scene study, circus, elementary text breakdown, and masks," under the instruction of Thomas Haas.

"Tom Haas was Meryl's bane," Brustein said. "He was my bane, too, as it turned out. He was an unfortunate human being who had the great capacity to pick out the most talented people in the class and want to throw them out for being talented." Others had a warmer view. Meryl's classmate Steve Rowe called him "one of the luminaries"—so brilliant that Rowe followed him to Yale from Cornell, where the thirty-four-year-old Haas had done part of his Ph.D. But the class of 1975 clashed with him from the start. Privately, they would make fun of his "wall eyes": one went this way, the other went that way. There was talk that his wife had run off to join the women's movement, leaving him

with two small sons: the kind of newfangled family dynamic that would inspire *Kramer vs. Kramer.*

His personal troubles might have darkened his mood in the Vernon Hall rehearsal studio, where Haas led the first-year students in improvisational theater games. There was the subway exercise, where you had to walk into a subway car and immediately establish who you are and where you're going. There was the painting exercise, where you had to embody a classic work of art. That first day, Haas gave the class its inaugural assignment: improvising their own deaths. "He said most people didn't die well enough," Linda Atkinson recalled.

To kick off the first round of deaths, Haas called up a cocky acting student named Alan Rosenberg. Rosenberg had double-majored in theater and political science at Case Western Reserve University. His parents, who owned a department store in New Jersey, had given him a couple hundred dollars to apply to graduate schools, but he lost most of it in a poker game. With only enough left for a single application, he had auditioned for the Yale School of Drama and somehow gotten in. Like everyone else, he thought he was the mistake.

When he walked into the studio, Rosenberg saw a gorgeous young woman sitting on a folding chair. "I

was knocked out," he recalled. "I looked at her and couldn't stop looking at her." Meryl had a beauty he couldn't quite define, "like a work of art you can contemplate forever."

Unfortunately for him, she had a boyfriend: Philip Casnoff, who had joined the Green Mountain Guild in the summer of 1972. Meryl and Phil had costarred in a play by Peter Maeck, in which they alternated nights in the same gender-neutral role. After the summer, he got a job touring the country in *Godspell*, but would visit New Haven on days off. Phil had flowing hair and a Prince Charming face. As with Bruce Thomson in high school and Bob Levin in college, he and Meryl looked good together.

Rosenberg got up to perform his death scene, hiding his insecurity behind a veneer of goofiness. He performed a pantomime of a guy walking down the street who gets attacked by a swarm of killer bees. The students laughed. Success?

He sat back down and watched the others. One student pretended to set himself on fire. Another shot himself in the mouth and slowly bled to death. Then it was Meryl's turn. Her demise was one that few in the room would forget: she performed an abortion on herself. Not only was this disturbing to watch—and a

hell of a way to make a first impression. It was also timely. *Roe v. Wade* was still being argued before the Supreme Court and wouldn't be decided until the following January. In the meantime, women were forced to come up with their own solutions to unwanted pregnancies, often with tragic results.

One thing was clear: Meryl brought a level of commitment to her work that was unmatched in the room. It was "incredibly intense," Rosenberg recalled. He noticed that the colors of her face would change when she was onstage—she was that deep into the character. Rosenberg, however, had been flip. After everyone took a turn at self-destruction, Haas said, "I don't think Alan quite understood what the exercise was about."

Rosenberg went home elated and distraught. On the one hand, he'd met the woman of his dreams. On the other, Haas had asked him to be more "specific," and he was stumped. He called a doctor friend and asked for a specific way to die. The friend said: bone-marrow embolism. Back in class, Haas called Rosenberg up for a second try. He pantomimed a guy driving a car who gets a flat tire. He pulls over and tries to fix it, but the jack splits in two and he breaks his leg. Within twenty seconds, he dies. It was still flip, but it was better than bee stings. And if it didn't impress Haas, maybe

it would impress Meryl. In any case, Haas informed them, the class would be practicing its death scenes through Thanksgiving.

Slowly but surely, the students began to realize that Meryl Streep could outdo them in almost everything. "She was more flexible, more limber, had greater command of her body than the rest of us," her classmate Ralph Redpath said. She danced. She could swim three lengths of the pool without taking a breath. She made delicious soufflés with Gruyère cheese. In tumbling lessons with the Olympic gymnast Don Tonry, she surprised everyone by doing a back flip from a standing position. In fencing class, taught by the Hungarian fencer Katalin Piros, she wielded her foil like Errol Flynn. Someone asked if she had fenced before, and she replied, "Not much." Who *was* this person?

In improvisation exercises, she was more inventive, as if dozens of possibilities swarmed her head when one would do. At one point, Haas told them each to walk through a fake door and wordlessly communicate where they were coming from and where they were going. They couldn't use their faces, just their bodies. Meryl was wearing a long caftan with a hood. As she stood facing the door, she pulled her arms inside and

turned the caftan around so that the hood was covering her head. Her face was not only expressionless but obscured. "Even in the way she did the exercise, she beat us," Walt Jones said.

In Moni Yakim's movement class, the students were instructed to blow around the room like leaves in the wind. The actors wafted about, arms akimbo, trying not to make eye contact lest they burst into laughter. "All of us were blowing around the room making asses of ourselves, and she was in what looked like a modern-dance position up against the wall," Jones recalled. Another student blew by and asked, "What's up with you?" Meryl answered dryly: "I got caught on a twig."

A new phrase entered circulation: "to Streep it up." William Ivey Long defined it this way: "Take the stage. Own your character. Make us look at you." For better or worse, she was now setting the standard for her own classmates.

She undercut her burgeoning reputation with playful humor. One day after a rehearsal, she and Jones were goofing off at the piano. Jones pretended to be her accompanist in a nightclub act as she sang the Roberta Flack song "The First Time Ever I Saw Your Face." "How long do you think I can hold that note?" she asked him. He played the phrase "the first *tiiime.*" As Meryl held the note, Jones ran to the lobby and pre-

tended to make a phone call. When he got back, she was still singing "*tiiime.*" He sat down, played the next chord, and the song continued. "It was just for us," he said. "There was nobody else there."

After drilling the students' death scenes for weeks on end, Haas finally moved on. They would perform Chekhov's *Three Sisters*, but with a few twists. Each actor would pull the name of a character from a hat, regardless of gender. Meryl picked Masha, the middle sister. In their scenes, they were allowed to speak only in numbers, or to isolate a single word from each line and repeat it over and over. The idea was to find the potency within the poetry, to dive beneath language and return with pearls of subtext.

Alan Rosenberg was playing Solyony, the boorish army captain. In one scene, he proclaims that when women philosophize, the result is "nothing." Masha snaps back, "What do you mean, you dreadful man?" Meryl reduced the line to the word "what," which she hurled at Rosenberg like a fusillade of darts. "What." "What?" "*WHAT.*" "It had to be thirty times," Jones recalled. "And Alan kind of shrunk back into the floor."

In truth, he was falling into a deep infatuation.

"I was in painfully unrequited love with Meryl," Rosenberg said. Since they both lived in New Jersey, they would travel together on holidays. He visited her

over Christmas and met her family. Some weekends, they'd go to New York—maybe to catch the new Ingmar Bergman movie, maybe just to crash at a friend's place, where they'd play guitar and sing and forget to go outside. Rosenberg didn't take Haas's improv games seriously, and his irreverence rubbed off on Meryl. "She'd be a bit of a bad girl with me sometimes," he recalled. In January, 1973, they went to Washington to protest Nixon's second inauguration. Meryl wasn't as politically minded as Rosenberg, but she skipped classes to go. The faculty noted her absence.

The problem, at least for Rosenberg, was Phil Casnoff. When he visited on breaks from *Godspell*, the other students took note of his pretty-boy good looks. Not only was Meryl the perfect fencer, tumbler, singer, and improviser: she had a perfect-looking boyfriend, too. But Phil was barely around, and even when he was, he would float on the margins of the drama students' close-knit, high-stress little world. Meryl drifted closer to Rosenberg, juggling the attentions of two very different suitors: Prince Charming and the Court Jester.

Meanwhile, the *Three Sisters* exercise reached its culmination, a three-hour-long presentation for the faculty. Michael Posnick, a directing teacher, recalled, "Center stage was a sofa. On the sofa was Meryl Streep in the role of Masha with a book. She was lying down

on the sofa holding the book, reading the book. And I became aware that she was humping the sofa. And I suddenly saw something about Masha that I had never understood or seen before."

Posnick, like others, had come to realize that Meryl was up to something far more ambitious than her classmates. She was taking more risks, making stranger choices. By the spring term, the first-year students were calling themselves the Meryl Streep Class, though the phrase might have carried a tinge of resentment. And then Haas did something no one anticipated: he put her on probation.

It didn't make sense. "Our class names ourselves the Meryl Streep Class, and this asshole puts the namesake of the class on probation!" William Ivey Long said. "Of course, we all assumed he was jealous of her. Everyone was just in revolt of him because of this behavior." Rosenberg worried that it was because she was spending too much time with him. He never got put on warning, because no one had any expectations of him. With her, it was different.

"What Tom said to us is that there is nothing that she can't do, but I don't think she's pushing herself hard enough," said Walt Jones, who noticed that Haas had been in tears by the end of *Three Sisters*. "And I

remember thinking that that was bullshit. I mean, who could do more than she did?"

Even the staff was mystified. In one faculty meeting, Haas said of her talent, "No, I don't trust it. It doesn't seem to have future potential." Posnick couldn't believe what he was hearing: it was like standing in front of the Empire State Building and complaining that it's blocking the sun.

"He said that I was holding back my talent out of fear of competing with my fellow students," Meryl would recall. "There was some truth in that, but there was no reason to put me on warning. I was just trying to be a nice guy, get my M.A. and get out of drama school." Besides, she was beginning to doubt Haas's whole conception of character. "He said, 'The minute you come into a room in a play, the audience should know who you are.' I feel that the minute you leave a room, half the audience should know who you are, and the other half should be in complete disagreement with them."

Branded a problem child for the first time, Meryl burrowed into her work. The acting students were rehearsing Gorky's *The Lower Depths*, set in a Russian boardinghouse for the destitute. This was the first time the older classes at the drama school would see the first-years at work. Albert Innaurato, then a second-

year playwright, attended expecting—maybe even hoping for—a train wreck. "Everyone was saying, 'They're awful, they couldn't find anybody good. And the pretty one is just horrible. She's just really bad.'"

The "pretty one" was Meryl Streep, who was playing the keeper's wife. At the climax of Act III, she attacks her own sister in a jealous rage, pushing her down the stairs and scalding her with a bucket of hot water. In the lobby afterward, there was talk of the "charming" actress playing Vassilisa, despite the violence she had just inflicted onstage. "I knew this girl was obviously destined for something very big," Michael Feingold said, "because if you can do that and have everyone talk about how charming you are, you obviously have some hold over an audience."

Even Brustein got a taste of Meryl's abilities. In December, he flew back from London for eight days. On the afternoon of the last day of classes, the school held a Christmas party at the Cabaret. Orange juice and vodka were on the tables, and students performed ribald interpretations of fifties pop songs. After a long semester, it was a welcome opportunity to blow off steam. But, for the first-year students, it was another audition of sorts: their chance to make an impression on the all-powerful dean. In his memoir, Brustein wrote, "I took special note of a very beautiful and talented first-year

actress from Vassar named Meryl Streep." He had finally found someone with the "languorous sexual quality combined with a sense of comedy" to play Lulu in Frank Wedekind's *Earth Spirit*, though he never did get to see her in the part. What he didn't realize was how little Tom Haas cared for her supposed talents.

Relief, of sorts, came in the spring, when Haas was pulled away to direct a Brecht play at the Yale Rep. Allan Miller, an associate acting professor, came in to direct the first-years. No one was pained to see Haas go, but they were unnerved. Whereas Haas was academic, Miller was more "street." A Brooklyn guy with no appetite for bullshit, he preferred scene studies to improvisations. It was a completely different approach.

Miller had mentored a young Barbra Streisand when she was just fifteen, and later coached her during rehearsals for *Funny Girl*. When he got to Yale, he thought the student actors were "pretty intelligent" but "hardly ever visceral." He was blunt in his criticisms, and proud of the fact that he didn't filter his thoughts or lard them with tact. He was also coming off an eighteen-year marriage. Meryl was taken aback one day when he asked her out on a date. It was a Friday night, and he was going to see a show at the Yale Rep. Would she come? "She was a little weirded out by it and

said no," Rosenberg said. She told him she already had plans with her boyfriend from New York. Rebuffed, Miller asked out Meryl's classmate Laura Zucker, who accepted.

As the term went on, the students became aware that Miller and Zucker were a couple. Meanwhile, his treatment of Meryl hardened. "There was no question about her talent—she was brilliant some of the time, but cold," Miller said. He started calling her the Ice Princess in faculty meetings. In class, he would scold her for not trying hard enough. Maybe, on some level, she wasn't. But the students suspected Miller and Zucker were teaming up on Meryl. "They expressed their vociferous and vindictive feelings passively at first," Walt Jones said, "but it grew."

The semester culminated with a production of Shaw's *Major Barbara*. Miller thought that Meryl's "great galloping zeal" would be right for the title role, the moralistic Salvation Army girl who spars with her father, an arms industrialist. He cast Zucker as Barbara's mother. In rehearsal, she would glower at Meryl with a look that said: "She's not that great, *really.*" At night, she'd needle Miller: "How come I'm sleeping with the director and I don't get the part of Major Barbara?"

Miller pushed the students to ground Shaw's pro-
nouncements in rage, disgust, or self-doubt. But no
matter how hard Meryl tried, she couldn't please
Miller. "She was having a miserable time with him,"
Walt Jones said. "She didn't know what he was actu-
ally trying to say to her. She was doing everything she
could, but he was pushing her like she wasn't." The
other students were struggling, too. One actor was so
irked by Miller that he raised his fist at him, but at the
last moment punched the wall instead of the director's
face.

During one improvisation, Miller threw out a sug-
gestion and noticed Meryl shaking it off like a bad
scent, turning her back to him. "Come on, Meryl,
let it out," he urged her. "She whipped around at me
with this terrific look of both desire and pain, and then
stopped," Miller recalled. "She stopped the emotional
flow. She didn't want to be vulnerable, and that's why
her nickname was the Ice Princess."

Meryl found Miller's tactics "manipulative." She
was skeptical about the concept of mining her own
pain, believing that misery was irrelevant to artistry.
What her instructors saw as laziness or evasion was a
growing intellectual revolt against the orthodoxy of
Method acting, which had shaped the previous genera-

tion of actors. She wasn't willing to excavate her personal demons to fuel Major Barbara's. She preferred imagination—and thought that Miller's approach was "a lot of bullshit." "He delved into personal lives in a way I found obnoxious," she said later. Then again, maybe she *was* holding something back.

By most accounts, though, Meryl's Major Barbara was an object lesson in "Streeping it up." "They'd gotten rid of the artificiality," Feingold said. "This was generally true, but not everybody in the class did it with Meryl's fervor."

The Monday after the performance, the cast gathered in the studio for a formal evaluation. (The students had taken to calling them "*de*valuations.") One by one, the faculty critiqued the actors, starting with the minor parts and working up to the leads. The movement teacher would declare, "Well, you *cahn't* really move." The voice teacher would trill, "Your accent was a *disgrrrrace!*"

"It was a bloodbath," said Walt Jones, who played Barbara's father. "We were all crisped, but Meryl got it between the eyes. A final dose of Allan's vitriol he had been giving her throughout the term."

By the end, she was holding back tears. But then, so was everyone.

The students were stunned. The easiest target, they reasoned, was the most preposterous target. Meryl had delivered something that Miller couldn't recognize, and certainly couldn't take credit for. So better to tear it down, in public.

At the end of the semester, Allan Miller left Yale. So did Laura Zucker. Not long after, they moved to Los Angeles together and got married. The acting class was down one.

Meryl was torn about whether Yale had a place for her. She had friends there, including the smitten Alan Rosenberg. But her teachers had been dismissive at best, authoritarian at worst. Much of this was trickle-down from Brustein. "They were very influenced by Bob's high-handedness and meanness," Innaurato said. In the absence of a coherent power structure, the students had found solidarity in each other. "We were allowed to feel ownership of our time, of our year," William Ivey Long recalled.

In the kitchen of their yellow Victorian house, Meryl poured out her grievances to Long, whom she affectionately called "Wi'm." If she was as flawed an actress as they claimed, why stay? Then again: If she was as talented as her classmates seemed to believe, why give up?

If she had learned anything her first year, it was tenacity. Maybe if she worked hard—even harder than she had on *Major Barbara*—someone with sway would recognize her.

And then Robert Brustein came back.

On September 5th, 1973, the Yale School of Drama assembled in the University Theatre. The man who walked out onstage was known only to the third-year class, which now included Sigourney Weaver and Christopher Durang. To the rest, he had lived only in legend: the indomitable Robert Brustein, here to give his welcome address.

"It's a curious sensation to see so many unfamiliar faces gathered together in this auditorium," he said from the podium. "For the first time since I've been Dean, I find it necessary to introduce myself not only to the incoming class, but to the second year as well." He looked out over those faces, including Meryl Streep's. "Still," he went on, "you can be certain, given the small size of the school and the intimate nature of the work, that we'll all get to know each other fairly fast."

For the uninitiated, Brustein laid out his ideals— and his disappointment when they weren't met. "I still find it flabbergasting that a performer could turn down

a series of challenging roles in exciting plays, earning a decent wage among a community of artists, for a chance at a television series, a film, or a minor part in some commercial play," he proclaimed. "It's rather like a writer working all his life to be a novelist, and when a publisher finally offers him a contract for a book, rejecting the offer for the sake of a more highly paid job in advertising."

Over the summer, Brustein had become obsessed with the unfolding Watergate scandal. He even did a dead-on Nixon impression. As someone who ruled his own small kingdom with a tight fist, he was tickled by the foibles of the powerful. But the scandal troubled him.

"Some years ago," he continued, "in a spirit of optimistic renewal, some Americans were proclaiming that we were a Woodstock nation. From this vantage point, it seems more accurate to call us a Watergate nation. All of us—young and old, culture and counter-culture, men and women, politicians and artists—must bear the taint of that event."

He concluded: "The American theatre is now testing our characters, and our parts in it will determine its future. If the profession fails the test, it has joined the Watergate nation, and helped to deliver the coun-

try over to its betrayers. To change the face of theatre, then, we must change our own faces, keep the faith, and try to rekindle the light that once kept our hearts aflame."

Lofty stuff, but not everyone was sold. "He arrived with a red Mercedes that he brought from London," one of the acting students recalled. "Then he gave a big speech about how we never should go into the theater as a way to make money. I'm looking at the red Mercedes, I'm looking at this guy, and I'm thinking: Who *is* this guy?"

Brustein had decided to overhaul the acting program, which he observed was "rife with factionalism, competitiveness, backbiting." He later wrote, "My resolve was strengthened when I discovered, soon after returning from England, that the actress who had impressed me so much the previous year, Meryl Streep, had been put on probation."

Chief among his worries was the absence of a guiding philosophy. To that end, he had brought in Bobby Lewis as "master teacher." Lewis was a legend in the profession. As an original member of the Group Theatre, along with Harold Clurman, Stella Adler, and Lee Strasberg, he had helped popularize the Method in American acting. In Hollywood, he had acted alongside Charlie Chaplin and Katharine Hepburn.

Some of the students found Lewis (and Method training) old-fashioned. "There was a tradition about him that seemed dated to us," Walt Jones said, "but I don't know who we thought we were." Once again, they were getting instructional whiplash. "Every year, there'd be a coup d'état," Meryl recalled. "The new guy would come in and say, 'Whatever you learned last year, don't worry about it. This is going to be a new approach.'"

Still, it was hard to resist Lewis's Elmer Fudd voice ("I'm *whiting* my *memwaws*") or his eccentric teaching style. With his golden retriever, Caesar, at his side, he would spout anecdotes about himself and the greats: Marlon Brando, Charlie Chaplin. Then he would tell the same stories a second time, or a third. It was a wonder anyone got to act.

And yet they did, occasionally. In one class, Meryl and Franchelle Stewart Dorn performed a scene from Jean Genet's *The Maids*. They were in a dance studio the students called the "mirror room," and the two actors used the mirrored walls to reinterpret the scene, using their reflections as alternate selves. No one in the class quite understood what it meant, but Lewis was rapt.

Consciously or not, Meryl would create her characters as composites of people in her life: a vocal in-

flection here, a gesture there. Cast as an old woman in a Richard Lees play, she adopted an odd physical tic, twitching her hand like she was strumming a harp. Afterward, she told her classmates that it was borrowed from her aunt. The voice had been her grandmother's.

In November, the second-year class put on Brecht's *Edward II* in the Experimental Theatre (the "Ex"), a cramped space downstairs at the University Theatre. Steve Rowe played the title role, and Meryl was Queen Anne. She kept her focus, even when the *Yale Daily News* ran a caption calling her "Meryl Sheep."

Christopher Durang was cast as her son. "We rehearsed it for a couple of weeks and it wasn't going well," he recalled. "Now, the director had mentioned that he wanted to use a circus conceit in the staging, but when the costume parade came around, Meryl was dressed like a trapeze artist: she had beads on her chest, beads on her crotch—they made noise whenever she walked. Well, Meryl put this on and shot the director a look of daggers. She said there was no way she'd perform in that outfit." The beads went.

Meryl was determined to prove her worth to the people who mattered. One night, William Ivey Long came to drop off a costume in her dressing room and saw blood in the sink. With all the pressure she was putting on herself, Meryl had developed awful stom-

ach problems—she worried she was getting an ulcer. Before the performance, she had thrown up.

She looked at him. "Wi'm," she said. "Don't tell."

Though she had vanquished her reputation as "the pretty one," Meryl was a radiant presence on campus. Classmates could spot her from down the block flipping her lemon hair—a burst of color amid the ersatz Gothic façades. All the more remarkable, then, that her breakout role at Yale would be one for which she made herself hideously ugly.

The part came courtesy of the school's resident jesters, Christopher Durang and Albert Innaurato. Chris had grown up in Catholic schools, before majoring in English at Harvard. He had got into Yale on the merit of an absurdist play called *The Nature and Purpose of the Universe*. Albert, likewise a lapsed Catholic, had come from Philadelphia. Both were gay, and both were running away from religious backgrounds that had no place for them, finding refuge in menace. (They tended to write plays about evil nuns.) Chris showed up late for the first day of classes with a pronounced limp. Albert saw instantly that he was faking it. They became inseparable.

Unlike some of their classmates, they were too hopelessly flamboyant to hide their sexuality. "We were like

Christmas trees walking lit down the street," Innaurato said. But while Albert was openly catty, Chris was sly, with a cherub's face and a viper's wit. Brustein, who took a quick shine to him, called him a "deadly piranha with the manners of an Etonian and the innocence of a choirboy."

When a Yale gallery held an exhibition about William Blake and Thomas Gray, they were asked to write and perform a scene. They dressed as priests and mashed up fifty plays in five minutes. One minute, Chris was Laura from *The Glass Menagerie*. The next, Albert was Eleanor Roosevelt in *Sunrise at Campobello*. Then they sang Mass to the tune of "Willkommen" from *Cabaret*. Midway through, a woman in the audience said to another, "Come, Edith!"—and they left in a huff. But Howard Stein, the associate dean, thought the show was hilarious and urged the duo to perform it at the Cabaret.

Their collaboration continued with a madcap spoof of *The Brothers Karamazov*, performed at Silliman, one of Yale's residential colleges. The play was shot through with allusive glee: Dostoyevsky meets the Three Stooges, with cameos from Djuna Barnes and Anaïs Nin. They billed it as "The Brothers Karamazov, starring Dame Edith Evans" as Constance Garnett, the famed British translator of Russian classics. The audience arrived to discover that "Dame Edith Evans" had

broken her hip, and the eighty-year-old "translatrix" would be played by Albert in a mustache and a floral hat. Once again, mischief was their meal ticket: despite complaints, Howard Stein booked it for the Ex in the spring.

But there would be changes. The play was renamed *The Idiots Karamazov*, and the female roles would be played by women. That meant rethinking the Constance Garnett part. The playwrights had conceived her as a witchy, sexually frustrated hag in a wheelchair, serving as absentminded narrator. When she wasn't smashing a monocle or screaming at her butler, Ernest Hemingway, she would vainly try to make sense of the proceedings:

CONSTANCE:

The Brothers Karamazov. This is one of the greatest novels ever writ in any tongue. It deals with the inexorable misery of the condition humain. Hunger, pregnancy, thirst, love, hunger, pregnancy, bondage, sickness, health, and the body, let us not forget the body. *(Shudders luxuriously.)*

Who could pull off this grotesque tour-de-force? The answer was as inspired as it was perverse: the

pretty one, Meryl Streep. In *The Lower Depths*, she had shown that viciousness could be charming. Could she make it funny, too?

The catch: the director was the dreaded Tom Haas. When Chris and Albert suggested the idea of casting Meryl as Constance, he balked: "Have you ever *seen* Meryl be good?"

The young playwrights persisted, and got their wish.

Meryl threw herself into the role, shedding whatever vanity she had. Even as Chris and Albert wrote her more and more spastic soliloquies, Haas would leave her off of the rehearsal schedules. Silly as it was, Constance was an enormous part, and she needed time to discover the character. Was the director sabotaging her?

One day, Meryl cornered Albert at the Hall of Graduate Studies. He and Chris and Sigourney Weaver would usually gather there for meals, bouncing jokes off each other or griping about school politics. Now in her third year, Sigourney still wasn't getting any decent parts at the Rep. Instead, she found her own path, starring in whatever absurdist spree Chris and Albert were putting up at the Cabaret.

Sure enough, Meryl found them in the dining hall. "Can I speak to you privately?" she told Albert, pull-

ing him aside. "What can you do to get me to come to rehearsals? Tom won't let me in."

Albert replied that Haas had shut him and Chris out, too. The director had taken to cutting their punch lines and slowing the pace, while instructing the actors to play their scenes with dead seriousness. Startled, the playwrights went to Howard Stein, begging to be let in to rehearsals of their own play. They weren't in a position to lobby for Meryl as well. When they did mention it, Haas insisted that Meryl got worse the more she rehearsed—better to leave her on her own.

A few weeks later, Albert saw Meryl in the alley that connected the University Theatre with the Cabaret. She was visibly upset.

"What's the matter?" he said.

Meryl vented her frustration: "He won't call me to rehearsal. I was going to ask him—he wouldn't even look at me." Her speeches, besides being long, were dense with academic references, and she barely got her own jokes. "I really need work," she said.

"You know," Albert said, "I've played the part."

She had almost forgotten. "How did you do it?"

With that, Albert burst into his grand Edith Evans impersonation: "*Weeell*," he trumpeted like a drunk Lady Bracknell, "I just talked like *thiiis*."

Her mind was turning. "That's actually pretty help-ful," she said. She went home and percolated: How to make this camp caricature her own?

When she was finally invited to rehearsal, Meryl came in with a full-fledged comedic persona: the grand, erratic, batty Constance Garnett. She even fashioned her own scratchy wig and prosthetic nose, with a bulg-ing mole on the end. She looked like the Wicked Witch of the West.

Soon Constance—the framing device—dominated the play. In the first act, the Karamazovs sang a vaude-ville number called "O We Gotta Get to Moscow." One night, Meryl joined in with an obbligato. It was so funny and unexpected that it got written into the show. "You knew more because she was doing that," said Walt Jones, who composed the score. "You knew more about that character, how central she was to the event, that she was causing this play to happen in her mixed up, crazy mind."

Haas wasn't amused. He still "had it in for Meryl," Durang said. "Haas also thought Meryl took too much focus away from another character's speech at the end; Haas told her to do less. So she did." Days before tech, fate gave her a boost: Haas came down with the flu and left the second act to his student assistants, who rein-stated the original wacky tone.

"Why the fuck are *you* here?"

"*I* was supposed to be with her tonight!"

Before they could come to blows, the two men realized that Meryl was gone. Fed up with their machismo, she had slipped out without a coat. Not only was it freezing, but the streets of New Haven were dangerous after dark, with the students constantly dodging muggers after long hours in the rehearsal room. Alan and Phil went out in search of Meryl, quarreling all the while. But it was no use: she had disappeared into the New Haven night.

She and Phil had been together for more than a year, and Alan knew he was at a disadvantage. Still, he was around when Phil wasn't. They would go for weekends on Cape Cod, and he bought her gifts: glass beads, a Christmas plate from his family's department store. Meryl would confide her anxieties: she was having nightmares about professional failure, what Alan called her "abiding fear of not succeeding." She was obsessed with the book *The Limits to Growth*, about how civilization would someday exhaust the Earth's resources. Her bedroom looked out over a tranquil square, but she missed the woods of Bernardsville. "I later found out that it was the quietest spot in New Haven," she would recall. "The point is I thought it was the noisiest corner on earth, so noisy I couldn't sleep nights."

By the time Haas recovered, he seemed to have caught on to the new screwball pace. During one run-through, he sat in the audience and snapped his fingers—*Faster! Faster!*—as the actors scrambled to keep up. When they came out for notes, Meryl said, in front of everyone, "That was the most unpleasant thing I've ever been through in theater up to now."

Haas looked at her blankly. "Uh-huh," he said. "Here are the notes."

The play opened in the spring of 1974. Nutty and cryptic as it was, the students recognized it as a homegrown hit, with the irreverent sensibility they had forged at the Cabaret. Smack in the center of the action—or, rather, whipping around its perimeter— was Meryl Streep. At the end, for reasons unknown to anyone but the playwrights, Constance morphs into Miss Havisham from *Great Expectations*. In a gossamer wedding dress designed by William Ivey Long ("It was the very first time I worked with silk tulle"), she wheeled into a pink spotlight and sang a lament:

> *You may ask,*
> *Does she cry,*
> *Unassuming translatrix,*
> *Could it be she's the matrix,*
> *The star of the show,*

If so, you know
She'll never let it go . . .

Not only had caricature deepened into pathos; she was also displaying her vocal agility, melting from a Broadway belt into a fragile, floating high note on "let it go," which sputtered away like a deflating balloon. Some people assumed she was a faculty wife, an actress of fifty or sixty, at least.

The first few nights during the curtain call, as the audience howled with approval, she would wheel up and jab the front row with her cane, yelling, "Go home! Go home!" The playwrights loved the ad-lib, but Haas told her to cut it out. So the next night she mimed a heart attack and died dramatically. "We knew that she was upping Tom," Durang said.

Meryl's performance, Michael Feingold said, combined "outrageous extravagance and the completeness of belief." Nothing was fake. Nothing was hammy. Constance's delusions were perfectly reasonable to her, which made them all the funnier. Bobby Lewis thought it was the most imaginative farcical performance he'd ever seen.

Most important, she had impressed the person whose opinion really counted: Robert Brustein. The play ful-

filled his vision of antinaturalistic, Brechtian as did its leading lady. "Meryl was totally disg this part," he recalled in *Making Scenes.* "H line nose was turned into a witch's beak with a the end, her lazy eyes were glazed with ooze, he voice crackled with savage authority. This perfo immediately suggested she was a major actre wrote in his diary: "Meryl Streep, a real find."

Ecstatic, he scheduled *The Idiots Karamazov* Rep that fall.

Just as Meryl was finding validation onstag love life was getting complicated. Her two s Phil Casnoff and Alan Rosenberg, were well aw each other's existence. Her relationship with Ala vague: something more than friendship and less romance. That was enough to irk Phil, who had cast as the Teen Angel in the Broadway producti *Grease.*

Things came to a head one night in the de winter, when both men found themselves at M place. Phil had come to town on short notice, expe to spend time with his girlfriend. But she had plans with Alan. When she broke them, he mar over in a rage. The rivals got into a screaming mat

Alan decided to go for broke. One day, when Meryl was idling in his apartment, he proposed marriage. Knowing it was a long shot, he made it seem off the cuff: no kneeling, no ring. But he meant it. "I think we could do wonderful things together," he told her.

They talked about it a bit and laughed. Somehow, the conversation trailed off to another subject. She hadn't given him a yes or a no, which was, in essence, a no. Alan knew she wasn't serious about him, not like he was about her. Phil was still in the picture, and, regardless, she wasn't ready to settle down with anyone.

In February, Bobby Lewis split the class in two: half would perform Genet's *The Balcony*, the other half Saul Bellow's *The Last Analysis*. Meryl was cast as the Pony Girl in *The Balcony*, a small, kinky part for which she wore a corset, lace-up boots, fishnet stockings, and a horse's tail. Alan was the lead in *The Last Analysis*, a part that Bellow had originally written for Zero Mostel (who had turned it down for *Fiddler on the Roof*). The role intimidated Alan—he was a young man, not a rotund Borscht Belt–style buffoon.

His nerves, like Meryl's, turned physical. He became severely dehydrated, and Meryl had to take him to the campus hospital. After a few days of bed rest, he returned in time to perform. Afterward, his friends gathered backstage and congratulated him on pulling

off the impossible. But they also reported that Bobby Lewis had left at intermission. Rosenberg was incensed. At the next class, Lewis gave a detailed critique of the first act. When he started making more general observations about the second act, Alan raised his hand.

"Excuse me," he said, "but I heard you walked out of the play after the first act. So why are you talking about the second act?"

Lewis admitted it. He hadn't liked the direction.

Alan's face went red. "Bobby, we all paid a lot of money to go to this school," he said. "If you didn't like the way we were directed by one of the directing students, then maybe you should have hung in there and watched the play. Maybe we could use your help!"

After leaving the class in a huff, he went to Howard Stein and told him that he was withdrawing from the program. Two days later, he packed up his apartment. There was no time for goodbyes, even with Meryl. And yet he knew that the blow-up with Lewis was just a front. Had Meryl accepted his proposal, he could have endured all the pressure and the egos and the bullshit. Without her, what was the point?

"What I was really running away from," he said, "was her. And my feelings for her."

The acting class was down two.

The Yale rep ended the spring season with a *ribbit*. In London, Brustein had asked the Broadway director Burt Shevelove to stage a musical version of Aristophanes' *The Frogs* in the swimming pool of the Payne Whitney Gym. The show would serve as a frivolous postseason lark, and a chance to make some quick money for the Rep.

To compose the songs, Shevelove enlisted Stephen Sondheim, with whom he had written *A Funny Thing Happened on the Way to the Forum*. At forty-four, Sondheim was midway through a run of landmark musicals, including *Company* and *Follies*. With Sondheim came his orchestrator, Jonathan Tunick, and with Tunick came a full orchestra. Soon the postseason lark became a splashy extravaganza with a cast of sixty-eight, including twenty-one swimmers in frog costumes and netted jockstraps, drafted from the Yale swim team.

To fill out the chorus, Brustein grabbed whatever drama students he could find, including Christopher Durang, Sigourney Weaver, and Meryl Streep. No one knew quite what was going on. "I remember coming in, getting in that pool, sidling up to Chris Durang, and saying, 'What's happening?'" Kate McGregor-

Stewart recalled. "He said, 'I don't know!'" Bored and amused, the chorus members joked about throwing Sondheim in the pool. Ralph Redpath, who had played Ernest Hemingway in *The Idiots Karamazov*, got Meryl to teach him the butterfly stroke.

Sondheim, who found the whole thing mortifyingly unprofessional, saw Brustein as a sneering academic without producing chops. (It didn't help that Brustein had criticized Sondheim's work in print.) Brustein, meanwhile, was aghast at how lavish the show had become, complete with a clown car full of Broadway-size egos. One day at rehearsal, he publicly thanked the company and crew for their hard work. Afterward, Sondheim blew up at him for neglecting to thank the musicians. On top of that, the acoustics of the pool were awful, to the point that Sondheim added a lyric to the opening number: "The echo sometimes lasts for days . . . days . . . days . . . days . . ."

On opening night, a tony Broadway crowd, among them Leonard Bernstein and Harold Prince, descended on New Haven in a circus of air-kissing and quarreling over seats. To Sondheim's unpleasant surprise, Brustein had invited the New York critics, including Mel Gussow of the *Times*, who compared the show favorably to "a splashy M-G-M epic." Had he focused his

attention on the bleachers to the left, he would have noticed a slender blonde dressed like a Greek muse, consigned to the chorus for one of the last times in her life.

Despite rapturous reviews, *The Frogs* garnered some backlash. A neurologist from the medical school wrote Brustein an angry letter, complaining that the "scanty" costumes exposed the swimmers' backsides. "In your outrage and embarrassment over the bare buttocks of the swimmers," Brustein replied, "you apparently failed to notice that the show also featured an exposed breast of one of the actresses. Whatever your preference for male behinds as opposed to female mammaries, I hope you will agree that, in this time of equal rights for women, your failure to take note of this fact is an insult to the opposite sex." Meanwhile, the New Haven Women's Liberation Center complained that the show treated women as "sex objects." Brustein retorted, "I think your satire on the humorlessness of the extremist elements of our society is priceless."

The mocking tone was indicative of Brustein's feelings toward second-wave feminism. The go-to response was disdain. When *Ms.* magazine sent him a survey with questions like "How many plays about women have been produced at your theater?" and "How many plays at your theater were written or directed by

women?" Brustein sent back a scoffing questionnaire of his own: How many articles by or about men had they published? How many of their editors were men?

Brustein's contempt made life difficult for a first-year playwriting student named Wendy Wasserstein, who had arrived in the fall of 1973. The product of a middle-class Jewish household in Brooklyn, Wasserstein was frizzy-haired, zaftig, and effusive. Having studied history at Mount Holyoke, she was interested in writing plays about women's lives, but her jokey, naturalistic style clashed with Brustein's avant-garde ideals. He would openly question her admission to the school, calling her work "sophomoric"—never mind that Christopher Durang, whose work was overtly sophomoric, was one of his favorites. In class, she didn't fare much better. At the first reading of what would become *Uncommon Women and Others*, one of the men said, "I just can't get into all this chick stuff."

Wendy hid her insecurity—about her weight, her talent—behind a girlish giggle. Even as her mother called every day at seven a.m. to ask if she had found a husband, she was neglectful of personal hygiene, spending weeks on end in the same velvet dress with a rose embroidered across the bosom. Like Sigourney, she was uninterested in (and incapable of) dressing the way people expected.

She was most comfortable around gay men like Chris, with whom she instantly bonded. They had a writing seminar together, and Chris noticed Wendy zoning out during class. "You look so bored, you must be very bright," he told her after class. (Decades later, she put the line in her Pulitzer Prize–winning play *The Heidi Chronicles*.) They started swapping notes on their messed-up families. "She had her own sadness inside her," Durang said, "but I didn't see it back then."

Women were more nervous around her: everything they feared about themselves she wore on the outside. "There was something about Wendy I found very scary to me," Sigourney told Wendy's biographer. "She was a more naked version of the vulnerability I felt."

Meryl was exactly the kind of woman Wendy spent her life avoiding: the tall, thin, blond shiksa goddess who seemed to breeze through life. She was inclined to distrust such women, who she imagined wanted nothing to do with her. But Meryl was kind, and Wendy would later rank her as No. 8 on her list of "Perfect Women Who Are Bearable." "She'll never pass you a poison apple," she wrote. "Meryl just goes about her business."

On costume duty, required of all the drama students, Meryl and Wendy mended dresses and cracked each

other up. But there was a quality to her laughter that unsettled Meryl: it seemed less a genuine release than a contrived offering to the general bonhomie. "To me she always seemed lonely," Meryl would recall, "and the gayer her spirits and the more eager her smile, the lonelier she seemed."

Meryl stayed in New Haven for the inaugural season of the Summer Cabaret, an off-season outgrowth of the student-run theater. Those who remained staged ten (barely rehearsed) plays in ten weeks. One week, Meryl was Lady Cynthia Muldoon in Tom Stoppard's *The Real Inspector Hound.* The next, she was Beatrice in *Much Ado About Nothing,* or the bitter sister in Durang's *The Marriage of Bette & Boo,* for which the Cabaret was transformed into "Our Lady of Perpetual Agony Catholic Church and Bingo Hall." The costumes were whatever junk William Ivey Long found lying around, and the sets were held together with spit and luck. Before a performance of *Dracula Lives,* the smoke machine ran out of juice, and the gang replaced it with drug-store mineral oil, which turned the entire theater into a greasy, acrid swamp.

Without air conditioning, the Cabaret was sweltering. Nevertheless, some company members squatted on the third floor, until the campus police kicked them out. On Saturdays, Meryl would make French toast for

everyone at her apartment off campus. Before shows, they would serve Junior's cheesecake and soda, clandestinely sweeping cockroaches off the plates before setting them down. Then they'd stay up late cleaning for the next day. At their favored pub on Chapel Street, they practiced "the Yale Stretch": whenever they were about to badmouth someone, they would crank their heads around to check who might be in earshot.

One week, the company was so exhausted that they decided to put on something completely improvised. The result was *The 1940's Radio Hour*, a wartime spoof. Dressed in fedoras and fur coats (which nearly gave them heat stroke), the actors made up the show as they went, speaking into vintage RCA microphones and hurling crumbled Styrofoam over their heads to signal snow. Meryl's solo was the 1938 standard "You Go To My Head." "You melted when you listened to it," said Walt Jones, who eventually brought the show to Broadway, sans Meryl. By the second night, the line was around the block. Nobody knew how word of mouth had got out that fast.

Amid the frolic, Meryl was looking toward her future. Bobby Lewis hadn't taught her much about acting, but he had found her an agent at the newly formed ICM: Sheila Robinson, one of the firm's only African-American reps. Meanwhile, through Alvin Epstein, a

veteran actor with the Yale Rep, she got her first professional voiceover gig. The married animation team John and Faith Hubley had adapted Erik Erikson's theory of the eight stages of psychosocial development into a series of cartoon vignettes, called *Everybody Rides the Carousel*. Meryl and her classmate Chuck Levin were hired for "Stage Six: Young Adulthood."

The two actors went into a recording studio in New York, where they were shown a storyboard and asked to ad-lib a scene dramatizing the conflict "intimacy versus isolation." They improvised a charming seven-minute scene of a young couple in a rowboat. When the man gets a splinter, the woman tenderly removes it with a safety pin. As they pull away, their faces transform into two-faced masks. They wonder, separately: Will they even be together in two years? The question must have reverberated in Meryl's mind, as she weighed her ambitions against the attentions of guys like Alan and Phil.

On another trip to New York, she saw Liza Minnelli at the Winter Garden. The entertainer's "straight-out, unabashed performing"—miles away from the scene studies she did in class—made her rethink her presumptions about acting.

"If I were not protected by a play, I would die," she said later. "But I learned something from watching

Liza Minnelli. Encountering and truth-telling are the initial steps of acting. But there is a further leap to the understanding of the importance of brilliance, sparkle, and excitement. 'Performing' is the final gloss. It's a means to attract the audience to your character."

In her third year, Meryl joined the Yale Rep as a company member, for which she got her Actors Equity card. Brustein, by now well aware of her gifts, cast her in the first show of the season, an adaptation of Dostoyevsky's *The Possessed*, to be directed by the Polish filmmaker Andrzej Wajda. To play Stavrogin, he hired the sinewy young actor Christopher Lloyd.

Wajda spoke through a translator—no one was quite sure how much English he understood. But he was taken with Meryl and Christopher Lloyd, and even added extra dialogue for them. He told Feingold, the Rep's literary manager, "I cut scene in Kraków, but I put back here because your actors are so much better."

With Wajda came the Polish film star Elzbieta Czyzewska, an outcast from her home country since her husband, the American journalist David Halberstam, was expelled for criticizing the Communist regime. Czyzewska had an off-center way of working that fascinated Meryl. She would end the first act by slithering across the stage and screaming at Lloyd—"*Antichrist!*

Antichrist!"—with a ferocity that seemed to make the theater quake.

But the significance of Meryl's encounter with Czyzewska wouldn't be apparent for several years. As Brustein's friend William Styron wrote his novel *Sophie's Choice*, he drew on Czyzewska's Polish speech patterns. Several years later, when Meryl played Sophie on film, her Yale classmates noticed something uncanny: there was Czyzewska, or at least elements of her, refracted through both Styron and Streep.

After Dostoyevsky, the Rep turned to a Dostoyevsky spoof: the mainstage production of *The Idiots Karamazov*. Meryl reprised her role as Constance Garnett—without the direction of Tom Haas, whom Brustein had ousted, at the urging of some of the students. Even so, tensions were high as rehearsals got under way. Christopher Durang and Albert Innaurato, Yale's mischievous Tweedledum and Tweedledee, had grown apart. The reason was Wendy Wasserstein.

Wendy's infatuation with Chris disgusted Albert, who felt he was being replaced. He would notice Wendy waiting for Chris after class like a lovesick schoolgirl, clearly barking up the wrong tree. In Albert's mind, Wendy had "poisoned" his friend, exploiting his insecurities. "When you hate yourself, and then someone comes along and loves you for the very thing you hate

in yourself, then it's very hard not to respond to that," he said later.

Brustein lorded over rehearsals, driving the cast up the wall. Even in front of Chris, who was playing Alyosha, Brustein would tamper with the script—Chris was so stressed he developed a rash all over his chest. When Linda Atkinson, who was playing Mrs. Karamazov, objected after Brustein cut one of her lines, he called out, "You can get out of my school!" "*Good,*" she yelled back from the stage. (The line in question was: "Yes.")

Even the genteel William Ivey Long, who was doing costumes, reached his breaking point. He had designed a decrepit black-lace-on-magenta number for Grushenka, the prostitute. "She's supposed to be a whore," Brustein told him. "She looks like a duchess!"

"But, Dean Brustein . . ."

"Change it!"

As Brustein walked away, William shouted, despite himself: "Fuck you, Bob!" Brustein turned around and smiled a Cheshire Cat grin.

Meryl, meanwhile, had to re-create the comedic magic of the previous year, this time in a vastly larger space. The stage was steeply raked, and Meryl was constantly on guard to keep her wheelchair from rolling away with her. One night, Durang had to reach out

and grab her before she careened into the front row. Still, she loved acting in the wheelchair: "You're limited, and it frees you."

The Rep drew audiences from far beyond the drama school, including critics from every newspaper within driving distance. Meryl's zany Constance Garnett, who had decisively taken over the play, became her coming-out. Raves came from the *Stratford News* and the *Hartford Courant*. Even Mel Gussow, of the *New York Times*, took notice: "The star role is the translator, Constance Garnett. As portrayed by Meryl Streep, she is a daft old witch (the play is daft, too) in a wheelchair, attended by a butler named Ernest, who eventually blows his brains out."

If it wasn't clear to Brustein before, it was now: Meryl was his secret weapon. The rest of the season would be all Streep, all the time, whether she liked it or not.

It's difficult being an outcast, but sometimes just as hard to be an asset. Wendy and Sigourney knew what it was like to work in the shadows, at least as far as Brustein was concerned. Meryl was now firmly on the other side, the leading lady in a professional company. In the 1974–75 season, she would act in six out of the seven shows at the Yale Rep. She was miserable.

Under Bobby Lewis, the acting department had become increasingly fractious. The second-year class rebelled after he fired three of the teachers. One student offered to audition *him*. Students were surly, or simply cut class. When Lewis put up a sign reminding them that attendance was mandatory, someone tore it down. Because of her grueling rehearsal schedule at the Rep, Meryl was missing classes as well, but Lewis was hesitant to reprimand her. Brustein was left with the "distressing job" of calling her into his office and telling her that she would have to start attending class regularly if she wanted her degree.

Juggling her multiple roles was hard enough. At the Rep, she appeared in a soap-opera satire called *The Shaft of Love*. One night, Norma Brustein—the dean's wife, who was playing her shrink—missed an entrance. To stall for time, Meryl ambled around the psychiatrist's office, inspecting props. Finally, she looked at one of the Rorschach inkblots on the wall and, pretending that her character had found some deep, horrible truth within it, burst into tears.

In the Brecht-Weill musical *Happy End*, Meryl was cast in the ensemble. Her one line, shrieked amid crowd babble, was "*Where's Lillian?*" "The incisiveness of the moment always knocked people on their asses," said Feingold. Mid-run, the soprano from the

music school who was playing Lillian lost her voice. With only an afternoon to rehearse, Meryl stepped in. Far from getting a break in a minor part, she was now the lead. Her first time going on, Brustein sat in the front row in a bright-red tie. At intermission, Meryl sent him an urgent message: the red tie was making her nervous and he needed to clear out if he expected her to make it through the matinee.

Even more stressful was a production of Strindberg's *The Father*, starring Rip Torn. Meryl played his daughter, Bertha. Torn was notoriously erratic, inhabiting his role so fully that the cast worked in perpetual fear. He would stop rehearsals to obsess over a minor costume element or prop. During a tech rehearsal, he announced that he wanted to tear down the door on the set. After yanking it from its hinges, he declared: "More resistant. It's too easy."

Elzbieta Czyzewska was playing his wife, and Torn "tended to treat her offstage with the same cruel contempt with which he regarded her in the play," Brustein recalled. "You just want the *New York Times* to kiss your ass," he would say, to which she countered, "If you care so much about this play, how come you don't know your goddamn lines?" Meryl was stuck between them, like a shuttlecock.

A student dramaturge who was keeping a rehearsal log captured the tumult. From February 1st: "Torn scares everyone by almost throwing Elybieta [*sic*] out the window." February 12th: "Torn starts his scene with Elybieta in Act II by dumping her on the floor." February 19th: "Torn preoccupied with the guns. Doesn't think captain should have an antique gun collection." Meryl, he wrote, "has been having trouble with Bertha because she feels, rightly, that although Bertha is a teenager, the lines are written for a much younger child."

Meanwhile, her status at the Rep was eroding her relationships with her classmates. The women in her class had labored for years, expecting a chance to act on the Rep stage. Now Meryl was getting all the parts. While they couldn't begrudge her her talent, they were demoralized. One actress even went to Kingman Brewster, the president of Yale, and told him, "You know, there are people that are paying to go to this school, and they're never getting a chance to *act*."

At the end of the fall term, the Cabaret once again held a Christmas show. This time, Meryl poked fun at her own ubiquity, singing a winking rendition of Randy Newman's "Lonely at the Top." "A chill went around the room," Walt Jones recalled. "It was icy."

She was back on the homecoming float, isolated by her own success.

"The competition in the acting program was very wearing," she would recall. "I was always standing in competition with my friends for every play. And there was no nod to egalitarian casting. Since each student director or playwright was casting his or her senior project, they pretty much got to cast it with whomever they wanted. So some people got cast over and over and others didn't get cast at all. It was unfair. It was the larger world writ small."

That she was on the sunny side of the street didn't make the pressure-cooker atmosphere any better. Instead, she said, "I got into a frenzy about this. It wasn't that I wasn't being cast. I was, over and over. But I felt guilty. I felt I was taking something from people I knew, my friends. I was on a scholarship and some people had paid a lot of money to be there."

She was worn down. Her costar was volatile. Her acting teacher was censuring her. The stress was roiling in her stomach. And her classmates were upset about the stage time she was getting—not that she had any choice in the matter.

Finally, she went to Brustein's office and said, "I'm under too much pressure. I want to be released from some of these commitments."

"Well," Brustein told her, "you could go on academic probation." But that was more threat than compromise; she didn't want to get kicked out of school.

Meryl had been cast as Helena in *A Midsummer Night's Dream*, the final production of the season. Could she get out of that? Brustein blanched: he knew she'd be perfect for it. Instead, he countered, why doesn't she go on as Helena and let her understudy take over in *The Father*?

"Impossible!" Meryl said. "Rip would never stand for it. He really thinks I *am* his daughter. If anybody went on in my place, even if you told him about it beforehand, he would stop the show immediately and say, '*Where's Bertha?*'"

They were at an impasse. She left the office, still booked through the end of the season.

Distraught, she went to see a school psychiatrist, who told her: "You know what? You're going to graduate in eleven weeks, and you'll never be in competition with five women again. You'll be competing with five thousand women and it will be a relief. It will be better or worse, but it won't be this."

Still, those were eleven long weeks, and the tenor of the school was more rancorous than ever. Over Christmas, Bobby Lewis had suffered a heart attack, catalyzed by the pressures of running the acting de-

partment. He asked that Norma Brustein, who had been his class assistant, take his place. The second-year students were furious that the dean's wife had been made their teacher without their consultation. They sent a telegram to a bed-ridden Lewis, describing their "surprise" and "disappointment." The *Yale Daily News* ran the headline: "Dissent Stirs Drama School."

Brustein had had just about enough. "Jealousy and meanness of spirit were rife in the School," he wrote. "I think I preferred revolution." He gathered all the second-year actors into the Ex and proceeded to pass out blank withdrawal slips. If anyone was dissatisfied, he informed them, they were free to fill out the forms and leave. No one took him up on it.

Who cared if Brustein was, in his words, a "Genghis Khan presiding over a Stalinist tyranny"? He had a school to run. He fantasized about quitting or disbanding the entire program, but Norma would tear up his resignation letters. For Passover that year, he had Meryl and Chuck Levin over for seder and discussed the turmoil in the acting program, clearly singling them out as students he trusted.

She had one more production left: *A Midsummer Night's Dream*, with Christopher Lloyd as Oberon. Despite her exhaustion, Helena was an irresistible role:

beautiful but frenzied, farcical yet melancholy. The director, Alvin Epstein, had a romantic vision, melding Shakespeare's text with Henry Purcell's score for *The Fairy-Queen*. The set featured a gigantic shimmering moon made out of popcorn, and the quarreling lovers—Helena, Hermia, Demetrius, and Lysander— would shed their costumes as the play went along, as if melting into the sylvan scenery.

Epstein was constantly arguing with the conductor, Otto-Werner Mueller, leaving little time to focus on the lovers. This concerned the four actors, who had to pull off one of the most intricate comic scenes in Shakespeare. "Alvin would never direct the scene," said Steve Rowe, who played Demetrius. "He said, 'Go off in a room and work it out.' And we did. We came back and showed it to him. And he would say stuff like, 'Well, it's coming, but I just think you look like pigs in swill. Go off and work on it some more!'"

Robert Marx, the student dramaturge assigned to the production, recorded the mounting anxiety in his rehearsal log. April 21, 1975: "lovers want more rehearsal time—the pressured schedule has led to disjoint[ed] characterizations . . . results in tense discussion with Alvin . . . general feeling of uselessness over pre-rehearsal 'talk' sessions about play . . . actors: too many scenes remain 'unsolved' for them."

April 29th: "evening: scheduled run-through cancelled . . . explosion with Otto: claims he hasn't enough time for preparing and integrating the music . . . Alvin wants to use the time to stage the chorus sequences . . . orchestra dismissed early . . . Otto threatens to resign, but doesn't . . . Staging time used for the chorus."

May 6th: "first complete run-through with live music . . . Chorus moves like death incarnate—they have no freedom of gesture or posture (and they wear the costumes very badly); the enunciation is poor; soloists are generally off-pitch . . . still some question as to how the music will integrate with the text . . . fairy costumes are awkward without being outrageous—a net of Victoriana seems to hang over the big fairy sequences . . . Meryl Streep (Helena) times her melodrama extremely well, but she seems too beautiful for the part; she should be Hermia."

By May 9th—opening night—it somehow came together: "wildly enthusiastic audience . . . everything coalesces: rustics, lovers, battles, fairies . . . cuts performed seamlessly, although the show is still running just over three hours . . . chorus moves a bit better; orchestra relatively on pitch . . . some rumblings in a few corners of the audience as to whether the play has been sufficiently dealt with from an intellectual point

of view; also, some questions about the use of music . . . general consensus—a success."

Most everyone agreed. Brustein called the production "the culmination of everything we had ever done." Linda Atkinson, who played Puck, said that it "just took off like a flying carpet." Mel Gussow, from the *Times*, found it "haunting" and "lustrous," though he added, "The production falters a bit with its star-crossed lovers. Except for Meryl Streep (who clearly is one of the most versatile members of the Yale company) as Helena, they are not quite sportive enough."

Word spread that *Midsummer* was the funniest thing in New Haven, particularly the "Pyramus and Thisbe" scene, led by Meryl's friend Joe "Grifo" Grifasi as Flute. Spectators would crowd in just to see it. "The house manager used to have to pry people away, because he was a retired fire marshal and it was a fire hazard," Feingold recalled. As Helena, Meryl made herself an awkward, teetering mess, someone unaware of her luminous beauty. Amid the reverie, the fall of Saigon, on April 30th, had brought the Vietnam War to an end, closing a nightmarish chapter for the country. The mood on campus, buoyed by the intoxicating *Midsummer*, was one of belated release.

Approaching graduation, Meryl took stock of her Yale experience. What exactly had she learned there?

There had been no cohesive training, just a mishmash of techniques. "That kind of grab-bag, eclectic education is invaluable, but only out of adversity," she said later. "Half the time you're thinking, I wouldn't do it this way, this guy is full of crap, but in a way, that's how you build up what you believe in. Still, those years made me tired, crazy, nervous. I was always throwing up."

She had an agent in New York and a fluency with diverse theatrical styles: Brustein's ideal of the repertory player. But there had been darker lessons, too. The pain of not being noticed for one's achievements. The bitterness of competition, even when you win. She had learned what happens when you succumb to powerful men and allow them to rob you of your agency.

And she learned that she was good. Really good.

Brustein begged her to remain with the company after graduation. He knew what he had, and didn't want her to sacrifice her talent to something as banal as stardom. Three days after she turned twenty-six, she wrote to Brustein, apologizing for taking so long with her decision. "The Rep is home," she wrote, "I'm no ingrate, and you've given me opportunities and encouragement that form the basis of my confidence in and commitment to the theatre." However, she continued, "right now everything in me wants to try out what I've

learned in New Haven away from New Haven. Just got to see what it's like."

On May 19th, the class of 1975 marched into Old Campus in caps and gowns. Within the sea of black, one woman stood out like a blaze of light. It was Meryl Streep, in a bright white picnic dress. Viewed from the Connecticut sky, she must have looked like a diamond glistening in the muck. Once again, Meryl had done everyone one better.

"All the rest of the women in the class went: '*Bitch*,'" William Ivey Long recalled. "'*Why didn't I think of that?*'"

Isabella

The summer of 1975 was a brutal time to start an acting career, and the graduates of the Yale School of Drama had that drummed into their heads. The country had been slogging through a recession, taking the entertainment industry and all of New York City down with it. Times Square had devolved into a wasteland of garbage and strip joints. Broadway theaters were empty, or being turned into hotels. Even day jobs were hard to come by. As Linda Atkinson sighed to the *New Haven Register* shortly after graduation, "Unfortunately, the jobs selling gloves at Macy's are getting as hard to find as acting jobs."

The math was bleak: six thousand more degrees in dramatic arts had been awarded across the country than the previous year. The cast of *A Midsummer*

Night's Dream would soon disappear into an ocean of aspiring Pucks and Hermias, each armed with a stack of eight-by-ten glossies. Many would try their luck in New York, while others fanned out to regional theaters. One Yale actor was off to Massachusetts to operate a kite shop.

And where was Meryl Streep, the undisputed star of the class of 1975? Meryl Streep, who had two degrees, four thousand dollars in student loans, and almost no professional credits to her name? Stuck on the interstate from Connecticut, an hour late to meet Joseph Papp, one of the biggest producers in New York City. *I'm twenty-six,* she had told herself. *I'm starting my career. I better make it next year.*

A lot was riding on this one, because she had already screwed up. Before graduation, the acting students had taken a trip to New York to audition for the Theatre Communications Group, which placed young actors at regional theaters across the country. The TCG audition was so important that Yale offered a special class on it. The drama students would be up against their counterparts from Juilliard and NYU, and whoever made it through the New York round would be sent to finals in Chicago. Impress the panel, and you might get hired to join a company in Louisville or Minneapolis. It wasn't New York, it wasn't Hollywood, but it was a job.

Meryl stayed over in New York the night before the audition. When she woke up the next morning, she looked at the clock and went back to sleep. She just didn't go. She couldn't stand the idea of going up against the same seven or eight people again. Perhaps she also knew that she didn't belong in Louisville. As she drifted back to unconsciousness, she could hear her classmates' voices in her head: "Gawd, where's Meryl? Oh, man, she's really fucked herself now!"

Was she finished? Not quite. Because soon after, Milton Goldman, the head of the theater division at ICM, called up Rosemarie Tichler, the casting director at the Public Theater.

"I want you to meet someone," he told her. "Robert Lewis, the acting teacher at Yale, said she's one of the most extraordinary people he's ever taught."

"If Robert Lewis says that, I'd be happy to meet her," Tichler replied from her office in the East Village. Of course, this could be Milton exaggerating, she told herself.

Days later, Meryl was standing onstage on the third floor of the Public, a mazelike red building that had once housed the Astor Library. Now it was the hub of the downtown theater world, the place where *Hair* had originated and where *A Chorus Line* had opened that April to ecstatic reviews.

Like most casting people, Tichler asked for a classic monologue and a modern one. Meryl began with the warlike Queen Margaret from *Henry VI, Part 3*, taunting the captured Duke of York:

Off with the crown, and with the crown his head
And, whilst we breathe, take time to do him dead.

Watching from the house, Tichler smiled. Meryl had captured not just Margaret's viciousness but the glee she takes in torturing her political rival. "She was," Tichler recalled, "a wonderful monster."

Then Meryl shifted her body, becoming girlish, sexy, demure. Her voice melted into a sultry Texas drawl. She was now Southern Comfort, a flirtatious twentysomething wild child from Terrence McNally's *Whiskey*.

"I grew up right here in Houston," she purred. "I was pretty, I was the national champion baton twirler and I only dated football players. Sound familiar?"

It did, to the actress onstage—this was her high school persona, the character she had played to the hilt in Bernardsville, recast as a Southern hussy.

She went on, as Southern Comfort, to describe all the jocks she'd made it with: Bobby Barton, in the backseat of his father's Ford Fairlane; Tiny Walker, who had a

blood-red Plymouth Fury with dual carburetors. All the boys were killed on the football field shortly after sleeping with her, but she described their liaisons with delectation—especially the cars.

Tichler was in hysterics. "When she talked about sleeping with them, it was always about the car," she recalled. Meryl had shown some of her chameleonic gift, but Tichler didn't know the full extent of it. "I just knew she had great beauty, she had a lightness of touch," she said. "She had grace."

A few weeks later, Tichler was casting *Trelawny of the "Wells,"* a Victorian comedy by Arthur Wing Pinero, about the ingénue of a theater troupe who gives up the stage for marriage. The show would go up at the Vivian Beaumont at Lincoln Center, which had lately become an outpost of the New York Shakespeare Festival, a sprawling entity that included the Public Theater and Shakespeare in the Park. Tichler was looking for someone to play Miss Imogen Parrott, an actress who doubles as a theater manager. She had to be charming but authoritative, good with money and at telling people what to do. Tichler thought back to the Yale actress who had done that crackling Queen Margaret and called her in for the director, A. J. Antoon.

But Antoon wasn't sold. He liked Meryl, but he liked other people, too. At her second audition at the Public,

he hadn't seen what Tichler had seen—that one-in-a-million thing. Tichler kept pushing, but Antoon's wasn't the opinion that really mattered. The person who mattered was Joe Papp, the man who founded the New York Shakespeare Festival and ran the Public and employed just about half of the actors, playwrights, and directors in New York City.

Meryl was still in Connecticut and couldn't make the normal audition times, so Tichler and Antoon had her come in for Papp after hours. Seven o'clock turned to eight o'clock, and there was no Meryl Streep. Papp was getting restless—patience wasn't his strong suit—and the sky was getting dark. As he paced, Tichler nervously kept the conversation going. She wanted him to see this girl. Where in God's name was she?

In some ways, Joe Papp was another Robert Brustein. Both were powerful, pugnacious men who started theaters, started fights, and towered over an army of artists from whom they extracted undying loyalty. Both were New York Jews educated in public schools, and both thought that theater could change the world. Between New York and New Haven, they competed over plays and actors, maintaining a (mostly) friendly rivalry.

And there, for the most part, was where the simi-
larities ended. While Brustein operated from the ivory
tower, Papp never went to college. Brustein summered
in Martha's Vineyard; Papp rented cottages on the
Jersey Shore. Born Joseph Papirofsky, to penniless
Eastern European immigrants, he had worked as a
barker at Coney Island as a teenager and sold tomatoes
and pretzels from a pushcart. After serving in World
War II, he joined the Actors' Lab in Los Angeles, where
he forged his populist ideology: theater was for every-
one, not just for the elite. Even as he fought his way to
the top of the New York theater world, he felt out of
place, a working-class *Yid* in a white-collar universe.

Like Shakespeare's best characters, he was a walk-
ing, bellowing contradiction. The critics could never
make up their minds about whether he was a cultural
paragon or an autodidactic huckster. He spoke of his
impoverished Brooklyn boyhood with Dickensian
relish, yet two of his four consecutive wives were under
the impression that he was Polish Catholic. He joined
the Young Communist League when he was fifteen and
kept his affiliation through his early thirties, but he
rarely spoke of it, wary of putting his theater's funding
at risk. As he dashed through the halls of the Public,
a trail of assistants would scurry behind, trying to

make sense of his conflicting pronouncements. He was punny, allusive. When someone burst into his office to tell him that an actor had been injured rehearsing *Hamlet*, he shot back: "Well, you can't make a *Hamlet* without breaking legs."

With little more than chutzpah (which he had in spades), Papp had built an empire. In 1954, he staged *Romeo and Juliet* in a church on Avenue D, the beginning of what he would call the New York Shakespeare Festival. His dream was to build a home for free Shakespeare in Central Park, leading him into a contentious standoff with the city's all-powerful parks commissioner, Robert Moses, who was in his seventies and had no intention of bending to the will of "an irresponsible Commie." The ensuing battle made Papp a municipal celebrity, a scrappy showbiz Robin Hood who took on the big bad commissioner and brought high art to the masses.

Finally, Moses allowed the plans for a Central Park amphitheater to move forward, and the Delacorte opened in 1962, when Meryl Streep was thirteen. The first Shakespeare in the Park production was *The Merchant of Venice*, starring James Earl Jones and George C. Scott. Four years later, Papp opened the Public Theater, in the East Village, where he would

produce bold new plays by writers like David Rabe, whom he treated as a surrogate son.

From the beginning, part of his mission was to forge an American style of Shakespearean acting: muscular and raw, nothing like the plummy British oratory of Laurence Olivier. "We seek blood-and-guts actors . . . actors who have the stamp of truth on everything they say or do," he wrote. "This humanizes the language and replaces verse-reading and singsong recitation— the mark of old-fashioned classical acting—with an understandable, living speech." His actors would look and sound like New York City itself: multiethnic and real and tough.

Although Papp kept up a face of irrepressible bravado, he was plagued by anxiety, usually over the Festival's constant money problems. His attitude was: do something big now, pay for it later. "He always felt under duress and embattled," said Gail Merrifield Papp, who ran the play-development department and in 1976 became the fourth and final Mrs. Papp. The Festival was perpetually in debt, and the fiscal worries of the seventies made the crisis an existential one. Then came a deus ex machina: *A Chorus Line*, the revolutionary musical drawn from the stories and struggles of Broadway dancers. The show opened downtown in

April, 1975, and transferred to Broadway that July. Its smash run would bankroll the Festival for years, keeping the Delacorte open and free to the masses and allowing Papp to keep coming up with crazy schemes.

One scheme in particular had him worried. In 1972, the management of Lincoln Center, the massive cultural complex that had revitalized Manhattan's West Sixties, asked him to consult in finding a new director for its theater division. The more he consulted, the more he realized he had the perfect candidate: himself. He loathed the idea of catering to well-to-do matinee ladies uptown, but the Festival was more than a million dollars in debt. Taking over the Vivian Beaumont, Lincoln Center's cavernous eleven-hundred-seat house, he could tap into the kind of cash flow that was unavailable to him at the Public. And, in the process, he could give his brood of audacious young playwrights a national platform.

The addition of Lincoln Center as his new satellite made his reach unprecedented, with outposts downtown, uptown, in Central Park, and on Broadway. Bernard Gersten, his longtime associate producer, called it Papp's "expansionist period." A 1972 New Yorker cartoon imagined all of New York City as a Joseph Papp production. But he was uneasy at Lincoln Center,

which to him represented the establishment he had spent his life fighting against. The Vivian Beaumont reminded him of a mausoleum. He didn't even keep an office there.

Lincoln Center subscribers returned his disdain. When he announced the lineup for his inaugural season—a rock musical, a "black" play, a working-class drama by David Rabe—they fled in droves. One woman, describing herself as "one of the lily white subscribers who I think you would like to drop anyway," told him: "I'm not interested in a black playwright. I'm interested in a good playwright." "We got bales of mail," Gail Papp recalled. "People protesting the production of black plays on the main stage. Really hateful kind of mail." Within a year, subscriptions plummeted from 27,000 to 22,000. Far from being a goldmine, Lincoln Center was turning into financial quicksand.

Finally, Papp relented. The Vivian Beaumont would now house the classics. He flew to Oslo to persuade the Norwegian film star Liv Ullmann to play Nora in *A Doll's House*, which opened to packed crowds. He booked Ruth Gordon and Lynn Redgrave to star in Shaw's *Mrs. Warren's Profession*. But he gnashed his teeth the whole time. None of this was why he got into theater. Downtown, he was premiering groundbreak-

ing works like Ntozake Shange's *for colored girls who have considered suicide / when the rainbow is enuf.* Uptown, he was a sellout.

He put together the 1975–76 season at the Vivian Beaumont in a hurry. Along with *Mrs. Warren's Profession*, he would transfer the Delacorte's popular production of *Hamlet* starring Sam Waterston, followed by Ibsen's *Peer Gynt.* The season would open with *Trelawny of the "Wells,"* Pinero's crowd-pleasing comedy of manners. On July 13th, less than two weeks before *A Chorus Line* opened on Broadway, the *Times* ran the headline: "Can Shakespeare, Ibsen, Shaw and Pinero Save Joseph Papp?" He should have been riding high, but he was under fire.

Trelawny wasn't just a chestnut: it was a chestnut *within* a chestnut. Written in the late 1890s, Pinero set the play thirty years earlier. According to the author, the play "should follow, to the closest detail, the mode of the early Sixties—the period, in dress, of crinoline and the peg-top trouser. . . . No attempt should be made to modify such fashions in illustration, to render them less strange, even less grotesque, to the modern eye. On the contrary, there should be an endeavour to reproduce, perhaps to accentuate, any feature which may now seem particularly quaint and bizarre." Nothing could be more antithetical to Papp's vision.

And now here he was, stuck late at work, waiting for some Yale-trained nobody—one of *Brustein's* people—to read for the part of the dainty but determined Imogen Parrott. And she was an hour late.

The same day the *Times* had run its dire headline about Joseph Papp, Meryl arrived at the Eugene O'Neill Theater Center, in Waterford, Connecticut. The O'Neill was founded in 1964 on the Hammond farm, a leafy ninety-five-acre expanse not far from where Eugene O'Neill had spent his summers. The following year, the National Playwrights Conference was established there, providing a forum for playwrights to work far away from the critical gaze of New York City. In 1977, Wendy Wasserstein would develop *Uncommon Women and Others* there. The *Times* called it "Tryout town, USA."

For young actors like Meryl Streep, Joe Grifasi, and Christopher Lloyd, it was like theater summer camp. They would sprint from play to play, rehearsing under copper beech trees and spending off hours on the beach. Lloyd was the only actor with a car, a red Triumph convertible. They bunked nearby at Connecticut College, in a dorm affectionately called "The Slammer," which Grifasi later described as "tastefully appointed with glossy enameled cinderblock, sea-green Nauga-

hyde with cigarette-burn appliqué, and each room with a curiously dappled set of linens and a humble Protestant pillow, with the plushness of matzo."

Meryl loved the open air and free-wheeling atmosphere of the O'Neill, with its "motley, idiosyncratic bunch." There was the scholar Arthur Ballet, doused in expensive French suntan oil. There was Edith Oliver, *The New Yorker*'s theater critic and a midwife of plays—a "little old lady with a smile as big as the beach." George C. White, the O'Neill's founder, presided in a white linen suit. From their chatty, exuberant suppers on the sloping lawn, she could see "the lights from the amusement park flickering across the water from the other side of the harbor, the other fun house no one had any time to visit because we were lighting up the sky from our own side as well."

Meryl would perform in five plays in four weeks— the kind of rapid-fire, improvisatory acting she had honed at the Yale Cabaret. There was no time to over-think character choices: just pick something and go with it. In *Marco Polo*, a commedia play for children, she and Grifo played twin Truffaldinos, clowning around like amateur acrobats. "When people saw Meryl in that first play, they realized she wasn't just another pair of fetching cheekbones with a goofy last name," Grifasi recalled. "No one expects a pretty girl to be that funny

or insane, but the truth is that others always find Meryl prettier than she considers herself to be."

The most alluring title that year was *Isadora Duncan Sleeps with the Russian Navy*. Meryl played Isadora, the dancer who had famously died when her long, flowing scarf got caught in a wheel of the car she was riding in. Meryl's only prop was the scarf, which she used to ensnare her many lovers before it ultimately strangled her. They had five days to stage the play, and Meryl couldn't manipulate the scarf and hold the script at the same time. So she memorized the whole play, to the amazement of her fellow actors. (A "dull" achievement, if you asked her.)

On a rare night off, she and Grifo went to see the year's inescapable blockbuster movie, *Jaws*. It was the perfect diversion in their carefree summer, the last they'd have before the entertainment industry swallowed them whole—or took a nasty killer-shark bite out of them. The next day, Meryl jumped into Long Island Sound and splashed dramatically, as if daring the great white shark to attack. Under the setting sun, she and Grifo swam out to a float bobbing in the distance. She turned to him and confided:

"I'm going to get married and have a bunch of children by the time I'm thirty-five."

Then they swam back.

Three weeks in, Meryl got a call that turned her peaceful summer on its head. She had a callback for *Trelawny of the "Wells"* at Lincoln Center. When could she be in New York? Her schedule at the O'Neill was jam-packed, but she managed to convince the Public to give her a special audition slot. She would have to get in and out of the city like lightning.

She and Grifo borrowed a car and zoomed down the highway. As Meryl drove and lit cigarettes, Grifo held the script and ran her lines. White-knuckling the wheel at eighty-five miles per hour, she calmly recited her speeches as he fed her cues, the two of them enveloped in a Marlboro cloud. As they passed New Haven, Grifo imagined the *Variety* headline: "Dead Thesps, Dreams Dashed in High-Speed Curtain Call."

By the time they pulled up to Lafayette Street—alive—she was despondent. They were so absurdly late. *They're not going to hire me*, she thought. *I'm going to go, but it's doomed.* She got out of the car while Grifo kept the motor running, like a getaway driver in a bank heist. The air was sticky, and she didn't want to start sweating, so she walked instead of ran. Not that it mattered. She was doomed.

But that's not what Rosemarie Tichler saw. Having desperately tried to keep Papp occupied as the clock ticked, she was about to give up when she stepped out-

side and took one last look down the street. There was Meryl Streep, an hour and a half late, but *walking*.

She swept Meryl inside and introduced her to Joe. After quickly apologizing for being late, she went right into the scene—no time for fuss.

Tichler watched her in awe. Here she was, fresh out of drama school, meeting the kingpin of downtown theater for the first time, late for a callback for a major part at Lincoln Center. "Ninety-five percent of actresses would get hysterical, but she just . . . handled it," Tichler recalled.

When she left, Tichler let a momentary silence linger. Then she turned to Papp and said: "That's it, right?"

Outside on the curb, Meryl hopped back into the car. She finally breathed. They would have to book it back to Connecticut.

"I saw Joe Papp," she told Grifo.

And?

"He liked me."

She was right. Meryl Streep had just clinched her first role on Broadway. And she hadn't even moved to New York.

Four years before Woody Allen romanticized it in *Manhattan*, New York City was in a rut. Budgetary

foibles and urban decay had left a miasma of neon, sleaze, and crime. Murders and robberies had doubled since 1967. Under Mayor Abraham Beame, the city was hurtling toward bankruptcy. In July, 1975, the city's sanitation workers went on a wildcat strike, leaving garbage to pile up and fester in the heat—people were worried about the health risks of flies.

Filmmakers like Sidney Lumet and Martin Scorsese captured the grime and corruption in *Mean Streets*, *Serpico*, and *Dog Day Afternoon*, the last of which opened on September 21st, just as the muggy "dog days" of summer were turning into a ruddy fall. Soon after, the city was denied a federal bailout, and the *Daily News* ran the immortal headline "Ford to City: Drop Dead." Like a dirt-smudged orphan, New York was on its own.

For Meryl Streep, who had just moved to Manhattan, it was the place to be. She had a job on Broadway and a room on West End Avenue, in an apartment she shared with Theo Westenberger, a photographer friend she had met at Dartmouth. Westenberger would become the first woman to shoot the cover of *Newsweek* and *Sports Illustrated*. For now, she found an ideal subject in her roommate, whom she shot leaning on a television in a kimono, or straddling a stool in a leopard-print jumpsuit.

Soon after, Meryl got her own place a few blocks away, on West Sixty-ninth Street, just off Central Park West. The neighborhood was rough—there were drug deals on Amsterdam Avenue all the time—but it was the first time she was living alone, free of roommates or brothers. However hazardous, she found the city glamorously lonesome.

"I got three bills a month—the rent, the electric, and the phone," she recalled. "I had my two brothers and four or five close friends to talk to, some acquaintances, and everybody was single. I kept a diary. I read three newspapers and the *New York Review of Books.* I read books, I took afternoon naps before performances and stayed out till two and three, talking about acting with actors in actors' bars."

And, unlike much of New York City, she was employed.

At her first reading of *Trelawny,* she was petrified. The company was large, with veteran stage actors like Walter Abel, who was born in 1898, the same year the play premiered. But there was a younger set, too. A tightly wound twenty-two-year-old Juilliard dropout named Mandy Patinkin was also making his Broadway debut. So was the bug-eyed character actor Jeffrey Jones. At twenty-nine, the broad-faced Harvard graduate John Lithgow was on his third Broadway

show. And, in the title role of Miss Rose Trelawny, the bee-voiced, auburn-haired Mary Beth Hurt was on her fourth.

Mary Beth was also twenty-nine, having come out of NYU's drama school in 1972. Her marriage to William Hurt, a drama student at Juilliard, had imploded just as she was finding her professional footing. In 1973, Papp cast her as Celia in *As You Like It* in Central Park, and during rehearsals she became so distraught that she checked into the psych ward at Roosevelt Hospital. "I thought that I had really failed," she said later, "that I was supposed to be the perfect wife." Papp called her every day at the hospital, saying, "We'll hold the role open for you as long as we can. Please come back."

"Once Joe loved you—and it really did feel like love; it didn't feel like trying to use someone—he loved you forever," Mary Beth said. After three days, she checked herself out and went on as Celia.

At the read-through of *Trelawny*, Meryl was trembling. At one point, she realized her upper lip was wiggling, completely independent of the lower one. A. J. Antoon had reset the British play in turn-of-the-century New York, and smack in the middle of one of her lines, she heard a booming voice: "Do a Southern accent."

It was Joe Papp.

"Yessuh," she said, instinctively modeling her drawl on Dinah Shore's. ("See the U.S.A. in your Chevrolet . . .") And suddenly her character started to make sense—an ingénue getting on in years, shifting from Southern belle to savvy theater manager, able to boss people around. Joe was right.

"The curvaceous, desperately subtle flirtation in the cadences moved me toward a way of holding myself and of moving across the room, a way of sitting, and above all an awareness, because a Southern accent affords self-aware self-expression," she said later. "You shape the phrase. Not to get too deep into it, it was a valuable choice and it was not mine, it was his and I still don't know where the hell he got the idea. This is the essence of his direction. *He's* direct. Do it, he says."

John Lithgow had met Meryl a few months earlier, at a reading of a play by a Harvard friend of his—something about hostages in Appalachia. He had noticed "a pale, wispy girl with long, straight, cornsilk hair" and an odd name. "She appeared to be in her late teens," he would recall. "She was so shy, withdrawn, and self-effacing that I couldn't decide whether she was pretty or plain. The only time I heard her voice was when she spoke her lines. She had a high, thin voice and a twangy hillbilly accent. She was so lacking in theatrical airs that I surmised that perhaps she wasn't

an actress at all." He wondered whether the play was actually based on her.

When he spotted her at the first rehearsal of *Trelawny of the "Wells,"* she was like a different person, animated and eager and confidently beautiful. As usual, she wasn't letting her nerves show. "I'd been watching actors act my whole life," he recalled. "I wasn't easily taken in. But when I'd mistaken her for a hayseed hillbilly at that play reading a few months before, either I had been a myopic fool or this young woman was a brilliant actress."

October 15, 1975: opening night of *Trelawny of the "Wells."* Meryl was backstage at the Vivian Beaumont, waiting to go on. Her upper lip, once again, was trembling. She willed it to stop, but it was no use. She tried not to think about the critics, who were out there scowling in the dark. She told herself: *My student loans are going to be paid off!*

Michael Tucker, the thirty-one-year-old actor playing Tom Wrench, was already onstage. He was nervous, too. Meryl thought of the swanning, confident woman she was about to play, and walked onstage.

"Well, Wrench, and how are you?" was her first line on Broadway.

They played the scene, a little stiffly. Then Tucker caught his sleeve on a prop, and it fell onto the table. Meryl caught it before it broke. She placed it back up.

"And from that moment everything was just fine," she recalled, "because something real had happened, and it pulled us right onto the table, into the world. And then all the work we had done in rehearsal and the life we had lived and who we were, we just located ourselves in the tactile world and there we were."

The critics had other ideas.

"Mr. Antoon has transposed the play to New York at the turn of the century. Why?" Clive Barnes practically screamed in the *Times* the next morning. "What new resonances does he get from it? Is he trying to make it more relevant to American audiences or easier for American actors? Does this make it more meaningful? Or is it merely another example of the Shakespeare Festival determination to do almost anything just as long as that anything is different. This is a folly. And symptomatic folly at that."

Walter Kerr piled on in the Sunday edition, under the headline " 'A Chorus Line' Soars, 'Trelawny' Falls Flat." "The lights are no sooner up on a theatrical rooming-house," he wrote, "than the good folk carrying the opening exposition are cackling like wild geese

to assure us that something is, or is going to be, hilarious around here." However, he added: "In the overstressed onrush, only two figures emerge at all: Meryl Streep as a glossily successful former colleague who has gone on to 'star' in another theater, tart, level-headed, stunningly decked out in salmon gown and white plumes; and Mary [B]eth Hurt, as Rose Trelawny herself, who is at the very least deeply satisfying to look at."

No doubt, the show was a turkey, at least with critics. The cast was stunned—the audiences seemed to be having a good time.

Meryl wasn't glum. Along with Kerr's peck on the cheek, the show had collateral benefits. Shortly before Thanksgiving, the screen legend Gene Kelly came and greeted the starstruck cast backstage. With him was Tony Randall, famous from *The Odd Couple*. Randall told the actors that he was planning to start a national acting company and he wanted the *Trelawny* cast to join. It sounded heavenly (though it wouldn't materialize until 1991). Still, the young cast didn't take him entirely seriously: Why wait for Tony Randall? They already felt like a repertory company. They had each other.

Meryl's new cohort included Mary Beth Hurt, with whom she shared Dressing Room No. 4. "It was full of smoke," Hurt recalled. "It was fun. We laughed.

Mandy would drop in, or Michael Tucker. Everybody was visiting everybody. The doors were open. Nobody ever shut their doors unless they were changing clothes."

And she had a new collaborator: J. Roy Helland, the production's hair designer. The son of a hairdresser, Roy had run a salon in California and moonlighted as a female impersonator before going into theater. The previous spring, he was hired to primp Liv Ullmann for the Lincoln Center production of *A Doll's House*. *Trelawny* was his second Broadway show. He was painstaking with curlers and wigs, and he knew how to soften facial flaws (say, a crooked nose) with just the right shading. Roy was appalled when the stagehands pinned up naked girlie posters backstage, so he hung up hunky *Playgirl* centerfolds in the wig room, where Meryl and Mary Beth became habitués. Roy told them that Ullmann was trying to lure him to Norway to style her for Ingmar Bergman films. The two young actresses straightened their backs and said, "Well, when *we* get to do movies, we'll take you, too!"

"He wasn't just a guy down there in the darkness doing wigs," Jeffrey Jones recalled. "He had strong opinions and good taste, and he decided immediately that she was the person to whom he would hitch his wagon." When Roy watched Meryl in rehearsal, he

noticed a professionalism similar to Ullmann's—she didn't act like it was her first Broadway show. He saw Meryl as a living canvas, someone who seemed to work from the outside in and the inside out at the same time. When she needed a touch-up, she would slink down to the wig room and yodel, "Oh, *Rooooooy!*" Soon, everyone in the cast was doing it.

Meryl Streep came to New York with a primary goal: not to get typecast. At Yale, she had played everyone from Major Barbara to an eighty-year-old "translatrix." In the real world, it wasn't so easy. "Forget about being a character actress. This is *New York*," people kept telling her. "They need an old lady, they'll get an old lady—you're going to get typed, get used to it." More than once, she was told she would make a wonderful Ophelia.

But she didn't want to play Ophelia. And she didn't want to be an ingénue. She wanted to be everything and everybody. If she could just hold on to that ability to carousel through identities—that repertory thing she had mastered at Yale and the O'Neill—she could be the kind of actress she wanted to be. Had she landed in a movie or a Broadway musical right out of school, she might have been pegged as a pretty blonde. Instead,

she did something few svelte young actresses would do: she played a 230-pound Mississippi hussy.

The Phoenix Theatre company had been around since 1953, when it opened a play starring Jessica Tandy in a former Yiddish theater on Second Avenue. Since then, despite its shoestring existence, it had produced dozens of shows, from the Carol Burnett vehicle *Once Upon a Mattress* to *The Seagull*, starring Montgomery Clift. Its gentlemanly cofounder, T. Edward Hambleton (his friends called him "T"), wasn't ideological like Papp. His guiding principle was: produce good plays.

By 1976, the Phoenix was operating out of the Playhouse, a small Broadway theater on West Forty-eighth Street. Like other theater companies in town, it was planning an all-American season to celebrate the coming Bicentennial. First up: a double bill showcasing the twin titans of mid-century American playwriting, Tennessee Williams and Arthur Miller. Both men were in their sixties, their reputations secure enough to render them slightly out of date. And yet the contrast would give the evening some frisson: Williams, the lyrical, sensuous Southerner; and Miller, the lucid, pragmatic Northerner.

When Meryl saw the part she was reading for, she couldn't quite believe it. Set on a front porch in the

Mississippi Delta, Williams's *27 Wagons Full of Cotton* is a tour de force for whoever plays Flora, a raunchy Southern sexpot with a big cup size and a low IQ. Flora is married to the unsavory owner of a cotton gin who calls her "Baby Doll." When a rival cotton gin mysteriously burns down, the superintendent comes by asking questions. Flora suspects her husband (who of course is guilty as sin), and the superintendent traps her in a randy cat-and-mouse game, wangling information out of her with coercion, threats, and sex. In *Baby Doll*, Elia Kazan's 1956 film adaptation, Carroll Baker had immortalized the role as a Lolita-like seductress, her sexuality practically bursting from her dress—nothing like the 125-pound slip of a thing that called itself Meryl Streep.

Exhausted after an eight-hour *Trelawny* rehearsal, Meryl arrived at the audition in a plain skirt, a blouse, and slip-on shoes. Carrying a supply closet's worth of tissues she had swiped from the ladies' room, she introduced herself to Arvin Brown, the director. Sitting next to him was John Lithgow, who was directing another Phoenix show. Lithgow recalled what happened next:

"As she made small talk with Arvin about the play and the character, she unpinned her hair, she changed her shoes, she pulled out the shirttails of her blouse, and

she began casually stuffing Kleenex into her brassiere, doubling the size of her bust. Reading with an assistant stage manager, she began a scene from *27 Wagons Full of Cotton*. You could barely detect the moment when she slipped out of her own character and into the character of Baby Doll, but the transformation was complete and breathtaking. She was funny, sexy, teasing, brainless, vulnerable, and sad, with all the colors shifting like mercury before our eyes."

Arvin Brown hired her immediately. But he must not have noticed the transformation that had occurred right in front of him, because when rehearsals began, he took a good look at his leading lady and panicked. Her magic trick had worked so well he hadn't realized it was all an illusion. "She was so slim and blond and beautiful, and somehow or another in the audition she had convinced me that she was this really slatternly, sluggish redneck," Brown recalled. He thought, *Is this going to work?*

Meryl was getting worried, too. Her fake D cup had been a way to trick not just the audition room but herself. Without the reams of paper stuffed in her brassiere, she was losing her grip on the character. "Let me try something," she told Brown.

She went out and returned with a slovenly old housedress and prosthetic breasts. She had found Baby

Doll—and Brown once again saw a "zaftig cracker." Far from playing a femme fatale, Meryl tapped into Flora's innocence and vulgarity, which should have contradicted each other but didn't. Like Evert Sprinchorn at Vassar, Brown sensed a hint of rebellion: "I had the feeling she was kind of kicking the traces of a fairly conventional background."

Onstage at the Playhouse in January, 1976, Meryl's Baby Doll announced herself with a squeal in the dark:

"Jaaaaaake! I've lost m' white kid purse!"

Then she clomped into view in high heels and a loose-fitting dress, a buxom, babbling dingbat with a voice like a bubble bath. Between her lines, she cooed, cackled, swatted at imaginary flies. At one point, sitting on the porch with her legs splayed, she looked down at her armpit and wiped it with her hand. Moments later, she picked her nose and flicked away her findings. It was the funniest and most grotesque thing Meryl had done since *The Idiots Karamazov*. But, like Constance Garnett, her Flora was rooted in a goofy kind of humanity.

The *Village Voice* called her

a tall, well-upholstered, Rubenesque child-woman; a sexy Baby Snooks, tottering around on dingy cream-colored high-heeled shoes, giggling, chat-

tering in her little-girl voice, alternately husky and shrill, mouthing her words as if too lazy to pronounce them properly (and yet you can understand every word), tonguing her lips, smiling wet smiles, playing with her long blonde hair, cuddling her boobs in her arms, lolling and luxuriating in her body as if it were a warm bath. And all this extravagant detail is as spontaneous and organic as it is abundant; nothing is excessive; nothing is distracting; everything is part of Baby Doll. What a performance!

Few people in New York—Rosemarie Tichler, John Lithgow—had known the extent of Meryl's talent for metamorphosis. While her Baby Doll was a bravura feat of physical comedy, the true shock of *27 Wagons Full of Cotton* was what came after. The play was on a double bill with Arthur Miller's *A Memory of Two Mondays*, set in an auto-parts warehouse in Depression-era New York City. The look and feel couldn't have been more different: where the Williams play oozed sex and lemonade, the Miller was pert, industrial, like a dry martini. The cast included Lithgow and Joe Grifasi, with Meryl in the throwaway part of Patricia, a secretary.

But that's where she played her trump card. At the end of the Williams play, the lights went down on Flora,

singing "Rock-a-bye Baby" to her purse in the Missis-sippi moonlight. After intermission, she marched back on as Patricia: black marcelled hair, smart dress, hand on her hip, showing off her pin from a date the night before. As if on cue, there was a rustling of paper in the dark as playgoers thumbed through their programs: Could this possibly be the same actress?

"It's not just that she was playing these two wildly different characters," Arvin Brown recalled, "but she also had created two entirely different energy outlays. *27 Wagons* was all languorous and at times almost bovine. And all of a sudden, there would be this slash of energy as she walked onstage in the second play, and she had this dark wig and everything was urban, steely, fast. It was just a jolt."

Tennessee Williams and Arthur Miller avoided being seen together. They knew that the pairing of their plays would inevitably play like a competition, and they didn't want to encourage the question of who was the great American playwright. So Miller came to the final dress rehearsal and Williams came to open-ing night. When the curtain came down on *27 Wagons*, Meryl ran backstage to transform from blowsy hillbilly to steely secretary. Aiding her was J. Roy Helland, who had followed her from Lincoln Center and helped mas-termind the two competing looks. In the lobby, Wil-

liams cornered Arvin Brown to tell him how much Meryl's performance had astounded him.

"It's never been played like that!" he kept saying, which Brown took to mean her naïveté—nothing like the purposeful, pouty bombshell Carroll Baker had played in the film.

Brown slipped into the dressing room to tell Meryl about the playwright's euphoria. After the show, he would bring Williams backstage so he could praise her in person. But Williams never showed up at their appointed meeting place. By curtain call for *A Memory of Two Mondays*, he had vanished.

No one knew why until the next day, when the director got an apologetic call from Williams's agent. What happened was this: Meryl had an understudy named Fiddle Viracola, whose round face and kooky personality made her a natural Baby Doll. Viracola had a bizarre pastime: she would go up to celebrities and ask them to draw her a picture of a frog. At the dress rehearsal, she'd approached Arthur Miller and requested a frog for her collection.

On opening night, Williams had been walking into the lobby to meet Brown when a woman bore down on him yelling something about a frog. The playwright panicked and ran for a taxi. He never made it backstage to tell Meryl how much he loved her Baby Doll.

Despite her advancements, she still didn't see herself as a movie star, and neither did the rest of the world. Or so it appeared one afternoon, as she sat across from Dino De Laurentiis, the Italian film producer whose credits included everything from Fellini's *La Strada* to *Serpico*. De Laurentiis was casting a remake of *King Kong*, and Meryl had come in to audition for the part made famous by Fay Wray—the girl who wins the heart of the big gorilla.

De Laurentiis eyed her up and down through thick square spectacles. From his office at the top of the Gulf and Western Building, on Columbus Circle, you could see all of Manhattan. He was in his fifties, with slicked-back salt-and-pepper hair. His son, Federico, had seen Meryl in a play and brought her in. But whatever the younger De Laurentiis saw in her, the older certainly did not.

"*Che brutta!*" the father said to the son, and continued in Italian: *This is so ugly! Why do you bring me this?*

Meryl was stunned. Little did he know she had studied Italian at Vassar.

"*Mi dispiace molto,*" she said back, to the producer's amazement. *I'm very sorry that I'm not as beautiful as I should be. But this is what you get.*

She was even more upset than she let on. Not only was he calling her ugly—he was assuming she was stupid, too. What actress, much less an American, and a blonde at that, could possibly understand a foreign language?

She got up to leave. This was everything she feared about the movie business: the obsession with looks, with sex. Sure, she was looking for a break, but she had promised herself she wouldn't do any junk. And this was junk.

When she learned that Jessica Lange had gotten the part, she didn't pout. She hadn't wanted it that badly, to tell the truth. She knew she wouldn't have been any good in it. Let someone else scream at a monkey on top of the Empire State Building. They wanted a "movie star," and she wasn't one.

She was too *brutta*.

Theater was where her heart was. After the victory in *27 Wagons Full of Cotton*, she stayed on with the Phoenix for another play that spring: *Secret Service*, a Civil War melodrama by William Gillette. Her old friend Grifo was in the cast. So were her *Trelawny* castmates John Lithgow and Mary Beth Hurt.

The play was a thriller from 1895—nothing revelatory, but it was fun to play Edith Varney, a Richmond belle who falls for a Union spy, cannons booming in

the background. In her plaid dress and bonnet, she and a mustache-twirling Lithgow played love scenes that would have seemed overblown in *Gone With the Wind*:

"What is it—love and Good-bye?"

"Oh no—only the first!—And that one every day—every hour—every minute—until we meet again!"

It was borderline camp, and the actors never quite figured out how tongue-in-cheek to play their scenes. But the Phoenix kids just wanted to work together, on anything. A close-knit ensemble formed, onstage and off: spunky, squeaky Mary Beth; impish Joe Grifasi; chin-stroking leading man John Lithgow; and Meryl, the Waspy blonde who could do just about anything. They would drink at Joe Allen after shows, then bike home together to the Upper West Side, like New York transplants from *Jules and Jim*. They felt, Mary Beth recalled, like "princes of the city."

Meryl was still riding the success of *27 Wagons* and *A Memory of Two Mondays*. "Those two plays at the Phoenix Theatre did more to bring me attention, along with *Trelawny*, than any three plays I could have done on Broadway in three years playing three blondes," she said later. She won her first professional theater prize, the Theatre World Award, and was nominated for a Drama Desk. Then, in late March—less than a year out of drama school—she was nominated for a Tony

tensed. But the winner was Shirley Knight, for *Kennedy's Children*. Both Meryl and Mary Beth went home empty-handed. When they showed up for work the next Tuesday, it was back to Richmond, Virginia, 1864.

At the dress rehearsal for *Trelawny of the "Wells,"* Joe Papp had told her, cryptically, "I may have something for you." Then, on Christmas Eve, 1975, the phone rang.

"How would you like to play Isabella in *Measure for Measure* in the park?" the producer said. "And maybe Katherine in *Henry V*?"

Meryl was . . . confused. Had he lost his critical faculties? She knew he had his favorites, and anyone let into Joe's inner circle was employed for life, like at a Japanese corporation. But Isabella? Wasn't that the lead?

"What I thought was great about him was that he treated me as a peer," she said. "Right from the beginning, when I was this unknown, completely ignorant drama student, way before I was ready for it, he admitted me to the discussion as an equal." The two of them had the same birthday, June 22nd, and they felt like they were cosmically linked.

Award for the Phoenix double bill. She was up ag
her own castmate Mary Beth, who was nominate
Trelawny.

On April 18th, a few days after *Secret Service* op
at the Playhouse, both actresses filed into the Shu
Theater for the ceremony. Backstage were the he
of the entertainment world: Jane Fonda, Jerry L
Richard Burton. Onstage was the bare set of *A Ch
Line,* which was up for nearly every musical cates
Its cast members kicked off the ceremony with th
ready iconic opening number, "I Hope I Get It."
the nominees in the audience, the sentiment was a

It was Easter Sunday. Mary Beth showed up in
size glasses and her trademark red bob. Meryl sti
Civil War ringlets falling across her brow. Sitting
audience, she felt "profoundly uncomfortable." D
commercial breaks, she could sense the nomine
ing their lips. It all felt so silly.

Sure enough, *A Chorus Line* made a clean
winning half of the eighteen award categories.
time it beat out *Chicago* and *Pacific Overtures*
Musical, the orchestra seemed to have "What I
Love" playing on a loop. No one could deny it
Papp had a juggernaut.

Alan Arkin came out to present Best Feat
tress in a Play. When he read Meryl's name

"His conviction about me was total," she recalled, "but somewhere in the back of my brain I was screaming: 'Wow! Wow! Look at this! Wow!'"

Winter turned to spring, and she rode her bicycle everywhere. Downtown to the Public, where she was rehearsing *Measure for Measure*. Uptown to Lincoln Center, where Papp was rehearsing *Henry V.* One day in May, she deposited her bike in the checkroom at Café des Artistes, on West Sixty-seventh, two blocks from her new apartment. A bit early, she wandered the wood-paneled dining room, staring at the bucolic murals of wood nymphs dancing merrily in the nude. The surrounding trees had something of Bernardsville about them—the old Bernardsville, when she was a bossy little girl. Now there were expressways going up, and the whole place was different. Besides, her father had just retired, and he and Mary Wolf were relocating to Mason's Island, in Mystic, Connecticut.

By any actor's standards, her first season in New York had been charmed: back-to-back Broadway plays, a Tony nomination, and, coming up, two roles in Shakespeare in the Park. Plus, a few days earlier, there was a phone call.

Them: "Would you like to fly to London?"

Meryl: "Sure." (Pause.) "What for?"

The answer was an audition for *Julia*, a film based on a chapter from Lillian Hellman's memoir *Pentimento*. The story (of questionable veracity) concerned the playwright's childhood friend, who was always more daring than she. Julia becomes an anti-Nazi activist, and enlists Lillian to smuggle money to Resistance operatives in Russia. Unlike *King Kong*, this was the kind of movie Meryl saw herself in: a tale of female friendship and daring—i.e., not junk. Jane Fonda was playing Lillian. The director, Fred Zinnemann, was thinking about casting an unknown for Julia.

For now, Meryl couldn't stop staring at the plane ticket to London: $620.

"When I was at Yale, people on partial assistance like me got $2.50 an hour when we were on stage," she told her lunch date at Café des Artistes, a *Village Voice* reporter named Terry Curtis Fox. It was her first professional interview. "Before this year the most money I ever made was waitressing. $620. And that's only for an *audition*. It's crazy."

Another thing: she didn't have a passport. She had never needed one.

Meryl was deep into rehearsals for *Henry V.* Papp's vision was simple: the bigger, the better. Down at the harbor, historical ships were converging for the coming Bicentennial, like a flotilla of ghosts. Papp would re-

create the pomp and pageantry in Central Park, staging the Battle of Agincourt like a bloody reprise of Lexington and Concord. The success of *A Chorus Line* had given some respite from his cash-flow problems, but the producer was still banging his head against Lincoln Center. He must have understood the words of the put-upon king:

What infinite heart's-ease
Must kings neglect, that private men enjoy!

To Meryl, he seemed undaunted. "He's going to fly right into it: let the critics compare us to the British and tear us to bits," she told Fox, beaming. "He's going to have the whole stage open up and shoot flaming arrows into the lake." As the French princess Katherine, she would be offstage for the extravagant fight sequences. "I just wish I were in those scenes," she said hungrily.

They got the bill and headed for the door. She took her bicycle from the checkroom, threw on her backpack, and wheeled down to Rockefeller Center to see about that passport. The twenty-six-year-old actress seemed to Fox like a character from a movie: the starlet on the rise, the fresh face. Still, he would write, "There is something in Meryl Streep of the killer."

———————

From her apartment on Sixty-ninth Street it was less than a block to Central Park. A quick bike ride got her to the Delacorte, the open-air oasis Joe Papp had built. A few steps more, and she was onstage, the Belvedere Castle towering in the background like expensive scenery, the midsummer sky wide and hot above her. Then the battles would begin.

Papp had assembled a massive cast—sixty actors, many of them recent drama school grads looking for a break. Most had auditioned down at the Public, in the theater where *A Chorus Line* had originated before its move to Broadway. The white line where the chorus members had stood still ran across the stage.

"They had a whole group of us come in and stand on that white line," an auditioner named Tony Simotes recalled. "All of a sudden, Joe started to talk about the show and what he saw in the show. Just kind of getting the background on it. And he says, 'Oh, by the way, you're all cast.' He kept talking and we're all like, 'What?' We all started screaming and cheering and hugging each other."

A cigar perpetually hanging from the side of his mouth, Papp wielded his power like a king's scepter. "Build me a tower," he would say, and a swarm of carpenters would rush onstage with hammers and lumber.

At one point, he took to skipping rope in front of the cast to show that he hadn't lost his vitality.

A few days in, he fired the guy delivering the prologue ("O, for a muse of fire that would ascend / The brightest heaven of invention!") and replaced him with Michael Moriarty. By now, Moriarty was a Tony-winning Broadway actor. From offstage, Meryl would delight at his menacing take on the prologue. It was, she said later, "the first time I realized you can pull out anything, absolutely anything, from Shakespeare. Michael found every ribald line and pulled them out for our delectation, and it was wicked and wise."

The two actors had something in common, besides their onstage tryst in *The Playboy of Seville* five years earlier. They were the only members of the company who didn't seem terrified of the director.

"Michael Moriarty couldn't give two shits about Joseph Papp, which was pretty cool," one ensemble member recalled. "He just said, 'Yeah, you want me to play that? Alright, I'll do it.' A lot of the people on the set were really intimidated by him. But what I was struck by was how Meryl Streep would come and wrap her arm around him, treating him like she was his old friend."

She even started sounding like him in interviews. When the *Times* visited the Delacorte and asked her

whether she envied the Shakespearean training enjoyed by the British, she shrugged and said, "I envy the wealth of experience they can call on, but we have a different tradition in America that is just as strong. It has to do with heart and guts." Heart and guts: a Papp specialty.

As Katherine, she had just two scenes, but they were minor coups de théâtre. One was entirely in French, as the princess learns the English words for body parts, mangling "the elbow" as "de bilbow." Later, she returns in a ridiculous headdress and charms the English king. "It was just one light, delicious cameo, and she floated through it," Rosemarie Tichler recalled. "You watch this poor, befuddled king being turned around and fall in love. And as he fell in love, the audience fell in love."

Working in Central Park had its own peculiar magic. By three in the afternoon, masses of New Yorkers would line up outside the Delacorte for free tickets. (Papp never wavered on the price, even when the city begged him to charge even a dollar.) Snaking counterclockwise toward the softball fields on the Great Lawn, the line became its own sort of Shakespearean scene, where the freaky energy of the city came out to play. One July afternoon, a conservatively dressed woman with law books stood behind a guy in a Hobie's Surf-

ing Shop T-shirt, as a troubadour in Elizabethan dress sang madrigals in a midwestern accent for dimes and quarters. Nearby, a hot-dog vendor competed with a falafel cart, while a man in a purple shirt and purple jeans with a purple bike told anyone who would listen, "You do not really see me. You are hallucinating. You think you are seeing purple because that is the color of the magic mushroom."

Around five, the staff would hand out cards to be redeemed for tickets, and the luckiest 1,800 would file into the amphitheater for the eight-o'clock show. When Michael Moriarty came out invoking the muse of fire, the sun was still blazing overhead. By Act V, when Henry kissed Katherine, the scene was lit by moonlight. At night, the park turned into a den of muggers and gropers, and the small army of actors knew to walk out together in a self-protecting horde. Then Meryl was back in her lobby, back in her elevator, and back in the apartment she had all to herself.

Four days after *Henry V* closed at the Delacorte, *Measure for Measure* opened at the Delacorte. Ten minutes before the first show, a man in the audience had a heart attack. An ambulance rushed him to Roosevelt Hospital, but he was dead on arrival. At eight o'clock, the rain began, and the stage manager held

the show for twenty minutes. They got through Act I before the downpour intensified. The performance was finally canceled, and everyone went home soaked.

Even in dry weather, the play was challenging. Neither tragedy nor comedy, *Measure for Measure* is one of Shakespeare's ambiguous "problem plays." The plot rests on a moral quandary: Vienna has become a den of brothels, syphilis, and sin. The Duke (played by the thirty-five-year-old Sam Waterston) leaves his austere deputy, Angelo, to clean up the mess. To instill fear of the rule of law, Angelo condemns a young man named Claudio to death for fornication. Claudio's sister, Isabella, is entering a nunnery when she hears the news. She begs for mercy from Angelo, who is knocked senseless by lust. He comes back with an indecent proposal: Sleep with me and I'll spare your brother's life. Despite her brother's pleas, Isabella refuses, telling herself:

Then, Isabel, live chaste, and, brother, die:
More than our brother is our chastity.

The line usually draws gasps.

"The role is so beautiful, but there are so many problems in it," Meryl said at the time. "One is that it's so hard for a 1976 audience to sit back and believe that

purity of the soul is all that matters to Isabella. That's really hard for them to buy." *Sure, Angelo's a pig,* most people think. *But, come on, it's your brother's life! Just sleep with the guy!*

Meryl was determined to find Isabella's truth, to make her dilemma real even if the audience was rooting against her—the same hurdle she would face in *Kramer vs. Kramer.* Could she get people to side with a fanatic nun? "Men have *always* rejected Isabella, right through its history," she said during rehearsals, with anticipatory relish. From his retirement in Connecticut, her father dug up all the reading material he could find on the play. "He's really quite a scholar," Meryl would brag.

A plum role for Meryl Streep was one reason Papp had booked *Measure for Measure,* but the timeliness of the plot was likely another. Shakespeare's Vienna is rife with corruption and perversity and grit, and the New Yorkers who had lived through the city's near bankruptcy could relate. Meanwhile, the whole country had gotten a lesson in official pardons, like the one Isabella seeks for Claudio. Two years earlier, President Gerald Ford had pardoned Richard Nixon for his Watergate crimes and now was paying a heavy toll in his electoral run against Jimmy Carter. Everywhere you

turned, someone in the halls of power was making a shady backroom deal, or a city was crumbling under the weight of its own filth.

The director, John Pasquin, envisioned a Vienna that would reflect New York back to New Yorkers. Santo Loquasto's set looked like a subway station, or like the men's room right outside the theater: all sickly white tiles, practically reeking of urine, against a skyline of painted demons. While Angelo and his officials sneered from a raised walkway, the bawds and whores of Vienna rose up from a trapdoor, as if ascending from the underworld. It was Park Avenue society meeting the drifters of Times Square, the bifurcated city Papp had tried to unite in his theaters.

Meryl read the long and churning play over and over again. Cloaked in a white habit, she had only her face and her voice to work with. And in the park, exposed to the elements, her meticulous characterization could get easily thrown off course. One night, during the climax of her big soliloquy—"I'll tell him yet of Angelo's request, / And fit his mind to death, for his soul's rest"—what sounded like a Concorde blasted overhead, and she had to scream "his soul's rest." "It's ludicrous," she said soon after, "but it costs me my heart's blood, because I carefully put together a person and a motive,

and then something comes along that's not even in the book, and ruins it."

But something else was happening to Meryl Streep, something she had even less control over than jumbo jets roaring over Manhattan. In her scenes with the forty-one-year-old actor playing Angelo, it was there for everyone to see: the push and pull of wills, the saint and the sinner locked in a battle of sex and death. It gave off heat. She stared into her leading man's coal-like eyes, his sallow face betraying a whimpering sadness. He gave her fire, she answered with icicles:

ANGELO
Plainly conceive, I love you.

ISABELLA
My brother did love Juliet,
And you tell me that he shall die for't.

ANGELO
He shall not, Isabel, if you give me love.

Meryl's understudy, Judith Light, would watch the Isabella and Angelo scenes every night, memorizing the contours of Meryl's performance in case she ever

had to go on. (She didn't.) "It was their dynamic that carried the production along, and watching the two of them develop something together was incredibly electric," Light recalled. "You could see that something was developing, and that she was allowing herself to also be lifted by him."

Michael Feingold, Meryl's old friend from Yale, saw it, too. "The physical attraction between them was very real," he said. "And the idea of starting an Isabella-Angelo relationship with that present, not only in the actors' lines but in their lives . . . It puts an extra charge on everything, and she had that even inside the nun's habit."

Even the *Times* critic Mel Gussow picked up on it: "Miss Streep," he wrote, "who has frequently been cast as sturdier, more mature women, does not play Isabella for sweetness and innocence. There is a knowingness behind her apparent naïveté. We sense the sexual give-and-take between her and Angelo, and she also makes us aware of the character's awakening feelings of self-importance and power."

If he only knew the half of it.

When *Measure for Measure* is about a nun putting her principles over her brother's life, it's a problem play. But this *Measure for Measure* was about a man and a woman battling their unquenched sexuality,

making pronouncements and questioning them at the same time, their ideals betrayed by their irrepressible desire. It is Isabella's purity that lights Angelo aflame, as the whores of Vienna could not. The two actors were nearly as preposterous a couple as their characters: the ice princess and the oddball. And yet everyone, onstage and off, seemed to feel their spark.

On opening night, Meryl and her Angelo slipped away from the cast party. They wound up at the Empire Diner in Chelsea, a greasy spoon tricked out in Art Deco silver and black, with a miniature Empire State Building on its roof. They ate and talked, and by the time she got home it was five in the morning. She couldn't sleep.

She woke up the next morning to let a reporter up to her apartment. As they talked over orange juice and croissants, her eyes were bloodshot, her face devoid of makeup. Even as she fielded questions about her extraordinary first year out of drama school, her mind kept returning to John Cazale. There was something about this guy. Something.

She heard herself say, "I've been shot through with luck since I came to the city . . ."

Fredo

Time moved differently for John Cazale. Everything went slower. He wasn't dim, not by a long shot. But he was meticulous, sometimes maddeningly so. Even simple tasks could take hours. All of his friends knew about the slowness. It would drive them crazy.

His friend Marvin Starkman: "We had a house up in the country, and John would come up quite a bit. If his car was ahead of mine and we got to a tollbooth, he'd pull up and he'd look to see if the guy had a name or a number listed outside. He'd look at the guy, make sure he knew who he was talking to, take out a quarter or whatever it was: 'Here you go.' I mean, you would die in the car behind him."

Robyn Goodman, who was married to his friend Walter McGinn: "We got a color television. It was a

brand-new thing, and we were all excited. Walter called John and said, 'Come up and help me, we're going to put it together.' And John said, 'Well, let's get the color all right.' That was around ten o'clock at night. I went to sleep about midnight, and they were still working. I think they were up most of the night tuning that thing."

The playwright Israel Horovitz: "We had to give him a key to the theater, because he was so slow taking off his makeup. We'd go to the restaurant around Astor Place, and he was supposed to meet us. We were all going to eat, and we'd be finished before he got there. He was just the slowest person I knew."

His friend Al Pacino: "You eat a meal with him, I mean, you'd be done—washed, finished, and in bed—before he got halfway through his meal. Then the cigar would come out. He'd light it, look at it, taste it. Then *finally* smoke it."

John moved like he had all the time in the world.

He was like that with characters, too. Directors called him "Twenty Questions," because he wouldn't stop interrogating them in rehearsal. Before he could do anything, he had to know everything. He would try one thing a million different ways—there were so many possibilities. Marvin Starkman used to kid him: "Jesus, I bet your foreplay takes five hours."

He looked like no one else in the movies: spindly frame, honking nose, forehead as high as a boulder, bisected by a throbbing vein. When John set his sunken eyes on something, he could look as wounded and desperate as a dying dog.

"He was like from another planet," Robyn Goodman said. "He had such depth and truthfulness. There wasn't a false bone in his body, as a person or as an actor. And he experienced the world in a profound way."

John was slow because everything fascinated him. He loved his Datsun. He loved *The Bicycle Thief.* He loved Cuban cigars, which he smoked like crazy. "With John, he had a childlike curiosity and it wasn't put on," Starkman said. "If you didn't know him, you'd say, 'What's this bullshit?' It was no bullshit."

One time, he and Walter McGinn (John called him Speedy) found a parking meter lying on the sidewalk. They decided to bring it back to John's place and take it apart so they could see how it worked. Somebody must have reported them, because the police showed up and arrested him. He spent the night in jail.

"God, what was that like?" Starkman asked when he got out.

"Well, I made some friends there," John said. "And I found out how to get two lights off one match."

His characters shared his childlike innocence, but there was always melancholy pulsing underneath. "There was an undercurrent of sadness about him," his brother, Stephen, said. "I don't know how you'd explain it." He and Walter would talk for hours about acting, as Robyn Goodman watched. "They both had a very profound understanding that at the center of every character was a kind of pain," she recalled. "You could see that there was a little bit of damage in both of them that they were turning into art."

It was pain that defined his most vivid character, Fredo Corleone, in *The Godfather* and *The Godfather: Part II*. It's there when he's drunkenly hitting on his brother's girlfriend, Kay, at their sister's wedding. It's there when he's in his mustard-yellow suit and aviator sunglasses, playing big shot with girls and booze in Las Vegas. And it's there in the boathouse in Tahoe, when it all comes roaring to the surface.

MICHAEL

I've always taken care of you, Fredo.

FREDO

Taken care of me? You're my kid brother and you take care of *me*? Did you ever think about that? Did you ever *once* think about that? Send Fredo

off to do this, send Fredo off to do that. Let Fredo take care of some Mickey Mouse nightclub somewhere. Send Fredo to pick somebody up at the airport. I'm your older brother, Mike, and I was stepped over!

Most actors would kill to play Sonny or Michael Corleone, the macho brothers who run the family racket. What young man doesn't want to play brave or cocky or strong? But John was like the B-side of American masculinity. Without flinching or show-boating, he could play weakness, cowardice, shame, or fear. John could make the runt of the litter the best part in the film—that is, if you were paying attention. Most people walked out of his movies talking about Al Pacino or Robert De Niro or Gene Hackman, the guys who played the troubled heroes. But if you cared to notice him, John Cazale could break your heart.

It started with music. As children, John and his little brother idolized Toscanini. They spent hours listening to the wind-up Victrola: Bach's Second and Third Brandenburg Concertos, Debussy's Nocturnes, Wagner's overtures to *Meistersinger* and *Parsifal.* They wore out their albums of Haydn's Symphony No. 99—until Stephen, who was two years younger, sat on the

fourth movement and broke it. "He was mad as hell," Stephen said. "He used to slug me a lot. My arms would be black and blue sometimes from his slugs."

They inherited the music bug from their Aunt Kitty, who took them to concerts and museums in New York City. She got it from their grandmother, Nonna, who sang snatches of Italian opera around the house. In her youth, Nonna had worked in a textile factory producing jute, and she proudly re-created the arm motions she had repeated at the loom. Her grandsons imitated the gesture behind her back and snickered.

Despite starring in the defining film saga of Italian-American immigration, John showed little interest in his heritage. Stephen would later unravel the family history, a real-life version of *The Godfather: Part II*, minus the mob. Their grandfather, Giovanni Casale, was born in Genoa and sailed to New York City on September 27, 1868—sixteen years old, dirt poor, and largely illiterate. Sixteen years later, for reasons lost to history, he signed his naturalization papers "Giovanni Cazale," with a "z"—the name that his children and grandchildren would bear. By then, he was working as a fruit vendor and an itinerant knife sharpener. With his wife, Annie, he moved to Revere, a seaside city near Boston, and he and two partners opened its first hotel. As Revere became a bustling resort, Giovanni bought

up more property. Like Vito Corleone, he had built a new life in a new land, running his own business. Only this one didn't involve dumping bodies in the river.

Giovanni and Annie had a daughter, Catherine, whom John and Stephen knew as Aunt Kitty. Another daughter, Elvira, died young. Then there were the twins, John and Charles, born premature. Annie covered them with olive oil and warmed them in the oven; they survived. The brothers both became coal salesmen, and they loved betting on horses at the Suffolk Downs racetrack. John, the elder twin, married an Irish Catholic girl, and they had three children. Born in 1935, John Cazale was their middle child, a shy kid who worshiped the Red Sox and Ted Williams.

When John was five and Stephen was three, the family moved to Winchester. Their parents sent them to separate boarding schools: John to Buxton, in Williamstown, Massachusetts, and Stephen to Woodstock Country School, in Vermont. John was quiet and withdrawn, and no one could foresee his announcement that he had joined the school's drama club. "I was as surprised as anyone else when he realized he wanted to go into the theater," Stephen said. "It was the most unlikely thing for him to do."

As a teenager, John worked as a messenger for Standard Oil. One of his fellow messengers was Al Pacino,

five years his junior. John went on to study drama at Boston University, where he met Marvin Starkman and Walter McGinn. They all revered their acting teacher, Peter Kass, who pushed his students to mine their own darkness, not to shy away from pain but to locate it in a character. (It was the same lesson Meryl resisted her first year at Yale.) John stayed in Boston and acted at the Charles Playhouse, part-timing as a cabdriver. Again, the slowness. "He didn't leave people off in the middle of the street," Starkman said. "He came right to the curb. He would open the door for people, he would come out. He was the perfect guy to be a cabdriver."

He moved to New York and found a walkup apartment in the West Sixties. "His housekeeping was abominable," Stephen recalled. The brothers spoke in nonsense Latin, and a pigpen was a "porcus pennus." When John first showed Stephen his apartment, he proclaimed, "Welcome to the Porcus Hilton." Part of the mess was from his makeshift darkroom; he made money shooting sculptures for gallery brochures and headshots for actor friends. Photography suited his compulsive nature: he would painstakingly adjust the lighting on the sculptures, making sure they looked fully three-dimensional instead of flat. Some of the photos were just for him: landscapes in the Berkshires, or studies of Aunt Kitty at her piano.

Acting jobs were sparse. Starkman, who was producing commercials, tried to get him work, but the answer was always some version of "too ethnic." The best he could do was a TV spot for New York Telephone, in which John played an Indian chief. So he and Marvin made their own movies. In 1962, they shot an antic short film called *The American Way*, in which John plays an anarchist who can't manage to blow anything up. There were already glimmers of his contradictory screen presence: comedic but sorrowful, dangerous but feckless. Offscreen, the danger was absent, but his innocence was so genuine it could get him out of a jam. One Sunday morning, he was headed over to Starkman's place to start the day's shoot, carrying a fake TNT box under his arm. A policeman stopped him and said, "Hey, come here. Where are you going?"

John looked at him blankly and replied, "I'm going to Marvin's house."

"Oh, okay," the cop said, and sent him on his way.

His breakthrough came in the form of two plays by Israel Horovitz. While Horovitz was in drama school in England, he saw some hooligans harassing an Indian student in a turban. The incident inspired *The Indian Wants the Bronx*, which he staged back in New York. As the main hooligan, he cast Al Pacino, an unknown actor he had seen in a play in somebody's living room.

As his victim—now Gupta, a frightened father lost in New York, trying to reach his son on a pay phone—he cast an Indian actor. But the man didn't have much acting experience and would inexplicably raise his hand whenever he had a line. "It became a play about this guy's hand," Horovitz recalled.

Pacino, who was intensely Method-oriented, couldn't focus. They had to replace the Indian, and Israel already knew John Cazale, having grown up in a neighboring town. Gupta's dialogue was all in Hindi, and John and Israel wrestled with whether an Italian actor should play the role. In the end, John agreed. The play was going up in Provincetown, and when Pacino got to the house on Cape Cod where everyone was staying, his costar poked his head out of the bedroom. Pacino recognized the face from years earlier, when he was working for Standard Oil.

"You again," Pacino said. "I know you."

The play moved to New York, to the Astor Place Theatre, in January, 1968. It won instant acclaim, typifying the raw, live-wire, from-the-streets aggression that was electrifying the downtown theater scene. Horovitz, Pacino, and Cazale all won Obie Awards. That summer, they brought the play to the Spoleto Festival in Italy. Between shows, John would gather the company in the main piazza and lead them in six-

part harmony. They didn't know Italian, so they'd sing the words off the tourist maps: "Piazza del Duomo! Spoleto! Spoleto!"

It was another Horovitz play that gave John the boost he was so anxious for. *Line* was the kind of late-sixties minimalist experiment that was upending received notions of what constituted a play. There was no set, and barely a plot. All you needed was five actors to stand in a line, four men and one woman. What they're waiting for is never explained. Over the course of the play, they fight, fornicate, and fool each other into losing their place in line: a Hobbesian state of nature for cultured New Yorkers, who never see a line without wondering if they should be on it.

John played Dolan, a self-described "Mr. Nice Guy" who nonetheless almost chokes another character to death. At one point, Dolan describes his "Under*dog* philosophy," which could double as John's approach to acting, or at least his effect:

"Everybody wants to be first, right? . . . Now you can be obvious about it. Just jump in like the kid and yell and brag about being first. Or about deserving to be first. What I mean is you got to stand back a little . . . The easiest way to kick a dog in the balls is to be underneath him. Let him walk on top of you for a while. Take good aim. And . . ."

Line opened at the East Village theater La MaMa in the fall of 1967. Four years later, it was revived at the Theater de Lys, on Christopher Street, starring Cazale and Richard Dreyfuss, in his Off Broadway debut. One night, Dreyfuss invited Francis Ford Coppola and his casting director, Fred Roos, who were in preparation for *The Godfather*. When they saw Cazale onstage, Roos said instantly, "That's Fredo."

"The second son, Frederico, called Fred or Fredo, was a child every Italian prayed to the saints for," Mario Puzo wrote in his novel *The Godfather*. "Dutiful, loyal, always at the service of his father, living with his parents at age thirty. He was short and burly, not handsome but with the same Cupid head of the family, the curly helmet of hair over the round face and sensual bow-shaped lips."

John Cazale wasn't short or burly, and he certainly didn't have a curly helmet of hair. But to Coppola and Roos, he had the look of someone who had always been passed over. Coppola, who had accomplished siblings (the author August Coppola and the actress Talia Shire, who played Connie Corleone), had a soft spot for Fredo. "In an Italian family, or at least in my family, there are always those brothers who are considered, you know, not as talented as the others," the director said. "They

are made fun of. Maybe I was in that category some of the time, I don't know. I certainly had uncles that were put down. I think Italians that come from that little-town mentality are very hard on their own and very cruel unto those who don't quite cut the mustard at the same level that the star brothers or the star uncles do."

John was reunited with Al Pacino, as Michael Corleone. But the real thrill was acting alongside Marlon Brando, as his father, Vito. Brando was the undisputed giant of American film acting, and the younger actors— Pacino, Cazale, James Caan, Robert Duvall—revered him just as the Corleone brothers do their capo father. "Brando was our hero," Marvin Starkman said. "We would go to see *On the Waterfront*, *Streetcar*, all those early films, like you were going to a master class. We worshiped him. John gets to work with Brando, and it just lit him."

It came time to film the scene when Vito is shot in the street outside the fruit market, while Fredo fumbles with his gun as the would-be assassins get away. With the Godfather bleeding in the gutter, Fredo leans over him in hysterics, having failed his father in the worst way. Coppola filmed Brando playing near-dead on the curb, then turned the camera around for John's reaction shot. "Brando thought enough of John to get back and lie down in the gutter, so that John could work off

him," Starkman said. "It was, like, the highest compliment."

The Godfather was released in March, 1972, while Meryl Streep was still performing in ski lodges in Vermont. It was nominated for eleven Academy Awards, and won Best Picture and Best Actor, for Marlon Brando, who sent the Native-American activist Sacheen Littlefeather to decline the prize. Al Pacino, James Caan, and Robert Duvall crowded the Best Supporting Actor category. John wasn't nominated.

Buoyed by the success of *The Godfather*, Coppola shot a drama about surveillance called *The Conversation*, starring Gene Hackman as "the best bugger on the West Coast." John played his assistant, Stan, an inquisitive technician in headphones and thick glasses. Once again, John tapped into the character's weaknesses—his immaturity, his nosiness—and infused them with childlike sweetness. The movie was nominated for three Oscars, including Best Picture. John wasn't nominated.

In *The Godfather: Part II*, Coppola brought Fredo's self-loathing to a crescendo. In his plaid suit and pencil mustache, Fredo was gregarious and impotent, unable to control even his drunken wife on the dance floor. After Fredo colludes on a failed attempt against his brother's life, guilt and fear devour him. In John's

most iconic film moment, Michael clutches Fredo on the cheeks and tells him: "I know it was you, Fredo. You broke my heart. You broke my heart."

Fredo's betrayal of Michael, and Michael's decision to murder him, are at the heart of the film, giving John more to do onscreen than he'd ever had. *The Godfather: Part II* was nominated for eleven Academy Awards, including Best Picture, which it won. Al Pacino was nominated for Best Actor. Robert De Niro, Michael V. Gazzo, and Lee Strasberg competed for Best Supporting Actor, which De Niro won. John wasn't nominated.

Despite his Fredo-like knack for being passed over, John's gift grew more complex with each film, his capacity for exposing a character's psychic wounds more heartrending. At the same time, his appearance became increasingly sickly, his vitality receding along with his hairline. One summer, he was at Starkman's house in the Catskills when he took ill at the county fair. "We gotta get back to the city," he pleaded. Marvin and his wife drove him back, every bump and bang bringing John fresh agony.

They rushed to Roosevelt Hospital, where John was diagnosed with chronic pancreatitis. When Marvin came back to visit him, he was hooked up to tubes and could barely talk. Against the wall was a glass jar filling up with watery green bile from his stomach. "It

was just awful," Starkman recalled. "I left there feeling, What can we do for this guy?" The doctors told John to quit drinking immediately, or else the alcohol would eat up his pancreas.

Somehow, his pallor only added to his singular onscreen presence. "There is a kind of moral decay in Fredo that's entirely borne out by the fact that, from the first picture to the second, Cazale has become more ghost-like," the critic David Thomson has observed. "He's thinner, his eyes are more exaggerated, his forehead is sticking out further."

By then, the filmmaking boom of the late sixties and seventies had opened the door for actors who were eccentric, ethnic, or just plain odd. Warren Beatty and Robert Redford aside, leading men were now olive-skinned like Al Pacino, or nebbishy like Dustin Hoffman, or black like Sidney Poitier, or devil-eyed like Jack Nicholson. Movie stars looked less and less like matinee idols and more and more like the people you might see on the street. Even Robert De Niro, the new standard-bearer of big-screen virility, was Italian. John's ashen face and off-kilter energy, which had once precluded him from TV commercials, were now his currency.

Not that he didn't possess a strange kind of sex appeal. John exemplified the French notion of *jolie laide*, or "ugly-beautiful." It was a concept that Hol-

lywood was just beginning to grasp (at least when it came to men). As Horovitz liked to say, he looked like St. Francis of Assisi, but he never seemed to lack for beautiful dates, among them the actresses Verna Bloom and Ann Wedgeworth, his costar in *Line*. None of his friends knew how he did it. "He always had girlfriends," Starkman said. "He had some of the most beautiful girlfriends to be found, and eventually many of them broke up [with him] because of his slow snail pace about things."

As his career took off, he began dating a redheaded actress from Texas named Patricia. Patricia was a chilly beauty who hadn't had her big break. Some of John's friends detected an opportunistic streak, but he was smitten. Perhaps at her urging, he left his cluttered Upper West Side apartment, which had scared away previous girlfriends, and put down a chunk of his *Godfather* money on a loft downtown on Franklin Street. It was in a former storage building, with a fire escape, an elevator, and a diamond-plate loading platform facing the street. The traditionally industrial neighborhood was just on the cusp of transformation, as artists and experimental theater troupes took over buildings formerly owned by ship chandlers. New Yorkers would soon know it as Tribeca. For now, it was No Man's Land.

When John first saw the place, stacked floor to ceiling with tomato cans, he couldn't believe it. *Those floors must be strong*, he thought.

"You know what a No. 10 can is?" he told Marvin. "You've seen those big tomato cans? I mean a real can, about this big—they're heavy!"

Once the cans were gone, it was all bare brick and open space. John brought in wood planks and hammers. He and Patricia would be pioneers, building a nest in a stockroom.

But it didn't last. Patricia took off for California, leaving John with the apartment to himself.

Meanwhile, Pacino had signed on to Sidney Lumet's new film, *Dog Day Afternoon*. It was based on a real incident, in which a hapless criminal had held up a Brooklyn bank to pay for his lover's sex-change surgery. As the guy and his sidekick try to keep the hostages in line, cops and gawkers swarm outside, a kind of perverse street theater. Pacino begged Lumet to see John for the part of Sal, the sidekick, even though he looked nothing like the real guy. Reluctantly, Lumet agreed. John read about two sentences before the director said, "It's yours."

John's appearance as Sal was his most bizarre yet. With his oily hair now starting halfway up his cranium

and slinking down to his shoulders, he looked like a beatnik vulture. Wielding his machine gun, he seemed, unlike Pacino's Sonny, like someone who might actually resort to using it. And yet his performance was still shot through with sorrow, as if even Sal, the bank-robbing thug, was once a neglected little boy.

Pacino marveled at how John would amp himself up, ad-libbing wildly until the cameras started rolling. At one point, they were shooting a scene in which the two crooks plan their escape. Everything's going to hell fast: the hostages need to pee, the cops are outside, and the whole operation has become a three-ring circus. Sonny tells Sal that if they ever get out of this mess, they'll have to leave town. Is there any special country he'd like to flee to?

Sal thinks for a moment and answers, "Wyoming."

On set, Lumet had to choke back his laughter, or else he'd ruin the take. Same with Pacino. In the script, John didn't have a line there. Naturally, "Wyoming" made the final cut.

Dog Day Afternoon was nominated for six Academy Awards, including Best Picture, and won for its screenplay. Al Pacino was nominated for Best Actor, and Chris Sarandon, as Sonny's lover, was nominated for Best Supporting Actor. John wasn't nominated.

As they shot *Dog Day Afternoon*, Pacino was acting in a workshop of a play, Brecht's *The Resistible Rise of Alberto Ui*. He gathered a cast together, including John, and found a place to rehearse: Joseph Papp's Public Theater. Papp had met Pacino in 1968, when he fired him from a play for mumbling. Now, he was happy to underwrite the actor's passion project, paying the cast of thirty to rehearse for weeks on end, with no guarantee of a final production. Papp didn't mind; it was enough to give Pacino a testing ground.

But he did notice John Cazale, who might have just the right menace for *Measure for Measure*, which he was casting for Shakespeare in the Park that summer. Papp had given Sam Waterston the choice to play Angelo or the Duke, and Waterston chose the Duke. So the producer invited John to audition for Angelo.

The night before the audition, John went to Walter McGinn and Robyn Goodman's place, at Eighty-sixth and Riverside. He was nervous; he hadn't done much Shakespeare. To make matters worse, he would be auditioning opposite the leading lady, a young drama school graduate who came with the project—Papp adored her. If he wanted the part, he'd have to impress Meryl Streep.

Walter, who was in *Henry V*, knew her a bit. John peppered him with questions—about the play, about the role, and, most of all, about the actress playing Isa-

bella. "Walter assured him that Meryl would react well to a real actor's actor," Goodman said. "That's what John was."

The next day, John went in and read his scene from *Measure for Measure.* "I remember how intense John was," Goodman said, "and how scared he was, and how he called right after to say that he thought it went okay. You know, it could have gone better . . . He was never satisfied with his work."

But he had satisfied Joe Papp, and, just as important, Meryl Streep. He got the part.

In the rehearsal room, John kept mostly to himself, puffing on cigars by the window during breaks. "These are Cubans that I have brought in," he'd tell his castmates. "Do you smoke?"

Shakespeare's Angelo was a prudish, domineering creep—nothing like the weaklings John had played—Fredo, or Stan, or even gun-toting Sal. Or was he? Once again, John looked for the pain, and found it.

"He brought menacing. He brought the pain," Rosemarie Tichler said. "But the pain, instead of being weakness, was anger. There was anger under it. If you poked at it, he wouldn't fall apart. He would become dangerous."

As a casting director, she knew that the right mix of actors could give a play a startling new subtext. In

the clash of wills that was *Measure for Measure*, John brought something that wasn't quite on the page. His Angelo was the guy who never got the girl, the loser who sat in the corner while everyone else partied on the dance floor. That's why he was clamping down on the brothels of Vienna. That's why he condemned Claudio to death for fornication. That's why he lusted so feverishly for pure-as-snow Isabella. She was every beautiful woman who never gave him the time of day.

> . . . Never could the strumpet
> With all her double vigor, art and nature,
> Once stir my temper, but this virtuous maid
> Subdues me quite. Ever till now,
> When men were fond, I smiled and wondered how.

And so, on opening night, John Cazale and Meryl Streep sat at the Empire Diner, having ditched their own cast party, talking and laughing until five in the morning, the rising sun just beginning to glint on the mirrored walls and coffee cups and bar stools and her lemon hair. John had discovered something absolutely extraordinary. She was better than a Datsun. She was better than a Cuban cigar. She was better than getting two lights off of one match. She was someone worth staying up all night for, like a color TV—only better,

because her colors were so infinite you couldn't possibly tune them all.

He told his friend Al Pacino, "Oh, man, I have met the greatest actress in the history of the world."

He's just in love, Pacino thought. *How good can she be?*

All that August, the subways in New York City were plastered with illustrated posters of John Cazale and Meryl Streep: Meryl in her white nun's habit, lips parted and eyes cast down, as if in mid-thought; John gazing at her from behind, with a yearning look and a cocked eyebrow. The thought bubbles coming out of their heads converge into a single cloud, bearing the words "Measure for Measure."

John was besotted. "Once he was in that play, the only thing he talked about was her," Marvin Starkman said.

"Walter said to me, 'I think he's falling in love with Meryl,'" Robyn Goodman recalled. "And I said, 'I hope she's falling in love with him.' By the time the show opened they were madly in love." Watching them, Robyn wondered if she was making out with her own husband enough—that's how explosive John and Meryl were. Arriving at the theater, Goodman said, "Her whole mouth was chapped from kissing."

Meryl was transfixed by this odd, tender, hawk-like creature, whose hold over her was something she couldn't quite explain. "He wasn't like anybody I'd ever met," she said later. "It was the specificity of him, and his sort of humanity and his curiosity about people, his compassion."

Acting was their lingua franca. "We would talk about the process endlessly, and he was monomaniacal about the work," Meryl recalled. John would think and rethink his characters, opening them up and studying them like a parking meter, never content with the obvious or easy choice. "I think probably I was more glib and ready to pick the first idea that came to me," she said. "And he would say, 'There's a lot of other possibilities.'"

One night after the show, John introduced Meryl to his brother, Stephen, who had become a musicologist. For reasons neither brother could remember, they had always called each other by nicknames: Stephen was Jake, John was Bobo.

"Meryl," John said proudly, "talk to Jake! He knows Italian."

Stephen and Meryl stumbled through some conversation in Italian, until she broke down and laughed, "I can't! I can't!" Stephen was charmed.

Onstage at the Delacorte night after night, they enacted a forbidden attraction by moonlight. Offstage, their attraction wasn't forbidden, but it was certainly offbeat. Never had Meryl fallen for someone so peculiar. Side by side, they somehow accentuated each other's imperfections: her forked nose, his bulbous forehead. His pale skin, her close-set eyes. They looked like two exotic birds, or like Piero della Francesca's portraits of the Duke and Duchess of Urbino.

"They were great to look at, because they were kind of funny-looking, both of them," Israel Horovitz said. "They were lovely in their way, but it was a really quirky couple. They were head-turners, but not because 'Wow, is she a beauty!' " He was nothing like her previous boyfriends: hunky Bruce or strapping Bob or pretty Phil or even brooding Mike Booth. Perhaps she no longer needed a Prince Charming to reassure her of her beauty. She and John didn't "look good" together, but you couldn't take your eyes off them.

Everywhere they went, people would roll down their windows and scream, "Hey, Fredo!" "He was absolutely conflicted about the whole idea of fame," his brother said. "I don't think he really knew how to deal with it or wanted to." The *Godfather* films had made him recognizable, but they hadn't made him

rich. When he and Meryl went to Little Italy, the restaurant owners would refuse to let them pay. So they went to Little Italy all the time, dining out on free pasta and caprese, their nights and bellies filled with "Hey, Fredo"s.

"The jerk made everything mean something," she said later. "Such good judgment, such uncluttered thought. For me particularly, who is moored to all sorts of human weaknesses. 'You don't need this,' he'd say, 'you don't need that.'" And yet John was Meryl's gateway to the elite of the acting world; in November, she accompanied him to the legendary acting teacher Lee Strasberg's seventy-fifth birthday bash at the Pierre, where the guest list included Al Pacino, Celeste Holm, and Ellen Burstyn.

The romance moved as fast as John moved slow, and before long Meryl moved into the loft on Franklin Street. Now they would be pioneers together, discovering a downtown that had barely discovered itself. She soon learned what John's past girlfriends had learned before her. "He took his time with stuff," she recalled. "It took him a really long time to leave the house, to lock the car." One time John decided to wallpaper a room. It took him three weeks.

But she didn't mind. Let time move as slow as molasses. They were happy.

A few weeks after Meryl's audition for *Julia*, Fred Zinnemann gave the title role to Vanessa Redgrave—hardly an unknown. He offered Meryl a small part as Lillian Hellman's gossipy friend Anne Marie. But he had too many blondes in the movie already: Would she consider wearing a wig? Of course, Meryl told him. She'd do anything.

In the fall, she flew to London to film her scenes. It was her first time acting in a movie—in the company of Jane Fonda and Vanessa Redgrave, no less. As on that first plane ride out of Bernardsville, her world was getting bigger.

Her first day on the set, she broke out in hives. For one thing, she looked awful: the curly black wig she'd been given made her look harsh, and her costumes were all absurd hats and furs and red period dresses. The scene was a party for Lillian Hellman thrown at Sardi's, the theater-district restaurant that had been replicated in London. Meryl prepared dutifully, as she would for Shakespeare, but when she showed up she was handed a rewrite. Her panic was evident in the red splotches below her neck, which the makeup people frantically pancaked over.

Most intimidating: her scenes were all with Jane Fonda. At thirty-eight, no film actress was more prom-

inent or more controversial. Her sex-kitten *Barbarella* days were behind her. So was "Hanoi Jane." With *Fun with Dick and Jane,* she had reclaimed her stature as a mainstream star, and now used her clout to foster socially conscious projects like *Julia,* which featured her bravely outwitting Nazis.

Meryl was brought over to meet Fonda. "She had an almost feral alertness," Meryl recalled, "like this bright blue attentiveness to everything around her that was completely intimidating, and made me feel like I was lumpy and from New Jersey, which I am."

They rehearsed once through, and Fonda encouraged her to improvise. On the first take, Meryl embellished a bit. It seemed to work well. On the second take, feeling bold, she thought: *I'll try something else!*

Fonda leaned in and told her, "Look down."

"What?"

"Over there." Fonda pointed down. "That green tape on the floor. That's you. That's your mark. And if you land on it, you will be in the light, and you will be in the movie."

She was grateful for the help—she needed it—but she also observed the way Fonda carried her stardom. It seemed as if half of what Jane Fonda did was maintain the machinery of being Jane Fonda, as opposed to acting. "I admire Jane Fonda," Meryl said not long

after. "But I also don't want to spend all my time immersing myself . . . in the business of myself . . ."

She was similarly awed by Vanessa Redgrave. They didn't share any scenes, but they shared a car ride. Meryl worried about being tongue-tied, but luckily Redgrave talked the whole time about politics and Leon Trotsky. Meryl didn't know much about Trotsky, but she knew something about Redgrave: this was the kind of screen actress worth revering, someone who led with her convictions and never cowed to expectations.

On days off, she would hang out with John Glover, who played her brother. Neither of them had much to do, so they'd kill time in the bar below her hotel, in South Kensington. (Meryl kept her per-diem money in a suitcase in her room, until one day she returned to find it had all been stolen.) Or they'd go to Harrods, where Meryl would study the shopgirls' accents. She was determined to nail the English pronunciation of "actually."

Other days, she would visit Glover at the house where he was staying. Over lavish homemade dinners, the actors and their hosts would play a game called Adverbs: whoever was up had to act in the manner of a word, and the other players would guess what it was. When it was Meryl's turn, she pretended to wake up in the morning and look out the window.

Everyone yelled out the word at once: "Beautifully!"

Midway through, Cazale flew over to visit. Her socializing with the other actors abruptly ended: she and John were back in their own all-consuming universe. When they returned to New York, John found out his agent had been trying to reach him. There was an offer to do a TV movie about the blacklist. No one could find him, and the part had slipped away. "What do you mean, you couldn't find me?" John said, uncharacteristically furious. They knew he was going to England, and he and Meryl needed the money.

When *Julia* came out the following fall, Meryl was equally vexed. Not only did she look ghastly in her marcelled black wig; half of her part had been cut, and the lines from one vanished scene had been transported to her mouth in another. Fred Zinnemann sent her a note of apology.

I've made a terrible mistake, Meryl thought. *No more movies.*

Joe Papp was flailing at Lincoln Center. Like a losing baseball coach, he kept changing his strategy, but nothing stuck: challenging new plays, well-mannered chestnuts. Finally, he hit on a hybrid idea: matching classic plays with experimental directors, who could radically rethink them on a grand scale. "You can't do

the classics conventionally anymore," he said. "They lay on you like bagels."

He hired Richard Foreman, the outré founder of the Ontological-Hysteric Theater, to direct *Threepenny Opera*. The production, which opened in the spring of 1976, was a controversial success. As *Measure for Measure* ran at the Delacorte, Papp was juggling a trio of hits: *Threepenny* at the Vivian Beaumont, the Broadway-bound *for colored girls*, and *A Chorus Line*, which was grossing more than $140,000 a week at the Shubert. But somehow it wasn't enough. Despite playing to capacity, Lincoln Center was running a $1.2 million deficit.

Amid the turmoil, there were at least two people Papp wanted to keep busy: John Cazale and Meryl Streep. John and Al Pacino were anxious to work together again, and they talked about doing a double bill of Strindberg's *Creditors* and Heathcote Williams's *The Local Stigmatic* down at the Public. Meryl, meanwhile, would help ring in 1977 at the Beaumont, in a new production of Chekhov's *The Cherry Orchard* directed by Andrei Serban.

The Romanian-born, thirty-three-year-old Serban had been working at La MaMa when Papp discovered him. Serban found the Off Off Broadway world amateurish, preferring the discipline of the Eastern

European avant-garde. Meryl saw his rigidity as an incentive. "That's when you can really work," she said before rehearsals began, "when a director knows exactly the construct he wants. I hate 'laid back' directors. I'd probably fare very badly in California."

Serban's *Cherry Orchard* would do away with the solemn psychological realism of most Chekhov productions and look for, in his words, "something much lighter and closer to the fluidity of real life." Chekhov had, tantalizingly, called *The Cherry Orchard* a comedy, a description that Stanislavsky had ignored when he directed the 1904 premiere, enraging the playwright. Serban wanted to defy Stanislavsky and restore *The Cherry Orchard* as a rip-roaring farce.

He would be aided by Elizabeth Swados, a moody twenty-six-year-old composer and Serban's frequent collaborator at La MaMa. Serban, Swados, and Foreman were key to Papp's last-ditch plan to solve the riddle of the Vivian Beaumont. For the role of Madame Ranevskaya, Papp secured the sixty-year-old stage star Irene Worth. Meryl had seen her the previous season, in a Broadway revival of Tennessee Williams's *Sweet Bird of Youth*, and gushed soon after that "you could have taken away all the other characters in the play, the sets, everything, and still have understood every theme in the play."

In the lead-up to the Tony Awards, Meryl and Mary Beth Hurt had attended an awards breakfast at the Regency Hotel. When the young actresses arrived, Arvin Brown offered to introduce Meryl to Miss Worth, who was nominated for Best Actress in a Play. Starstruck, she and Mary Beth decamped to the ladies' room to smoke cigarettes, until Arvin knocked on the door: "Come out of there—I've got Irene."

Meryl slinked back out and was delivered to Miss Worth.

The great actress looked Meryl up and down and asked her, "What do you plan to do in December?"

"Unemployment, I guess," she stammered.

"Fine," Worth said. "Think about *The Cherry Orchard*."

She did. Her regard for Worth—or, more to the point, Papp—was enough that she took the role of Dunyasha, the chambermaid. It was a small part, one that she might have otherwise turned down. "Everybody was talking about this fantastic young actress, and many were surprised she accepted to play such a small part in *The Cherry Orchard*, when she could have already been offered a Broadway lead," Serban recalled. "But she decided she still wanted to learn from watching the elders, in this case from the great Irene Worth playing Ranevskaya. I remember Meryl coming to rehearsals

even when she was not called, quietly sitting and knit-
ting on the side, watching every detail of Irene's unique
technique and being fascinated."

Papp had assembled a powerhouse cast, including
Mary Beth Hurt as Anya and the high-spirited Puerto
Rican actor Raúl Juliá (one of Papp's notable finds) as
Lopakhin. He envisioned the *Cherry Orchard* ensem-
ble forming the nucleus of an American classical acting
company, the kind Tony Randall dreamed of as well.
Meryl and Mary Beth shared Dressing Room No. 18.
J. Roy Helland was back doing the wigs, and he fash-
ioned Meryl a wacky, nimbus-like updo.

Rehearsals got off to an awkward start. Serban knew
Meryl only from *27 Wagons Full of Cotton*, and when
she walked in the first day, he looked at her and balked.
"You're not fat!" he growled in his thick Romanian
accent. "*No fat, no funny!*" Things got tenser from
there. Serban hated the concept of "style" and told the
cast he wanted the acting to be "simple." But what did
that mean? Meryl questioned him: Wasn't "simple" a
style in itself?

More frustrating were the improvisation exercises
that Serban led in rehearsal. In one, he had the stage
managers read out the text as the actors mimed the
action. In another, he had them invent a nonexistent
fifth act after the play ends. Irene Worth embraced

Serban's methods, at one point impersonating a swan on the attack. But Meryl was impatient. Perhaps she was unhappy playing the servant, or maybe the improv games reminded her of those dread early days at Yale. Her irritation boiled over during one exercise, in which she acted out Dunyasha's resentment, which by that point seemed to have fused with her own.

"I've never seen an angrier improvisation come out of anyone than the one that Meryl did when she was asked to improvise how this person, this servant, viewed her life," Mary Beth recalled. "She was crawling on the floor and spitting and hocking. That girl was really angry at Andrei Serban."

But Serban was pleased. "She was fearless," he recalled. "One is usually afraid to throw oneself outside the norm of what is accepted as the standard heavy method of acting the 'Russians': an artificial, sentimental way of feeling for the character, but Meryl was only concerned with what was valid and alive in the moment. No methods were of any help to her except the pure discovery that came to life in improvisation."

Serban encouraged Meryl's "Lucille Ball tendencies." In return, she developed a dead-on Serban imitation, bellowing, "Falling down *verrry verrry* funny." By the time the play opened, on February 17, 1977, she had found a singular take on Dunyasha: a sexy, frantic,

pratfalling Matryoshka doll who tumbled to the floor whenever she made an entrance. As in *27 Wagons*, her knack for physical comedy was evident, but even more so in *The Cherry Orchard*, which she played for pure slapstick. When Yasha the butler kissed her in Act I, she fainted and broke a teacup. When he left her in Act IV, she tackled him to the ground. She spent much of Act II with her bloomers around her ankles.

Naturally, Serban's clownish take on *The Cherry Orchard* polarized critics. In *The New Leader*, John Simon called it "coarse" and "vulgar," adding, "We are not interested in the truth as a Romanian parvenu pipsqueak sees it. We're interested in the truth as the great master Chekhov saw it." But Clive Barnes, in the *Times*, delivered a rhapsody: "It is a celebration of genius, like the cleaning of a great painting, a fresh exposition of an old philosophy. . . . The State Department should send it instantly to its spiritual home—the Moscow Art Theater."

Audiences were similarly divided. One spectator wrote to Papp and Serban, "I think that if this horrifying production had been done in Russia, the two of you and perhaps Mr. Julia would have to face a firing squad." Another suggested, in a letter to the *Times*, that the play be retitled "The Wild Cherry Orchard." Some believed Meryl was shamelessly hogging the spotlight.

When Papp wrote to subscribers about his "respect and admiration" for Serban, one recipient sent back the letter with blue scrawl in the margins: "Are you kidding?! Impossible! Can you understand a production in which the maid is the outstanding performer?"

A month into performances of *The Cherry Orchard*, Meryl hit a quiet milestone: her debut as a screen actress. With *Julia* not yet released, the occasion was a television movie called *The Deadliest Season*, about the rough-and-tumble world of professional ice hockey.

Michael Moriarty played a Wisconsin hockey player under pressure to rev up his aggression on the ice. He checks a buddy on the opposing team during a game, and the guy is carted off to the hospital with a ruptured spleen. When the friend dies, Moriarty is tried for manslaughter. John's friend Walter McGinn played the district attorney. Meryl was Moriarty's wife, who desperately wants to believe her husband is innocent. The role was a variation on Adrian from *Rocky*, which was released in November, 1976, the same month *The Deadliest Season* was shot.

Meryl had gotten the part on the suggestion of the casting director Cis Corman. When the director, Robert Markowitz, saw her audition, he went back to the screenwriter and told him to beef up her scenes.

Much of the dialogue was between the hockey player and his lawyer, but Markowitz wanted to shift some of that action to the husband and wife. "She was like a centrifugal force," Markowitz recalled.

On set in Hartford, Meryl was jumpy. Moriarty noticed her continually twirling her hair or biting her nails. She gave her character a similar set of nervous tics—biting her lip, chewing her hand, rolling her eyes. She adopted a flat Wisconsin accent ("Maybe I'll take some *cawffee* out") and a low-grade uneasiness that matched Moriarty's disassociated gentle giant. In one scene, she sank on a hotel bed and told him, "When I watched you in a game, hittin', checkin', it would turn me on. I couldn't wait to get home in bed with you. I don't know, there was something different tonight."

It wasn't exactly Tennessee Williams, and Meryl was usually hesitant to play somebody's wife or girlfriend. But the character had her own kind of dignity, confronting her husband about the violence on the ice. As the director saw it, "She was not a subjugated wife, because she was confronting him at the heart of what he does."

Word of her talents was spreading. While *The Deadliest Season* was still being edited, three notable filmmakers came to look at the footage: Miloš Forman, who had just made *One Flew Over the Cuckoo's Nest*;

Louis Malle, who would soon direct *Pretty Baby*; and the Czech-born director Karel Reisz, who was four years away from *The French Lieutenant's Woman*. Meryl's performance also impressed the special's producer, Herbert Brodkin, who was preparing for the miniseries *Holocaust*.

The Deadliest Season got a warm response when it aired on CBS, on March 16, 1977. Two weeks later, Walter McGinn was driving in Hollywood before dawn and plunged off a cliff near Mulholland Drive. He was forty years old. Robyn Goodman had lost a husband, and John Cazale had lost one of his closest friends. A black cloud had formed over their little world, but, for Meryl and John, the worst was yet to come.

Three days after *The Cherry Orchard* closed at Lincoln Center, Meryl was announced as Shirley Knight's replacement in *Happy End*. Nothing could be less appropriately titled than the Chelsea Theater's production. The show was, in a word, cursed.

The trouble started early on. Michael Posnick, who had directed the Brecht-Weill musical at the Yale Rep, was restaging it at the Brooklyn Academy of Music, where the Chelsea was in residence. Christopher Lloyd played the Chicago gangster Bill Cracker. Shirley Knight, who had beaten Meryl and Mary Beth for the

Tony the previous year, was playing Hallelujah Lil, the Salvation Army girl who tries to convert him—the part that Meryl had taken over in New Haven on an afternoon's notice.

Posnick was relatively inexperienced, and the temperamental Knight was walking all over him. To make matters worse, she wasn't much of a singer, and the conductor never knew when she'd come in. "The songs went west, the cues went north," said Michael Feingold, who had adapted the script. One night after her first song, Knight turned to the orchestra and said, "I didn't like how I did that. I think I'll do it again." The second go-round wasn't much better.

Chaos broke out. One actress stomped out center stage moments before the first preview, raging that there was a mistake in her bio. Another actor pushed a castmate off of a four-foot riser during the song "Brother, Give Yourself a Shove." Two of the gangsters who were constantly fighting got locked in a dressing room together. And Christopher Lloyd was having an extreme case of nerves. "In my gut," he recalled, "I felt this production was a disaster."

With the show bound for Broadway, he expressed his concerns to the Chelsea's artistic director, Robert Kalfin. Overwhelmed by his leading lady, Posnick quit at the same moment that he was fired. Then Kalfin

took over as the director and promptly fired Shirley Knight. It was then that Joe Grifasi, who was playing Brother Hannibal Jackson, made a suggestion. Meryl Streep already knew the part from Yale. Why not ask her?

Once again, Meryl learned the part of Hallelujah Lil under duress. With her kohl eyes, bowler hat, and curly yellow wig, she looked like a demented Kewpie doll, or an extra from *A Clockwork Orange*. "She saved the show," Christopher Lloyd said.

But the *Happy End* curse continued. Two days before it opened at BAM, Lloyd fell onstage during a fight scene and dislocated his knee. He was told he would need major surgery. The Broadway opening was postponed, and Lloyd was replaced by his understudy, Bob Gunton. At the same time, Kalfin retooled the script, infuriating Feingold and antagonizing the Brecht estate.

As if that wasn't enough, Bob Gunton came down with rubella, a.k.a. the German measles. On a Tuesday at one p.m., the cast lined up to receive gamma globulin injections to prevent further infection. That night, Christopher Lloyd returned in a hip-to-ankle cast and a painkiller haze, becoming the understudy to his understudy. "When I opened my mouth to sing my first song, I was an octave too high," he recalled. "It was

kind of torture. But Meryl was there, and she had a wonderful way of teasing and fun."

Meanwhile, John Cazale's plans to share a double bill with Al Pacino had fallen apart, now that Al was starring on Broadway in *The Basic Training of Pavlo Hummel.* Still mourning over Walter McGinn, John had found a suitable alternative: Andrei Serban's production of Aeschylus's *Agamemnon*, with music by Elizabeth Swados. John would play Agamemnon and Aegisthus. It would start at the Vivian Beaumont two weeks after *The Cherry Orchard* closed, continuing the Serban streak.

By the end of April, 1977, Meryl and John were both in rehearsals for separate Broadway shows. Come May, she'd be starring in *Happy End* as it limped to the Martin Beck, while he played the title role in *Agamemnon* twenty blocks north. By day, they'd have the cobblestones of Franklin Street. At night, they'd have the lights of Broadway.

There was just one problem: John Cazale was coughing up blood.

"The girls didn't buy it," she said of her high school persona. "They didn't like me; they sniffed it out, the acting."

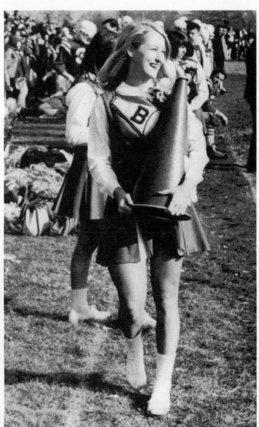

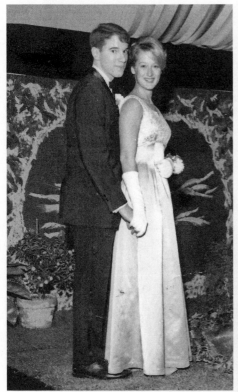

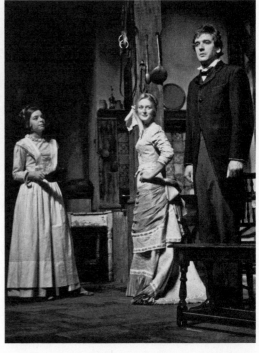

Above, at the prom with Mike Booth. Right, as Miss Julie at Vassar in December, 1969. It was the first serious play she ever saw, and she was starring in it.

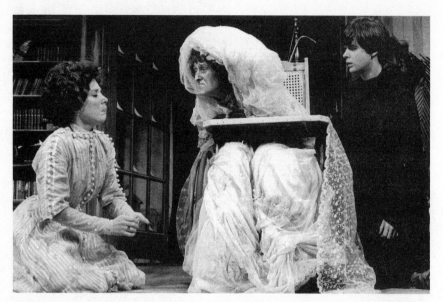

Her breakout role at the Yale School of Drama, the eighty-year-old "translatrix" Constance Garnett in *The Idiots Karamazov*. Christopher Durang, kneeling on right, played Alyosha.

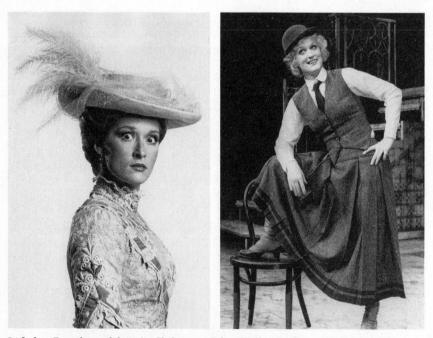

Left, her Broadway debut, in *Trelawny of the "Wells."* Right, as Hallelujah Lil in *Happy End*.

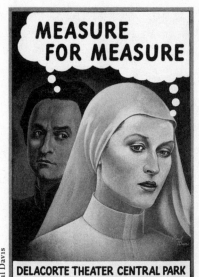
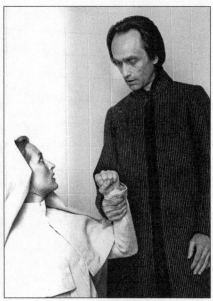

"We sense the sexual give-and-take between her and Angelo," the *Times* critic wrote of her performance as Isabella in *Measure for Measure*, opposite John Cazale.

With Cazale at Lee Strasberg's seventy-fifth birthday party. "The jerk made everything mean something," she said later. "Such good judgment, such uncluttered thought."

Above, shooting *The Deer Hunter* with Michael Cimino and Robert De Niro. Below, with Chuck Aspegren, De Niro, and Cazale, in the wedding scene that seemed to go on forever. Cazale didn't survive to see the film. Of the five movies he acted in, all were Oscar-nominated for Best Picture. He never got a nomination.

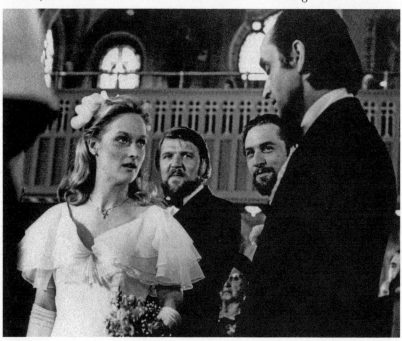

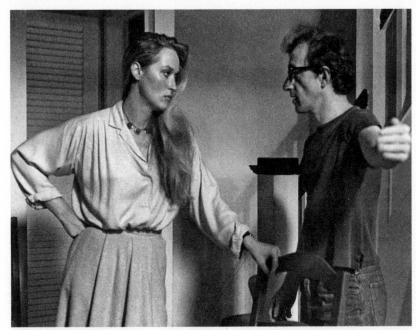

"I think he just hated my character," she said of Woody Allen, who cast her as his ex-wife in *Manhattan*. Below, reading Germaine Greer backstage at *The Taming of the Shrew*.

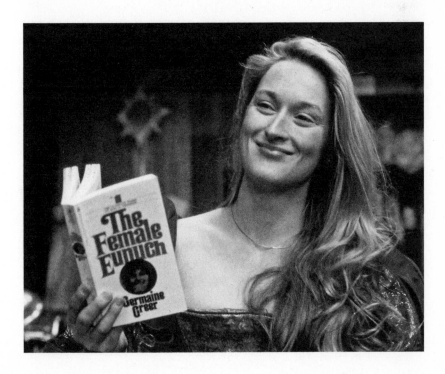

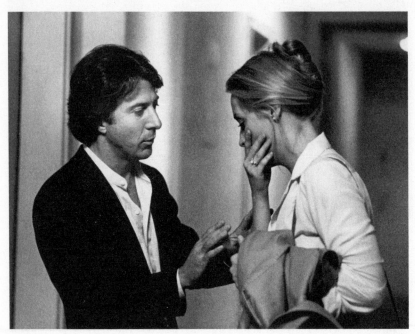

Above, Joanna leaves Ted in the opening scene of *Kramer vs. Kramer*. Below, Ted's lawyer asks, "Were you a failure at the one most important relationship in your life?"

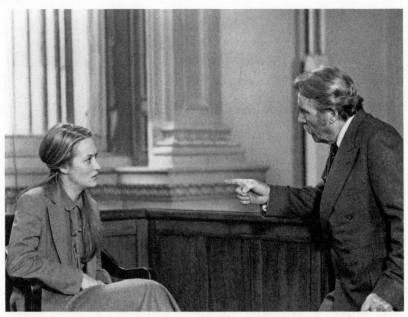

Above, meeting the queen at a royal screening of *Kramer vs. Kramer*. Below, trying and failing to share a private moment with Don Gummer.

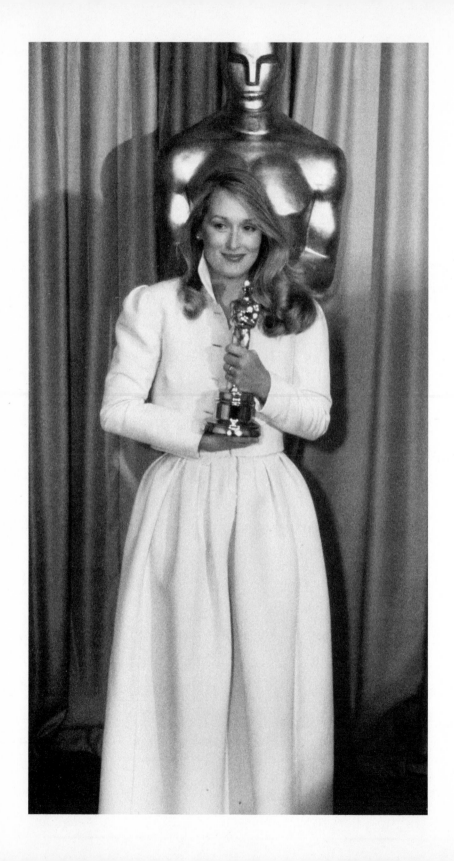

Linda

*T*he mourners are gathered at a hilltop cemetery. It's November: bare trees, gray skies pumped with smoke from the nearby steel mills. A priest swings a censer and sings a dirge. Meryl Streep turns to her left and, through a thick black veil, sees Robert De Niro. She searches his face—he seems utterly lost. She looks down at her feet in the withered grass. The grief in the air is lacquered by disbelief. Nobody thought it would turn out like this, least of all her.

One by one, they approach the coffin. Meryl lays down a white flower with a long stem, looking like a woman whose innocence has been torn asunder, her great love scythed down before it ever got to blossom. She crosses herself and follows De Niro to the cars. She does not turn around, and therefore does not see the

pale, mustachioed face of John Cazale. He is the last one to lay down a flower, and the last to leave.

Pull the frame out a few inches, and the trees are resplendent, the grass green. A vast stretch of summer surrounding a patch of brown fall, like an oasis in reverse. It's the set of The Deer Hunter. *The coffin is empty.*

Happy End was finally getting to Broadway, curse or no curse. Despite its haunted house's worth of calamities, it had one unassailable asset: Meryl, who had relearned the part of Hallelujah Lil in three afternoons. Still, time was short, and on the day the scenery loaded into the Martin Beck, everyone was on edge. The cast had one chance to run through the show. And Meryl was nowhere to be found.

Uptown, *Agamemnon* was wrapping up its first week of previews, and it, too, was missing its star. On May 3, 1977, the stage manager wrote in his daily report: "John Cazale was out most of the day for medical tests, so Jamil played Agamemnon."

It had become clear that something was seriously wrong with John. Meryl had noticed "disturbing symptoms," and at her urging he agreed to see a doctor—previews be damned. But the two actors knew nothing about navigating the Manhattan medical world, where

the doctors' offices on Park Avenue could be booked up for weeks. Luckily, they knew someone with clout, maybe the one person in the downtown theater who could get anything he wanted with a phone call: Joseph Papp.

Beleaguered as he was by his bloated theatrical empire, Papp would throw everything aside to help an actor or a playwright in an hour of need. Mary Beth Hurt had learned this firsthand, when he salvaged her from the psych ward at Roosevelt Hospital. For Meryl and John, he would do no less. He arranged for them to see his doctor, William Hitzig, at his practice on the Upper East Side.

An Austrian-born septuagenarian, Dr. Hitzig had a warm bedside manner that belied his vast influence. Aside from Papp, his patients included Emperor Haile Selassie of Ethiopia and the Indian statesman V. K. Krishna Menon. He had been given the key to the City of Hiroshima after treating two dozen women disfigured by the atomic bomb, and later flew to Poland to care for survivors of Nazi medical experiments. Despite his global humanitarian efforts, he was also one of the few New York doctors who made house calls.

If Dr. Hitzig had an extravagance, it was his vintage Rolls-Royce, painted, Gail Papp recalled, in "some outrageous color like citron." At Papp's request, Hitzig

agreed to have his chauffeur pick up John and Meryl, and they spent the day being driven to what seemed like every cancer specialist in the city. It was grimly ironic: here they were, like two movie stars arriving at a premiere, but with any sense of luxury erased by the hovering dread.

John called in sick to *Agamemnon* the next night. And the next. That first week of May was a blur of medical tests, hopping in and out of Dr. Hitzig's Rolls-Royce, with Joe Papp on hand to make sure they were treated like royalty. "He checked us in at the hospital, sat in the chair for hours and waited for the results of the tests," Meryl would recall. "He asked the questions we were too freaked out or too ignorant to ask." After this, Papp would no longer be the man who gave Meryl her first job in New York City. He would be Papa Joe, the only boss she ever loved.

After several exhausting days, Meryl and John sat in Dr. Hitzig's office with Joe and Gail Papp. Nothing in the doctor's kindly demeanor betrayed the horror of the diagnosis: John had advanced lung cancer, and would need to start radiation immediately. "He broke the news to him in his way, holding out a branch of hope for the future, although there was in fact none," Gail Papp recalled. "His cancer had spread all through-

out." It was the kind of news, she said, that makes you feel "like you've been struck dead on the spot."

John fell silent. For a moment, so did Meryl. But she was never one to give up, and certainly not the kind to succumb to despair. Maybe it was just the uncanny sense of confidence that she was always able to trick herself into having, or at least showing. But right then, Meryl dug into some great well of perseverance and decided that, as far as she was concerned, John was going to live.

She looked up and said, "So, where should we go to dinner?"

Like Agamemnon, who returns home from the Trojan War only to be killed by Queen Clytemnestra, John Cazale had been dealt a terrible fate. With Meryl on his arm, he sulked into the Vivian Beaumont on May 6th and took aside the director, Andrei Serban. He would no longer be able to continue with the production. That evening, the stage manager's report simply read: "After tonight, Jamil Zakkai will play Agamemnon and Aegisthus."

Meryl returned to *Happy End*, in some sense the latest victim of the curse. If she was roiled by the backstage chaos or the unfolding tragedy at home, she didn't

show it: her fellow actors saw nothing but dogged professionalism. One time, she took John and the cast to Manganaro's, the old-school Italian eatery on Ninth Avenue, famed for its hanging salamis and meatballs in marinara sauce. It was John's favorite restaurant, Meryl told her castmates, a steely grin on her face.

When John showed up backstage, everyone who knew what was going on was staggered to find him still smoking Cuban cigars. Meryl had declared her own dressing room smoke-free, so John would go down to her costar Grayson Hall's quarters, which had become the company's unofficial smoking lounge. Christopher Lloyd, still in his hip-to-ankle cast, took note of Meryl's fortitude. "She had a kind of a tough love about it," he said. "She didn't let him malinger."

But the reality was becoming hard to ignore, especially for John. When his brother, Stephen, showed up at the loft and heard the words "They found a spot on my lung," he knew instinctively that it was a lost cause. He went out onto John's fire escape and broke down into heaving sobs. All John could say was, "Did you ever think of quitting smoking?" Not long after, the three of them went out to lunch in Chinatown. Stephen was horrified when John stopped on the curb, hunched over, and spit blood into the gutter.

Their friends were hopeful, or tried to be. Robyn Goodman, still adjusting to life as a young widow, thought to herself, *John always looks sick. How bad can this be?* Al Pacino sat in the waiting room as John went in for treatment, but the patient's attitude was always some variation of "We're gonna get this thing!" John repeated the sentiment, like an incantation, to Israel Horovitz, interrupting his optimism only to wonder aloud, "Will they let me work?"

Night after night at the Martin Beck, Meryl sang her weary solo, "Surabaya Johnny," Hallelujah Lil's account of a distant love affair with a pipe-smoking scoundrel from the East. In the song, she follows him down the Punjab, from the river to the sea, until he leaves her flat. With her own stage-door Johnny lying in her dressing-room cot, Meryl gave each lyric a rueful sting:

Surabaya Johnny, why'm I feeling so blue?
You have no heart, Johnny, and I still love you so . . .

That June, *Happy End* was up for a Tony Award for Best Musical. The producers asked Meryl to perform "Surabaya Johnny" live at the broadcast. She looked at them and said, "No, I don't have enough confidence

to do that," in a manner so confident that the answer seemed to contradict itself. In any case, Christopher Lloyd performed another song, on crutches, and the show lost to *Annie*.

By then, Meryl and John were planning their next move, one that had little to do with doctors and radiation and everything to do with what brought them together in the first place: acting. While John had the strength, they would give a piece of themselves to the only thing they considered sacred, which was make-believe. They would star together in a movie.

A certain mythic miasma would forever cloud *The Deer Hunter*. Even as it marched to the Academy Awards, a Writers Guild arbitration would have to sort out its byzantine list of screenwriters. The murkiness of its origins was indicative of the deeper mysteries that came to haunt the film, among them: Was Russian roulette really played in Vietnam? Does it matter? Is it even a Vietnam movie, or a meditation on grand themes of friendship and manhood? Is it antiwar—or fascist—propaganda? A masterpiece, or a mess?

At the center of the fog, and most often its source, was the director, Michael Cimino, a man later prone to such gnomic statements as "When I'm kidding, I'm serious, and when I'm serious, I'm kidding" and "I am not who

I am, and I am who I am not." Short and soft-spoken, with a bulbous nose, thick jowls, and puffy hair, Cimino looked nothing like a debonair movie director. If his appearance was modest, his ego was boundless—he once claimed that he had been an artistic child prodigy, "like Michelangelo, who could draw a perfect circle at age five." Of his family, he said little. He grew up in New York and started his career making commercials for L'eggs and United Airlines, before directing Clint Eastwood in *Thunderbolt and Lightfoot*, in 1974.

Two years later, Cimino was approached by the British producer Michael Deeley, of EMI Films. Deeley wanted him to take a look at a screenplay he had lying around, by Quinn Redeker and Lou Garfinkle. Redeker had based it on a photo spread he had seen in a magazine two decades earlier, showing a man playing Russian roulette with a Smith & Wesson revolver. He and Garfinkle spun the image into an adventure story about two guys who join a Russian-roulette circuit. Over the course of a year and some twenty-one drafts, they kept changing the setting: South Dakota, the Bahamas. By the time the script reached Deeley, who bought it for $19,000, it was set in Vietnam and titled *The Man Who Came to Play*.

America had only begun to reckon with the catastrophe of the Vietnam War, but Michael Deeley was undeterred, even after five major studios told him dif-

ferent versions of "It's too soon." Besides, the real hook was not Vietnam but the harrowing scenes of Russian roulette played by American POWs. Still, Deeley thought the story needed character development, and he set out in search of a writer-director who could flesh out the script. Enter Michael Cimino. When Deeley met him, he thought he had a "muted" quality, or at least had shown one with Clint Eastwood, with whom one does not mess.

Whether Cimino saw himself that way is another matter. After the moderate success of *Thunderbolt and Lightfoot*, he was poised to join the crop of pioneering directors who were shaping the New Hollywood: rambunctious auteurs like Martin Scorsese, Peter Bogdanovich, and Francis Ford Coppola, who had jolted American movies by importing the racy inventiveness of European art-house cinema. Films like *Bonnie and Clyde, Easy Rider,* and *Midnight Cowboy* had ushered in a creative revolution that belonged squarely in the hands of directors, who wielded more and more control over budgets and tone.

Deeley and Cimino met for lunches at EMI's rooftop garden in Beverly Hills, agreeing that some character background was called for, maybe twenty minutes at the beginning. Some time after Cimino had gone on his way, Deeley discovered that the director had sub-

contracted a writer named Deric Washburn, without mentioning it to Deeley. It was a red flag—a minor one, but the first in a series that led Deeley to doubt everything he had thought about Cimino. "All I can possibly say," the producer said later, "is that from my point of view he appeared to be quite peculiar in lots of different ways, and one of them was in difficulty telling the truth sometimes."

Washburn, whom the Writers Guild would deem sole screenwriter (Redeker and Garfinkle, along with Washburn and Cimino, got story credit), remembered Cimino as "very guarded." The exception was the three days they spent at Cimino's house in Los Angeles, transforming *The Man Who Came to Play* into something decisively their own, namely *The Deer Hunter*.

"The thing just flowed out," Washburn said. "It was like a tag-team thing. We had an outline and dialogue and characters. We had the whole damn thing in three days. Never happened to me again. So I sat down and started writing. I think it took three weeks. And every night Cimino would send an assistant in to take the pages away. Of course, I had no copies of them, which came up later, because when the script was finished my name wasn't on it."

Washburn worked twenty-hour days. When he was done, Cimino took him out to a cheap restaurant off

the Sunset Strip, along with his associate producer and sidekick, Joann Carelli. When they finished dinner, according to Washburn, Carelli looked at him and said, "Well, Deric, it's fuck-off time." The next day, Washburn got on a plane and resumed his life in Manhattan as a carpenter.

The script that Cimino then delivered to EMI retained almost nothing of *The Man Who Came to Play*. It was set in the industrial town of Clairton, Pennsylvania. The original protagonist had been split into three, all steelworkers of Russian extraction. The movie would have a triptych structure. In Act I, the carefree young men of Clairton prepare to go off to war. In Act II, they face the verdant hell of Vietnam, where prison guards force them to play Russian roulette. Act III, back in Clairton, shows the devastating aftermath. Michael, the noble sufferer, returns alive but alienated. Steven comes back without his legs. And Nick becomes a shell-shocked zombie, doomed to play Russian roulette in a Saigon betting ring, until a bullet finally ends the pain.

Deeley's business partner Barry Spikings recalled being on a plane with Cimino, who turned to him and said, "You know what that Russian roulette thing is? It's really a metaphor for what we're doing with our young men, sending them off to Vietnam." Ultimately, the script had less to do with the politics of the war than

with the profundity of male friendship. Critics would later observe that the director and his protagonist shared a first name, Michael. More revealing was the character's last name, Vronsky, borrowed from *Anna Karenina*—a clue, perhaps, to Cimino's Tolstoyan sense of scale. He had solved the problem of character development with a raucous Act I wedding party for Steven and his girlfriend, Angela. In the screenplay, it took up seven and a half pages.

"Michael, this could really eat us up a bit," Spikings would say.

"Oh, no, it's going to be a flickering candle," Cimino assured him. "We can knock it out in a couple of days."

In the midst of the men's camaraderie, Cimino and Washburn placed a woman: Linda, a supermarket checkout girl, torn between her engagement to Nick and the deeper allure of Michael. Described in the screenplay as "a fragile slip of a thing with a hauntingly lovely face," she was less a fully realized character than the archetypal girl back home, the Penelope waiting at the end of a modern-day Odyssey.

Knowing that a movie about Vietnam would be a hard sell, EMI needed a star to play Michael Vronsky. Aside from being noticeably non-Russian, Robert De Niro couldn't have been more tempting. His roles in *Mean Streets*, *The Godfather: Part II*, and *Taxi Driver*

had solidified him as the rough-and-tumble hero of the New Hollywood. EMI paid the asking price of $1.5 million, then placed a full-page ad in *Variety* announcing its coup, showing De Niro in sunglasses, holding a rifle.

Cimino and De Niro began scouting for actors to round out the cast. At a steel mill in Gary, Indiana, they got a tour from the burly foreman, Chuck Aspegren, and then enlisted him to play Axel, the group's hard-drinking rascal. Back in New York, De Niro nabbed the thirty-four-year-old Christopher Walken, who had recently starred opposite Irene Worth in *Sweet Bird of Youth* on Broadway, to play Nick. He saw John Savage in *American Buffalo* and thought he would be perfect for Steven, the bridegroom turned amputee. And at the Vivian Beaumont, he saw Meryl Streep as the pratfalling Dunyasha in *The Cherry Orchard*. The role was nothing like the demure Linda, but when Cimino caught her a few weeks later, singing "Surabaya Johnny" in *Happy End* at BAM, she got the offer.

Movies didn't rank high among her ambitions, and she had told herself she wasn't an ingénue. Linda, she would say, was "the forgotten person in the screenplay and also in the other characters' lives." The girlfriend part, the blonde in the love triangle—that was someone else's job, someone else's dream. Rather than

"hitting it big as some starlet," Meryl had planned her burgeoning stage career to achieve the opposite. In less than two years she'd been a nun, a French princess, a Southern floozy, a Manhattan secretary, a Civil War belle, a clumsy Russian maid, and a Salvation Army crusader—not to mention the menagerie of parts she'd played at Yale. Linda the checkout girl could erase all that.

"They needed a girl between two guys," she said later, "and I was it."

But there was another pull to *The Deer Hunter*, one that superseded her typecasting concerns: it had a role for John Cazale. Stanley the steelworker was the jester of the group, the "failed alpha male" (in Cimino's summation) who rankles his buddies with cheap jabs and gossip. He was the guy who preens in the mirror despite his receding hairline, who wagers twenty bucks that the Eagles quarterback is wearing a dress. Like Fredo Corleone, he was the weakling in a band of brothers, quick to overcompensate with a trashy date or a defensive barb, always fighting a comic brawl with his lagging masculinity.

John, according to Cimino, wanted the chance to act alongside De Niro. But he was hesitant to take the role, for reasons he didn't initially make clear. Finally, he came to Cimino and told him he was undergoing radia-

tion for lung cancer. If the director didn't want to take the risk, he would understand. Stunned, Cimino told him they would go ahead as planned. The actors were required to take medical exams before the shoot—what should I say? John wondered. Tell the truth, Cimino told him. They would all hold their breath and wait.

The Deer Hunter was set to begin filming in late June, just as Meryl was wrapping up her run in *Happy End*. Weeks went by without a word about the physical, until, the day before shooting, Cimino got a frantic call from an executive at EMI, most likely Michael Deeley. The studio had to insure the film, and suddenly the awful reality of John's health was a matter of dollars and cents. According to Cimino, "the morons at EMI" told him to fire John. The director exploded. "I told him he was crazy," Cimino said later. "I told him we were going to shoot in the morning and that this would wreck the company. I was told that unless I got rid of John, he would shut down the picture. It was awful. I spent hours on the phone, yelling and screaming and fighting."

Barry Spikings and Michael Deeley both deny that EMI ever demanded that John be fired. "There was no question of letting him go," Deeley said. "He was Meryl Streep's lover and had been introduced to us by Robert De Niro, and both of them would have been

very upset." The medical advice they received indicated that John would not reach a "crisis-point" until his work on the film had been completed. They would shoot out of order to get his scenes in the can first. Still, Deeley thought it sensible to have some kind of Plan B. He asked Cimino to devise a backup scene explaining Stan's disappearance, so that any completed footage would not be compromised in the event of John's death.

This set off another explosion. In Cimino's telling, the director found the request so unseemly that he consulted a psychiatrist. This was beyond moviemaking. *I'm getting out*, he thought. *I can't do this. It is not worth it, talking about life and death like this.* Finally, he agreed to write the alternative scene, some "absolute dreadful piece of shit" that he had no intention of using. He slammed down the phone in disgust.

But there was still the matter of insurance. In later years, the story got out that Robert De Niro secured the bond on John's participation with his own money. It was a real-life analogue to the loyalty portrayed in *The Deer Hunter*, in which Michael vows not to leave Nick in the wilds of Vietnam. Publicly, De Niro would play coy about the insurance, with vague assertions like "He was sicker than we thought, but I wanted him to be in it."

But Deeley and Spikings both insist this never happened. "Who was going to be the beneficiary?" Deeley said. "EMI wasn't, because EMI had no involvement in insuring him. We couldn't get insurance. What makes anybody think that Robert De Niro has any special edge in the insurance business?" Nevertheless, Meryl was so convinced of De Niro's magnanimity that she repeated the story decades later. Like almost everything about *The Deer Hunter*, it acquired the ring of legend.

If John were to go uninsured, as the producers claim he did, everyone would simply have to pray that his health held out long enough to complete his scenes. According to Savage, the actors were asked to sign an agreement, promising that if John were to pass away during filming they would take no legal action.

Time was now everything. The longer the shoot went on, the more complicated it would be to edit around his scenes if the unspeakable occurred. The making of *The Deer Hunter* was turning into its own game of Russian roulette, with each round of dailies a fresh bullet in the chamber.

Two figures *walk along the main street of Clairton, Pennsylvania, arm in arm. The man is a Green Beret*

in uniform, the woman in a crisp blue coat. To the townsfolk passing by, they look like a happy couple promenading down the dusty boulevard. But their faces are tense, and they rarely make eye contact. When someone stops to greet the man on the street, the woman furtively glances at a shop window to fix her hair.

"Cut!"

Meryl removed her arm from Robert De Niro's. It was the first day of shooting on *The Deer Hunter*, and everything was out of order. The scene of Michael and Linda stepping out together in Clairton was from the story's post-Vietnam third act. They would have to imagine all that came before: the flirtatious glances across the wedding hall, the tentative homecoming. All that they'd film later.

Also, this wasn't Clairton. The real town hadn't fit Michael Cimino's vision for *his* mythic middle-American hamlet. Instead, he had cobbled together bits and pieces of seven different towns in the corner of the heartland where Ohio, Pennsylvania, and West Virginia converge. The movie's Clairton would be a compendium of places like Weirton, Duquesne, Steubenville, and Follansbee. In Cleveland, he had handpicked St. Theodosius, a historic Russian Orthodox cathedral, for

the wedding ceremony. In Mingo Junction, Ohio, he remodeled Welsh's Lounge, a dive bar down the street from the steel mill, to serve as the local watering hole.

Wherever the cast and crew descended like a traveling circus, the local papers rushed to the scene, printing headlines like "Mingo Citizens Elated by Film" and "Movie Makers Leave Cash, Not Pollution, Here." Only Lloyd Fuge, the mayor of the real Clairton, Pennsylvania, seemed wary, telling Steubenville's *Herald-Star*, "They say the nature of the scenes down there would not be beneficial to our town." He was probably right. The Clairton of Cimino's imagination was a gray place, with dusty shop signs and furnaces choking the sky with smoke.

The screenplay called for drab November: deer-hunting season. But when the crew set up in the Rust Belt, it was one of the hottest summers on record. Once the cast and the financing had come together, the filmmakers knew they had to move fast, and the ticking time bomb of John Cazale's health made waiting for autumn even more dangerous. Instead, they would tear the foliage off the trees, spray the green grass brown, and scatter the ground with dead leaves. The citizens of Mingo Junction could be forgiven for wondering why the trees outside the Slovak Citizens Club had gone bare in late June.

The heat was punishing on the actors, too. Even in scorching ninety-degree weather, the actors wore flannel shirts and wool caps, while the crew was in shorts. After each take, they would trade their sweat-drenched clothes for a dry set. George Dzundza, who played the barkeep, wore fake sideburns that continually slid off his face. Meryl kept a blow dryer handy, to make sure her hair wasn't limp on camera.

Few people around Mingo Junction took notice of her—unlike De Niro, who couldn't walk down Commercial Street without his picture landing in the Steubenville *Herald-Star*. She filled the dead hours between shots knitting sweaters, just like her character. When she could, she explored the town. At Weisberger's clothing store, she bought a scarf and made small talk with the owner. The shopkeeper delighted in conversing with a movie actress, unaware that she was working, absorbing the pace and the particulars of life on the Ohio River.

She still had her doubts about Linda, and she wasn't keeping them quiet. When the *New York Times* came to town to report on the "Vietnam Movie That Does Not Knock America," she was astonishingly forthright.

"Linda is essentially a man's view of a woman," she said. "She's extremely passive, she's very quiet, she's someone who's constantly vulnerable. She's someone

who always has a tear in her eye but an unbreakable spirit, someone who cares a lot but who is never depressed. Someone who's beaten down a lot by everybody, but who never gets angry about that."

Driving the point home, she continued, "In other words, she's really far from my own instincts. I'm very much of a fighter myself. So this is very hard for me. I want to break her out of her straitjacket, but of course I can't even let that possibility show. I tend to think she's someone who will grow up into one of the millions of neurotic housewives. But this is a man's movie, it isn't about Linda's problems. I think the point of view of the story is that she's a lovely person."

For a no-name actress filming her first big movie role, airing such grievances to the *Times* was beyond bold.

Her main concern wasn't Linda, though; it was John. On set, she watched him carefully, making sure he didn't overextend himself. He was weak, and it showed. Beneath his flannel shirt was a small tattooed mark on his chest made by the radiation techs, like the crosshairs in a hunting rifle's scope. Most of the cast knew what he was up against, though nobody really talked about it. Perhaps Meryl had finally convinced him to quit smoking, and now he would chastise anyone who lit a cigarette. "One look and he'd come

up behind us and grab it and put it out, scream at us," John Savage recalled. "He put people at ease by slamming them with criticism, with humor. Basically, 'If you're gonna smoke, you're gonna die. Don't screw around with that!'"

Those first few weeks, Cimino knocked out the movie's final third, the downcast post-Vietnam scenes. In Duquesne, Pennsylvania, he converted a small field into a cemetery, where they shot the funeral for Christopher Walken's character. When they were done, they gave it to local kids to use as a ball field. In Welsh's bar, they filmed the indelible finale, in which the mourners sing a doleful rendition of "God Bless America." Meryl and John sat side by side, singing of mountains and prairies and oceans white with foam.

Having shot the movie's tragic end, Cimino then backtracked to its raucous beginning. By then, the cast had developed an easy camaraderie, which would serve the freewheeling tone. Cimino wanted these scenes to feel like home movies, as if the audience were watching snatches of its own past. He had gone to great lengths to imbue the actors with a sense of authenticity, even mocking up Pennsylvania driver's licenses that the guys kept in their pockets.

The centerpiece of the first act was the wedding party, which Cimino envisioned as a richly detailed set

piece—far from the quick scene-setter Michael Deeley had in mind. Cimino had been the best man at a Russian Orthodox wedding just like it, and his aim was to shoot the sequence like a documentary, with as many real-life elements as possible. In that spirit, the location would be Cleveland's Lemko Hall, a ballroom where the neighborhood's Slavic community held celebrations.

For three days, an instructor named Olga Gaydos taught the actors Russian folk dances like the korobushka and the troika, the dance of the three stallions. Meryl and her fellow bridesmaid Mary Ann Haenel would twirl on either side of John, laughing at his two left feet. "That's enough," he'd say, a little peeved. Suddenly, everyone would flood him with concern: "Are you okay?" "Do you need to take a break?"

When they could, the couple would steal some private moments. "They talked quietly together," Mary Ann Haenel recalled. "They had their heads together. They walked together. They looked happy. But every now and then, you would see that look that they would give each other—it was a deep look."

The world of Clairton was just background noise to John's health problems. "Being in a movie was like the smallest part of the tricky part of that landscape of our lives," Meryl would recall. "I mean, it was really

tough, and nobody really knew whether these protocols would work. And we were always really hopeful that everything would work out well."

Finally, on August 3rd, with the schedule already delayed by weeks, Cimino began shooting one of the craziest, drunkest, *longest* wedding parties in movie history. Outside Lemko Hall, the street was closed to traffic and crammed with trucks and generators. Inside, the windows were cloaked in black, so that the hall remained in perpetual night. Giant high school portraits of Savage, Walken, and De Niro hung on the walls, along with banners wishing the boys well in Vietnam. The barroom in back was kept open all day long, so that everyone could pass the time playing gin rummy, maybe guzzle a bottle of Rolling Rock. Of course, Cimino didn't mind if the actors were soused. All the better.

The filmmakers had advertised for extras from the community, hiring some two hundred wedding guests from three different parishes. They were paid twenty-five dollars a day—two bucks extra if they showed up with a wrapped gift box. They were told to leave the presents at the back of the hall, where the boxes towered to the ceiling. Right before filming, the assistant director went up to Cimino and said disbelievingly, "Michael, everybody brought a gift!"

"Well, we told them to," the director said.

"You don't understand." Inside the boxes were toasters and appliances and silverware and china. The parishioners had bought actual gifts, as if they were attending a real wedding.

The party began each morning at seven-thirty and raged until nine or ten at night. Everyone was tired and confused and happy. Cimino captured the chaos with anthropological curiosity, intervening only to choreograph a moment here or there. At one point, John's character is dancing with a bridesmaid, and the bandleader, played by Joe Grifasi, cuts in. When John notices him grabbing her behind, he leaps up and pulls them apart, then turns to the girl and slugs her on the cheek. Cimino said that his uncle did the same thing at a family wedding.

Other moments of carousal came organically. An old man gorging himself on stuffed cabbage. Christopher Walken leaping over a mug of beer. Chuck Aspegren hauling a bridesmaid to the coatroom as she pummels him with an umbrella. During one take, De Niro was so exhausted as he carried John over to take a group photo that he lost his balance, and both men collapsed to the floor. Cimino kept the take: he was looking for accidents, not grace.

Meryl got caught up in the revelry, at least when the camera was pointed at her. When De Niro spun her on the dance floor, she erupted into dizzy laughter. When she caught the bouquet, she screamed with joy. She may not have thought much of her character, but she had found a way to play her. "I thought of all the girls in my high school who *waited* for things to happen to them," she said later. "Linda waits for a man to come and take care of her. If not this man, then another man: she waits for a man to make her life happen."

In essence, she was playing the character she'd perfected in high school: the giggling, pliable, boy-snatching cheerleader. In her poofy pink gown and bow, she channeled that forgotten girl, who knew that the best way to land a second date with a Bernards High football player was to forgo all opinions; when Michael Vronsky asks Linda what beer she prefers, she shrugs and says, "Any kind." Meryl found that she had "stockpiled" that character and could revive her at will. Only now, of course, she was self-assured enough to banish her once the cameras stopped rolling.

In place of the cheerleading squad, she had her fellow bridesmaids, Mary Ann Haenel, Mindy Kaplan, and Amy Wright. One day, the four of them were getting restless during a break. Meryl went out to see what the

holdup was and returned to say that they had run out of film stock. (Cimino, trying to capture every moment, was burning through miles of it.) On the bright side, a guy had shown her how to kill a fly—there had been one buzzing around the dressing room all day. Meryl showed the girls what to do: clap your hands just *above* the fly, and it'll zip up so you can kill it. When she tried it, the fly swooped up and escaped, finding shelter in Amy Wright's cleavage. The girls squealed and guffawed as she frantically lifted her petticoat to let it out.

At long last, Cimino called it a wrap, and the wedding that seemed to go on for eternity finally ended. The banners came down. The stuffed cabbage went in the trash. The extras were paid their day rates and dispersed. So did Meryl and John and Christopher Walken and Robert De Niro. With the hall eerily empty, Cimino saw a local man sitting on the stage, holding a half-empty glass of beer. He was weeping quietly.

"What's wrong?" the director asked him.

Through his tears, the man said, "It was such a beautiful wedding."

By the time *The Deer Hunter* rolled out of the Rust Belt, Meryl's scenes as Linda were done. But Cazale still had the hunting scenes, in which the hungover

bachelors head to the mountains in the morning light. Cimino treated these scenes with a mythopoetic reverence, scoring De Niro's trek through the mist to the sound of an angelic choir. Of course, Meryl might have pointed out that this celestial hunting trip was boys only, a girl like Linda having no place in the sacred union between man and nature.

It was late summer, and none of the mountains in the Northeast were snowcapped. So Cimino flew the actors across the country, to the Cascade range in Washington State. As Stan, Cazale's job was once again to play the fool, and the foil, amid all the bravado. On a mountain road, he emerges from the Cadillac in a rumpled tuxedo and a ridiculous fur hat. He has forgotten his hunting boots—as *always*—and De Niro's Michael Vronsky refuses to let him borrow his own. "This is this," Michael explains.

"What the hell's that supposed to mean?" Stan snarls back. " 'This is this.' I mean, is that some faggot-sounding bullshit or is that some faggot-sounding . . ."

Stan grabs the boots anyway, and Michael glares, holding his rifle. "What?" Stan retorts. "Are you gonna shoot me? Huh? Here."

With that last word, John Cazale opened part of his tuxedo shirt, exposing a small wedge of skin. He had chosen the spot of the crosshairs tattooed on his

chest during radiation. It was, Cimino said later, "some strange prefiguration of his own death."

The crew built a cottage between two peaks, where the guys gathered to shoot a scene from the second hunting trip, after Michael has returned from Vietnam. Stan is now carrying a dinky little revolver everywhere, and, after some mild provocation, Michael grabs it and threatens to shoot Stan in the head. We see then how truly far away he is, how the inferno of war has sundered him from the old gang. At the last moment, he points the gun heavenward and shoots the ceiling.

De Niro, who had studied everything from POW testimonials to hunting guides in preparation, thought the scene would play better if there was a live round in the gun. "Are you crazy?" Cimino said. De Niro insisted that they ask John.

"John, Bob would like to play this with a live round in the gun," the director said.

Cazale looked at him and blinked.

"Okay," he said. "But I have to check the gun first."

Before each take, John would spend a half an hour checking the gun to make certain the bullet wasn't in the wrong place, driving everyone crazy: again, the slowness. Why had he agreed to this? He had spent months looking his own mortality in the face. And yet

nothing thrilled him like the electric charge between two actors.

Those days in the mountains were majestic but harried. Whenever the fog cleared, Cimino would sound the alarm and everyone would rush into position, knowing the sun might disappear again at any moment. But time worked differently for John Cazale. Cimino would catch him between takes, smelling the mountain flowers.

All Meryl wanted to do was be with John, but fate was pulling her in two directions. One: the hard-fought road to his recovery. The other: show business, where she was increasingly in demand.

Herbert Brodkin, the producer of *The Deadliest Season*, had hired her for his next project, the nine-hour television miniseries *Holocaust*. The series would tell the story of a single German family scattered to the winds by the rise of the Nazis. In scope and seriousness, it would follow the mold of *Roots*, the epic ABC mini-series about the African-American experience, which had aired the previous January to unprecedented ratings. Hoping to give NBC its own prestige blockbuster, Brodkin hired Marvin Chomsky, one of the directors of *Roots*, to film the entirety of *Holocaust*.

Meryl took the job for one reason: money. She had been quietly helping to pay John's medical bills, and after *The Deer Hunter*, neither of them knew when he'd be able to work again. She expected John would go with her to Austria, but when the time came he was just too weak.

In late August, she flew to Vienna alone. Austria was "unrelentingly Austrian," she said later. "The material was unrelentingly grim. My character was unrelentingly noble." She was playing Inga Helms Weiss, a gentile German woman who marries into a Jewish family, not expecting the calamity that would follow. Her husband, Karl, played by James Woods, is a painter and the son of a prominent Berlin doctor. Seized for "routine questioning," Karl is sent to Theresienstadt, which the Nazis presented as a "model" camp for propaganda purposes. There, he joins a band of artists plotting to smuggle drawings of their true conditions to the world.

Like Linda, Inga represented an ideal: the "good Aryan" bystander who stands with the Jews in the face of Nazi treachery. In one sickening sequence, she allows an SS officer to defile her in exchange for taking Karl off quarry duty and delivering her letters. ("I've had to do things to get these letters to you," she writes, "but my love for you is undying.") Finally, she materializes

at his art studio in Theresienstadt, having sacrificed her freedom to be with her husband.

Vienna was "extraordinarily beautiful and oppressive," Meryl wrote in a postcard to Joe Papp on August 29, 1977. She was entranced by the city's artistic legacy but appalled by its lingering Nazi presence. The city would shut down at nine; sometimes, there would be two separate movie houses showing films on Hitler on the same night. It was not lost on her, either, that Vienna was the setting of *Measure for Measure.* It had been only a year since she and John had played those scenes. She told Joe that she missed the "hurly burly" of New York.

In *Holocaust,* Meryl was reunited with Michael Moriarty, who played the über-Nazi Erik Dorf with sociopathic relish. She didn't do much research, apart from reading Erich Fromm's *The Anatomy of Human Destructiveness.* But the wrenching history she was enacting was evident all around her. Filming on location at the Mauthausen concentration camp was "too much for me," she recalled. "Around the corner there was a *hofbrau,* and when the old soldiers got drunk enough, and it was late enough, they would pull out their souvenirs of the war; it was very weird and kinky. I was going crazy—and John was sick and I wanted to be with him."

The shoot kept extending; she felt like she was in prison for two and a half months. Marvin Chomsky saw how badly Meryl wanted to be somewhere else, and he knew why. "She may have made associations between the potential of losing John and the character of her husband," he said. "How she used it was how she used it. I didn't ask, I didn't suggest. I did not want to take advantage of the passion that she had privately. She wanted to rely on professional passion. That was more than enough." Stunned by her abilities, he asked her between takes, "Meryl, tell me: where does it come from?" She replied coyly, "Oh, Marvin . . ."

Her cheery professionalism, though it masked an internal restiveness, was a relief, given the subject matter. On their days at the gas chambers in Mauthausen, the set would erupt in squabbling. "The reason was that we felt so awful in a place like that, and we tended to take it out on the people we were working with, when in fact, we were feeling this rage against the Nazis," James Woods observed soon after. "In a situation like that—and there were many of them—Meryl was the one who could always say just the right thing to defuse the tension."

Blanche Baker, the twenty-year-old playing Meryl's sister-in-law, was in awe of the older actress, who at twenty-eight seemed like the most sophisticated person

in the world. Despite being the daughter of an Auschwitz survivor (the director Jack Garfein), Blanche was less interested in atrocities than in flirting with Joseph Bottoms, who played her brother. On days off, she and Meryl went out to Viennese bakeries and ordered pastries *mit Schlag* (with whipped cream). Meryl confided in Blanche about her ailing boyfriend back home—to her, it all seemed very grown-up.

Blanche was raised in show business; her godfather was Lee Strasberg and her mother was the actress Carroll Baker, who had immortalized Tennessee Williams's Baby Doll on screen. Still, the impressionable Blanche saw Meryl as the model of serious acting, and did her best to imitate her. Before "Action," Meryl would take a quiet moment to turn away and collect herself; Blanche started doing the same. Meryl's script was scrawled with notes in the margins; Blanche started writing notes in her script, too. She had studied sculpture as a girl, and Meryl's meticulous scribbles reminded her of a sculptor's sketches.

Meryl spent her last three weeks on set counting the hours, sleeplessly waiting for dawn under "that damn eiderdown" covering her bed. She didn't stay in Austria a moment longer than she had to. "She was very anxious to do her very last scene and then zip back and out," Chomsky recalled. "I mean, I don't even think

we had a moment to say goodbye." When she returned to New York, John was limping. He was in worse shape than ever.

No one saw Meryl for a while. No one saw John, either. Offers for parts came and went. Friends called the loft for John, and Meryl would pick up.

"He's really ready to go to sleep at the moment. Maybe another time . . ."

Click.

They went out sparingly, and with great effort. One time, Meryl's old Yale classmate Albert Innaurato spotted them at a diner on Barrow Street, and was startled to find Meryl supporting John as they made their way to the table. "It was not a side of her I ever expected to see," he said.

On trips to Memorial Sloan Kettering Cancer Center, the doctors took note of John's undaunted companion. When one surgeon remarked on her distinctive beauty, John said that it was an example of nature at its finest: "One that I hope to keep seeing as long as possible."

Her resolve convinced everyone—couldn't they tell she was acting her heart out? As she wrote her Yale acting teacher Bobby Lewis, "My beau is terribly ill and sometimes, as now, in the hospital. He has very wonderful care and I try not to stand around wringing

my hands but I am worried all the time and pretend-
ing to be cheery all the time which is more exhaust-
ing mentally physically emotionally than any *work* I've
ever done. I have *not* worked, thank God, since Octo-
ber, or I don't know how I'd have survived."

John's lung cancer had metastasized to the bone, and
he got weaker by the day, which Meryl attributed to
the chemotherapy. The accoutrements of her old life
now seemed trivial; the only role she had time for was
nurse. Despite their troubles, Meryl valued that time,
with the distractions of show business far away and the
two of them alone together, sharing the intimacy of
close quarters. "I was so close," she said, "that I didn't
notice the deterioration."

The months went by: 1977 turned to 1978. In Janu-
ary, freezing snow and rain covered the city, and hun-
dreds of thousands of people lost power. Two weeks
later, thirteen inches of snow came down—the big-
gest blizzard of the decade. The metropolis that had
just weathered a blackout and Son of Sam now found
itself unable to clear the mountains of drifted snow and
trash in the streets. Every few days, the city would de-
clare a "snow emergency," a phrase used so often that it
became meaningless.

On Valentine's Day, four more inches fell. From
their fire escape, John and Meryl could see Franklin

Street paved with white. It couldn't have been a romantic image. Buried beneath the snow were muck and garbage bags and potholes. The city was sick in its guts.

Now without Meryl, production of *The Deer Hunter* moved to Thailand, Cimino's stand-in for Vietnam. The movie was over budget, and the schedule had gone out the window. The wedding scene, far from being a "flickering candle," had eaten up considerable time and money, worrying EMI executives. Barry Spikings took the director on a walk by a lake.

"Michael," he asked, "are you doing your best?"

Cimino assured him he was.

Shooting in Thailand was not only costly but dangerous. The State Department had warned the filmmakers away from the country, which was controlled by a right-wing junta. On the Burmese border, where armed insurgents were rampant, Cimino and his cast stayed in thatched huts and ate green cobra, said to increase virility.

Cimino wanted the Vietnam sequence to have the same vérité style as the Clairton scenes. He hired local nonactors to play the boys' Vietnamese captors. As POWs, De Niro, Walken, and Savage wore the same clothes every day. They didn't shave or shower. They slept in their uniforms. They "smelled to high heaven,"

Cimino would brag. During a scene in a submerged tiger cage, a rat began nibbling at Savage's face. Cimino put it in the movie.

There was a strict military curfew in effect, so the film crew would set up in secret locations at two in the morning, as CIA officers supervised. (Cimino put them in the movie, too.) They were allowed to export negatives but not to reimport the prints, so they were shooting blind, without the benefit of dailies. Spikings had flown in to oversee production, and his point man was General Kriangsak Chomanan, the Supreme Commander of the Royal Thai Armed Forces. Mid-shoot, he summoned Spikings to Bangkok and kindly asked for the weapons, helicopters, and armored personnel carriers they had borrowed, since he was staging a military coup that weekend. He promised Spikings they would have everything back by Tuesday.

The most treacherous scene was the helicopter escape, shot on the River Kwai. (Cimino relished the David Lean connection.) The water was ice-cold and full of snakes and saltwater crocodiles, and riverboat traffic had clipped the underwater bamboo into deadly spears. The scene called for De Niro and Savage to plunge almost a hundred feet from the helicopter into the current. The stunt doubles refused.

"We'll do it," De Niro said. "The actors."

"Understand, you won't be insured," Spikings told him.

"Who's gonna tell the insurance people?"

Savage and De Niro climbed onto a temporary steel crossing, which the crew had made to look like a rickety rope bridge. As the helicopter pulled in, one of its skids got stuck under the thirty-ton cable holding up the bridge. The copter tilted and roared, as De Niro frantically tried to free the skid. While the pilot screamed into a radio in dialect, Cimino, dressed in fatigues in the helicopter, reached out his hand for De Niro's, knowing that the spinning rotors might very well tip over and kill him, his stars, and half his crew.

The copter broke free, flipping the bridge upside down. The cameras were still rolling as it flew off, with De Niro and Savage dangling above the river.

"Michael, should we drop?" Savage screamed to his scene partner, still using his character name.

"Savage, for Christ's sake," De Niro howled, "we're not in character anymore! We're not in the fucking movie!"

They dropped, one after the other, into the spiky, crocodile-infested, freezing river. After a moment, they emerged—still in the scene and, like their characters, astounded that they were still alive.

———

"Meryl! Hi!"

She would have recognized that voice anywhere: the bubbly, high-pitched warble of Wendy Wasserstein. At twenty-seven, she was still the warm, unkempt, insecure woman Meryl remembered from the costume crew. Now she was calling for a favor.

Two and a half years after graduation, Meryl's Yale classmates were making inroads in the theater world. Christopher Durang and Sigourney Weaver had continued their madcap collaboration with *Das Lusitania Songspiel,* a Brecht-Weill parody that played on Vandam Street. Albert Innaurato's *Gemini* was produced at Playwrights Horizons, also with Weaver. And William Ivey Long was about to design costumes for his first Broadway show, kicking off what would be a multi–Tony Award–winning career.

Now, it was Wasserstein's turn. In the summer of 1977, she had gone to the O'Neill to workshop *Uncommon Women and Others*, the play she'd begun at Yale. The Phoenix produced it that fall on the Upper East Side. The all-female cast, whose characters were based on Wendy's classmates at Mount Holyoke, included rising talents like Jill Eikenberry and Swoosie Kurtz. The thirty-year-old actress Glenn Close played Leilah,

the restless wallflower who longs to graduate and study anthropology in Iraq.

With *Uncommon Women*, Wendy had dramatized her generation's ambivalence about second-wave feminism and the sky-high promises it failed to keep. In the college-flashback scenes, the girls gab about Nietzsche and penis envy and how they'll be "pretty fucking amazing" by the time they're thirty. When they reunite six years later, they're in therapy or working at an insurance company or pregnant, certain they'll be pretty fucking amazing when they're forty. Maybe forty-five.

The three-week run garnered good reviews and Wasserstein's first taste of public validation. By the time the play closed, on December 4, 1977, TV's Thirteen/WNET had selected it to air on PBS, as part of its "Great Performances" series. (*Secret Service*, the Civil War drama starring Meryl and John Lithgow, had aired the previous winter.) The Off Broadway cast would reunite for the filming, with one exception: Glenn Close was due at a Buffalo tryout of *The Crucifer of Blood*, a Broadway-bound Sherlock Holmes drama. Wendy needed a fast replacement. She called Meryl.

Leilah was one of the smallest parts in the play, and it certainly wouldn't do anything for Meryl's career. But Wendy was asking for a favor, and it would be only

a few days. She said yes. But she would have to bring John.

A few weeks into 1978, Meryl took the trip to Hartford, Connecticut, where the play was being shot in a television studio. (For PBS, "pretty fucking amazing" became "pretty amazing.") John mostly stayed at the hotel. Steven Robman, who directed the play and codirected the taping, remembered Meryl from her first year at Yale, when she was in his production of *The Lower Depths*. Her air of confidence had always struck him, but now it was accompanied by camera experience that outpaced his own. Filming a scene with Ellen Parker, she stopped and said, "Steve, do we have a camera on Ellen's face right now? It's a really great reaction, and I think you might want to have it in the can." It was like a replay of *Julia*, with Meryl now the knowing scene partner Jane Fonda had been to her.

Meryl's take on the part was appropriately lost and languorous. Her interpretation didn't diverge widely from Close's: both were angular beauties who managed to tap into Leilah's yearning solitude. But Robman saw the gap in their upbringings leak through. Close had grown up in a stone cottage in Greenwich, Connecticut, the daughter of a surgeon. "That was the difference to me," Robman said. "How does an aristocratic

girl feel about being isolated like this, versus a girl who wishes she was homecoming queen?" It was the first of many times the actresses would be compared to each other.

As February turned into March, the snow kept pummeling New York City, and layers of sludge coated the streets. With its broken-down fleet of mechanical sweepers, the city was powerless against the onslaught. When the snow finally began to thaw, it revealed sidewalks covered in slimy debris that had been buried for two months. Tribeca reeked of rotting trash.

Meryl's brother Third had been calling the loft, hoping for good news about John, who was now too ill to leave the house. Usually Meryl averted his concern with an upbeat deflection: "We're doing great!"

Then, one day, her answer was different. "He's not doing so good."

It was the first time she had betrayed any lack of hope. It was the day John Cazale moved into Memorial Sloan Kettering for the last time.

Meryl kept watch in the hospital at all hours, as John seemed to shrink into his neat white bed. She kept his spirits up with the only elixir she had: performance. She filled the room with comic voices, reading him the sports pages with the whiz-bang delivery of Warner "Let's go to the videotape!" Wolf.

When friends visited, they saw not Meryl's weariness but her fortitude. "She took care of him like there was nobody else on earth," Joe Papp said. "She never betrayed him in his presence or out of his presence. Never betrayed any notion that he would not survive. He knew he was dying, the way a dying man knows it." Nevertheless, "She gave him tremendous hope."

Decades later, Al Pacino would say, "When I saw that girl there with him like that I thought, There's nothing like that. I mean, that's it for me. As great as she is in all her work, that's what I think of when I think of her."

Around three in the morning on March 12, 1978, John closed his eyes. "He's gone," the doctor said. But Meryl wasn't ready to hear it, much less believe it. What happened next, by some accounts, was the culmination of all the tenacious hope Meryl had kept alive for the past ten months. She pounded on his chest, sobbing, and for a brief, alarming moment, John opened his eyes.

"It's all right, Meryl," he said weakly. "It's all right . . ."

What was it that brought him back? A final rush of blood to the brain? Her sheer force of will? Whatever it was, it lasted only for a second or two. After that, John Cazale closed his eyes again. He was forty-two.

Meryl called his brother, waking him up.

"John is gone," she told him.

"Oh, God," Stephen said.

She burst into tears. "I tried."

She returned to the loft, shell-shocked. In the days that followed, she found herself unable to help plan a memorial or even "negotiate the stairs." She meandered from room to room in John's apartment, the one with the floor so strong it could hold stacks of tomato cans. Suddenly, that didn't seem strong enough.

She sleepwalked through the memorial service, where luminaries of theater and film paid homage to their perpetually undersung collaborator. Israel Horovitz wrote in his eulogy:

> John Cazale happens once in a lifetime. He was an invention, a small perfection. It is no wonder his friends feel such anger upon waking from their sleep to discover that Cazale sleeps on with kings and counselors, with Booth and Kean, with Jimmy Dean, with Bernhardt, Guitry, and Duse, with Stanislavsky, with Groucho, Benny, and Allen. He will make fast friends in his new place. He is easy to love.
>
> John Cazale's body betrayed him. His spirit will not. His whole life plays and replays as film, in our picture houses, in our dreams. He leaves us, his

loving audience, a memory of his great calm, his quiet waiting, his love of high music, his love of low jokes, the absurd edge of the forest that was his hairline, the slice of watermelon that was his smile.

He is unforgettable.

Meryl was "emotionally blitzed." "It was a selfish period, a period of healing for me, of trying to incorporate what had happened into my life," she recalled. "I wanted to find a place where I could carry it forever and still function."

After the memorial, she packed some things and went to Canada to stay at a friend's house in the country. Left alone, she drew sketches. The same images kept recurring, as if they were living things trying to break through. Sometimes she drew Joseph Papp, the man who had held her hand throughout this ordeal, and who now had her unconditional loyalty.

But mostly she drew John, over and over again, like the French lieutenant's woman sketching her faraway paramour. She just wanted to see his face.

It took Michael Cimino three months just to look at all the footage he had shot, working thirteen or fourteen hours a day. With the editor Peter Zinner, he began chipping away at it, carving out a movie. He finished

dubbing one night at three in the morning and deliv-
ered a rough cut to EMI. It was three and a half hours
long.

By then, Michael Deeley, the president of EMI
Films, had come to think of Cimino as "deceitful" and
"selfish." The movie, budgeted at $8.5 million, had cost
$13 million. The character development he had asked
for had ballooned into an extra hour. A three-hour film
would lose a quarter of the potential revenue, since it
could only be shown in theaters so many times per day.
Even so, Deeley and Barry Spikings were thrilled with
the rough cut, sensing its raw power.

But when they screened the film for their American
partners at Universal, it got a decidedly lukewarm re-
action. The suits were appalled by the movie's violence
and, especially, by its length. Even Cimino conceded
the screening was a "disaster," recalling one executive
exclaiming, when De Niro shot the deer, "That's it! We
lost the audience! It's all over!" Another, Sid Sheinberg,
took to calling it "The Deer Hunter and the Hunter
and the Hunter." They wanted an hour cut. Why not
start with that wedding scene?

Cimino refused to shrink his epic, certain that the
movie's dark magic lay in its "shadows." EMI threat-
ened to take him off his own picture. "I told them I
would do everything I could," he said. "I took things

out of the movie and then put them back in. The thought that I would be removed and someone else would take over made me physically ill." He went to bed every night with a headache, then woke up with his head still throbbing. He gained weight. "I was willing to do anything I could to prevent this picture from being taken away from me and ruined."

Universal agreed to test-run two different cuts: an abridged version, which they'd show in Cleveland, and Cimino's longer version, which they'd show in Chicago. According to Cimino, he was so worried that the Cleveland audience would like what they saw that he bribed the projectionist to jam the film halfway through. The three-hour version won.

Meryl watched the film over and over again at a screening room on Sixth Avenue, six times in all. She always shielded her eyes during the torture scenes, but somehow it wasn't quite as hard to watch John. As the screen flickered in front of her, she saw all the sly and silly human touches he had left behind in his final performance:

John crossing himself in the church.

John tapping his foot as the bride walks down the aisle.

John checking his fly as the wedding guests pose for a photo.

John running after the newlyweds, throwing rice like a boy hurling a baseball.

John's craggy profile, half in shadow, as the barkeep plays a Chopin nocturne.

John telling Meryl at Michael Vronsky's welcome-home party, "I know Nick'll be back soon. I know Nick. He'll be coming back, too."

John looking at his pale reflection in the Cadillac window, straightening his collar, and declaring: "Beautiful."

One Sunday morning, John's brother, Stephen, met Meryl at the screening room. They waited anxiously for the movie to roll. "When is it going to *staaart*?" Meryl groused with mock impatience. They sat back and watched. When he got home that night, Stephen went to bed with a bottle of vodka.

Meryl had barely worked during the five months she cared for John. Now her schedule was bleakly open. "I don't want to stop replaying the past—that's all you have of someone who is dead," she said at the time, "but I hope that working will offer some diversion." She was ready to dig out of the trenches and act again.

Fortunately, there was a movie offer: *The Senator*, a political fable written by Alan Alda, the amiable star of *M★A★S★H*. Alda would play the senator, Joe Tynan, a

principled family man lured astray by backroom deal-
ing and adultery. Meryl was offered the part of his mis-
tress, a Louisiana labor lawyer with a breezy sexuality
and an insider's grasp of the Washington game. "When
I want something, I go git it," she tells Joe Tynan. "Just
like you."

In other words, she was everything Linda the
checkout girl was not: a brashly independent "modern
woman," as Meryl described her. As a vocal feminist
and advocate for the Equal Rights Amendment, Alda
had observed the sleaze of politics close up. Campaign-
ing for the ERA in Illinois, he saw a state legislator tell-
ing a female lobbyist he'd consider voting for it while
offering her a key to his hotel room. Alda didn't have
the blind spots Meryl had encountered in other male
collaborators, who shoehorned female characters into
broad archetypes. Had her heart not been so heavy, it
would have been a thrilling opportunity.

The director, Jerry Schatzberg, visited her in John's
loft. He could sense the sadness of the place, but they
didn't discuss why. He told her he was looking for a
pinch of Southernness, but not a strong accent. Meryl
adopted the same Dinah Shore drawl she had used
in *Trelawny of the "Wells."* Then, four disorienting
weeks after John's death, she packed a bag and headed
down to Baltimore.

As on *Holocaust,* her upbeat presence masked a dull pain. "I did that film on automatic pilot," she said soon after. Work was a distraction, not a comfort: "For some things, there is no comfort." In keeping with her character, she kept things light. Rip Torn, her former costar in *The Father* at the Yale Rep, had a supporting role as a skirt-chasing lawmaker. Schatzberg was working with Meryl on her costume and told her he was about to see Rip. "Oh," she responded, "tell him not to be such a pain in the ass!"

She was also reunited with Blanche Baker, her sister-in-law from *Holocaust,* who was playing Joe Tynan's teenage daughter. Baker had a big crying scene with Alda, and she made the mistake of bawling her eyes out during the master shot. Then everyone broke for lunch. When they came back for her close-up, she felt tapped out. Meryl saw that the young actress was panicking, and once again played the role of big sister. "It's there," she assured her. "You just have to trust it. Just be more specific."

She applied the same bedrock of technique to herself, and the results pleased Schatzberg. "The scenes with her were so great," he said, "that when the film was finished, I had a problem, because I felt that she was so good maybe Joe Tynan *should* have gone off

with her. So I had to think of a way to diminish her character so that he goes back to his wife."

At the Maryland State House, in Annapolis, Schatzberg enlisted local politicians to play senators and congressmen. One delegate was under the impression that the movie was about a senator who has an affair with his secretary. "I'm actually his lawyer," Meryl said when she heard that, adding, "That really tells you something, doesn't it?"

As they shot, Schatzberg and Alda continually clashed over the script. Alda wanted the actors to stick to the dialogue he'd written, while he freely improvised. Barbara Harris, who was playing his wife, complained to Schatzberg, "Anytime he wants to change *his* dialogue, he does."

Meryl stayed out of the bickering and sailed through her scenes, the beauty of autopilot being that you don't get too involved. Alda, she said later, couldn't have been "a more lovely, more understanding person," given the timing. But she was nervous about their frisky bedroom scenes. Apart from the melancholy love scenes with De Niro in *The Deer Hunter*, she had never had to play sexy on camera. Dino De Laurentiis's "*che brutta*" comment may have still echoed in her mind. At any rate, she didn't feel so frolicsome.

"It's a scene that demands tremendous high spirits and a great deal of sexual energy," John Lithgow said soon after, "and at that time, right after John Cazale had died, Meryl was in no mood for either. And she was embarrassed by the scene. She said she would perspire until she was dripping wet from embarrassment."

Schatzberg called as few crew members as possible to the Baltimore hotel room where they were shooting, to avoid gawking. Meryl slipped under the sheets along with Alda. The cameras rolled. In their postcoital glow, she grabbed a beer, poured it on Joe Tynan's crotch, peeked under the covers, and drawled: "It's true, things *do* contract in the cold!"

Then it was over. "She looked at the movie as some kind of test, a test she had to pass," Alda said later. "She was determined not to buckle."

Midway through the shoot, *Holocaust* aired on NBC. The relentlessly hyped broadcast lasted four nights, from April 16th through 19th. Some 120 million Americans tuned in—more than half the U.S. population. For the first time, Meryl Streep's face was seen internationally, by families gathered around television sets.

The broadcast inevitably ignited controversy. On the first day of its airing, Elie Wiesel, who, since the

publication of *Night*, had become the world's most recognized Holocaust survivor, published a scathing appraisal in the *Times*, calling the series "untrue, offensive, cheap." Next to a photo of Meryl struggling against SS officers, he wrote, "It tries to show what cannot even be imagined. It transforms an ontological event into soap-opera. Whatever the intentions, the result is shocking."

Among the scores of letters in response to Wiesel's was one from Joe Papp, who admitted to wincing at the series' "Errol Flynn heroics." Still, he argued, "The acting was first-rate. As hour by hour went by, the actors, many of whom I know personally, were no longer actors or my friends. They were Jews and Nazis."

In Germany, where the word "Holocaust" was not widely used, the impact was seismic. More than twenty million West Germans tuned in, many describing themselves in an official survey as "deeply shaken." In Meryl's fair-haired Inga, they saw a model of gentile righteousness worth emulating. The broadcast touched off a national debate that played out in newspapers, schools, call-in shows, and the halls of government. In Bonn, the Bundestag was readying to debate the statute of limitations for Nazi war criminals, many of whom were still in hiding. In the weeks following the broadcast, public support for continuing the prosecu-

tions shot up from 15 to 39 percent. Six months later, the Bundestag voted 255 to 222 to suspend the statute of limitations, opening the door to more trials and a national reckoning.

For Meryl, who was entrenched in tiny tragedies rather than historic ones, all this must have felt unfathomably distant. But the change in her day-to-day existence was palpable. Wandering Annapolis one Wednesday in May, wearing baggy jeans and a badly matched tweed blazer, she was approached by fans wielding Kodak Instamatics. Before *Holocaust* aired, she had eaten in Maryland restaurants unnoticed—unless, perhaps, she was sitting next to Alan Alda. Now, people were coming up to *her*.

That first brush with fame was "something surreal," she said at the time. Back in New York, she was riding her bicycle through Chelsea and some guys in a Volkswagen called out, "*Hey, Holocaust!*" Meryl shuddered. "Can you imagine?" she said soon after. "It's absurd that that episode in history can be reduced to people screaming out of car windows at an actress."

In September, she won an Emmy Award for Outstanding Lead Actress in a Limited Series. She didn't attend the ceremony. The statuette arrived a few months later, in a box. She placed it in her study, "propped up like an object" amid pictures of friends: inert. "I wish

I could assign some great importance to it," she said at the time, but the honor had "no lasting power."

The day after the Emmys, a woman came up to her at Bloomingdale's and said, "Did anyone ever tell you that you look exactly like Meryl what's-her-name?"

"No," she replied, "nobody ever did."

Universal had a plan: they would open *The Deer Hunter* in single theaters in Los Angeles and New York, then pull it after a week. That way, it would qualify for the Academy Awards, attract some buzz during its sold-out run, and then open wide in February as public interest percolated.

The bid worked. On December 15th, Vincent Canby described the film as "a big, awkward, crazily ambitious, sometimes breathtaking motion picture that comes as close to being a popular epic as any movie about this country since 'The Godfather.'" *Time* echoed the praise: "Like the Viet Nam War itself, *The Deer Hunter* unleashes a multitude of passions but refuses to provide the catharsis that redeems the pain."

But a backlash was brewing. Leading the charge was *The New Yorker*'s Pauline Kael, who clucked at the film's treatment of "the mystic bond of male comradeship," echoing the "celibacy of football players before the big game." More damning was her assess-

ment of the Vietnamese torturers, portrayed in "the standard inscrutable-evil-Oriental style of the Japanese in Second World War movies." She wrote, "The impression a viewer gets is that if we did some bad things over there we did them ruthlessly but impersonally; the Vietcong were cruel and sadistic. The film seems to be saying that the Americans had no choice, but the V. C. enjoyed it."

Few critics could deny the movie's psychological potency, or its agonizing depiction of war and its aftermath. But the more scrutiny it got, the more questions nagged. Did the Vietcong *really* force American soldiers to play Russian roulette? Was there not something homoerotic about those all-male hunting trips? And what about that final rendition of "God Bless America"? Was it meant to be ironic? Or deadly earnest?

Providing a direct counterpoint was another Vietnam film, Hal Ashby's *Coming Home*. Both featured a wheelchair-bound veteran and a woman caught between two military men. But the politics of *Coming Home* was explicitly antiwar, and its liberal credentials were synonymous with its star, Jane Fonda. After *Julia*, Fonda had been hyping Meryl around Hollywood, even trying to find her a part in *Coming Home*, but the scheduling didn't work out. Playing an army wife

tapped on the shoulder by history, Fonda once again personified political conscience. With her tin-soldier husband (Bruce Dern) in action, she finds a deeper bond with Jon Voight's paraplegic pacifist, who ends the film lecturing to high school kids about the senselessness of war.

Whereas *The Deer Hunter* showed people losing their way, and one another, *Coming Home* was about finding connection and purpose—political kinship as opposed to spiritual discontent. Fonda's character, unlike Linda, doesn't wait around for a man to rescue her: she volunteers at a VA hospital, becomes radicalized, and, with Voight's help, achieves her first orgasm. The straightforward liberalism of *Coming Home* seemed to expose an unconscious conservatism in *The Deer Hunter*, though it lacked the latter's sweep and horror and ambiguity.

On February 20, 1979, the showdown was made official. *The Deer Hunter* was nominated for nine Academy Awards, *Coming Home* for eight. They would compete for Best Picture, along with *Heaven Can Wait*, *Midnight Express*, and *An Unmarried Woman*. Robert De Niro was up against Jon Voight for Best Actor, with Christopher Walken competing with Bruce Dern for Best Supporting Actor.

John Cazale wasn't nominated. But he had achieved a quiet landmark: of the five features he had acted in, all were nominated for Best Picture. And though he hadn't lived to see it, Meryl Streep was nominated for her first Academy Award, for Best Supporting Actress.

As the Oscars approached, the debate over *The Deer Hunter* intensified. In December, Cimino had given an interview to the *New York Times*, in which he insisted that anyone attacking the film on its facts was "fighting a phantom, because literal accuracy was never intended." The piece noted that Cimino, who gave his age as thirty-five, "joined the Army about the time of the Tet offensive in 1968 and was assigned as a medic to a Green Beret unit training in Texas, but was never sent to Vietnam."

Michael Deeley was among the first to raise an eyebrow: his insurance records indicated that Cimino was just short of forty. Thom Mount, the president of Universal, got a call from a studio publicist: "We got a problem." The reporter couldn't corroborate what Cimino had said about his military service, and, as far as Mount was concerned, "He was no more a medic in the Green Berets than I'm a rutabaga." (The *Times* ran it anyway.) In April, the Vietnam correspondent Tom Buckley published a full accounting in *Harper's* of what

he considered Cimino's distortions. The Pentagon had told him that Cimino enlisted in the Army Reserve in 1962—nowhere close to the Tet Offensive—and spent a placid six months in New Jersey and Texas.

What bothered Buckley was not the personal distortions (which Cimino vehemently denied) but the way they were "mirrored" in the film. His most pungent criticism, like Kael's, was of its portrayal of the Vietnamese. "The political and moral issues of the Vietnam war, for ten years and more this country's overriding concern, are entirely ignored," Buckley wrote. "By implication, at any rate, the truth is turned inside out. The North Vietnamese and the Vietcong become the murderers and torturers and the Americans their gallant victims."

But the legacy of The Deer Hunter was far from settled. Jan Scruggs, a former infantry corporal, saw the film one night in Maryland. Back in his kitchen, he stayed up until three a.m. with a bottle of scotch, kept awake by a torrent of flashbacks. In the boys of Clairton, he saw the unspoken pain of a generation of soldiers, some who came back, some who didn't. The next morning, he told his wife that he'd had a vision: a memorial for Vietnam veterans, listing the names of the fallen. It was the beginning of a three-year journey that ended on the National Mall.

————

One veteran who agreed with the criticisms was Mike Booth. Five or six years had passed since he had seen Meryl, having lost himself in his studies in Mexico. After changing his major from art to philosophy to Latin American studies and, finally, to American literature, he finished up his degree in Santa Cruz, where he met a girl and got engaged. One day in 1977, he took her to see *Julia* and blanched midway through. "That's my old high school girlfriend!" he told her.

Now approaching thirty, Mike yearned to settle down, to "try to be a normal person instead of a vagabond." He brought his fiancée back east, to Newport, Rhode Island. He dreamed of being a writer, but he wanted to support a family, so he took a job at his father's pigment business, in Fall River, Massachusetts. It had a small office in an old mill building, and Mike took on various tasks: typing invoices, loading trucks, sometimes mixing batches of color in the factory. He would end his days in sweaty coveralls splotched with red and yellow pigment.

When he saw Meryl in magazines, he admired how she was pursuing the thing she loved, how accomplished she was. He had just gotten married when his sister told him not to see *The Deer Hunter*, because she thought it would "hit close to home." He went anyway.

When he saw the Vietcong holding the Clairton boys in underwater tiger cages, he started feeling the old fire that had propelled him to Nixon's motorcade. "The Communists did plenty of nasty things," he said later, "but from what I recall *our* side used the tiger cages." And Russian roulette? He had never heard of anything like that in Vietnam.

But, as he sat in the Newport movie theater, he saw other things, too. He saw Robert De Niro, on his first night back in Clairton, seeing the "Welcome Home" sign hung in his honor and telling his driver to keep on driving. He saw Christopher Walken, at a military hospital in Saigon, staring at a photo of the girl back home. He saw verdant jungles rocked by explosions, and halting conversations with old friends, and some inkling of the way he felt when he got home to Bernardsville.

And he saw Meryl.

Meryl catching the bouquet.

Meryl tossing rice at the newlyweds.

Meryl giggling and twirling on the dance floor.

Meryl fixing her hair in the shop window.

Meryl breaking down in tears in the supermarket storeroom for reasons she can't possibly explain.

Meryl telling a distant Michael Vronsky, "Can't we just . . . comfort each other?"

Stepping out into the New England night, Mike was shaken. He had seen distortions, yes. But he'd also seen the girl to whom he'd once given that "JUNIOR PILOT" ring, now arm in arm with her man in uniform. For all the reasons his sister had warned him, the movie did hit home. But "it hit home, also," he recalled, "because she looked so beautiful."

On April 9, 1979, Meryl arrived at the Dorothy Chandler Pavilion in Los Angeles, wearing a black silk crêpe dress she had bought off the rack at Bonwit Teller and ironed herself the night before. ("I wanted something my mother would not be ashamed of," she said.) That week, she had passed through the Beverly Hills Hotel unrecognized. She even took a dip in the pool: a rookie move, as it was designed to be lounged beside, not swum in. But Meryl knew little of the etiquette of Hollywood, nor did she care. Apart from the palm trees swaying overhead, it might as well have been the community pool in Bernardsville.

Now, as the car pulled closer, Meryl heard demonstrators from Vietnam Veterans Against the War, protesting the movie for which she was nominated. Some, in fatigues and berets, waved placards that said "NO OSCARS FOR RACISM" and "THE DEER HUNTER IS A BLOODY LIE." There were reports of rocks being hurled

at limos. By the end of the night, thirteen people had been arrested.

The case against *The Deer Hunter* had become increasingly rancorous. At the Berlin International Film Festival, the socialist states had protested in solidarity with the "heroic people of Vietnam." At a house party, a female war journalist went up to Barry Spikings and punched him in the chest, saying, "How *dare* you?" When confronted, Cimino would say that the characters "are not endorsing anything except their common humanity." Meryl was similarly apolitical. "It shows the value of people in towns like that," she said. "There is such a fabric of life to look at."

Inside the hall, the tensions were subdued. Neither Michael Deeley nor Deric Washburn was on speaking terms with Michael Cimino. As the awards began, Johnny Carson, hosting for the first time, welcomed the crowd with the immortal line, "I see a lot of new faces. Especially on the old faces."

Over the next three hours, *The Deer Hunter* went head to head with *Coming Home*, in what seemed like a battle for Hollywood's political soul. Jane Fonda won Best Actress and delivered part of her speech in sign language, because "over fourteen million people are deaf." Christopher Walken beat Bruce Dern for Best Supporting Actor. Robert De Niro, who had stayed home in

New York, lost to Jon Voight for Best Actor. *Coming Home* won Best Screenplay, but then Francis Ford Coppola handed his "paisan" Michael Cimino the Oscar for Best Director. "At a moment like this," Cimino said in his speech, "it's difficult to leaven pride with humility."

And in the race between Meryl Streep and *Coming Home*'s Penelope Milford, the winner was . . . Maggie Smith, for *California Suite*. Meryl smiled and applauded gamely.

At the end of the night—an endless one; the East Coast broadcast lasted until 1:20 a.m.—John Wayne came onstage to present Best Picture. The Duke looked uncharacteristically feeble, ravaged by the stomach cancer that would kill him two months later. When he announced *The Deer Hunter* as the big winner, the applause, the *Los Angeles Times* reported, was "respectful but well short of thunderous," as if tinged with buyer's remorse.

On the way to the press area, Michael Cimino found himself in the elevator with Jane Fonda, who had blasted *The Deer Hunter* as a "racist, Pentagon version of the war," before admitting that she had not seen it. Both of them held their Oscar statuettes. Fonda refused to look him in the eye.

When the Oscars were over, Michael Cimino went back to work on his next film, *The Johnson County*

War, which would be released the following year as *Heaven's Gate*. John Cazale slid into a posthumous obscurity, forever the ghost in the New Hollywood machine. And Meryl Streep, having begun what no one yet knew to be a record-breaking streak of Academy Award nominations, returned to New York City with her husband.

Joanna

Six months.

That's how long it took. Six months and change. On March 12, 1978, the love of Meryl Streep's life died as she sat by his bedside. By late September, she was married to another man.

Six months in which Michael Cimino hacked away at the dailies. Six months in which *Holocaust* broadcast her face into living rooms from Hollywood to Hamburg. Six months in which the actress who was now turning twenty-nine would play three indelible roles at the exact same time. Six months in which, depending on whom you ask, she was either an emotional wreck or a virtuoso reaching the culmination of her craft.

Six months to pick up the pieces of her life without John and refashion them into something new and whole and lasting. How?

It started with a knock on the door. And not a welcome one.

She must have been some combination of baffled and distraught when she opened the front door of the loft on Franklin Street and saw a wan, redheaded Texan she had never met. No doubt, John had told her about the girlfriend who had picked up and left for California. Or maybe not.

Only three weeks had passed since John died, and Meryl was still wandering the apartment like a blank-eyed zombie. Traces of him were in every corner, making the fact of his absence counterintuitive. When was he coming home? Because she was having trouble with everyday tasks, her brother Third had moved in with her. At least she wouldn't have to face the day alone. Automatic pilot.

As if to break the fog and force her back into the practicalities of living, the redheaded woman now stood before her, claiming that her name was on the deed with John's and that it was she, Patricia, who had rights to the apartment. Meryl would have to vacate at once.

Of all the things she wanted to think about, this was surely dead last. Not the apartment, exactly, but the claim this woman professed to have on John's home. *Their* home. He and Meryl had been together less than two years, but what they went through seemed to bear the weight of a lifetime. What had Patricia really meant to him? And why hadn't he handled this mess when he was alive? In a way, it was typical John, so spellbound by the present that he was blind to the future, which had now brought a ghost from his past.

Also, where was she going to live?

Her friends were shocked. "We just assumed that she could live there, or maybe Patricia would give up her rights," Robyn Goodman said. "I mean, honestly, if it was me I would have said, 'Meryl, it's your loft now.' We all thought, Oh, it'll be fine. Because what person would kick Meryl out?"

Robyn called Patricia and pleaded with her. Was it money she wanted? Then ask for money.

When pleading didn't work, Robyn tried intimidation: "You're going to get a terrible reputation, because everybody knows about this."

"Everybody" was their community of actors, the people who loved John and loved Meryl and couldn't believe what was happening. One night, Robyn was at

a bar called Charlie's when an Italian actor they both knew came up to her.

"I hear Meryl's having trouble with this Patricia about the loft."

"I'm trying to make it not happen," Robyn said. "I'm trying to help."

The actor leaned in. "You know, I know guys in New Jersey who can take care of this girl."

Robyn blinked. Was she being offered a hit man? This was getting into *Godfather* territory. "No," she said, a little reassured but slightly terrified. "I don't think we want to be responsible for something like that."

Patricia wouldn't budge.

"My brother says it's valuable and I should have it," she said. Her brother was right: the neighborhood increasingly known as Tribeca (though the name was in contention with Lo Cal, Washington Market, and SoSo) was already being hyped as the "international art center" of the future, and property there could be a goldmine.

"Things are not going to go well for you," Robyn told Patricia, as if placing a curse.

It didn't do Meryl much good. She was grieving. She was tired. And now she was homeless.

New Yorkers measure their lives in apartments. The two-bedroom on West End Avenue that first year in the city. The loft on Franklin Street. The rental on Sixty-ninth Street. What summer was that? How many apartments ago?

When Meryl got kicked out of John's loft, it was the end of her old life and the beginning of something she couldn't have anticipated. But sometimes apartments write the next chapters themselves.

She and Third began packing up their stuff: an overwhelming task, and not just physically. Each box was a talisman of her life with John, holding its own sad weight. Maybe the best thing was to put it all out of sight. Third had a friend in SoHo, a block or two away, who offered to help. He was a sculptor: brawny, curly-haired, with a sweet smile, like Sonny Corleone with more bulk and less temper. Meryl had met him two or three times, but she didn't remember him.

Even after the three of them had put everything they could into storage, there were still more boxes left over. They were like a force that couldn't be contained, a cumbersome reminder of how messy everything was. The sculptor offered to store the remaining possessions in his studio, on lower Broadway.

With all that sorted out, Meryl went off to Maryland to shoot *The Senator.* One day, Third came to visit her on set, along with the sculptor. Once she got back to New York, she wouldn't have a place to stay, so the sculptor said she could crash at his loft. He was about to go on a trip around the world on grant money, so she'd have the place all to herself. She accepted the offer.

Left alone, she started to wonder about her host. Once again, she was living among the detritus of an absent man, though this time the house was full of life, not death. She was intrigued by the sculptures spilling from his workspace: massive, gridlike hulks of wood and cable and Sheetrock.

She began writing him letters. Replies came from faraway places like Nara, Japan, where he was studying the patterns on folding screens and floor mats. In his second year of college, the master sculptor Robert Indiana had told him, "If you're going to be an artist, you should travel and see the world." Now he was heeding the advice, soaking in the geometry of the Far East, which would linger in his mind before surfacing someday in his hands, just as Meryl absorbed people's gestures and cadences, knowing they might turn up one day in a character.

As she pored over his letters, surrounded by his handiwork, Meryl learned more about the man she

had met only a handful of times. His name was Don Gummer, and he was thirty-one. He was born in Louisville, Kentucky, and grew up in Indiana with five brothers. Objects had always spoken to him. As a boy, he built tree houses and model airplanes and forts. There were new houses going up in his neighborhood all the time, and he would play for hours in the construction sites. Then he'd come home and make his own edifices with an Erector Set.

He was at art school in Indianapolis when Robert Indiana told him to see the world, so in 1966 he moved to Boston, with little more than $200 and a pair of pants. He was married to his college girlfriend, but she stayed back in Indiana and the relationship fell apart. While Meryl was at Vassar, discovering *Miss Julie*, Don was at the Boston Museum School, discovering the hidden voice of objects. A lecture by the painter T. Lux Feininger planted the idea that abstract shapes could be expressive, a lesson reiterated by George Rickey's book *Constructivism*. He became obsessed with materials and space and what happened when you put the two together.

In 1969, he found a dark piece of stone that reminded him of Brancusi's *Fish*. He sawed it in half and suspended the two pieces above a concrete slab, placing a small patch of grass below the bisected stone. Between

the two halves of rock, he kept a tiny sliver of empty space—like the space between two repelling magnets, or the schism within a soul. He called it *Separation*.

The next year, he went to Yale for his M.F.A., where he continued making large-scale installations. He covered an entire room with dry earth and rock, stretched a wire mesh over the expanse, and called it *Lake*. He got his degree in 1973, unaware of the drama student improvising her own death down the street. In New York, he took a job as a union carpenter at the Olympic Tower. The work trickled into his sculptures, which started resembling deconstructed tabletops. Gravity interested him. Shadow interested him. A year into his New York life, he was picked by Richard Serra to mount his first solo show, on Wooster Street. He filled the gallery with a huge, complicated structure he called *Hidden Clues*.

All this was new to Meryl, a language she didn't speak but could instinctively understand, as someone who was also constantly remixing the raw materials of life. Then again: What exactly was going on here? It had been only weeks since John died, and here she was in another man's apartment, her mind pulled between her grief and the vitality that seared through Don's letters.

Their epistolary flirtation came to a head with the alarming news that Don had been injured in a motorcycle accident in Thailand. He was laid up at the Lanna Hospital, in Chiang Mai, where he spent the hours making sketches for a new piece—a relief of painted wood, arranged in crisp rectangular patterns like the ones he had seen on Tatami floor mats. He would construct it when he got home to New York, which would now be sooner than expected.

Meryl sat with Robyn Goodman in the loft, a note from Don in her hand. It wasn't a love letter, exactly, but the tone had changed. He wanted to spend time with her when he got back, in some serious way that frightened her. As in her best roles, the conflict must have played out across her face. She was pulled between desire and guilt, past and future, loss and life. She had nursed John for so many months, putting his needs before her own with a single-minded devotion that rendered everything else irrelevant. Now the world beyond was coming back into focus, and her eyes hadn't quite adjusted. Was it too soon? Was she betraying John? Should she be chaste like Isabella? Surely not—but this was all happening so quickly.

She showed the letter to Robyn and said, "I think he's trying to say something that I'm not ready for."

Robyn knew how she felt. After Walter McGinn's car plunged over the Hollywood Hills the year before, she had found herself a widow at twenty-nine. For a while, she couldn't leave the house. "Nobody's ready to be a widow," she said later. "Nobody at that age—at our age—was ready. You don't know until it happens to you whether you're ready for it or whether you're any good at it."

Then Robyn got a call from Joe Papp, who, in his benevolent way of commanding people what to do, informed her that he had a role for her at the Public. Arguing was useless.

"Joe, I don't—"

"Here's the rehearsal date."

Robyn had forced herself to leave the house to do the play. And then life kicked back in. She met someone and had an affair, ignoring the concerned comments from friends who thought it was too soon. "It's been eight months!" she'd say. "I mean, can I sleep with someone, please?" It wasn't long after that that Joe told her she was meant to be a producer. In 1979, she would cofound the company Second Stage, which would make its home at an Upper West Side theater christened the McGinn/Cazale.

It had been eerie, John and Walter dying a year apart, leaving these two young women to sort out the

pain. But with her running start at rejuvenation, Robyn knew the worst thing that Meryl could do was wait.

"Look," Robyn told her. "I had an affair. I'm not judgmental about that. You have to get on with your life. If you like Don, spend time with him."

It seemed so simple. But it wasn't. Any room she made for Don in her heart would have to coexist with the huge space she had carved out for John.

When Don got back, he built Meryl a little room of her own in his loft. Suddenly, she was home. She'd snapped out of automatic pilot, in more ways than one. She was now, as she recalled later, "greedy for work."

Fortunately, there was someone just as greedy for Meryl's success: Sam Cohn, the show-business swami of ICM. Since Yale, her representatives at the agency had been Sheila Robinson and Milton Goldman, in the theater department. But now that her star was rising in movies, she'd caught the attention of Cohn, whose official title was "head of the New York motion-picture department." That didn't even begin to cover it.

Since negotiating the merger that created ICM, in 1974, Cohn presided over his own busy fiefdom, a boutique agency within the agency. His colleague Sue Mengers called him "agent-auteur." From his desk on West Fifty-seventh Street, he would cook up projects

for the dozens of actors, writers, and directors he represented, from whom he expected—and received—bone-deep loyalty.

His deal-making prowess was legendary. "Sam gets away with more than anybody else I know can get away with," the Broadway producer Gerald Schoenfeld once said. "He does more what he wants to do when he wants to do it and in the way he wants to do it than anybody I know and gets away with it."

But he didn't look like a bigwig, his wardrobe consisting of baggy V-neck sweaters, ill-fitting khakis, and thick glasses through which he squinted enigmatically. At first glance, he seemed shy, until you got an earful of his speaking voice, which *The New Yorker* described as "a confident staccato, as unstoppable as a bunch of marbles rolling down a hill." By the end of a meeting at an associate's office, he'd somehow wind up in the host's chair, his feet perched on the other man's desk.

As notorious as his power-brokering—but connected to it by mysterious threads—were his habits, at once peculiar and rigidly consistent. Morning: arrive at work, fling his coat across the desk for an assistant to retrieve, and bark out the names of the four or five people he needed to get on the line. Sam Cohn and the telephone were a curious pair: by one estimate, the phones in his offices would ring about two hundred

times per day, and he was never off of them. And yet he was one of the hardest people to reach in New York City.

"We had a rolling list every morning, called the Unreturned List," Susan Anderson, his executive assistant for twenty-eight years, recalled. "And the further you got down on the Unreturned List, the chances were likely you weren't going to be hearing from him. Because he was such a person who lived in the present that the top of the Unreturned List is pretty much what got done every day." Friends joked that his tombstone should read: "Here lies Sam Cohn. He'll get back to you."

Lunch, without fail, was at the Russian Tea Room, where Cohn had the first booth on the right. (The first booth on the left was reserved for Bernard B. Jacobs, the head of the Shubert Organization.) Cohn relished the fact that he was the only male patron not required to wear a blazer. "Oh, that guy's not wearing a jacket," the other diners would say. "It must be Sam Cohn."

Then it was back to the office until quarter to eight, when he would leave for the opera, or, more often, the theater, which he loved—he saw approximately seventy-five plays a year. After curtain call, he'd eat dinner, typically at Wally's, where he ordered the sirloin steak with peppers and onions. There, or at lunch,

he met with his high-strung, high-powered cadre of friends, who were almost always his clients: Bob Fosse, Roy Scheider, Paddy Chayefsky, Paul Mazursky. "It was never one on one," recalled Arlene Donovan, who worked in the literary department. "It was like one on five."

The next morning, he'd start the crazy routine again: dodging calls, making deals. New York (midtown, specifically) was his universe. He loathed Los Angeles, which he considered a cultural desert, and spent as little time there as someone in the movie business possibly could. At the Oscars, which he attended grudgingly, he'd sit and read the *New York Times*. "I can't stay longer," he'd say, running to catch a redeye. "I'm afraid I'll like it." But he never did.

Of all Cohn's eccentricities, the strangest was his tendency to eat paper. Newspapers, matchbooks, screenplays: somehow they'd end up wadded into little balls in his mouth, before he deposited the remains in an ashtray. He would rent a car at the Los Angeles airport and eat the claim check before reaching the garage. "One time, he was supposed to meet me somewhere," Donovan recalled, "and he ate the paper about where he was supposed to meet me." Another time, a seven-figure check arrived for his client Mike Nichols,

who had sold some fine art. It had to be reissued after Cohn unconsciously ingested the signature.

By 1978, one of the few people who could break through the bulwark of Cohn's telephone line was Meryl Streep. As a compulsive theater-goer, he knew what she was capable of before Hollywood did. Unlike his inner circle of nebbishy middle-aged men, she was like a daughter to be doted on. (Along with Robert Brustein and Joe Papp, she was lousy with Jewish father figures.) He didn't consider most people smart, but Meryl was smart.

"He was in awe of her," Donovan said. "And he was very careful in her selection of material." Cohn saw Meryl as she saw herself: as an actress, not a starlet. But he also knew how big a career she could have. It was just a matter of picking the right projects. No shlock.

"She wasn't making the kind of money that being in a blockbuster would have afforded her," Anderson said. "But that was never the plan. The plan for Sam was always quality first."

At the moment, there was a screenplay on his desk that hadn't yet been chewed up into spitballs. It was written by another client, Robert Benton, based on a novel by Avery Corman, and it was called *Kramer vs. Kramer.*

Until Avery Corman was eleven years old, he believed his father was dead. In the Bronx apartment where he lived with his mother and sister, the man was seldom discussed. When pressed, his mother said he'd been killed in the Canadian Army. Later, the story shifted to a car crash. Avery got suspicious.

One day around 1947, he was playing cards with his aunt and told her that some boys at school had teased him for being fatherless. This was a lie. "Do you want to know where your father is?" his aunt, who was deaf, said in sign language. She swore him to secrecy.

"California."

Avery fished out the truth by means of another lie. He told his mother brightly, "If your father is dead, you have to be bar mitzvah-ed at twelve and not thirteen because you have to become a man earlier in the Jewish religion." As the boy was about to turn twelve, she had no choice but to sit him down in the living room and confess that his father was alive.

The details spilled out: Avery's father had always struggled to hold down a job. He'd sold newspapers and been fired. He ran a shoe store, but it went under. As his debts mounted, he resorted to gambling—Avery's mother was still paying off a collection agency on his behalf. At one point, Avery learned later, he'd been

caught robbing a candy store. He had filed divorce papers in 1944, making Avery's mother one of the only divorced women in the neighborhood. "I told you he was dead," she said, "because he's as good as dead."

Three decades later, Corman was living on East Eighty-eighth Street with his two small sons and his wife of ten years, Judy Corman. His novel *Oh, God!* had brought him some acclaim, especially after it was made into a movie starring George Burns. His father had called him once, when Avery was twenty-six; the conversation was fruitless, and for years he did nothing. By the time he hired a private detective to learn more, his father had been dead for six years.

For now, Avery concentrated on being the husband and parent his father never was. When he met Judy, she was a music publicist, but now she stayed home with the kids, taking an occasional job as an interior decorator. She didn't mind not working full time, but it wasn't the fashion. In 1974, she joined a women's consciousness-raising group, one of many that were sprouting up in living rooms and church basements across the country. Each member would speak on a topic—anything from breast-feeding to orgasms—the idea being to organize women into a self-empowered political class. Judy did and didn't fit in. At one meeting, she asked the group, "If we met at a party and you asked me what I did, and

I said I was home with two young children, what would you do?" One woman admitted she'd probably go talk to someone else across the room.

Inspired by what she heard at the group, Judy created a fixed schedule dividing domestic responsibilities between her and Avery. Whoever shopped for dinner also cooked and did the dishes, giving the other person an uninterrupted night off. The experiment fell apart after six months. Their older son, Matthew, had little concept of one parent being on duty or off, and would constantly disrupt Avery's writing. The bulk of the childcare fell back to Judy.

Avery began noticing something he didn't care for in the women's movement. "I could not reconcile some of the rhetoric I was hearing with my own personal experience as a father, as well as the personal experiences of many of the men I knew," he said later. "It seemed to me that the rhetoric from feminists was lumping all men together in one box as just a whole bunch of bad guys."

Avery felt that there was an entire precinct going unrecorded: good fathers. From what he could tell, the loudest voices of the feminist movement were those of unmarried women, who were more qualified to tackle workplace inequality than to dictate how married men and women should behave at home. Not only that: he

had seen some seemingly happy relationships collapse after the woman aired her grievances at a consciousness-raising group. One friend's wife had even walked out on her marriage. "I saw a few examples of what we would call self-absorption and narcissism in the service of fulfilling one's personal destiny," he recalled.

In these disconcerting trends, Avery saw the makings of his next novel, one that would counteract the "toxic rhetoric" he was hearing and make the case for the good father. His protagonist was Ted Kramer, a thirtysomething workaholic New Yorker who sells ad space for men's magazines. He has a wife, Joanna, and a little boy named Billy. In the early chapters, their marriage is portrayed as superficially content, with wells of ennui underneath.

The problem is Joanna Kramer. Described as "a striking, slender woman with long, black hair, a thin elegant nose, large brown eyes, and somewhat chesty for her frame," she quickly finds that motherhood is, by and large, "boring." She tires of playing with blocks and of discussing potty training with other mothers. When she suggests to Ted that she might want to return to her job at an advertising firm, he balks—after the babysitting fees, they'd end up *losing* money. She starts taking tennis lessons. Sex with Ted is mechanical. Finally, about fifty pages in, Joanna informs Ted that

she's "suffocating." She's leaving him, and she's leaving Billy.

"Feminists will applaud me," she says.

"What feminists? I don't see any feminists," he snarls back.

After that, Joanna more or less disappears. Ted gets over his shock, hires a nanny, and gets back into the swing of single life. More important, he learns how to be a good father. The turning point comes when Billy falls and slashes his face. Ted rushes him to the emergency room, standing close as the doctor stitches him up. The child, who once seemed alien to Ted, is now "linked to his nervous system."

It is at this revelatory moment that Joanna does the unthinkable: she returns and tells Ted she wants custody. Having undergone a journey of self-discovery in California, she is now fit to be a mother. The ensuing custody battle, which gives the novel its title, lays bare the ugliness of divorce proceedings and the wounds they allow people to inflict on each other. The judge awards custody to Joanna, but in the final pages she has a change of heart and leaves the boy in the care of his father.

As Avery wrote the climactic court scenes, Judy came down with pneumonia. Saddled again with the household chores, he struggled to get to the final page.

When his wife read the manuscript, she was pleased to see that Joanna hadn't been demonized. "That was my main concern," she said when it was published, "how the woman was going to be portrayed." Still, in the wrenching last chapters, it's hard to see Joanna as anything but an obstacle between father and son, who now share a loving bond, and an exemplar of the "narcissism" Avery had observed in his social circle.

The novel was destined to hit a nerve. Divorce had become a staple of American life, with the trend line only going up. In 1975, divorces in the United States passed the million-per-year mark, more than double the number recorded a decade earlier. When *Kramer vs. Kramer* was published, many readers assumed that it was the story of Avery Corman's own awful divorce. In fact, he was happily married, and would be for thirty-seven years, until Judy's death. What almost no one realized—"the Rosebud," he said—was that the author was the child of divorce. He wasn't Ted Kramer. He was Billy Kramer.

Before *Kramer vs. Kramer* even hit the bookstores, the manuscript fell into the hands of Richard Fischoff, a young film executive who had just accepted a job with the producer Stanley Jaffe. Fischoff read the book overnight in Palm Springs. He thought it tapped into something new: the divorce phenomenon from a

father's point of view, allowing that the man's side of the story had the same "range, depth, and complexity of feeling" as the woman's. It was the first property he brought to Jaffe's attention.

Ted Kramer reminded Fischoff of an older version of Benjamin Braddock, the character played by Dustin Hoffman in *The Graduate*. In perhaps the most indelible screen image of the sixties, Benjamin ends the film in the back of a bus with his beloved Elaine, having rescued her from her own wedding to someone else. Riding off into their future, their exhilarated faces melt into ambiguity and something like fear. Did they think this through? What really lies ahead? Ted and Joanna Kramer, Fischoff thought, were Benjamin and Elaine ten years later, after their impulsive union has collapsed from the inside. The movie would be a kind of generational marker, tracking the baby boomers from the heedlessness of young adulthood to the angst of middle adulthood. No one was yet calling people like the Kramers "yuppies," but their defining neuroses were already in place.

Jaffe had gone through a difficult divorce involving two young children, so Fischoff knew the book would resonate with him. It did. What they needed next was a director, and Jaffe went to Robert Benton. Kindhearted and approachable, with a rumpled white beard

(his friend Liz Smith called him "Professor Bear"), Benton, as everyone called him, was best known for cowriting *Bonnie and Clyde*. Jaffe had produced his first directorial feature, *Bad Company*, and Benton was presently in Germany promoting his second, *The Late Show*. He had already read and rejected *Kramer vs. Kramer*, after getting the manuscript from Arlene Donovan, Avery's agent at ICM. Unlike his previous work, *Kramer* was completely character-driven. *How am I going to do this?* he thought. *Nobody carries a gun.*

Benton thought of writing the screenplay for his friend François Truffaut to direct, but the French auteur had other projects lined up. Jaffe wanted to move fast, and started talking to other directors. Benton, meanwhile, was working on a draft of an art-world whodunit called *Stab*, which would later become the Meryl Streep movie *Still of the Night*. When he showed the screenplay to Sam Cohn, the agent told him, "This is terrible." (It probably tasted bad, too.) Scrambling for a directing project, Benton asked Jaffe if *Kramer* was still available. The producer reached him in Berlin to tell him it was.

Everyone liked the idea of a spiritual sequel to *The Graduate*, which meant that the one and only choice for Ted Kramer was Dustin Hoffman. *Midnight Cowboy*

and *All the President's Men* had made the forty-year-old actor the era's antsy everyman, but he was now at one of the lowest points of his life. Amid contentious experiences filming *Straight Time* and *Agatha*, he was mired in lawsuits and countersuits and had decided to quit movies and go back to the theater, where he'd have more creative control. He was in the middle of an emotional separation from his wife, Anne Byrne, with whom he had two daughters. She wanted to pursue her acting and dancing career; Dustin objected. "I was getting divorced, I'd been partying with drugs, and it depleted me in every way," he said later. Instead of endearing him to *Kramer*, as with Stanley Jaffe, the familiarity of the material repelled him. He sent word to Jaffe and Benton that the character didn't ring true: "not active enough."

Taking the criticism to heart, Benton rewrote the script. In the winter of 1977, he and Jaffe flew to London, where Dustin was still filming *Agatha*. At four in the afternoon, they went to the Inn on the Park and found the actor alone in the lobby. Benton knew immediately he was going to say no—otherwise, he would have invited them up to his room. When they went to sit for tea, the maître d' apologized that there were no free tables. They had no choice but to go up

to Dustin's suite, where the three men talked for more than two hours. Benton laid out the case, dad to dad: "This is a movie about being a father." (His son went to preschool with Dustin's oldest daughter.) By the end of dinner the next night, Dustin had agreed to play Ted.

Back in New York, the trio met at a suite at the Carlyle Hotel, where they spent a week hashing out the script, working twelve-hour days. "It was almost like group therapy: talking, talking, knowing that no one would repeat outside what was being said," Jaffe recalled. With a tape recorder on, Benton and Dustin would spiral off into "what if"s, until Jaffe reeled them back in. Benton's aim was to tailor the script to Dustin, "like fitting a suit." Minor characters from the novel— the grandparents, the nanny—fell away, leaving a taut chamber drama in which every moment throbbed with emotion. The "spine" they agreed on, Dustin would recall, is that "what makes divorce so painful is that the love doesn't end."

The men wrote as fathers and as husbands, as people who had loved and failed and picked up the pieces. But, as they refashioned the script in their own image, the thing they were missing was the voice of Joanna Kramer, the woman who abandons her child and then reclaims him for reasons she is barely able to articulate.

In the case of *Kramer vs. Kramer*, the scales of dramatic justice were weighed decidedly toward Ted. "We didn't do that much work on Joanna," Benton recalled. "Now that I think back on it, probably because Joanna wasn't in the room."

Joe Papp had once again coaxed a traumatized actor from the brink, offering a renewed life on the stage. This time the actor was Meryl Streep, and the play was *The Taming of the Shrew*, which he announced for the 1978 summer season at Shakespeare in the Park. Meryl was playing the shrew.

It was a bold choice: an all-out war of the sexes in which a man turns a headstrong woman into an obedient wife. In Shakespeare's plot, the demure Bianca cannot wed until a husband is found for her older sister, Katherina, known throughout Padua as an "irksome, brawling scold." In comes Petruchio to woo the unruly Kate, whom he starves, deprives of sleep, and practically abducts in his quest to domesticate her.

Clearly, the play was at odds with the consciousness-raised New York City of 1978. In modern times, directors had undercut the play in every which way, trying to make sense of what seemed like a sexist broadside. How could any self-respecting actress deliver the final monologue, a paean to feminine submission?

I am ashamed that women are so simple
To offer war where they should kneel for peace,
Or seek for rule, supremacy and sway,
When they are bound to serve, love and obey.

One day, Meryl sat in a rehearsal room at the Public, her skirt hiked up to reveal two red kneepads—protection for Act II, Scene i, Kate's first knockout brawl with Petruchio. Beside her was her leading man, Raúl Juliá.

With his flamenco dancer's physique and peacock's flair, Juliá seasoned Shakespeare's blank verse with piquant Latin cadences. "She swings as sweetly as the nightingale," he said, reciting a line. Then he caught himself—"Jesu Christ!"—and leaped out of his chair. "*Sings*. She *sings* as sweetly as the nightingale."

Picking up on his flub, Meryl snapped her fingers and swing-danced in her chair. When she first met Raúl, she was "terrified" by the sheer size of his eyes, his gestures, his smile. As she came to discover, he was an engine of combustible joy. At one point, he stopped a rehearsal mid-scene to declare, "The girl is an *acting factory*!" If anyone could match his live-wire machismo, zinger for zinger, it was Meryl.

To her, the play was perfectly compatible with the women's movement, if you saw it—and acted it—with

the right slant. In preparation, she was reading Germaine Greer's *The Female Eunuch,* one of the sharpest polemics of second-wave feminism, which argued that women are victims of their own enforced passivity, muzzled by a male-supremacist society that seeks to repress the female sexual instinct. Greer wrote of Kate and Petruchio, "He wants her spirit and her energy because he wants a wife worth keeping. He tames her as he might a hawk or a high-mettled horse, and she rewards him with strong sexual love and fierce loyalty." Imagine a woman like Greer succumbing to the charms of Petruchio, who calls his conquest "my goods, my chattels." What contortion of the will would it take?

Meryl found the answer between the verses. "Feminists tend to see this play as a one-way ticket for the man, but Petruchio really gives a great deal," she told a reporter. "It's a vile distortion of the play to ever have *him* striking *her.* Shakespeare doesn't do it, so why impose it? This is not a sadomasochistic show. What Petruchio does is bring a sense of verve and love to somebody who is mean and angry. He's one of those Shakespearean men who walk in from another town. They always know more, see through things. He helps her take all that passion and put it in a more lovely place."

A year ago, her answer might have been different, her judgment of Kate harsher. But in talking about "giving," she was talking about her months at John Cazale's bedside. "I've learned something about that," she continued. "If you're really giving, you're totally fulfilled." She had put a man's needs before her own and come out more fully human—a counterintuitive feminist principle if there ever was one. Now she would have to stand in front of a crowd of Manhattanites and exhort the women to "place your hands below your husband's foot."

"What I'm saying is, I'll do *anything* for this man," she reasoned. "Look, would there be any hang-up if this were a mother talking about her son? So why is selflessness here wrong? Service is the only thing that's important about love. Everybody is worrying about 'losing yourself'—all this narcissism. Duty. We can't stand that idea now either. It has the real ugly slave-driving connotation. But duty might be a suit of armor you put on to fight for your love."

In a way, Petruchio reminded her of John, the way he had stripped her down to the essentials: "you don't need this," "you don't need that." In their darkest hours, only the life she gave him remained, and "losing yourself" hadn't been a question. That truth

still guided her like a torch, not just through Shakespeare but through her breakneck romance with Don Gummer. On afternoons, they would go to museums; he'd see shapes, she'd see characters. Or vice versa. "She's learned how to look at objects and I've learned how to look at people," as Don put it soon after. Theirs was a bond built on "a very deep-rooted feeling of trust," he said, as sturdy and foundational as the concrete base of one of his sculptures.

It was this Meryl Streep—simultaneously grieving and infatuated—who got word from Sam Cohn about a possible role in *Kramer vs. Kramer*. The part of Joanna had been given to someone else: Kate Jackson, the "smart one" on *Charlie's Angels*. Jackson had the name recognition and the crystalline beauty that Columbia Pictures required. But the negotiations had hit a snag when Aaron Spelling asked for a firm stop date, so that Jackson could get back to production on *Angels*. The *Kramer* team knew they couldn't guarantee one, and Spelling wouldn't bend his schedule. Jackson was forced to pull out of the film, kicking and screaming.

According to Richard Fischoff, who was billed as associate producer, the studio sent over a list of possible replacements, essentially a catalog of the bankable female stars of the day: Ali MacGraw, Faye Dunaway, even Jane Fonda. Katharine Ross, who had played

Elaine in *The Graduate*, was a natural contender. With *The Deer Hunter* still in postproduction, the name Meryl Streep meant nothing to the West Coast, apart from sounding like a Dutch pastry. But she and Benton shared an agent, and if anyone knew how to get someone into an audition room, it was Sam Cohn.

Meryl had met Dustin Hoffman before, and it hadn't gone well. During drama school, she auditioned for *All Over Town*, a Broadway play he was directing. "I'm Dustin"—*burp*—"Hoffman," he said, before putting his hand on her breast, according to her. *What an obnoxious pig*, she thought.

Now surer of herself, she marched into the hotel suite where Hoffman, Benton, and Jaffe sat side by side. She had read Avery's novel and found Joanna to be "an ogre, a princess, an ass." When Dustin asked her what she thought of the story, she told him in no uncertain terms. They had the character all wrong, she insisted. Her reasons for leaving Ted are too hazy. We should understand why she comes back for custody. When she gives up Billy in the final scene, it should be for the boy's sake, not hers. Joanna isn't a villain; she's a reflection of a real struggle that women are going through across the country, and the audience should feel some sympathy for her. If they wanted Meryl, they'd need to do rewrites.

The trio was taken aback, mostly because they hadn't called her in for Joanna in the first place. They were thinking of her for the minor role of Phyllis, the one-night stand. Somehow she'd gotten the wrong message. Still, she seemed to understand the character instinctively. Maybe this was their Joanna after all?

That, at least, was Meryl's version. The story the men told was completely different. "It was, for all intents and purposes, the worst meeting anybody ever had with anybody," Benton recalled. "She said a few things, not much. And she just listened. She was polite and nice, but it was—she was just barely there." Dustin said, "She never opened her mouth. She never said a word. She just sat there."

When Meryl left the room, Stanley Jaffe was dumbfounded. "What is her name—Merle?" he said, thinking box office.

Benton turned to Dustin. Dustin turned to Benton. "That's Joanna," Dustin said. The reason was John Cazale. He knew that Meryl had lost him months earlier, and from what he saw, she was still shaken to the core. That's what would fix the Joanna problem: an actress who could draw on a still fresh pain, who was herself in the thick of emotional turmoil. It was Meryl's weakness, not her strength, that convinced him.

Benton agreed. "There was a fragile quality she had that made us think that this was Joanna, without making her neurotic," he said. "Meryl's Joanna wasn't neurotic, but she was vulnerable, frail." According to the director, she had never been considered for Phyllis. It was always for the role of Joanna.

Clearly, there was a discrepancy between what they saw and how Meryl saw herself. Was she a fearless advocate, telling three powerful men exactly what their script was missing? Or was she a basket case whose raw grief was written all over her face? Was she Germaine Greer or "barely there"? Whichever Meryl Streep walked out of that hotel room, she got the part.

The woman is in profile, eyes cast down on her child's bed. Her chin rests on her hand, which sports a gold wedding band. Lit by the glow of a lamp covered by a red handkerchief, her face is all cheekbones and shadows, an ambivalent chiaroscuro. She could pass for a Vermeer.

"I love you, Billy," she says.

She leans down and kisses the boy, then packs a bag.

It was the first day of principal photography on *Kramer vs. Kramer*, and everything was hushed in the 20th Century Fox soundstage at Fifty-fourth Street

and Tenth Avenue. Robert Benton was so anxious he could hear his stomach grumbling, which only made him more anxious, since he worried the sound might wind up in the shot.

The little boy under the covers was Justin Henry, a sweet-faced seven-year-old from Rye, New York. In her search for a kid who could play Dustin Hoffman's son, the casting director, Shirley Rich, had looked at hundreds of boys. The blond, cherubic Justin Henry hadn't seemed right to Dustin, who wanted a "funny-looking kid" who looked like him. But Justin's tender, familial way with Dustin in screen tests changed his mind, along with the realization that Billy Kramer shouldn't look like Dustin. He should look like Meryl: a constant reminder of the absent Joanna.

Getting Meryl past the studio hadn't been easy. Some of the marketing executives at Columbia thought she wasn't pretty enough. "They didn't think that she was a movie star. They thought that she was a character actress," Richard Fischoff said, describing exactly how Meryl saw herself. But she had her advocates, including Dustin Hoffman and Robert Benton, and that was enough to twist some arms.

In preparation, Meryl flipped through magazines like *Cosmopolitan* and *Glamour*, the kind Joanna might read. (Meryl hadn't bothered with beauty magazines

since high school.) They all featured profiles of working mothers, brilliant judges who were raising five adorable children. The assumption now was that any woman could do both: the dreaded cliché of "having it all." But what about the Joanna Kramers, who couldn't manage either? Meryl called her mother, Mary Wolf, who told her: "All my friends at one point or another wanted to throw up their hands and leave and see if there was another way of doing their lives."

She sat in a playground in Central Park and watched the Upper East Side mothers with their perambulators, trying to outdo one another. As she soaked in the atmosphere—muted traffic noises, chirping birds—she thought about the "dilemma of how to be a woman, how to be a mother, all the gobbledygook about 'finding yourself.'" Most of her friends were actors in their late twenties who didn't have children, women at their peak career potential, which, paradoxically, was the height of their baby-making potential. Part of her wished she'd had kids when she was twenty-two. By now, she'd have a seven-year-old.

She thought about Joanna Kramer, who *did* have a seven-year-old, who looked at those same superwomen in the magazines and felt she couldn't hack it. "The more I thought about it," Meryl said, "the more I felt the sensual reason for Joanna's leaving, the emo-

tional reasons, the ones that aren't attached to logic. Joanna's daddy took care of her. Her college took care of her. Then Ted took care of her. Suddenly she just felt incapable of caring for herself." In other words, she was nothing like Meryl Streep, who had always felt supremely capable.

While brushing her teeth one morning, she thought about Margaret Mead, the famed anthropologist who had journeyed to Samoa and New Guinea. Meryl was reading her memoir, *Blackberry Winter.* It occurred to her that people outside an experience often have greater insight than the ones living it. Mead had wed her own instincts with the power of observation and gotten at something very deep. Unlike Joanna Kramer, Meryl wasn't a mother or a wife, and she didn't live on the Upper East Side. But she could travel there in her imagination, just as Mead had traveled to the South Pacific.

"I did *Kramer vs. Kramer* before I had children," she said later. "But the mother I would be was already inside me. People say, 'When you have children, everything changes.' But maybe things are awakened that were already there. I think actors can awaken things that are in all of us: our evil, our cruelty, our grace. Actors can call these things up more easily than other people."

Before shooting, Dustin, Meryl, and Justin had gone to Central Park with a photographer to pose for blissful group portraits. These were the photos that would decorate the Kramer household, snapshots of a once happy family. Benton had wisely cut the first part of the novel, showing the buildup to Joanna's departure. The movie would start on the night she leaves—the night the bomb goes off in Ted Kramer's life.

When he first saw the set, Dustin said, "My character wouldn't live in this apartment." The whole thing was quickly redesigned to fit whatever was in his head. Unlike with most films, they would shoot the scenes in order, the reason being their seven-year-old costar. To make the story real to Justin, they would tell him only what was happening that day, so he could *experience* it instead of *acting* it, which would inevitably come off as phony. His direction would be communicated solely through Dustin, as a way of bonding onscreen father and son.

On the second day, they continued shooting the opening scene, when Ted follows the hysterical Joanna into the hallway. They shot the bulk of it in the morning, and then after lunch set up for some reaction shots. Dustin and Meryl took their positions on the other side of the apartment door. Then something happened that shocked not just Meryl but everyone on set. Right

before their entrance, Dustin slapped her hard across the cheek, leaving a red mark in the shape of his hand.

Benton heard the slap and saw Meryl charge into the hallway. *We're dead*, he thought. *The picture's dead. She's going to bring us up with the Screen Actors Guild.*

Instead, Meryl went on and acted the scene.

Clutching Joanna's trench coat, she pleaded with Ted, "Don't make me go in there!" As far as she was concerned, she could conjure Joanna's distress without taking a smack to the face, but Dustin had taken extra measures. And he wasn't done.

In her last tearful moments, Joanna tells Ted that she doesn't love him anymore, and that she's not taking Billy with her. The cameras set up on Meryl in the elevator, with Dustin acting his part offscreen.

Improvising his lines, Dustin delivered a slap of a different sort: outside the elevator, he started taunting Meryl about John Cazale, jabbing her with remarks about his cancer and his death. "He was goading her and provoking her," Fischoff recalled, "using stuff that he knew about her personal life and about John to get the response that he *thought* she should be giving in the performance."

Meryl, Fischoff said, went "absolutely white." She had done her work and thought through the part—she

didn't need Dustin throwing shit at her. This was just like Allan Miller in her first year at Yale, pushing her to mine her own pain for *Major Barbara*. She wasn't that kind of actress. Like Margaret Mead, she could get where she needed to go with imagination and empathy. And if Dustin wanted to use Method techniques like emotional recall, he should use them on himself. Not her.

They wrapped, and Meryl left the studio in a rage. Day 2, and *Kramer vs. Kramer* was already turning into Streep vs. Hoffman.

Woody Allen was making his next picture in luminous black and white, which is how he saw his subject, Manhattan. Coming off of *Annie Hall* and *Interiors*, he'd established himself as the chronicler of the modern urban neurotic: the squash players and the therapy-seekers and the name-droppers he met at Elaine's, where he ate dinner nearly every night for ten years.

Meryl arrived one morning at Washington Mews, a gated row of houses just north of Washington Square Park. She was there to film two short scenes for *Manhattan*, playing Woody's ex-wife, Jill. For a comedy, the mood on set was dead serious: no joking around. The director sat in a corner, reading Chekhov. He said

very little, even to the actress he had hired to belittle him.

It was a small part, requiring only three days' work. That's all she had anyway, given that she was also acting in *Kramer vs. Kramer* and *The Taming of the Shrew*. Woody's longtime casting director, Juliet Taylor, recalled feeling "very, very lucky" to get her—so white-hot was the buzz that had attached itself to her name, even with *The Deer Hunter* still six months from release.

Of the film's constellation of women, Jill was easily the least developed: "more of an authors' idea than a character," according to Woody's cowriter, Marshall Brickman. Unlike Diane Keaton's pretentious journalist or Mariel Hemingway's underaged ingénue, or even the oblivious hausfrau played by Anne Byrne—Dustin Hoffman's real-life estranged wife—Jill is more talked about (derisively) than seen. Having left Woody's character, Isaac, for another woman, she is now penning a devastating memoir of their relationship, *Marriage, Divorce, and Selfhood*, which reveals not only Isaac's sexual foibles but the fact that he cries during *Gone With the Wind*. For Allen, who had been divorced twice, she was clearly the manifestation of some Freudian anxiety: a woman who castrates her husband not just once, with lesbianism, but again, with public hu-

miliation. "I think he just hated my character," Meryl said later.

Taylor, who had done casting for *Julia*, needed someone with "dimension," who could bring fullness to a part that was "maybe even slightly underwritten." There wasn't much chance to dig deeper. As was Woody's custom, Meryl got her six pages shortly before filming; only a select few got to read the whole script. Over at *Kramer vs. Kramer*, Benton encouraged the actors to improvise, treating his own screenplay as a mere blueprint. At *Manhattan*, the script was more like scripture. "Woody would say, 'Um, there's a comma in the middle of that sentence,'" Meryl would recall. "'It's there for a reason, and maybe you should just do it the way it's written.'"

When she got to the set, she introduced herself to Karen Ludwig, the woman playing her lover. In the scene they were about to shoot, Isaac shows up at their door to pick up his son and pleads with Jill not to publish the memoir. (This is after he stalks her on the street, begging her not to write about their marriage.) Jill accuses him of trying to run her lover over with his car. Upon meeting, the two actresses had only moments to establish their screen relationship.

"Let's pretend that we've just made passionate love on the kitchen table," Meryl told Ludwig.

"Okay," Ludwig said. She took off her chunky turquoise necklace and gave it to Meryl—a secret token of their intimacy.

Woody got up from his chair and called "Action." Then he was "Isaac," the bumbling television writer, in love with Groucho Marx and Swedish movies and the second movement of the *Jupiter* Symphony, and a mess when it came to everything else, especially women. As in all her scenes, Meryl's job was to keep moving—clearing the table, gliding from room to room—like a morose firefly Isaac can never quite catch in his net. None of the three actors made eye contact. But the erotic secret Meryl had concocted with Ludwig made Isaac seem like even more of an intruder, a man always chasing after a woman's turned back.

Despite her short screen time, Meryl would leave a memorable mark on the film, her silk hair and darting frame more a compositional element than a person. "I don't think Woody Allen even remembers me," she said two years later. "I went to see *Manhattan* and I felt like I wasn't even in it. I was pleased with the film because I looked pretty in it and I thought it was entertaining. But I only worked on the film for three days, and I didn't get to know Woody. Who gets to know Woody? He's very much of a womanizer, very self-involved."

The urbane world that Woody had created didn't impress her, either—more of the "narcissism" that she, like Avery Corman, saw pervading the culture. "On a certain level, the film offends me because it's about all these people whose sole concern is discussing their emotional states or their neuroses," she remarked at the time. "It's sad, because Woody has the potential to be America's Chekhov, but instead, he's still caught up in the jet-set crowd type of life and trivializing his talent."

Across a small table covered in a checkerboard cloth, Dustin Hoffman glared at Meryl Streep. The crew had taken over J. G. Melon, a burger joint on Third Avenue and Seventy-fourth Street. Today's pages: a pivotal scene in *Kramer vs. Kramer*, in which Joanna informs Ted that she plans to take back their son.

The weeks had been fraught, and Benton was panicking. "I was in unfamiliar territory," he said: no guns, no outlaws. "The suspense had simply to do with emotion, not anything physical." Benton and his wife had planned to take their son skiing in Europe after the shoot. But two-thirds of the way through, convinced he was never going to work again, he came home and told his wife, "Cancel the trip. We need to save all the money we have."

Dustin, meanwhile, had been driving everyone nuts. In his effort to fill every screen moment with tension,

he would locate the particular vulnerability of his scene partner and exploit it. For little Justin Henry, who experienced the story day by day, Dustin's methods elicited a child performance of uncommon nuance. Before playing a serious scene, Dustin would tell him to imagine his dog dying. For the harrowing sequence in which Billy falls from the monkey bars at the playground, Justin had to lie on the pavement and cry through fake blood. Knowing how Justin had befriended the crew, Dustin crouched over and explained that film families are temporary, and he would probably never see his pals again.

"You know Eddie?" Dustin said, pointing to a crew guy. "You may not see him."

Justin burst into tears. Even after the scene was done, he couldn't stop sobbing.

"Did it feel like you did a good job?" Dustin asked him.

"Y-yeah."

"How do you feel about that—when you do a scene you really cry?"

"T-terrific."

"You're an actor, then."

With his grown-up costars, Dustin's tactics had more mixed success. Gail Strickland, the actress hired to play

Ted's neighbor Margaret, was so rattled by the intensity of their scenes that she developed a nervous stammer within the first few days. When it became clear that most of her dialogue would be unusable, she was replaced by Jane Alexander. (The papers reported "artistic differences.") Alexander had acted with Dustin in *All the President's Men* and enjoyed his "febrile" way of working. She was taken aback, though, when she told Dustin she didn't care to watch the dailies and he responded, "You're a fucking fool if you don't."

Then there was Meryl. Unlike Strickland, she hadn't buckled when Dustin identified her vulnerability. When asked, she'd say she regarded him like one of her kid brothers, always seeing how far he could push. "I never saw one moment of emotion leak out of her except in performance," Benton said. She thought of the movie as work, not as a psychological minefield.

At the moment, she had a question. The way the restaurant scene was written, Joanna starts off by telling Ted that she wants custody of Billy. Then, as Ted berates her, she explains that all her life she's felt like "somebody's wife or somebody's mother or somebody's daughter." Only now, after going to California and finding a therapist and a job, does she have the wherewithal to take care of her son.

Wouldn't it be better, Meryl asked on set, if Joanna made the "somebody's wife" speech *before* revealing her intention to take Billy? That way, Joanna could present her quest for selfhood as a legitimate pursuit, at least as the character saw it. She could say it calmly, not in a defensive crouch. Benton agreed that restructuring the scene gave it more of a dramatic build.

But Dustin was pissed. "Meryl, why don't you stop carrying the flag for feminism and just *act the scene*," he said. Just like Joanna, she was butting in and mucking everything up. Reality and fiction had become blurry. When Dustin looked across the table, he saw not just an actress making a scene suggestion but shades of Anne Byrne, his soon-to-be ex-wife. In Joanna Kramer, and by extension Meryl Streep, he saw the woman making his life hell.

In any case, Dustin had a scene suggestion of his own, one he kept secret from Meryl. Between takes, he approached the cameraman and leaned in, as if they were plotting a jailbreak. "See that glass there on the table?" he said, nodding toward his white wine. "If I whack that before I leave"—he promised to be careful—"have you got it in the shot?"

"Just move it a little bit to the left," the guy said out of the corner of his mouth.

Dustin sat back down. "Action!"

In the next take, Dustin's agitation was palpable. "*Don't talk to me that way*," Ted says at the end of the scene, wagging his finger in Joanna's face. Then, as he stood up, Dustin smacked the wineglass and shattered it on the restaurant wall, its contents bursting in a deafening splat. Meryl jumped in her chair, authentically startled. "Next time you do that, I'd appreciate you letting me know," she said.

There were shards of glass in her hair. The camera caught the whole thing.

"Dear Mr. Papp," wrote a resident of 5 Jane Street:

> *Last week I saw the Festival's production of the Taming of the Shrew in Central Park and found it so offensive that I feel obliged to protest both your choice of the play and the interpretation it was given.*
>
> *At best, it can only be called insensitive to put on a play that celebrates the subjugation of women. But to play it straight, without any acknowledgment of the dehumanization and suffering inflicted on women by the canon of male dominance, is an act of aggression against women.*

It is particularly ironic that you should choose to celebrate the oppression of women this year. Just a month or two ago, the New York Police Department, under pressure of a lawsuit brought by battered women, agreed for the first time to start enforcing the laws against assault, battery, and attempted murder where women have been attacked by their husbands. Right now, after six years of politicking and back room deals, this country is still denying women the constitutional right to equal protection of the law.

If discrimination, rape, exploitation, and myths of the inferiority of women were mere antiquities, I too could laugh at the Taming of the Shrew. But I still have to get home from the theater by public transportation and be on my guard against the male criminals who think I'm an easy or deserving target because I'm a woman. I still have to earn my living in competition with men who are never held back by the notion that their true vocation is raising children. I still have to pay taxes to support programs like yours, which ennoble my oppression and call it culture.

I have urged all my friends to boycott this production, but the more I think about it, I think we really should be picketing it.

August, 1978. Onstage at the Delacorte, Meryl Streep and Raúl Juliá came at each other like poet gladiators, unleashing a nightly arsenal of wit and wordplay and physical force. Meryl, in her unkempt strawberry curls, would come on doing chin-ups, hike up her skirt, stomp on some shrubbery, then wail and slap and spit in Petruchio's face. Raúl, strutting in his black boots, would throw her over his knees, grab her ankles and tickle her feet, wrestle her to the ground and then sit on her like a stool. And that was just Act II, Scene i.

It was love as blood sport, and the riled-up spectators were willing participants. When a sweaty, snarling Petruchio called Kate "my horse, my ox, my ass, my anything," in Act III, he'd get an eruption of applause, followed by a smattering of boos, then a few whistles and, finally, some nervous laughter. One night, Raúl threw a piece of "mutton" and accidentally hit a woman in the audience ("but she was not injured," the stage manager reported).

At intermission, the battle of the sexes continued. "I can't believe how many people were applauding when he did that 'my horse, my ass' bit!" a young woman in the audience said one night.

"That scene is a good representation of what our relationship strives to be," her boyfriend quipped, as the woman rolled her eyes.

During one performance, a documentary crew followed Meryl into her dressing room, where she opined on Kate the Shrew. "She lives in a very—a highly conventional society where brides are bought and sold. This is a society that *constricts her*," she said, choking on the words as a dresser laced up her corset. "Don't you think the corset's a little tight, girls?"

By Act V, the shrew was tamed, or at least that's how it looked. Kate's closing monologue was the hardest part to sell. How to convince a 1978 audience that wives should "serve, love and obey" their husbands? Was Kate just another brainwashed version of "the female eunuch"? If Meryl was "playing it straight," as the woman from Jane Street had it, you could certainly see it that way. But there was something else at work. When Kate advised the ladies to "place your hands below your husband's foot," Meryl would kneel at Petruchio's boot. But then Raúl would grab her palm and kiss it, lowering himself beside her as they shared a knowing gaze. Was this subjugation or an alliance?

"I feel very ambiguous," a thirtyish woman said one night after curtain call. "Yes! I feel sick. But I also say, 'Oh, isn't she lucky,' you know? And I feel sick of myself for feeling that. And it's that whole ambiguity that makes it such a fabulous play—and such a disgusting play."

Backstage, Meryl and Raúl put on a play of their own for the cameras.

MERYL:

When you give, it's the greatest happiness you can feel.

RAÚL:

The ultimate satisfaction is service, believe it or not. Man or woman.

MERYL:

That's it! Why is it so hard for someone to say, just because it's a man, that "I'd—I'd do anything for you"? Why is it so hard?

As a stagehand mended their torn costumes, she continued, "That's *love*. That's absolute selflessness. It's where the self disappears into the love that you're giving to this person."

"Exactly."

"Absolute selflessness" was what she had learned that terrible winter at John's bedside. Five months later, her life was like a one-woman repertory theater. Uptown, she was Joanna, the mother who leaves her

son. Downtown, she was Jill, the wife who humiliates her husband. By night, in Central Park, she was Kate, the shrew to be tamed. Joanna, Jill, and Kate: three women who break the rules, leaving the men around them befuddled, cowed, and furious.

At *Kramer vs. Kramer*, Stanley Jaffe didn't understand how she could possibly do his movie *and* a play, not to mention *Manhattan*. But it didn't bother Meryl in the least. At Yale, she'd been trained to switch from part to part, slipping characters on and off like masks. Do it right, and they begin to speak to each other, a repertory of the mind. If anyone understood that, it was Joe Papp.

"Joe had no problem with that schedule as long as I showed up for work and chewed up the scenery nightly in the park," Meryl told his biographer. "The movie producers, on the other hand, were very nervous about whether or not I'd be able to maintain the concentration and physical stamina necessary to the part of Joanna Kramer. Joe looked at actors as dray horses, muscular and fearsome, while the movies were more prone to mollycoddling. Even now when I see Joanna Kramer in television showings of the movie, I think of her red-haired alter ego, Katherine the Shrew, spitting and sweating all over the first four rows of spectators at the Delacorte."

She showed up at the appointed time at Tweed Court-
house, the massive stone edifice at 52 Chambers
Street. It was named after William M. Tweed, the
Tammany Hall boss who embezzled funds from the
construction budget, then was tried and convicted in
1873, in an unfinished courtroom of the very same
building. By the time Meryl Streep arrived, 105 years
later, it had long been converted into municipal of-
fices. Now, there would be one more hearing, in the
matter of *Kramer vs. Kramer.*

"We were all wrecked and tired," Robert Benton
recalled. Dustin was getting sick. Everyone else was
sick of Dustin. And the courtroom scene would be
particularly onerous. For every shot of a witness giving
testimony, Benton would need three or four reaction
shots: Ted, Joanna, the judge, the opposing counsel.
The whole thing would take several days.

First on the stand: Joanna Kramer. Benton had been
struggling with her testimony, which he saw as abso-
lutely crucial. It is the one chance she has to make her
case—not just for custody of Billy, but for her personal
dignity and, by extension, womankind. For most of the
movie, she has been a phantom, with phantom motives.
Then her lawyer asks, "Mrs. Kramer, can you tell the
court why you are asking for custody?"

Benton had written his own version of her reply, a spin on Shylock's "If you prick us, do we not bleed?" speech from *The Merchant of Venice*:

JOANNA:

Because he's my child . . . Because I love him. I know I left my son, I know that's a terrible thing to do. Believe me, I have to live with that every day of my life. But just because I'm a woman, don't I have a right to the same hopes and dreams as a man? Don't I have a right to a life of my own? Is that so awful? Is my pain any less just because I'm a woman? Are my feelings any cheaper? I left my child—I know there is no excuse for that. But since then, I have gotten help. I have worked hard to become a whole human being. I don't think I should be punished for that. Billy's only six. He needs me. I'm not saying he doesn't need his father, but he needs me more. I'm his mother.

Benton wasn't happy with it. At the end of the second day of shooting—right after Dustin slapped her and goaded her in the elevator—the director had taken Meryl aside. "There's a speech you give in the court-room," he told her, "but I don't think it's a woman's

speech. I think it's a man trying to write a woman's speech." Would she take a crack at it? Meryl said yes. Then Benton walked home and promptly forgot he'd asked her.

Now, several weeks and many frayed nerves later, Meryl was handing the director a legal pad scrawled with her handwriting and telling him brightly, "I have the speech you told me to write." She had written it on the way back from Indiana, where she was visiting Don Gummer's parents.

Oh, why did I do that? Benton thought. He had no time for this. Now he'd have to overrule her. *I'm going to lose a friend. I'm going to lose a day of shooting. I'm going to maybe destroy a performance.*

Then he read the speech, and exhaled. It was wonderful—though about a quarter too long. Working fast, he and Meryl crossed out a few redundant lines, then had it typed up.

She took the stand in a tan blazer and a matching skirt, her hair in a ponytail flung over her left shoulder. As the cameras rolled, Meryl delivered her lines with the precarious certitude of a woman who'd rehearsed them carefully. Unlike Kate or Jill, or certainly Meryl, Joanna is always one inch from collapse, even as she reveals that her new salary as a sportswear designer is more than what Ted makes.

When it came time for the big speech, Meryl spoke the words she had written herself:

JOANNA:

Because he's my child . . . And because I love him. I know I left my son, I know that that's a terrible thing to do. Believe me, I have to live with that every day of my life. But in order to leave him, I had to believe that it was the only thing I could do. And that it was the best thing for him. I was incapable of functioning in that home, and I didn't know what the alternative was going to be. So I thought it was not best that I take him with me. However, I've since gotten some help, and I have worked very, very hard to become a whole human being. And I don't think I should be punished for that. And I don't think my little boy should be punished. Billy's only seven years old. He needs me. I'm not saying he doesn't need his father. But I really believe he needs me more. I was his mommy for five and a half years. And Ted took over that role for eighteen months. But I don't know how anybody can possibly believe that I have less of a stake in mothering that little boy than Mr. Kramer does. I'm his mother.

Tearily, she repeated, "I'm his *mother.*" But the word that slayed Benton was "mommy." "I could have never imagined writing that," he said. No longer the aloof tennis addict of Avery Corman's novel, Joanna now had a vivid inner life, full of yearning and tenderness and regret.

Benton filmed the speech in wide shot first, reminding Meryl to save her energy for the close-up. But she delivered it with "the same sense of richness" each time, even when the cameras turned on Dustin for his reaction. "Part of the pleasure she must have taken is showing to Dustin she didn't need to be slapped," the director said. "She could have delivered anything to anybody at any time."

They wrapped for the day. When they returned to Tweed Courthouse, it was to shoot one of the most wrenching scenes in the film: Joanna's cross-examination by Ted's lawyer, Shaunessy, played with cowboy-like bluster by Howard Duff. Benton had taken this sequence nearly word for word from the book, and its purpose was clear: to dismantle Joanna's tenuous self-esteem in a way that even Ted finds heartless.

Right away, Shaunessy badgers Joanna with questions: Did Mr. Kramer ever strike you? Was he unfaithful? Did he drink? How many lovers have you

had? Do you have one now? As Joanna begins to falter, he goes in for the kill. Hunching over her on his cane, he asks her to name the "longest personal relationship" of her life. Wasn't it with her ex-husband?

"Yes," she murmurs.

So, hadn't she failed at the most important relationship in her life?

"It did not succeed," she answers weakly.

"Not *it*, Mrs. Kramer," he bellows, sticking an accusatory finger in her face. "*You.* Were you a failure at the one most important relationship in your life? *Were you?*" It's at that moment we see the "whole human being" Joanna believes herself to be crumble before our eyes, trapped like a sea creature in a fisherman's net.

Before the take, Dustin had gone over to the witness stand to talk to Meryl. He needed her to implode on camera, and he knew the magic words to make it happen: "John Cazale." Out of Benton's earshot, he started whispering the name in her ear, planting the seeds of anguish as he had in the elevator scene. He knew she wasn't over the loss. That's why she'd gotten the part. Wasn't it?

Now, with a fat finger waving three inches from her face, Meryl heard the words "Were you a failure at the one most important relationship in your life?" Her eyes

watered. Her lips tensed. Dustin had instructed her to look at him when she heard that line. When she did, he gave a little shake of his head, as if to say, "No, Meryl, you weren't a failure."

Who exactly was up on the stand? Was it the actress who had stormed into the hotel room, guns blazing, telling three powerful men to rewrite their screenplay? Wasn't that who she had always been: self-assured, proficient at everything, the girl who could swim three lengths without taking a breath? Or was Dustin right? Was she "barely there," just like Joanna Kramer?

Since *Miss Julie*, acting was the one thing that had never failed her. She had willed herself through the wasp's nest of Yale Drama School. She'd done Constance Garnett in a wheelchair, Shakespeare in the rain, Tennessee Williams in a fat suit. She'd learned Hallelujah Lil on three days' notice. She'd danced the troika and done pratfalls. There was only one problem her talent hadn't been able to solve: it hadn't kept John alive.

Had she been a failure at the most important relationship of her life? The question wasn't a fair one, but it had been asked, and answered, by Dustin Hoffman. "No," he said, with a shake of his head.

As she sat on the witness stand, defending her life, was she thinking about John? Or was she acting *de-*

spite Dustin's meddling? By her own admission, the grief was still with her. "I didn't get over it," she said soon after. "I don't want to get over it. No matter what you do, the pain is always there in some recess of your mind, and it affects everything that happens afterwards. John's death is still very much with me. But, just as a child does, I think you can assimilate the pain and go on without making an obsession of it."

She had never believed that actors had to suffer. With almost alien precision, she could simulate any emotion she needed to. But if Meryl was now an emotional wreck playing an emotional wreck, could anyone (including her) really say whether she was faking it? Could she be "real" and a simulacrum at the exact same time?

When Benton saw Meryl glance to the side, he noticed Dustin shaking his head. "What was that? What was that?" the director said, bounding over to Dustin. Unwittingly, Dustin had created a new moment, one that Benton wanted in the scene. He turned the cameras around and had Meryl act the cross-examination again, this time recording Dustin's reactions. Now, the head shake meant something else. It was Ted Kramer telling Joanna Kramer, "No, you didn't fail as a wife. You didn't fail as a mother." Amid the rancor of the

court proceeding, it was a final gesture of the love they once had.

They filmed the remaining testimonies, and the court sequence was in the can. At one point between takes, Dustin went up to the actual court stenographer they'd hired to sit behind the typewriter.

"Is this what you do?" he asked. "Divorces?"

"Oh, I did them for years," the woman said, "but I burned out. I couldn't do it anymore. It was just too painful." She added cheerfully, "I really love what I'm doing now."

"What?" Dustin asked.

"Homicides."

On September 30, 1978, an Indian-summer day, Meryl Streep married Don Gummer. The Episcopal ceremony took place in the garden of her parents' home on Mason's Island, in front of about fifty guests. Don, who was still recuperating from the motorcycle accident, limped down the aisle on crutches. Some of the guests may have been forgiven for thinking, *Wait a second. Who is this guy?*

"I was worried at the time that it was a rebound thing," said Robyn Goodman, even though she'd encouraged it. Meryl and Don had been dating for just a

few months. How could she possibly be sure? Was she really over John? Did it matter?

Even the mother of the bride was a little confused. "What is she thinking about?" she asked Joe Papp at the wedding. Papp sensed some "strain" between mother and daughter, despite the appearance of good fellowship. *The Taming of the Shrew* had closed earlier in the month, and he could see that Meryl had "not recovered by any means" from John's death.

But he knew that she had a clear head, because he had seen how she worked. In a way, it all made sense: after everything that had happened, she was making her life stable again. "She does the right thing for herself at the moment," he said later. "She is a shrewd analyst of herself." The old leftist that he was, he observed that she was marrying "within her class."

Ten days later, at her mother's insistence, Meryl wrote to Joe and Gail Papp to thank them for the clock they'd given as a wedding gift. "What immense support you have provided throughout some insupportable times," she wrote to the couple who had once guided her and John through the medical maze. "You have been there at the bottom and top of things. We are all now in each other's lives indelibly, forever."

Some thirteen years later, as he was dying of prostate cancer, Papp began looking for a successor to run

the Public. His first choice was Meryl Streep. By then, she had three young children and lived in Connecticut, and hadn't been in a play for a decade. She said no right away, stunned that Joe would ever think her capable of all the schmoozing and the fund-raising. She kissed him goodbye and went back to Connecticut, feeling "unspeakably touched that he would choose me to be his successor, stupefied that he could misconceive me so thoroughly, and sad to realize that there was no one, *no one*, who could fill his shoes."

Robert Benton knew there was something wrong with the ending of *Kramer vs. Kramer* virtually the moment he shot it. He had toyed with the idea of closing the movie on a reunited Ted and Billy walking through Central Park. The camera pans out to reveal that they're just two out of thousands of parents and children enjoying a sunny afternoon in New York City.

But he realized early on that there were two stories embedded in the movie. One is Ted's relationship with Billy, which is resolved somewhere around the playground-accident scene, when Ted realizes that nothing in the world comes before his love for his son. The second story is about Ted and Joanna: After the brutality of the custody hearing, how can they ever be functioning coparents?

That's the conflict Benton needed to resolve in the final scene, which he set in the lobby of Ted's building. It's the day Joanna comes to take Billy, some time after she wins the custody battle. She buzzes up and asks Ted to come downstairs, where he finds her leaning against the wall in her trench coat. She tells him she isn't taking Billy after all.

JOANNA:

After I left . . . when I was in California, I began to think, what kind of mother was I that I could walk out on my own child. It got to where I couldn't tell anybody about Billy—I couldn't stand that look in their faces when I said he wasn't living with me. Finally it seemed like the most important thing in the world to come back here and prove to Billy and to me and to the world how much I loved him . . . And I did . . . And I won. Only . . . it was just another "should."

(she begins to break down)

Then Joanna asks if she can go upstairs and talk to Billy, and both parents get in the elevator. The picture ends with the doors closing on the Kramers, united as parents, if not as spouses.

They shot the scene in late 1978, in the lobby of a Manhattan apartment building. But as Benton pieced the film together, the ending didn't sit right. One problem was Joanna's reasoning. If she had really come back because of how people looked at her in California, that meant she was the same deluded narcissist of Avery's novel, not the ambivalent, vulnerable woman Meryl was playing. It was too much about *her*: her pride, her guilt, her endless search for self-actualization.

The second problem was the final shot in the elevator. It looked too much like Ted and Joanna were getting back together. This couldn't be a Hollywood ending, with the audience imagining the final kiss behind the elevator door. Benton wanted to leave no doubt: even if the Kramers were moving forward as parents, their marriage was definitively over.

Early in 1979, the director called back Dustin and Meryl for reshoots. Meryl had been rehearsing a new play at the Public called *Taken in Marriage*, an all-female ensemble piece by Thomas Babe. She had ended 1978 with a disappointment, playing the title character in Elizabeth Swados's musical adaptation of *Alice's Adventures in Wonderland*. The twenty-seven-year-old Swados was overwhelmed with her directing duties, and shortly before previews Papp scuttled the production. Instead, he offered a three-night concert

version over Christmas. Meryl played not only Alice but Humpty Dumpty and other denizens of Wonderland. "This is a mature actress who has reinvented herself as a magical, ageless child," the *Times* review said. "By the end of the concert we are convinced that Alice is tall, blond and lovely—just like Meryl Streep."

The lobby where Benton had filmed the first ending of *Kramer vs. Kramer* was unavailable, so the crew built a replica. It had been the cinematographer Néstor Almendros's idea to paint Billy's room with clouds around his bed. They would symbolize the cocoon of home and act as a reminder, like Justin Henry's flaxen hair, of the missing mother. In the rewritten ending, the clouds were the catalyst for Joanna's change of heart, which was no longer about her but about her son.

JOANNA:

I woke up this morning . . . kept thinking about
Billy. And I was thinking about him waking up in
his room with his little clouds all around that I
painted. And I thought I should have painted
clouds downtown, because . . . then he would
think that he was waking up at home. I came here
to take my son home. And I realized he already is
home.

Meryl delivered the speech with trembling certainty, inserting a fortifying gasp between "painted" and "clouds." It was Joanna, as Benton saw it, who now performed the film's ultimate heroic act: sacrificing custody not *despite* her love for Billy but *because* of it.

This time, Joanna got in the elevator alone. In the final moments, she wipes the tear-drenched mascara from her eyes and asks Ted how she looks. "Terrific," he says, as the door closes between them. Her wordless, split-second reaction was as richly textured as Dustin's stare at the end of *The Graduate*—both flattered and disbelieving, the face of someone who's been given just the right gift at just the right moment, by the most unlikely person. What does the future hold for this woman, dangling between fragility and conviction?

"This picture started out belonging to Ted Kramer, and by the end it belonged to both of them," Benton said. "And there was no way Dustin could shake her. No way he could do anything to shake her. She was just there, and she was an incredible force." When she told Dustin she planned on going back to the theater, he said, "You're never going back."

Something else had changed between the first ending and the second: this time, Meryl was pregnant. Not enough to show, but enough that Joanna's choice—a harbinger of Sophie's—suddenly seemed unconscio-

nable. She told Benton, "I could never have done this role now."

"This is the season of Meryl Streep," Mel Gussow wrote to his editor at the *New York Times Magazine* in the fall of 1978:

> On Dec. 14, "The Deer Hunter," her first starring movie, opens. Advance reports (I have not seen it yet) indicate that it is a powerhouse and an Academy Award contender—both the movie and her performance in it. She co-stars in this Vietnam period movie with Robert De Niro and the late John Cazale (her former love; she was recently married to someone else). Meryl also plays the title role in Liz Swados's "Alice in Wonderland," now in rehearsal at the Public Theater, and beginning previews Dec. 27. This fall she also filmed "Kramer Vs. Kramer," playing the female lead opposite Dustin Hoffman, as well as Woody Allen's "Manhattan."
>
> Before her "season," she was clearly the most interesting and original actress on the American stage. I say this having followed her career from its genesis at the Yale Repertory Theater, where she did everything from Strindberg to Christo-

pher Durang and Albert Innaurato. What makes her special is that before she became a lovely leading lady, she was already a versatile character actress. Her most notable Yale appearance was as an octogenarian, wheelchair-confined Constance Garnett in a Durang-Innaurato mad musical travesty of all arts and literature called "The Idiots Karamazov." Shall we be the first to do the complete Streep?

On November 13, 1979, a year after Mel Gussow's pitch, Meryl gave birth to a six-pound, fourteen-ounce baby boy, whom she and Don named Henry Wolfe Gummer. He was due on Halloween but arrived two weeks late, delivered by Caesarean section to avoid a breech birth. The father, *Variety* noted, was a "non-pro."

She had spent the final months of her pregnancy like a student cramming for a test, reading *The First Twelve Months of Life* and *Our Bodies, Ourselves.* But she still felt unprepared for motherhood. When she saw Don holding the newborn, it felt, she said, like "the most natural thing in the world." They brought the baby home, where Don had made him a nursery. To avoid confusion with the other Henrys in her family, she nicknamed him "Gippy."

Any journalist looking for the "complete Streep"— there were now many—would have to be prepared to pause the interview for breast-feeding. "My work has been very important," she told one of them, "because if you want a career, I feel that you have to build a foundation in your twenties. But we wanted to have a child because we felt that not enough people in our circle of friends were having children. Friends of mine from college, who are very accomplished, are delaying children until they are older because of their careers."

She had turned thirty that summer, during her second trimester. While they still had their freedom, she and Don took a cruise ship to France and spent two and a half months driving a rental car through Europe, stopping at the tiny towns between Paris and Florence. They got back for the premiere of *The Senator*, in August. At the insistence of Lew Wasserman, the chairman of Universal, Alan Alda had retitled it *The Seduction of Joe Tynan*, lest anyone assume that the adulterous "senator" was based on Wasserman's friend Ted Kennedy. The movie was a modest success, with cordial reviews. But the "season of Streep," which began with her Oscar nomination for *The Deer Hunter* and continued with the April release of *Manhattan*, was now in full swing.

Robert Benton spent the intervening months finishing *Kramer vs. Kramer* with his editor, Jerry Greenberg. It was beginning to feel less like a total disaster. (Too bad his wife had already canceled that ski trip.) In test screenings, he would stand in the back of the theater and watch the audience, taking note of every fidget and cough. Wondering how a divorce movie would play in middle America, he screened the film in Kansas City, Missouri. He was dismayed when he saw a man get up during a critical scene. How could anyone go to the bathroom *now*? He followed the man outside. Instead of going to the men's room, the guy stopped at a pay phone and called his babysitter to check on his child.

We're home free, Benton thought.

The film opened on December 19, 1979. As the producers had hoped, it was received less as a movie than as a cultural benchmark, a snapshot of the fractured American family, circa now. "Though the movie has no answers to the questions it raises, it recharges the debate by restating issues in new and disturbing terms, or perhaps in the oldest terms of all: through agonizingly ambiguous human truths," Frank Rich wrote in *Time*. From Vincent Canby, in the *Times*: "'Kramer vs. Kramer' is a Manhattan movie, yet it seems to speak for an entire generation of middle-class Ameri-

cans who came to maturity in the late 60's and early
70's, sophisticated in superficial ways but still expect-
ing the fulfillment of promises made in the more pious
Eisenhower era."

Avery Corman had not been involved in the film ad-
aptation of his novel. He was shown a rough cut, which
he found "tremendously powerful." (A colleague of his
remembered him being "pissed" that so many second-
ary characters had been cut.) Shortly after it opened,
Avery took his wife and two sons to a public screening,
at Loews Tower East on Seventy-second Street. He re-
called, "When the movie ended and the lights came on
and I looked around, gathered throughout the theater
were a bunch of teenagers sitting sort of silently, qui-
etly in their seats. They didn't get up to leave. They
were just sitting there. And I said to my wife, 'Oh, my
God. That's the secret audience for all of this: children
of divorce.'"

Indeed, the public greeted the film with open wal-
lets. On its opening weekend, it played in 524 theaters,
grossing more than $5.5 million. In the filmmaking
world that *Star Wars* had wrought, a chamber drama
about a failed marriage was no longer Hollywood's idea
of big money. But the U.S. gross of *Kramer vs. Kramer*
would total more than $106 million, making it the big-
gest domestic moneymaker of 1979—beating out even

Star Wars progeny like *Star Trek* and *Alien*, starring Meryl's former classmate Sigourney Weaver.

It was a movie people wept over and argued over, a well-made tearjerker about a father and son. Anyone who was or ever had a loving parent could relate to that story. But there was a trickier story lurking within— the shadow narrative of Joanna Kramer. In celebrating the bond between Ted and Billy, had the movie sold out not only her but the feminist movement? Some people seemed to think so. The *Washington Post*'s Gary Arnold found it "difficult to escape the conclusion that Dear Mrs. Kramer is a dim-witted victim of some of the sorriest cultural cant lately in vogue."

Leaving the theater with her fifteen-year-old daughter, the writer Barbara Grizzuti Harrison felt a trifle manipulated. Why do we applaud the noble self-sacrifice of Ted Kramer, she wondered, when the same thing is merely expected of women? How does Joanna land a reentry job for $31,000 a year? Why can't Ted seem to hire a babysitter? And what to make of Joanna's hazy quest for fulfillment? "I keep thinking of Joanna," Harrison wrote in *Ms.* magazine, the standard-bearer of mainstream feminism. "Is she outside howling at the gates of happiness, or is she satisfied with her job, her lover, and occasional visits to Billy. Who *is* Joanna, and did she spend those 18 months in California in vain?"

More and more journalists, not to mention the vast ticket-buying public, were asking themselves a related question: Who is Meryl Streep?

Here are a few things you might have been interested to know, if you were *Time* or *People* or *Vogue* or even *Ms.* magazine: Meryl Streep bought her dungarees on MacDougal Street. One of her favorite articles of clothing was a Hawaiian jacket she'd had since college. She was partial to pearl earrings and ate apple slices and took out the garbage herself. If you called her answering machine, you got a recorded message saying, "Hello . . . um . . . if you want to leave a message, please wait for the beep, because . . . um . . . I don't know . . . otherwise the thing cuts off. Thank you."

She loved visiting art galleries. She loved riding the subway. She thought that all politicians should ride the subway and be forced to confront the "reality of life." She was outspoken about male contraception, because too many of her female friends had fertility problems after using IUDs or the pill. She was looking, for the first time, for a lawyer and an accountant. Also, a part-time nanny. She preferred doing theater to movies, and she hoped one day to play Hamlet. Her dream was to put together an all-star Shakespeare troupe that would

perform in repertory across the country, with actors like Al Pacino and Robert De Niro and Mary Beth Hurt. Joe Papp would produce, and they would go to places "less glamorous than Gary." If not now, maybe when they were all fifty-five.

She did not always get what she wanted. She had put out her "feelers" for *Evita* on Broadway, because "charismatic leaders are very interesting," but she was pregnant and the part went to Patti LuPone. She was approached about a remake of *The Postman Always Rings Twice*, but it required nudity, and when she asked if Jack Nicholson would be willing to show the same amount of skin, the role went to Jessica Lange. She thought people who described French actresses as "mysterious" and "sexy" because they talked in a babyish whisper were "full of shit." She loved Bette Davis and Rosalind Russell and Lina Wertmüller and *Amarcord*. She admired Zero Mostel because he "put his life on the line for comedy." She hated parties—the most boring thing in the world was a night at Studio 54. She disapproved of the new "slink" in fashion, preferring the green cowboy boots her husband bought her for Christmas.

She was, various journalists suggested, one of the "anti-ingénues" who were now on the rise in Holly-

wood. She was like Faye Dunaway, but less vampy. Jane Fonda, but less self-satisfied. Jill Clayburgh, but less ingratiating. Diane Keaton, but less neurotic. She was a throwback to Katharine Hepburn or Carole Lombard. Her name sounded like the "cry of a bird." She looked like a "tapered candle" or a "Flemish master's angel." She was a dead ringer for Alesso Baldovinetti's *Portrait of a Lady in Yellow.* Her cheekbones were "exquisite." Her nose was "patrician." There wasn't even a word for her pale blue eyes—maybe "merulean"? She was "more than just a gorgeous face." She could make you "identify with Medea." She was living, by her own admission, a "Cinderella story." She evinced a "go with the flow" philosophy. She hated hot weather, which made her feel like cheese left in the sun. She had never been south of Alexandria, Virginia.

In truth, she had no idea why anyone should care where she bought her dungarees, or why her face should appear on the covers of *Parade, Playgirl,* and *Ladies' Home Journal.* The "excessive hype" mystified her at best and irritated her at worst. "For a while there it was either me or the Ayatollah on the covers of national magazines," she complained two years later, in a cover story for a national magazine (*Time*). Perhaps Brustein's admonitions about Hollywood "personalities"

still lingered, but she saw celebrity as an unwelcome side effect to her craft. Also, it was becoming harder and harder for her and Don to visit art galleries.

When the magazines came to call, she could be charming and self-effacing, but sometimes she was just impatient. For *Vogue*, she gamely did cheerleader splits for the photographer. But the writer who showed up at the loft couldn't help but feel intrusive as Meryl nursed the two-month-old Gippy while complaining into the tape recorder, "I think that the notion that you owe it to your public is kind of odd. Nobody else does that except elected officials, and I'm not elected, I never ran for anything . . . And it seems bizarre to think that I have to share the few private moments I have with other people."

She and Dustin did their best to qualify their on-set sparring, at least in front of journalists. But the results could sound passive-aggressive. "Dustin has a technician's thoroughness and he is very demanding, but it isn't the star temperament I'd been led to expect," she told the *Times*. "It isn't vanity. He is a perfectionist about the craft and the structuring of the film, and his own ego is subjugated to that." Dustin gave similarly tortured compliments. "I hated her guts," he said when the movie came out. "But I respected her. She's ulti-

mately not fighting for herself, but for the scene. She sticks with her guns and doesn't let anyone mess with her when she thinks she's right."

The press infatuation hit a crescendo the first week of 1980, when Meryl appeared on the cover of *Newsweek*. She wore her (by then) signature pearl earrings and a Mona Lisa smile, accompanied by big white letters: "A Star for the '80s." The article posited that Meryl Streep may well become "the first American woman since Jane Fonda to rival the power, versatility and impact of such male stars as Dustin Hoffman, Jack Nicholson, Robert De Niro and Al Pacino." She had not yet had a leading role in a movie, and already evoked the language of superlatives. When the *Time* cover followed, in 1981, she "didn't feel anything."

It seemed to her she had already passed the sweet spot, when she could focus solely on the pleasure of acting. When she started out, she would spend 80 percent of her time on headshots or auditions or résumés, and the other 20 percent on her work. Now it was again 80 percent on peripheral things, like talking to *Newsweek* and *Vogue*. Part of her wished she had remained a "middling successful actor," the kind nobody wants to know anything about. She was high on the homecoming float once again, flabbergasted by how thin the air was up there. Somehow it always came as a disap-

pointment, as if someone had put her there other than herself.

The star for the '80s spent the first moments of the eighties at a New Year's Eve party thrown by Woody Allen. The director, still at work on *Stardust Memories*, had taken over a ballet school on Seventy-fifth Street, and its rehearsal studios and winding marble staircase were now peopled with boldface names. On the second floor, Bianca Jagger leaned against a barre talking with Andy Warhol. One flight up, Kurt Vonnegut danced on a red disco floor with his wife, Jill Krementz, as George Plimpton and Jane Alexander watched from the sidelines. Gloria Vanderbilt came early; Mick Jagger came late. There were movie stars (Lauren Bacall, Bette Midler, Jill Clayburgh), literary grandees (Norman Mailer, Lillian Hellman, Arthur Miller). Ruth Gordon, of *Harold and Maude*, could be overheard saying, "I'm astonished that anybody *knows* this many people."

Earlier in the day, some teenagers had sneaked in, pretending to be with the caterers, and now wandered among the beau monde, eating appetizers. Much of the talk was about how the host, known for his shyness, was either courageous or masochistic to be throwing such a lavish affair. When the sentiment got back to

Woody, he deadpanned, "There is a lot of valiancy going around." Up in the dining room, Tom Brokaw fought through the crowd to talk to Meryl Streep, who had attended despite her apparent misgivings about the host. In a party where everybody was a somebody, she now made as big a ripple as the rest. Famousland may have been where she belonged, but she was already plotting her retreat.

She and Don had found a ninety-two-acre property in Dutchess County, which they bought for around $140,000. It was a furnished three-floor house, surrounded by five thousand Christmas trees. There was a free-standing garage that Don could turn into a studio, and they were talking about installing a windmill and a solar-power system and freeing themselves of utility companies completely. Mostly, they wanted a place where they could avoid the grime and noise of downtown Manhattan, not to mention the autograph-seekers. Before having Henry, Meryl would wander SoHo contemplating the interesting characters lurking behind each window. Now, for the first time, it seemed ugly. She had nowhere to bring the baby, and buying Tampax at the drug store made her self-conscious. They'd keep the apartment, of course, but in their wooded oasis they'd feel like homesteaders on a vast frontier. In the rush of fame, some self-protective instinct had kicked

in. She would need to draw the curtain to keep a part of herself small and quiet and private.

When the clocks struck midnight at the ballet school, Meryl Streep and practically every celebrity in New York said farewell to the seventies. People were already talking about a "new conservatism," which would penetrate not just politics but the movies. Some people saw it in Meryl's refined face and pearl earrings—"the Lady," as *Vogue* called her—but that was mostly a projection. In any case, the new conservatism couldn't have been much in evidence at Woody Allen's New Year's party: this was the man, after all, who in *Annie Hall* had affectionately described his city as the epicenter of "left-wing Communist Jewish homosexual pornographers."

In February, *Kramer vs. Kramer* was nominated for nine Academy Awards, including Best Picture (Stanley Jaffe, producer), Best Actor (Hoffman), Best Director (Benton), and Best Adapted Screenplay (Benton again). Eight-year-old Justin Henry, nominated for Best Supporting Actor, became the youngest Oscar nominee in history. And Meryl, along with Barbara Barrie (*Breaking Away*) and Candice Bergen (*Starting Over*), would compete for Best Supporting Actress against two of her costars: Jane Alexander from *Kramer vs. Kramer* and Mariel Hemingway from *Manhattan*.

There was no doubt now that Meryl could carry a leading role in a movie, and Sam Cohn set to work finding the right project—or projects. After *Manhattan* and *Kramer vs. Kramer*, she wanted to play anyone but another contemporary New Yorker. "Put me on the moon," she told Cohn; he got her as far as the end of a stone pier on the English Channel. By mid-February, she was contracted to star in *The French Lieutenant's Woman*, a costume drama based on the John Fowles novel, with a screenplay by Harold Pinter. It would begin shooting in Dorset in May. She would play two characters: a mysterious Victorian siren and the modern-day actress portraying her in a big-budget film.

At the same time, she was in contention for a screen adaptation of William Styron's novel *Sophie's Choice*, about a Polish Holocaust survivor living in Brooklyn. Landing the role would be a fight: the director, Alan J. Pakula, had a Czech actress in mind, and Meryl would beg him to reconsider. And as early as March, her name was being tossed around in connection with a project about the Oklahoma nuclear-plant worker Karen Silkwood. Nineteen-eighty had hardly begun, and her next three years of work were already mapped out—as was her niche as an accent-wielding tragedian. It would be

a long time before anyone thought of Meryl Streep as funny.

Meanwhile, *Kramer vs. Kramer* was cleaning up the awards season. At the Golden Globes, Meryl wore her white-silk wedding dress and began lactating during the ceremony. She accepted the award with one arm across her chest. The movie was now opening on screens around the world, from Sweden to Japan. On March 17th, it was shown at a special screening in London at the Odeon Leicester Square, for an audience that included Queen Elizabeth II and Prince Philip. Meryl flew over, along with Dustin Hoffman, Robert Benton, Stanley Jaffe, and Justin Henry. She wore a long white dress and a matching blazer with the collar turned up. As Liv Ullmann and Peter Sellers looked on, she held out a hand to Her Majesty, touching white glove to white glove. The queen leaned in to talk to Justin. Was this his first acting job?

"Yes," he told her.

The queen asked if the movie would make her cry.

"Yes," he replied. "My mom cried four times."

April 14, 1980. Outside the Dorothy Chandler Pavilion, the stars of the new decade arrived in style: Goldie Hawn, Richard Gere, Liza Minnelli, George

Hamilton. Among the movie gods was Meryl Streep, one of the only women not in sequins. She wore the same white dress she'd worn to meet the queen, minus the gloves.

Inside, she took her seat between her husband and Sally Field, nominated for Best Actress for *Norma Rae*. Henry Mancini, in a huge bow tie, opened the show by conducting the theme from *Star Trek*. Meryl applauded when the Academy president, Fay Kanin, spoke of the institution's "glorious heritage." She sat nervously through Johnny Carson's monologue, with zingers covering *The Muppet Movie*, Bo Derek's cornrows in *10*, the Iranian hostage crisis, Dolly Parton's chest ("Mammary vs. Mammary"), and the fact that three of the big films that year were about divorce. "It says something about our times when the only lasting relationship was the one in *La Cage aux Folles*," Carson joked. "Who says they're not writing good feminine roles anymore?"

Two gentlemen from Price Waterhouse, charged with guarding the envelopes, came onstage and took a bow. Then Jack Lemmon and Cloris Leachman came out to deliver the first award of the night: Best Supporting Actress.

When she heard her name, last among the nominees, Meryl rubbed her hands together and mumbled

something to herself. "And the winner is . . . ," Leach-man said, before handing the envelope to Lemmon.

"Thank you, my dear."

"You're welcome, my dear."

"Meryl Streep in *Kramer vs. Kramer.*"

The hall reverberated with Vivaldi's Mandolin Concerto in C Major, the movie's theme. As she hurried to the stage, she leaned over and kissed Dustin on the cheek. Then she glided up the stairs to the microphone and took hold of her first Academy Award.

"Holy mackerel," she began, glancing down at the statuette. Her tone was placid. "I'd like to thank Dustin Hoffman and Robert Benton, to whom I owe . . . this. Stanley Jaffe, for giving me the chance to play Joanna. And Jane Alexander, and Justin"—she blew a kiss— "for the love and support during this very, very delightful experience."

To the people in the audience, and to the millions watching at home, she seemed like a star fully hatched, a poised Venus on the half shell. Only she knew how unlikely the whole thing was: that "movie star" was her job description. It was another metamorphosis, like the one that had set her course a decade ago, as she stood amid the ersatz scent of lilacs as Miss Julie. That she had scaled the mountain of show business in ten

short years was merely a reflection of what Clint Atkinson knew then, and what Joe knew, and what John knew, and what perhaps even she knew: that Meryl Streep had it in her all along.

After one last "thank you very much," she held up the Oscar and headed left, before Jack Lemmon was kind enough to point her right.

Vivaldi played again for Best Adapted Screenplay, Best Director, and Best Actor. Dustin Hoffman, accepting his Oscar from Jane Fonda, reiterated his well-known contempt for award shows ("I've been critical of the Academy, and for reason"). Justin Henry lost to Melvyn Douglas (*Being There*), seventy-one years his senior, becoming so distraught that Christopher Reeve, a.k.a. Superman, had to be called over to console him. At the end of the night, Charlton Heston announced the winner for Best Picture: it was a *Kramer vs. Kramer* sweep.

In the moments after the ceremony, the *Kramer* winners were shown into a room of about a hundred reporters. "Well, the soap opera won," Dustin boomed as he walked in, anticipating their disdain. It was clear that this wouldn't be a typical glad-handing press conference, and the reporters were eager to match Dustin's feistiness. The columnist Rona Barrett remarked that

many women, particularly feminists, "feel this picture was a slap to them."

"That wasn't said at all," Dustin snapped back. "I can't stop people from feeling what they are feeling, but I don't think everyone feels that way."

As they argued, Meryl bounded onto the platform. "Here comes a feminist," she said. "I don't feel that's true at all." Having commandeered the stage, she continued, "I feel that the basis of feminism is something that has to do with liberating men *and* women from prescribed roles."

She could have said the same about acting—or at least her version of it, the kind she had fought so hard to achieve. She was no longer the college freshman who thought that feminism had to do with nice nails and clean hair. In fact, it was inseparable from her art, because both required radical acts of imagination. Like an actress stretching her versatility, Joanna Kramer had to imagine herself as someone other than a wife and a mother in order to become a "whole human being," however flawed. That may not have been apparent to Avery Corman, but it was to Meryl, and tonight's triumph seemed to underscore that she was right.

No longer would she have to sneak her character through the back door, the forgotten woman in the

screenplay. In the decade to come, she would bend the movies toward her, stretching her ability to reveal the wrinkles of consciousness as wide as the screen could allow. With the help of Sam Cohn, who remained her agent until 1991, she would command the kind of complicated female roles she had thought impossible in Hollywood: a Danish adventurer, a Washington grandee, a Depression-era wino, an Australian murder suspect. After 1981, she would all but give up theater, returning only for stints at the Delacorte. Part of the reason would be her children: three more after Henry, named Mamie, Grace, and Louisa, raised with nary a gap on her résumé. Her marriage to Don Gummer, which seemed almost impetuous at the time, would prove one of the most enduring in Hollywood.

In later years, she would voice her politics more firmly, urging Congress to revive the Equal Rights Amendment and describing Walt Disney as a "gender bigot" at the 2014 National Board of Review gala. She would note with dismay that of all her characters, men her age—Bill Clinton among them—always told her that their favorite was Linda, the pliant checkout girl from *The Deer Hunter*. No wonder she had taken the role with such trepidation; she knew how easily the world could turn a woman into an ingénue. It was a measure of how much times had changed, she said in

2010, that men had finally started mentioning another favorite character: Miranda Priestly, the power-fluent fashion editor from *The Devil Wears Prada*. "They relate to Miranda," she reasoned. "They wanted to date Linda."

For now, she stood in front of a room of reporters, Oscar in hand, with a simple declaration: "Here comes a feminist."

Someone asked her, "How does it feel?"

"Incomparable," she said. "I'm trying to hear your questions above my heartbeat." If she seemed composed, it was all an act. Earlier, as she wandered backstage after her acceptance speech, she had stopped in the ladies' room to catch her breath. Her head was spinning. Her heart was pounding. After a moment of solitude, she headed back out the door, ready to face the big Hollywood hoopla. "Hey," she heard a woman yell, "someone left an Oscar in here!" Somehow, in her tizzy, she had left the statuette on the bathroom floor.

Supporting Characters

ALAN ALDA—Actor best known for the long-running TV show *M*A*S*H*. Writer and star of *The Seduction of Joe Tynan*.

JANE ALEXANDER—Stage and screen actress and four-time Oscar nominee, for her roles in *The Great White Hope*, *All the President's Men*, *Kramer vs. Kramer*, and *Testament*.

CLINT ATKINSON—Streep's drama teacher at Vassar who directed her in *Miss Julie* and other plays. He died in 2002.

LINDA ATKINSON—Yale acting student, class of 1975.

BLANCHE BAKER—Streep's costar in *The Seduction of Joe Tynan* and *Holocaust*, for which she won an Emmy Award. Later played the title role in *Lolita* on Broadway.

ROBERT BENTON—Oscar-winning writer and director of *Kramer vs. Kramer.* Also known as the cowriter of *Bonnie and Clyde* and as the director of *The Late Show, Places in the Heart,* and *Nobody's Fool.*

MIKE BOOTH—Streep's high school boyfriend, with whom she corresponded from Vassar while he served in the Vietnam War.

ARVIN BROWN—Director of *27 Wagons Full of Cotton* and *A Memory of Two Mondays.* He was the longtime artistic director of the Long Wharf Theatre, in New Haven, Connecticut.

ROBERT BRUSTEIN—Dean of the Yale School of Drama from 1966 to 1979 and the founding director of the Yale Repertory Theatre. He later founded the American Repertory Theater, in Cambridge, Massachusetts.

STEPHEN CASALE—Brother of John Cazale. As a young man, he changed his last name from "Cazale" to its original Italian spelling.

PHILIP CASNOFF—Stage and television actor who dated Streep while she was at Yale.

JOHN CAZALE—Stage and screen actor best known as Fredo Corleone in *The Godfather* and *The Godfather: Part II.* His other films include *The Conversation, Dog Day Afternoon,* and *The Deer Hunter.* Costarred

with Streep in *Measure for Measure* in 1976 and dated her until his death, in 1978.

MICHAEL CIMINO—Oscar-winning director of *The Deer Hunter*. His other films include *Thunderbolt and Lightfoot*, *Year of the Dragon*, and *Heaven's Gate*, considered one of the most disastrous financial flops in movie history.

SAM COHN—Talent agent at ICM who represented Streep until 1991. His clients also included Bob Fosse, Woody Allen, Mike Nichols, Nora Ephron, Robert Benton, Paul Newman, and Whoopi Goldberg. He died in 2009.

AVERY CORMAN—Author of the novels *Kramer vs. Kramer*, *The Old Neighborhood*, and *Oh, God!*

MICHAEL DEELEY—Former president of EMI Films and producer of *The Deer Hunter*, *Blade Runner*, and *The Man Who Fell to Earth*.

CHRISTOPHER DURANG—Playwriting student, class of 1974, at Yale, where he cowrote *The Idiots Karamazov* with Albert Innaurato. His later plays include *Beyond Therapy*, *Sister Mary Ignatius Explains It All for You*, and the Tony-winning *Vanya and Sonia and Masha and Spike*.

MICHAEL FEINGOLD—First literary manager of the Yale Repertory Theatre, for which he adapted *Happy End*.

He began writing for the *Village Voice* in 1971 and was its chief theater critic from 1983 to 2013.

RICHARD FISCHOFF—Associate producer of *Kramer vs. Kramer.*

CONSTANCE GARNETT—British translator who lived from 1861 to 1946. She was one of the first English translators of Russian classics by Tolstoy, Dostoyevsky, and Chekhov.

ROBYN GOODMAN—Theater producer, former actress, and friend of John Cazale, through her late husband, Walter McGinn. She cofounded the theater company Second Stage in 1979.

JOE "GRIFO" GRIFASI—Yale acting student, class of 1975. He appeared with Streep onstage in *A Midsummer Night's Dream*, *A Memory of Two Mondays*, *Secret Service*, and *Happy End* and onscreen in *The Deer Hunter*, *Still of the Night*, and *Ironweed*.

DON GUMMER—Sculptor and husband of Meryl Streep.

HENRY WOLFE GUMMER—Son of Meryl Streep and Don Gummer, nicknamed "Gippy" as a baby. He is now an actor and musician.

MEL GUSSOW—Longtime theater critic and cultural reporter for the *New York Times*. He died in 2005.

TOM HAAS—Acting teacher at the Yale School of Drama. He later became the artistic director of the Indiana Repertory Theatre, and died in 1991.

J. ROY HELLAND—Streep's longtime hair stylist and makeup artist. In 2012, he won an Academy Award for *The Iron Lady*.

LILLIAN HELLMAN—Playwright whose works include *The Children's Hour, The Little Foxes*, and *Toys in the Attic*. Her memoir *Pentimento* was the source for *Julia*. She died in 1984.

JUSTIN HENRY—Former child actor who played Billy Kramer in *Kramer vs. Kramer*.

ISRAEL HOROVITZ—Playwright and director. John Cazale starred in his plays *The Indian Wants the Bronx* and *Line*.

MARY BETH HURT—Streep's costar in *Trelawny of the "Wells," Secret Service*, and *The Cherry Orchard*. Also known for the films *Interiors* and *The World According to Garp*.

ALBERT INNAURATO— Playwriting student, class of 1974, at Yale, where he cowrote *The Idiots Karamazov* with Christopher Durang. His later plays include *Gemini* and *Passione*.

STANLEY R. JAFFE—Producer of *Kramer vs. Kramer*. His later credits include *Fatal Attraction, The Accused*, and *School Ties*.

WALT JONES—Yale directing student, class of 1975. He later wrote and directed the Broadway production *The 1940's Radio Hour*.

RAÚL JULIÁ—Stage and screen actor who costarred with Streep in *The Cherry Orchard* and *The Taming of the Shrew*. Known to film audiences as Gomez in *The Addams Family*. He died in 1994.

PAULINE KAEL—Film critic for *The New Yorker*, who wrote for the magazine from 1968 to 1991. She died in 2001.

SHIRLEY KNIGHT—Actress best known for her Oscar-nominated roles in *The Dark at the Top of the Stairs* and *Sweet Bird of Youth*. Replaced by Streep in *Happy End*.

BOB LEVIN—Streep's college boyfriend when she was a Vassar student and he was the fullback for the Yale football team.

CHARLES "CHUCK" LEVIN—Yale acting student, class of 1974. Brother of Bob Levin.

ROBERT "BOBBY" LEWIS—Cofounder of the Actors Studio and original member of the Group Theatre. Later served as head of the acting and directing departments at the Yale School of Drama. He died in 1997.

ESTELLE LIEBLING—Influential singing coach who taught the adolescent Streep. She died in 1970.

JOHN LITHGOW—Streep's costar in *Trelawny of the "Wells," A Memory of Two Mondays*, and *Secret Service*. He was later Oscar-nominated for his roles in *The World According to Garp* and *Terms of Endearment*.

CHRISTOPHER LLOYD—Costarred with Streep in *The Possessed* and *A Midsummer Night's Dream* at Yale and in *Happy End* on Broadway. Best known for his roles in *Taxi, Back to the Future,* and *The Addams Family.*

WILLIAM IVEY LONG—Yale design student, class of 1975. As a Broadway costume designer, he won Tony Awards for *Nine, The Producers, Hairspray,* and others. In 2012, he was elected chair of the American Theatre Wing.

WALTER MCGINN—Actor and college friend of John Cazale. He was married to Robyn Goodman, and died in 1977.

KATE MCGREGOR-STEWART—Yale acting student, class of 1974.

ALLAN MILLER—Acting coach who directed Streep in *Major Barbara* at Yale.

MICHAEL MORIARTY—Stage and screen actor who co-starred with Streep in *The Playboy of Seville, Henry V,* and *Holocaust.* Later known for his role as Benjamin Stone in *Law & Order.*

GAIL MERRIFIELD PAPP—Widow of Joseph Papp and former head of the play-development department at the Public Theater.

JOSEPH PAPP—Founder of the New York Shakespeare Festival, Shakespeare in the Park, and the Public The-

ater, which was renamed the Joseph Papp Public Theater after his death, in 1991.

RALPH REDPATH—Yale acting student, class of 1975.

ALAN ROSENBERG—Yale acting student (dropped out). Later known for his roles on *Civil Wars*, *L.A. Law*, and *Cybill*. President of the Screen Actors Guild from 2005 to 2009.

JOHN SAVAGE—Screen actor who played Steven in *The Deer Hunter*. Also known for *Hair*, *The Onion Field*, and *Salvador*.

JERRY SCHATZBERG—Director of *The Seduction of Joe Tynan*. His other films include *The Panic in Needle Park*, *Scarecrow*, and *Honeysuckle Rose*.

ANDREI SERBAN—Romanian stage director who directed *The Cherry Orchard* and *Agamemnon* at Lincoln Center.

BARRY SPIKINGS—Film producer, formerly of British Lion and EMI Films, whose credits include *The Deer Hunter* and *Convoy*.

EVERT SPRINCHORN—Former head of Vassar College's Drama Department, now Professor Emeritus of Drama.

MARVIN STARKMAN—Filmmaker and friend of John Cazale, whom he directed in the short film *The American Way*.

HARRY STREEP, JR.—Father of Meryl Streep. He died in 2003.

HARRY STREEP III—Younger brother of Meryl Streep, known as "Third."

MARY WOLF WILKINSON STREEP—Mother of Meryl Streep. She died in 2001.

ELIZABETH SWADOS—Experimental theater composer whose musical *Alice in Concert* starred Streep in its various incarnations. Best known for *Runaways*, which ran on Broadway in 1978.

BRUCE THOMSON—Streep's boyfriend her senior year of high school.

ROSEMARIE TICHLER—Head of casting at the Public Theater from 1975 to 1991 and then its artistic producer until 2001.

RIP TORN—Costarred with Streep in *The Father* and *The Seduction of Joe Tynan*. Best known for his roles in *Payday*, *Cross Creek*, and *The Larry Sanders Show*.

DERIC WASHBURN—Screenwriter of *The Deer Hunter*.

WENDY WASSERSTEIN—Yale playwriting student, class of 1976. Her plays include *Uncommon Women and Others*, *The Sisters Rosensweig*, and the Pulitzer Prize– and Tony Award–winning *The Heidi Chronicles*. She died in 2006.

SAM WATERSTON—Streep and Cazale's costar in *Measure for Measure*. Later known for his roles in *The Killing Fields* and on *Law & Order* and *The Newsroom*.

SIGOURNEY WEAVER—Yale acting student, class of 1974, best known for her roles in *Alien, Working Girl, Gorillas in the Mist,* and *Avatar.* In 2013, she starred in Christopher Durang's Tony Award–winning *Vanya and Sonia and Masha and Spike.*

IRENE WORTH—Streep's costar in *The Cherry Orchard* and the winner of three Tony Awards, for *Tiny Alice, Sweet Bird of Youth,* and *Lost in Yonkers.* She died in 2002.

FRED ZINNEMANN—Director of *Julia;* best known for *High Noon, From Here to Eternity,* and *A Man for All Seasons.* He died in 1997.

Acknowledgments

My gratitude, first and foremost, belongs to my agent, David Kuhn, who all but commanded me to write this book, in that remarkable way he has of knowing what people have in them before they know it themselves. Thanks, as well, to Becky Sweren, for making sure I got it all done.

Thank you to my wonderful editor, Gail Winston, for her insight, her vision, and her endless class, and to everyone at HarperCollins, including Sofia Groopman, Beth Silfin, Martin Wilson, and Jonathan Burnham.

I would not have gotten anywhere without the generosity, of time and of spirit, of the many people I interviewed. Researching this book was a scavenger hunt that took me to all kinds of unexpected places, nudged

along by a motley crew of spirit guides. I am indebted to everyone who rooted through a box in the garage, dusted off an old photograph, or called forth an old memory (or many), just to help me piece it all together.

Thank you to the librarians and archivists at the Paley Center for Media (especially the indefatigable Jane Klain), the Robert B. Haas Family Arts Library at Yale University, the Harry Ransom Center at the University of Texas at Austin, the Howard Gotlieb Archival Research Center at Boston University, Kent State University Libraries, the Bernardsville Public Library Local History Collection, the Cleveland Public Library, the New Haven Free Public Library, the Adriance Memorial Library in Poughkeepsie, the Public Library of Steubenville and Jefferson County, the Margaret Herrick Library in Beverly Hills, and, especially, the New York Public Library for the Performing Arts. I would move in there if I could.

For permission to use material, thank you to Christopher Durang, Albert Innaurato, Christopher Lippincott, William Baker, Michael Booth, William Ivey Long, Paul Davis, Israel Horovitz, Robert Marx, Ann Gussow, Robert Brustein, the European American Music Corporation, and the Liveright Publishing Corporation.

For their encouragement, their wisdom, and their friendship, my deepest thanks to Natalia Payne, Laura Millendorf, Ben Rimalower and everyone from Theaterists, Jesse Oxfeld, Rachel Shukert, Shira Milikowsky, Deb Margolin, and the ingenious Dan Fishback. For advice, pep talks, and commiseration: Daniel Kurtz-Phelan, Christopher Heaney, Jason Zinoman, James Sanders, Michael Barbaro, and Sam Wasson, whose book *Fifth Avenue, 5 A.M.* I took around with me like a talisman. Thank you to my colleagues at *The New Yorker,* particularly Rhonda Sherman, Richard Brody, John Lahr, Rebecca Mead, Shauna Lyon, Paul Rudnick, Susan Morrison, and David Remnick. Thanks to Molly Mirhashem, for fact-checking, and Ed Cohen, for copy-editing. For various indispensable things, thanks to Frederik Ernst, Michael Feingold, Barbara De Dubovay, Richard Shepard, Candi Adams, Aimee Bell, and Leslee Dart.

Thank you, also, to Meryl Streep, for living a fascinating life, and for not throwing up any significant roadblocks.

Thank you to my endlessly supportive family: my father, Richard, my sister, Alissa, and my mother, Nancy, who also grew up in suburbia in the fifties, had long hair and loved folk music in the sixties, moved

to dirty old New York City in the seventies, juggled motherhood and a career in the eighties (and to this day), and painted clouds in my bedroom.

And, above all, my love and gratitude to Jaime Donate, who endured countless evenings of Streepiana. Everything I value most in our lives, you've given me.

Notes

In researching the early life and career of Meryl Streep, I was helped tremendously not only by the eighty-odd people who were kind enough to give me interviews but by the work of the journalists who had the privilege of interviewing her as an up-and-comer. Especially useful were Mel Gussow's notes and transcripts for his February 4, 1979, *New York Times Magazine* profile "The Rising Star of Meryl Streep," which are available in the Mel Gussow Collection at the Harry Ransom Center, the University of Texas at Austin, Series II, Container 144, abbreviated in the notes below as "MG."

I spent many happy afternoons at the New York Public Library for the Performing Arts, which is not only an exalting place to work but a trove of theater and film ephemera. Anyone wishing to see Meryl Streep in

27 Wagons Full of Cotton, A Memory of Two Mondays, or *The Taming of the Shrew* need only call up the Theatre on Film and Tape Archive and make an appointment. (Do it!) Particularly helpful were the New York Shakespeare Festival records in the Billy Rose Theatre Division, indicated below by "NYSF," followed by a box number. Materials found at the Robert B. Haas Family Arts Library at Yale University are abbreviated "HAAS."

PROLOGUE

3 "Do you agree": Catherine Kallon, "Meryl Streep in Lanvin—2012 Oscars," www.redcarpet-fashionawards.com, Feb. 27, 2012.

4 "Stiff legged and slow moving": A. O. Scott, "Polarizing Leader Fades into the Twilight," *New York Times,* Dec. 30, 2011.

4 "Do you ever get nervous": Full dialogue from Hollyscoop at https://www.youtube.com/watch?v=p72eu8tKlbM.

6 "Oh, I didn't have anything prepared": 60th Golden Globe Awards, Jan. 19, 2003.

7 "There are some days": 56th Primetime Emmy Awards, Sept. 19, 2004.

7 "I think I've worked with everybody": 64th Golden Globe Awards, Jan. 15, 2007.

7 "I didn't even buy a dress!": 15th Screen Actors Guild Awards, Jan. 25, 2009.

7 "Oh, my God. Oh, *come on*": Onstage remarks from the 84th Academy Awards, Feb. 26, 2012.

10 "Spare him, spare him!": William Shakespeare, *Measure for Measure*, Act II, Scene ii.

12 "It's like church for me": "Meryl Streep: Inside the Actors Studio," Bravo TV, Nov. 22, 1998.

13 "She has, as usual, put thought and effort": Pauline Kael, "The Current Cinema: Tootsie, Gandhi, and Sophie," *The New Yorker*, Dec. 27, 1982.

14 "Women . . . are better at acting": Commencement address delivered by Meryl Streep at Barnard College, May 17, 2010.

15 "I have come to the brink": From the private collection of Michael Booth.

MARY

17 On the first Saturday of November: "Miss Streep Is Crowned," *Bernardsville News*, Nov. 10, 1966.

18 "Streep has the clear-eyed blond handsomeness": Pauline Kael, "The Current Cinema: The God-

Bless-America Symphony," *The New Yorker*, Dec. 18, 1978.

20 "I was six": Commencement address delivered by Meryl Streep at Barnard College, May 17, 2010.

21 "I remember taking my mother's eyebrow pencil": Ibid.

21 Her mother's side was Quaker stock: Streep's lineage and her recollections of her father and grandparents are detailed in Henry Louis Gates, Jr., *Faces of America: How 12 Extraordinary People Discovered Their Pasts* (New York: New York University Press, 2010), 34–50.

22 "joie de vivre": *Good Morning America*, ABC, Aug. 3, 2009.

25 "special days": "Meryl Streep: Inside the Actors Studio," Bravo TV, Nov. 22, 1998.

26 "shooting out sparks": MG.

26 "pretty ghastly": Paul Gray, "A Mother Finds Herself," *Time*, Dec. 3, 1979.

26 "I didn't have what you'd call a happy childhood": Ibid.

27 Her father had studied with Franz Liszt: Biographical information about Estelle Liebling from Charlotte Greenspan's entry on Liebling in the Jewish Women's Archive Encyclopedia, www.jwa.org.

27 "There's room in the back!": "Meryl Streep: The *Fresh Air* Interview," National Public Radio, Feb. 6, 2012.

28 "Miss Liebling was very strict": Beverly Sills, *Beverly: An Autobiography* (Toronto: Bantam Books, 1987), 41.

28 "Cover! Cover! Cover!": Gerald Moore, "Beverly Sills," *Opera Magazine*, Dec., 2006.

29 *The Wings of the Dove*: Gray, "A Mother Finds Herself."

30 "Empathy . . . is at the heart": Commencement address delivered by Meryl Streep at Barnard College, May 17, 2010.

30 "tricky negotiation": Ibid.

30 "I worked harder on this characterization": Ibid.

31 "*Seventeen* magazine knockout": Gray, "A Mother Finds Herself."

31 "We felt like we were in a little shell": Debbie Bozack's quotations are from an author interview, Apr. 30, 2014.

33 "Just remember Biology": Streep gave her signed 1965 *Bernardian* yearbook to Michael Booth, and it remains in his possession.

34 Opinions, for now, took a backseat: "Meryl Streep: The *Fresh Air* Interview," Feb. 6, 2012.

34 she met Mike Booth: Booth's high school recollec-
tions are from an author interview, July 10, 2014,
and from his piece "Meryl & Me," *US*, Aug. 25,
1986.

38 "Songbird": "An Interview with Meryl Streep,"
The Charlie Rose Show, WNET, Nov. 5, 1999.

38 "Almost every day for the past two months": " . . .
And the Music Lingers On," *The Crimson*, Apr.,
1966.

39 "I thought about the singing part": Rosemarie
Tichler and Barry Jay Kaplan, *Actors at Work*
(New York: Faber and Faber, 2007), 290.

39 "I thought that if I looked pretty": Diane de
Dubovay, "Meryl Streep," *Ladies' Home Journal*,
March, 1980.

39 Barbra Streisand albums: "Meryl Streep: The
Fresh Air Interview," Feb. 6, 2012.

39 "Often success in one area": Commencement ad-
dress delivered by Meryl Streep at Barnard Col-
lege, May 17, 2010.

43 "I reached a point senior year": Ibid.

43 first plane ride: "Spotlight: Meryl Streep," *Seven-
teen*, Feb., 1977.

44 "Handsome quarterback of our football team":
Senior testimonials from *The Bernardian*, 1967.

45 Bennington College admissions office: Susan Dworkin, "Meryl Streep to the Rescue!," *Ms.*, Feb., 1979.

46 "a nice girl, pretty, athletic": Commencement address delivered by Meryl Streep at Vassar College, May 22, 1983.

JULIE

47 "successful in preparing young women": Elizabeth A. Daniels and Clyde Griffen, *Full Steam Ahead in Poughkeepsie: The Story of Coeducation at Vassar, 1966–1974* (Poughkeepsie: Vassar College, 2000), 18.

48 *Though we have had our chances*: Wendy Wasserstein, *Uncommon Women and Others* (New York: Dramatists Play Service, 1978), 36.

49 "I suppose this isn't a very impressive sentiment": Ibid., 21.

49 "On entering Vassar": Commencement address delivered by Meryl Streep at Vassar College, May 22, 1983.

50 The repertoire: This drawing, and Streep's letters from her freshman year, are from the private collection of Michael Booth.

52 "I made some very quick": Commencement address delivered by Meryl Streep at Barnard College, May 17, 2010.

52 Bob Levin, the fullback: Author interview with Bob Levin, Dec. 16, 2014. Kevin Rafferty's 2008 documentary *Harvard Beats Yale 29–29* tells the full story of the legendary 1968 football game.

53 "I remember when I was, like, a sophomore": "Meryl Streep: The *Fresh Air* Interview," National Public Radio, Feb. 6, 2012.

54 "Welcome, O life!": James Joyce, *A Portrait of the Artist as a Young Man* (New York: B. W. Huebsch, 1916), 299.

55 At two o'clock in the morning: Booth's recollections throughout are from an author interview, July 10, 2014.

59 By 1967, nearly two-thirds: This account of Vassar's transition to coeducation comes largely from Daniels and Griffen, *Full Steam Ahead in Poughkeepsie.*

60 "How unthinkable": Ibid., 29.

60 A survey in the spring: Ibid., 34–35.

62 "Vassar to Pursue Complete Coeducation": *Vassar Miscellany News,* Oct. 4, 1968.

62 "Vassar Men—Facing a Comic Doom": Susan Casteras, *Vassar Miscellany News,* Oct. 11, 1968.

62 "genuine sense of identity": Diane de Dubovay, "Meryl Streep," *Ladies' Home Journal*, March, 1980.

66 "Read *Miss Julie*": Susan Dworkin, "Meryl Streep to the Rescue!," *Ms.*, Feb., 1979.

67 "You can't do that!": Evert Sprinchorn's quotations are from an author interview, Apr. 7, 2014.

68 "Tonight she's wild again": From Evert Sprinchorn's translation, which was used in the Vassar College production. Collected in Robert Brustein, ed., *Strindberg: Selected Plays and Prose* (New York: Holt, Rinehart and Winston, 1964), 73.

68 lilac scent: Author interview with set designer C. Otis Sweezey, Sept. 26, 2014.

68 "She just seemed much more mature": Author interview with Judy Ringer, Apr. 12, 2014.

69 "I don't remember her having any particular investment in it": Author interview with Lee Devin, Apr. 7, 2014.

69 "It was a very serious play": "Meryl Streep: Inside the Actors Studio," Bravo TV, Nov. 22, 1998.

70 "She is the first neurotic": Michel Bouche, "Don't Miss 'Miss Julie' in Vassar Performance," *Poughkeepsie Journal*, Dec. 13, 1969.

70 "I loved my father": In Brustein, ed., *Strindberg: Selected Plays and Prose*, 99.

70 "modern characters, living in a transitional era": Ibid., 61.

71 "Being the only man": Daniels and Griffen, *Full Steam Ahead in Poughkeepsie*, 124–25.

72 "The men came my junior and senior years": Commencement address delivered by Meryl Streep at Vassar College, May 22, 1983.

73 "That was the Garden of Eden": In Brustein, ed., *Strindberg: Selected Plays and Prose*, 85.

76 "They really didn't want us here": Except where noted, Streep's recollections of Dartmouth come from Mark Bubriski, "From Vassar (to Hanover) to Hollywood: Meryl Streep's College Years," *The Dartmouth*, May 19, 2000.

76 Meryl's classmate Carol Dudley: Dudley's recollections are from an author interview, May 5, 2014.

77 "I got straight A's": Commencement address delivered by Meryl Streep at Vassar College, May 22, 1983.

78 "highly symbolic": MG.

78 "Living the Revolution": Commencement address delivered by Gloria Steinem at Vassar College, May 31, 1970.

79 "I don't even think that question is *valid*": *The Dartmouth*, May 19, 2000.

80 "Men of all degrees": George Lillo, *The London Merchant*, Act IV, Scene ii.

81 "Meryl Streep coos, connives, weeps": Debi Erb, "Meryl Streep Excels in 'London Merchant,'" *Miscellany News*, March 12, 1971.

82 "Even in production": Author interview with Philip LeStrange, May 21, 2014.

84 "I had never given it to anybody before": Author interview with Sondra Green, May 21, 2014.

85 "I'd never made myself cry": "Meryl Streep: Inside the Actors Studio," Nov. 22, 1998.

86 "You lackey! You shoeshine boy!": In Brustein, ed., *Strindberg: Selected Plays and Prose*, 95.

88 Meryl sang jazz standards: E-mail to author from Marj O'Neill-Butler, July 10, 2014.

88 Left to their own devices: Author interview with Peter Parnell, May 28, 2014.

89 "It was really quite idyllic": Author interview with Peter Maeck, May 22, 2014.

89 "dilettante group": MG.

90 "This just shows what kind of cross-section": Jack Kroll, "A Star for the '80s," *Newsweek*, Jan. 7, 1980.

90 "The quality of mercy": William Shakespeare, *The Merchant of Venice*, Act IV, Scene i.

91 "You want to provide for her?": Recalled by Levin, Dec. 16, 2014.

CONSTANCE

93 "I feel instinctively": Christopher Durang, "New Again: Sigourney Weaver," *Interview*, July, 1988.

94 "The first year sent me into therapy": Kate McGregor-Stewart's quotations are from an author interview, Feb. 10, 2014.

94 "They didn't take your strong points": Linda Atkinson's quotations are from an author interview, Jan. 22, 2014.

94 "When I was in drama school": Hilary de Vries, "Meryl Acts Up," *Los Angeles Times*, Sept. 9, 1990.

96 green pajama pants: Durang, "New Again: Sigourney Weaver."

96 "I'm sullen in the hallways": Author interview with Sigourney Weaver, June 9, 2015.

97 "I didn't know what was happening": William Ivey Long's quotations are from an author interview, Jan. 19, 2014.

98 "Every class at the drama school": Walt Jones's quotations, except where noted, are from an author interview, Jan. 30, 2014.

99 "It was all fans and flutterings": Author interview with Robert Brustein, Jan. 14, 2014.

99 "stagnant ponds": Robert Brustein, *Making Scenes: A Personal History of the Turbulent Years at Yale 1966–1979* (New York: Random House, 1981), 8.

99 "My plan was to transform the place": Ibid., 10.

100 "the liberal on a white horse": Author interview with Gordon Rogoff, Jan. 16, 2014.

100 "I wanted to develop an actor": Brustein, *Making Scenes*, 15.

100 "blasphemous ritual sacrifice": Ibid., 104.

101 "I had tried to be a mellow": Ibid., 90.

101 "You know the Sara Lee slogan": Thomas Meehan, "The Yale Faculty Makes the Scene," *New York Times Magazine*, Feb. 7, 1971.

102 official Drama School bulletin: Class schedules and descriptions can be found in the Yale Repertory Theatre and Yale School of Drama Ephemera Collection, HAAS, Box 16.

103 "The things that I honestly really think about": Rosemarie Tichler and Barry Jay Kaplan, *Actors at Work* (New York: Faber and Faber, 2007), 291.

104 "Tom Haas was Meryl's bane": Author interview with Robert Brustein, Jan. 14, 2014.

104 "one of the luminaries": Steve Rowe's quotations are from an author interview, Feb. 16, 2014.

106 "I was knocked out": Alan Rosenberg's quotations are from an author interview, March 10, 2014.

108 "She was more flexible": Ralph Redpath's quotations are from an author interview, Jan. 13, 2014.

110 "What do you mean, you dreadful man?": Jean-Claude van Itallie, trans., *Anton Chekhov's Three Sisters* (New York: Dramatists Play Service, 1979), 9.

111 "Center stage was a sofa": Michael Posnick's quotations are from an author interview, Jan. 16, 2014.

113 "He said that I was holding back my talent": Mel Gussow, "The Rising Star of Meryl Streep," *New York Times Magazine*, Feb. 4, 1979.

114 "Everyone was saying, 'They're awful' ": Albert Innaurato's quotations are from an author interview, Jan. 10, 2014.

114 "I knew this girl was obviously destined": Michael Feingold's quotations are from an author interview, Feb. 11, 2014.

114 "I took special note": Brustein, *Making Scenes*, 152.

115 "languorous sexual quality": MG.

115 "hardly ever visceral": Allan Miller's quotations are from an author interview, July 28, 2014.

116 "They expressed their vociferous": E-mail to author from Walt Jones, March 30, 2014.

116 "How come I'm sleeping with the director": Recalled by Miller, July 28, 2014.

118 "He delved into personal lives": MG.

118 "It was a bloodbath": Several other students remembered a "bloodbath" as well. Miller, for his part, had no memory of the evaluation and said that Streep was "a pleasure to work with."

120 "It's a curious sensation": Robert Brustein Collection, Howard Gotlieb Archival Research Center at Boston University, Box 34.

122 "rife with factionalism": Brustein, *Making Scenes*, 168.

123 "Every year, there'd be a coup d'état": Diana Maychick, *Meryl Streep: The Reluctant Superstar* (New York: St. Martin's Press, 1984), 37.

124 Cast as an old woman: Recalled by Jones, Jan. 30, 2014.

124 "We rehearsed it for a couple of weeks": David Rosenthal, "Meryl Streep Stepping In and Out of Roles," *Rolling Stone*, Oct. 15, 1981.

126 "deadly piranha": Brustein, *Making Scenes*, 240.

127 "Constance: *The Brothers Karamazov*": Christopher Durang and Albert Innaurato, *The Idiots Karamazov* (New York: Dramatists Play Service, 1981), 22.

128 "Have you ever *seen* Meryl be good?": Recalled by Christopher Durang, whose quotations, except where noted, are from an author interview, Sept. 26, 2014.

130 "had it in for Meryl": Rosenthal, "Meryl Streep Stepping In and Out of Roles."

131 "That was the most unpleasant thing": Recalled by Durang, Sept. 26, 2014.

131 *You may ask*: Durang and Innaurato, *The Idiots Karamazov*, 51.

133 "Meryl was totally disguised": Brustein, *Making Scenes*, 188.

133 Things came to a head: The events in this section were recalled by Rosenberg, March 10, 2014.

134 *The Limits to Growth*: Recalled by Streep in the interview tapes for Diane de Dubovay's March, 1980, profile in *Ladies' Home Journal*, provided to the author by the de Dubovay family.

134 "I later found out": Terry Curtis Fox, "Meryl Streep: Her 'I Can't Wait' Jumps Right Out at You," *Village Voice*, May 31, 1976.

138 mortifyingly unprofessional: Stephen Sondheim gives his perspective in his book *Finishing the Hat: Collected Lyrics (1954–1981) with Attendant Comments, Principles, Heresies, Grudges, Whines and Anecdotes* (New York: Knopf, 2010), 285–87. Brustein recalls his own frustrations and campus responses to *The Frogs* in *Making Scenes*, 178–82.

138 "The echo sometimes lasts": Aristophanes, Burt Shevelove, Stephen Sondheim, *The Frogs* (Chicago: Dramatic Publishing Co., 1975), 8.

138 "a splashy M-G-M epic": Mel Gussow, "Stage: 'Frogs' in a Pool," *New York Times*, May 23, 1974.

139 "How many plays about women": Brustein, *Making Scenes*, 218.

140 "I just can't get into all this chick stuff": Julie Salamon's excellent *Wendy and the Lost Boys: The Uncommon Life of Wendy Wasserstein* (New York: Penguin Press, 2011), 135.

141 "There was something about Wendy": Ibid., 126.

141 "She'll never pass you a poison apple": Wendy Wasserstein, *Bachelor Girls* (New York: Knopf, 1990), 78.

142 "To me she always seemed lonely": Salamon, *Wendy and the Lost Boys*, 177.

142 Summer Cabaret: Recollections of the Summer Cabaret from Walt Jones, Jan. 30, 2014.

144 "straight-out, unabashed performing": Gussow, "The Rising Star of Meryl Streep."

145 "If I were not protected": Ibid.

145 "I cut scene in Kraków": Recalled by Feingold, Feb. 11, 2014.

145 Elzbieta Czyzewska: Bruce Weber, "Elzbieta Czyzewska, 72, Polish Actress Unwelcome in Her Own Country, Dies," New York Times, June 18, 2010.

146 without the direction of Tom Haas: Haas became the artistic director of the Indiana Repertory Theatre. He died in 1991, after getting hit by a van while jogging.

147 "You can get out of my school!": Recalled by Atkinson, Jan. 22, 2014.

147 "She's supposed to be a whore": Recalled by Long, Jan. 19, 2014.

148 "You're limited, and it frees you": MG.

148 "The star role is the translator": Mel Gussow, "Play: 'Idiots Karamazov,' Zany Musical," New York Times, Nov. 11, 1974.

149 "distressing job": Brustein, Making Scenes, 190.

150 the red tie: Ibid., 198.

150 "More resistant": Recalled by Rowe, Feb. 16, 2014.

150 "the same cruel contempt": Brustein, *Making Scenes*, 199.

150 "You just want the *New York Times* to kiss your ass": Recalled by Redpath, Jan. 13, 2014.

151 "Torn scares everyone": Ira Hauptman's dramaturgical log for this production of *The Father* can be found in the Yale School of Drama Production Casebook Collection, HAAS, Box 1.

152 "The competition in the acting program": Andrea Stevens, "Getting Personal about Yale's Drama School," *New York Times*, Nov. 12, 2000.

152 "I'm under too much pressure": Ibid.

153 "Rip would never stand for it": Brustein, *Making Scenes*, 199.

153 "You're going to graduate in eleven weeks": Stevens, "Getting Personal about Yale's Drama School."

154 "surprise" and "disappointment": Brustein, *Making Scenes*, 192.

154 "Jealousy and meanness of spirit": Ibid., 191.

154 "Genghis Khan presiding": Ibid., 194.

155 "lovers want more rehearsal time": Robert Marx's dramaturgical log for *A Midsummer Night's Dream* can be found in the Yale School of Drama Production Casebook Collection, HAAS, Box 1.

157 "the culmination of everything": Brustein, *Making Scenes*, 201.

157 "The production falters a bit": Mel Gussow, "Stage: Haunting Shakespeare 'Dream,'" *New York Times*, May 15, 1975.

158 "That kind of grab-bag": Jack Kroll, "A Star for the '80s," *Newsweek*, Jan. 7, 1980.

158 "The Rep is home": Robert Brustein Collection, Howard Gotlieb Archival Research Center at Boston University, Box 8.

ISABELLA

161 "Unfortunately, the jobs selling gloves": Michael Lassell, "Waiting for That 'First Break,'" *New Haven Register*, July 13, 1975.

162 *I'm twenty-six*: Mel Gussow, "The Rising Star of Meryl Streep," *New York Times Magazine*, Feb. 4, 1979.

163 "Gawd, where's Meryl?": Susan Dworkin, "Meryl Streep to the Rescue!," *Ms.*, Feb., 1979.

163 "I want you to meet someone": Tichler's recollections are from Kenneth Turan and Joseph Papp, *Free For All: Joe Papp, The Public, and the Greatest Theater Story Ever Told* (New York: Doubleday, 2009), 363–64; and from an author interview, June 25, 2014.

164 "Off with the crown": William Shakespeare, *Henry VI, Part 3*, Act I, Scene iv.

164 "I grew up right here in Houston": Terrence McNally, *Whiskey: A One-Act Play* (New York: Dramatists Play Service, 1973), 48.

168 "Well, you can't make a *Hamlet*": Biographical information about Joseph Papp is drawn from Helen Epstein's indispensable *Joe Papp: An American Life* (Boston: Little, Brown, 1994). This quotation appears on p. 11.

168 "an irresponsible Commie": Ibid., 158.

169 "We seek blood-and-guts actors": Ibid., 167.

169 "He always felt under duress": Gail Papp's quotations are from an author interview, June 19, 2014.

170 "expansionist period": Epstein, *Joe Papp: An American Life*, 345.

171 "one of the lily white subscribers": Ibid., 296.

172 "should follow, to the closest detail": Arthur Wing Pinero, *Trelawny of the "Wells"* (Chicago: Dramatic Publishing Co., 1898), "A Direction to the Stage Manager."

173 "Tryout town, USA": The history of the Eugene O'Neill Theater Center is available at its website: www.theoneill.org.

173 "glossy enameled cinderblock": Grifasi's recollections of the summer of 1975 were delivered in a speech honoring Streep at the O'Neill's Monte Cristo Awards, held in New York City on Apr. 21, 2014.

174 "motley, idiosyncratic bunch": Jeffrey Sweet, *The O'Neill: The Transformation of Modern American Theater* (New Haven: Yale University Press, 2014); Foreword by Meryl Streep.

175 A "dull" achievement: Ibid.

176 She and Grifo borrowed a car: Grifasi's and Tichler's accounts differ slightly; Tichler remembers Streep getting stuck on a train.

176 *They're not going to hire me*: Rosemarie Tichler and Barry Jay Kaplan, *Actors at Work* (New York: Faber and Faber, 2007), 305.

177 "Ninety-five percent of actresses": Turan and Papp, *Free for All*, 363.

179 "I got three bills a month": Commencement address delivered by Meryl Streep at Vassar College, May 22, 1983.

180 "I thought that I had really failed": Mary Beth Hurt's quotations are from an author interview, July 16, 2014.

181 "The curvaceous, desperately subtle flirtation": Turan and Papp, *Free for All*, 364.

181 "a pale, wispy girl": John Lithgow, *Drama: An Actor's Education* (New York: Harper, 2011), 275–76.

183 "And from that moment": Tichler and Kaplan, *Actors at Work*, 305–6.

183 "Mr. Antoon has transposed": Clive Barnes, "The Stage: Papp Transplants Pinero's 'Trelawny,'" *New York Times*, Oct. 16, 1976.

183 "The lights are no sooner up": Walter Kerr, "'A Chorus Line' Soars, 'Trelawny' Falls Flat," *New York Times*, Oct. 26, 1975.

185 hunky *Playgirl* centerfolds: Dave Karger, "Oscars 2012: Love Story," *Entertainment Weekly*, March 2, 2012.

185 "Well, when *we* get to do movies": Recalled by J. Roy Helland at "Extreme Makeover," a panel discussion at the New Yorker Festival, held in New York on Oct. 11, 2014.

185 "He wasn't just a guy": Author interview with Jeffrey Jones, June 26, 2014.

186 "Forget about being a character actress": Terry Curtis Fox, "Meryl Streep: Her 'I Can't Wait' Jumps Right Out at You," *Village Voice*, May 31, 1976.

188 "As she made small talk": Lithgow, *Drama*, 277.

189 "She was so slim and blond": Arvin Brown's quotations are from an author interview, Apr. 8, 2014.

190 "I've lost m' white kid purse!": Tennessee Williams, *27 Wagons Full of Cotton: And Other Plays* (New York: New Directions, 1966), 3.

190 "a tall, well-upholstered": Julius Novick, "The Phoenix Rises—Again," *Village Voice*, Feb. 9, 1976.

194 "*Che brutta!*": "Meryl Streep: The *Fresh Air* Interview," National Public Radio, Feb. 6, 2012.

196 "What is it—love and Good-bye?": William Gillette, *Secret Service* (New York: Samuel French, 1898), 182.

196 "Those two plays at the Phoenix Theatre": Joan Juliet Buck, "More of a Woman," *Vogue*, June, 1980.

197 "profoundly uncomfortable": MG.

198 "What I thought was great about him": Epstein, *Joe Papp: An American Life*, 334.

200 "When I was at Yale": Fox, "Meryl Streep: Her 'I Can't Wait' Jumps Right Out at You."

201 "What infinite heart's-ease": William Shakespeare, *Henry V*, Act IV, Scene i.

202 "They had a whole group": Author interview with Tony Simotes, May 2, 2014.

203 "O, for a muse of fire": William Shakespeare, *Henry V*, Act I, Prologue.

203 "the first time I realized": Eric Grode, "The City's Stage, in Rain, Heat and Ribald Lines," *New York Times*, May 27, 2012.

203 "Michael Moriarty couldn't give two shits": Author interview with Gabriel Gribetz, Apr. 23, 2014.

204 "I envy the wealth": Thomas Lask, "Rudd, Meryl Streep, Actors to Hilt," *New York Times*, June 19, 1976.

204 Snaking counterclockwise: This description of the line comes from George Vecsey, "Waiting for Shakespeare," *New York Times*, July 16, 1976.

206 "Then, Isabel, live chaste": Shakespeare, *Measure for Measure*, Act II, Scene iv.

206 "The role is so beautiful": Judy Klemesrud, "From Yale Drama to 'Fanatic Nun,'" *New York Times*, Aug. 13, 1976.

207 "Men have *always* rejected Isabella . . . quite a scholar": Fox, "Meryl Streep: Her 'I Can't Wait' Jumps Right Out at You."

208 "I'll tell him yet": Shakespeare, *Measure for Measure*, Act II, Scene iv.

208 "It's ludicrous": Klemesrud, "From Yale Drama to 'Fanatic Nun.'"

209 "Plainly conceive, I love you": Shakespeare, *Measure for Measure*, Act II, Scene iv.

210 "It was their dynamic": Author interview with Judith Light, June 18, 2014.

210 "The physical attraction between them": Author interview with Michael Feingold, Feb. 11, 2014.

210 "We sense the sexual give-and-take": Mel Gussow, "Stage: A 'Measure' to Test the Mettle of Actors," *New York Times*, Aug. 13, 1976.

211 "I've been shot through with luck": Klemesrud, "From Yale Drama to 'Fanatic Nun.'"

FREDO

213 "We had a house up in the country": Marvin Starkman's quotations are from an author interview, Apr. 24, 2014.

213 "We got a color television": Robyn Goodman's quotations are from an author interview, June 5, 2014.

214 "We had to give him a key": Israel Horovitz's quotations are from an author interview, Apr. 17, 2014.

214 "You eat a meal with him": Richard Shepard, dir., *I Knew It Was You: Rediscovering John Cazale*, Oscilloscope Laboratories, 2010.

216 "There was an undercurrent of sadness": Stephen Casale's quotations are from an author interview, Apr. 2, 2014.

216 "I've always taken care of you, Fredo": Francis Ford Coppola, dir., *The Godfather: Part II*, Paramount Pictures, 1974.

218 "He was mad as hell": The details of Cazale's ancestry and childhood come from an author interview with Stephen Casale, Apr. 2, 2014, and from Clemente Manenti, "The Making of Americans," *Una Città*, Sept., 2011.

218 "Giovanni Cazale": John's brother, Stephen, changed his own name back to "Casale" in 1967.

221 "I'm going to Marvin's house": Recalled by Starkman, Apr. 24, 2014.

222 "You again": Recalled by Pacino in *I Knew It Was You* (Shepard, dir.).

223 "Everybody wants to be first, right?": Israel Horovitz, *Plays: 1* (London: Methuen Drama, 2006), 64.

224 "That's Fredo": *I Knew It Was You* (Shepard, dir.).

224 "The second son, Frederico": Mario Puzo, *The Godfather* (New York: Putnam, 1969), 17.

224 "In an Italian family": Francis Ford Coppola, director's commentary, *The Godfather: DVD Collection*, Paramount Pictures, 2001.

226 "the best bugger on the West Coast": Francis Ford Coppola, dir., *The Conversation*, Paramount Pictures, 1974.

227 "I know it was you, Fredo": *The Godfather: Part II* (Coppola, dir.).

228 "There is a kind of moral decay": Tim Lewis, "Icon: John Cazale," *British GQ*, Jan., 2010.

230 "You know what a No. 10 can is?": Recalled by Starkman, Apr. 24, 2014.

230 "It's yours": Sidney Lumet, director's commentary, *Dog Day Afternoon*, Warner Home Video, 2006.

231 "Wyoming": *Dog Day Afternoon*, Sidney Lumet (dir.), Warner Bros., 1975.

232 Papp had given Sam Waterston the choice: Author interview with Sam Waterston, June 26, 2015.

233 "These are Cubans": Author interview with Tony Simotes, May 2, 2014.

233 "He brought menacing": Author interview with Rosemarie Tichler, June 25, 2014.

234 "Never could the strumpet": William Shakespeare, *Measure for Measure*, Act II, Scene ii.

235 "Oh, man, I have met the greatest actress": *I Knew It Was You* (Shepard, dir.).

236 "He wasn't like anybody I'd ever met": Ibid.

236 "We would talk about the process": Ibid.

236 "He knows Italian": Recalled by Casale, Apr. 2, 2014.

238 "The jerk made everything mean something": Brock Brower, "Shakespeare's 'Shrew' with No Apologies," *New York Times*, Aug. 6, 1978.

238 "He took his time with stuff": *I Knew It Was You* (Shepard, dir.).

240 "She had an almost feral alertness": From Streep's tribute speech at "The 42nd AFI Life Achievement Award: A Tribute to Jane Fonda," held in Los Angeles on June 5, 2014.

240 "I admire Jane Fonda": Susan Dworkin, "Meryl Streep to the Rescue!," *Ms.*, Feb., 1979.

241 politics and Leon Trotsky: From Streep's tribute speech at "An Academy Salute to Vanessa Redgrave," held in London on Nov. 13, 2011.

241 On days off, she would hang out with John Glover: Author interview with John Glover, Apr. 7, 2015.

242 "Beautifully!": Joan Juliet Buck, "More of a Woman," *Vogue*, June, 1980.

242 "What do you mean, you couldn't find me?": Recalled by Starkman, Apr. 24, 2014.

242 *I've made a terrible mistake*: "Streep's Debut Turned Her Against Hollywood," *WENN*, Nov. 1, 2004.

242 "You can't do the classics": Helen Epstein, *Joe Papp: An American Life* (Boston: Little, Brown, 1994), 343.

244 "That's when you can really work": Terry Curtis Fox, "Meryl Streep: Her 'I Can't Wait' Jumps Right Out at You," *Village Voice*, May 31, 1976.

244 "something much lighter and closer": Andrei Serban's quotations, except where noted, are from an e-mail from Serban to the author on June 2, 2014.

244 "you could have taken away": Fox, "Meryl Streep: Her 'I Can't Wait' Jumps Right Out at You."

245 "Think about *The Cherry Orchard*": Diana Maychick, *Meryl Streep: The Reluctant Superstar* (New York: St. Martin's Press, 1984), 53.

246 "You're not fat!": Recalled by Michael Feingold, whose quotations are from an author interview, Feb. 11, 2014.

247 "I've never seen an angrier improvisation": Author interview with Mary Beth Hurt, July 16, 2014.

247 "Falling down *verrry verrry* funny": Mel Gussow, "The Rising Star of Meryl Streep," *New York Times Magazine*, Feb. 4, 1979.

248 "We are not interested in the truth": John Simon, "Deadly Revivals," *The New Leader*, March 14, 1977.

248 "It is a celebration of genius": Clive Barnes, "Stage: A 'Cherry Orchard' That Celebrates Genius," *New York Times*, Feb. 18, 1977.

248 "I think that if this horrifying production": The outraged letters are lovingly collected in NYSF, Box 2-56.

250 "She was like a centrifugal force": Robert Markowitz's quotations are from an author interview, Oct. 6, 2014.

250 "When I watched you in a game": *The Deadliest Season* (Robert Markowitz, dir.), CBS, March 16, 1977.

252 "I felt this production was a disaster": Author interview with Christopher Lloyd, June 28, 2014. More on this disaster-prone production can be found in Davi Napoleon, *Chelsea on the Edge* (Ames: Iowa State University Press, 1991), 212–16.

LINDA

256 "John Cazale was out most of the day": NYSF, Box 5-114.

256 "disturbing symptoms": Helen Epstein, *Joe Papp: An American Life* (Boston: Little, Brown, 1994), 4.

257 An Austrian-born septuagenarian: Ronald Sullivan, "Dr. William M. Hitzig, 78, Aided War Victims," *New York Times*, Aug. 30, 1983.

257 "some outrageous color like citron": Gail Papp's quotations are from an author interview, June 19, 2014.

258 "He checked us in": Epstein, *Joe Papp: An American Life*, 4.

259 "After tonight, Jamil Zakkai": NYSF, Box 5-114.

260 Manganaro's: Author interview with cast member Prudence Wright Holmes, June 17, 2014.

260 "She had a kind of a tough love": Author interview with Christopher Lloyd, June 28, 2014.

260 "Did you ever think of quitting smoking?": Author interview with Stephen Casale, Apr. 2, 2014.

261 "We're gonna get this thing!": Richard Shepard, dir., *I Knew It Was You: Rediscovering John Cazale*, Oscilloscope Laboratories, 2010.

261 *Surabaya Johnny, why'm I feeling so blue?*: Bertolt Brecht, lyrics; Kurt Weill, music; original German play by Dorothy Lane; book and lyrics adapted by Michael Feingold, *Happy End: A Melodrama with Songs* (New York: Samuel French, 1982), 59.

261 "No, I don't have enough confidence": Recalled by Holmes, June 17, 2014.

262 "When I'm kidding, I'm serious": Steve Garbarino, "Michael Cimino's Final Cut," *Vanity Fair*, March, 2002.

263 "like Michelangelo": Ibid.

263 Redeker had based it on a photo spread: This account of the origins of *The Deer Hunter* derives from an author interview with Quinn Redeker on Nov. 11, 2014, an author interview with Michael Deeley on Sept. 27, 2014, and Deeley's book *Blade Runners, Deer Hunters, and Blowing the Bloody Doors Off* (New York: Pegasus Books, 2009), 130–31.

265 "All I can possibly say": Author interview with Michael Deeley, Sept. 27, 2014.

265 "very guarded": Deric Washburn's quotations are from an author interview, Sept. 29, 2014.

266 "Well, Deric, it's fuck-off time": Peter Biskind, "The Vietnam Oscars," *Vanity Fair*, March, 2008.

266 "You know what that Russian roulette thing is?": Barry Spikings's recollections, except where noted, are from an author interview, Sept. 26, 2014.

267 "a fragile slip of a thing": Michael Cimino, *The Deer Hunter*, second draft written with Deric Washburn (Feb. 20, 1977), 12. Robert De Niro Papers, Harry Ransom Center, the University of Texas at Austin, Series I, Box 44.

267 EMI paid the asking price: Deeley, *Blade Runners, Deer Hunters, and Blowing the Bloody Doors Off*, 168–69.

268 "the forgotten person in the screenplay": Mel Gussow, "The Rising Star of Meryl Streep," *New York Times Magazine*, Feb. 4, 1979.

269 "hitting it big as some starlet": MG.

269 "They needed a girl": Susan Dworkin, "Meryl Streep to the Rescue!," *Ms.*, Feb., 1979.

269 "failed alpha male": Michael Cimino, director's commentary, *The Deer Hunter*, StudioCanal, 2006.

269 Finally, he came to Cimino: Jean Vallely, "Michael Cimino's Battle to Make a Great Movie," *Esquire*, Jan. 2–16, 1979.

270 "the morons at EMI": David Gregory, dir., *Realising "The Deer Hunter": An Interview with Michael Cimino*, Blue Underground, 2003.

270 "I told him he was crazy": Vallely, "Michael Cimino's Battle to Make a Great Movie."

271 The medical advice they received: Deeley, *Blade Runners, Deer Hunters, and Blowing the Bloody Doors Off*, 170.

271 *I'm getting out*: Vallely, "Michael Cimino's Battle to Make a Great Movie."

271 "absolute dreadful piece of shit": *Realising "The Deer Hunter"* (Gregory, dir.).

271 "He was sicker than we thought": *I Knew It Was You* (Shepard, dir.).

272 repeated the story decades later: As she does in *I Knew It Was You* (Shepard, dir.).

272 asked to sign an agreement: Recalled by John Savage, whose quotations, except where noted, are from an author interview, Sept. 19, 2014.

274 "Mingo Citizens Elated by Film": *Herald-Star* (Steubenville), July 6, 1977.

274 "Movie Makers Leave Cash": *Sunday Plain Dealer* (Cleveland), July 31, 1977.

274 "They say the nature of the scenes": Steve Weiss, "Mingo Gets Robbed—No Name in Lights," *Herald-Star*, July 1, 1977.

275 Weisberger's clothing store: Dolly Zimber, "Mingo Citizens Elated by Film," *Herald-Star*, July 6, 1977.

275 "Linda is essentially a man's view": Roger Copeland, "A Vietnam Movie That Does Not Knock America," *New York Times*, Aug. 7, 1977.

278 Olga Gaydos: Interview with Olga Gaydos, The Cleveland Memory Project, Cleveland State University Libraries, www.clevelandmemory.org.

278 "That's enough": Recalled by Mary Ann Haenel, whose quotations are from an author interview, Sept. 21, 2014.

278 "Being in a movie was like the smallest part": *I Knew It Was You* (Shepard, dir.).

279 Outside Lemko Hall: Chris Colombi, "Where's the Glamour?," *Plain Dealer* (Cleveland), Dec. 9, 1977.

279 They were paid twenty-five dollars: Donna Chernin, "Clevelander Finds Extras for Film-Shooting Here," *Plain Dealer*, July 22, 1977.

279 "Michael, everybody brought a gift!": Cimino, director's commentary, *The Deer Hunter*.

280 Cimino said that his uncle: Ibid.

281 "I thought of all the girls": Dworkin, "Meryl Streep to the Rescue!"

281 "stockpiled": Commencement address delivered by Meryl Streep at Barnard College, May 17, 2010.

282 how to kill a fly: Recalled by Haenel, Sept. 21, 2014.

282 "It was such a beautiful wedding": Cimino, director's commentary, *The Deer Hunter*.

283 "This is this": Michael Cimino (dir.), *The Deer Hunter*, Columbia-EMI-Warner/Universal Pictures, 1978.

284 "some strange prefiguration": Cimino's account of shooting in the mountains is from his director's commentary for *The Deer Hunter*.

286 "unrelentingly Austrian": Dworkin, "Meryl Streep to the Rescue!"

286 "I've had to do things": Marvin J. Chomsky, dir., *Holocaust*, NBC, 1978.

287 "extraordinarily beautiful and oppressive": NYSF, Box 1-160. The front of the postcard is a photo of the Johann Strauss Monument.

287 "too much for me": Dworkin, "Meryl Streep to the Rescue!"

288 she was in prison: Paul Gray, "A Mother Finds Herself," *Time*, Dec. 3, 1979.

288 "She may have made associations": Marvin Chomsky's quotations are from an author interview, Nov. 6, 2014.

288 "The reason was that we felt so awful": Jane Hall, "From Homecoming Queen to 'Holocaust,'" *TV Guide*, June 24, 1978.

288 Blanche Baker, the twenty-year-old: Author interview with Blanche Baker, Oct. 9, 2014.

289 "that damn eiderdown": Brock Brower, "Shakespeare's 'Shrew' with No Apologies," *New York Times*, Aug. 6, 1978.

290 "It was not a side of her": Author interview with Albert Innaurato, Jan. 10, 2014.

290 "One that I hope to keep seeing": William G. Cahan, M.D., *No Stranger to Tears: A Surgeon's Story* (New York: Random House, 1992), 264.

290 "My beau is terribly ill": Undated letter, Robert Lewis Papers, Kent State University Libraries, Special Collections and Archives, Sub-Series 3B, Box 33.

291 "I was so close": Diane de Dubovay, "Meryl Streep," *Ladies' Home Journal*, March, 1980.

291 "snow emergency": Andy Newman, "A Couple of Weeks Without Parking Rules? Try a Couple Months," www.nytimes.com, Jan. 7, 2011.

292 "smelled to high heaven": Cimino, director's commentary, *The Deer Hunter*.

293 Mid-shoot, he summoned Spikings: Unpublished recollections by Barry Spikings, provided to author.

293 "We'll do it": Ibid.

294 "We're not in the fucking movie!": Biskind, "The Vietnam Oscars."

296 "pretty fucking amazing": Wendy Wasserstein, *Uncommon Women and Others* (New York: Dramatists Play Service, 1978), 33.

297 Her air of confidence: Recalled by Steven Robman, whose quotations are from an author interview, Dec. 21, 2014.

297 "Steve, do we have a camera": Author interview with Ellen Parker, Dec. 3, 2014.

298 "He's not doing so good": Gussow, "The Rising Star of Meryl Streep."

298 Warner "Let's go to the videotape!" Wolf: Brower, "Shakespeare's 'Shrew' with No Apologies."

299 "She took care of him": MG.

299 "When I saw that girl": *I Knew It Was You* (Shepard, dir.).

299 "It's all right, Meryl": This story was told by Israel Horovitz in Tim Lewis, "Icon: John Cazale," *British GQ*, Jan., 2010, as well as to the author by another of Cazale's friends.

300 "negotiate the stairs": Epstein, *Joe Papp: An American Life*, 4.

300 "John Cazale happens once in a lifetime": Israel Horovitz, "A Eulogy: John Cazale (1936–1978)," *Village Voice*, March 27, 1978. Used by permission of Israel Horovitz.

301 "emotionally blitzed": Gray, "A Mother Finds Herself."

301 she drew sketches: Epstein, *Joe Papp: An American Life*, 4.

302 "deceitful" and "selfish": Deeley, *Blade Runners, Deer Hunters, and Blowing the Bloody Doors Off*, 178.

302 "That's it! We lost the audience!": *Realising "The Deer Hunter"* (Gregory, dir.).

302 "The Deer Hunter and the Hunter and the Hunter": Biskind, "The Vietnam Oscars."

302 "I told them I would do everything I could": Vallely, "Michael Cimino's Battle to Make a Great Movie."

303 he bribed the projectionist: *Realising "The Deer Hunter"* (Gregory, dir.). Barry Spikings said of this story, "I would describe that as artistic liberty."

303 She always shielded her eyes: MG.

304 One Sunday morning: Recalled by Casale, Apr. 2, 2014.

304 "I don't want to stop replaying the past": Hall, "From Homecoming Queen to 'Holocaust.'"

305 "When I want something, I go git it": Jerry Schatzberg, dir., *The Seduction of Joe Tynan*, Universal Pictures, 1979.

305 "modern woman": MG.

305 Campaigning for the ERA: Howard Kissel, "The Equal Opportunity Politics of Alan Alda," *Chicago Tribune*, Aug. 12, 1979.

305 He could sense the sadness: Jerry Schatzberg's quotations are from an author interview, Oct. 6, 2014.

306 "I did that film on automatic pilot": Dworkin, "Meryl Streep to the Rescue!"

306 "Oh," she responded: Recalled by Schatzberg, Oct. 6, 2014.

306 "It's there": Recalled by Baker, Oct. 9, 2014.

307 "I'm actually his lawyer": Karen Hosler, "Tinseltown Entourage Reveals Star-Struck City," *Baltimore Sun*, May 7, 1978.

307 "Anytime he wants to change *his* dialogue": Recalled by Schatzberg, Oct. 6, 2014.

307 "a more lovely, more understanding person": Dworkin, "Meryl Streep to the Rescue!"

308 "It's a scene that demands": Jack Kroll, "A Star for the '80s," *Newsweek*, Jan. 7, 1980.

308 "It's true, things *do* contract in the cold!": *The Seduction of Joe Tynan* (Schatzberg, dir.).

308 "She looked at the movie": Kroll, "A Star for the '80s."

309 "untrue, offensive, cheap": Elie Wiesel, "Trivializing the Holocaust: Semi-Fact and Semi-Fiction," *New York Times*, Apr. 16, 1978.

309 "Errol Flynn heroics": Joseph Papp, "The 'Holocaust' Controversy Continues," *New York Times*, Apr. 30, 1978.

309 In Germany: Nicholas Kulish and Souad Mekhennet, "How Meryl Streep Helped the Nazi Hunters," www.salon.com, May 9, 2014, from their book *The Eternal Nazi: From Mauthausen to Cairo, the Relentless Pursuit of SS Doctor Aribert Heim* (New York: Doubleday, 2014).

310 Wandering Annapolis: Hosler, "Tinseltown Entourage Reveals Star-Struck City."

310 *"Hey, Holocaust!"*: Scot Haller, "Star Treks," *Horizon*, Aug., 1978.

310 "I wish I could assign": MG.

311 The day after the Emmys: Tony Scherman, " 'Holocaust' Survivor Shoots 'Deer Hunter,' Shuns Fame," *Feature*, Feb., 1979.

311 "a big, awkward, crazily ambitious": Vincent Canby, "Blue-Collar Epic," *New York Times*, Dec. 15, 1978.

311 "Like the Viet Nam War itself": Frank Rich, "Cinema: In Hell Without a Map," *Time*, Dec. 18, 1978.

311 "the mystic bond of male comradeship": Pauline Kael, "The Current Cinema: The God-Bless-America Symphony," *The New Yorker*, Dec. 18, 1978.

314 "fighting a phantom": Leticia Kent, "Ready for Vietnam? A Talk with Michael Cimino," *New York Times*, Dec. 10, 1978. Cimino's later dealings with the press seem to have wounded him; he declined an interview for this book via his associate Joann Carelli, who said, "You can thank your peers for this response."

314 "He was no more a medic": Biskind, "The Vietnam Oscars."

315 "The political and moral issues": Tom Buckley, "Hollywood's War," *Harper's*, Apr. 1979.

315 Jan Scruggs, a former infantry corporal: Mary Vespa and Pat Gallagher, "His Dream Was to Heal a Nation with the Vietnam Memorial, but Jan Scruggs's Healing Isn't Over Yet," *People*, May 30, 1988.

316 One veteran who agreed: Michael Booth's recollections are from an author interview, July 10, 2014.

318 "I wanted something my mother": Bettijane Levine and Timothy Hawkins, "Oscar: Puttin' on the Glitz," *Los Angeles Times*, Apr. 6, 1979.

318 She even took a dip: Janet Maslin, "At the Movies: Meryl Streep Pauses for Family Matters," *New York Times*, Aug. 24, 1979.

319 thirteen people had been arrested: Aljean Harmetz, "Oscar-Winning 'Deer Hunter' Is Under Attack as 'Racist' Film," *New York Times*, Apr. 26, 1979.

319 "not endorsing anything": Lance Morrow, "Viet Nam Comes Home," *Time*, Apr. 23, 1979.

319 "It shows the value of people": Gussow, "The Rising Star of Meryl Streep."

319 "I see a lot of new faces": Onstage remarks from the 51st Academy Awards, Apr. 9, 1979.

320 "respectful but well short of thunderous": Charles Champlin, " 'Deer Hunter'—A Life of Its Own," *Los Angeles Times*, Apr. 11, 1979.

320 "racist, Pentagon version of the war": Morrow, "Viet Nam Comes Home." Cimino relates his elevator encounter with Fonda in his director's commentary for *The Deer Hunter.*

JOANNA

325 "We just assumed": Robyn Goodman's quotations are from an author interview, June 5, 2014.

326 "international art center": Grace Glueck, "Art People: The Name's Only SoSo, But Loft-Rich TriBeCa Is Getting the Action," *New York Times*, Apr. 30, 1976.

328 Left alone, she started to wonder: The story of the apartment is recounted in Diane de Dubovay, "Meryl Streep," *Ladies' Home Journal*, March, 1980.

328 "If you're going to be an artist": Donor Highlight, "Don Gummer," Herron School of Art + Design, www.herron.iupui.edu.

329 He was born in Louisville: Biographical information about Don Gummer comes from Irving Sandler, "Deconstructive Constructivist," *Art in America*, Jan., 2005.

331 Tatami floor mats: Gallery label, *Nara and Lana*, Indianapolis Museum of Art, www.imamuseum.org.

331 "I think he's trying to say something": Recalled by Goodman, June 5, 2014.

333 "greedy for work": Michael Arick, dir., *Finding the Truth: The Making of "Kramer vs. Kramer,"* Columbia TriStar Home Video, 2001.

334 "Sam gets away with more": Mark Singer, "Dealmaker," *The New Yorker*, Jan. 11, 1982. Many more wonderful details about Sam Cohn lie therein.

334 "a confident staccato": Ibid.

335 "We had a rolling list": Susan Anderson's quotations are from an author interview, Oct. 6, 2014.

336 "It was never one on one": Arlene Donovan's quotations are from an author interview, Sept. 22, 2014.

338 Avery got suspicious: The details of Avery Corman's childhood are recounted in his book *My Old Neighborhood Remembered: A Memoir* (Fort Lee: Barricade Books, 2014), 5–6, 80–86.

Otherwise, Corman's recollections are from an author interview, Sept. 30, 2014.

341 "a striking, slender woman": Avery Corman, *Kramer vs. Kramer* (New York: Random House, 1977), 6.

342 "Feminists will applaud me": Ibid., 44.

342 "linked to his nervous system": Ibid., 161.

343 "That was my main concern": Judy Klemesrud, "Avery Corman on His Latest Book: A Father's Love Note to His Family," *New York Times*, Oct. 21, 1977. Judy Corman later became the head publicist for Scholastic, Inc., where she oversaw the publicity launch for several *Harry Potter* books. She died in 2004.

343 In 1975, divorces in the United States: Keith Love, "For First Time in U.S., Divorces Pass 1 Million," *New York Times*, Feb. 18, 1976.

344 "range, depth, and complexity of feeling": Richard Fischoff's quotations are from an author interview, Nov. 9, 2014.

345 *How am I going to do this?*: Robert Benton's quotations, except where noted, are from an author interview, Oct. 15, 2014.

346 She wanted to pursue her acting and dancing career: Tony Schwartz, "Dustin Hoffman Vs.

Nearly Everybody," *New York Times*, Dec. 16, 1979.

346 "I was getting divorced": Stuart Kemp, "Dustin Hoffman Breaks Down While Recounting His Past Movie Choices," *Hollywood Reporter*, Oct. 16, 2012.

347 "It was almost like group therapy": *Finding the Truth* (Arick, dir.).

347 "what makes divorce so painful": Ibid.

348 "irksome, brawling scold": William Shakespeare, *The Taming of the Shrew*, Act I, Scene ii.

349 "I am ashamed": Ibid., Act V, Scene ii.

349 "She swings as sweetly": Brock Brower, "Shakespeare's 'Shrew' with No Apologies," *New York Times*, Aug. 6, 1978.

349 When she first met Raúl: Eric Pace, "Raul Julia Is Remembered, with All His Panache," *New York Times*, Nov. 7, 1994.

349 "The girl is an *acting factory!*": Author interview with cast member George Guidall, Dec. 12, 2014.

350 "He wants her spirit": Germaine Greer, *The Female Eunuch* (New York: McGraw-Hill, 1971), 206.

350 "Feminists tend to see this play": Brower, "Shakespeare's 'Shrew' with No Apologies." She was

paraphrasing Greer, who writes, in *The Female Eunuch* (206), "Kate's speech at the close of the play is the greatest defense of Christian monogamy ever written. It rests upon the role of a husband as protector and friend, and it is valid because Kate has a man who is capable of being both, for Petruchio is both gentle and strong (it is a vile distortion of the play to have him strike her ever)."

352 "She's learned how to look": Jack Kroll, "A Star for the '80s," *Newsweek*, Jan. 7, 1980.

353 *What an obnoxious pig*: Ronald Bergan, *Dustin Hoffman* (London: Virgin, 1991), 137.

353 "an ogre, a princess": Stephen M. Silverman, "Life Without Mother," *American Film*, July–Aug., 1979.

354 "She never opened her mouth": *Dustin Hoffman: Private Sessions*, A&E, Dec. 21, 2008.

356 "funny-looking kid": *Finding the Truth* (Arick, dir.).

357 "All my friends at one point": Susan Dworkin, "Meryl Streep to the Rescue!," *Ms.*, Feb., 1979.

357 "dilemma of how to be a woman": MG.

357 Part of her wished: Ibid.

357 "The more I thought about it": Kroll, "A Star for the '80s."

358 While brushing her teeth one morning: MG.

358 "I did *Kramer vs. Kramer* before I had children": Ken Burns, "Meryl Streep," *USA Weekend*, Dec. 1, 2002.

359 "My character wouldn't live": Recalled by Fischoff, Nov. 9, 2014.

360 Dustin slapped her hard: As told by Streep on *Friday Night with Jonathan Ross*, BBC One, July 4, 2008, and recalled by Fischoff and Benton.

360 "Don't make me go in there!": Robert Benton, dir., *Kramer vs. Kramer*, Columbia Pictures, 1979.

362 "very, very lucky": Juliet Taylor's quotations are from an author interview, Nov. 17, 2014.

362 "more of an authors' idea": E-mail to author from Marshall Brickman, Nov. 6, 2014.

363 "I think he just hated my character": Rachel Abramowitz, "Streep Fighter," *Premiere*, June, 1997.

363 "Woody would say": *Finding the Truth* (Arick, dir.).

363 "Let's pretend that we've just made passionate love": Recalled by Karen Ludwig in an author interview, Oct. 16, 2014.

364 "I don't think Woody Allen even remembers me": de Dubovay, "Meryl Streep."

365 "On a certain level": Ibid.

366 "You're an actor, then": Recalled by Hoffman in *Finding the Truth* (Arick, dir.).

367 "artistic differences": Clarke Taylor, " 'Kramer': Love on the Set," *Los Angeles Times*, Nov. 12, 1978.

367 She was taken aback: Author interview with Jane Alexander, May 8, 2015.

367 "somebody's wife or somebody's mother": *Kramer vs. Kramer* (Benton, dir.).

367 "Meryl, why don't you stop": Christian Williams, "Scenes from the Battle of the Sexes," *Washington Post*, Dec. 17, 1982.

368 "See that glass there on the table?": Recalled by Hoffman in *Finding the Truth* (Arick, dir.).

369 *"Don't talk to me that way"*: *Kramer vs. Kramer* (Benton, dir.).

369 "Next time you do that": Nick Smurthwaite, *The Meryl Streep Story* (New York: Beaufort Books, 1984), 53.

369 "Dear Mr. Papp": NYSF, Box 2-122.

371 "my horse, my ox, my ass": William Shakespeare, *The Taming of the Shrew*, Act III, Scene ii.

371 "but she was not injured": NYSF, Box 5-121.

371 "I can't believe how many people": Christopher Dixon, dir., *Kiss Me, Petruchio*, 1981.

372 "I feel very ambiguous": Ibid.

373 "When you give": Ibid.

374 "Joe had no problem": Helen Epstein, *Joe Papp: An American Life* (Boston: Little, Brown, 1994), 335.

375 Tweed Courthouse: The history of the courthouse appears on its webpage at www.nyc.gov.

376 "Because he's my child": The first version of the speech appears in the shooting script, dated Sept. 5, 1978, provided to the author by Richard Fischoff. The second is transcribed from the final film.

380 "longest personal relationship": *Kramer vs. Kramer* (Benton, dir.).

380 Before the take, Dustin had gone over: Hoffman himself tells this story, with some pride, in *Finding the Truth* (Arick, dir.).

382 "I didn't get over it": de Dubovay, "Meryl Streep."

383 "Homicides": Recalled by Hoffman in *Finding the Truth* (Arick, dir.).

384 "She does the right thing": MG.

384 "What immense support": NYSF, Box 1-173.

385 "unspeakably touched": Epstein, *Joe Papp: An American Life*, 427. Papp's eventual successor was JoAnne Akalaitis. He died on Oct. 31, 1991.

386 "After I left": Benton, *Kramer vs. Kramer*, shooting script, Sept. 5, 1978.

388 "This is a mature actress": Mel Gussow, "Stage: 'Alice' Downtown, with Meryl Streep," *New York Times*, Dec. 29, 1978.

388 "I woke up this morning": As transcribed from the final film.

390 "This is the season of Meryl Streep": MG.

391 "non-pro": "Births," *Variety*, Nov. 28, 1979.

391 *The First Twelve Months of Life*: Streep talks about her preparations for motherhood and the trip to Europe in her interview tapes for Diane de Dubovay's March, 1980, profile in *Ladies' Home Journal*, provided to the author by the de Dubovay family.

391 "the most natural thing in the world": de Dubovay, "Meryl Streep."

392 "My work has been very important": Ibid.

392 At the insistence of Lew Wasserman: Alan Alda, *Things I Overheard While Talking to Myself* (New York: Random House, 2007), 116.

393 "Though the movie has no answers": Frank Rich, "Grownups, A Child, Divorce, And Tears," *Time*, Dec. 3, 1979.

393 "'Kramer vs. Kramer' is a Manhattan movie": Vincent Canby, "Screen: 'Kramer vs. Kramer,'" *New York Times*, Dec. 19, 1979.

394 the U.S. gross: Box Office Mojo.

395 "difficult to escape": Gary Arnold, "'Kramer vs. Kramer': The Family Divided," *Washington Post*, Dec. 19, 1979.

395 "I keep thinking of Joanna": Barbara Grizzuti Harrison, "'Kramer vs. Kramer': Madonna, Child, and Mensch," *Ms.*, Jan., 1980.

396 dungarees on MacDougal Street: MG.

396 Hawaiian jacket: Mel Gussow, "The Rising Star of Meryl Streep," *New York Times Magazine*, Feb. 4, 1979.

396 She was partial to pearl earrings: Joan Juliet Buck, "More of a Woman," *Vogue*, June, 1980.

396 "Hello . . . um . . .": Paul Gray, "A Mother Finds Herself," *Time*, Dec. 3, 1979.

396 "reality of life": de Dubovay, "Meryl Streep."

396 male contraception: "Meryl Streep," *People*, Dec. 24, 1979.

397 "less glamorous than Gary": Tony Scherman, "'Holocaust' Survivor Shoots 'Deer Hunter,' Shuns Fame," *Feature*, Feb., 1979.

397 "charismatic leaders are very interesting": MG.

397 *The Postman Always Rings Twice*: Kroll, "A Star for the '80s."

397 "full of shit": MG.

397 "put his life on the line": Kroll, "A Star for the '80s."

397 the new "slink": MG.

398 "cry of a bird": Buck, "More of a Woman."

398 "tapered candle": Dworkin, "Meryl Streep to the Rescue!"

398 "Flemish master's angel": "People Are Talking About . . . ," *Vogue*, July, 1979.

398 *Portrait of a Lady in Yellow*: Buck, "More of a Woman."

398 "merulean . . . more than just a gorgeous face": Gray, "A Mother Finds Herself."

398 "identify with Medea": Buck, "More of a Woman."

398 "Cinderella story": Gray, "A Mother Finds Herself."

398 "go with the flow": de Dubovay, "Meryl Streep."

398 Alexandria, Virginia: MG.

398 "excessive hype": John Skow, "What Makes Meryl Magic," *Time*, Sept. 7, 1981.

399 "I think that the notion": Buck, "More of a Woman."

399 "Dustin has a technician's thoroughness": Schwartz, "Dustin Hoffman Vs. Nearly Everybody."

399 "I hated her guts": Kroll, "A Star for the '80s."

400 "the first American woman": Ibid.

400 "didn't feel anything": Bob Greene, "Streep," *Esquire*, Dec., 1984.

400 "middling successful actor": Buck, "More of a Woman."

401 New Year's Eve party: The details of the party come from Charles Champlin, "An 'A' Party for Woody," *Los Angeles Times*, Jan. 4, 1980.

402 homesteaders on a vast frontier: de Dubovay, "Meryl Streep."

403 "the Lady": Buck, "More of a Woman."

403 "left-wing Communist Jewish": Woody Allen, dir., *Annie Hall*, United Artists, 1977.

404 "Put me on the moon": David Rosenthal, "Meryl Streep Stepping In and Out of Roles," *Rolling Stone*, Oct. 15, 1981.

405 At the Golden Globes: As told by Streep on *The Graham Norton Show*, BBC, Jan. 9, 2015.

405 "My mom cried four times": Beverly Beyette, "Justin Henry: A Little Speech, Just in Case . . . ," *Los Angeles Times*, Apr. 14, 1980.

406 "glorious heritage": Onstage remarks from the 52nd Academy Awards, Apr. 14, 1980.

408 "Well, the soap opera won": The details of the press conference come from Lee Grant, "Oscars Backstage: A Predictable Year," *Los Angeles Times*, Apr. 15, 1980, and from " 'Kramer' Family Faces the Hollywood Press," UPI, Apr. 15, 1980.

411 "They relate to Miranda": Commencement address delivered by Meryl Streep at Barnard College, May 17, 2010.

411 "someone left an Oscar in here!": "The Crossed Fingers Worked, but Then Meryl Left Her Oscar in the John," *People*, Apr. 28, 1980.

About the Author

MICHAEL SCHULMAN is a contributor and arts editor at *The New Yorker*. His work has appeared in the *New York Times*, *The Believer*, and other publications. He lives in Manhattan.

HARPER **LUXE**

THE NEW LUXURY IN READING

We hope you enjoyed reading
our new, comfortable print size and found it
an experience you would like to repeat.

Well – you're in luck!

HarperLuxe offers the finest in fiction and
nonfiction books in this same larger print size and
paperback format. Light and easy to read, HarperLuxe
paperbacks are for book lovers who want to see
what they are reading without the strain.

For a full listing of titles and
new releases to come, please visit our website:

www.HarperLuxe.com

W9-ADG-894

HARRIETTE SIMPSON ARNOW

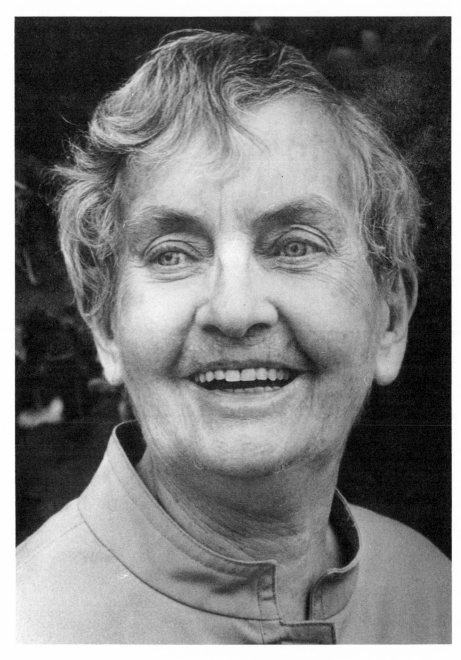

Harriette Simpson Arnow
Photograph by Patricia Beck, courtesy of the *Detroit Free Press*

HARRIETTE
SIMPSON
ARNOW

CRITICAL ESSAYS ON HER WORK
Haeja K. Chung, Editor

Michigan State University Press
East Lansing

Copyright © 1995 Haeja K. Chung

All Michigan State University Press books are produced on paper which meets the
requirements of American National Standard of Information Sciences—Permanence of
paper for printed materials ANSI Z23.48-1984.

Printed in the United States of America

Michigan State University Press
East Lansing, Michigan 48823-5202

03 02 01 00 99 98 97 96 95 1 2 3 4 5 6 7 8 9 10

Library of Congress Cataloging-in-Publication Data

Harriette Simpson Arnow : critical essays on her work / Haeja K. Chung.
 p. cm.
 Includes bibliographical references (p.) and index.
 ISBN 0-87013-381-0 (alk. paper)
 1. Arnow, Harriette Louisa Simpson, 1908-1986—Criticism and interpretation.
2. Women and Literature—United States—History—20th century. 3. Appalachian
Region—In literature. 4. Mountain life in literature. 5. Kentucky—In literature.
I. Chung, Haeja K.
PS3501.R64Z69 1995
813'.52—dc20 95-31806
 CIP

Permission to use material from Harriette Arnow's work was graciously granted by
Marcella and Thomas Arnow.

CONTENTS

ACKNOWLEDGMENTS

I would like to express my special thanks to Marcella and Tom Arnow for permission to use and quote from their mother's work, to Bernice Mitchell for permission to use one of her rare photographs of Arnow, and to Dr. Fred Bohm and Julie Loehr of the Michigan State University Press for their unwavering commitment to Arnow scholarship. I am grateful to the Appalachian Center in Berea College for the fellowship that made my trip to Kentucky possible, and to Kate Black, curator of the Appalachian Collection at the University of Kentucky Libraries in Lexington for her generous assistance during my research. My sincere gratitude to Pauline Adams for her suggestions as well as her encouragement throughout my association with her as a colleague, and to all the contributors, notably Kathleen Walsh and Kathleen Parker who, along with my friend Sandy Holy, critically read portions of the manuscript and offered many insightful suggestions. I am especially indebted to Sandra Ballard for her friendship and generosity; her contributions to this collection as a friend, reader, and researcher/archivist are too numerous for me to list in this limited space. Finally, my deepest appreciation to my husband, Kisuck, and to my sons, Eugene and Eric, who have sustained me with their loving support throughout the arduous years of my career; they have truly been my invaluable intellectual companions.

INTRODUCTION

HAEJA K. CHUNG

This collection of essays began as an avid reader's personal mission. In 1983, as a freelance writer for *The Lansing State Journal*, I interviewed Harriette Simpson Arnow at her home in Ann Arbor, in anticipation of the soon-to-be-released television movie of her novel, *The Dollmaker* (1954). The interview gave Arnow's fascinating fictional characters an immediate presence. As if revisiting old friends, Arnow commended this character's behavior or commiserated over that character's misfortune.[1] She seemed committed to explicating her work for her readers, and by the close of the interview I felt called to share what she had said.

Subsequently, I continued to research Arnow and taught her work at Michigan State University. I soon realized, however, that studies of Arnow are few in number and often inaccessible. *Harriette Arnow*, by Wilton Eckley, the only book-length study of Arnow, has long been out of print. In any case, that book did not cover Arnow's last two books—*The Kentucky Trace: A Novel of the American Revolution* (1974) and *Old Burnside* (1977), the former containing one of Arnow's favorite characters. Furthermore, even in the 1980s, Arnow was treated basically as a regional writer, and critical essays on her work were published primarily in the South; journals such as the *South Atlantic Review* and the *Southern Literary Journal* that contain excellent essays on Arnow are still not readily available in other parts of the country. The inaccessibility of these secondary sources creates a void in Arnow scholarship, which this collection of critical essays is designed to fill.

An essayist, short story writer, novelist, and social historian, Harriette Simpson Arnow was a multifaceted writer whose work contributed significantly to our understanding of the American experience. Arnow wrote insightful social history books, such as *Seedtime on the Cumberland* (1960)

and *Flowering of the Cumberland* (1963), which reconstruct pioneer settlements in the Cumberland River country. She also wrote with consummate artistry about mid-twentieth century America in a number of short stories and novels, such as *Hunter's Horn* (1949) and *The Dollmaker*. Whatever medium she chose, Arnow was motivated to write by a strong sense of community and an acute social conscience. Although Arnow wrote about the region she knew best, her writing transcends regional boundaries. She clearly illustrates that regional literature is what Werner Sollors terms "prototypically American literature," an integral part of the canonized mainstream of American writing.

Arnow became a writer because she loved to write; she had her own "demon" inside, as Faulkner used to call it, that would not leave her alone. Her writings and interviews indicate that she was an unpretentious and meticulous writer, for whom being prolific was never a measure of success. When she died in 1986 in Ann Arbor at the age of 78, she left a modest sum of publications: ten short stories, five novels, two nonfiction books, a short autobiography, and nineteen essays and book reviews. Perhaps more revealing is what she left unpublished: countless manuscripts in various stages of revision. The Arnow Special Collection at the University of Kentucky Libraries houses an unpublished novel, "Between the Flowers," seventeen unpublished short stories, and numerous letters to and from personal and professional friends; especially valuable to Arnow scholarship are the letters from her editor Harold Strauss, who exerted tremendous influence on Arnow as a budding writer.[2]

Arnow's work was well received during her lifetime. *Hunter's Horn* was selected as one of the ten best novels of the year by writers for the *New York Times Book Review*, and *The Dollmaker* was named runner-up to Faulkner's *A Fable* for the National Book Award in 1955. For *Seedtime on the Cumberland*, Arnow won an Award of Merit from the American Association of State and Local History in 1961. For her achievements, Arnow received three honorary doctoral degrees and numerous awards, including the Mark Twain Award from the Society for the Study of Midwestern Literature in 1984. That same year, she became the first contemporary writer inducted into the Michigan Women's Hall of Fame.

Nevertheless, Arnow remains an underrated writer. At best, she is known as the writer of one novel, *The Dollmaker*. The novel's compelling narrative and engrossing main character, Gertie Nevels, have continued to draw passionate reactions from diverse audiences since its publication, prompting the author to comment, "the doll [*The Dollmaker*] has been and continues to be a different story to each reader."[3] Although in 1985 the University Press of Kentucky reissued Arnow's major works in hardbound edition, *The Dollmaker* is the only one available in paperback. It is unfortunate that *Hunter's Horn*, equally as compelling and superb as *The Dollmaker*, is not available for classroom use.

Such literary slight has occurred largely because reviewers have long stereotyped Arnow as a regional writer who lacks widespread appeal. Alfred Kazin called her first book, *Mountain Path* (1936), one of the best "novels of its type"—a mountain story. Her subsequent novels, *Hunter's Horn* and *The Dollmaker*, received better reviews, especially for their realism—"extraordinary power" and "terrific reality"—and Victor P. Hass said that *Hunter's Horn* would have "wider appeal for people everywhere" than any of Faulkner's work. But, ironically, her stinging realism has been seen as evidence of her regionalism, evidence that she is of the Cumberland—an area somehow more "regional" than others might be. Coleman Rosenberger said, "'The Dollmaker' could only have been written out of intimate knowledge of the people with whom Harriette Arnow is concerned."[4] Aside from the failure of some critics to perceive the universality of her characters, Arnow, herself, often lamented that readers and reviewers gave her little or no credit for her imagination.

Arnow has received sporadic yet significant critical attention during the past two decades. Although the sum of critical studies is small, her work has been examined from regionalist, Marxist, feminist, and other critical perspectives. The 1970s saw the first serious attempts to revive interest in Arnow. In 1971, Tillie Olsen identified Arnow as a writer whose "books of great worth suffer the death of being unknown, or at best a peculiar eclipsing."[5] The same year, Joyce Carol Oates wrote in the *New York Times Book Review* that *The Dollmaker* is "our most unpretentious American masterpiece." In 1974, Wilton Eckley published *Harriette Arnow*, the first critical study of Arnow. At Harvard in 1975, despite the protests of her professors, Glenda Hobbs wrote a dissertation on Arnow and subsequently produced three other critical essays on her work. In 1978, *Critique* published Dorothy Lee's essay, the first serious study of *The Dollmaker* as a *bildungsroman*.[6]

Both public and academic interest in Arnow continued throughout the 1980s. Largely because of Jane Fonda's 1984 TV movie, "The Dollmaker," Arnow gained wider recognition. Feminists claimed, as *Ms.* magazine did in 1983, that *The Dollmaker* was a must for feminist intellectuals. Academic interest in the author also grew steadily, with many high schools and colleges using *The Dollmaker* in literary and social science classes. Several dissertations were written on Arnow, and the first comprehensive bibliography was compiled by Sandra L. Ballard.[7]

In the 1990s, it is appropriate to take stock of the earlier work and to prompt new examination of this powerful and not yet fully evaluated writer. This collection of critical essays examines established, and offers new, perspectives on Arnow. It also attempts to suggest future directions in Arnow scholarship by including studies on most of Arnow's writings—fiction and nonfiction, published and unpublished.

Part one, "Arnow's Life and the Critics," covers Arnow's life and offers representative critical views of her writing. To avoid repetition, I have included only a few essays representing established Arnow scholarship up to the 1980s—the critical perspectives of Arnow as a naturalist, a humanist, a regionalist, a feminist, and a social-historian. A number of superb essays have also been excluded either because their focus is too narrow or because they are readily available elsewhere.

The first two essays discuss Arnow's life. As indicated in the title, "Harriette Simpson Arnow's Life as a Writer" traces Arnow's literary biography from her childhood in Kentucky to her final days in Ann Arbor, Michigan. Sandra L. Ballard, who is currently writing Arnow's biography, discusses Arnow's overwhelming drive to be a writer and her strong sense of people and place; whether writing fiction or nonfiction, she was mainly interested in Kentucky and its people. Arnow might have protested, but Ballard cites numerous situations in her characters' lives that parallel Arnow's own life. Additionally, in "Harriette Simpson and Harold Arnow in Cincinnati: 1934-1939," Danny Miller highlights the "formative and influential" years in Arnow's life. In 1934, at the age of 26, the budding writer came to Cincinnati, resolved to write, and stayed there until 1939, when she met her future husband, Harold Arnow. Arnow supported herself with odd jobs, such as typing and waitressing, that allowed her time to read and write; she also did historical research as a staff member of the Federal Writers Project. Miller concludes that Arnow's personal and professional experiences during this period greatly influenced her later writing.

In "Artistic Vision," a chapter from *Harriette Arnow*, Wilton Eckley attempts the earliest comprehensive definition of Arnow's artistry. Eckley describes Arnow as "a simple story teller" whose stories are shaped by characters, in particular by women who "are trapped by social restrictions and environmental forces." Further, in Eckley's view, Arnow's artistic vision is complex and paradoxical: despite her naturalistic outlook on life, Arnow is also a realistic humanist who recognizes man's "indomitable spirit."

Barbara L. Baer, a premier essayist on Arnow, stresses the naturalistic outlook in all of Arnow's fiction. In "Harriette Arnow's Chronicles of Destruction," Baer contends that Arnow expressed "her persistent vision of man's destruction" in her "Kentucky trilogy" as well as in *The Weedkiller's Daughter*. By incorporating Arnow's life story and interview responses into her discussion, Baer offers new readers of Arnow a good introduction to her major works of fiction. Especially valuable are Arnow's explanations of her motivations for writing.

In "Harriette Arnow's Kentucky Novels: Beyond Local Color," Glenda Hobbs draws a fine distinction between a regionalist and a local colorist. Critics in the 1950s often misconstrued Arnow as a local-color writer because her stories are firmly rooted in rural Kentucky. Hobbs argues that Arnow is a "traditional" regionalist; in keeping with Allen Tate's definition, she used "the regional life " she knew well, not as "the message," but as "the medium of expression."

In "Harriette Arnow's Cumberland Women," Linda Wagner-Martin advances Hobbs's thesis further by discussing the "thematic patterns" in *Hunter's Horn* and *The Dollmaker*. Both novels, she contends, are "critical of the position of women and the power of organized religion." De-emphasizing Arnow's regionalism, Wagner-Martin draws attention to her realism. Her argument that Arnow describes a culture in which people use religion to "coerce women" coincides with some feminist readings of Arnow.

Part one concludes with Danny Miller's new essay, "Harriette Arnow's Social Histories." Miller discusses Arnow as a social historian who successfully fused the two disciplines of research and creative writing. Like Sandra Ballard, Miller maintains that the impetus for writing nonfiction books such as *Seedtime on the Cumberland* and *Flowering of the Cumberland* is the same as for writing fiction: the "kinship" with the Kentucky region and the need to preserve a fast-disappearing community. Since Arnow is a social, rather than a political, historian, she does not focus on particular historical events, but on the "lives of the average settlers" in the Cumberland region.

Part two of this collection, "Individual Fiction," focuses on individual works, including unpublished short stories and an unpublished novel. Many essays in this section are new, solicited for inclusion in this volume. They are arranged chronologically, following the publication dates of Arnow's works.

In "The Harbinger: Arnow's Short Fiction," I examine Arnow as a short-story writer. This aspect of her career has received little attention from critics, largely because many of her stories are unpublished and unavailable to the public.[8] Although she wrote most of her short stories in the 1930s and 1940s, when proletarian and agrarian literature was prevalent, Arnow maintained her artistic integrity, apart from those traditions. The technical felicity and thematic concerns of her great novels are prefigured in these short stories.

"'Fact and Fancy' in *Mountain Path*," by Joan R. Griffin, discusses the genesis of the first novel in Arnow's trilogy, which describes the gradual erosion of eastern Kentucky hill life from the 1920s into the mid-1940s. Griffin argues that Arnow has both "fact"—her personal experience in the region—and "fancy"—her imagination—in concert in this novel. In *Mountain Path*, Arnow captures "the essential qualities of hill life and hill people," featuring Cora, the first of many long-suffering women in her fiction.

Contrary to common belief, Arnow's second novel is "Between the Flowers" rather than *Hunter's Horn*. In "'Between the Flowers': Writing beyond Mountain Stereotypes," Beth Harrison offers valuable insights into why Arnow's second novel has never been published. Unlike other regional writers of the 1930s, Arnow does not concentrate on "female entrapment," but develops her first "autonomous female protagonist" in the main character, Delph; according to Harrison, such artistic independence in a woman writer frustrated her editors and publishers, who treated Arnow as a local colorist and nothing more. This novel is an important "transitional piece" in the evolution of Arnow's artistry, anticipating future female characters in Arnow's later "female *bildungsroman{e}*."

Following Harrison are two essays on Arnow's second published novel, *Hunter's Horn*. "The Central Importance of *Hunter's Horn*," by Sandra L. Ballard, is a call to reassess the novel that has been unduly neglected by critics. Treating *Hunter's Horn* as a central piece in Arnow's development and calling attention to the way it "integrates Arnow's central concerns in her published fiction and nonfiction," Ballard traces Arnow's artistic

maturation. In the second essay, *"Hunter's Horn* and the Necessity of Interdependence: Re-Imagining the American Hunting Tale," Kathleen Walsh discusses how *Hunter's Horn* examines traditional hunting tales and the frontier myth they promote. By focusing on "the conflict between independence and interdependence," rather than on the novel's regional appeal, Walsh contends that Arnow's novel departs from the traditional hunting tales that idealize the "independence" of a hunter. Arnow challenges the "monomyth of the hunter" through the compelling episodes of childbirth that dramatize "the necessity of interdependence" in the family and community. She concludes that Arnow's "non-canonical counterpointing of these gendered paradigms" accounts for this novel's long obscurity.

Discussions of Arnow's most celebrated novel, *The Dollmaker*, begin with Glenda Hobbs's essay, "A Portrait of the Artist as Mother: Harriette Arnow and *The Dollmaker.*" Hobbs examines the long-held "assumption that marriage and art are mutually exclusive," as implied in Tillie Olsen's *Silences*. Hobbs sees parallel situations in Gertie's life and Arnow's. Despite her self-deprecating comments about her "whittlen foolishness," Gertie is a "mother-artist" struggling to "create a masterwork" while torn between two passions—her art and her family. Similarly, Arnow referred to herself as a mere housewife-storyteller, but nonetheless wrote her masterpiece, *The Dollmaker*. Hobbs concludes that *The Dollmaker* is Arnow's "man-sized wildcherry wood," marked by the strain of the struggling mother-artist. Kathleen Walsh disagrees with Hobbs and insists that "within the context of Gertie's felt needs and priorities" the wooden figure is created "not so much for Gertie's imagination as for her guilt." In "Free Will and Determinism in Harriette Arnow's *The Dollmaker,*" Walsh also questions the prevailing perceptions of Gertie as an unfortunate victim of cruel external circumstances, or as a heroic woman idolized by feminist readers. She argues that, although readers tend to exonerate Gertie for her failure because of the tremendous adversity she faces, Arnow never "relaxes the tension between responsibility and inability." In the final essay on *The Dollmaker*, "American Migration Tableau in Exaggerated Relief: *The Dollmaker,*" Kathleen Parker examines the novel from the unique perspective of "a cultural historian" and discusses the Nevels's dislocation within a larger historical context, a culture replete with various "antithetical themes." She contends that the novel's "exaggerated pastoral/urban themes . . . have persisted historically in the American consciousness" and that

"the conflicts posed by the American migration experience" are largely responsible for "the ambivalence" readers reportedly feel about the novel's conclusion.

Part two closes with Charlotte Haines's essay, "*The Weedkiller's Daughter* and *The Kentucky Trace*: Arnow's Egalitarian Vision," which examines Arnow's last two novels as companion pieces. Haines elaborates on Arnow's kinship with Kentucky, which Ballard and Miller stressed in their own essays, and further considers her sensitivity to ethnic identity in the American experience. The two seemingly different stories reflect a sense of nostalgia for the place and time of *Seedtime on the Cumberland* and *Flowering of the Cumberland*, the nonfiction books underlining "the individualistic yet democratic ethos" in the Cumberland region. *The Weedkiller's Daughter* expresses "Arnow's anger over a lost way of life and yearning for the natural world of Appalachia"; in contrast, *The Kentucky Trace*, dealing with a multicultural family, is Arnow's allegorical journey back to "a utopian recreation of the Cumberland region."

Part three, "Authorial Views," contains Arnow's own essays, a lecture, and an interview. Arnow's essays attest to the remarkable social sensibilities that shaped her artistic vision; her authorial statements affirm the artistic intentions that are achieved in her fiction.

Arnow's "Introduction" to *Mountain Path* (1963) and "Some Musings on the Nature of History" (1968) are perhaps two of her most important essays, illustrating her vision as both a social historian and a fiction writer. In the former, Arnow describes the cultural and economic conditions of the backhill communities of Eastern Kentucky in the 1920s-30s that became the setting of her first novel. She also demonstrates how the transformation of the region by encroaching civilization became her preoccupation in her trilogy: "At a very early age I saw much of life in terms of roads," she writes. Later in Michigan, Arnow continued to see life the same way. In "Musings," Arnow deplores the fact that her farmland in Ann Arbor, once "a living museum"—a natural habitat for wildlife—was being ravaged by "progress." The essay also offers insight into Arnow's writing career during her residence in Michigan, where she became a productive and recognized author. Perhaps the central issue in this essay is Arnow's honest attempt to answer the question, "What is history, at least to me?" To Arnow, history is "a shy girl, not coming close unless she can be certain of some kinship . . . with her." Developing "a kinship with the past" is essential to good citizenship, whether in Kentucky or in Michigan.

Arnow gave many interviews when the TV movie of *The Dollmaker* was about to be released. "Fictional Characters Come to Life" is a transcription of an interview I had with Arnow in August 1983. Arnow's comments offer unique insights into her characters and writing process, often challenging the established scholarship on her work.

"Help and Hindrances in Writing" is one of the last public speeches Arnow gave. In 1985, a year before her death, she discussed the chronology of her writing career, beginning with a childhood that was steeped in oral tradition. From this speech emerges a woman who was clearly meant to be a writer, despite various "hindrances," including her mother's warning that writing would bring her nothing but "disappointment and sorrow."

As Ballard, Miller, and Haines conclude, to a great extent, Arnow's Kentucky roots motivated her to write. She was not, however, merely interested in documenting regional particularities; rather, as Harrison, Hobbs, and Walsh argue, Arnow transcended both the regional and historical influences of her time. She maintained her artistic independence throughout her career by approaching the regional life of Kentucky, not as the sole message, but as a medium for exploring the larger issue of human hearts in conflict. In this sense, Arnow scholars need to reexamine her regional perspective in terms of "a cosmopolitan regionalism—a regional perspective which does not exclude a knowledge of the wider world, but is concerned with and appreciative of the little traditions within the great traditions of human history. . . ."[9] Arnow's writing demands an inclusive definition of regional literature.

The immediate challenge Arnow scholars face in the 1990s is that of freeing Arnow from yet another unfair label—that she is a single-work author. Arnow scholars need to expand their scope of critical attention beyond the studies of the 1970s and 1980s that have focused on *The Dollmaker*; they must recognize and examine the totality of Arnow's work. For instance, although several readers gave *The Dollmaker* a feminist reading, it is not clear to what extent Arnow is a feminist author. With the exception of Wagner-Martin, most feminist readers seem to draw their conclusions mainly from *The Dollmaker*, basing their arguments on either the "heroic" Gertie or the stifling patriarchal culture portrayed in the

novel. In addition, in 1984, Arnow told me, "Gertie is not much of a feminist as we use the word today." Arnow gave numerous interviews late in her career, and her thoughtful explications of her work would seem to enrich the interpretive relationship between reader and text.

This collection of essays offers comprehensive but by no means exhaustive views of Arnow from the perspective of the 1990s. I hope it will contribute to and, more importantly, stimulate Arnow scholarship, enriching the canon of American literature.

NOTES

1. Alex Kotlowitz, who interviewed Arnow, had a similar experience. He writes, "She lives her books. Her characters are her neighbors and she says she knows them better than anyone, even Harold." See Alex Kotlowitz, "The View from the End of the Road," *Detroit News,* 4 December 1983, 14-29. Also see Haeja Chung, "'Dollmaker' Author Leads Humble Life," *Lansing State Journal,* 3 May 1984, D1+.

2. The Margaret King Library at the University of Kentucky Libraries has the greatest collection of Arnow's manuscripts and letters, which the library purchased from the Arnow estate before and after her death. Anyone interested in this collection should contact Kate Black, the curator for the Appalachian archives at the library. According to Dr. Sandra L. Ballard, there are two more unpublished novels that are not yet available from the library (see her essay, "Arnow's Life as a Writer," in this work).

3. See Arnow's "Letter to Barbara Rigney," *Frontiers: A Journal of Women Studies* 1-2 (1976): 147.

4. See the following reviews: Alfred Kazin, *New York Herald Tribune Books,* 6 September 1936, 10+; Herschel Brickell, "Kentucky Man and King Devil," *The New York Times Book Review,* 28 May 1949, 4; Vicor P. Hass, "A Way of Life Down South," *Saturday Review of Literature* 32 (25 June 1949): 20; Coleman Rosenberger, "A Novel of Extraordinary Power, One That Will Be Long Remembered: *The Dollmaker,*" *New York Herald Tribune,* 25 April 1954, 3.

5. See Tillie Olsen, *Silences* (New York: Dell, 1983), 59. The speech was originally delivered in 1971 at the Modern Language Association Forum on Women Writers in the Twentieth Century.

6. These and other influential essays are frequently cited in this collection. A bound copy of Glenda Hobbs's dissertation, a pioneering work on Arnow, is also available at the University of Kentucky Libraries.

7. See Sandra L. Ballard, "Harriette Simpson Arnow," *Appalachian Journal* 14, no. 4 (Summer 1987): 360-72. See also Mary Anne Brennan, O. P.

"Harriette Simpson Arnow: A Checklist," *Bulletin of Bibliography and Magazine Notes* 46, no. 1 (March 1989): 46-52.

8. Thomas and Marcella Arnow have given Sandra L. Ballard and me permission to coedit a volume of the published and unpublished stories.

9. See Jim Wayne Miller, "Anytime the Ground is Uneven: The Outlook for Regional Studies and What to Look Out For," *Geography and Literature: A Meeting of the Disciplines*, edited by William E. Mallory and Paul Simpson-Housley (Syracuse: Syracuse University Press, 1987), 13. Werner Sollors advances similar argument on regional literature in his chapter, "The Ethics of Wholesome Provincialism," *Beyond Ethnicity: Consent and Descent in American Culture* (New York: Oxford University Press, 1986), 174-207.

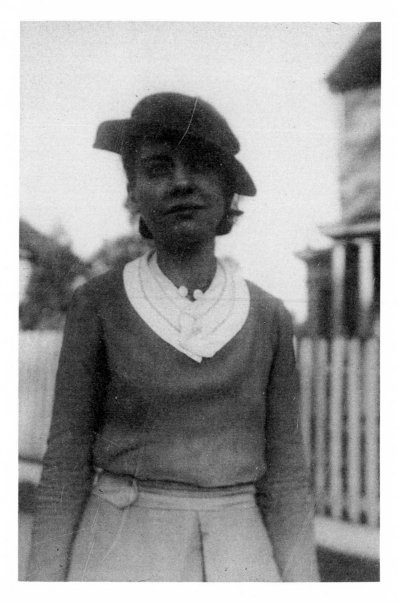

Harriette Simpson in 1937, photograph by Bernice Mitchell.

ARNOW'S LIFE AND THE CRITICS

HARRIETTE SIMPSON ARNOW'S LIFE AS A WRITER

SANDRA L. BALLARD

Trying to determine when Harriette Simpson Arnow began her life as a writer is like trying to identify the first genuine day of spring or fall. There are official dates, of course: she was twenty-seven when she published her first short story in 1934, and two years later she published her first novel. It is more difficult, however, to know precisely when she began to write, and when she first began to think of herself as a writer.

Arnow traced her beginnings as a writer back to her childhood, before she could read. The second-oldest of six children, she credits her father, Elias Thomas Simpson, and his stories, told in the evenings after work, as part of the impetus for her becoming a fiction writer. His repertoire included such classics as "Jack and the Beanstalk," as well as "handed-down tales from the Revolution and other wars, or stories of a grandfather's boyhood or his own." He was, in her words, "a great teller of ghost tales that made us shiver with fright . . . but some were so sad, tears would start dripping off my chin before he was finished." Another major influence was her maternal grandmother, Harriette LeGrand Foster Denney, who also told "blood-chilling tales." Rather than cry herself to sleep every night, Arnow explains, "I soon began to imagine happy endings for the sad stories and stopped crying. That is how I began writing" (Commire 1986, 42: 30), though the stories she later wrote never had unqualified happy endings.

At five or six years of age, Harriette Simpson did most of her composing in her head. But after Christmas, during her first year in school, she remembers her mother's encouragement to write letters to her grandmothers. "I rather enjoyed writing letters, but often thought I would rather be writing stories. There were so many untold stories in the world" (Commire 1986, 42: 30). Most of the records of Harriette Simpson Arnow's life—her

letters, manuscripts, and other papers—point to the fact that she wanted to be a writer before she began school. Her life is the story of a child, student, teacher, wife, and mother who felt compelled to write.

Harriette Simpson was born on 7 July 1907, according to her birth certificate, despite her repeated claim that she was born a year later. She insisted that her birth certificate contained an error, although it is based on the affidavits of her mother, Mollie J. Denney Simpson, as well as a family friend and census records showing Harriette Louisa Simpson to have been two years old on 15 April 1910. As an adult, Harriette Arnow usually proclaimed with irritation that those who gave 1907 as her birthdate were simply mistaken. While it is possible that her mother was in error about her daughter's date of birth,[1] the census record corroborates the mistake. We may never know the reasons for the contradictions in the record of Harriette Simpson's birth.

Born at home in Wayne County, Kentucky, Harriette moved with her family from Bronston to Burnside in March of 1913, according to *Old Burnside* (1977), her slim autobiographical book about her hometown, the most complete record available of her youngest years. In it, she says that her parents married in 1905 and moved to Burnside in March of 1913 because of her father's job, "feeding the hog" (fueling the boiler) at the Chicago Veneer factory (29). Another reason for moving was her mother's desire to send her daughters to Burnside's graded school, which separated students into different grade levels, unlike the rural one-room schools that Harriette's oldest sister, Elizabeth, had already attended (32).

Attending first through fourth grades at Burnside Graded School, Harriette's first efforts at fiction apparently came in fourth grade, when she wrote a story about "something I'd always wanted—a writing desk," imagining its life and the people who had used it. Her teacher encouraged her by praising the story and reading it to the class ("Ahead of Her Time" 1983, 7).

Yet, her excitement about fifth grade waned with the onset of the Spanish influenza epidemic of 1918. Mrs. Simpson, who had taught school in Wayne County before she had married, decided that year to teach her daughters at home—by now there were four, three of school age and a baby—to reduce their risk of exposure to the disease responsible for many deaths in the community.

It was a disheartening year: Harriette missed public school; the daily papers were full of war news and deaths; her maternal grandmother and

namesake died; and to make matters worse, just after Christmas in 1917, her father left home to start a lucrative job as a tool dresser in a new oil field in Wolfe County. Arnow writes that "Papa's absence left a hole nothing could fill," although she found consolation in writing to him (Arnow 1977, 114). In *Old Burnside*, she laments, "my world seemed a place forgotten by God or could it be that God had died? I tried to put such a sinful thought out of my mind, and think of the one bright spot in my life; Papa told us in his letters that he was well and enjoying his work" (118).

Sometime in 1918, the whole Simpson family moved to the oil field at Torrent, Kentucky (Arnow 1977, 119). Because there were no public schools, the girls continued to study at home for the rest of the school year. During the summer, Mrs. Simpson began to investigate a small boarding school less than thirty miles away, where she decided to send Harriette and her older sister. In the time she studied with her mother, Harriette learned that she "had apparently done two grades," because Mrs. Simpson entered her as a seventh grader at St. Helen's Academy. Arnow disparagingly referred to the place as "a cram school," because she completed seventh and eighth grades during her nine-month term there, even though she "knew nothing" when she left (Arnow 1973, 13). Harriette was apparently so vocal about her experience at St. Helens that her mother did not force her to return the next fall; instead, she sent Harriette to Stanton Academy, a Presbyterian school in Powell County. Arnow claimed that she "liked everything about this place" and would have been happy to graduate in Stanton (Arnow 1977, 121). By then, however, the oil field on Bobbie's Ridge where her father worked was nearly "drilled out," and her family returned home to Burnside (Arnow 1977, 122). She graduated from Burnside High School in May of 1924.

It was on the oil fields that Harriette Simpson gained exposure to the setting that would become part of her first published short story, "Marigolds and Mules," which appeared in 1934 in the little literary magazine, *Kosmos*. She heard not only of natural gas explosions and drilling accidents that killed men, but also of workers blown apart as a result of mishandling nitroglycerin: "if a cartload blew, nothing was left but a wide hole in the road; horseflesh could not be distinguished from manflesh" (Arnow 1977, 121). The most powerful scene in "Marigolds and Mules" is the one in which a young boy witnesses the aftermath of such an explosion; he finds bloody pieces of a mule virtually indiscernible

from the flesh of a man he knew, until he discovers a bloody human hand. Even Arnow's earliest published fiction shows her unflinching approach to gritty reality.

Though Arnow's mother did not approve of her daughter's writing, she evidently believed that typing was a useful skill. When still in high school, Harriette wanted a typewriter because she privately thought that editors would not be able to read her handwriting. (Penmanship was the only subject in which she never seemed able to improve her marks on her report cards.) So she and her mother struck a deal: her mother bought a second cow and told Harriette, "You learn to milk this cow and sell the milk and buy a secondhand typewriter" (Warfel 1949).

Harriette Simpson had not yet completed high school when she used this typewriter for the first story she submitted for publication, probably an early version of "Winky Creek's New Song," a fairy tale featuring wild-flower characters. In a lecture at Morehead State University, she said that she "sneaked out some of mother's writing paper, typed [the story] single-spaced on that paper . . . folded the thing up as it shouldn't have been, and sent it to *Child Life*." When it was returned, retyped double-spaced on standard paper, because, according to a note, it had been torn in handling, Arnow admitted that at the time she did not realize she was receiving a gentle lesson in the way to prepare a manuscript, as well as the encouragement of a letter instead of a rejection slip (Arnow 1985).

She felt "cast down" by the rejection, and her mother's anger and lecture did not make her feel any better. Mrs. Simpson complained of her daughter's wasting time, writing paper, and postage on "scribbling" which could not bring anything but unhappiness. In droll tones, Arnow reports, "she was telling me this . . . only for my own good because it would be far better to have a steady job like teaching school, as she had done . . . than wasting time on scribbling" (Arnow 1985). Understandably, Arnow did her writing "chiefly in secret" after that episode (Arnow 1973, 13), though it is significant that she felt compelled to write her stories despite her mother's disapproval.

Because Arnow's mother was a commanding presence who wielded influence over her children for as long as she could, Harriette knew she was destined for teacher's training at a normal school, as her mother wished. However, she was able to convince her mother to allow her to go to Berea College. "I had chosen Berea mostly because that school required fewer hours of education for an elementary school teaching certificate than did

the state's normal schools. This gave me an opportunity to take botany and geology as electives" (Arnow 1977, 125).

A Berea College student from 1924 until 1926, Harriette Simpson continued to write and often complained that she did not receive any encouragement there to write. "I put in two years at Berea College," she told one interviewer, as though she were describing a prison term, where she "found no one, either teacher or pupil, the least bit interested in writing." In fact, some of the other students thought she was "crazy," she said, because they found out that she actually "enjoyed writing themes." Sometimes she wrote unassigned essays, just because she felt like it, and she admitted, "sometimes I'd write one for another girl. Get a good grade" (Miller 1982, 88).

Despite Arnow's complaints, Berea College officials who want to refute her statements point to a small promotional booklet that she wrote for them in 1949, *What Berea Meant to Me*. In it, she explains that she received from Berea much more than college credits at a small expense. "There is nothing on the transcript of my credits to show that in required English I had a teacher [Dr. Weeks] who along with the marks he gave, also helped give me the courage to try to write, not of long ago far off things but of the world I knew" (2). Berea Archives also contain several appreciative letters to Dr. Weeks and Berea's President Hutchins, who had invited her back to speak shortly after her first novel was published in 1936.

Harriette Simpson left Berea in 1926, at the end of her sophomore year, with a teacher's certificate. Despite her youth and inexperience, the Pulaski County school superintendent soon contacted her about a job vacancy. She taught nineteen students, although all could not attend regularly, as "older ones often had to stay home to help in some way. They were the sons and daughters of subsistence farmers," and the younger students "couldn't walk four or five miles to school in bad weather, especially since some didn't get shoes until late November and early December" (Arnow 1985).

In her introduction to the 1963 reprint of her first novel, *Mountain Path*, Arnow describes more fully the rural area where she lived in 1926-1927. As the local teacher of a one-room school, she earned $65 a month, from which she paid $15 a month to room and board with the family of one of her students in a remote Pulaski County community.

While boarding there, in November of 1926, Harriette Simpson began her first elective college course in writing, an extension course offered through the University of Kentucky. Her work and the correspondence with her teacher, Mr. L. B. Shackleford, are among the Arnow papers in

the University of Kentucky Libraries' Special Collection. Despite some remarkable descriptions and interesting characterizations in her work for this course, she must have repeatedly had disappointing evenings after receiving her teacher's comments, which always pointed out stylistic problems and advised her to get a dictionary, but never once remarked on the content of her writing.

Recognizing the rarity of the time and place where she lived, she later wrote that the world she first saw in the summer of 1926 was "gone; more completely vanished than ancient Greece and Rome," but "different from Pompeii under the ashes, it cannot be excavated and re-created":

> Pine and sassafras roots destroy, instead of preserve, as do ashes; and anyway, who can excavate a fiddle tune, the coolness of a cave now choked with the water of Lake Cumberland, or the creakings and sighings of an old log house? (Arnow 1963, xiv)

Harriette Simpson knew very well that she could preserve this place and time with words. By 1936, she had translated her impressions of that first year of teaching into her first novel, *Mountain Path*.

After completing her year at the one-room school in Pulaski County, in 1928 she moved back to Burnside and found a "less rewarding" job as an elementary school principal within five miles of home (Eckley 1974, 35). "After teaching a while," she says, "I decided finally that if I wanted to get a degree, I should do it now" (Arnow "Writing and Region" 1984), so she moved to Louisville, probably in the fall of 1928.

During her time as a student at the University of Louisville, she joined her first writers' group. With the encouragement of the Dean of Women, Harriette became an active member of the national literary sorority Chi Delta Phi. She entertained the idea, briefly, of becoming a poet. She was fond of ballads because she was attracted to the simple, direct style, able to "tell so much" in a few well-chosen words (Lucas 1976, 127). Among her efforts extant in the Arnow Special Collection at the University of Kentucky is a poem entitled "Homecoming." She admits to trying to imitate the dramatic monologues of Robert Browning—with miserable results, she thought—and then deciding that she would never be a poet.

She told her college friend, Cora Lucas, also a member of Chi Delta Phi, that she had once composed a number of poems, hoping to write enough for several volumes, until she realized that her poetic muse was costing her

more than she could afford: "my grades began sliding to my ankles" (Lucas 1976, 127), so she abandoned poetry and concentrated on her science studies and on writing prose.

The writers' society at the University of Louisville met regularly with a faculty sponsor, Dr. McDowell. Lucas remembered him as a young "firebrand," a man who was "unconventional enough for us to feel free in expressing our ideas." Although their meeting place, the "Women's Building" on campus, allowed no men, Dr. McDowell was willing to risk coming up the back stairs during a lunch hour to meet with the aspiring writers at least once a month (Lucas 1976, 128). The group was small enough to give each one a chance to read and offer opinions (Miller 1982, 89), and Harriette Simpson must have lived for those meetings.

Her writing was already showing her strong sense of identification with Kentucky hill people. While other students were writing their "semi-myths, sad love-poems full of Weltzschmerz [world pain], and parodies of Edgar Lee Masters' poetic biographies" (Lucas 1976, 128), Harriette followed one of the first rules of writing: she wrote about what she knew. That is, Lucas remembered that Harriette, unlike the others, wrote about blooming plum trees, traveling mountain trails on muleback, and living among Kentucky hill people (128-29). The writers' group offered Harriette Simpson the opportunity to share her writing with others and to receive the encouragement she had long sought. "I felt better then about my hope to be a writer. I no longer was the lonesome stranger" (Miller 1982, 89). She earned her Bachelor of Science degree in education from the University of Louisville in February 1931.

Partly because her father had died in July of 1929, she felt obligated to find a job that would allow her to contribute to the family income, so she returned to teach in the new rural high school near Somerset, the county seat of Pulaski County, Kentucky. Even though she liked her job, after some time there (apparently 1931-33), she resigned and moved midyear when she found out about an opening for a social studies teacher in a junior high in Louisville. She told an interviewer, "I was a fool to accept the job" (Hudson 1982), but "I thought how great it would be to be back in Louisville with a great library, theater, and . . . some of the friends I'd made at the University of Louisville" (Arnow, "Writing and Region" 1984). Barely four months later, in 1934, after being assigned the pupils with the lowest IQ's and the most discipline problems, the worry and work had taken their toll on Harriette Simpson's health; she was hospitalized for

anemia and a tonsillectomy. "I didn't stick it out till the end of the semes-
ter," she explained. "I don't think the principal would have had me back. I
hadn't done a very good job with those unruly children. . . . I was glad I
came down at the end of the semester with a throat infection, had my ton-
sils out, and went north" (Hudson 1982).

After working as a waitress in Petoskey, Michigan, during the summer,
Harriette Simpson moved to Cincinnati in the fall of 1934, to 118
Garfield Place, where she began what she called her "five-year plan." She
gave herself five years to write and support herself with whatever jobs she
could find. Even when discouraged in 1937, she would repeat her resolve
in a letter to an editor: "I still have some time of my five years to go, and I
guess I will stick to that if it kills me" (Letter to Harold Strauss, 25 March
1937).

Apparently, she shared a rented room or apartment with two younger
sisters. In December, their mother wrote, "Do you all three live together?
You have never sent any address but from the letters I gather you are all
together or nearby each other" (Letter, 1 December 1934).[2]

While in Cincinnati, some of her short stories were accepted for publi-
cation, mostly by "little magazines" of the 1930s. Arguably, two of her
most important short stories were published at this time: "A Mess of
Pork," which appeared in *The New Talent* (October-December 1935), and
"Washerwoman's Day," accepted by Cleanth Brooks and Robert Penn
Warren, editors of the prestigious *Southern Review*. The latter, her most
anthologized story, is an exposé of small-town hypocrisy, for which she
earned her first money as a writer—a check for $25. The former, a grim
tale of revenge masterminded by a young widow, caught the attention of
many readers, including Harold Strauss, an editor for Covici-Friede, a New
York publisher with a young novelist named John Steinbeck under con-
tract. After reading this story, Strauss wrote a letter praising it and asking
if she had ever considered working on a novel (3 October 1935). That let-
ter began a long, friendly correspondence, which led to the publication of
her first novel, *Mountain Path* (released August 1936).

Mountain Path is the story of Louisa Sheridan, a young teacher who, like
Harriette Louisa Simpson, took a job in a remote, one-room school in
Kentucky because she did not have the money to continue in school,
though she learned more in this rural community than in college. Arnow
began with "just a collection of characters" (Hudson 1982), and then, at
the urging of her editor to put in action, she "put in every kind of action

you could: moonshining, murder, romance." She admitted, "I wish now I'd left it alone but, my, I was happy when it was published" (Silberman 1980). Arnow recalled that the reviews were "surprisingly good" for a first novel (Arnow 1985). Before she could complete "Between the Flowers," her second novel, which remains unpublished, Covici-Friede went out of business.

She continued to live and work in Cincinnati and just across the Ohio River, in the northern Kentucky city of Covington. From the winter of 1935 until the winter of 1938, her address alternated between 118 Garfield Place, Cincinnati, and 1528 Greenup Street, Covington. With sisters living in Cincinnati for at least part of that time, she may have lived with one of them; or she may have rented a room closest to whatever work she had at the time. Her routine was to work for several weeks or months at a time, save some money, and then quit her job to stay home and write until her money ran out. Even though it was midst of the Depression, she claimed that she was "young and quick, and . . . could always get a job at something" (Hudson 1982). She worked as a waitress, typist, and sales clerk. She also worked as a writer for the Federal Writers Project, where she met Harold Arnow, a Chicago reporter, in 1938.

In August of 1938, Harold Arnow was living in Chicago and was writing to a Cincinnati acquaintance about job prospects, but by December, he had already written a friend about his plans to marry Harriette Simpson. By February, Harriette's address was a Cincinnati post office box. They married in a civil ceremony in Cincinnati on 23 March 1939, apparently without notifying either of their families.

When they married, they were already planning to become subsistence farmers and writers in Kentucky. Mollie Denney Simpson knew of her daughter's desire to move back to Kentucky and kept her ears open for news of local land for sale. After she wrote about some available acreage in the Keno neighborhood, Harriette and Harold came down to have a look at the old Cassada place, on Little Indian Creek, off the Big South Fork of the Cumberland River. The tract remains part of the Cumberland National Forest.

In June 1939, a bank in Somerset, Kentucky, acknowledged the receipt of Harriette Simpson's check for $493 and sent along a $300 promissory note for her to sign. She decided to buy the 150 acres in her maiden name, probably because she believed she could get a better price as a Simpson than as an Arnow, although this decision was to cause the Arnows a few

problems. They confused their neighbors, who believed men's names should be on deeds, and that a married man should buy land in his own name. When they moved to Keno in August, with Harriette five months pregnant, some of the neighbors rumored that the couple was not really married. Harriette Arnow reported, "the opinions and forebodings of most of our friends and all of our relatives . . . added little to our happiness." She nevertheless decided to keep a journal of their "first year in the backwoods, make a few carbons, send it out month by month, and let the curious circulate it among themselves" (Arnow "O Pioneer" 1949, 18).

This unpublished journal, titled "Early Days at Keno," is the most complete record available about her early married life in Kentucky. On the one hand, it reveals a domestic image of Arnow, the farmer and farm wife, wearing "overalls" (75) and what she called her "carefree garb" (166), busy outside looking after her chickens and vegetable garden, or busy inside cooking, canning, or cleaning up after chickens that she kept upstairs in the two-story farmhouse because there was no proper chicken coop. Her daily routine included milking and carrying water from a spring. On the other hand, the journal also shows Arnow the writer, typing at the kitchen table between chores, and in the evenings, sitting by the fire reading old copies of the *New York Times* (37, 72), drinking tea and working on drafts of short stories (66, 69), though it was far from an idyllic life.

An image that does not appear in the journal is that of Arnow as a mother. Although she records some days of lying in bed and reading, she has edited out most references to her first pregnancy, which ended in the stillborn death of her child, a son named Denny Abel Arnow. When he was born in December of 1939, the Arnows, who had read extensively about childbirth, did not anticipate the complications that nearly caused Harriette's death. They thought they could deliver the child themselves, without a doctor, though there may have been a midwife present. Arnow's experience with this first child, and with a third—a daughter who lived only a few hours—undoubtedly influenced her creation of such fictional mothers as *Hunter's Horn*'s Milly Ballew, who repeatedly looks at her living children and thinks of the two small graves of the children who continue to play in her memory.

The Arnows' dream to be subsistence farmers and writers in this remote place was, to say the least, more ambitious than they imagined. In the years they lived in Kentucky (1939-1945), they discovered that merely "subsisting" in a run-down farmhouse surrounded by deteriorating out-

buildings and unfenced, poorly managed land left little time for writing. They called their home the "Submarginal Manor." "We cooked and heated with coal," Arnow explained, "used kerosene lights, and water from a hard-water spring. I gardened, canned, jellied, preserved, pickled, [and] churned, . . . and through it all struggled against soot and coal dust" (Arnow 1973, 14).

When their savings were depleted, she taught at the local one-room school for two years (Arnow 1973, 14). One year was 1940-41, before her second child, Marcella Jane, was born on 9 September 1941. When Arnow became a teacher again in 1943, taking her daughter to school with her, she wrote to a relative that they met with "twelve pupils, two hound dogs, and two mules from about nine until three or for whatever hours the children decide to come and stay." She claimed to have done "practically no writing," though she was working on *Hunter's Horn* in her head (Arnow 1973, 14).

Arnow wrote most of *Hunter's Horn* after moving to Detroit. In 1944, when Harold received his induction notice, he moved to the city to find work and a place for his family to live. In January 1945, the Arnows moved into one of Detroit's Wartime Housing Projects, like the one that provides a crucial setting in Arnow's best-known novel, *The Dollmaker*. Living in wartime housing, she had become one of the immigrants that she would write about in her third novel. By then, the Arnows also had a two-year-old son, Thomas Louis, born 15 December 1946.

In 1946 Harriette Arnow signed a book contract with Macmillan and published two short stories from the novel manuscript. *Esquire* magazine, which did not accept submissions from women in the 1930s, had published "The Two Hunters" (July 1942) after she had signed it "H. L. Simpson" and sent along a photograph of her brother-in-law, when the editor requested a picture. She smiled mischievously when she later told an interviewer, "it worried me a little, that big lie, but I thought if they wanted a story, let them have it. So I did" (Kotlowitz 1983, 24). The *Atlantic Monthly* published "The Hunter" (November 1942), a story for which she gave her husband credit for coauthorship.

Arnow thought of *Hunter's Horn* as a sort of sequel to *Mountain Path,* because it further recorded the way of life and changes brought by "progress" in the same south central region of Kentucky that had been the setting for her first novel, which she originally entitled *Path.* For that reason, her working title for *Hunter's Horn* was "End of the Gravel," referring to the influence of roads on remote rural communities (Arnow 1963, xii-xiv).

When the novel was released in 1949, it not only received outstanding reviews, it was also named by the *New York Times Book Review* as one of the year's ten best novels, and *Saturday Review*'s national critics' poll voted it best novel of the year. It was concurrently released in England, and later released in Italian, Swedish, German, and French translations.

Riding this success, the Arnows began, once again, to think of buying land, this time in rural Ann Arbor, Michigan. In May of 1950, they purchased a forty-acre farm with a partially completed three-room house, a well, and a chicken house. They took a mortgage to complete the house and moved as soon as the renovations were finished. Living in Ann Arbor, Harold continued to work as a reporter for the *Detroit Times*, and Harriette received many requests for book reviews, articles, and speaking engagements. Some of these she accepted, but her main projects during this time were historical research for a "Cumberland book" she wanted to write and a novel manuscript that she thought of titling "The Highway," but that her editors encouraged her to entitle *The Dollmaker*.

The Dollmaker, released in April 1954, was immediately popular, a best seller and runner-up for the National Book Award, which was won that year by William Faulkner, for *A Fable*. The *Saturday Review*'s critics' poll voted *The Dollmaker* best novel of the year. The novel also had international appeal and was eventually translated into a number of foreign languages, including Spanish, French, German, Portuguese, Finnish, Israeli, Japanese, and Russian. The flurry of speaking invitations and correspondence had never been greater in the Arnow household.

Interviewers who sought out Harriette Arnow were often surprised at her petite 4' 10" appearance, because they expected to find big, raw-boned Gertie Nevels. When asked where Gertie, the dollmaker, came from, Arnow described some of the women she had known in the Kentucky hills. "I started imagining," she said, "how a woman who had never used gas or electricity, or lived in a place without plenty of space outdoors was making out. I began to think of that, and out of it all, slowly Gertie evolved" (Hudson 1982). To an Ann Arbor reporter, she admitted, "Do you know, I've never been certain what Gertie's face looked like?" (Silberman 1980). Gertie used to call her out of bed at 3 or 4 A.M., she said, so that she could write until 7 A.M., when the rest of her family would begin their day.

Long before *The Dollmaker* was so well received in 1954, Arnow had begun work on a nonfiction project, a history book titled *Seedtime on the Cumberland* (1960). This nonfiction book, which she had researched for

roughly twenty years, reconstructs the transitional years of early exploration and settlement from 1780 to 1803 along the Cumberland River in southern Kentucky and middle Tennessee.

Arnow's view of history makes the time and place very real. She explained that "times and places were mingled in my head. The past was part of the present, close as the red cedar water bucket in the kitchen. . . . Two things tied all time together . . . the land and the Cumberland" (Dykeman 1983, xii). *Seedtime* received an Award of Merit from the American Association of State and Local History, praising its "meticulous documentation, painstaking research, and colorful writing" ("Historical News and Notices" 1961, 299). The reviewers of this work agree that when a storyteller as talented as Harriette Arnow writes history, history comes alive.

When Arnow finished her first historical volume, she discovered that she literally had enough left for another book. In 1963, Macmillan published her second nonfiction book, *Flowering of the Cumberland*. It covers the same time period as *Seedtime* (1780-1803), so it is not a sequel, but "a companion piece," as she called it. Having already focused on the Cumberland pioneer as an individual, a lonely explorer, or a solitary settler, she turns next, in *Flowering,* to "the pioneer as a member of society" (Arnow "Introduction" [1963] 1984, xi)—the social life of the pioneer community. Her prose in this work, too, is often as captivating as in her fiction.

About the same time that Arnow's history books were going to press, she was sending another novel manuscript to Macmillan. Her title, *To You No Place* (1961), had previously been "Lucinda's Journey" (and "Journey for Lucinda"), as well as "John Dick's Travelogue." Arnow's letter accompanying the 427-page manuscript suggests that it may not be suitable for Macmillan, or any other publisher, but that she is ready for someone to read it. This strange story of "DD," a minister/farmer obsessed with finding a rare book in an Orwellian place, remains unpublished.[3]

When she talked about her next novel, *The Weedkiller's Daughter* (1970), Arnow acknowledged that it had not been a critical or a popular success, though she got letters from readers who told her it was the best book she had ever written. Set in a mid-1960s Detroit suburb, the novel focuses on the Schnitzer family: a father obsessed with killing weeds and destroying nature; his militant young son; and Susie, his daughter, a rebellious teenager with a social conscience.

Although Gertie Nevels makes an appearance in this novel as a character referred to as "the Primitive," Arnow explained that she did not use a

Kentucky setting when she resumed fiction writing at least partly because she had never wanted to be labeled as a writer who had concerns exclusively with one region or ideology. "I don't like to be labeled," she said, "but there is nothing I can do about it." She could rattle off a list of labels with which she had been tagged: realist, naturalist, Appalachian writer, regionalist, feminist, Marxist, even transcendentalist. Arnow preferred to be called simply "a writer" ("Ahead of Her Time" 1983, 7). If addressing problems in a locale far removed from Kentucky in *The Weedkiller's Daughter* made it more difficult to "pigeonhole" her, then that suited her fine.

Unlike the Schnitzers in her novel, the Arnows did not like the idea of living in "suburbia." They said they lived in "exurbia," in a slightly cluttered home they nicknamed "Bedlam" (Kotlowitz 1983, 15). She worked in a small room beside the garage, where the small-scale furniture fit her and where she could block out distractions by drawing the curtains and turning off her hearing aid. Sitting in a child-sized wooden chair, she wrote in longhand in a spiral composition book. Then, sitting "on an antiquated wooden milk crate turned on its side," she typed her manuscripts and correspondence on her manual typewriter (Kotlowitz 1983, 15; Smith 1987).

For her final two novels, one published in 1974, *The Kentucky Trace: A Novel of the American Revolution*, and the other as yet unpublished, Arnow returned to her knowledge and research of Cumberland and American history. Certainly she was disappointed in the unenthusiastic critical response *The Kentucky Trace* received, although she hardly mentioned it in interviews. She said that the Kentucky media had never reviewed many of her books—a debatable statement at best—and that she had fewer letters from Kentucky readers than from any other state. Even though she received the state's highest award for the arts, the Milner Award, in 1983, and was honored by Berea with an Outstanding Alumni Award the same year, the attention came, she thought, because of the 1984 Jane Fonda film version of *The Dollmaker*.

In 1983 she admitted that she was working on another novel, though she would only call it "a long manuscript." When asked about its subject, she usually said, "it's about people," but when pressed for more details, she confided to an audience at the University of Tennessee that it was "set in 1861 and '62 in the same south-central part of Kentucky" as much of her other work (Arnow 1984). This unpublished 867-page manuscript, which

she was revising when she died, she named for its main character, "Belle." Reminiscent of Gertie Nevels who faces the destructive changes brought by World War II to her family, Belle experiences the Civil War in intensely personal terms. In "Belle," Arnow again creates a strong female protagonist who faces wartime with courage, survival instincts, and the determination to protect her family. This novel, like her other best fiction, shows Arnow's concern for maintaining historical accuracy in telling a compelling story about a married woman who must live with her own choices, as well as those imposed upon her by others.[4]

Arnow returned annually to Kentucky to visit family and friends and to teach at the Hindman Settlement School Writers Workshop from 1978 until 1985. Her husband, Harold, a retired publicity director for the Michigan Heart Association, usually accompanied her, until his death in February 1985. While at Hindman in the summer of 1985, Harriette fell sick with pneumonia and had to be taken to the University of Kentucky hospital. There she felt "incarcerated, imprisoned" with a nurse who hated her: the nurse had taken her cigarettes. Soon she was well enough to transfer to the University of Michigan hospital and then home, where a nurse came by daily. On 22 March 1986, she died at her home in Ann Arbor. She had once said that when she died, she wanted her ashes scattered on the grave of Ronald Reagan, but that he would probably outlive her (Flynn 1990, 280). On 16 May 1986, her ashes were buried at Keno, Kentucky, next to her husband and their two infants.

Arnow's writing, of course, has a life of its own. The writer whose imagination gave us *The Dollmaker*, also gave readers four other published novels—*Mountain Path*, *Hunter's Horn*, *Weedkiller's Daughter*, and *Kentucky Trace*—as well as numerous short stories and essays, the autobiographical book *Old Burnside*, two "social histories" of the Cumberland, and a wealth of unpublished manuscripts and correspondence. The inscription on her tombstone, a line from Wallace Stevens's "The Idea of Order at Key West" stands as a tribute to her imagination and life as a writer: "she was the maker of the song she sang."

NOTES

1. When Harriette Simpson was born, the Commonwealth of Kentucky did not routinely issue birth certificates. When she applied for one in March of 1958, her eighty-year-old mother (born 9 April 1877) made two errors on the birth certificate concerning her own age: she listed her age at the time of Harriette's birth as thirty-one, though she would have been thirty in 1907, and she listed her current age (in March 1958) as eighty-one, though she was then eighty. These mistakes caused Harriette to dispute her mother's affidavit.
2. The most complete information about Harriette Simpson Arnow's life and work in Cincinnati can be found in Danny Miller's essay, "Harriette Simpson and Harold Arnow in Cincinnati: 1934-1939," *Queen City Heritage* 47 (Summer 1989): 41-48.
3. This text and others will be discussed in the literary biography of Harriette Arnow that I am currently writing.
4. Arnow published a chapter from "Belle" as a short story entitled "Interruptions to School at Home" in *Adena: A Journal of the History and Culture of the Ohio Valley* 5, no. 1 (Spring 1980): 40-55.

WORKS CITED

"Ahead of Her Time." 1983. *The Berea Alumnus* (July-August): 5-7.

Commire, Anne, ed. 1986. "Arnow, Harriette (Louisa Simpson)." Pp. 42: 30-31 in *Something About the Author*. Detroit: Gale Research Co.

Arnow, Harriette Simpson. [Harriet L. Simpson]. 1934. "Marigolds and Mules." *Kosmos* 3 (August-September): 3-6.

_____. [Harriette Simpson]. 1935. "A Mess of Pork." *The New Talent* 1 (October-December): 4-11.

_____. [Harriette L. Simpson]. 1936. "Washerwoman's Day." *Southern Review* 1 (Winter): 522-27.

_____. [H. L. Simpson]. 1942. "The Two Hunters." *Esquire* 18 (July): 74-75, 96.

_____. 1944. "The Hunter." *Atlantic Monthly* 174 (November): 79-84.

_____. 1949. *Hunter's Horn*. New York: Macmillan.

_____. 1949. "O Pioneer." *Writer's Digest* (January): 15-21.

_____. n.d. [1949] *What Berea Meant to Me*. Archives of Berea College, Berea, Kentucky.

_____. 1963. "Introduction." Pp. v-xiv in *Mountain Path*. Berea, Kentucky: Council of the Southern Mountains.

_____. 1970. *The Weedkiller's Daughter*. New York: Knopf, 1970.

_____. 1973. "Personal Recollections." *Appalachian Heritage* 1 (Fall): 11-15.

_____. 1977. *Old Burnside*. Lexington: The University Press of Kentucky.

_____. [1963] 1984. "Introduction." Pp. xi-xv in *Flowering of the Cumberland*. Reprint, Lexington: The University Press of Kentucky.

_____. 1984. "Writing and Region." Address to the Stokely Institute, University of Tennessee-Knoxville, 19 July.

_____. 1985. "Help and Hindrances in Writing." Address to Appalachian Writers Association, Morehead State University, Morehead, Kentucky, 29 June. See pp. 281-91 in this work.

_____. "Early Days at Keno." Special Collection. University of Kentucky Libraries, Lexington, Kentucky. Unpublished.

_____. Unpublished letters. Special Collection. University of Kentucky Libraries, Lexington, Kentucky.

Dykeman, Wilma. 1983. "Foreword." Pp. xi-xiv in *Seedtime on the Cumberland,* by Harriette Simpson Arnow. Lexington: The University Press of Kentucky.

Eckley, Wilton. 1974. *Harriette Arnow*. New York: Twayne.

Flynn, John. 1990. "A Journey with Harriette Simpson Arnow." *Michigan Quarterly Review* 29, no. 2 (Spring): 241-60.

"Historical News and Notices." 1961. *Tennessee Historical Quarterly* 20 (September): 299.

Hudson, Patricia L. 1982. Interview with Harriette Simpson Arnow. Hindman Settlement School, Hindman, Kentucky, 6 August. Unpublished.

Kotlowitz, Alex. 1983. "A View from the End of the Road." *Detroit News,* 4 December, 14+.

Lucas, Cora. 1976. "'A Dream . . . That's What I Came Out For': A Recollection and Appreciation of Harriette Arnow." *Adena: Journal of the History and Culture of the Ohio Valley* 1, no. 2 (Fall): 126-36.

Miller, Danny. 1982. "A MELUS Interview: Harriette Arnow." *MELUS* 9, no. 2 (Summer): 83-97.

_____. 1989. "Harriette Simpson and Harold Arnow in Cincinnati: 1934-1939." *Queen City Heritage* 47 (Summer): 41-48.

Silberman, Eve. 1980. "Harriette Arnow: Ann Arbor's Most Acclaimed Novelist, Author of *The Dollmaker*, Shuns the Literary Scene." *Ann Arbor Observer,* March: 3+.

Smith, Herb E. 1987. *Harriette Simpson Arnow*. Whitesburg, Kentucky: Appalshop. Film.

Warfel, Garnet. 1949. "Woman Novelist Recounts Career Rescued by a Cow." *Detroit News,* 24 May, n.p.

HARRIETTE SIMPSON AND HAROLD ARNOW IN CINCINNATI: 1934-1939

DANNY L. MILLER

In midautumn 1934, at the age of twenty-six, Harriette Simpson came to Cincinnati. She lived in Cincinnati for six years, leaving in 1939, never to live here again. Those six years in Cincinnati were very important in Harriette Simpson's life, both personally and professionally; the years spent here were formative and influential. During her years in Cincinnati, she published her first short stories, finished and published her first novel, gained "worldly" experience working at numerous odd jobs, worked as a writer for the Federal Writers Project of the WPA, and met and married Harold Arnow. As Wilton Eckley, her only biographer thus far, has stated, "The largest town she had ever known, Cincinnati was probably for Harriette what London was for Boswell" (Eckley 1974, 37).

During the years preceding her arrival in Cincinnati in 1934, Harriette Simpson had alternately been a student and teacher in her native Kentucky. Following her graduation from Burnside High School in Pulaski County at the age of sixteen in 1924, she attended Berea College. There were several aspects about the College which Harriette found disturbing. One day, for example, while Harriette was doing her student labor at the college's Fireside Weaving, a "woman with an accent very different from the ones [she] knew," asked her if either of her parents, both of whom were well-educated, could read or write (Eckley 1974, 32). Harriette was mortified and angered by this stereotype of the Berea student. She was also not happy with Berea's attitude against smoking or wearing silk stockings (Joyner 1986, 52). She was even more discouraged by the fact that at Berea she "found no one, either teacher or pupil, the least bit interested in writing"

Originally published in *Queen City Heritage* 47 (Summer 1989): 41-48.

(Miller 1982, 88). She received a teaching certificate from Berea in 1926 and began teaching in the rural schools of Pulaski County.

Her first teaching position was at Possum Trot (Hargis One Room School), "in the bend of the Cumberland River, a remote place, about sixteen miles from [Burnside]" (Miller 1982, 89). She was eighteen and was doing what her family, especially her mother, had long planned for her. Harriette's mother had herself been a rural schoolteacher before her marriage and wanted her daughters, including Harriette, to become teachers. After teaching in Pulaski County for another year, this time as principal of a two-year elementary school closer to Burnside, Harriette continued her education at the University of Louisville, where she received the Bachelor of Science degree in 1931. She found life in Louisville exciting and her experience at the university more rewarding than at Berea. One reason was that she found others interested in writing and was a member of an informal literary society which made her feel better about her aspirations to be a writer (Eckley 1974, 36). After receiving her degree she returned to Pulaski County, where she took a teaching position in the newly-built high school, one of the best schools in the state at that time. However, longing for the city once more, Harriette left Pulaski County at mid-year and took a replacement position in a Louisville junior high school.

There were many motivation and discipline problems in the school in which Harriette taught in Louisville, and by the end of four months she was suffering from anemia and low blood pressure (Eckley 1974, 36). At the end of the school year she went to the Conway Inn in Petosky, Michigan, where she had worked one summer before as a waitress. Here, while again waitressing, she began to recover her health, but more importantly, she began to write her first novel and to think of herself as a writer. Of those years leading up to the summer of 1934, Harriette wrote: "I earned the required certificate [teacher certification at Berea] and taught two terms in the Pulaski County rural schools. Mama was pleased. I next attended the University of Louisville until I had earned a degree. Meanwhile, I had learned my future depended not on the plan of another, but on fate and myself" (Arnow 1977, 125). When she left the Conway Inn, Harriette had resolved that she would never be a teacher again. Instead of going back to Kentucky, she came to Cincinnati, determined to be a writer. "I decided I would rather starve as a writer than a teacher," she has said (Joyner 1986, 53). Even though she was twenty-six at the time,

her family saw this move as quite scandalous. Harriette described it: "I said good-bye to teaching, and much to the horror of my relatives, settled myself in a furnished room in downtown Cincinnati. I did what I had dreamed of doing all my life: gave the major part of my time and mind to reading the great novels and trying to write, while supporting myself with odd jobs—typing, waitressing, salesgirl" (Miller 1982, 83).

Cincinnati in the 1930s was a stimulating and exciting place for Harriette to be, despite the national Depression. Harriette has described her move to Cincinnati as "big emotionally" and that in making the move she "was no longer a coward" (Smith 1987). Wilton Eckley has described Cincinnati during the 1930s:

> Cincinnati in the 1930s was quite an interesting place—a city where the old German culture mingled with the beginning of the invasions from the South. Then, too, there were the old, old families who had migrated westward from the colonies during the eighteenth century. German bands, strolling musicians, the call of newspaper boys—all filled the streets with sounds. . . . (Eckley 1974, 37)

All of this must certainly have had an influence on the young woman from Kentucky. Harriette supported herself with jobs which allowed her time to write. She found a place to live close to the Public Library, a furnished room on Garfield Place. She must have felt then about Cincinnati as she later felt about living near Detroit: "I like to live near a city. A city is, or was, supposed to be man's greatest achievement—a symbol of civilization" (Miller 1982, 85). Likewise, she has said about the lure of the city: "I grew up within hearing of train and steamboat whistles [at Burnside], and most of the time I looked toward the world of which they spoke—Nashville, Cincinnati, Detroit, Louisville, Chicago. That world had taken most of my people and would I knew in time take me; it offered most" (Arnow 1985, v).

Harriette must have found great excitement and enthusiasm in having one of the nation's largest and best public libraries close at hand. In the 1930s Cincinnati's Public Library, whose history extends back to 1802, was located at 629 Vine Street, next to the Enquirer Building on the site of the present Shillito's Garage. This building had been the site of the city's library since 1874. The building was described thus:

Its most conspicuous feature was the huge main hall surrounded by four tiers of balconies joined by circular iron stairs. Fluted columns, carved black walnut woodwork, circular stained glass windows, sculptured panels, patterned marble floors, and the wide marble stairs leading from the lobby to the main hall contributed to its Victorian elegance. Then said to be the most magnificent and imposing library building in the country, it was destined to house Cincinnati's Public Library for 81 years and to be demolished when the Library was removed [in 1955]. ("The Library—Its History")

During the decade of the 1930s, the Library was described as "the most important example in the country" of the type of library governed by boards, the county commissioners, or other governing body of the county (*A Decade of Service*). Harriette has stated that one of the things a writer needs is a "great library system" (Miller 1982, 85), and she must have spent many pleasant and productive hours at the Cincinnati Library.

Harriette mapped out a plan of study of the novel for herself and began reading the great novelists, among them Tolstoy, Dostoyevsky, Sigrid Undset, Zola, Flaubert, Hardy and Wladyslaw Reymont (Miller 1982, 95; Eckley 1974, 38). As well as reading the great novelists, Harriette also "became more cogently aware of what was going on in the world," as Wilton Eckley states:

Close to the restaurant where she worked was a newsstand where the *New Masses* and the *Daily Worker* were on sale; and, having heard so much about the proletariat, Harriette decided to learn what she could about them through reading in magazines and books. What she found, however, disappointed her. Or perhaps it would be better to say what she did not find: she did not find people treated as individuals, only as faceless masses. Her own background had taught her that even illiterate, humble people could carry on an organized and meaningful life and that such people were not without insight and emotion. (Eckley 1974, 37)

These insights surely influenced Harriette in her Appalachian novels, which present the Appalachian hill people not as faceless masses but as unforgettable individuals.

Personally, as she has stated, Harriette worked in Cincinnati at various odd jobs—only "to pay the rent and eat" (Ulman 1954-55, 200). One of her first

jobs in the city was working as a waitress at one of the city's most respected establishments, The Woman's Exchange, a Cincinnati institution dedicated to helping the city's women. A non-profit cooperative founded in 1883, the Woman's Exchange, which ceased to exist in 1985, began as a small shop on Race Street which served a lunch of oyster stew, chicken pie, tea and sandwiches. By the 1930s the Exchange was a multi-million dollar consignment cooperative, similar to others in the nation but unique in that it kept its commission to the lowest in the country. Women of Cincinnati's leading philanthropic and long-established families had begun the cooperative, their articles of incorporation stating their aims: "The object of said corporation is not for profit, but is for charitable and benevolent purposes, by assisting women in need of aid and assistance, by helping them to help themselves; and in furtherance of this design to maintain a depot for the reception and sale of woman's work or of articles in her possession, and which she may wish to dispose of . . ." ("Woman's Exchange"). When Harriette Simpson worked there the Woman's Exchange was located in a four-story building at 113-115 West Fourth Street, where they sold articles made by consignors in their various shops, such as their bakery and specialty shops. The lunchroom of the Exchange "had a humble beginning" ("Woman's Exchange"). At first, a few tables and chairs were placed in the small space under the stairs, but the specialties served there made it so famous that the public demand resulted in an ever-increasing space. The restaurant/lunchroom was the mainstay of the Exchange's operating expenses.

One interesting short story of Harriette's, written in 1937 or 1938 but not published until 1979, uses her experience as a waitress (probably at the Woman's Exchange) as a background. The story, "Fra Lippi and Me," is about a poor waitress who chances to overhear a conversation between two diners, one an obviously wealthy matron, Mrs. George Henry Wakefield, the other a struggling young artist. Mrs. Wakefield is obviously more interested in the artist than his art, although she tells him that as an impressionable sixteen year old she was painfully impressed by Browning's "Fra Lippo Lippi" and vowed "if it ever lay within [her] power to save a struggling young artist from the fate that strangles [a] genius [such as Fra Lippi's]," she would (Arnow 1979, 871). The artist has apparently "sold" himself for Mrs. Wakefield's patronage. Explaining Fra Lippi (and himself) to Patsy, the waitress, he says: "He didn't want to starve, so he worked to please. When he was sorry he couldn't change" (874). Like the artist, Patsy, apparently a country girl (from Kentucky), is also confronted with a choice

between integrity and survival. A wealthy man who comes into the restaurant daily, and to Patsy appears very "lonesome," presses her to become his mistress, although she has a husband in Detroit. In the end, like the artist, who has walked slowly and reluctantly away to join Mrs. Wakefield, Patsy slowly walks to the phone to call her suitor. The theme of the story seems to be that life and art are the same, that when one sells oneself in either case, the outcome is tragedy. "Fra Lippi and Me" vividly evokes the harassed lot of the waitress, trying to please customers and supervisor with a smile all too hard to maintain (Patsy has twice been reported for "not smiling"). The story reveals Harriette's personal knowledge of being a waitress, as well as the class consciousness which is also a theme in *The Dollmaker*.

In 1936, at the time she published her first novel, *Mountain Path*, Harriette was a waitress at the Woman's Exchange, although the dust jacket of the book stated that she had had fourteen jobs during the year before the book was published ("Cincinnati Waitress"). As she remembered it, the *Enquirer* headline which announced the publication of *Mountain Path* was "Waitress Writes Book" (Eckley 1974, 39), perhaps remembered this way because of its shocking effect on her mother. It wasn't bad enough that Harriette had left the security and stability of home and profession to become a waitress; her mother was also scandalized by the novel's story of a young woman somewhat like Harriette herself who goes to a remote Kentucky community to teach school (as Harriette had done) and who falls in love with a moonshiner: "My mother was furious. She said, 'Everybody will think you fell in love with a moonshiner down there'" (Miller 1982, 91). Actually, the title of this article was "Cincinnati Waitress Revealed As Novelist By Publishers of Kentucky Hills Story." The opening sentence stated: "Disclosure that a young woman who waits on tables at the Woman's Exchange is 'a new and remarkably gifted novelist' was made yesterday with the announcement that Covici Friede, New York publishers, will release the first novel written by Harriette Simpson, 1528 Greenup Street, Covington, next Tuesday." It is interesting to note that at this time Harriette was living in Covington, perhaps desiring to get back to her native state, even if in its northernmost reaches.

Not all of Harriette's jobs in Cincinnati were odd jobs such as waitressing. Soon after the publication of *Mountain Path*, Harriette joined the staff of the Federal Writers Project. According to Harry Graf, the first director of the Federal Writers Project in Cincinnati, "The primary purpose of the WPA was employment, preferably at worthwhile work not intrusive to pri-

vate industry and the unions. All projects required non-profit sponsorship" (Graf "A Long Look Back"). Graf became the district supervisor of the guide work in Cincinnati in late spring 1935. This office went on to produce a substantial amount of materials relative to Cincinnati and Ohio history, including the Ohio Guide, the Cincinnati Guide, and several other works.

Historical research and writing were the dual aims of the Writers Project, which had a staff eventually of about 45. None of these had prior historical research experience although several, including Harriette, came to the project with different kinds of writing backgrounds. When asked about those who "went on to do something else, or to become prominent," Harry Graf unhesitatingly said, "Yes, Harriette Simpson. . . . Harriette came in fresh from teaching school down in the mountains of Kentucky. I remember when she first came in, in a gingham dress, white stockings, flat heeled shoes, big eyes, wearing glasses." Graf stated that Harriette did a lot of work on one of the books, *Tales of Old Cincinnati*: "I remember it was 64 pages or something. But illustrated. It's a children's book, more or less. Harriette dug up a lot of these stories about old Cincinnati. It has a lot of folklore in it. We published it as one of a series of booklets which were used in the public schools" (Graf "Interview"). This series of books, which was sponsored by the Cincinnati School Board, seems to have consisted of three volumes, or four if we include *Tales of Old Cincinnati*. Harriette was credited as one of three Federal Writers Project authors responsible for *Cincinnati: Glimpses of Its Youth* (1938) and *Cincinnati: The Childhood of Our City* (1938), in addition to *Tales of Old Cincinnati*, as well as working on the Ohio and Cincinnati Guides. Harold Arnow, also a member of the Writers Project, was credited in *Cincinnati: Highlights of a Long Life* (1938), the third in the series. It was while working for the WPA that Harriette met Harold Arnow.

Harold Arnow arrived in Cincinnati around 1936. Born in Chicago, the son of Louis Arnowitz and Ida Abelowitz, immigrant European Jews, Harold actually had several connections in Cincinnati. Harris Abelowitz, Harold's maternal grandfather, appears to have arrived in Cincinnati in the early 1890s. His first wife, the mother of Harold Arnow's mother, Ida Abelowitz, died in Riga, Latvia, when Ida was only two or three. This woman, whose maiden name was Schneider, had many relatives who emigrated to Patterson, New Jersey where they worked in silk mills (and possibly woolen mills) before moving on to Cincinnati and Chicago. The

orphaned Ida was sent, "alone with a tag around her neck, to America at the age of six" (Marcella Arnow). Ida was raised partly in Cincinnati and partly in Chicago. Harold and Harriette's daughter, Marcella Arnow, states: "[Ida's] father was, apparently, a cantor, and also worked in the family matzoh factory, but I have not been able to find any more information about his role in the Orthodox Jewish community of Cincinnati of that day." In 1903 Harris Abelowitz remarried and had one child, Meyer (Mike) Abel, who was a painter and art teacher in Cincinnati. These connections to Cincinnati may in part explain why Harold come to this city in the 1930s.

Marcella Arnow continues the story of her grandparents' lives: "Sometime in 1907 a marriage was arranged between Ida, then 17, and Louis Arnowitz, a tailer who had emigrated from Telz, Lithuania in the mid 1890's with his father, brothers and a sister. He was about sixteen when he came. The name 'Arnowitz' is exceptionally rare, and may be Sephardic in origin. Louis settled in Chicago, and soon had a thriving tailor shop; he specialized in making suits for oddly shaped and sized men—concealing deformities and hiding paunches." Harold was born in Chicago in 1908 and his brother Robert in 1912. Around 1920 Louis and Ida were divorced, and, as Marcella Arnow states: "After the divorce, Ida became an insurance agent— apparently a reasonably successful one. Thus, the two boys grew up in Chicago in circumstances which ranged from penury to relative affluence." Harold went to Austin High School and for a year to the University of Illinois. He then spent three years in Alaska as a fur trader and salmon fisherman before returning to Chicago as a crime reporter for the City News Bureau. A union organizer for the Newspaper Guild in the mid 1930s, he was blacklisted, and, having been promised a job on a paper in Cincinnati (which did not come through), he moved to Cincinnati where he went to work as an editor for the Federal Writers Project and met Harriette Simpson. Their backgrounds could not have been more dissimilar and perhaps that is what attracted them to each other.

One of Harriette's unpublished short stories, entitled "Sugar Tree Holler," is, according to their daughter Marcella, "extremely autobiographical." Loosely organized around a young WPA worker's fear that the little money she has saved will be taken away from her by the FBI, "something like G-men only they work on the WPA people instead of just plain criminals" (3), this story concerns the courtship and marriage of two people whose lives are in many ways those of Harriette and Harold. The woman is called Susie (Susan Hardwick) and the man Abel (his full name

being Mike Abel, interestingly the name of Harold Arnow's uncle in Cincinnati). Susie is a Kentucky girl working for the WPA in Cincinnati and Abel, also working for the WPA, is "that new editor from Chicago." It is told in an epistolary form as letters from Susie to her cousin Sadie in the Kentucky hills and tells on the one hand of Susie's fears for her money and her job and on the other of her relationship with Abel, first suspicion, then increasing admiration and finally marriage. The respect which Susie feels for Abel is obviously a reflection of Harriette's feelings for Harold Arnow, a deep and abiding love which sustained them until their deaths. This great respect and love were extremely evident even in their last years as evidenced in the film *Harriette Simpson Arnow*. "Sugar Tree Holler" gives interesting insight into the everyday life of the WPA Federal Writers Project office and some insight into life in Cincinnati at the time. One vivid description is of the poorer West End, where Abel lives.

One of the most interesting features of this unpublished story is its humor. For example, in the middle of a letter to Sadie, as fellow co-workers pass by Susie will abruptly break off her personal letter and into a section of the WPA Guide book which she is supposed to be writing rather than a letter to Sadie:

> Maybe they've already investigated all the WPA workers, and they know I have a Postal savings, and when that investigator comes she'll know it, too, and she will ask me right out what about my $140 dollars [sic]. I never could lie to do any good. And what if I take it out right quick. That will show intent to deceive and that will be worse than dinosaurs and elephants in this country several million years before Christ. The dinosaurs ate grass and were related to snakes and fishes and looked something like overgrown crocodiles. The elephants also ate grass but were not related to fishes. Before the mastadons and the dinosaurs lived the country was covered with oceans and in the oceans swam—Lawton passed by, and I didn't want to take any chances of his looking over my shoulder. He didn't though. (3-4)

Another noteworthy aspect of this story is its foreshadowing, much like "Fra Lippi and Me," of some of Arnow's major themes in *The Dollmaker*. One, for example, is the class struggle and the negative attitudes of city dwellers toward "hillbillies" from the country. Susie writes Sadie, "They couldn't fine me more than $140 dollars, but they might send me to prison

for I don't think from some of the remarks they make that they like Kentuckians up here working on the WPA so well anyhow . . ." (3). Another theme of *The Dollmaker* foreshadowed in "Sugar Tree Holler" is the importance of owning one's own land. Susie dreams of Sugar Tree Holler, "all that pretty poplar and cedar and pine" and of how she wants to escape from "all these beer drinking people" (3). She tells Abel about her "plan of saving money for land all of [her] own, so that [she] can be independent and not starve . . ." (2). This is the very same attitude of Gertie Nevels in *The Dollmaker*.

Certainly the kind of writing experience which Harriette received while working for the Federal Writers Project must have benefited her. The influence of this kind of social-historical research, particularly in its oral, folklore aspect, can be seen in Harriette's two widely acclaimed social histories of the Cumberland area, *Seed Time on the Cumberland* and *Flowering of the Cumberland*. She had, of course, had a native interest in folklore, spurred by the stories handed down for generations in her own family of long established Kentucky pioneer stock, and her work in Cincinnati with the WPA perhaps gave her the confidence and skill to undertake a historical study such as her study of the Cumberland region. In addition, Cincinnatians are indebted to Harriette, Harold, and other writers of the Federal Writers Project for much of the history of Cincinnati which might have otherwise been lost.

One other major experience in Harriette's life in Cincinnati made a lasting impression on her, the great Flood of 1937. Marcella Arnow states: "The Cumberland River at Burnside was in the habit of flooding, but my mother's memories of the great Cincinnati flood were particularly vivid. She might have been writing "Between the Flowers" when it occurred (she evidently finished the manuscript sometime in 1938) and its spectacular account of a flood must have made use of her memories of the runaway Ohio, as well as of the Cumberland."

Harriette and Harold Arnow spent the last years of the 1930s in Cincinnati. They were married in Kentucky on March 23, 1939 and shortly afterward moved to a farm in Kentucky, much like the dream of Susie Hardwick in "Sugar Tree Holler." Here, at what they called "Submarginal Manor" (Harriette has referred to them as the "original hippies"), they hoped to be subsistence farmers and to write (as Susie Hardwick had written to Sadie, she hoped to buy the land in Sugar Tree Holler and "still try to write my animal stories for children"). Much of what they had experienced

in Cincinnati shaped their lives and their work, especially Harriette's novels and stories. Not the least of the results of their coming to Cincinnati was that they met and were married, a loving union which lasted until Harold's death in 1985. Harriette died in 1986 (during the night of March 22-23, March 23rd being her wedding anniversary). They never returned to Cincinnati to live but the years spent here in the 1930s were indeed significant.

WORKS CITED

Arnow, Harriette. 1979. "Fra Lippi and Me." *The Georgia Review* 33 (Winter): 867-75.

———. 1985. Introduction to *Mountain Path*. Lexington: The University Press of Kentucky.

———. 1977. *Old Burnside*. Lexington: The University Press of Kentucky.

———. 1988. "Sugar Tree Holler." Unpublished story. Used by permission, estate of Harriette Arnow.

Arnow, Marcella. 1988. Letter to Danny L. Miller, 27 February.

"Cincinnati Waitress Revealed As Novelist." 1936. *Cincinnati Enquirer,* 19 August, 22.

A Decade of Service: 1930-1940. Folder in Public Library of Cincinnati and Hamilton County.

Eckley, Wilton. 1974. *Harriette Arnow*. New York: Twayne.

Graff, Harry. 1986. "Interview." By Deborah Overmyer, Geoffrey Giglierano and Frederick propas. Cincinnati, Ohio, 2 October. *Bicentennial Guide* files, Cincinnati Historical Society.

———. 1987. "A Long Look Back." *The WPA Guide to Cincinnati*. Cincinnati, Ohio: Cincinnati Historical Society.

Joyner, Nancy Carol.1986. "Harriette Simpson Arnow." *Appalachian Journal: A Regional Studies Review* 14, no. 1 (Fall): 52-55.

"The Library—Its History." Folder in Public Library of Cincinnati and Hamilton County.

Miller, Danny. 1982. "A MELUS Interview: Harriette Arnow." *MELUS* 9, no. 2 (Summer): 83-97.

Smith, Herb E. 1987. *Harriette Simpson Arnow*. Whitesburg, Ky.: Appalshop, 1987. Filmstrip.

Ulman, Ruth. 1954-55. "Harriette Arnow." *Wilson Library Bulletin* 29:20.

"Woman's Exchange Is Unique: Helps Others Help Themselves." 1944. *Cincinnati Enquirer* 16 January, sec 4:1.

ARTISTIC VISION

WILTON ECKLEY

That Harriette Arnow will go down in the American literary chronicle as a major figure is, at this point at least, highly improbable. Four conventionally written novels—in a time, unfortunately, when such have not been readily accepted by critics and scholars as being on the cutting edge of creativity—are hardly enough to establish her in the major category. As an artist, however, she certainly needs no defense. A realist who rejects such things as experimental forms, complex plots, sentimental themes, the pyrotechnics of sex, and the contemporary mania for neurotic protagonists, she combines in her work a penetrating and sensitive insight into the human condition with a lean prose style—a combination that has been responsible for a literary output that, though thin in quantity, is abundant in quality.

Reflecting on modern stylistic trends in literature in a paper presented at the Book and Author Luncheon of the Special Libraries Association Convention in Detroit in 1955, Mrs. Arnow decried what she regarded as a movement away from simplicity in writing to complexity:

> But today our modern literature, the work of most of the big five, productions labeled as art, reflect something of the feeling of the age that mankind is not worth the study of the artist; that art and its medium belong to a world which too often only the initiated can enter. Once men attempted to convey complex thoughts in simple words and though sentences might be long they were based on a long study of the language. Today we often cannot find the thought for the complexity of words. A

From Wilton Eckley, *Harriette Arnow,* copyright 1974 and reprinted with the permission of Twayne Publishers, a division of G.K. Hall & Co., Boston.

sentence can be loaded down with useless whiches, average five preposi-
tions to every verb, violate all rules of grammar, and wander thus for two
pages. Still, if it be comprehensible to the learned few it is art; the fewer
who can understand, the greater the art is held to be. Thus our young
ones who would write poetry and novels look not to the world for inspira-
tion, nor to a period of apprenticeship to learn a craft; craftsmanship is
out, and art springs forth full-blown. There are learned ones to criticize
and explain; only the few can understand the criticism. Literature is not
for the masses but for the student of literature, and unlike former times,
people learned in other fields but uninitiated in modern literary symbol-
ism cannot enter. They can follow the literary artist no more than the lit-
erary artist can understand a paper concerned with some chemical change
brought about by a nitrogen-fixing bacterial. I often think, in all this hue
and cry over atomic secrets, that if only scientists could invent a language
as obscure as much of that of our modern literary art, we need never worry
again over atomic leaks.[1]

Some years later, in another discussion of style in writing, she stated, "I
think a mistake the young make is studying style overmuch—say of such a
writer as Faulkner. Style alone does not make a writer, and I'm happy to
say that I think there is less emphasis on style now than there was a few
years ago. I prefer reading the letters and journals of such a one as
Stendahl, who wanted no style, who wanted his writing to be as clear and
concise as a police report."[2]

A reader of any of Mrs. Arnow's works would surely agree that her writ-
ing is clear and concise—not so much, perhaps, as a police report, but cer-
tainly enough so that her story-lines, her characters, and her descriptions
are not obstructed by verbal effusion or highly stylized rhetoric. Using
short, precise strokes, she evokes a mood, paints a scene, focuses on a dra-
matic moment, or isolates some aspect of a character that makes him live
for the reader. The result is a style that serves as an unobtrusive and artisti-
cally effective vehicle for Mrs. Arnow's themes.

In her writing, then, Mrs. Arnow has been content to be a simple story-
teller, attempting to record honestly the nature of human experience as she
conceives it. Her mountain fiction, for example, goes beyond the mere
local-color approach that marked that genre for so long. More than just
presenting the sights, sounds, beliefs, customs, institutions, and such of
the area and its people, she brings out the tragedies and ironies engendered

in a severely isolated and circumscribed way of life. In the same way, she casts a hard light on the environmental and social conditions that limit her characters in urban settings—a housing project in *The Dollmaker* and an exclusive suburb in *The Weedkiller's Daughter*.

Background, of course, is of great significance in this process. In reminiscing about her own reading choices, Mrs. Arnow remarked, "I know there are novels and novels, but I have always enjoyed reading a novel with background that takes me sometimes into an entirely different world. When I was in my early teens, I first read Thomas Hardy; and I could feel a kinship, because his characters were in hills and woods—different from what I knew; but the backgrounds merged with the people."[3] In this comment, she might well have been talking about her own work. Sense of place, for example, could hardly be more strongly evoked than it is in *Hunter's Horn* and *The Dollmaker*; and the same could be said to a somewhat lesser degree of *Mountain Path*. Only in *The Weedkiller's Daughter* does this sense seem diminished—the reason perhaps being that Mrs. Arnow was writing not so much from experience as from observation, and thus she was a little less sure of her material.

Through all of Mrs. Arnow's fiction, character rather than plot shapes the stories. In discussing how *Hunter's Horn* came about, for example, she explained that it started with a man.[4] She had never owned a fox hound, but she had heard of men obsessed with fox hunting—forever hunting but very seldom getting; for a good, swift, young fox is elusive indeed. Out of it all came Nunn Ballew, a man who drops everything to hunt a fox—a man whom Mrs. Arnow does not see as worthless and irresponsible, but as one whom she "rather loved."[5] He was, she said, "no different from the modern businessman who sacrifices all for position and money in the business world."[6] These views of Nunn are interesting because they underscore what the reader sees reflected in the stories. First, Mrs. Arnow is able to instill individuality in types. Second, she is able to project herself into her characters—seeing things the way they see them. Third, she does not evaluate her characters, either ethically or morally—letting their actions speak for themselves. Fourth, she gives her characters a universal significance.

Of Mrs. Arnow's characters, the women stand out as the strongest and the most fully developed. Other than Nunn in *Hunter's Horn*, no male character is developed to any real degree. The reason for this lack of significant male characters is not that Mrs. Arnow is unable to portray men, because

as her treatment of Nunn illustrates, she can project herself into the male psyche as well as into the female one. Perhaps it is engendered in her feeling that American literature has exhibited a paucity of truly substantial women characters.[7] In an interview with Evelyn Stewart of the *Detroit Free Press* in 1958, she remarked that she hated to "emerge from the Eighteenth Century" because "life was better for women way back then."[8] Though women did not have to compete with men then, they had, in Mrs. Arnow's mind, more power than now. "And the men didn't hate women then, the way they do now," she went on. "Men and women were yoke-mates, pulling together. Now they're pulling different ways, each trying to manipulate the other and run the other's life."[9] No better example of this view, perhaps, can be found in her own fiction than in the conflict between Gertie and Clovis Nevels in *The Dollmaker*.

Mrs. Arnow's characters, more often than not, are trapped by social restrictions and environmental forces from which they cannot escape. In *Mountain Path*, Chris Bledsoe seeks violence and revenge because they are part of the code under which he has grown up. Louisa knows the potential that is within Chris, but she also knows that it can never be realized in Cal Valley. Time for him has run out, and all that remains is for Louisa to build her future in light of what she has learned.

In *Hunter's Horn*, Milly, Nunn, and Suse—all three—are limited by conditions which they do not fully comprehend. Milly stoically accepts her lot with a fatalistic "Oh, God, it's hard to be a woman."[10] Nunn and Suse both try to escape: Nunn, through chasing King Devil; Suse, through dreaming of a life in the outside world. When Nunn's chase is finished, he, too, is in a sense finished. By condemning Suse, he has reverted to a viewpoint common enough among his neighbors, but which he for a time had escaped. Suse has never tasted the pleasures nor felt the opportunities of the outside world, but she knows that somewhere there exists a place better than Little Smokey Creek—a place where excitement abounds and where love is possible. She doesn't really learn from Lureenie's experiences that the outside world also has its relentless forces that can grind one to the ground.

In *The Dollmaker*, Gertie Nevels learns firsthand of such forces in the world away from the mountains. She sees her family come apart: Reuben rejects Detroit and returns home; Clytie and Enoch drift away from the old traditions amid the pressures to conform; and Cassie is killed because she is unable to express her own innocent version of love and affection in a world

that will not understand. More than learning about city life, Gertie experiences a kind of revelation. Her creative spirit that flourished so freely in Kentucky is crushed in Detroit, but in return she achieves an understanding of humanity that was not available to her before. Whether the price she pays is too great is left for the reader to decide.

In *The Weedkiller's Daughter*, Susie Schnitzer serves as a contemporary illustration of the theme of the individual versus the human condition. She is Louisa Sheridan, Suse Ballew, Gertie Nevels embodied in a teenaged girl. Wise beyond her years and clever almost beyond belief, Susie rejects everything that militates against her being herself. She triumphs—at least temporarily. In doing so, she is not so much a real person as she is a symbol of what Mrs. Arnow has been driving at all along—that only when one searches out and nourishes his own natural yearnings and only when he learns humility and compassion can he truly be an individual.

All of Mrs. Arnow's fiction reflects an ironic approach. While she may be simply a storyteller, she does not oversimplify; for life is not to be explained in simple terms or easy philosophies. She knows, and her characters learn, that life is full of contradictions as well as harmonies and that good and evil are not always clearly discernible, but often overlap or fuse. Moreover, while she does not have an uncritical faith in human nature, she does not take a stance of superiority over her characters. She sees them as human beings—often cruel, often kind, and often bewildered by the world in which they live. Nor is she the obvious iconoclast or preacher with regard to human institutions and beliefs. She may, for example, draw devastating pictures of fundamental religion, be it of the Kentucky Protestant variety or of the Detroit Catholic variety, and of the right-wing bigotry of such people as Susie Schnitzer's father; but she does not let thesis impinge upon art. Rather, her characters and their actions speak for themselves—and often eloquently.

Closely related to Mrs. Arnow's ironic point of view is her treatment of nature. Throughout her stories runs the idea that nature, timeless and bigger than man, is the ultimate reality; but it, too, has its ironies. While in all the novels Mrs. Arnow sees an affinity between natural life and moral life, she does not flinch from the threatening aspects of nature. Indeed, the relationship between man and nature is not a reciprocal one so much as it is a one-sided one. It is a man that must adapt to nature, for only in a correct adaptation can he find real sustenance; and this lesson is what many of Mrs. Arnow's characters either know or learn. Nunn Ballew, for example,

discovers the folly of making nature (the fox in his case) a symbol of something more than it is. King Devil is neither good nor evil but merely a fox trying to stay alive in the world in much the same way that Nunn is. Nunn, by attributing malice to the fox, suffers from an intellectual and moral misconception of the way things are. He does not understand what Susie Schnitzer does—that man's dignity comes not from a foolhardy defiance of nature but from a recognition and acceptance of its beauty and power. And the same may be said for a recognition and acceptance of a man's worth—what Gertie Nevels learns.

Thus, while most of Mrs. Arnow's stories could not be said to have unqualified happy endings, they do not hum the umbra's note to the extent that the works of so many contemporary American authors do. She is not, to be sure, a rear-guard romanticist, but neither is she one who has lost hope in the present and future of man. She recognizes that human plans do not always coincide with the way things go. She also recognizes, however, that man has within him a certain indomitable spirit that, though occasionally stifled, can never be permanently erased. Nitro Joe in "Marigolds and Mules," for example, may be blown to bits in an ugly oil field, but the genuine love he had for pretty flowers is no less real. And the world may defeat Suse Ballew, but her counterpart, Susie Schnitzer, at least for the moment, prevails.

Writing for Mrs. Arnow, as she put it, "has been very hard work. But people don't realize it. I recall an editor who said about one of my two later fiction books, 'The ending just wrote itself, didn't it?' Very little of my writing—sometimes there's been a good streak when it goes forward—has written itself. Most of it has been very difficult work after a good deal of thought."[11] The duties of wife and mother have no doubt impinged upon her writing career. Yet, in another sense, those duties, along with the wild flowers she still nurtures, reflect the very "going-on" of life that so predominantly marks all of her writing, be it fiction or history. Both her life and her literary contribution offer proof that the worthwhile is often attainable only through the proper application; conversely, the "labor of the file" increases the depth and significance of the act of living and heightens the sensitivity and charm of the resultant literary expression. One offers thanks to Mrs. Simpson for that second-hand typewriter and to Harriette Simpson Arnow for her resistance to knitting needles.

NOTES

1. Harriette Simpson Arnow, "Language—The Key That Unlocks All the Boxes," *Wilson Library Bulletin* 30 (May 1956): 685.
2. A taped reminiscence by Mrs. Arnow.
3. Ibid.
4. Ibid.
5. Ibid.
6. Ibid.
7. Ibid.
8. Interview, *Detroit Free Press*, 6 April 1958.
9. Ibid.
10. Harriette Simpson Arnow, *Hunter's Horn* (New York: Macmillan, 1949), 68.
11. A taped reminiscence by Mrs. Arnow.

HARRIETTE ARNOW'S CHRONICLES OF DESTRUCTION

BARBARA L. BAER

When, at the age of 26, Harriette Simpson Arnow began to write her first novel, there were still no roads into much of Kentucky's backwoods and mountains. The great migration of Southern Mountain people from hill to city had not yet started. But the young writer sensed that life as she had known it along the Cumberland in southeastern Kentucky was doomed. To keep a record of a culture and a people in the process of destruction, Harriette Arnow began writing her Kentucky trilogy; that writing spanned the next two decades.

"At an early age I saw my work as a record of people's lives in terms of roads," Mrs. Arnow told me. "At first, it was only a path, then a community at the end of a gravel road that took men and families away, and finally, where gravel led to a highway, the highway destroyed the hill community.

"I was aware that nothing had been written on the Southern migrants, of what was actually happening to them and to their culture, of how they came to the cities the first time in the 1920s, leaving their families behind. I began writing during the depression, which had sent hill people back home again. And then, as I was still writing during the Second War, I witnessed the permanent move the men made by bringing their wives and children with them to the cities. With that last migration, hill life was gone forever, and with it, I suppose, a personal dream of community I'd had since childhood and have been trying ever since to recapture in my writing." As Mrs. Arnow talked, she stoked the burning logs in the fireplace of her small farmhouse outside Ann Arbor. The morning had begun with a blustery rain and winds so the fire brightened the sunless day.

Barbara L. Baer, "Harriette Arnow's Chronicles of Destruction," *The Nation*, 31 January 1976: 117-20. Copyright © 1976 The Nation Co., Inc.

Harriette Simpson Arnow's Kentucky trilogy began with *Mountain Path* (1936), continued with *Hunter's Horn* (1949), and was completed with her finest novel, *The Dollmaker* (1954). Whether the books are read today as regional, or realistic or even feminist writing, they are first of all a coherent vision, in the best tradition of American fiction, of Americans coming of age on the edge of the shrinking frontier; they tell the stories of men and women who see their dreams of self-sufficiency shrink and their personal freedoms foreclosed by a rapacious industrial society.

Mountain Path is the only novel of Harriette Arnow in which we can identify the author with her central character. Like her heroine, Louisa Sheridan, Mrs. Arnow was forced to leave the university and earn her living by teaching in a rural school. "I taught for two years in the July-through-February Pulaski County schools when I was 18," Mrs. Arnow said. "It was good for me. I had been so preoccupied with myself and knew so little of life. Those children, who were bright and eager to learn, taught me more than I taught them. They knew the names for everything, for parts of trees and plants I had never heard of. If, later, they were considered 'ignorant hillbillies' in the city schools, it wasn't because they lacked intelligence but through a misunderstanding of language. They didn't know the names for things they had never seen before, and many words were different."

Louisa, the young teacher, a precocious intellectual in her circle at the university, arrives in Canebrake, a spot no one has been able to locate for her on any map. She is thrown immediately into the life of the Cal family, subsistence farmers who moonshine for cash and who love according to a strict, nearly martial code that stems from a feud with a family "at the other end of the valley." The children Louisa teaches, the man she falls in love with, the women she watches at work, all cause the young woman to question her education, values, assumptions and herself: "For the first time in her life, perhaps, she saw herself with absolute candor and the sight wasn't an inspiring one."

Rarely in American fiction has the leading character of a *Bildungsroman*— a coming-of-age novel—been a woman who, like Huck Finn, makes her way through physical as well as emotional trials and emerges whole as an adult. Basically it is through identifying herself with Chris, the man she loves, an outsider who has killed one of the Cal family's "enemies," that Louisa perceives what she had missed while studying life through books. Like Huck Finn's identification with Jim, Louisa begins to see through the eyes of a fugitive.

He (Chris) ought to be insensitive and stupid and unthinking. It would be easier that way. He had taken another man's life; and because of what he had done he should have lost all love for his own life. Instead, it seemed to her that he lived with a consciousness of being alive and a love of life about him more than most men.

However, Louisa cannot easily resolve the contradictions between two worlds, two female lives: there is the life cycle of the hill woman, taken up with giving birth and burying the dead, that allows no time for questions, but nevertheless permits her to feel "secure and safe and filled with husband and child"; and there is her own civilized, intellectual life, filled with nothing but questions, "empty, trying to live so as to feel nothing, watching, thinking, 'This is not my life. I am preparing for my real life. Some day I shall live and be a success.'"

Louisa is about to say, yes, to marry Chris and stay in the valley—"she was running now—building years of a lifetime with each step"—when her dilemma is resolved: Chris, critically wounded in a gunfight with the rival family, must be left alone in the icy cave beside the whiskey still. Were a doctor called, the whole Cal family would be arrested for moonshining and for harboring a criminal. Louisa learns that there are times when one must choose between two tragic outcomes, and when Chris dies, she packs up to leave. She can't even cry. "She would forget them all—dog's eyes, trumpet vine—poplar leaves—and woe, woe, over the hearthstones."

While *Mountain Path* clearly stands on its own as fiction, it is also a woman's book, particularly a young woman's book, and should be reissued for a new generation of readers. The cloth edition has long been out of print and the paperback reprint (Council of the Southern Mountains, 1963) is almost unobtainable. I came upon my copy of *Mountain Path* in an Ann Arbor motel run by friends of Mrs. Arnow, whose books stand on their shelves for guests to see.

Thirteen years passed between the publication of *Mountain Path* and that of a second novel, *Hunter's Horn* (1949). In 1939, Harriette Simpson had married Harold Arnow, a newspaperman, and with him moved back to southeastern Kentucky along the Little Indian Creek on the Big South Fork of the Cumberland. For five years, in pursuit of a dream of the simple life, the couple tried to live off the land by farming. A daughter, Marcella, was born in 1941. Though the Arnows had left the city in order to write, writing was impossible.

"There just wasn't time for it. It was my husband who dreamt of that simple life," Mrs. Arnow said in a voice whose ironic tone was unmistakable. "I'd never wanted to leave the city. Simply cooking off a coal stove and cleaning up after it took half of my time. We never mastered the skills necessary for subsistence farming. After the baby was born, and we became afraid of being too far from a doctor, we moved back to Detroit. I started writing *Hunter's Horn*." Another child, a son, was born in 1946. The novel came out three years later.

Since that time, Mrs. Arnow has returned to Kentucky on visits. The process of destruction begun during the war has kept accelerating. "Where twenty-two families used to live scattered near us over the hills, not a single homestead remains. Only tumbledown houses stand where there once was a community. The wild Cumberland has been flooded and turned into Lake Cumberland. The big companies killed all the wild rivers to serve tourists and provide electric power. They made a dam and then they tore up the hills with strip and auger mining. Flooding and erosion are everywhere and now the dam is leaking. Strip mining is still allowed under the broad-form deeds that date from the Civil War. For a small sum local people leased their mineral and timber rights to the big companies in perpetuity. After that, they had nothing to say about the use of their land or rivers. Little people are never consulted when it's a question of big companies and big profits."

In a very particular way, the naturalistic outlook is ever present in Harriette Arnow's fiction. Man, even a good man, is always on the verge of violating nature and suffering nature's repayment in misfortunes. Nature tempts man to use it badly, to kill one of its messengers, and when the violent and acquisitive instinct has prevailed, the transgression must be paid for. The dynamic of temptation and retribution must go back deeply in Mrs. Arnow's memory, back to seeing animals killed, to witnessing her countryside despoiled and stripped; this dynamic almost allows her best writing to plot itself.

Hunter's Horn, written after the author returned from Kentucky to Detroit, tells how nature repays man for violating it. Before the novel begins, man has exploited the land along the Cumberland. Rich bottom soil has run off into gullies, gullies are overgrown with rough brush. Nunn and Milly Ballew, the last of an old family, return to their grandparents' neglected homestead where they set out to farm the abused soil.

Nunn Ballew is a hard worker and a good man, but he neglects his land and his family to pursue a red fox called King Devil who stalks the

neighborhood, killing farm animals and luring hounds to their deaths. Everyone else in the area has given up chasing the devilish animal, but Nunn is obsessed with the fox. He lives only for the chase. "Nunn had the same compulsion for catching King Devil as other men have for making a million dollars, or I had for writing," Harriette Arnow explained. "Nunn knows he's bedeviled."

> "I've heard say that a lot of men sell their souls to the devil and if I foller a red fox to hell it won't be so different. An sometimes," he went on, speaking with a seriousness he had not meant to uncover, "I wonder would God have my soul."

During a night of storm and childbirth, as the river runs at flood level along the bluffs, King Devil is finally killed by the Ballew hounds. The fox turns out to be a vixen, pregnant with a litter, and Milly Ballew, who has just helped in a difficult delivery, is filled with a premonition of their own misfortune, for "the vixen had run so free: not many things could be so free."

> Nunn looked up at her, and with the lantern on the floor and the strange shadows falling upward, his face seemed all gray-shadowed eyes as he said in a low, absent-minded voice, "He allus seemed big some-how—bigger lots of times than anything else in the world."

No sooner is the fox killed than the eldest daughter, Suse, who also wanted to be free—"she wouldn't be like Milly and she wouldn't be like Lureenie; she'd make her own life; it wouldn't make her"—reveals that she is pregnant. Like Persephone, the girl is caught and doomed by nature to a life of penance. Nunn insists that Suse salvage his reputation by marrying her seducer and entering into nearly feudal servitude to another family. Part of Nunn has died with his victory over nature's tormentor, the fox.

Harriette Arnow was not a one-book writer, and yet the only novel that has survived and been reprinted a number of times in paperback, and taught in college courses, is *The Dollmaker*. A runner-up for the 1955 National Book Award (won by Faulkner with *A Fable*), *The Dollmaker* is Mrs. Arnow's finest work and deserves its growing reputation.

The dollmaker of the title, Gertie Nevels, first appears only as a large sexless figure in silhouette, coming out of the heavy fog astride a mule.

When we see her in the lights of a car, we are immediately aware of her size. Gertie Nevels, with a sick baby under her arm, is larger than life, a rawboned figure hewn from some matriarchal past. Her first act in the novel is to perform an unassisted roadside tracheotomy on her choking baby. She fells a tree to find a branch in which she hollows out a tube to insert in the hole she has cut in her baby's throat.

Gertie also has the vision, and the talent, of a primitive artist. Although she whittles dolls to support her family during a strike in Detroit, she is constantly carving a figure of Christ, whose face, emerging and receding from a great block of cherry wood, is the central image of the novel.

While Harriette Arnow was working on *The Dollmaker*, her Macmillan editor came to Detroit to meet his author. "He expected to be met by Gertie Nevels herself," Mrs. Arnow remembers with a chuckle. "He just stood at the screen door gaping, not able to grasp that I wasn't the big woman I had been writing about." Mrs. Arnow is, in fact, small-boned with delicate features, very large light gray-blue eyes and fine wispy gray hair. Her quickly moving hands seem to be perpetually seeking something to light on—a cigarette, wood for the fire, a book or a map to show an inquisitive guest—and her voice, light and with a full Kentucky accent, is charged with salty wit. No one could be further from the straight-speaking, lumbering Gertie, who differs from her creator in another fundamental respect: although Mrs. Arnow has written for most of her life about Kentucky, she could never stand to go home again. Gertie, by contrast, is indifferent to any part of the country, and the world, but her home.

Gertie is almost as unawakened and vulnerable, despite her size, as those Kentucky hills and valleys. Everything is taken from her by the outside world. Her dream of self-reliance, and the small farm she has managed to buy, are lost when her husband finds a factory job in the accelerated wartime economy of Detroit and social pressure decrees that she must follow her husband. The Nevels, without knowing it, join thousands of others with one-way tickets to make that historical phenomenon, the great migration.

Gertie's strength is sapped by the city. Two of her children turn away from their mother because her country ways embarrass them; two others never quite forgive her for taking them to the city. And Gertie's husband, Clovis, doesn't need his wife to help earn the family wages until there is a strike.

Slowly her hand dropped from the doorknob, and she turned back to Clovis. It wasn't the way it had used to be back home when she had done her share, maybe more than her share of feeding and fending for the family. Then, with the egg money, chicken money, a calf sold here, a pig sold there, she'd bought almost every bit of food they didn't raise. Here everything, even to the kindling wood, came from Clovis.

Then tragedy, hanging over the sooty red air of Detroit from the novel's beginning, strikes the family. The youngest daughter, Cassie Marie, a fey child whose only friend in the city has been her imaginary companion, slips through a hole in a railway fence and is caught between onrushing trains. Her legs are severed from her body, as the family is severed from its roots and its members from one another. Gertie nearly loses her sanity in the weeks that follow the child's death.

> She sprang up, looking wildly about her as she lived again the losing battles—all the battles: to have the land, to make Reuben happy, to reach Cassie, and the last big battle—to hold the blood. . . .

The Dollmaker ends in 1945 with the war's end, when the last stage of the Southern migration was nearly complete. Most hill families were so in debt from installment buying that they could not afford to return home, even if they still had a home and land to return to, and even if their children had not become addicted to the city and its distractions. Gertie knows that she will never return to her hills. The block of wood in which she has been trying to bring forth the individual meaning, the specific face, of man's suffering and sacrifice and death, is wheeled to the woodcutter. In the beautiful last dialogue, as the woodcutter gives Gertie his axe, we learn what Gertie has learned: no individual face can encompass the complexity of human suffering, whether a man's or a woman's, a relative's or a stranger's, a friend's or an enemy's.

> He touched the wood where the face would have been, and nodded, "Christ yu meant it to be—butcha couldn't find no face fu him."
> She shook her head below the lifted axe. "No, they was so many would ha done; they's millions and millions a faces plenty fine enough—fer him."

She pondered, then slowing lifted her glance from the block of wood
and wonder mixed in the pain. "Why, some a my neighbors down there in
the alley—they would ha done."

During the long hiatus between *The Dollmaker* and her next novel,
Harriette Arnow published two personal and social histories of her home
country, the Cumberland basin, *Seedtime on the Cumberland* (1960) and
Flowering on the Cumberland (1963).

Then came *The Weedkiller's Daughter* (Knopf, 1970), a radical departure
in subject matter and locale from the Kentucky trilogy. The novel is set in
suburban Detroit in the mid-1960s. Its characters are affluent Americans,
two generations of a politically and emotionally alienated family named
Schnitzler. The family is split down the middle over race, the Vietnamese
War, communism and how to "treat" nature. Mrs. Arnow was trying to
extend her persistent vision of man's destruction of place from the
Kentucky hills to the poisoned urban society where the obsession with
clearing away nature—symbolized by the weedkilling father of the title—
has left man bereft of his reason.

Mrs. Arnow herself gave me two reasons for shifting her focus from
her own culture and locale to new material. First, she had never wanted
to be a writer with a label, whether regional, realist, transcendentalist,
Marxist (she's been called all those things) or, as is happening now, femi-
nist. Second, she believed she had something to write about Middle
America.

About being labeled, Harriette Arnow said she never thought of herself
as any particular kind of writer. She was surprised to learn that *The
Dollmaker* was being taught as "source material" in a sociology class on
Appalachian migrants. "I wrote it as a novel," she replied. And she reacted
strongly when one teacher asked, should she teach *The Dollmaker* even
though it was Marxist? "I don't like the term Marxist, any more than I like
'proletariat.' Neither term allows for the person's individual qualities to
come through. When I write about poor people I don't want tags put on
them or on me. In the North people are always tagged by what they do,
how much money they make, rather than what they are themselves. In the
South, we were more known for ourselves, from what place and back-
ground we came from."

The second reason for writing *The Weedkiller's Daughter* was to depict the
contrast the author felt existed between Americans of the pioneer period—

she had finished researching her Cumberland histories in 1959—and Americans of the 1950s and 1960s. "As our ancestors crossed the Frontier, they lived constantly with physical fear, and after taking all possible precautions, continued on in the face of real dangers. The United States Government had faith in democracy; in the early years we worried little about other ideologies." Mrs. Arnow felt the country had changed after World War II. "I used to hear people in government calling us a democracy. Now all we hear is 'a nation of free enterprise' or a 'capitalist country.' In the 1950s, our government appeared to feel that given an opportunity most of their fellow Americans would become Communists. Everybody was afraid of something: of blacks, Latin Americans, hillbillies, other objectionable characters." Mrs. Arnow told me she had met dozens of parents at PTA meetings who, like the Schnitzlers in her novel, were "afraid of a variety of things from the atom bomb to mingling with the wrong people . . . and like other people they hated the things they feared."

Harriette Arnow herself was aware that *The Weedkiller's Daughter* had not been a success even with her "own" readers. Where the book fails to convince is not in its vision of uprooted people further destroying everything that has roots around them but in the characters of the children and parents, cut out of pasteboard models of good and evil. In the Kentucky novels, Mrs. Arnow succeeds so well in placing her characters in their setting, and giving them individuality, that one forgot one was reading about strange and unfamiliar people. The realism of the Kentucky trilogy resides not only in its exceptionally well done details of speech and daily life but in the central truths about the characters' souls. The intimacy and the perspective of the earlier books are lacking in this more recent novel. Which is not to say that the writer should stick to her Kentucky material. Mrs. Arnow's latest novel, *The Kentucky Trace* (Knopf, 1974), is a return to the Cumberland during the Revolutionary War. But neither it nor *The Weedkiller's Daughter* takes the vision of the Kentucky trilogy any further. That vision, at once historical and creative, may not be transplantable. One kind of rural past is gone. Destruction of another kind continues within the city. I would like to see Harriette Arnow tell us what she knows about rootlessness, whether that of the "hillbillies" or her own, in the present time.

Harriette Arnow is about to start a new novel, already in her mind and tugging at her to write it. She didn't talk about its subject or place, only that she can't really begin writing until she finishes a history of her

hometown, Burnside, Kentucky, for their Bicentennial committee. "And I can't get caught up writing a novel until I've everything else finished. It's something you can't stop once started, like eating peanuts," Mrs. Arnow said, as we left the fire, the lunch table and the large Arnow dog who had several times climbed into my lap just as I was writing down what his mistress was saying. (Mrs. Arnow was kind enough to fill in our interview with a long letter, from which I have quoted.) Outside the sky had cleared and it felt as though autumn had arrived at last. The fallen leaves blown over the lawn were mixed with the last moist orange petals in Harriette Arnow's summer garden.

HARRIETTE ARNOW'S KENTUCKY NOVELS: BEYOND LOCAL COLOR

GLENDA HOBBS

Aside from specialists in American literature and women's studies, few people have heard of Harriette Arnow, and fewer still know any of her novels except *The Dollmaker* (1954). Writing about hill people from her native state of Kentucky, she is alternately labeled a "woman" or a "regional" writer. While it is generally conceded that the former tag is pejorative, few have considered the assumptions behind the term "regional." It is, I suspect, employed as condescendingly as the qualifier "woman": a "regionalist" can be "good," but only in a limited sphere.

A reason for the negative connotations of the classifier "regional" is its confusion with a more specialized term, "local color." While "local color" usually describes a nineteenth-century American literary movement, it can refer to any work whose author points out decorative regional details to add interest to the narrative. "Regional" works may include descriptions of landscape and customs, but they are intrinsic and crucial to an understanding of plot or character. Confusion arises when critics use the terms interchangeably or assume that any work containing a significant amount of regional detail must be merely highlighting the area's picturesqueness.

Perhaps, then, *The Dollmaker* is better known than Arnow's previous two novels because it is less obviously "regional," and has been spared the unfortunate blemish of the misused word. Three-fourths of the novel takes place in wartime Detroit, where the Nevels family migrates so the father can work in a factory and contribute to the "war effort." Arnow's first two novels, *Mountain Path* (1936) and *Hunter's Horn* (1949), are set entirely in rural Kentucky, and both describe hill people struggling with

Originally published in the *Kate Chopin Newsletter* 2 (fall 1976): 27-32.

a barren, gully-ridden land, with a vestigial fundamentalist fatalism, and with their own tribalism. While enthusiastic critics heartily lauded both novels, unknowingly they undermined their own praise and relegated the works to obscurity when they categorized them as "regional." Some, mistaking necessary descriptions for decoration, meant "local color"; others, assuming that any work rooted firmly in rural Kentucky must have only a limited appeal, used "regional" to mean folksy, and therefore of minor importance.

Mountain Path established Harriette Arnow as a writer whose gift was her poignant evocation of a poor but starkly beautiful "Appalachia."[1] The story of a city-bred college student who goes to a remote "hollow" to board with a hill family and teach in a one-room school, *Mountain Path* dramatizes the young woman's emotions as she learns to appreciate their familial devotion, their intimacy with the land, and their unique brand of justice. Reviewers called the book a "good regional novel." One tried to account for its appeal: "There is something in the beauty and isolation of the setting, in its traditional lawlessness, in the archaic speech and customs of its people, which makes it an excellent background for romance—for romance of passion and violence on the one hand, or of poetic imagination on the other."[2] Authors can do without "praise" that applauds the quaintness, the picturesqueness of a land and its delightfully rustic people. Arnow's exact dialect is hardly "archaic," and the "tradition" of feuding is portrayed as horrifying and unromantic. Even an astute critic like Alfred Kazin, who noted the novel's "spiritual indignation" and "power," thought it a marvelous novel "of its type."[3] While most southern regional novels, he felt, concentrate more on background than on people and document an area without any larger design, he applauded *Mountain Path*'s concern with the way setting affects people's lives. But Kazin still objected to one of the novel's most "regional" aspects; he wondered why "every novel written about Kentucky must have a feud in it."[4] Arnow's inclusion of the feud is not gratuitous or merely colorful. It's used to demonstrate the heroine's transformation: initially outraged by the thought of justifiable killing, she is shocked to find herself demanding vengeance on her hosts' enemies. The other reason for its inclusion seems obvious: even in the 1930s feuds were a fact of life in remote corners of southeastern Kentucky.

When critics saw that Arnow's second novel focused on a Kentucky hill man obsessed with fox hunting, they were quick to hail *Hunter's Horn* for its realistic depiction of a quaint old mountain custom. This novel, too,

was called an "unusually good book of its kind. This is partly because the details of life in rural Kentucky are described with authority."[5] One wonders how Melville would have felt if *Moby Dick* were praised only for its accurate documentation of whale-hunting, for Arnow's book is as little "about" fox hunting as Melville's is about whaling. Nunn Ballew searches for the elusive red fox, King Devil, with as maniacal a compulsion as Ahab stalks Moby Dick. Arnow's talent makes Little Smokey Creek as vast a territory as the Pacific Ocean. A handful of critics perceived *Hunter's Horn's* "fine, strong, frame of universality,"[6] but most damned it with tainted praise. One critic said it was his "candidate for the Pulitzer Prize"; it was, he argued, "a really remarkable regional novel."[7]

The Dollmaker escaped the label. It was called "an important new novel"[8] and "an unflinching and compassionate novel of contemporary America."[9] (Contemporary America must exclude nonindustrial areas, for Arnow had always written about contemporary "Appalachia.") *The Dollmaker* was unanimously hailed as a masterwork. Harriett T. Kane's remarks in the *New York Times Book Review* are representative of its critical reception: "If 1954 produces more than one or two novels of this power and compassion, it's a banner year."[10] It is ironic that critics did not call this novel "regional," because more than Arnow's other novels, *The Dollmaker* probes the way of life and the character of Kentucky hill people. She dramatizes the difficulty of safeguarding one's religion, of deriving strength from nature, and of preserving pride in one's dialect and native crafts in an alien culture. Perhaps a novel is considered "regional" only if all the action occurs in the same rural setting. By allowing her hill people to leave Kentucky and go to a northern city, Arnow silenced critics who intimated parochialism by calling her early novels "regional."

But the label has stuck. Because Harriette Arnow and other modern "regionalists" are seen as literary descendants of the local colorists, they are considered technicians of a minor mode. Critics believe them to continue their predecessors' preoccupation with the quaint, the picturesque, and the sentimental. Although the precise dates for the local color movement vary (roughly from 1865 to 1900), its literary reputation does not. After the Civil War, increased mobility fostered an upsurge of curiosity about life in all parts of the country. At the same time, growing industrialism caused people to look closely at a rapidly fading agrarian culture; they began to feel nostalgia for the individuality of isolated sections that would soon become standardized. As a result, local color literature became touristic:

often written by outsiders, it self-consciously pointed out the uniqueness of various rural pockets, usually exaggerating idiosyncrasies to make the section seem more "quaint." Dialect, dress, customs, and landscape were conscientiously and excessively documented, and the author's attitude was often patronizing: characters could be ridiculed or affectionately mocked, as long as they were "colorful." Those writers who escaped much of the condescending naturalism of local color—Kate Chopin, Mary E. Wilkins Freeman, Sarah Orne Jewett—were either called masters of that mode or were said to transcend it entirely. Modern regionalists should not be judged for their mistaken connection to the local colorists. Not all predecessors are ancestors; anyone who must name literary sires should consider Mark Twain rather than Bret Harte.

While critics of regional literature assert that an author preoccupied with Kentucky (or any rural area) ignores Athens and Rome, its advocates argue that Athens and Rome can only be reached through Kentucky, Nebraska, or Yoknapatawpha. As one partisan puts it, regionalism is not "an ultimate in literature, but . . . a first step . . . the coming to close knowledge about the life of a region in which (the writer) lives as a first necessity for sound writing, even as knowledge of oneself—'know thyself'—is also a first necessity. The 'universal' when healthy, alive, pregnant with values, springs inevitably from the specific fact."[11] Some supporters of regional literature believe that "universal" works must evoke a recognizable locale. One such group was the self-styled Agrarians, who advocated the economic and social superiority of ruralism over industrialism and applauded southern writers who celebrated rural life. "Regionalism," wrote Donald Davidson, "is not an end in itself, nor a literary affectation, not an aesthetic credo, but a condition of literary realization. The function of a region is to endow the American artist with character and purpose."[12] Davidson and his fellow Agrarians felt that any work unrooted in a particular time and place loses its humanity and evaporates into abstraction. While they argued persuasively for the strengths of regional literature, they failed to acknowledge the possibility that a work with a nebulous setting could dramatize recognizable emotions and dilemmas. They would deny the power of Beckett's *Waiting for Godot* and Kafka's *The Trial* on theoretical grounds.

An ideological commitment to regionalism could cause a writer to sacrifice idea and character to descriptive detail. It is the use, rather than the accumulation of regional material, Robert Penn Warren wrote, that determines literary merit.[13] The life of a region should be the medium of

expression, not the message. Hence, "The theoretically perfect regionalist must be someone like Mary Austin, but the best regional literature is something like 'The Adventures of Huckleberry Finn,' which is not theoretically regional at all."[14]

Ideally, a writer intimately connected to the history and culture of a particular community sees peculiarities of his region as givens, as points of departure, not as oddities to be explained or "expressed." He perceives his neighbors from an insider's perspective. Mary Austin, whose essays provide better arguments for regional writing than her fiction, explains that a writer's "regional environment . . . forces upon him behavior patterns such as earliest become the habit of blood, the unconscious factor of adjustment in all his mechanisms. Of all the responses of his psyche none pass so soon and surely as these into that field of consciousness from which all invention and creative effort of every sort proceed."[15]

Arnow does not write "about" Kentucky any more than Twain wrote about Missouri. These writers create art from experiences that include details of memory and observation, but their backgrounds are more important for the ideas and attitudes that have evolved over generations. A writer cannot deny his heritage. Living in a close-knit community gives the writer a special focus—what Arnow calls "a sense of belonging"[16]— and creates a world of moral choice the characters accept or protest against. Arnow's fiction demonstrates her belief that character is more important than setting: "I had to have some setting because the people were either at one with the setting or rebelling against it."[17] In Allen Tate's famous essay, "Regionalism and Sectionalism" (1931), he describes the distinction between conscious sectionalism and an awareness of tradition:

> By regionalism, then, I mean only the immediate, organic sense of life in which a fine artist works . . . tradition has nothing to do with "expressing" a region, though of course tradition is always local in origin. The most traditional of writers can use all of his personal tradition, it is indeed inescapable that he should use it, without ever writing about the society, the region, the nation, from which his tradition is derived. To write traditionally is not to use local color or one's past; it is the assumption that people up to a certain point will behave in a manner to which one is accustomed. . . . From this point of view a great deal of regional literature is the very contradiction of traditional writing. A self-conscious regionalism destroys tradition with its perpetual discovery

of it; makes it clumsy and sterile. And regionalism in this sense, when it merges with sectionalism, is death to literature. Sectionalism is politics.[18]

Arnow's work is "traditional" by Tate's definition. She is not interested in pointing out the uniqueness of her region; she is a native Kentuckian who understands how the Kentucky hills and hollows affect the attitudes and the psychology of her characters.

Both advocates and critics of regionalism are mistaken when they assign values to a term that must be purely descriptive if it is to inform rather than to confuse. Reviewers of Arnow's early novels who called them good novels *of that type* implied her provinciality. But supporters who hailed her novels *because* they were "regional" did her as great a disservice: they suggested that only those readers with sectional pride could fully appreciate her work.

Harriette Arnow's first three novels should no more be read because they are "regional" than because she is a "woman writer." Her contribution to literature is her harshly moving portrayal of people struggling to maintain their integrity in an oppressive, often hostile environment, wherever they find it. But citizens of any world will find her novels more gripping because her characters' dilemmas grow out of the "habits of blood" they acquired from generations in the Kentucky hills. Attempts to break those habits—Reuben's carrying a knife, or Cassie's talking with her imaginary playmate Callie Lou—are met with deep and often fatal resistance. Perhaps Arnow will begin to receive her due acclaim when critics realize that she has gone far beyond local color. Labels like "regional" do not trouble Arnow's readers, who find it difficult to recover their own worlds once they have entered hers.

NOTES

1. Natives of the southern Appalachian Mountain region object to the term "Appalachia." Used by sociologists studying the hill poor, it is, they feel, condescending and does not take into account any difference among the seven states the term encompasses.
2. Margaret Wallace, "'Mountain Path' and Some Other Recent Works of Fiction," *New York Times Book Review*, 30 August 1936: 6.
3. Alfred Kazin, "Diverse Themes in Fall Fiction," *New York Herald Tribune Books*, 6 September 1936, 10+.

4. Ibid., 11.

5. John Farrelly, "Fiction Parade," *New Republic* 121 (1 August 1949): 26.

6. Florence Haxton Bullock, "Kentucky Hill Folk, Vividly Seen," *New York Herald Tribune Books*, 25 June 1949, 5.

7. Robert W. Henderson, Review of *Hunter's Horn* by Harriette Simpson Arnow. *Library Journal* 74 (1 May 1949): 735.

8. Earle F. Walbridge, *Library Journal* 79 (15 March 1954): 550.

9. Walter Havighurst, "Hillbilly D. P.'s," *Saturday Review* 37 (24 April 1954): 12.

10. Harnett T. Kane, "The Transplanted Folk," *New York Times Book Review*, 25 April 1954, 4.

11. "Expression in Northwest Life," *New Mexico Quarterly*, May 1934: 128-29.

12. Donald Davidson, "Regionalism and Nationalism in American Literature," *American Review* 5 (April 1935): 61.

13. Warren warns of the hazards of willful regionalism in two articles: "Not Local Color," *Virginia Quarterly Review* (1932), and "Some Don'ts for Literary Regionalists," *American Review* (1936).

14. "Regionalism or the Coterie Manifesto," *Saturday Review of Literature*, 28 November 1936, 8.

15. Mary Austin, "Regionalism in American Fiction," *English Journal* 21 (February 1932): 97-106.

16. Harriette Simpson Arnow, *Some Musings on the Nature of History*, The Clarence M. Burton Memorial Lecture (Kalamazoo: Historical Society of Michigan Publications, 1968), 6.

17. Diana Orban, "Harriette Arnow Reflects on a Writer's Life," *Ann Arbor News* 2 November 1969, 13-24.

18. Allen Tate, "Regionalism and Sectionalism," *New Republic*, 23 December 1931: 158-61.

HARRIETTE ARNOW'S CUMBERLAND WOMEN

LINDA WAGNER-MARTIN

For several important reasons, Harriette Arnow's novels *Hunter's Horn* and *The Dollmaker* may be more widely read now than they were in the 1950s. Stories of Appalachian farmers lured to Detroit and Cincinnati by the promise of high wages, both novels convincingly describe the hopeless lives of the rural (and urban) poor. While Arnow's characterization of male protagonists—like Nunn Ballew, the hunter of *Hunter's Horn*—is excellent, her consistent forte is the portrayal of the Cumberland women, born to endless poverty and equally endless childbearing. The novels also re-create vividly the often unjust power of fundamentalist religion in these bleak lives. Characters who thrive on personal cruelty are those safe in the bosom of the Church, and that Arnow can so compellingly present the theme of self-satisfied hypocrisy without becoming didactic is proof of her expert narrative skill. As books critical of the position of women and the power of organized religion, *Hunter's Horn* (published in 1949) and *The Dollmaker* (in 1954) were well ahead of their time.

I do not mean to suggest that Arnow is only a propagandist for causes. Like all great writers, she creates characters so real that their sufferings and enthusiasms become the reader's, and it is only in retrospect that thematic patterns show clearly. *Hunter's Horn*, on first reading, is the tale of the passionate maverick Nunn Ballew, a man who intends to be a good provider, husband, and father. Once hunting season begins, however, Nunn resumes his obsession with catching the larger-than-life red fox, King Devil. Driven to both exhaustion and drink by his fanaticism, Nunn remains a

Originally published as "Harriette Arnow in the 1980s," *The Great Lakes Review* 8 (1) (Spring 1982): 1-10.

marginal farmer and an often thoughtless, angry parent and husband. The tragedy of *Hunter's Horn* is that as the Ballew children mature, their lives are injured irretrievably by Nunn's failures. The irony of his name—signifying religious dedication when his devotion is purely temporal and self-serving—is only one of the many ironies in the novel.

Nunn's character is a dominant thread in the rich fabric Arnow weaves of many vivid personalities in the community. His is dominant because the men in this culture have all power, all authority. Whether Nunn is fighting a roomful of men when he is crazy-drunk or selling the family livestock in order to buy a pair of pedigreed pups—dooming his family to a completely meatless year, he is above reproach. A man's sins are expected; quick and unforgiving penalties fall to women and children for their foibles. Such a dichotomy helps to explain the children's joy when Nunn returns home sober, or their delight at the token Christmases: the four children and their mother Milly have been conditioned to be content with very little.

Arnow builds the novel's irony structurally. *Hunter's Horn* begins and ends with scenes in which Nunn is obviously in control of the family destiny. In Chapter One, Nunn is buying winter provisions for his family—yardgoods, sugar, shoes, candy. Affable, well-meaning, Nunn talks with the storekeeper about his desires, his family, his hopes of improving the farm. Arnow undermines this positive image of Nunn by showing his poor judgment in operation. Although the family needs many things, he buys a large quantity of canned dog food. Inappropriate as his purchase seems to be, one might be won by his apparent sympathy for the old dog; yet his treatment of Zing once he returns home, and his constant references to Zing's being ready for hunting season, suggests that Nunn suffers from the sin of pride. He has boasted that he will take King Devil. Any means of killing the fox is justifiable.

This initial scene, and Nunn's homecoming which follows it, sets the pattern for much of the novel. Nunn never thinks of the consequences of his acts. Like Melville's Ahab, he rationalizes whatever will help him conquer the strange natural being—even if that quest threatens destruction to those he loves. While Nunn does not take his family on the fox hunts or put them in outright physical danger, he robs them of what little supplemental nourishment they might have had; he keeps them too poorly clothed to continue schooling. He also risks his own life repeatedly while drunk, threatening the family indirectly with the loss of its breadwinner.

Most important, he keeps Milly pregnant. Inadequately nourished as the family is, her own condition and the fragile health of the children are dangers Nunn conveniently overlooks: two of their children have already died (needlessly, Arnow suggests), and Milly's inescapable fear is for the lives of the others. Another example of Arnow's irony is Nunn's explanation for his buying sheep feed, using still more of the family food money: "a body can't handy starve a lamben yoe."[1] Yet he effectively comes close to starving both the pregnant Lureenie Cramer and his own wife.

In the closing scene of *Hunter's Horn*, Nunn is again forced to choose between alternatives. If the choice in Chapter One was physical well-being, the choice here is emotional and psychological (as well as physical) health. Nunn's daughter's pregnancy has been disclosed. Does Nunn continue to be the nonreligious iconoclast and provide Suse and her baby a home, or does he acquiesce to the pressure of the religious element (the hypocritical Cramer clan) and send Suse to live with the abominable Keg Head and his family while Mark Cramer is forced home from Detroit to marry the unwilling Suse. When Nunn succumbs to social pressure, he destroys not only Suse but also Milly. The immensity of this decision (to send Suse away—"Suse, you'd never lived by God and the neighbors no more than he, to go as Keg Head's hired girl into the never done work of raising Lureenie's children along with her own and waiting on Keg Head and his wife in their old age; Suse, the proud one, to be tolerated and shamed and prayed over" [566]) places firmly in the reader's mind the fact that Nunn has not matured. Even though he has sold the hounds and bought supplies for the family, in the larger needs he will remain deficient. Lee Roy has already acknowledged that:

> Lee Roy's eyes in his tear-smudged face were like Lucy's arms, reaching out to him, clinging, never noticing the bundles in his arms. He took a step forward as if he, too, would fling himself on his father, but stopped, as if remembering his father was only Nunn, a man, and held no ease for pain or refuge from all-embracing trouble. (561)

For the reader who expected a bildungsroman, with Nunn benefiting from his experience, Arnow's ending is devastating proof that Nunn is not redeemable. More irony derives from the fact that Nunn stands high on the scale of relative values of the men in the community. The Cramers— headed by the religious bigot Keg Head who allows his daughter-in-law to

die in childbirth and then condemns her to hell for wishing to die after her two-day, fruitless labor—fall much lower. Once his wife has died, Rans Cramer returns from Cincinnati (complete with a thirty-dollar Bible and new clothes, and religion) to court another wife; yet compared to Rans, his brother Mark is said to be "wild, wilder they say than . . . any of his brothers," and it is to Mark that Suse will be married. Nunn's decision, then, is more a betrayal than the closing scene might suggest.

Within the framework of Nunn's story, Arnow establishes the spheres of the women characters' lives. Much of *Hunter's Horn* deals with the less important life activities—those of women and their nurturing, tending the sick, mourning the dead. Chapter Two is devoted entirely to Milly Ballew as she gathers food, works a charm for the health of her youngest child, and enjoys a time in nature. A fearless, loving woman, Milly has made the best of her poverty. She reveres Nunn; she understands her children; she has bonded with other women, especially the older midwife Sue Annie. That Arnow chooses to close Milly's chapter with the visit from the majestic red fox links Milly with that presence (Nunn had hunted the fox for five years and had never yet seen it). And the true acts of heroism throughout the novel belong to Milly or Sue Annie or Lureenie: crossing the flooding river to bring a child, doing inhuman amounts of work for the benefit of all, learning to exist with next to nothing. It is surely fitting irony that the hounds kill King Devil when they are with Milly and Sue Annie rather than with the men, officially hunting; and that the notorious "King Devil" is then found to be a pregnant bitch fox. All her supernatural wiliness had gone into feeding her various litters. Nunn is dumbfounded when he realizes how wrong he and his friends have been about the fox, and he can only repeat, "'But he's so little—so little,'" (548).

The motifs of size and sexual differences, nourishment and depravation, permeate the novel. Misleadingly, largeness is considered superiority (the Cramers are bigger than Nunn; men are larger than women; male foxes are larger than bitches) and Arnow establishes quickly the error of the simple-minded judgments the Cumberland people adopt. The inclusion of the pleasure-loving Lureenie Cramer serves to warn us about making judgments prematurely. Seemingly frivolous, Lureenie follows Rans to Cincinnati but returns without funds or food and is too proud to beg for herself and her children. The scenes of near-starvation and Lureenie's actual death in childbirth serve to make the issues more than rhetorical. People *can* starve to death; women *can* die in childbirth. In the Cumberland culture, the

essentials are never far from the center of life. Nunn's obsession and his expensive implementation of his plan to catch King Devil are thus much more grievous flaws than they might have been in more affluent circumstances.

The novel *Hunter's Horn* is remarkable not only for its separate characterizations and scenes—memorable though they are—but also for its cumulative impact. Staying within the nucleus of the Ballew family, Arnow graphs the destructiveness of Nunn's behavior through the development of the two older children. Suse, twelve when the novel opens, and Lee Roy at ten are surrogate parents, capable and loving. In the two years of the novel, Lee Roy learns how to manage the mule and plow, handle the stock, and become the effective physical equivalent of the much larger Nunn. Pride in his accomplishments turns sour, however, as he sees Nunn's poor judgment repeatedly. Yet his family loyalty is so great that when men he thinks are federal agents interrupt Nunn's illegal whiskey distilling, Lee Roy hides with the rifle, ready to kill if necessary. Embittered and angry, the first son may have some chance to be more than a marginal farmer.

For Suse, the oldest child, however, life is already plotted in a downward spiral. The bright child, she finishes eighth grade but is then forced to give up her dream of going on to high school, even though the paved road is finished and the school bus will carry children from her area. Staying home, in charge of cooking and watching babies, she has no position any longer, and cannot expect even minimum clothing or attention. Arnow points out how little value she seemed to have as she matured: "it had been so long since Nunn or Milly had hugged or kissed her the way they had used to do when she was a little girl" (442). Yet the opening chapter of the novel had stressed her importance to Nunn and the family; Suse is the dreamer, the reader. She appears outside to watch the plane that passes overhead, jumping up and down and pointing, "There it comes; see it, like a star a walkin, only redder, ever minnit it looks like it was goen to bump into the stars, only a body knows they're lots higher" (16). The promise of the family seems caught here, as the chapter closes.

> Nunn shook his head and smiled, "She is the readenest youngen," he said, with more of pride in his voice than complaint.

A year later, no one is concerned that she does not have clothes to go to high school. She can only watch sadly as her old schoolmate and former

beau plans for college; and as Andy's successes take him further from her, Suse grows willing to settle for less, for any kind of human affection. The severe shocks to her expectations culminate in Lureenie's return from the city, her near starvation because of the unconcern of her neighbors, and her death in childbirth; and in Suse's mother's coercion during the revival meeting that she confess her sins (What sins? the innocent girl must think). In two short years, Suse has changed from a confident, bright adolescent to a shabby, despairing woman. Betrayed by her parents and Mark—as well as by nature when the farm fire destroys the forty dollars that might have given her an escape—Suse has no recourse but to submit to living death with the vindictive Cramers. Suse's final betrayal is, fittingly, the culmination of the entire novel, a picture of a culture that relegates the female to a second-class position, and finds only shame in sex and all its manifestations.

In retrospect, the title *Hunter's Horn* is ironic rather than literal. The importance of the horn, of the activity of hunting, is that it provides Nunn an acceptable means of avoiding his responsibilities. Rather than leading him to maturity, this manly activity leads to his self-indulgence. Arnow points this out often, particularly in the spotlight scene, when all the hunters and hounds trap King Devil and give Nunn the chance to shoot the blinded animal. He passes the gun to someone else, sensing a presence greater than that of an animal in the fox's eyes. Had Nunn killed the fox then, there would have been no need for the pair of hound pups, for the two devastating winters, for Suse leaving school and becoming pregnant.

The horn itself, as a symbol for assistance, is also a travesty. When Milly's seventh child is about to be born, she tries to sound the horn for help. Nunn has taken the horn hunting, however; and she barely has time to fire the cumbersome shotgun before the child is born. When Nunn asks Suse to sound the horn during the farm fire, its power is again subverted because Rans has already blown it and Suse has nothing to do to help. Reliance on the horn, on the act of sounding it, is futile. Any secondary associations—as phallic symbol, as cornucopia of harvest plenty—also seem perverted in the context of the Cumberland poverty.

What Arnow achieves by choosing the title *The Dollmaker* for the 1954 novel is to focus attention on the female protagonist, Gertie Nevels, who is wood carver as well as farmer and mother. Androgynous in her assumption of male roles and responsibilities, Gertie is as much a religious outcast, a maverick, as Nunn, Sue Annie, and Suse before her. Many of the statements

Arnow had made in *Hunter's Horn* about the lot of women seem as well illustrated in *The Dollmaker* as in the 1949 novel, but by clearly stressing the centrality of Gertie's place in the book and the culture, Arnow makes a stronger statement. The closing scenes of *The Dollmaker* also show the results of personal choice: their conclusions about gains and losses apply more directly to Gertie than do the last scenes of *Hunter's Horn* to Milly. We can only infer what Milly is experiencing. In *The Dollmaker*, we see only Gertie at the close of the book.

If one of the central ideas of both novels is that women, and female children, have no options for their lives, Arnow has worked through the concept differently in each book. Milly, Suse, Lureenie all follow the accepted patterns; Gertie, to some extent, does not. Suse may think, in *Hunter's Horn* (303), "she wouldn't be like Milly and she wouldn't be like Lureenie; she'd make her own life; it wouldn't make her"; the novel concludes with a different image of Suse. Her description of Lureenie foreshadows her own life: "How would it be to be a woman like Lureenie, married with little youngens, but wanting still the outside world, tied down to a house and youngens, with one baby in your arms and another big in your belly like Milly—and always the knowing that you could never get away until you were dead?" As Milly had meditated earlier, "Aye, Lord, it would be better never to have a girl child; they saw nothing but pain and trouble and work, and so many went wrong, or else married some good-for-nothing little feist when they were too little to know that kisses come easier than victuals and that a houseful of youngens comes easiest of all" (74). In a poignant dialogue between Sue Annie and Lureenie, just before the latter's childbirth, the view of women's lives as misery is well-established:

> Lureenie smiled, almost gaily. "Me, I don't want to last a long time. I think I'd ruther go out like a cedar bush in a brush fire than wear out slow like a doorsill."
>
> Sue Annie sighed. "Child, th world cain't git along without doorsills to walk on; that's why th good God made women; but it's allus seemed to me that all women, when they died, they ought to go to heaven; they never have nothen much down here but hell."
>
> "Aw, Sue Annie," Milly said, "men has their troubles, too."
>
> Sue Annie spat into the fire. "Nothen hurts a man much; if it does it kills him." (417)

When Arnow creates a final awareness for Suse at the end of the novel, it is with the exclamation mark of Sue Annie's spitting into the fire in anger at Nunn's response, that she should go to Cramers'. The role of Sue Annie, as source of much physical and psychological wisdom, even though derogated by conventional society, carries much weight in *Hunter's Horn*. Milly, Lureenie, Suse—all learn from her, and depend on her. That Milly comes to take the same stances Sue Annie does by the end of the book is another means of charting Nunn's ability to disillusion those who have depended on him. Sue Annie's relative powerlessness is also clearly drawn: even though she demands a doctor from town for Lureenie, no one—the minister, Lureenie's devout but stingy father-in-law, friends—will go for him. People may scoff at her abilities as midwife, but they will also not provide other kinds of aid for women who need more than Sue Annie can supply.

In *The Dollmaker*, Gertie has no older woman to depend on. She stands alone, with her mother one of the troublemakers who spoil whatever convictions she has been able to maintain. Structurally, Arnow gives Gertie a magnificent opening chapter. Nunn may have been buying provisions, but Gertie is riding a stubborn mule through rain and mud to get her sick child to a doctor. She hijacks an Army vehicle, nearly throwing it over a cliff, to complete the trip; then she uses her knife to do a tracheotomy on the child once it becomes clear he will not make it to town alive. Dramatic and yet comic, this opening scene establishes clearly that Gertie will take on any opposition so that her children remain safe. Her fall from the position of confidence and physical and moral strength is the pattern of *The Dollmaker*. Given that women have the decks stacked against them, Gertie's ability to survive by herself is even more unusual. That her society joins forces to make her go to Detroit with Clovis, relinquishing her dream of having her own land, creates a double tragedy.

Never accepted by either her mother or the other women of the community, Gertie prefers farming to housekeeping, dancing and happiness to the dour fire-and-brimstone of formal fundamentalist religion. A sinner in the same sense that Lureenie was (that her freedom to choose led her into truth rather than convention), Gertie is the object of her mother's censure and hatred. And because Clovis maintains conventional values and sympathizes with her mother, Gertie feels that she is an outsider to even her own family.

Particularly now that her younger brother has been killed in action, Gertie devotes her love to the land and to rearing her five children. Again,

the Nevels children—like those of the Ballew family—are the index of the success or failure of their parents. Gertie does a good job of balancing recognition for the abilities of the five children, but the youngest girl—Cassie Marie—is much more imaginative and less able to learn formally than the other four. She requires more time with Gertie; she also creates an imaginary playmate, Callie Lou, and is accordingly ridiculed by other children. Reuben, the oldest boy, has developed a love of the land like his mother's and an ability to understand the relative strengths of his parents. He tolerates Clovis' obsession with machinery (his father will never be a farmer, and uses the excuse of the draft examination to travel to Detroit for a job in the auto plant) but prefers to live in the Cumberland and farm. Eventually, both Reuben and Cassie are casualties of the move to Detroit.

Arnow invests the move to Detroit with great emotional weight. Gertie has saved enough money to buy her family a farm so that they would no longer have to share crop someone else's land. Unfortunately, she has saved this money secretly, fearing that Clovis would spend whatever cash she had on truck repairs. When Clovis finds what appears to be a well-paying job in Detroit, he expects his family to join him; so far as he knows, they have no other choice. While he has been gone, however, Gertie and Reuben have purchased the Tipton Place. His summons, then, prompts a major conflict between Gertie and her mother. The hypochondriacal mother appears riding the family mule, racked with sobs, muttering that her own children have brought disgrace to the family. Gertie's innocence is apparent in her own confusion about her mother's sorrow:

> Gertie's heart went out to her sister, Meg, gone so long. What had she done—lied, fornicated, danced, played cards? "Mom, Mom," she began, "I don't know what Maggie's done but it cain't be much."
>
> "Meg?" her mother shrilled, lifting her head, anger bright in her eyes. "Meg's a decent woman. She ain't a sneaken an a slippen around a conniven to leave her man an make her children fatherless. Fatherless. Fatherless. . . . There he is . . . away off in that cold, dirty, flat, ugly factory town, a haven to mix up with all kinds a foreigners an sich, a haven to pay money to a union—him that's never been make to belong to nothen. He ain't got nobody to cook him a decent bit a victuals. He could be took in the army, an you'd never see him agin. An what does yer mom do?"
>
> Reuben's shoulders stiffened. "She bought us a place a our own."

> Her mother turned away, weeping now into the saddle blanket, talk-
> ing both to the gray mule and to God. "Oh, Lord, oh, Lord, she's turned
> her own children against their father. She's never taught them the Bible
> where it says, 'Leave all else an cleave to thy husband.' She's never read
> to them the words writ by Paul, 'Wives, be in subjection unto your hus-
> bands, as unto th Lord.'"[2]

Giving the concept of wifely duty a religious source makes her mother's
argument unbeatable. Only Reuben has direct answers for his grand-
mother; only he can see past the rhetoric to the fallacy. But for Gertie, a
lifetime of these arguments adds conviction, and she agrees to go to
Detroit.

The use of religion to coerce women has been common throughout
Hunter's Horn; it is the reason Suse must marry Mark Cramer, that Lureenie
may well be in hell instead of heaven (in Sue Annie's flip words, "One
bunch a you has got pore Lureenie's soul in hell an one bunch has got her
in heaven. You'd all ought to git together an put her someplace fer good;
she had too hard a time on earth, pore soul, to be treated this way after
she's dead. If I was God, I'd give her a seat right by my side an give her
everthing she wanted" (495). Even as devout a person as Milly asks realisti-
cally, "Oh, dear Lord God in heaven, why do you send trouble thick as the
falling snow on a woman? Did you have a spite against us when you cre-
ated us from Adam's rib? Oh, God, it's hard to be a woman" (77).

Once in Detroit, Gertie's strength and sense of personhood crumbles.
Arnow's implication is that much of her will come from her bond with the
land, and once she was torn from that, she was adrift in strange and fright-
ening circumstances. Her oldest children, Clytie and Reuben, manage to
get her from the train station to the address Clovis has given them;
throughout the rest of the novel, Gertie barely manages to meet situations,
but several of her children are adaptable—Clytie the most adaptable of all.
The only source of strength for Gertie is the large block of cherry wood she
brings along from Kentucky, thinking someday to have the leisure to carve
the Jesus figure that she has begun from the wood. By placing this symbol
of Christ centrally in the Nevel's small apartment, Arnow forces the reader
to view the Nevels' life in comparison and contrast with the life Gertie had
planned on the Tipton Place.

Prejudice, poverty, differing standards of living, differing back-
grounds—the Detroit community gives Gertie a range of new experiences.

At first she is reproving, even dismayed, at some of the women who live near her; eventually she comes to see that women's problems are the same regardless of external differences. Other women turn to Gertie for comfort and strength. She falters only twice—once, after Reuben has run away back to Kentucky, leaving his farewell note for his father instead of her. A second time, for a much longer period, after Cassie's brutal death under a train. In a long scene that works much as Lureenie's child-bearing and death scene in *Hunter's Horn*, Arnow builds the numbing disappointment of Cassie when her distraught mother shames her for the existence of Callie Lou. Running away from Gertie, trying to find a place where Callie Lou can exist, Cassie misunderstands the arrangement of train tracks, and loses her legs in their pathetic red boots. Gertie's frenzy to reach and save her child stands in ironic parallel to her successful herculean efforts in the first chapter, when she has been able to save Amos's life. In Detroit, Gertie is ineffectual. Cassie not only dies a most horrible death, but the remaining family nest egg goes toward an over-priced funeral. The Nevels lose all hope of returning to Kentucky.

Survival is possible because one of Gertie's friends commissions her to carve the authentic wooden dolls she loves, rather than the cheaply-made jumping jacks Clovis had designed. To get good wood for that project, Gertie has the block of cherry divided. Clovis has not only lost his job; but has been involved in one murder, at the least. The family has no resources except Gertie's carving. In the concluding scene of the novel, her triumphant walk to the scrap-wood lot testifies to her ability to go on despite pain and loss. Gertie remains "the dollmaker"; her life does continue. In many ways, the ending of *The Dollmaker* is much more affirmative than that of *Hunter's Horn*.

Taken together, Arnow's two novels present a full picture of the peaceful yet restrictive Cumberland culture, changed greatly with the intrusion of World War II, the opportunities for people to head north, the disillusion when urban life proves to be even less prosperous than rural. Each novel praises the person who follows his or her heart, who commits self to land and work, who lives for the good of the whole rather than selfishly. Gertie in this respect is the reverse of Nunn Ballew. Her one selfish passion was to carve the cherry wood into a Christ; she consciously renounces that desire at the close of the novel. Nunn may have taken a beginning step in selling the hounds, but his sense of appropriate action is still adolescent.

Leaving the Cumberland may be valuable if the harsh religious beliefs can be modified. Religion as Gertie, Sue Annie, and Milly practice it is preferable to the false conventions of Gertie's mother, the Cramers, and various minor groups in the two books. Love for others, the capacity to help others, the sense to avoid judgments about others—these are the qualities of Arnow's ideal Christian.

The chief difference between *Hunter's Horn* and *The Dollmaker* is the location Arnow selects. More of the latter novel takes place in Detroit, and the strangeness of that setting bemuses—incapacitates—Gertie for a long while. She finds it impossible to forget her beloved hills and farmlands (her whittling is one means back to that life); Gertie's love of her surroundings is presented more convincingly than is Milly's love for the land in *Hunter's Horn*. Arnow's achievement in *The Dollmaker*, capturing Gertie's feelings about nature as they relate to her as person, may be one of the best twentieth-century presentations of the ageless theme of person-nature relationships. (One of the reasons for the comparative ineffectiveness of Arnow's 1970 novel, *The Weedkiller's Daughter*, is its dislocation, its separation from the Cumberland. It is set entirely in suburban Detroit.)

Both *Hunter's Horn* and *The Dollmaker* could be termed "realistic" novels (and have been so labeled), and in many respects they are reminiscent of the Dreiser-Norris-Lewis work twenty and thirty years earlier. Yet Arnow succeeds in making her readers feel that every detail is important, that her selection is discriminate. The stark delineation of recurring themes, the ironic treatments of motifs as difficult to handle as apple pie and motherhood, and the intensity of the climactic scenes make these books important studies of characters who learn how to live despite conventions they found niggardly and restrictive—even life-denying. No reader will forget Gertie Nevels, or Cassie, or Suse, or Milly. No reader of the [1990s] will leave Arnow's Cumberland novels untouched.

NOTES

1. Harriette Arnow, *Hunter's Horn* (1949; reprint, New York: Avon Books, 1976), 15. Hereafter cited in text.
2. Harriette Arnow, *The Dollmaker* (New York: Macmillan, 1954), 123-24. Hereafter cited in text.

HARRIETTE ARNOW'S SOCIAL HISTORIES

DANNY L. MILLER

In 1960, six years after her great success with *The Dollmaker*, and when she was fifty-two years old, Harriette Arnow finally realized a dream that had "haunted" her for thirty years, and that she had worked to fulfill for that long: she published *Seedtime on the Cumberland*, a history of the daily lives of the ordinary people of the Cumberland River country during the period of about 1780 to 1800. Three years later she published a companion volume, *Flowering of the Cumberland*. Her third nonfiction work (an autobiography and social history) was a slim volume for the Kentucky Bicentennial Bookshelf Series, a history of her Pulaski County hometown, entitled *Old Burnside* (1977). Lesser known than her novels, Arnow's nonfiction social histories make up about a third of her published writings and are valuable to the historian and the general reader for the insights they give into the lives lived in pioneer times in Tennessee and Kentucky, as well as for their insights into the impulse toward history and the way history can be viewed.

As Wilton Eckley, her one biographer to date, says, "That Harriette Arnow should have turned to writing about the Cumberland River basin in a factual way is not so strange when one remembers how much a part of her life that area has always been" (Eckley 1974, 101). Indeed, as a novelist, Arnow had shown her intimate knowledge of and familiarity with this place of her people. In her novels Arnow focused on the lives of the Cumberlanders during the 1930s and 1940s, a time when their world was being invaded, changing as "progress" arrived (Arnow wrote an essay entitled "Progress Reached Our Valley" for *The Nation* in 1970 in which she questioned this "progress").[1] In *Seedtime on the Cumberland* and *Flowering of the Cumberland* she turned back to the days of the explorers and settlers of

this region, her own ancestors, and those who came with them. Writing these books was something she had "prepared" for all her life.

Arnow disclosed a great deal about the impetus for and process of the writing of her social histories and about her ideas of what history is in a talk she delivered to the 94th Annual Meeting of the Historical Society of Michigan in 1968.[2] She begins by admitting, "I am not exactly a historian." But, she continues, "I have at times pondered on: 'What is history?'" What answers she was able to find to this question, she says, "came late in life" but had their origins very early:

> Beginning somewhere behind memory, stories of the "old days" as my people called them, were a taken-for-granted part of childhood. They were of all kinds and ages, some going behind the French and Indian War. Yet I never thought of them as a form of history; history was in the books I would read when I was old enough. (1)

As a child, she says, she had many questions. For example, she recalls the first time she sat on a horsehair sofa and wondered how horsehair was made: "were the horses shaved or was only hair from manes and tails used? My mind was always going off to such questions" (4). These questions often went unanswered, but, she says, she comforted herself "with thoughts that when I studied history in school I would learn how ordinary people such as my own had lived." Alas, she continues, "[t]hat day never came. I studied a great deal of required history, including that of my own state, Kentucky, but found no answers to my wonderings on the day to day lives of the average early settlers." Disappointed by this obvious lack in traditional notions of "history," Arnow says, "I told myself that in later years when I lived near large libraries I would learn what I wanted to know. In time, I found many good books but never the one to answer my questions, which had multiplied as I grew older. . . . Sometime during my later college years, a dream began to haunt me: I would write the book I couldn't find" (2).

Thus was born the kernel of *Seedtime on the Cumberland* and *Flowering of the Cumberland*. During the next thirty years, Arnow worked on "writing the book [she] couldn't find": "And so the years went: research, typing up notes, background reading, correspondence of all kinds, cogitation on the arrangement of the whole, plus the usual housewifery along with gardening, chauffeuring, and this and that" (5). And the process of gathering the

material and writing these two books also helped Arnow to answer for herself the question "What is history?" As she grew older and became aware of the almost imperceptible changes occurring around her, she realized: "I at long last had learned that history, whatever she is, does not always make headlines; nor does she tap one on the shoulder and say: 'I am history. Look at me as I pass by'" (10). She learned that the everyday little things of life, not just major actions or events, made up "history":

> I could never comprehend the really big things. I had not even been aware of all the little changes, the little things—only those I had literally felt as I had the horse-hair sofa, or emotionally like the sight of a barn being torn down. Why? I had never been in that particular barn. Yet, it had become a part of my life, a landmark to admire and love. And so another partial answer came of: "What is history, at least to me?" Study and appreciation of the past are not always purely intellectual processes. History for some of us is a shy girl, not coming close unless she can be certain of some kinship, some common bond, some self identification with her. (10)

The key term here is "kinship." For Arnow, there had to be some kinship with history, and it is her own and her people's kinship with history that she examines in *Seedtime* and *Flowering*. She did not see herself as a "historian," but as an observer and a recorder of a vanished and vanishing past.

Seedtime on the Cumberland and *Flowering of the Cumberland* are not history books in the commonly accepted sense, just as Arnow is not an academic historian. As Arnow herself states of *Seedtime*, it is "not a history, nor is it concerned with the lives of famous men and women, nor does it pretend to be an exhaustive study of the pioneer. I have tried to re-create a few of the more important aspects of pioneer life as it was lived on the Cumberland" (vii). Because Arnow was not a trained historian, Wilma Dykeman states:

> There were those historians who looked with some doubt, perhaps dismay, on the entrance into their discipline of a storyteller with no formal academic degree in the field of history. At the other extreme were critics and fellow novelists who wondered why so gifted a weaver of fiction should withdraw to the dry and dusty archives of the past. (Arnow 1960, xi)

But Arnow, despite her lack of formal academic training in history, possessed many qualities of the historian and devoted much of her life to "gathering" (both consciously and subconsciously) materials for her histories; and to her the past was anything but "dry and dusty." In fact, it seems to me felicitous that history is not always told from the historiographer's point of view, but from the humanist's. That Arnow was not a trained historian, but simply a person seeking to explore and preserve the past, makes her books far more accessible to the general reader than many of the "dry and dusty" history books.

Seedtime on the Cumberland and *Flowering of the Cumberland* are social histories, relating to the life, welfare, and relations of human beings in a community. The focus of these works is on the daily lives of the ordinary people: what they wore, what they ate and how they prepared it, how they spoke and sang, how they worked, and how they entertained themselves. The emphasis in these histories is on community and community relations, as it is also in her novels. Kathleen Walsh, for example, writes of *Hunter's Horn* that the novel is not only about Nunnely Ballew and the hunter's quest, but that it is about "community": "Arnow's interest in portraying a community is indicated by her proposed title for the novel, 'End of the Gravel,' a choice which she has explained by describing *Hunter's Horn* as 'the story of a hill community near the end of a graveled road where the outside world was bringing change.' She depicts the community at the moment of its passing, poised for change . . ." (65). Arnow herself commented on the importance of community in her works in an interview with Barbara Baer:

> I was aware that nothing had been written on the Southern migrants, of what was happening to them and to their culture, of how they came to the cities the first time in the 1920s, leaving their families behind. I began writing during the depression which had sent hill people back home again. And, then, as I was still writing during the Second World War, I witnessed the permanent move the men made by bringing their wives and children with them to the cities. With that last migration, hill life was gone forever, and with it, I suppose, a personal dream of community I'd had since childhood and have been trying ever since to recapture in my writing. (117)

Arnow's humanistic "dream of community" is revealed as much in her nonfiction social histories as in her fiction.

Arnow herself describes *Seedtime on the Cumberland* in the introduction to *Flowering of the Cumberland*:

> [*Seedtime*] was the story of how men, chiefly from the southern colonies, learned to live away from the sea and look to the woods if need be for most of their necessities from log house to lye. It told of how this long learning was then applied to exploring, hunting over, and at last settling the Valley of the Cumberland, or chiefly what is now Middle Tennessee. Attention was centered on the physical aspects of pioneering—food, clothing, shelter, and the struggle to hold the land against Indians and governments.(v)

One reviewer of *Seedtime* described it thus:

> From wills, inventories, journals, colonial records, and the long folk-memory of a proud independent people comes this rich description of the Cumberland River Country in its formative years. Here, on the colonial frontier, hunter and farmer forced themselves into the rich soil of interior America, defying hunger and hardships, natural disasters and Indian massacre. Theirs was a magnificent achievement, and Mrs. Arnow has, with painstaking research and loving care, re-created every facet of their lives. No detail is overlooked, not an item of clothing nor frontier recipe, neither the loading of a long rifle nor the treatment of a scalped head. (Rea 1960)

Arnow spent years gathering the minute details of pioneer life.

Part of the effectiveness and readability of both *Seedtime* and *Flowering* lies in the skill with which Arnow tells her story, utilizing the tools of the fiction writer, such as characterization, plot devices, and, most of all, setting. As Tennessee historian Pollyanna Creekmore says, "[Arnow] combines the discipline of research with the creative imagination of a distinguished novelist, and indeed such details as a conscientious novelist would use to attain realism. She has lifted from sources incidents of pioneer life, and they are as full of vividness as fiction" (Creekmore 1961, 97). Likewise, Wilma Dykeman, herself both novelist and social historian, points to this merging of the historian and the fiction writer: Arnow combined "the historian's dedication to thorough research and factual authenticity with the novelist's sensitivity to nuance and irony, human foibles and

ingenuity in the service of survival and eventual shaping of a society" (Arnow 1960, xi). Arnow makes these men and women come to life and makes them seem not like remote "historical" figures but living people engaged in the process of settlement.

One vivid example of this novelistic characterization is the picture Arnow paints of the Cherokee Indian chief Attakullakulla, the Little Carpenter, in *Seedtime on the Cumberland*. One can see how she interweaves the "fictional" with the actual in this chapter, as she begins almost like a short story or novel:

> Late in November of 1774, "Two Indian men and a woman," listened to an organ played in the Moravian town of Bethabara near present-day Salem, North Carolina. The sweet singing both entranced and troubled the listening Cherokee, and the lid had to be taken off to prove no child was trapped within, making the sounds; the Cherokee took many scalps both white and Indian and burned a prisoner now and then, but they, like all Indians, loved children, and never in their raising of them found necessary the beatings the white man used. (172)

Later, Arnow weaves her storytelling thread through the narrative, again referring to the scene of the organ: "Attakullakulla as he listened to the organ on the November morning possibly went over the years that had earned him the title of Little Carpenter, building, cementing, mending the relations between English and Cherokee" (175). Among other people Arnow "creates" for us in a memorable way are the French trader Martin Chartier, who spent two years with the Shawnee on the Cumberland in the late 1690s; Dr. Thomas Walker, who explored the Cumberland region in 1750 and named the Cumberland River—the Riviere des Chauouanons of the French; the faithful mulatto slave Jamie, who accompanied the ballad maker James Smith into Tennessee and saved his life; the Long Hunters Elisha Wallen, the Blevinses, the Bledsoes, and Henry Scaggs; and Charlotte Reeves Robertson, whose bravery in setting loose the dogs upon the attacking Indians at Freeland's Station is credited with saving the fort and possibly all of Middle Tennessee. In almost every chapter, such as the one in *Seedtime* called "Indians" (the one recounting the Indian attack on Freeland's Station), Arnow centers on a particular person, weaving through the narrative the details of what his or her daily life was like.

Genealogy, geography, geology—these were all great interests of Arnow's and helped prepare her for writing these histories. At the age of eighteen, Arnow recounts in the Acknowledgments to *Seedtime on the Cumberland*, she became an amateur historian and realized the need to preserve: "It was not until I was eighteen years old, away from home in a remote place, that I made my first note—a description of a shot bag of ground hog hide, realizing as I looked at the old, worn thing that when the great storytellers died and mice and rats and time had their way, many little things of the ordinary people would be lost" (vii). That shot bag description forms part of the opening of *Seedtime on the Cumberland*.

All of her life Arnow was a keen observer of everything about her—sights, smells, sounds, people—and certainly the idea of *Seedtime on the Cumberland* had been planted in her earliest childhood, when she roamed hill and valley around her home at Burnside. In the autobiographical *Old Burnside* Arnow writes of her childhood romps and how she was aware of the sights, smells, and sounds around her. In one passage from *Old Burnside* she writes of how she first became aware of the Cumberland River:

> The woods were never silent. During the rare times when I could feel no breeze, the pines that crowned the hill talked in low voices, and on windy days they roared and quarreled in loud tones. . . . Now and then on an especially still day I would hear a faint roaring that was neither a distant train nor the murmur of the pines. I would wonder as I listened and then forget it, until one cloudy Sunday morning I heard the same sound. I asked Papa what it was, and learned it was Cumberland River roaring her way down Smith Shoals. (53)

It is no wonder, given Arnow's acute attention to sounds, that she should call one chapter of *Flowering of the Cumberland* "The Sounds of Humanity," a chapter that describes, among other things, the boisterous profanities of the pioneers, as well as their storytelling, their sermonizing, and their daily speech, "rich in simile, metaphor, parable" (152).

Even in her earliest youth Arnow was an inquisitive and inquiring person. She recounts in *Some Musings on the Nature of History* how, even before she started to school, she "quite often visited a museum." She "did not recognize the place as a museum. Neither did anyone else. It was the home of two elderly ladies, cousins of [her] then dead maternal grandfather" (1). In this "museum" Arnow learned many things, and in fact, she states that it

was there, listening to the stories told by these elderly cousins, that she first became aware of the intricate web of the Cumberland River that tied the whole country together. The cousins described the river's personal importance to them: if there were no good fall rains, Christmas treats could not be brought from Nashville, Memphis, and New Orleans, and since there were no railroads, Christmas presents depended on the river. Later, in 1939, when she and her husband Harold lived in "an ancient log house in the sheltered valley of Little Indian Creek of the Big South Fork of the Cumberland River," she "realized that about [her] was a living museum; a very different one from that of the elderly cousins, but with even more to learn" (Arnow 1968, 5). This was the people and the culture around her. And, even later, when she moved to Michigan and eventually bought a farm in Ann Arbor, Arnow still saw the world around her as a great museum, with so much to teach.

As well as being a keen observer of the world around her, curious and inquiring, Arnow was also very fortunate to be reared in a home where the oral tradition was very much alive, where folklore, local history, and genealogy merged in the stories of her family. As a child she took in all the stories told by her parents and grandparents.

Indeed, Arnow opens *Seedtime on the Cumberland* with a picture of herself as a wide-eyed and fascinated child listening to her father tell a story of one of her "grandsires":

> I could see Grandpa in spite of the pitch dark. His hat was dark felt, low-crowned, wide-brimmed, and his clothes were blue and faded; around him was none of the bright trappings of war, neither silver sword, nor waving flag; the long eight-sided gun barrel was dull; only the gunstock of close-grained, well oiled maple made a faint shine like a half-smothered star. The powder horn high up around his neck was old and yellowed; a fit mate for the shot bag of ground hog hide. Still, in the black foggy dark I could see everything, even the little charger of whittled bone, swinging and jingling on the powder horn string. . . . I remember my father's eyes were blue in the lamplight and his hair was black, and these I gave our grandsire; but of my father's voice and the other voices around me I remember nothing. Grandfather Merritt like all other people and things the voices brought to life, blotted out the world around me while I listened. . . . (1-3)

The world of storytelling, oral history—people talking with each other—was a nurturing environment for Arnow. She was tremendously influenced as both a novelist and a lover of history by this world. Arnow describes in the first chapter of *Seedtime on the Cumberland*: "Times and places were mingled in my head; the past was part of the present, close as the red cedar water bucket in the kitchen, or the big cherry press put together with pegs, or the parched corn a grandmother now and then made for us" (4).

In an interview I had with Arnow in 1982, she stated:

> I heard many stories. Our father was a great story-teller. And one grandmother [Grandma Denney] told handed-down stories of the days before our people had come to Kentucky, terrible tales of the French and Indian War. . . . Our father told all manner of stories of the Revolution. Some of them, especially my grandmother's, were sad as well as bloodcurdling. I remember a horror-story of a woman being chased by wild hogs—there were no real wild hogs in Kentucky—just razorbacks strayed from their owners and lived in the woods too long. They did have long tushes. I've seen their skulls—the woman was carrying her baby, and the hogs were close upon her and she threw the baby to the hogs to give her a chance to go on, save her own life. I couldn't bear that. (88)

The profound effect of this story on Arnow is evident in the opening chapter of *Seedtime on the Cumberland,* where she refers to it twice, as well as mentioning it in *Old Burnside.* In addition, she refers to this handed-down story in *The Dollmaker,* when she has the playful Cassie tell her mother: "'Mommie, Mommie, throw out some years a corn. These wild hawgs can eat them stid a my little youngen. They're a overtaken me'" (76). Thus we can see how the memory of one frightening story stayed with Arnow throughout her life and found its way into her various writings. Likewise, we can see in the above description of the long tushes and skulls of the strayed razorbacks Arnow's ever-present fascination with the factual aspects of history as she interrupts her bloodcurdling tale to discourse on the actual state of wild hogs in the Kentucky woods and her own observation of their skulls.

As she listened to all the stories told by her family Arnow became very aware of "her people" (as she always refers to them) and their history, of the

settlers who had moved into and populated the region. Genealogy was an important aspect of this oral tradition. Letters in the Eleanor Baker Reeves Genealogy Collection in the Ashe County, North Carolina Public Library reveal that Arnow corresponded with Mrs. Reeves about some of her ancestral lines. In one letter to Mrs. Reeves, Arnow writes:

> The name John Dick has always fascinated me; an ancestor by that name was as I recall in the War of 1812. . . . The Permelia Jane Dick to whom I referred in Seedtime with ancestors on New River, was the daughter of the John Dick mentioned above; Permelia married a Denney and should have been referred to as Permelia Jane Dick Denney; Permelia Jane Dick Denney was the daughter of John Dick Jr. and Elizabeth Chrisman; Elizabeth Chrisman her mother was the daughter of Isaac Chrisman and Elizabeth Gholson; Elizabeth was the daughter of Anthony Gholson, born 1733, son of William Gholson (born 1705) and Susanna Collins, daughter of Joseph Collins, son of John who was in turn a son of William Collins of Isle of Wight C[ounty] Va. who settled in 1635.

This impressive listing of ancestors obviously shows that Arnow had researched and was very much aware of her own genealogy. In fact, she often mentions her own ancestors in *Seedtime* and *Flowering*. Not coincidentally she uses the name Gholson for one of her characters in *Mountain Path*.

Perhaps Arnow's sense of her own family's history contributed to one of the most remarkable aspects of *Seedtime on the Cumberland* and *Flowering of the Cumberland*: besides recreating in vivid detail the daily lives of the Cumberland pioneers, these books also help to destroy the myths and stereotypes about the pioneers and, by extension, the Appalachian mountain people. The American frontiersman-pioneer had been described almost from the beginnings of American literature and history as of a different and inferior class to the East Coast colonials. Virginia gentleman William Byrd II, for example, in his "History of the Dividing Line" (between Virginia and North Carolina), written in 1728, described the laziness of the North Carolina backwoodsmen:

> Surely there is no place in the world where the inhabitants live with less labor than in North Carolina. . . . The men for their part, just like the Indians, impose all the work upon the poor women. They make their

wives rise out their beds early in the morning, at the same time that they lie and snore till the sun has run one-third of his course and disperst all the unwholesome damps. (Byrd 1991, 252)

Likewise, Michel-Guillaume Jean de Crevecoeur in *Letters from an American Farmer* ([1782], 1991) describes three types of Americans: those who live near the sea, the "intermediate" ones, and those who live in the woods. Of the latter, the backwoodsmen, Crevecouer has much to say: the backwoods pioneer-frontiersmen were a people of "contention, inactivity, and wretchedness," placed far "beyond the reach of government." In the backwoods frontiers, says Crevecoeur, "men appear to be no better than carnivorous animals of a superior rank." "There," too, he says, "remote from the power of example, and check of shame, many families exhibit the most hideous parts of our society, preceding by ten or twelve years the most respectable army of veterans which come after them" (Crevecouer 1991, 501). They are "ferocious, gloomy, and unsociable." They become victims of a "lawless profligacy" and "their wives and children live in sloth and inactivity" (504) and have little if any education. Theirs is a species of "degeneracy," lamented by Crevecouer and echoed of the Appalachian mountain people (the arrested frontiersmen of America) two centuries later by the famed historian Arnold Toynbee.[3]

The Appalachian mountain range and the area of Kentucky and Tennessee just to the west of it (indeed all of Kentucky and Tennessee suffer from the same generalizations as their Appalachian areas) were indeed the first frontier of America. When it was "decided" in the late 1800s that Appalachia was an "arrested frontier," inhabited by quaint and curious people, deprived of "progress" and the refining influences of "civilization," it is no wonder that grossly generalized and distorted perceptions of the mountain and hill people were perpetuated, since from the beginning the backwoodsmen had been seen by their more "civilized" eastern neighbors as depraved and degenerate.[4]

Harriette Arnow was well-read and well-versed in these attitudes. In *Seedtime*, for example, she mentions William Byrd II's works several times. In her novels Arnow focuses on individuals—plain common people—and shows that stereotypes of them are unfair and untrue, that they possess the same humanity as anyone else, redeeming them in some ways from the maledictions and gross generalizations of people like Byrd, Crevecouer, and Toynbee. Likewise, with reverence toward her own forebears and those like

them who had been frontiersmen—settlers, explorers, hunters—in the Tennessee-Kentucky area just west of the Appalachian mountains, Arnow provides a corrective to the often raised idea of degeneracy. In her Epilogue to *Seedtime on the Cumberland* Arnow stresses the resourceful adaptiveness of the pioneers:

> The kettle singing from the crane above the glowing hickory embers was like most other aspects of pioneer life, both new and old. Fire and kettles were old in Europe when Martin Chartier visited the Cumberland. The heat of hickory embers had long been known to the American Indian, but was strange to England. The pioneer put the three together. . . . The first settlers on the Cumberland, like first settlers elsewhere, invented nothing and most certainly not democracy. They pioneered no new system of government or religion or agriculture. Rather the successful pioneer was a master hand at adapting old learnings to a new environment. . . . (426)

In every way Arnow's descriptions of these people show them to be not only fully engaged in the act of survival but in the building of culture and community.

In the Epilogue to *Seedtime*, also, Arnow specifically addresses the idea of the "pioneer mind."[5] Again, she stresses individuality and not generalization or stereotyping:

> Much has been written of a thing called "the pioneer mind." I found no mind I could hold up and call "the pioneer mind," and no man I could call "the pioneer." The difference between the first settlers on the Cumberland and the rest of the country was one of degree and not of kind. They did not call themselves pioneers; later, other men, viewing them with different eyes, gave the name. . . . As one delves into the complexities of his social, intellectual, and educational life one realizes more and more that the purely physical aspects of his world were in a sense the least of him. One also realizes there can never be a complete and perfect seeing. (427)

It is these complexities of the social, intellectual, and educational lives of the Cumberland River area pioneers that Arnow sees and explores in *Seedtime on the Cumberland* and *Flowering of the Cumberland*, and to which she

adds immeasurably with her own wise and meticulous vision as she tries to truly understand and convey their daily lives. She found in the process of her lifelong search for the answer to the question "What is history?" that history must truly be felt as a personal impulse—the humanist's desire to feel the "common bond" of humanity. All of her life Arnow embraced the "shy girl" History, "certain of some kinship, some common bond, some self-identification with her."

NOTES

1. Arnow published, roughly, twenty nonfiction essays and reviews on a variety of subjects. Some of these essays contained materials that later appeared in *Seedtime* and *Flowering* ("Education and the Professions in the Cumberland Region," *Tennessee Historical Quarterly* 20, no. 2 (June 1961): 120-58, and "The Pioneer Farmer and His Crops in the Cumberland Region," *Tennessee Historical Quarterly* 19, no. 4 (December 1960): 291-327. Others showed her interest in the contemporary state of Appalachia ("Gray Woman of Appalachia," *The Nation,* 28 December 1970: 71-77; "No Rats in the Mines," *The Nation,* 25 October 1971: 401-4; and a review of Harry Caudill's *Night Comes to the Cumberlands* in the *New York Times Book Review,* 21 July 1963: 25). Still others of her essays were concerned with another one of her great interests: language and reading ("Language—The Key That Unlocks All the Boxes," *Wilson Library Bulletin* 30 (May 1956): 683-85, and "Reading Without a Purpose," *American Library Association,* November 1959: 837-9.

2. Harriette Simpson Arnow, *Some Musings on the Nature of History*, The Clarence M. Burton Memorial Lecture (Kalamazoo: Historical Society of Michigan Publications, 1968), 3-12.

3. Toynbee describes the Appalachian people thus: "The Appalachian mountain people are the American counterparts of the latter-day white barbarians of the Old World: the Rifis and Kaybles and Tuareg, the Albanians and Caucasians, the Kurds and the Panthans and the Hairy Ainu. . . . They are *ci-devant* heirs of the Western Civilization who have relapsed into barbarism under the depressing effects of a challenge which has been inordinately severe" (*A Study of History*, vol. 2 [London: Oxford University Press, 1935], 311-12).

4. See Henry D. Shapiro, *Appalachia On Our Mind: The Southern Mountains and Mountaineers in the American Consciousness, 1870-1900* (Chapel Hill: The University of North Carolina Press, 1978).

5. This is an obvious reference to at least one major study, Arthur K. Moore's *The Frontier Mind: A Cultural Analysis of the Kentucky Frontiersman* (Lexington: The University of Kentucky Press, 1957).

WORKS CITED

Arnow, Harriette Simpson. [1954]. 1972. *The Dollmaker*. New York: Avon.

_____. 1960. *Seedtime on the Cumberland*. New York: Macmillan.

_____. 1962. Letter to Mrs. Jesse A. Reeves, 17 February. Eleanor Baker Reeves Papers. Ashe County, North Carolina Public Library, West Jefferson, N.C.

_____. 1963. *Flowering of the Cumberland*. New York: Macmillan.

_____. 1968. *Some Musings on the Nature of History*, The Clarence M. Burton Memorial Lecture. Kalamazoo: Historical Society of Michigan Publications.

_____. 1977. *Old Burnside*. Lexington: The University Press of Kentucky.

Baer, Barbara. 1976. "Harriette Arnow's Chronicles of Destruction." *The Nation*, 31 January, 117-20.

Byrd, William II. 1991. "History of the Dividing Line." Pp. 246-65 in *American Literature: A Prentice Hall Anthology*, vol. 1. Emory Elliott, ed. Englewood Cliffs, N.J.: Prentice Hall.

Creekmore, Pollyanna. 1961. "Rev. of *Seedtime on the Cumberland* by Harriette Simpson Arnow." *The Journal of Southern History* 27 (February): 96-97.

Crevecouer, Michel-Guillaume Jean de. [1782]. 1991. "Letters from an American Farmer." Pp. 497-520 in *American Literature: A Prentice Hall Anthology*, vol. 1. Emory Elliott, ed. Englewood Cliffs, N.J.: Prentice Hall.

Dykeman, Wilma. 1984. "Foreword." In *Flowering of the Cumberland,* by Harriette Simpson Arnow. Lexington: The University Press of Kentucky.

_____. 1983. "Foreword." In *Seedtime on the Cumberland,* by Harriette Simpson Arnow. Lexington: The University Press of Kentucky.

Eckley, Wilton. 1974. *Harriette Arnow*. New York: Twayne.

Miller, Danny. 1982. "A MELUS Interview: Harriette Arnow." *MELUS* 9, no. 2 (Summer): 83-97.

Rea, Robert R. 1960. "Rev. of *Seedtime on the Cumberland*." *Library Journal,* 15 June, 2426.

Walsh, Kathleen, 1984. "'Hunter's Horn': Harriette Arnow's Subversive Hunting Tale." *Southern Literary Journal* 17 (Fall): 54-67.

Harriette Arnow in 1949, photograph by Lee R. Redman.

INDIVIDUAL FICTION

THE HARBINGER: ARNOW'S
SHORT FICTION

HAEJA K. CHUNG

Despite the renewed interest in her writing in the last two decades, Harriette Simpson Arnow remains underrated. At best, she is known as the author of *The Dollmaker* (1954) or as the "obscure" writer of the novel on which Jane Fonda's television movie of the same title was based. Not surprisingly, few readers are aware of Arnow's finely crafted short stories.

Before her death in 1986, Arnow had published eight short stories: "Marigolds and Mules" in *Kosmos: Dynamic Stories of Today* (1934), "A Mess of Pork" in *The New Talent* (1935), "Washerwoman's Day" in the *Southern Review* (1936), "The Two Hunters" in *Esquire* (1942), "The Hunter" in the *Atlantic Monthly* (1944), "Love?" in *Twigs* (1971), "Fra Lippi and Me" in the *Georgia Review* (1979), and "Interruptions to School at Home" in *Adena* (1980).[1] After her death, Arnow's children gave permission for two other stories to be published in the *Appalachian Heritage*: "Blessed . . . Blessed" (spring/summer 1988) and "The First Ride" (fall 1989). All of her unpublished stories are housed in the Arnow Special Collection at the University of Kentucky Libraries: fourteen completed stories, one in working draft stage,[2] and two incomplete.[3] The return addresses on the manuscripts indicate that, except for three stories written in Burnside, Kentucky[4] and two stories written in Detroit,[5] all of the stories were written during the 1930s and 40s, while she lived in Cincinnati, Ohio, and nearby Covington, Kentucky.[6] These short stories are crucial to Arnow scholarship: they serve as the barometer of Arnow's full range of artistic achievements, illustrating the central thematic and artistic concerns that would come to fruition in her later novels.

Arnow's letters and interviews indicate that, among the literary movements that flourished in the early twentieth century, she was keenly aware

of the revivals of naturalism and of Southern literature. Arnow began to write short stories during the Depression Era, a politically and economically turbulent period that found disillusioned American writers challenging Emersonian idealism. A growing number of writers such as James T. Farrell, John Dos Passos, Erskine Caldwell, and John Steinbeck attacked the evils of economic inequity, dramatizing the dreadful social conditions that pervaded both urban and rural areas. The 1930s thus provided fertile ground for the proletarian naturalism of left-wing writers, as well as for the social realism of many other writers who were acutely conscious of social injustice. As critics noted, another literary phenomenon prevalent from the 1920s to the 1940s came to be known as the "Southern Renaissance" (Current-Garcia and Patrick 1982, 332). A small group of Southern writers known as the Fugitives found "humanistic ideals" in such "antebellum southern traditions" as love of the land and respect for an agrarian way of life. But their ideals were not universally embraced. In 1930, when John Crowe Ransom, Allen Tate, Robert Penn Warren, and others published a collection of essays entitled *I'll Take My Stand*, its patrician lament for the Old South was denounced by non-Southerners as "a reactionary agrarian manifesto intended to undermine the political and industrial foundation of America" (Current-Garcia and Patrick 1982, 333).[7]

Although Arnow did not claim any affinity with either the Southern Renaissance writers or the practitioners of proletarian naturalism,[8] her short stories show a curious fusion of the two traditions. To a degree, Arnow's stories reflect the concerns of both Depression Era proletarian intellectuals and the Southern literary culture; yet she wrote with a distinct voice of her own. Arnow's stories deal with social injustice in both rural and urban settings, but her treatment of the subject is ironic rather than sensational or polemical, and her depiction of hill life in Kentucky is realistic rather than idealistic. Arnow is a social realist, who writes with a keen sense of irony.

The stories published before the 1940s embody Arnow's varied and complex talents. Each is a *tour de force*, precisely conceived and masterfully executed. Often focused on a single event in rural Kentucky, the stories deal with the timeless subjects of human aspirations and frustrations. Although her writing is naturalistic in its fidelity to detail, these stories make no obvious attempts at either proletarian or agrarian messages.

"Marigolds and Mules" (1934), as its title suggests, is a brutally ironic story. It opens innocuously with a loving wife cooking her husband's

favorite soup in the "pretty month" of October when the marigolds are in full bloom. But Arnow deftly foreshadows an impending tragedy through a series of jarring perceptions and descriptions. The young boy-narrator, for instance, challenges Mrs. Madigan's feeling of contentment by asking whether she is "worried" or "afraid" for her husband, Joe, who is hauling nitroglycerine to an oil field. And the narrator's mother, who has become cynical after losing a daughter in an explosion, scoffs at the illusory hopes of young people. When the boy brings home a bouquet of marigolds that Joe's wife picked for her husband, his mother ridicules the wifely gesture as foolish and reminds him of grim reality: "the mud is deep." When he admires "pretty" stars, she chides him again: "You don't belong to talk about the stars." At this precise moment, the devastating explosion occurs that blows Joe to bits along with his mules. Reminiscent of Stephen Crane's impressionistic images, Arnow places natural beauty alongside human tragedy. Just before the explosion, the narrator notices "a big star, orange red" that reminds him of the marigolds. Even after the explosion, the young narrator gravitates to the "bright and clean and beautiful" star, which is oblivious to the grisly scene on the earth, where "in a yellow beech tree a piece of intestine made a slimy red garland." The narrator also describes in gruesome detail the only discernible remnant of Joe, a hand: "It was black. The whole hand was black. The little hairs were still red gold. Drill Stem Cook had the cleanest handkerchief. They wrapped it in that" for his young wife. Life in this story is a cruel game; sensing the cosmic chill of the moment, the young narrator concludes that even a hell could not have "pretty stars to shine on bloody mules and dirty, bloody men." In conception and execution, "Marigolds and Mules" is perhaps Arnow's most naturalistic writing.

"A Mess of Pork" (1935)—another story with an ironic title—is about a consuming desire for retribution. Mrs. Fairchild of Somerset, Kentucky, is a strong-willed widow driven to avenge the murder of her husband, Tred, who was shot by two sheriffs for moonshining and left to be eaten by wild hogs. In this story, Arnow effectively uses an unnamed narrator, a fugitive from the law who has killed "a copper" and seeks refuge with Mrs. Fairchild. Through his observations and perceptions, readers learn crucial information that prepares them for a shocking ending. For instance, the narrator notices that the widow keeps "a hog's skull" in the house and fattens "a boar hog with teeth like the teeth of the skull," which the widow with a smile assures him is "a cannibal hog." The savage irony is not lost:

"He [the boar hog] will make a fine *mess* of pork," the widow adds, recalling the opening scene of the story when, referring to Tred's death, a man asks, "Did they [hogs] *mess* him up?" (emphasis mine). Finally, using as bait the $1000 reward for turning in the fugitive, Fairchild lures the officers responsible for her husband's death to the valley where wild hogs are roaming. Hidden at the top of a canyon, the nameless narrator listens to the boars attacking the men, and as readers we join him in this vicarious experience: "Their teeth made crunching sounds. The black boar's teeth when he ate the walnuts had sounded that way. I knew there were no walnuts down there." This understated analogy conveys the horror of the moment much more vividly than would graphic details.

In "Washerwoman's Day" (1936), Arnow treats a small town's hypocrisy with dramatic irony. The title and opening scene suggest that the story will focus on Clarie Bolin, a poor washerwoman who died of pneumonia after scrubbing a kitchen floor barefoot to protect her new shoes. But the main character turns out to be Clarie's daughter, Laurie Mae, skillfully chosen by Arnow to expose the town's hypocrisy. Jane, the young narrator of the story, is eager to go to Clarie's funeral, not to pay her last respects, but to keep an eye on Laurie Mae who has an illegitimate child. Jane and her friend, Susie, are appalled by Laurie Mae's conduct: she is "awful," not bowing her head in prayer; "she is not even crying"; she has "her nerve to bring that baby." The girls' insensitive comments and preoccupations ominously reflect the morality of the whole town, so their insensitivity serves indirectly as an indictment of the adults who have biased their children's judgment. By carrying her baby in public, Laurie Mae flaunts her status as an unwed young mother, thereby showing her disdain for a community that has ostracized her and her child. By crushing into the mud the white roses the Ladies' Aid Society has given her, this "white trash" woman defies the sanctimonious women who squander money on expensive flowers for her dead mother. Arnow reveals an ongoing concern for similar hypocrisy in both *Hunter's Horn* and *The Dollmaker*.

Two other published stories, "The Two Hunters" (1942) and "The Hunter" (1944) deal with the mountain mores that would later become motifs in *Hunter's Horn*; yet these finely crafted pieces transcend stereotyped mountain stories. On the surface, the former story entails the murder of a deputy sheriff by a seventeen-year-old boy, Lacey, who feels the need to protect the moonshining business of the community. In order to ward off a threatening intruder, Lacey follows the mountain code of con-

duct. But the narrative's beauty and effectiveness derive mainly from Arnow's adroit use of irony and foreshadowing. Reminiscent of the deceptively innocent opening scene in "Marigolds and Mules," the reader first sees "a tall boy, slender, with small hands and small feet. . . ." He carries a rifle but carefully cradles his old felt hat "half filled with flowers" in his other arm. His dog, Mose, is also with him, completing the picture of domestic innocence. The deputy sheriff compares him to a girl: "Lacey? Sounds like a girl's name, but maybe you are a girl." Belying such an unintimidating appearance, however, Lacey displays a steely inner resolve by coolly manipulating his victim to his advantage: he manages to win the deputy's "brass telescope" to mount on his own rifle and shrewdly instructs the deputy to remove his feet from the stirrups when he is in the creek in order to precipitate his fall from the horse.

The ritual of hunting fascinated Arnow, an aspect thus far ignored by feminist readers. "The Hunter" deals with the rigorous discipline involved in hunting and introduces one of Arnow's favorite characters, Nunn Ballew. After his hound, Zing, has been run to death by the red fox, Nunn yields to his cronies' suggestion that they trap the fox by spotlighting him with a carbide. But Nunn refuses to shoot the trapped fox, whose eyes remind him of the terror-stricken eyes of a trapped miner he once saw. He vows instead: "I'll ketch that big red fox for ye, ketch him fair an' true with a foxhound." Wilton Eckley has pointed out that Nunn proves to be "a variation of nature's nobleman," who stands by the "almost poetic ritual of the hunt" (62). Arnow thought that Nunn's fox hunting would make "a fragment of a ballet; so danced, that the observer couldn't tell whether Nunn was chasing the fox or the fox was chasing him" (Chung "Interview"). *Hunter's Horn* focuses on Nunn, "a more interesting character than Gertie" to Arnow (Flynn 1990, 256), and his almost religious obsession with the red fox, or "a red devil."

Clearly, Arnow's stories published prior to 1945 demonstrate her craftsmanship and command of diverse subjects. They are all aesthetically conceived and executed, with various structural and textural elements proportionally balanced; characterization, dialogue, irony, point of view, and detailed description all equally contribute to creating an artistic whole. The style to which she aspired later in her novels is also evident—"a style not exactly bleak, but not wordy, a narrative with no adverbs and few adjectives, a style of self" (Flynn 1990, 257). Indeed, these stories—both in substance and style—demonstrate Arnow's enduring, universal appeal.

The five stories that were published after 1970, along with twelve unpublished stories, further illustrate the thematic preoccupations that Arnow would more fully develop in her novels.[9] Arnow continues to treat her subjects ironically, but her ideological emphasis shifts with the setting, be it urban or rural.

Arnow's city stories seem more proletarian than her rural stories, for they focus on the struggle of the industrial world's oppressed. In one unpublished story, "White Collar Woman," a newspaper man, recently fired for his guild activities, recounts how a manipulative manager wielded power and destroyed the once vital and enthusiastic Press Guild. Kearney, now married to a former union member—a "white collar woman"—relinquishes his active leadership of the guild to protect his family's welfare, while Flannigan, another feisty guild member, becomes a dispirited man, slowly edged out of his job, brandished as an agitator. Another urban story, "Fra Lippi and Me," written in either 1937 or 1938 but not published until 1979, also deals with a situation in which compromise is necessary for survival. A poor waitress, Patsy, is harassed physically and verbally by her customers and supervisor. After overhearing a wealthy matron persuade a starving young artist to come under her wing, Patsy decides to phone her own wealthy suitor and compromise her integrity as a married woman. The choice between the art of painting and the art of living is a conflict familiar to readers of *The Dollmaker*. Perhaps the most proletarian subject is found in a working draft, "The Un-American Activities of Miss Prink," titled by the writer's daughter, Marcella Arnow. Apparently written later in Arnow's career, this story shows how a conscientious and morally upright teacher in Detroit is targeted as a "Red" because she exercises her freedom of speech and defends a wrongfully accused colleague. Here, Arnow deplores the McCarthyite persecution of individuals who courageously follow their social-political conscience. This theme, too, is one that Arnow treats more extensively in *The Dollmaker* and, particularly, in *The Weedkiller's Daughter*.

The most moving urban story is an unpublished story, "Almost Two Thousand Years." It chronicles the wretched life of Lupe, a half-witted "bastard boy," working for Tony, a street vendor, during a bitterly cold winter. The story is told from Lupe's point of view, a masterful narrative choice in which the child's shifting reactions toward the lights, sounds, fruits, and vegetables filter through his slow-paced consciousness. He sits beneath a snow-covered wagon and endlessly cleans fruits and vegetables,

measuring time by the feet he hears and sees. The child dreads the word "Christmas," because it brings much more work and longer days for him. And yet, through "the mad, pushing angry feet, the cold, the blood on his hands, the rotten cranberries, the red flower of the stiff poinsettias . . . , he knew that the time of the word was near." One Christmas Eve, his legs freeze stiff, and he cannot walk; but he stumbles upon the truth that most people of normal intelligence fail to recognize: "Me. . . like Christ. . . mooch money. . . make da people buy," he cries. This story condemns the perversity of the Christmas season's material excesses and delivers a stinging indictment of self-absorbed people, including Tony, who are preoccupied with making money while being oblivious to the pains the season inflicts on the dispossessed. The character Tony, in modified form, also shows up in *The Dollmaker*.

Though acutely aware of disparities in material wealth and power, Arnow does not uncritically follow the conventions of proletarian literature. In fact, she often expressed her displeasure with the genre: "I wanted to write of life in America without the ugly realism of Mr. Caldwell" (Flynn 1990, 257-58). Arnow does not, in the words of Glenda Hobbs, "proselytize for a political cause or an economic system"; and yet she depicts "persons of unusual mettle facing economic ruin or spiritual exhaustion" (149-150). Arnow awakens readers' social consciences by allowing them to identify with her characters' plight, an identification achieved through her "ability to remain detached from her material—to permit character and scene to carry the burden" (Eckley 1974, 56).

Arnow appears more equivocal about agrarian life than she is about urban life. She neither patronizes hill farmers as oppressed and exploited nor celebrates rural life in the backhills as ideal; she writes about characters who ache for rural life, as well as others who wish to escape it all. As a self-declared realist (Chung "Interview"), Arnow realistically exposes her hill people's poverty as well as their joys.

Three Kentucky stories depict the rural hill life, which, as Arnow explained in an interview, is "a personal dream of community I'd had ever since childhood and have been trying to recapture in my writing" (Baer 1976, 117). "Ketchup Making Saturday" is about a suspenseful day in the life of a female teacher, who comes to appreciate the physical strength of a mountain woman, as Louisa in *Mountain Path* and Arnow herself did as one-room teachers in the backhills. The teacher can hardly lift an ax, but big Lurie Haines swings the ax eleven times and leaves eleven sticks of

pine lying by the chopping block. Lurie Haines seems to be in good company with Gertie Nevels in *The Dollmaker*. "King Devil's Bargain," an early version of the third chapter of *Hunter's Horn*, is another beautifully executed hill story, in which Arnow revisits Nunn Ballew and introduces other characters—Milly, Suse, Lee Roy, Rans Cramer, and others—who reappear in *Hunter's Horn*. Nunn was her overall favorite character: "The more I wrote about him the more I liked him. I almost loved him before it [*Hunter's Horn*] was over," Arnow said, as late as 1985 (Flynn 1990, 256). The story contrasts Nunn, the conscientious hunter, with Rans, whose ignorance of hunting rituals brings on the premature death of his young pup, Del. Finally, "Blessed . . . Blessed" (1980) pits a new generation of Southerners against an older generation. Young Mrs. Fairchild, whom old Mrs. Fairchild calls "a hillbilly with loose wild ways," and her daughter Katy spontaneously set out to help Fiddlin' Turpin, a black man who has just escaped from prison. Mother and daughter communicate with each other not so much in words as through actions; Katy understands her mother's intentions by watching her tense hands and listening to her trembling voice. Katy manages to deliver a gray mare to the black man before the bloodhounds and men bring him to bay. Katy tries to recite a passage from the Beatitudes, "Blessed are the peacemakers . . . ," which becomes the moral incentive for the two young women to act against the racial standards that the community, including Katy's grandmother, dictates. Pursuing instincts that run counter to community norms and fighting for social justice are recurring themes in Arnow's fiction.

Arnow's unpublished stories of the Kentucky hills introduce what becomes a dominant theme in *The Dollmaker*: the power of land. Owning a piece of land is one of the deepest desires of her characters, as it was for Arnow in her own life. Some of her characters may venture into the city, but they can never completely free themselves of their attachment to the land. The unnamed narrator in the story "Failure," for instance, moves to the city to see the world, but fails to shake off what he calls "the ghosts" of the hills back home. When he finally goes back to the Cumberland for a visit, he no longer feels the constant "hunger" he had in the city. His mother explains, "You've got land in your blood." This young man clearly prefigures *The Dollmaker*'s Gertie who describes land as "a little piece a heaven right here on earth," "the promised land. . . for the Israelites."

Two stories about a "whittling mouse," probably written for children, also deal with the hold the land has over its rural inhabitants. "Zekie, the

Hill-Billy Mouse" describes the life of "a hill-billy mouse" whose family is forced by poverty to move out of the high hills. Before Zekie moves to his cousin's rich farm by the river, he whittles a fiddle out of a fallen red cedar tree, so that he can play on it whenever his family gets homesick, creating the sounds of home—"the wind in the cedar trees," "the laughter of the creek, and the chatter of the squirrels." Another mouse story, "An Episode in the Life of Ezekial Whitmore" is about a fiddle-playing hill mouse who, tempted by fame and fortune, moves to the city. But Ezekial cannot find any beauty in "the Finer Things of Life" in the city. When he plays "city music," he produces only harsh, discordant notes, much to the disappointment of the literary lady mouse, who has made a fortune by writing about Ezekial's musical talent. In this story, Arnow satirizes cultural snobs who patronize backhill people. Even in these children's stories, Arnow demonstrates the extent to which land is the root of existence for her characters; at the same time, she reveals her own apprehensions about modern technological progress, which she often suggested had eroded the pastoral simplicity of hill people's lives.

Arnow most forcefully asserts herself as a social realist when she writes about women in the backhills. Primarily, her stories show how the personal potential of mountain women went unfulfilled because of the constraints imposed by the hill culture: community belief in a retributive God who exacted obedience to a patriarchal order and submission in all things demanded of the mother-wife-housekeeper-farmer role. Two stories that illustrate this theme are "Love?" (1971) and "First Ride" (1989), both of which concern women's feeble attempts to free themselves from the confines of a patriarchal society. In the first story, Lulu, the obedient wife of the foul-mouthed Oscar, schemes to save a beautiful hawk from her husband's gun, but questions whether her secret attempts are sinful acts, violating her sacred marriage vows. When the bird's wing is "nicked," for instance, she creates an excuse to stay home alone and nurse the bird, planning to feed it the pieces of chicken she has saved to make dumplings for Oscar. She attempts to preserve natural beauty at the expense of her wifely duties to her husband, an obsessed hunter who has spent "a mint" for his gun but will not buy Lulu a pair of decent shoes or a refrigerator. Ultimately, the "proud and free" hawk awakens in Lulu vague stirrings of desire for freedom and independence, which she had not been ready to acknowledge before. The second story concerns a free-spirited woman whose family forced her to marry at age sixteen to keep her "straight."

Seeking release from the burden of her wifely duties, she finds ecstasy in her first "long wild ride" on her big gray stallion, Rebel. Riding through a treacherous hill pasture at night, she is finally one with nature's elements, "the sweet smell of the wild flowers" and "the roar of a creek"; moreover, she is free from her mother who "lived for the neighbors and God." But when heavy dew drops fall on her face like tears, she quickly becomes troubled, recalling her crying child and the concerned faces of her family. At the time Arnow wrote these stories, freedom remained as yet an unnamed yearning for most women in the backhills.

There is an exception, however. In "Home Coming," a woman seeks and finally claims her freedom. Resembling a dramatic poem or ballad, this short short story consists of a dialogue between a father and a son. While eagerly awaiting the mother's homecoming, they recall incidents that intimate the narrative's outcome. They talk about the mother who fancied the train whistling "I'm a go-a-a-a in aw-a-a-ay"; who said "whippoor-wills make her want to cry"; and who seemed fascinated by "women a dancin in the town." Near the end, even before the father picks up a letter left behind, the reader knows that the mother will never come home. It is no accident that Arnow later wrote compelling novels about women who unsuccessfully long for urban opportunities, or who suppress their independent spirit, all with tragic consequences; Suse in *Hunter's Horn*, Delph in "Between the Flowers," and Gertie in *The Dollmaker* are prime examples. These female characters' struggles for fulfillment have encouraged some critics to give Arnow a feminist reading.

Arnow is certainly no "local colorist," as John M. Bradbury defines the term, who highlights the "dialect, quaint custom, and unfamiliar scenery" of the Southern mountains for their own sake. Arnow appears to be one of the few exceptional Southern writers who practiced "a new atmospheric realism, in which realistic portraiture and the universal problem supplant the sensational" (Bradbury 1963, 20).[10] Arnow wrote mostly about Kentucky, the region she knew best, but labeling her a regionalist does not do justice to her writing. As the stories illustrate, her regional perspective is applicable to the world and people beyond Kentucky; the universal human conditions and aspirations she captured in her short stories transcend regional and gender boundaries.

Two unpublished stories, belonging to neither an urban nor a rural setting, reinforce Arnow's ironic vision of life. Arnow obviously saw reality as being full of discrepancies and incongruities, which she exposed to the

reader by raising provocative questions. "Tin Cup" is a well-crafted, sensitive story about a friendship between a terminally-ill yet imaginative narrator and her sensible, practical friend Peg. For once, compromising her principles, Peg chooses to do insensible and impractical things, embodied symbolically by a tin cup of poor quality: she buys expensive tickets to concerts and alters her friend's favorite blue suit permanently, instead of tucking it in temporarily, in order to make an unspoken but indisputable statement about the finality of her friend's illness. The story leaves the reader contemplating the nature of friendship. Another unpublished story, "No Lady," is a satirical piece that ponders the question, who, indeed, is a true lady? The narrator in the story repeats, like a refrain, that her great-great Aunt Kate is "a lady," an upper-class Southern belle, but her Nannie Mae, a slave woman, is "no lady." At the end of the story, however, the "lady" spirits her "come-by-chance child" away, along with her black Nannie, who is forced to desert her own children. The "lady" sheds no tears and suffers no pain, because she has successfully avoided a scandal. "Nothin' serious, a cold," she says, smiling up from her "lace covered bed." Such irony lends artistic distance to Arnow's stories, defying regional and ideological classifications.

Finally, one of Arnow's unpublished short stories, entitled "Sugar Tree Holler," stands out as "extremely autobiographical," according to her daughter, Marcella (Miller 1989, 46). Written during her stay in Cincinnati, this story concerns the courtship and marriage of two people whose lives closely resemble those of Harriette Simpson and her future husband, Harold Arnow. During the Depression era, Susie Hardwick is a Kentucky girl working for the Works Progress Administration (WPA), and Mike Abel, also working for the WPA, is "that new editor from Chicago," as was Harold Arnow. Written in an epistolary form, letters from Susie to her cousin Sadie in the Kentucky hills tell of Susie's desire to buy land in Sugar Tree Holler; they also tell of her relationship with Mike Abel, a bachelor, who complains about having to eat restaurant food. Susie is fearful about the illegality of having saved $140 for the land, and when Mike promises to solve her problem, she invites him over for dinner. Later in the evening, Mike lays out $695 of his own savings on the kitchen table, prompting an awestruck Susie to declare that he has enough money to buy "a hundred of acres of land" in Sugar Tree Holler. But Mike repeats that he cannot cook and that he needs somebody who will help with the farm. Slipping into a third-person monologue, Mike tells Susie: "Spend it

[the money] on house furnishings." Investigators would not say a word when a married woman withdrew her money from the bank to set up housekeeping. Mike's plan is accepted as a marriage proposal; at the end of his monologue, Susie simply nods her head. Three days before investigators come to question the WPA Project employees, Mike Abel and Susie Hardwick cross the river to Kentucky and marry, as did Harold Arnow and Harriette Simpson.

Readers may wonder why Arnow left so many stories unpublished. Papers in the Arnow Special Collection indicate that a few stories, such as "Ketchup Making Saturday," "Homecoming," "No Lady," and others, were rejected by magazines such as *New Masses, Scribner, Esquire*, and the *Southern Review*. Glenda Hobbs argues that they were rejected because the market was flooded with rural stories (155-56). Arnow was not, however, a helpless victim of circumstances. For one thing, not all of the stories are as richly textured and fully developed as were her best stories, published in the 1930s and the 1940s. In addition, Arnow was never passionately driven to publish short stories. Among the Arnow papers are letters from her editor, Galena Hopkins, urging Arnow to write short stories while her manuscript "Between the Flowers" was in circulation. But Arnow would never be content with short stories; her imagination took flight and kept her thinking about her characters until she had the satisfaction of developing them more fully in a novel. Arnow's self-described writing process lends validity to this argument:

> I wish I could turn out short books. I don't seem able to. It gets longer and longer. I start out with a character and there's a family or friends, and a community, and they all talk, and this happens . . . and oh God. I'd have to write about a person living alone in a cave, I think, to get a short book. (Chung "Interview")

To a large extent, Arnow's short stories constitute her initial conceptions of her great characters. This explains why many chapters in *The Dollmaker* and *Hunter's Horn* stand by themselves as self-contained short stories; it further explains why her short stories feature characters who reappear in the later novels.

Indeed, Arnow's short stories published in the 1930s and 1940s and some of the later stories—notably "Blessed . . . Blessed," "King Devil's Bargain," and "Almost Two Thousand Years"—have the nearly flawless

quality of all the best stories, in which thematic and technical elements are carefully interrelated and balanced. Furthermore, the distinctive features of Arnow's great novels—engrossing characters, keen social-political consciousness, superb craftsmanship, ironic vision of life, and spare but evocative language—all are presaged in these short stories. In particular, the agrarian subjects she explored in her rural stories are perfected in *Hunter's Horn*; the proletarian subjects with which she experimented in her urban stories are expanded in *The Weedkiller's Daughter*. It is not surprising that both the agrarian and proletarian subjects she worked with separately in her short stories become fused into a complex artistic whole in her greatest novel, *The Dollmaker*. Despite her achievements as a short story writer, it is clear that Arnow's most comfortable medium in fiction is the novel.

NOTES

1. According to Sandra Ballard, this last story comes from the unpublished novel, "Belle."
2. The manuscript, "The Un-American Activities of Miss Prink," has some names and words missing.
3. "Crazy Blanket" and "Witch-hazel Blooms in November" do not have endings.
4. "Winky Creek's New Song," which is the earliest writing by Arnow, "The Goat Who was a Cow," and "Dreams Come True" seem to have been written when Arnow was still young, growing up in Burnside, Ky.
5. These are "The Un-American Activities of Miss Prink" and "King Devil's Bargain."
6. For more detailed information about Arnow's personal life during this period, see Danny Miller's essay in this collection, "Harriette Simpson and Harold Arnow in Cincinnati: 1934-1939."
7. For further information about the thirties, see Alfred Kazin, "The Revival of Naturalism," in *On Native Grounds: An Interpretation of Modern American Prose Literature* (New York: Harcourt, 1942), 363-99; Irving Howe, "The Thirties in Retrospect," in *Literature at the Barricades*, edited by Ralph F. Bogardus and Fred Hobson (Tuscaloosa: University of Alabama Press, 1982), 14-28; John M. Bradbury, "The Awakening," in *Renaissance in the South: A Critical History of the Literature, 1920-1960* (Chapel Hill: The University of North Carolina Press, 1963), 7-21.
8. In her essay "Starting Out in the Thirties," Glenda Hobbs argues that Arnow is neither a proletarian nor an agrarian writer. She cites Arnow's letters to her in which Arnow denies her affinity with either tradition.

9. The following six stories are excluded from discussion in this essay: "The Goat Who was a Cow," "Dreams Come True," and "Winky Creek's New Song" are products of young age; "Crazy Blanket" and "Witch-hazel Blooms in November" do not have endings; "Interruptions to School at Home" is part of an unpublished novel.

10. For further information on "local color," see Bradbury, "The Awakening." Bradbury says, "The term, 'local color,' suggests an attitude toward environment, rather than simply interest in it."

Works Cited

Arnow, Harriette Simpson. [Harriet L. Simpson]. 1934. "Marigolds and Mules." *Kosmos* 3 (August-September): 3-6.

_____. [Harriette Simpson]. 1935. "A Mess of Pork." *The New Talent* 1 (October-December): 4-11.

_____. [Harriette L. Simpson]. 1936. "Washerwoman's Day." *Southern Review* 1 (Winter): 522-27.

_____. [H. L. Simpson]. 1942. "The Two Hunters," *Esquire* 18 (July): 74-75, 96.

_____. 1944. "The Hunter." *Atlantic Monthly* 174 (November): 79-84.

_____. 1971. "Love?" *Twigs* 8 (Fall): 1-15.

_____. 1979. "Fra Lippi and Me." *Georgia Review* 33 (Winter): 867-75.

_____. 1980. "Interruptions to School at Home." *Adena: A Journal of the History and Culture of the Ohio Valley* 5, no. 1 (Spring): 40-55.

_____. 1988. "Blessed . . . Blessed." *Appalachian Heritage* 16 (Spring/Summer): 7-12.

_____. 1989. "The First Ride." *Appalachian Heritage* 17, no. 4 (Fall): 13-16.

_____. "Between the Flowers." MS. Folders 33-34, Box 11. Harriette Simpson Arnow Collection, University of Kentucky, Lexington, Ky.

_____. Twelve unpublished short stories. Harriette Simpson Arnow Collection, University of Kentucky, Lexington, Ky.

Baer, Barbara L. 1976. "Harriette Arnow's Chronicles of Destruction." *The Nation* 222 (31 January): 117-20.

Bradbury, John M. 1963. "The Awakening." Pp. 7-21 in *Renaissance in the South: A Critical History of Literature, 1920-1960*. Chapel Hill: The University of North Carolina Press.

Chung, Haeja K. 1995. "Fictional Characters Come to Life: An Interview." In this collection, pages 263-80.

Current-Garcia, Eugene, and Walton R. Patrick. 1982. *American Short Stories*. Glenview: Scott, Foresman.

Eckley, Wilton. 1974. *Harriette Arnow*. New York: Twayne, 1974.

Flynn, John. 1990. "A Journey with Harriette Simpson Arnow." *Michigan Quarterly Review* 29, no. 2 (Spring): 241-60.

Hobbs, Glenda. 1982. "Starting Out in the Thirties: Harriette Arnow's Literary Genesis." Pp. 144-61 in *Literature at the Barricades: The American Writer in the 1930's*, Ralph F. Bogardus and Fred Hobson, eds. Tuscaloosa: University of Alabama Press.

Miller, Danny L. 1989. "Harriette Simpson and Harold Arnow in Cincinnati: 1934-1939." *Queen City Heritage* 47 (Summer): 41-48, reprinted in this collection, pages 33-43.

"FACT AND FANCY" IN
MOUNTAIN PATH

JOAN R. GRIFFIN

In the spring of 1983, during a three-day visit to the campus of the University of Nebraska in Lincoln, Harriette Simpson Arnow delivered a public lecture entitled "Fact, Fancy, and Failure." On one level, the talk contained a good deal of autobiographical information ("fact") previously published in the 1963 "Introduction" to *Mountain Path* (1936), in *Old Burnside* (1977), and in a number of interviews and secondary sources (Baer, Eckley, Hobbs, Lee). On another level, the lecture dealt with Arnow's tracing of the development of her aesthetics through her clever application of "fancy" to the factual details of her life, region, and development as a writer. What at first appeared to be a series of anecdotal recollections was instead a clever demonstration of the writer's imaginative process at work—a simultaneous telling and showing, a creative mix of fact and fancy. The "failure," in her mind, was her way of describing her reaction when faced with those readings of her fiction that equated her with some of her characters—that she was Louisa Sheridan or Gertie Nevels, for example. "They give me no credit whatever for imagination," she quietly complained, but was quick to add: "I don't mind that too much. It's part of our modern world. . . . Whimsy seems to have disappeared." Perhaps so. May the best brand of that "whimsy" be present in the subsequent discussion of Arnow's creative balancing of fact and fancy in *Mountain Path*.

In the "Introduction" to the 1963 reprint of *Mountain Path*, Arnow wrote:

> Rather than a finished work, the book were better looked upon as the beginnings of a long story that stirred in me at times when I was a small girl hunting the family cows on Tyree's Knob above Burnside on the

117

Cumberland, for it was then I saw the other world. This lay in the rows
and rows of hills to the east; I wondered on the life there, where few
people whom I knew had ever visited. (v)

When Arnow wrote these words in 1963, she had already finished the
telling of that "long story" begun in *Mountain Path* and completed in
Hunter's Horn (1949) and *The Dollmaker* (1954). Broadly speaking, these
three novels narrate the gradual erosion and near-dissolution of eastern
Kentucky hill life from the 1920s into the mid-1940s, a "record of a cul-
ture and people in the process of destruction" (Baer 1976, 117). Clearly,
Arnow was not going to allow this chapter of American cultural history
to go unnoticed or unrecorded. Yet, there is more. That story—the grad-
ual dying out of hill life as it had once been known—does not, finally,
describe or define all that is to be found in her trilogy. Region is medium
and a piece of the message in these novels, but not all of it. "Fancy" is
there too.

Along with the richly detailed, evocative picture of a region in decline,
Arnow creates characters caught up in dramas and moral dilemmas of their
own, individuals shaped and formed by the isolated environment around
them, whose struggles range from their trying desperately to live by and
perpetuate the dominant values of their known world to their trying to
escape and run away to the unknown outside world. What happens, in
effect, is that Arnow's trilogy consistently operates on at least two levels:
the communal and the individual—one inextricably bound up with the
other. As the outside world increasingly impinges upon the previously
enclosed, isolated world of the hills, and as history has its way with these
people, the tensions and conflicts at both the communal and personal lev-
els grow in scope and consequence (Griffin 1987, 95). Eventually, the real-
ities of World War II and technology deliver a near-death blow to a way of
life "as old as the hills." It was a pain-filled story that Arnow dedicated her
creative powers to tell, and it all began in *Mountain Path*.

The novel's published title was not quite Arnow's choice; hers had been
simply "Path." Editorial authority intervened, as it would again later in
the choice of a title for *Hunter's Horn*. In a discussion of these title changes,
Arnow talks at some length about her literal and metaphorical use of roads
in her first two novels. "Path" and "End of the Gravel" (her title for
Hunter's Horn) provided a historical emphasis that she wanted to bring to
her fictions. The outside world was gradually gaining entry into the once

isolated world of the hills, primarily because of improved roadways. This coming of the roads proved to be a mixed blessing for the hill people (Arnow 1985, xiii-xiv).

There were a number of other more substantive editorial changes applied to "Path" before its publication. Glenda Hobbs's essay "Starting Out in the Thirties: Harriette Arnow's Literary Genesis" is an informed and scholarly source for *Mountain Path*'s publication history, and its metamorphosis from a series of sketches on hill life to a fully developed novel. Following the advice of Harold Strauss, editor of Covici Friede Press, Arnow decreased Louisa's introspection and added all the material on the feud, "stock material of mountain fiction [that] had proven successful" (Hobbs 1982, 147). Understandably, Strauss's chief concern was the marketability of Arnow's first novel (Covici Friede Press's days were numbered, and in the 1930s there were no Chapter 11 or 13 escape hatches to slide into). Arnow, as Hobbs points out, was anxious to have her work published and did follow many of her editor's suggestions for more action and less meditation, convinced all the while that her "doing so would not impair the book's integrity." Including the feud was risky—too many trite and bad mountain fictions had relied solely on the melodramatic features of feuds to make their narratives. Yet, because of Arnow's roots, along with her narrative gifts—fact and fancy in concert—the feud in *Mountain Path* works to develop and explain character in both artistic and historically accurate ways. Hobbs is insightful when she asserts that Arnow's Cal Valley feud demonstrates the "horrifying tragedy of a practice too deeply rooted and grisly to be viewed as quaint custom" (148). Later sections of this essay will discuss in detail that "horrifying tragedy," as region shapes character and destiny in *Mountain Path*.

More recent than Hobbs's work is John Flynn's 1990 "A Journey with Harriette Simpson Arnow," a most readable discussion of his conversations with Arnow from 1984 until her death on 22 March 1986. His essay contains a number of previously unrecorded Arnow comments on the genesis of *Mountain Path* and provides Arnow scholars and enthusiasts alike with valuable new material for understanding the extent to which Arnow applied "fancy" to the "facts" of her life in her writing (251-53). Flynn's primary source materials (Arnow's words) have all the linguistic features and spirit of a conversation between two close friends, which the two of them were. "Oh, I was so young," Arnow recalled about the writing of her first novel. "I could work like a horse. I did nothing but write on that

novel. . . . The editor wanted action. Boy, did I give him action! I put in everything I could think of—moonshining, a feud, a love story" (247). It is all true, and Arnow's treatment of "everything" is careful and authentic.

Even though Arnow chose to make Louisa Sheridan, the first-year schoolteacher and outsider, the "limited" third person narrator in *Mountain Path*, it is important to keep in mind that Arnow intended for the novel to be the hill people's story, not Louisa Sheridan's. Given the code of the hills regarding secretiveness, it would have been inauthentic for any of the Calhouns or Barnetts to have assumed the narrative responsibilities. Louisa, the outsider, exists because Arnow needs her for narrative reasons and, of course, for the "love story." Then, too, Louisa's circumstances do closely parallel Arnow's own experiences in 1926 when financial exigencies and her mother's insistence forced her to take a teaching job in a one-room school in a remote area of the Kentucky hills (Arnow 1977, 125). Yet, to read *Mountain Path* as either a loosely veiled autobiography or as Louisa's story is to discredit Arnow's imagination and to violate the writer's intentions to record, even dignify, the story of a people and culture whose days were numbered.

While this dark world of hidden stills and destructive feuds in the Kentucky backhills of the 1920s is anything but a friendly environment, particularly for an outsider like Louisa, Arnow is not building a case against hill life. It is Louisa's view, not her creator's, that the Cal Valley, "so old and lost and forgotten, [could] be the home of people" (Arnow 1985, 31). Arnow presents, rather than proselytizes (Hobbs 1982, 149). The social historian in her prevents her from making those quick judgments that Louisa is all too inclined toward. Making a living and honoring family loyalties, traditions, and hatreds are what dominate the lives of the people of Cavecreek: home distilling and feuding are the specific forms these activities take in *Mountain Path* for the Lee Buck Cal family and their kin, as well as for the Barnetts, their arch rivals in the "other end" of the valley. The dangers inherent in both moonshining and feuding have forced the Cals and people like them to be secretive, suspicious, and absolutely close-mouthed toward anyone not their kin.

To make a go at moonshining, a hill family had to raise the needed corn and pretend to be feeding it all to the hogs, keep secret the location of the still, work there late into the night, and make dangerous midnight runs on the river with the brew. The risks were costly: either arrest and imprisonment in the penitentiary at Frankfort or being shot, and maybe even killed.

Moonshining and feuding, Arnow points out, might and often did coexist in backhill counterplay. While operating a home still was hard, risky work and keeping secret its location not easy for the mountain distillers, the carrying on of a family feud was even more demanding and, ultimately, more life-draining for these people. After all, home stilling was once a legal home industry in the Kentucky hills, a legitimate way for a farmer to turn a raw product into a manufactured article and thereby acquire a little cash. Feuding, on the other hand, cannot be said to have ever had legal or morally justifiable roots in hill life. Yet more than the making and selling of moonshine whiskey brewed from a recipe that may have been a family secret for generations, the contending with family hatreds was what dominated the lives of these backhill distiller-farmers, colored their every movement and word, regulated their comings and goings, determined their social and physical boundaries, worked on their superstitions and folklore, filtered into their churches and worship (the enemy "over there" was often more feared and hated than Satan "down there"), and, sadly, often precipitated early and untimely deaths for some.

On the backside of moonshining and in its defense was the reasonable claim a hill family could make to wanting a little cash, gained through hard work, to help support just slightly above impoverished living conditions; on the backside of feuding was a code of revenge and hatred, passed down for generations, origins forgotten or never known or no longer important, fed not by reason but by that blind, irrational impulse to do what always had been done—a code that gave license to one hill family to hate and fear and try to destroy another (Arnow 1985, i-xiv). Yet *Mountain Path* is not about moonshining and feuding in the abstract. Entering into the story as instigators of plot, moonshining and feuding are central to the novel for the part they play in the shaping of character and destiny in that "kind a lost like place" called Cavecreek (13).

The families in both ends of the Cal Valley live in what Arnow termed an "all-encompassing poverty of environment." The wishing after and acquiring of things in no way define their character. That they have little in terms of material possessions and comforts seems unimportant to them. Poverty is a given in their world. Few readers of the novel would deny that life in this kind of society was hardest on the women. For the most part, the women of Cavecreek live in "a world of dread and hatred and waiting in silence" (Arnow 1985, 300), created and perpetuated by the limitations of their men who, because of birth, need, and "habits of blood" (Austin

1932, 97), live lives circumscribed by the realities of moonshining and feuding. It is the tension between Arnow's commitment to recapturing the essential qualities of hill life and hill people and her innate sensitivity to human suffering, especially for her women characters, that help make *Mountain Path* more than a fiction of regional curiosity.

Corie Cal is the first of a number of Arnow's strong, hard-working, long-suffering Kentucky hill women in the trilogy (Millie Ballew in *Hunter's Horn* and Gertie Nevels in *The Dollmaker* are cut from the same cloth). Corie introduces herself to Louisa as "Miz Lee Buck Corie Cal" (Arnow 1985, 34). She is, in fact, first and last Lee Buck's wife; then the mother of his children, three living, three dead; and after that, she is Corie. Like most hill women, Corie has never gone beyond the boundaries of her own remote community and has never thought she should (37). Appearing to be a warm, talkative, inquisitive woman on most subjects, Corie will resort to an awkward, even stony, silence in conversations with Louisa that lead too near to family secrets. The obvious pleasure she takes in Louisa's company is frequently diminished when she is required to hide whole chunks of her reality from the outsider.

The reasons for Corie's awkward silences become more apparent when Louisa begins to get a sense of the troubles and fears that Corie and the other women in the valley have learned to live with. The accumulated effect on Louisa of having visited with the "plum crazy" Aunt Elgie (96) and having talked with the "wild, primitive appearing Samanthetie Pedigo"(107) causes her to view the valley as "some nightmarish foreign land she only walked through and could not live in" (140). In her fear she reflects upon the courage it takes to be a woman like Corie:

> Many women in this valley must have felt and still feel as she was feeling now. When that old trouble happened, breeding hatred strong enough to stamp children unconceived at the time, Corie had lived through it. She lived now, troubled every day, perhaps, for Chris and Lee Buck and their still. Yet she tended cows and pigs and children and chickens and laughed at times. If, as Louisa had seen her do once or twice, she lapsed into stony, cold-eyed silence, she would not stay that way but get up quickly and go singing about some piece of work. She did not forget her troubles and fears, for Louisa knew without Samanthetie's telling her that people here forgot nothing; she only laid them away in a corner of her mind where they were not easily stumbled upon. (140-41)

The longer Louisa is around Corie, the greater her admiration for this troubled woman of the hills. She learns from Corie those "things . . . never found in books—not information—[but] gratefulness and thankfulness for all things" (214-15).

Corie is not without her shortcomings, however. In one of the more humorous scenes in the novel, the revival meeting at the church, Corie seizes upon an opportunity to punish Ellie Stigall, a neighbor who, as Corie says, has "been needin' a good whackin' up a long time, she allus a tellin' tales" (189-93). It is difficult to deny Corie the delight she takes in pounding Ellie Stigall into next week when so much of her life has been filled with grief and pain. At thirty-two, she has already buried three of her children. Her own needs as an individual have been consumed by the demands made on her as wife and mother. Until the very end of the novel, when tragedy once again descends on her family, the most that Corie allows herself to say to Louisa about her troubles is, "Women folks has got hit awful hard" (278). In almost every aspect, Corie is a portrait of self-sacrifice, a woman haunted by fear, living on the edge of that time when something bad happens to her man. Some modern-day readers are not likely to admire Corie's ability to tuck away her troubles in that "corner of her mind," to suffer in silence and dread. Arnow, however, does not make it easy for readers to distance themselves from the Cals.

Lee Buck Cal, the source of so much of Corie's suffering, is no brute. He is a capable husband, father, farmer, moonshiner, and school trustee. Like a number of Arnow's other hill characters, he has a talent for woodworking, and he has whittled a lovely cedar wood fiddle though his fences and steps are in perpetual disrepair. Quite simply, Lee Buck "[did] the things he wanted to do because the doing of them gave him more pleasure than firm gates and solid steps could give" (183). For the most part, Lee Buck is a good-natured, good-humored man as long as the safety of his family, his still, and his honor are not seriously threatened. Even then he is not given to the tenseness of Corie, and his attitude toward the vicissitudes of hill life is considerably more casual than his wife's. "Wise and brave" about most things, Lee Buck cannot escape what is in his blood—to hate "them in th' other end" (144). Louisa, in a moment of enlightened thought, accurately observes that he was "no different from the rest of the world. The things he hated ruled his life, and not the things he loved" (145).

Not surprisingly, the children in *Mountain Path*, as young as most of them are, have inherited their parents' "habits of blood," those lessons of

secretiveness, fear, and hatred. Lander and Pete, two of the Cal boys, already dream of the day they can pack away Chris's "big Smith-Wesson" and "Pop's leetle Colt an' th' big Winchester he keeps in th' cave" and bring down terror on the heads of the Barnetts (168). Equally disturbing is the children's treatment of Samanthetie, that mysterious, shunned child whose mother is dead and whose father is old and sickly. At times these children seem "not children at all, but old things, hardly human, with hatred and suspicion so paramount in their nature that room was left for nothing else" (110). Arnow leaves little doubt that past is clearly prologue in Cavecreek.

Juxtaposed with these dark scenes are others that charm and lull both Louisa and the reader. Evenings in the Cal household, ones not shortened or interrupted by work, are filled with talking, playing checkers, set-back, or Blackjack, singing, or listening to Lee Buck play his fiddle or tell stories. In these evenings around the fire, on the surface a cameo of simple domestic tranquillity, Louisa is able to accept her place as outsider, even philosophize about it: "It all came from a difference in their sense of values. Who valued the right things, [she] would sometimes wonder, and then think again that in Utopia every man [sic] would be his own judge. More and more she was growing to think of Utopia as the dwelling place of individuals, not the home of a nation or a race or a system of culture" (213-14). These quiet domestic moments do help Louisa and the reader to forget about the trouble that seethes below the surface of these people's lives, that is, until the surface calm in the valley erupts, exposing a world closer to dystopia than utopia.

Arnow waits until the final four chapters of the novel (chapters 17-21) before she allows her women to speak openly of the pain they've carried for years in silence. Louisa is catalyst here. Through indirection she has uncovered everything that Corie, Lee Buck, and the children have worked so hard to keep from her. But they don't know she knows and she can't tell them that she knows. She is in a position a little like Robert Penn Warren's Jack Burden—the truth, instead of making her free, imprisons her. She is caught in the same vise that Corie, Molly Gholston, and most of the other women in the valley have been clamped in for years: an oppressive, torturing silence in that world of dread and hatred and waiting in silence. As the inevitable approaches—the still will be raided, Chris will be killed—Louisa tries to wait in silence, thinking that now she understood "why most hill women believed so in God. They had to have something. They were so alone" (303).

Arnow is quite clear about the ultimate horror for women like Corie. Finally, it's not the silence, not the anger, not the helplessness—it's the waiting. In Corie's words, "Ye're a woman . . . an' women has th' hardest work uv all. An' that's th' waitin'. 'Pears like all my life I've been a waitin'. . . . When I wuz leetle an' Maw died seemed like I waited ferever tu grow up. . . . Now I've waited nine months six times fer chillern tu be born. An' ever time wuz hard. . . . An' three I've set an' watched an' waited while they died. Me a knowin'. Not a hopin'. Jist a waitin'" (343). Unquestionably, the parameters of Corie's world, with its stifling limitations, make this otherwise strong, sensitive hill woman a pitiful figure. She is caught. She has no options. Louisa, however, does, and her "waitin'," unlike Corie's, is soon over.

Arnow leaves little doubt about any long-lasting effect Louisa, as teacher of the young, has had. Education from the outside is tolerated but, presumably, ineffective. On the last day of school, the third day after the bloodletting in the cave, Louisa focuses on the troubles ahead for her students, children she had grown to love and protect by shutting "the old hatreds and the old troubles away from them" as long as they were with her in the school house. She thinks of Clyde Meece, "sensitive and sullen and proud, poorly fed and overworked," who would too soon "coarsen rapidly into a wild and ignorant" young man (363); Lander who "would learn to play the fiddle and maybe grow up and kill men—and he would never know sin" (364); and Rie, whose "waist would twist yet more when she carried her own children instead of her mother's, and the bend of her shoulders grow as she grew with her children, so that at twenty-five she would be an old woman never having been a young one" (364). For a split second, Arnow allows Louisa to imagine herself as a self-appointed "savior" who will give her life to these people instead of hoarding it "for a mythical success: she would be a woman and bear children and learn the things that Corie knew. She was running now—building years of a life into each step. She would live in a loghouse and teach school when she was able, and have lots of flowers. . . . She would stay and send Rie to high school. . . . She would not say goodbye. She would come back—for always" (367-68).

Louisa's self-deception is short-lived and her "would's" crumble when she learns that Chris is dead, his body about to be dropped into the river. Her plea—to bury Chris under the poplars he loved so much—cannot be heeded by these people, who long ago have learned that sentiment can have no place in their reality—not if they are bent on surviving in a world that

operates at its lowest point on the motive of revenge. Arnow even has Louisa experience what it is like to desire revenge—that "something greater than grief," stronger than self that destroys "reason and [the] senses" (371). In a skillful and deliberate way, Arnow lets Louisa experience what it would really mean for her to stay in the world of Cavecreek and "learn the things that Corie knew." It is not to be. Time and space are likely to temper Louisa's final words—that she "would forget them all—dog's eyes—trumpet vine—poplar leaves—and woe, woe, over the hearthstones" (374).

Arnow's message is clear: Louisa cannot and does not stay, and *Mountain Path* ends with Louisa's "woe, woe, over the hearthstones," an ending that has created considerable confusion and misreading since the novel's publication in 1936 (Hobbs 1982, 151-53). The temptation for many readers, outsiders all, is to make the novel Louisa's story. It's not. Louisa is a participant-observer who loses her objectivity when she falls in love with Chris Bledsoe. Like Arnow before her, Louisa finds herself in the Cal Valley because of economic necessity. Her "habits of blood" are not the Cals' or Barnetts'.

Many contemporary readers will find this world of moonshining and feuding an oppressive one, and it surely must have been. Arnow, true to her own artistic intentions, resists any temptation to turn her work into the fiction of protest. Instead, she explores, in every possible way, the positive side of Kentucky hill life and their people with their sense of closeness to and respect for the land, their rich and strong family and communal ties. In the process, Arnow draws equally on those resources of fact and fancy.

Part of Arnow's genius as a writer is her ability to engage the reader's interest in and compassion for characters who are singular in their lack of education and sophistication, dead-set in their determination to live by their own codes, and downright suspicious and cool to anyone or anything from the outside who intrudes or interferes in their lives. Yet, engage Arnow does, partly because of the way she writes—a talent for dialogue, for pacing, for creating the "great" scene—partly because of her authorial stance—her unequivocal acceptance of the hill people for who and what they are—and partly because she is an aware and sensitive observer of human nature with an eye for matters of consequence, for matters of the heart. No one reading *Mountain Path* will fail to see that there are limitations to such a life, but there is also a dignity that, in the end, may have been what kept drawing Arnow back to those rows and rows of hills to the east, to that world of fiddle tunes, cool caves, and creaking log houses.

WORKS CITED

Arnow, Harriette Simpson. 1977. *Old Burnside*. Lexington: The University Press of Kentucky.

_____. 1983. "Fact, Fancy, and Failure." Lecture delivered at the University of Nebraska-Lincoln, 20 April.

_____. [1936]. 1985. *Mountain Path*. Reprint with new introduction, Berea, Kentucky: Council of Southern Mountains, 1963. Reprint of 1963 edition. Lexington: The University Press of Kentucky.

Austin, Mary. 1932. "Regionalism in American Fiction." *English Journal* 21 (February): 97-106.

Baer, Barbara. 1976. "Harriette Arnow's Chronicles of Destruction." *The Nation,* 31 January, 117-20.

Eckley, Wilton. 1974. *Harriette Arnow*. New York: Twayne.

Flynn, John. 1990. "A Journey with Harriette Simpson Arnow." *Michigan Quarterly Review* 29, no. 2 (Spring): 241-60.

Griffin, Joan R. 1987. "Geography as Destiny in Harriette Arnow's Kentucky Trilogy." Pp. 144-61 in *Geography and Literature*. William E. Mallory and P. Simpson-Housley, eds. Syracuse: Syracuse University Press.

Hobbs, Glenda. 1982. "Starting Out in the Thirties: Harriette Arnow's Literary Genesis." In *Literature at the Barricades: The American Writer in the 1930s*. Ralph F. Bogardus and Fred Hobson, eds. Tuscaloosa: University of Alabama Press.

Lee, Dorothy H. 1978. "Harriette Arnow's *The Dollmaker*: A Journey to Awareness." *Critique* 20: 92-98.

"BETWEEN THE FLOWERS": WRITING BEYOND MOUNTAIN STEREOTYPES

BETH HARRISON

"Between the Flowers," Harriette Arnow's unpublished novel, is a hefty, almost five-hundred-page, typed manuscript that gathers dust in the special collections at the University of Kentucky Library in Lexington. I have been curious about it ever since reading Glenda Hobbs's fascinating study of Arnow's early literary career, "Starting out in the Thirties: Harriette Arnow's Literary Genesis." Written in the mid-1930s after *Mountain Path* (1936) and before *Hunter's Horn* (1949), the manuscript, I felt, might provide some clues about Arnow's development as a writer. I decided to examine it in more detail, with two questions in mind. First, I wanted to know how the author was able to overcome stereotypical portrayals of mountain characters, a skill she has obviously mastered in *Hunter's Horn* and *The Dollmaker* (1954). I read in Hobbs's article that Arnow's editor, Harold Strauss, actually coerced her into including a mountain feud in the plot of her first novel, *Mountain Path*, to make it more appealing to an audience expecting stock conflict (Hobbs 1982, 147-48). I suspected that Arnow, at some point in her career, had to pull away from her editor's and publisher's influence and assert her own artistic integrity. This speculation led me to my second question: why was "Between the Flowers" never published? Was it unmarketable, in her editor's opinion, because Arnow no longer conceded to the "local color" tastes of her audience? Was it indeed an inferior novel compared to *Mountain Path* and her later work?

From Cratis Williams and other critics we know that characters in Appalachian fiction have often been caricatured as "hillbillies" and "earth mothers," and in fact, Appalachian authors have often written deliberately to confirm these stereotypes. In "Herself: Woman and Place in Appalachian Literature," Carole Ganim makes some perceptive observations about ways

in which Appalachian women characters, in particular, have been stereo-typed, beginning with Mary Noailles Murfrees's "flower" heroines. "How women are 'naturalized',," Ganim asserts, "is what the feminist perspective of Appalachian literature is all about. This theme of women at one (or at odds) with their place or home is pervasive throughout Appalachian litera-ture" (259). Since Murfree, however, women writers of Appalachian fiction have begun to question this stereotype that associates female character with nature.

Arnow's Gertie Nevels, in *The Dollmaker,* illustrates this character revi-sion. Not a simple "earth mother" stereotype, Gertie gains strength and autonomy from her association with the land. In Arnow's earlier fiction, however, for the most part this connection to place is an ambivalent bless-ing for women characters. The natural world might function as a locus for self, as Ganim observes (258), yet it also limits both female and male char-acters. Subsistence farming is a harsh existence. Arnow thus faced a dilemma in moving beyond mountain stereotypes; to create autonomous women characters she needed to affirm the tie to place without dooming her characters to a life of toil and misery. With Gertie, Arnow avoids this trap by moving the Nevelses from the mountains to Detroit. And in her first novel, *Mountain Path,* the female protagonist is an outsider, and not subject to the stereotype of "naturalization." It is in her second manu-script, "Between the Flowers," that one finds her first attempt to develop an autonomous female protagonist in the character Delph.

Before a discussion of Arnow's characterization in "Between the Flowers," a brief summary of the plot is necessary. The story centers around a marriage between a young mountain girl, Delph, and her suitor, an oil-man named Marsh. Contrary to *The Dollmaker,* it is the female protagonist here who wants to leave the mountains. Marsh, a stranger, arrives in the small community where Delph has been raised and soon is struck by her beauty and her divine singing. Although the point of view is not limited to the male protagonist in the novel, clearly, from the opening scenes, Arnow makes the story his. The reader meets Delph through Marsh's "gaze," when he hears her singing at church:

> There was in her voice no supplication nor worship, more a straining
> and yearning as if she would on the instant go in search of the promised
> land. . . . Then suddenly her voice was not enough and he must look at
> her, stare with his shoulders thrust forward, while the forgotten hymn

book and fan slipped between his knees. When he looked at her he thought of curious things, foolish nothings he had never had, a mountain top dark violet in a blue twilight, the smell of clean oak wood, the stars. . . . (20)

From the first, *he* naturalizes *her*. Like Jim Burden in Willa Cather's *My Antonia,* he connects his view of woman to the unfamiliar landscape. Both Jim and Marsh are newcomers to their communities, and both attempt to understand their environments partly through mythologizing the woman that fascinates them.

After a period of secret courtship—Delph's aunt and uncle do not approve of her involvement with a stranger—the two young lovers run away to be married. Delph easily relinquishes her dream of finishing high school in town in order to join Marsh on his "adventure." They plan to go to South America, where Marsh will prosper working in the oil fields. Meanwhile, they live with Dorie, a mountain woman, who has raised her children and farmed the land single-handedly for years. When Delph learns that Marsh now plans to go to South America without her, she is crushed and angry. He finds a sudden solution to their impending separation by renting a nearby farm, and Delph is satisfied. She believes that they will farm for a short while, then move on "toward the wider world" (158).

Marsh has other plans. He becomes devoted to farming, to "making it," despite the tremendous struggle and the sacrifices that are required. The second half of the plot chronicles the growing respect Marsh earns in the community and the gradual yet complete disillusionment of Delph, who feels more and more trapped into a harsh, unfulfilling existence. The first years on the farm are especially difficult, and when Delph tells Marsh that she is pregnant, his first reaction is not delight, but worry. They argue over spending money; she accuses him of thinking only of the land, and the argument ends as he strikes her on the cheek with a piece of leather. This scene marks a turning point in their relationship—no longer are they adoring newlyweds. Their marriage becomes a battle of wills. Delph fights through silence and pours energy into their only son, Burr-Head, whom she is determined will escape the life that she has unwillingly accepted.

Three major events occur in the second half of the novel that symbolically mark the course of the conflict between the protagonists. First, shortly before Delph gives birth to Burr-Head, she is almost trapped by an

encroaching flood. Marsh is away hunting and she is rescued by a neighbor just as the water rises up to the second story of the house. After this brush with death, there is a brief reconciliation with Marsh. What is more noticeable than his feelings of guilt, however, is her numbness; she seems to have lost part of her spirit in the flood.

The second event takes place years later. Burr-Head is growing up and Delph is making sure that he spends more time with books than working on the farm. Dorie's son, Sam, who many years ago had left their small mountain community to establish a career as a chemist in the city, suddenly returns. Marsh recognizes him as a rival and almost deliberately, it seems, puts himself at risk for typhus by drinking unclean water. Sure enough, he does contract the disease, which gives Delph plenty of time to interact with Sam during Marsh's long struggle to recover. They spend hours together, partly with Dorie's encouragement, and Delph's dreams of the city are revived. Her infatuation with Sam and his "sophisticated" city ways is really more a rediscovery of her youthful visions than a sexual temptation. At one point the narrator reports:

> The day she picniced [sic] with Sam was the beginning of a strange way of life, like a long sleeping, often black with nightmares of fear and the shadow of death, but shot through sometimes with dream-like moments of seeing and of understanding a man who should have been remote and different to herself, but never was. And through him she was herself, the Delph she had used to be in the Little South Fork country. . . . There were moments when the sweetness of finding the echoes of herself and of having another find the same, seemed too precious for any moments not spent with Marsh. (405)

The drudgery of her daily life on the farm with Marsh had squelched Delph's self, as well as her goals for a different life.

Finally, she is tempted to run away with Sam when he returns to the city, in order to try to recover her dream. But fate intervenes. Dorie arrives with the news that Marsh has taken a turn for the better, and Delph is not overjoyed. Instead, "She could feel that old forced smile on her mouth like some familiar mask that she had taken off for a little time, but now must wear again—for always and always" (420).

Nonetheless, despite the dashing of her rekindled dream, Delph makes a conscious decision to stay with Marsh and accept the life they have built

together. The third major event, and the climax of the novel, occurs at the very end. Sam comes to say good-bye to Delph and leaves her alone in the field. She soon detects that her neighbor, Sadie, has been watching the farewell scene. Returning Sadie's stare, she feels "no fear and no shame, only that wild madness at being trapped and tied, bound for a long torture that would end only when she died—maybe in fifty years" (457). Ironically, in the next scene, perhaps predictive of Flannery O'Connor's "Greenleaf," Delph is gored and killed by a bull when she falls from the fence post into the pasture. The story ends with Marsh being told of his wife's death, and his determination to avenge Delph's death by confronting Sam.

Such a summary does not do justice to the complexities of character and development of Delph and Marsh, yet these salient points of the plot provide information about Arnow's growth as a writer. Like all of Arnow's novels until *The Weedkiller's Daughter*, "Between the Flowers" concerns female entrapment. It is an anti-*bildungsroman* of the female protagonist. After her first novel, Arnow makes the mountain woman, rather than the outsider, the focus of the plot. Early in the revision process she cutout a schoolteacher character resembling Louisa in *Mountain Path*, whose function was to introduce Delph to the outside world. In "Between the Flowers," forces within the mountain community itself, rather than the outside world, provide the basis of the conflict for the female protagonist. Delph's entrapment by the mores of her society foreshadows the theme of Arnow's next novel, *Hunter's Horn*.

In both *Hunter's Horn* and "Between the Flowers" the reader witnesses the limitation of choices for women through the patriarchal religion, lack of education, and pregnancy and child rearing. While *Hunter's Horn* highlights the physical pain of childbirth and the harsh daily routines of mountain women, "Between the Flowers" depicts Delph's emotional struggle, the dashing of her dreams, and the inability to assert her own will in her marriage. Delph is a more complex Suse Ballew in this sense.[1] Her bitter silences, her apathetic resignation to Marsh's insistence on farming after the flood, and her withholding of sex from her husband in an attempt not to bear more children so that she can focus her energy on their one son reveal her ultimate inability to shape her own destiny.

Both "Flowers" and *Hunter's Horn* depict a male quest at the price of female suffering. Arnow has not yet made the transition to the female quest that she accomplishes through Gertie's desire for the land. Instead, it

is Marsh who yearns for his own farm in "Flowers," even though Dorie, a woman, is his role model of the successful farmer. Not until *The Dollmaker* is Arnow able to establish a positive link with nature for her female protagonist. And even Gertie has no choice but to follow her husband and to be the "mother" of the family, a role that precludes a separate identity in her culture.

In "Flowers," as in *Hunter's Horn,* "nature" makes the biological destiny of motherhood inevitable. The naturalization of young female beauty in both novels makes Delph and Suse vulnerable to male desire. They cannot pursue their dreams of education because they cannot be "seen," that is, pictured by society—or by the novel's imagery—as anything beyond an object of male possession.

Nevertheless, "Between the Flowers" begins to move beyond this objectification of female character. Delph is, after all, a more autonomous, willful character than her successor Suse Ballew. Raised by her aunt and uncle, Delph has a dubious heritage. Her mother had "left the country" after her husband had died (5), at once abandoning her child and affirming her independence. Delph's desire for adventure seems to be based on her irresponsible, yet daring, mother. Secondly, Delph remembers stories about her male ancestors, whom she identifies with more than any female role models. Intermittently throughout the plot, she recalls stories told to her about an ancestor named Azariah, who had come with his clan to settle Kentucky. She wonders what made them come and concludes by realizing that perhaps, like her, they wanted always "what lay over the next hill" (57). Early in the novel her identification with Azariah is quite strong; even Marsh recognizes it. As the plot progresses, however, it is her son, Burr-Head, who takes over this yearning (369). Delph's relationship with Juber, an older man who encourages her and helps her during her early years, also wanes in the years after her marriage.

Aside from her relationship with male role models, another aspect of Delph's character that Arnow begins to develop is her singing. Like Gertie's wood carving, Delph's singing is both a creative outlet, a "place" where she can escape her drudgerous duties, and an undeveloped part of her identity. She gains recognition for her talent when she sings in church, but there is no way for this talent to be nurtured. It must be confined within the acceptable roles for women in a traditional society. Female artistry is a potential but nascent theme for Arnow at this point in her career.

Arnow's correspondence with her editor, Harold Strauss, as she was writing her first two novels, provides clues about the author's revisions of the manuscript and her lack of development of Delph's story. Glenda Hobbs has noted that, with *Mountain Path*, it seems Strauss and Covici-Friede, the publishers, wanted to develop Arnow as a "local color" author, a category too often reserved for women writers and regionalists. In an early letter about this first novel, Strauss advises Arnow "to develop some thread of central action, the precise nature of which I shall leave to you. I am certain, however, that even a conventional melodrama of mountain feuds, of bigoted suppression of normal sexual desire, or some such other theme would not harm the delicacy and beauty of your gallery of portraits. . . ." (Arnow letter, 24 October 1935). Over the course of the next year Strauss gives Arnow similar advice about "Between the Flowers," alternating between telling her to develop her plot more (i.e., add melodrama) and insisting that her characterization is thin.

Other comments Strauss makes during the correspondence indicate his misunderstanding of mountain culture and his insensitivity to the underlying theme of Delph's entrapment. In a letter dated 18 August 1937, he extols the finished manuscript and particularly praises Marsh's story: "You have been completely successful in getting inside of Marsh and telling us what he is like. AS A MATTER OF FACT, I THINK HE STEALS THE STORY FROM DELPH; at the end, the reader sympathizes with him, not with her" (Arnow letter, 24 October 1935). Strauss compares Delph to Madame Bovary and suggests that Arnow make her run away to the city early in the story. Arnow penciled in responses in the margins of his letters—and to this comment she responds, "I have read Madame Bovary three times; Madame Bovary was unfaithful with her body. Delph was not." Arnow's New York editors demonstrate little understanding of the mores of Delph's community.

The readers' reports on the manuscript in 1937 show an equal misunderstanding of mountain culture and a predilection for Marsh's story over Delph's. Two reports are included among the papers at the University of Kentucky Library. One finds Marsh's striking of Delph with a leather strap in a moment of frustration "sheer baloney," again, like Strauss, misunderstanding the patriarchal structure of family life in mountain culture. Arnow herself responded to a similar criticism from Strauss by noting that "Delph was a hill woman. The man's life was her life." In the scene mentioned, Delph does not question her husband's authority, just as she would

never think of abandoning her family to pursue a lover. Another comment on the reader's report criticizes the author's emphasis on Delph's morning sickness. Arnow's undated response to the reports states that she wishes she had dwelt on it more rather than less. As in her next novel, *Hunter's Horn*, she exposes the harsh reality of childbearing for mountain women—a reality editors interested in "local color" would just as soon ignore.

Circumstance as well as bad advice helped preclude a favorable review of Arnow's manuscript. In 1938 Covici-Friede went out of business, and though Strauss was eventually rehired at Knopf, he wrote to Arnow that there seemed to be no interest in her novel. Finally, in 1939, after a year of circulating the manuscript, Strauss wrote to Arnow that, in his view, "Flowers" "lacks story value and its characters do not seem to be organized into any convincing dramatic pattern" (Arnow letter, 24 August 1939).

Strauss's point that the manuscript lacked "story value" makes little sense. From the summary of the main events, it should be clear that the conflict between Delph and Marsh is well developed and their motivations for action are understandable. Rather, I think the problems with plot lie elsewhere.

"Between the Flowers" demonstrates Arnow's first attempt to portray a female hero, a woman protagonist whose dream reaches beyond the roles modeled for her in her traditional community. Ultimately and inevitably Delph's dreams are quelled by her inability to rebel against the social roles determined by that same community. In this manuscript Arnow underlines Delph's defeat with symbols from nature. In fact, "nature" becomes her antagonist—the flood, Marsh's typhoid, and Delph's violent death by goring are all deus ex machina events, too contrived to be believable. These unresolved plot elements, however, reveal an important stage in Arnow's development. Like the endings of nineteenth-century novels by women, the conclusion of "Flowers" underlines a dead end for female characters.[2] Delph's dream is dashed and Arnow cannot imagine another outcome for her. She emphasizes this spiritual death with a physical one. Likewise, the flood, reminiscent of the ending of George Eliot's *The Mill on the Floss*, symbolizes the death of Delph's girlhood aspirations. After this event she strives for her son's escape and education, not her own. Marsh's illness is a necessary plot device to allow Arnow to return to Delph's story—the author is not yet able to assume a female viewpoint from the beginning of the plot.

Like other regional women writers of the 1930s, Arnow had few models to follow in constructing a female-centered plot. Her Appalachian predeces-

sors, Elizabeth Madox Roberts and Edith Summers Kelly, had imagined women protagonists in their farm novels a decade earlier; however, their stories center on entrapment, rather than the growth and self-realization of their characters.[3] It is more relevant, perhaps, to compare Arnow's second novel with the fiction of her contemporaries, Fielding Burke (the pen name of Olive Dargan) and Zora Neale Hurston, both of whom attempted to make the transition from male to female *bildungsroman* in the thirties. *Call Home the Heart* (1932), Burke's novel about the famous Gastonia mill strike in 1929, concerns a young woman, Ishma, who, like Delph, longs to escape her mountain home. Unlike Arnow's protagonist, however, Ishma does leave for the city, where she becomes involved in labor politics and union organizing. Her independence is short-lived, though, and after an uneasy encounter with a fellow black worker, she impulsively catches a train to return back to her rural homeland and her duties as wife and mother. Ishma's quest ends in failure and disillusionment; like Delph she is unable to transform her dream into reality. Burke's novel was written with a more self-conscious political message than Arnow's, yet both authors reveal the ambivalence of rural women toward their environment. Mountain culture is at once imprisoning and liberating for Ishma and Delph; neither is able to reconcile her rootedness to place with her yearning for autonomy.

Hurston's first novel, *Jonah's Gourd Vine*, published in 1934 , is a semi-autobiographical portrait of her parents' marriage; in it, women's lives are also depicted as thwarted and bitter. Lucy's escape from her husband's mistreatment and unfaithfulness only occurs on her deathbed, when she is worn out from childrearing and the onerous duties of the household. The picture of rural life Hurston gives in this first novel is in no way idealized—that comes later with Janie Crawford in *Their Eyes Were Watching God*. In their early fiction both Hurston and Arnow focused on the biological destinies of women and their circumscribed social roles. *Jonah's Gourd Vine* and "Between the Flowers" are male quest plots by default: neither author can quite imagine a woman protagonist who is empowered, rather than enervated, by nature. Later Arnow's and Hurston's masterpieces, *The Dollmaker* and *Their Eyes Were Watching God*, move beyond the stark realism of the period to show female protagonists who transcend their biological destinies paradoxically through a close bonding with the natural world. Both authors begin to use nature imagery as a metaphor for female identity and autonomy in their fiction only after they have experimented with more conventional techniques of naturalism.

It is a mistake, I believe, to compare the fiction of Arnow, Dargan, Hurston, and others like Roberts, Kelly, and even Ellen Glasgow to their male contemporaries William Faulkner, Erskine Caldwell, and John Steinbeck, whose naturalistic portraits of southern rural life are often so denigrating or disillusioning that they become caricatures. Glenda Hobbs stresses that Arnow never intended to be a political novelist; Delph's inability to escape her drudgerous existence is no exposé of tenant farming or impassioned plea for rural reform, as Steinbeck or Caldwell might have written. Nor does Delph become an idealized, almost mythic female figure, like William Faulkner's Lena Grove in *Light in August*. Instead of idealizing female character, in fact, Arnow becomes one of the first twentieth-century authors to portray rural women as believable protagonists. Two earlier novels about women farmers, for example, Willa Cather's *O Pioneers!*, which idealizes the female hero (1913), and Elizabeth Madox Roberts' *The Time of Man* (1926), which denies the protagonist any empowerment are too extreme to be realistic. "Between the Flowers" is neither "local color" nor propagandist fiction—rather it participates in a new tradition in "naturalistic" writing by women writers of Arnow's region and time period, what I call "female pastoral," in which rural women characters finally become the heroes of their own stories.[4] By attempting to claim her own story, Delph Costello prepares the way for later Arnow heroes like Gertie Nevels.

"Between the Flowers" thus completes a missing link in the evolution of both Arnow's canon and the development of her female characters. It represents Arnow at a transition stage in her artistic development and as a victim of bad editorial advice. With more revision—perhaps chiefly by cutting the *deus ex machina* devices—"Between the Flowers" could have been a more "realistic" novel. But the unsatisfactory ending and the lack of "action" in the plot are in themselves an important story. Arnow begins, in this novel, to focus on the lives and aspirations of mountain women, a theme she develops more fully in *Hunter's Horn* and *The Dollmaker*. As it is, the manuscript provides an important link for the scholar and reader alike to understand not only the evolution of the author's later work, but to place Arnow and other women regionalists of the time period into the larger context of literary traditions.

NOTES

1. Suse Ballew is the daughter of Nunnely Ballew, the protagonist of *Hunter's Horn*.
2. See Du Plessis, who examines strategies twentieth-century women authors began to use to "write beyond the [prescribed] ending" of marriage or death.
3. Kelly's *Weeds* (1923) and Roberts's *The Time of Man* (1926) are two novels that, although they center on women's story and celebrate her bond with nature, ultimately depict the failure of female autonomy in a rural environment.
4. My book, *Female Pastoral: Women Writers Re-Visioning the American South*, discusses a new visionary pastoral genre explored by twentieth-century writers Ellen Glasgow, Margaret Mitchell, Willa Cather, Harriette Arnow, Alice Walker, and Sherley Williams.

WORKS CITED

Arnow, Harriette Simpson. "Between the Flowers." MS. Folders 33-34, Box 11. University of Kentucky Special Collections, Lexington, Kentucky.

_____. Letters, Harold Strauss, Covici-Friede Publishers. Folder 36, Box 12. University of Kentucky Special Collections, Lexington, Kentucky.

Burke, Fielding. [1932]. 1983. *Call Home the Heart*. Old Westbury, Connecticut: Feminist Press.

Du Plessis, Rachel Blau. 1985. *Writing beyond the Ending: Narrative Strategies of Twentieth Century Women Writers*. Bloomington: Indiana University Press.

Ganim, Carole. 1986. "Herself: Women and Place in Appalachian Literature." *Appalachian Journal* 13 (Spring): 258-74.

Harrison, Elizabeth J. 1991. *Female Pastoral: Women Writers Re-Visioning the American South*. Knoxville: The University of Tennessee Press.

Hobbs, Glenda. 1982. "Starting Out in the Thirties: Harriette Arnow's Literary Genesis." Pp. 144-61 in *Literature at the Barricades: The American Writer in the 1930's,* Ralph F. Borgardus and Fred Hobson, eds. Tuscaloosa: University of Alabama Press, 1982.

Kelly, Edith Summers. [1923]. 1982. *Weeds*. New York: The Feminist Press, 1982.

Roberts, Elizabeth Madox. 1926. *The Time of Man*. New York: Viking.

THE CENTRAL IMPORTANCE OF
HUNTER'S HORN

SANDRA L. BALLARD

While "Between the Flowers," an unpublished novel, was actually Harriette Arnow's second work, *Hunter's Horn* (1949), her second published novel, became a bestseller that received overwhelmingly favorable reviews when it was released. Set entirely in post-Depression, pre-World War II Kentucky, it is now almost always tagged a "regional" (therefore, minor) novel—as if any work depicting the land, people, and culture of a particular place must be gratuitously picturesque, provincial, and limited in appeal. Writers for the *New York Times Book Review* in 1949 selected *Hunter's Horn* as one of the ten best novels of the year and named it Book of the Year in *Saturday Review of Literature*, in competition with George Orwell's *1984*.

Ironically, these same reviewers who praised Arnow's work effusively, recognizing that she described "the details of life in rural Kentucky . . . with authority," also called the novel "an unusually good book of its kind" (Farrelly 1949, 27). The reviewers who declared *Hunter's Horn* to be "one of the finest 'grass roots' novels written in many a year" (Preece 1949, 18) and "our candidate for the Pulitzer Prize" (Henderson 1949, 735) also referred to it as a "pastoral of the Kentucky hills" (Preece 1949) and "a really remarkable regional novel" (Henderson 1949, 735).

As Glenda Hobbs observes in her fine article in *Regionalism and the Female Imagination*, such critics unconsciously "undermined their own praise and relegated the works [Arnow's first novel, *Mountain Path,* and *Hunter's Horn*] to obscurity when they categorized them as 'regional.'" She explains that some critics "mistaking necessary descriptions for decoration, meant 'local color'; others, assuming that any work rooted firmly in rural Kentucky must have only a limited appeal, used 'regional' to mean folksy, and therefore of minor importance" (84). The term "regional" continues to

be used so carelessly by reviewers and critics alike that it discounts the significance of *Hunter's Horn*, a powerful novel which deserves recognition for its traits that reach beyond its Kentucky setting. Reexamination of this novel reveals its central importance in the body of Harriette Arnow's work, as well as its treatment of timeless issues.

Hunter's Horn tells the story of a poor family and their struggles to survive while the father, Nunnely Ballew, neglects them and his farm because of his obsession with pursuing a red fox called King Devil. But unlike her other works, which feature the story of a single protagonist, the novel offers an "ensemble cast" of characters. Arnow's startling portrayals of hypocrisy, guilt, and alienation show she is capable of creating credible male characters while at the same time exposing her progressive views of the roles of women. *Hunter's Horn* is the keystone to her other works, developing themes already introduced in her fiction, introducing prototypes of later characters, and developing important and pervasive themes with unflinching realism. In fact, *Hunter's Horn* deserves reevaluation for the full and effective way it integrates Arnow's central concerns in her published fiction and nonfiction.

Before attempting a novel, Harriette Simpson was a writer of short stories, and at least two of the five stories she published between 1934 and 1944 strongly foreshadow *Hunter's Horn*. Readers familiar with Arnow's short story "The Two Hunters" (accepted by *Esquire* in 1938, published in 1942) will recognize in Lacey, a seventeen-year-old boy, the rudimentary characterization of a younger Lee Roy Ballew from *Hunter's Horn*. Although Arnow's chilling short story uses such stock devices as a feud, a whiskey still, and the murder of a deputy sheriff, Lee Roy, nevertheless, emerges as a character somewhat like Lacey.

Coincidentally, perhaps, Lee Roy, like Lacey, picks flowers for Milly. (In the short story, Millie is a young neighbor; in the novel, Milly is Lee Roy's mother.) In each case, the boy shows an appreciation for nature and a sensitivity that motivates him to try to please another. More significantly, Lee Roy, like Lacey, knows the location of his father's whiskey still and feels a deep sense of obligation to divert attention from it and protect his secret. Though Lee Roy is no murderer, he hides in the brush with his father's gun, prepared to kill federal agents to protect his father and his family. Each young man in these works has developed a code of behavior and a conscience that he must use in a confrontation with an outsider who challenges his family loyalty.

The short story that connects most directly with *Hunter's Horn* is "The Hunter" (1944), which should be no surprise, since it clearly derives from a manuscript draft of the novel. As it appeared in *Atlantic Monthly*, "The Hunter," with a few such minor changes as the names of neighbors, became chapter 4 of *Hunter's Horn*. In each version of this story, Arnow describes the late fall fox hunt in which King Devil runs Nunn's old hound, Zing, to death. In the story, as well as the novel, the men urge Nunn to spotlight and shoot the red fox, and Nunn accepts the challenge at first, but then changes his mind when he looks into the fox's eyes, which look like a man's. Instead of shooting the animal, Nunn vows to take King Devil "fair an' true with a foxhound," no matter what the cost. In each version, Nunn adheres to a hunter's "code" of honor that disallows taking unfair advantage of a hunted animal. Without calling it "honor," Nunn struggles throughout the novel with his guilt concerning questions of honor. He would like to be a respectable hunter, farmer, husband, and father, but he cannot give each role an acceptable priority. These parallels between her short fiction and her second novel reveal the extent to which characters and themes were taking shape long before she completed *Hunter's Horn*.

In Arnow's longer fiction, too, attentive readers find important thematic connections to *Hunter's Horn*. In her first novel, *Mountain Path* (1936), Arnow introduces the effects that physical isolation can have on a person unaccustomed to it, while she explores in her second novel the effects of psychological isolation—in familiar twentieth century terms, the theme of alienation. The central character in *Mountain Path*, a schoolteacher, an outsider, significantly views the setting as a "forgotten" and "lost place" (31). But in *Hunter's Horn*, Nunn, a native of Little Smokey Creek, has watched his community become less isolated and more abandoned, forgotten by those who knew it, not by outsiders who never did. He worries about the "lost people": "Where were they and their grandchildren? . . . people had lived in these houses . . . Where had they gone, those lost people?" (308). The "lost people" of *Hunter's Horn* represent an important development of the isolated "lost place" of *Mountain Path*. Arnow's shift in focus from the character in an isolated community in her first novel to the more complex psychological alienation of Nunn Ballew in her second shows a significant thematic development. As "lost places" are fast disappearing from American landscapes, Nunn presents a more universal question about the "lost people."

When Nunn's final words in *Hunter's Horn* focus on what happened to those people who died along the way to reaching their goals—"on th way" to "th Promised Land"—the scene anticipates the concerns of a much later character, Leslie Collins. He is the protagonist of *The Kentucky Trace: A Novel of the American Revolution* (1974), Arnow's final published novel, the only one of her other published novels in which she adopts a central male point of view. Despite the novel's subtitle, Arnow chose not to focus on battles or on such famous pioneers as Davy Crockett and Daniel Boone; instead, she created Leslie Collins, the surveyor, to explore what happened to the "ordinary" pioneers along the Cumberland Trail during the time of the American Revolution.

In *The Kentucky Trace*, Arnow continues to show her interest in the effects of guilt and alienation on the individual. As with Nunn, who feels guilty about his choices in life and is concerned about the mark he will make in his family history, Leslie worries about his family, his work, and how he will be remembered. Like Nunn, Leslie feels alienated from his family because he has done shameful things for which he must suffer and rationalize. Leslie, for instance, will never mention that he saw his brothers at the battle of Camden and that he knows he shot one of them. Like Nunn, who is not proud of his work, Leslie also feels guilty about his job as a surveyor: he believes that "the Indians had the right word for a sextant—land stealer" (150). Knowing that his family could never fully forgive his actions and accept him, each character wrestles with his own hypocrisy and identity.

In her later work Arnow sustains her interest in themes from *Hunter's Horn* as she continues to show her concern for people who do not make a name for themselves in history books, those ordinary ones about whom Nunn Ballew worried, those who, in a sense, "died on th way." Arnow's early interest in "lost" or forgotten people mirrors contemporary efforts among scholars of history and literature to publish diaries, journals, and biographical studies of those who did not gain fame in their lifetimes, although many now believe that such experiences have much validity and value.

Arnow's characterization of Nunn Ballew shows yet another development from her first novel. Like *Mountain Path*'s Lee Buck Calhoun, Nunn is also a Kentucky hill farmer, moonshiner, and hunter. But unlike Lee Buck, who is developed mostly with surface details, Nunn is a more complex character, who shows readers his obsession and torment. In only one scene in *Mountain Path* does Arnow reveal something of Lee Buck's inner

life: when she describes his emotional response to the feud in which his family is involved, Arnow writes that Lee Buck was "no different from the rest of the world. The things he hated ruled his life, and not the things he loved" (145). This simple statement well describes Nunn Ballew, a character Arnow explores more fully to show his range and depth of emotion. Nunn's hatred for the elusive fox, King Devil, consumes him, often to the exclusion of all else. But Nunn experiences more than hate; guilt also overwhelms him after he buys canned dog food for his fox hound, instead of the sugar and other supplies that he knows his family desperately needs. His tenderness for his family, his pride in his children and his twin foxhound pups, all feed his guilt and frustration.

Arnow herself has commented on Nunn's complexity. When she observed that Nunn's obsession with a fox overcame his dream to be a productive farmer, she also acknowledged that even though some had "compared him to Captain Ahab," she saw an important difference: "I don't think Captain Ahab felt guilt while trying to catch Moby Dick. He didn't care for those he made suffer in pursuit of his obsession. Nunn did feel guilty," she pointed out, "when he was sober" (Flynn 1990, 256). Arnow believed, according to Flynn, that "Nunn was a symbol of the good and bad in Appalachian people, damned by his stoicism and saved by his guilt" (256). Nunn's complexity and guilt are, in part, the bases of Kathleen Walsh's fine article arguing that Arnow's *Hunter's Horn* contributes an important and original treatment of the hunt to American literature.

Nunn's daughter, Suse, in *Hunter's Horn*, also emerges as a complex character, a much fuller development of a relatively flat character from *Mountain Path*. Suse, a twelve-to-thirteen-year-old girl, is about the same age as Rie (a shortened form of Marie), Lee Buck's daughter. Each is the eldest girl in her family, which means that she assumes early responsibility for child care and household chores. Each lives in a world that measures time by work, the seasons, and other signs of nature.

But an important difference is that Rie is satisfied with her life. She does not long for things unavailable to her, though Suse does. Suse "had always hated housework and had ever been an impatient baby tender" (261). Suse wants "the outside world" (228) beyond the hills, and no matter how unattainable it may be, she will always be aware that she wants it. Suse Ballew desperately wants to escape the physical and social restrictions of being a young woman in Little Smokey Creek, Kentucky. Suse already knows, "it was hard enough to be a girl child shut off from the world," but

she wonders, "how would it be to be a woman like Lureenie [the Ballews' neighbor], married with little youngens, but wanting still the outside world . . . and always knowing that you could never get away until you were dead?" (228). A more complex character than Rie, Suse will not unquestioningly accept as fate her poverty or others' expectations for her as a young woman. She allows herself to think that "it would be nice to belong to a family that always wore shoes like people she'd read about" (195), and she longs to attend high school.

Readers are led to expect that Rie will, without question or complaint, spend all of her life in the Kentucky hills, filling traditional roles of wife and mother. But Arnow creates in *Hunter's Horn* a more self-aware character, one who challenges authority and tradition. Showing a significant development of the adolescent girl from the one in *Mountain Path*, Suse is a strong individual who thinks for herself. Though Suse is not strong enough to get what she wants, Arnow demonstrates with the character her progressive depiction of a young native hill woman who holds feminist values before feminist values were popular.

In fact, Arnow brings to modern literature an unusually frank and insightful depiction of women and their roles in *Hunter's Horn*. Juxtaposing the women's hearth-bound activities with those of the hunt, Arnow focuses equal attention on the women's household activities of cooking, gardening, preserving, nursing, and tending children and livestock, the unglamorous events of life maintenance that fiction writers sometimes tend to ignore. Without becoming didactic or condescending, Arnow creates women who do not think of living in poverty; they think simply of living. "The true acts of heroism," as Linda Wagner points out, "belong to Milly or Sue Annie [the midwife] or Lureenie: crossing the flooding river to bring a child, doing inhuman amounts of work for the benefit of all, learning to exist with next to nothing." Ironically, Milly and Sue Annie, not the men, are with the hounds when they capture King Devil, a pregnant vixen (3). The strongest irony of all, however, is the fact that pregnancy results in the devastating vulnerability of many of the female characters in the novel, including King Devil. Writing out of her personal experience and understanding of the social status of rural women in America in the late 1930s and early 1940s, Arnow demonstrates with authenticity and wit the effects that society and biology have on her female characters.

Realizing the importance of the roles of daughter and mother, Arnow often defines her characters by those familial relationships. Thinking of her

future as a woman in the community, Suse vows that she will not be like her mother: "she'd make her own life; it wouldn't make her" (228). Suse's inner declaration of independence contrasts sharply with the thoughts of her mother, who regrets the inevitability that Suse's high-spirited youth will soon be over. Milly thinks, "poor child, soon enough would come the time when not just her body was tied down by work, but her mind, too, with troubles and worries—it seemed sometimes like God made women for trouble" (158). Her mother's stoic acceptance of the role of females in the family and the community tragically limits Suse's chances for self-determination.

Despite Arnow's recognition of such limitations, she openly explores—and apparently admires—those with the courage to challenge the community's values. For instance, after Suse sees Lureenie Cramer, deserted by her husband, weakened by starvation, and dying because her father-in-law insists that "God's will" be done (and because he begrudges spending money for a doctor), Suse interrupts his loud, pious prayer with a rock and the curse, "God damn th old stingy son of a bitch" (318). Then she expands the range of responsibility for Lureenie's death beyond that which any other community member (except perhaps Sue Annie) would dare to express: "God damn him, and you too, Nunnely Ballew. You let her starve. And God damn the God-damned God for setten around and letten you do it" (319). With Suse's outrage, Arnow defies complacent acceptance of "God's will" and acknowledges that Lureenie is an unnecessarily tortured victim of nature and the social order that makes the entire community bow to the word of a patriarch until it is too late to save a woman's life. Using Suse's response to the scene, Arnow exposes her view that religion can be used to coerce or torture women in particular.

Suse figures prominently in a number of scenes that challenge community standards. In a later scene, again defending Lureenie, Suse swears in church (340). Her main defiance, however, occurs because she resents the pressure of alienation she feels, as well as the weight of responsibility of caring for her younger brothers and sisters. Her act of rebellion is a one-time sexual encounter with Mark Cramer, Keg Head Cramer's son, who is home from his job in Detroit. During the revival meeting, when Milly instructs Suse to take the younger children home, Suse "hated Milly for sending her home now . . . she had to take the babies home like an old married woman" (342). She turns for comfort to Mark, who follows her out of church, takes her home with the children, and stays to seduce her. She

feels he understands her and her dreams to escape to the city. She doesn't love him, though "she lay lonesome in his arms, her thoughts like birds flying past him" (349). Longing for affection, Suse paradoxically becomes trapped by her escape. When her pregnancy is discovered, she stubbornly refuses to marry Mark because she holds onto the hope that her future will offer some measure of independence. "What she had done was done—it was over—sin it was, but for one sin only she wouldn't pay her whole life—all her life" (349). Her pregnancy, however, traps her just as surely as the pregnancy of the vixen known as King Devil results in its capture.

Arnow demonstrates her abiding concern for such rebellious female characters as Sue Ballew when, some twenty years later, she creates Susie Schnitzer in *The Weedkiller's Daughter* (1970). Despite its urban setting in Detroit in the 1960s, the novel's main character is another adolescent girl who resents the actions of her domineering father and submissive mother. Each girl longs to go to the North, where she believes she would find more tolerance and freedom to be herself than she has at home. Susie wants to fly away, much like Suse Ballew, who wants to "go away into a new fine country, as the wild geese were going now" (294); Susie believes it would be "nice to be a Canada goose" who could leave behind the "human-being part" of her world (204). Each feels alienated from her family and community because she has the courage to challenge authority and to form her own independent, unpopular opinions.

While such specific "modern" problems as McCarthyism, the Vietnam War, pollution, civil rights issues, and racial bigotry trouble Susie Schnitzer, her more general and pervasive dissatisfaction with hypocrisy and alienation, her appreciation of nature, and her longing for freedom are all central concerns she shares with Suse. Susie, the weedkiller's daughter, has inherited the sensitivity, sensibility, and rebellious spirit of her prototype, Suse Ballew.

While Suse wants to assume responsibility for her choices and control her own destiny, in the conclusion of *Hunter's Horn*, her father Nunn yields to social pressure and condemns her to the heartbreaking fate of a marriage she does not want. He forces his daughter to leave home: "Suse, who'd never lived by God or the neighbors no more than he, [has] to go as Keg Head's hired girl into the never done work of raising Lureenie's children along with her own and waiting on Keg Head and his wife in their old age." He sentences Suse to spiritual death by sending her away—"Suse, the proud one, to be tolerated and shamed and prayed over" (506). Though the

novel ends with Suse's defeat, it is to Arnow's credit that her character at least challenges the traditional role with such determination and dignity that her father's poor judgment glaringly eclipses her own.

Arnow's second novel lends a certain resonance to her third, *The Dollmaker* (1954). The echoes of place, people, and human problems reverberate from one novel to the next. In *The Dollmaker*, the connections with *Hunter's Horn* are much closer than with any of Arnow's other fiction, despite Arnow's claim that "some have said *Hunter's Horn* is the better book than *The Dollmaker*. I believe it is. . . . I made a mistake by permitting Gertie Nevels to tell the whole story. So there is much more to 'The Horn' than *The Dollmaker*" (Flynn 1990, 256).

The most obvious connection is the setting. *The Dollmaker*'s Gertie Nevels is from Ballew, Kentucky, named for Nunn Ballew's family. Many of *The Dollmaker*'s characters—the old midwife, Sue Annie Tiller, and such other neighbors as the Sextons, the Hulls, old John Ballew, Ann Liz Cramer, and Ansel Anderson—all make their first appearance in *Hunter's Horn*. Even Nunn Ballew receives one brief mention in *The Dollmaker*, when the postmistress is calling out names to distribute the mail.

Also creating thematic continuity, the main characters in each novel face social, economic, and psychological crises. Although her trilogy of *Mountain Path*, *Hunter's Horn*, and *The Dollmaker* records the breakdown of a way of life, Arnow focuses on individuals and, in her own words in the Introduction to *Mountain Path*, declares that "despite the disintegration of hill culture, hill people were not all destroyed to the point of dissolution" (xiv). The power of *Hunter's Horn* comes from Arnow's ability to move readers to empathy with the struggles of each member of the Ballew family. Nunn, in particular, struggles as he watches social changes coming to his community and feels powerless to alter the forces already in motion. He struggles financially, having too little cash and goods to meet his family's basic needs. And his debilitating guilt about his inadequacies as a parent and provider are fuel for the fires of his psychological torment.

The power of *The Dollmaker* likewise comes not, as some critics suggest, from the forces that oppose the central character, Gertie Nevels, but instead from her determination to endure, to survive, in the face of social, economic, and psychological threats of destruction. Gertie sees the entire social structure of Ballew, Kentucky, change with nearly all of the men leaving during World War II, but she takes charge and declares, "I reckon I'll have to be the man in this settlement" (102), and she manages very

well. The tough economic times eventually force Gertie's husband, Clovis, to move the family to Detroit, where they face a number of crises, the most tragic of which is the loss of their daughter, Cassie Marie, when a train runs over her legs and she bleeds to death. After grieving for days, Gertie gradually realizes that "she couldn't flop down and cry like some; a cross waited to be whittled" (407). So after the most wrenching experience of her life, Gertie shows tremendous will when she pulls herself out of her grief and begins her carving again to make money to support her family. The other psychological challenges she faces are like Nunn's: her guilt makes her feel alienated from her spouse, from her children, and from a God she cannot accept. The power of *The Dollmaker* lies in the spirit of Gertie Nevels, the spirit that grows out of facing many of the same challenges that Nunn Ballew and his family faced in Arnow's earlier novel.

Another remarkable feature of *Hunter's Horn* is its historical authenticity. In *Hunter's Horn*, Arnow fuses her fiction with the historical research she conducted over a twenty-year period and published in two later volumes: *Seedtime on the Cumberland* (1960) and *Flowering of the Cumberland* (1963). While the time period covered by the nonfiction works (1780-1803) is considerably earlier than the 1939-41 setting of *Hunter's Horn*, the mountain life Arnow describes is isolated enough to have resisted many changes. In *Hunter's Horn*, for instance, readers can recognize the convincing authenticity in her descriptions of such practices as fox hunting, midwifery, local law enforcement, household, and farm chores. In these descriptions, however, the attentive reader will hear beyond the regional sounds of baying foxhounds, barn animals, and backwoods speech patterns, to the universal sounds of humans struggling to assert identity and achieve social acceptance. John Unrue, in the only scholarship that catalogues specific comparisons between *Hunter's Horn* and her nonfiction books, asserts that "the Ballew family and their neighbors are not literary contrivances or novelties, but descendants of the past" (36). As evidence, Unrue cites a number of particular parallels in Arnow's fictional and nonfictional treatments of home remedies, superstitions, moonshining methods, foods, and dialect. *Hunter's Horn*, set entirely in a backwoods Kentucky community, reflects especially well Arnow's concern for describing with historical accuracy the practices and people she knew well.

Sounds from *Hunter's Horn* resonate throughout her fiction and nonfiction to establish the importance of this novel. It introduces and develops

Arnow's prototypical characters, who reflect her concern for such universal themes as the exposure of hypocrisy and the powerful effects of guilt and alienation. The novel shows her sympathetic but unsentimental views of independent, rebellious women. It underscores her appreciation of historical authenticity. Critic Malcolm Cowley believes that *Hunter's Horn* defies categorization. Cowley writes that no label can adequately name "the special quality of the novel, which is partly a poetry of earth, partly a sense of community, and partly a sort of in-feeling for the characters, especially the women" (94). *Hunter's Horn* deserves reexamination for its crucial role in highlighting Arnow's central concerns in fiction, as well as for being a modern American novel worthy of recognition for its unforgettable characters and its relevance to twentieth-century life and literature.

WORKS CITED

Arnow, Harriette Simpson. [Harriet L. Simpson]. 1934. "Marigolds and Mules." *Kosmos* 3 (August-September): 3-6.

_____. [Harriette L. Simpson]. 1936. "Washerwoman's Day." *Southern Review* 1 (Winter): 522-27.

_____. 1936. *Mountain Path*. New York: Covici-Friede.

_____. [H. L. Simpson]. 1942. "The Two Hunters." *Esquire* 18 (July 1942): 74-75, 96.

_____. 1944. "The Hunter." *Atlantic Monthly* 174 (November): 79-84.

_____. 1949. *Hunter's Horn*. New York: Macmillan.

_____. 1954. *The Dollmaker*. New York: Macmillan.

_____. 1970. *The Weedkiller's Daughter*. New York: Knopf.

_____. 1974. *The Kentucky Trace: A Novel of the American Revolution*. New York: Knopf.

Brickell, Hershel. 1949. "Kentucky Man and King Devil." *New York Times Book Review*, 28 May, 4.

Cowley, Malcolm. 1954. *The Literary Situation*. New York: Viking Press.

Farrelly, John. 1949. "Review of *Hunter's Horn*, by Harriette Simpson Arnow." *New Republic* 121 (1 August): 26-27.

Flynn, John. 1990. "A Journey with Harriette Simpson Arnow." *Michigan Quarterly Review* 29, no. 2 (Spring): 241-60.

_____. Manuscript on Harriette Arnow. Unpublished.

Henderson, Robert W. 1949. "Review of *Hunter's Horn*, by Harriette Simpson Arnow." *Library Journal* 74 (1 May): 735.

Hobbs, Glenda. 1984. "Harriette Arnow's Kentucky Novels: Beyond Local Color." Pp. 83-92 in *Regionalism and the Female Imagination*, Emily Toth, ed. New York: Human Sciences Press.

Preece, Harold. 1949. "Review of *Hunter's Horn*, by Harriette Simpson Arnow." *Churchman* 163 (1 September): 18.

Unrue, John. 1965. "The Major Novels of Harriette Arnow: A Study of *Hunter's Horn* and *The Dollmaker*." Master's thesis, Marshall University.

Wagner, Linda W. 1982. "Harriette Arnow and the 1980s." *Great Lakes Review* 8, no. 2 (Spring): 1-10. In this collection, pages 78-82.

Walsh, Kathleen. 1984. "'Hunter's Horn': Harriette Arnow's Subversive Hunting Tale." *Southern Literary Journal* 17 (Fall): 54-67.

HUNTER'S HORN AND THE NECESSITY OF INTERDEPENDENCE: RE-IMAGINING THE AMERICAN HUNTING TALE

KATHLEEN WALSH

Harriette Arnow's *Hunter's Horn* (1949) has too long been relegated to peripheral status as a regional novel, prized by fans of Appalachia for its lively treatment of "Little Smokey Creek" in the Cumberland Mountains. But Arnow's compelling treatment of the conflict between independence and interdependence merits wider attention. Reviewers sensed something more than local color in the novel, hailing it as a potential Pulitzer Prize winner and comparing it to *Moby-Dick*. Arnow seems deliberately to invite such comparisons through her depiction of Nunn Ballew's long and obsessive hunt for "King Devil," a brazen and elusive fox. However, reviewers who attempted to read Arnow as an Appalachian Melville were disappointed. One reviewer chided, "That Melville's influence can be dangerous is shown in the case by the fact that Nunn Ballew's chase of King Devil has little of the intensity of Ahab's passionate quest for the white whale" (*Time* 1949, 44). Another commented, "as a symbol, the fox is inadequately and only sporadically developed" (Farrelly 1949, 26). Actually, the context is appropriate: *Hunter's Horn* can best be understood in relation to the tradition of American hunting tales. The contribution of *Hunter's Horn* to our literature lies in its divergence from that tradition, a divergence which exposes the hunting tale's enshrinement of independence.

Both serious novels of hunting and traditional "tall tales" reflect in large measure the "strategy of evasion" which Leslie Fiedler finds characteristic of American literature: "the typical male protagonist of our fiction has been a man on the run, harried into the forest and out to sea, down the

An earlier version of the article was published as "*Hunter's Horn*: Harriette Arnow's Subversive Hunting Tale," *Southern Literary Journal* 17 (1984-85): 54-67.

river and into combat—anywhere to avoid 'civilization,' which is to say, the confrontation of a man and woman which leads to the fall to sex, marriage and responsibility" (Fiedler 1960, xx-xxi). More recently, David Mogen has described the "Myth of America" in more positive terms, "as a variant of the universal monomyth Joseph Campbell describes in *The Hero with a Thousand Faces*," a "variant that uniquely emphasizes the possibility of rebirth." But though Mogen emphasizes possibility—in contrast to Fiedler's emphasis on desertion—he also recognizes the centrality of separation: "Rather than bringing their knowledge home, our heroes more typically ride into the sunset, after blazing a trail for others to follow" (Mogen 1989, 26). The historical connection between this "monomyth" of separation and the "Frontier hunter-hero" is traced by Richard Slotkin, who links the rise of industrialization and the closing of the frontier to the "stereotype of the Frontiersman as an antisocial character—half white Indian or Leatherstocking, so much the pure wilderness man that he must vanish with the forest" (Slotkin 1985, 126). American novels centering on the hunt include some numinous, major works (*Moby-Dick*, "The Bear," *The Old Man and the Sea*), and share certain structural features: the hero is drawn away from his society by his absorption in the hunt; the prey is somehow unique, perceived to have abnormal power, possible malevolence, and a special significance for the hunter alone; by pursuing that mystery, the hunter seeks a confirmation of his individuality; whether or not the hunter returns to his civilization, the narrative centers upon his experience apart from it. An arguable exception to the last point is Faulkner's "The Bear," to which *Hunter's Horn* might profitably be compared, since Ike McCaslin at least exists within a narrative interspersed with reflections upon interdependence.

Much of *Hunter's Horn* is indeed puzzling when approached with the expectation that meaning will reside in Nunn Ballew's testing confrontation with a mysterious and significant adversary. The point of view is principally centered on Nunn, who is presented fully and sympathetically, but Arnow also explores the consciousness of members of his family, and these shifts present very separate lives and needs and grief which do not give resonance to Nunn's obsession. An occasional, vivid scene of hunting is depicted, but equally vivid, frequent—and resonant—are the scenes of childbirth which intersperse the narrative. The conclusion of Nunn's long contest coincides with the end of the novel, but the capture is overshadowed by a family crisis which is also reaching its culmination. If attention

is paid to these domestic details and the pattern of their juxtaposition with the hunt, it becomes clear that Arnow is interested in mapping the area of tension to which one is subject as a member of a group, the tension between self-definition and interdependence. She is sympathetic toward her hunter's drive for a more fulfilling experience than that afforded by the prosaic, impoverished, repetitive circuit of farming which he neglects, but she ultimately deflates the romance of his hunt while giving weight to the claims upon him. Dana Heller raises the question of what a "feminized" quest-romance would look like—"How is a capacity for both autonomy and relationship, attachment and independence, to be expressed?" (Heller 1990, 13) *Hunter's Horn* does not so much answer this question as make clear its complexity.

Perhaps Arnow's balanced and compassionate view of the conflict between individuality and interdependence results from her having deeply lived such a conflict. The question of family responsibility, a question cast in terms of the needs and dependency of children, also occurs in Arnow's later novel, *The Dollmaker* (1954). Both novels were written while her own two children were small (three and eight years old when *Hunter's Horn* was published). Arnow's husband was a Detroit newspaper reporter, she a homemaker and mother who rose to write by 4 a.m. and worked until the others woke at 7:00. In an interview with Bernard Kalb (1954), she commented, "Fiction, once you start it, has such a horrible pull" (Havighurst 1954, 12). Later, she specifically compared that pull to Nunn's: "Nunn has the same compulsion for catching King Devil as other men have for making a million dollars, or I had for writing" (Baer 1976, 118). Though Arnow did not stop writing to raise her children, she wrote slowly. An interviewer has reported of Arnow: "During those years she was often plagued with guilt at time spent with either the children or her writing: bouts of self-pity followed the guilt" (Hobbs 1979, 863). In *Hunter's Horn*, the problem of the individual's relationship to the family emerges as a genuine conflict: for Nunn to do other than he does would require of him to be other than he is, but the cost of his absence is reckoned against the life of his oldest child.

From the novel's opening scene, when Nunn elects to buy food for his foxhound, Zing, rather than sugar for his family, Nunn's decisions are clouded, though not controlled, by his awareness that what he gives to the hunt, in terms of cash or energy, he takes from his family. When Zing dies, Nunn determines to sell whatever he can to buy pedigreed pups. Yet he

cannot bring himself to tell his distraught wife, Milly, why he is selling the dairy cow and the winter's meat: "When he tried to find words for the telling, the thing he did seemed yet more nightmarish and unreal, the act of a man gone crazy—taking food out of his children's mouths he was" (Arnow 1949, 78). Nunn increasingly shifts his chores to other shoulders, and when he is chided for this, he is unable to respond: "he couldn't make his voice sound like that of a man with an easy conscience, a man who is doing what he ought to do" (160). Nunn is uncomfortably aware of the cost of his hunt to his family, but he plans to make up for such neglect later.

Such deferment is the principal means by which Nunn avoids the prompting of his conscience. He looks forward to the day King Devil will be caught, thinking that then, "he, Nunnely Ballew, could be a man again, working his land and raising his family" (46). Arnow focuses on time as the decisive factor in such a conflict as Nunn's: he has the best of intentions, but insufficient time. In the seventh year of the hunt, when his daughter Suse is kept out of school to work at home, he does briefly fear that time may not be elastic: "Seven years—that was a long time. None of the things planned were done—and he was getting old. . . . If he lived to be a hundred and caught King Devil and died a millionaire, that wouldn't help Suse now —unpardonable, unforgivable" (268). But he suppresses these doubts and continues to hunt, blaming the fox for his obsession, feeling himself to be acting out of compulsion rather than choice: "other men did what they pleased, he chased a fox because he had to" (92). The more he—or his family—give for the chase, the more he hates King Devil and the more he comes to credit the fox with mysterious power over his life.

Such stress on the prey's mysterious power may seem the familiar stuff of hunting tales, but in this novel, the power that Nunn projects unto the fox is obscured and undercut by other elements. Although Suse sees the fox as a symbol of freedom, and Milly once glimpses the animal to note its great size and a kind of bright, troubling beauty, such estimates are ultimately deflated. When the fox is finally taken, "King Devil" is found to be a vixen, and a pregnant one at that. Milly comments, "Pore thing, if she hadn't been a vixen, they'd never a caught her," and another neighbor mocks Nunn, "look at all the time an money he's spent a chasen a fox an it a vixen" (395). Nunn is not even present at the capture; his wife and a neighbor have inadvertently led the hounds to King Devil's den on their way to assist at a birthing. When Nunn finally examines his old adversary,

he fails to comment on—or perhaps even to notice—its gender: "there was a puzzled wonder in his voice, like a disappointed child's when he said: 'But he's so little.'" Milly interjects, "Why Nunn, she's uncommon big fer a fox," but he responds, "He allus seemed big somehow—bigger lots a times than anything else in the world" (398).

The fox's pregnancy is not precisely symbolic, but it is highly suggestive, and these suggestions are echoed in three episodes of childbirth. Such episodes dramatize the necessity of interdependence and form a counterpoint to the vexed monomyth of the hunter. Comparison of an extended scene of hunting in the novel with an earlier version of this chapter published as a short story, "The Hunter" (1944), reveals the deliberateness with which Arnow introduces the subject of childbirth into the hunting tale. The only substantive additions to the story refer to childbirth, particularly its urgency. In one addition, Old John Ballew, a consistent voice for responsibility in this community, tells one of the men to go home because his wife is due: "It's no way to do; stayen away from a woman in that shape." John urges promptness: "Sue Annie can't hold the youngen back till you make up your mind to git home" (Arnow 1949, 39). Throughout the novel, the response that must be made when a woman's "time has come" is emphasized; childbirth emerges as a process which is inexorable, unpredictable, and often perilous. It is Arnow's principal means of critiquing what David Noble in *The Eternal Adam and the New World Garden* identifies as "the central myth of our civilization—the transcendence of time" (Noble 1968, xi).

The birth of the Ballews' seventh child introduces the potential hazards of pregnancy. Milly, despite long fears, bears her child alone and easily. She has urged Nunn to go hunting, assuring him, "her time wouldn't be on hand for three or four weeks" (Arnow 1949, 230). She then waits alone with her fears: "A body wanted it over with, but oh, God, so many things could go wrong. What if it got caught on the crossbones like Vadie Anderson's third one. She suffered for six days, until she lost her strength and her nerve and her mind almost, and men had to push her legs down while she chewed her tongue till the blood ran and begged them to kill her" (232). Such details remind us that childbirth is particularly hazardous in this remote region, without doctors or the telephones—or the money— to bring them.

By far the strongest impression of the urgency of childbirth is made by the depiction of the long labor and death of Lureenie Cramer. Early in the

novel, Lureenie is presented as young, pretty, and silly. Despite her poverty and her husband's shiftlessness, she dreams of the fine life she will have when she follows him to Cincinnati. But Lureenie and her brood see no more of Cincinnati than can be glimpsed from an apartment window, and she soon returns to Little Smokey Creek, pregnant again. She is too proud to tell her neighbors that she has broken with her husband and lacks food or money. The neighbors are sporadically concerned that Lureenie is "bad run" but they are slow to offer help, put off by her pride and delayed by bad weather. By the time Nunn, the nearest neighbor, discovers her plight, Lureenie and the children are nearly starved and she soon goes into a difficult labor. The midwife demands a doctor, a rare request, but "Keg Head" Cramer, Lureenie's father-in-law, is determined to trust in God's will—and to save the fee. All the dreams of freedom in the novel find a point of sharp contrast in Lureenie's agony: she is told by the midwife, "Child, you know there ain't nothen you can do but lay flat an take it" (317). In the second day of labor, two of the more prosperous neighbors send to town for a doctor, but the journey is long and no one comes. There is no help for Lureenie, who dies that night, the baby still unborn.

Arnow underscores the importance of time with bitter irony in the next scene: however dilatory her father-in-law and others have been in responding to Lureenie's needs, they are quick in dispatching her, feeling superstitious about allowing the winter sun to set on her newly dug grave: "even as the coffin bearers went running toward the graveyard, the coffin bouncing on their shoulders, the shadows rose to the men's knees" (234). Their haste appears hypocritical, grotesque, and self-serving. Over her grave, Preacher Samuel insists that they take time to pray. In condemnation of the community, including himself, for letting Lureenie go in want, he reads from I Corinthians 13, counseling that care for others is the greatest good.

When Cordovie Foley sends for the midwife, Sue Annie, as the novel draws to a close, the birth is again less troubled than it might have been. Here as elsewhere, however, Sue Annie is a powerful—and colorful—voice for the necessity of heeding potential needs. Despite a high river and the lack of a man to row her across to Cordovie, the old midwife is determined to go: "God almighty, th devil must be a chasen me er mebbe the Lord's mistook me fer Job. But devil er God, nothen's a goen to keep me frum that girl." She is worried because "this Foley woman had nearly flooded to death last time" (381). But Sue Annie arrives on time and the birth is an

easy one. The contrast of so prompt a response with the long delays of Nunn's hunt is ironically underscored as King Devil is finally brought to ground outside.

Arnow's treatment of childbirth is unusually graphic and direct. Childbirth, unlike motherhood, was generally treated with respect in mid-twentieth century literature, but the event usually occurred offstage. Babies are born both in *Absalom, Absalom* and *Light in August*, for example, but the births are not narrated, and the women are encountered shortly afterward, ready for conversation. Childbirth is the subject of Hemingway's "Indian Camp," but here the woman who gives birth is notably absent as a character; Hemingway details the differing ways her pain is experienced by four male witnesses. Though the woman's labor is a significant event in their lives, she seems merely an animal in agony in their near vicinity. Another type of literary reference to childbirth is likewise distancing, though occasionally graphic: labor can be a literary metaphor for a difficult transition, but such metaphors generally focus on the travail of that which is being born, not of the woman who is giving birth: Randall Jarrell's "The Death of the Ball Turret Gunner" is a notable example. Just as Arnow's depiction of hunting contrasts with more common idealizing, symbolizing treatments, so also her presentation of the flat reality of childbirth runs counter to a strain of abstracting and symbolizing. Arnow juxtaposes the experiences of hunting and childbirth to explore the necessity and even the urgency of interdependence, but not to idealize either experience.

Nunn's failure to attend to urgent needs results in the blighted adolescence of his oldest child, Suse. Up to age fourteen, she has been encountered as a relatively happy schoolgirl, quick to learn, open to new ideas, and pantingly open to the "outside." The female model available to her is unappealing: "tied down to a house and youngens, with one baby in your arms and another big in your belly like Milly— and always the knowing that you would never escape until you were dead" (Arnow 1949, 228). She intends to escape, yearning to attend high school in town, an unusual ambition for a girl, or indeed for any of the hill children, but one recently made plausible by the further incursion of a graveled road, bringing the school bus within range. Though Suse is determined that "she'd make her own life; it wouldn't make her" (228), her parents keep her out of school to work at home. Arnow thus develops what Tony Tanner has termed a characteristic American theme, "the fate of innocence." According to Tanner,

"the child or adolescent caught at the moment when he refuses to be initiated, when he attempts to deny or avoid the world of experience ahead of him" is a figure "of abiding importance for American literature" (Tanner 1972, 437, 429).

Unlike Huck, who is, of course, Tanner's model, Suse does not escape the world of experience, and is soon pregnant, shamed, and cast out. In this fall from innocence, Arnow emphasizes expulsion rather than sin: Suse's bid for freedom is quashed both by the preeminence of her father's drive to achieve some measure of such freedom for himself and by her mother's resigned certainty that freedom is not the lot of woman. Milly is self-sacrificing and uncomplaining, and she is at home with growing things—her chicks, her garden, her babies—but she lacks empathy for her offspring beyond infancy. However, Arnow depicts Nunn as having the power of decision in this family; therefore, his troubled regret that he is unwilling to do more for his daughter while involved in the hunt appears of greater moment than Milly's unconcern. Additionally, Arnow presents Nunn's inner conflict over Suse more fully than she does with Milly. Thus we see Nunn using Milly's views to cloak his own, and we also see how self-serving this is. When asked if he will send Suse to high school, he answers, "Milly cain't see the sense a senden a girl to high school, an sometimes I don't neither." But remembering his answer later, he "had hated himself for hiding behind Milly's opinions" (Arnow 1949, 251). It becomes clear that Nunn fails Suse, not because he doesn't care for or understand her needs, but because they occur at the wrong time: "He wished she had another year in common school . . . maybe in another year he would have caught King Devil." He does fear that Suse's needs will not wait, thinking, "Suse was like the spring; it raced into summer whether a man planted his corn or no" (251).

Suse's springtime is indeed brief. Instead of entering high school, she tends the youngest children and keeps house, wearing such ragged clothes that she cannot show herself to visitors. Certainly the community is impoverished, but Arnow's comparisons of the Ballew children with other local children make clear that such disregard as Suse experiences is not the community norm. Suse's resentments erupt into angry and frightened disillusionment when she witnesses Lureenie's helpless labor. This alienation increases her vulnerability, which reaches its crisis following the revival conducted by the visiting evangelist, Battle John Brand.

While revivals are rather common spots of local color in Appalachian literature, Arnow makes the event a powerful vehicle for dramatizing the

tragic interaction of Suse's disillusionment, her mother's resignation, and her father's obsession. Arnow presents the responses of all three to the exhortations of Battle John, whose text, "The harvest is passed, the summer is ended, and still we are not saved," echoes the concern with time expressed elsewhere in the novel, though ironically so, since his listeners are encouraged to concentrate on the next life rather than the present one. The ironies are deepened by sanctimonious references to Lureenie on the part of the preacher and his auditors.

Battle John paints the evils of procrastination in homely images: "If you leave your sweet taters undug till there comes a hard killen frost, will you harvest th sweet taters?" He wails of the Devil's devices: "he leads em to put off till tomorrow what ought to be done today. 'I'll have my fun,' the sinner says, 'an when I'm old an wore out an my times comes to die, I'll repent.'. . . some day, some hour, some minute, it may be too late, everlastenly too late, too late, too late" (335). Battle John raises the specter of Lureenie, using her as an exemplum of sin: "was she saved? Did she repent? Ahhh, brethren, she put it off. An now it's too late, everlastenly too late" (336). Arnow then dramatizes the ways in which Battle John's call to ultimate considerations enables Suse's parents to evade immediate anxieties for a daughter so alienated, so needful, and so ripe.

Nunn is largely aloof but is briefly stung by guilt and makes a tentative step toward the "mourner's bench." He is stopped by the thought of King Devil; for Nunn that thought is proof that God "would never give him grace" (341). Secure once again in his sense of compulsion, he leaves the revival to join a fox hunt. For Milly, the revival releases the more aggressive tendencies within her Christian resignation. She is shamed that her neighbors are doing better than she at bringing their families to repent. She demands a demonstration from Suse: "Oh, my daughter, think on your sins, come up an mourn for your sins." Suse's smoldering dissatisfaction is aroused by Milly's "weeping slobbering kisses." She thinks, "At home, it was, 'Do this, do that—shit fire, Suse, you'll have all the neighbors a talken.' But here it was all love and kisses. She couldn't recall when anybody had kissed her at home" (340). When Suse's anger erupts, her mother retreats in disgust, and Suse is left "feeling alone, almost afraid in her loneliness, for it seemed to her she hated God" (342). Her "surrender" to the smooth Mark Cramer, who offers to help her home with the younger children, seems an act of rebellion, an expression of helplessness, and a plea for a moment's affection and attention.

With the combination of honesty and the hunger for life which makes her an appealing character, Suse takes responsibility for her error but turns down Mark's *pro forma* offer of marriage. Even when she realizes their one-time encounter has left her pregnant, she is determined to escape a nar-rowed future. But Suse's life is overdetermined; she would need the help and support of both parents at this point. For Mark and his father—old Keg Head Cramer, who proved a cruel patriarch to Lureenie—the solution is for Suse to marry Mark, who is soon to leave for Detroit, and live with his parents. She would thus be subject to Keg Head's moralizing and kept as a virtual servant to care for Lureenie's children along with her own. Her life so far has been hard but not without hope. It appears certain that Suse would be broken physically and mentally by a few years of such squalor, servitude, and shame.

Suse's pregnancy is revealed to her parents just after King Devil has been brought to ground—which again suggests that Arnow is answering rather than enacting the monomyth of the hunter. Nunn is away in town, gone to sell his pups so that he can get on with his farming now that the hunt is ended. He is also making plans to send Suse to high school in the fall, but, as predicted, it is too late. He returns to find that Keg Head has come to claim Suse; Milly, aflame with anger and shame, says, "I've tried all day to git her to go quiet-like home with Keg Head and spare you this" (410). Suse clings to the hope that Nunn will allow her to stay, apparently counting on his past disregard of community opinion. Arnow makes clear that Nunn is aware of what his decision means to Suse: ". . . to go as Keg Head's hired girl . . . Suse, the proud one" (411).

But despite this awareness, and despite his long guilt over Suse, Nunn's shamed pursuit of King Devil has apparently left him with a taste for respectability. He thinks that if Suse stays, "He couldn't hold his head up: all these years he'd held his head down in a way, drinking and fox-hunting and carousing around, but that was over now." He strokes the hand-hewn rocks of his chimney, thinking of his ancestors who built it, and tells Suse, "I ain't a holden the wrong you've done agin you —but this fire—it's never warmed a bastard" (411). Sue Annie spits angrily into the fire, but the dejected Suse leaves with Keg Head. Milly and Nunn bicker briefly because he has sold the pups, and he accuses: "You cry like that over two damned hounds, an your own child worse'n dead" (412). At the close of this scene of despair and division which concludes the novel, Nunn asks himself about the children who arrive in the Promised Land: "I wonder . . .

if'n the ones that got there ever thought about them that died on the way" (412). Typically, Nunn seems to feel that failure occurs because the way is long, and not because the will is weak. But Arnow has suggested that such questions are beside the point; doubt of whether salvation lies within one's power deflects attention from what does lie within one's power.

In her examination of group ties, Arnow concentrates, and thus we have concentrated here, on family interdependence. Within that context, Arnow clearly portrays her hunter as indissolubly linked to his own kind—just as his prey is found to be linked to its own kind. But whether Arnow presents larger social ties as equally compelling must finally be considered. That Nunn concedes to what he perceives to be a rigid community standard in his decision to oust his daughter might appear to suggest that the larger social tie is presented in a typically negative light. Many critics of American fiction have commented on the postwar concentration on individuals at variance with or cut adrift from society. Alfred Kazin, in "The Alone Generation: A Comment on the Fiction of the Fifties," notes, "Now we get novels in which society is merely a backdrop to the aloneness of the hero" (Kazin 1969, 115). Tony Tanner finds that in American fiction of 1950-1970, "Society is regarded almost without exception as unequivocally malevolent to the self," and comments, "it might be a valuable gesture if some novelist re-examined the premises underlying this age-old suspicion and repudiation of society by the American writer and his hero" (Tanner 1971, 417, 416). In fact, *Hunter's Horn* provides such a reexamination. Nunn is suspicious of the confining influence of his society, but Arnow presents the community as more diversified than he perceives it to be. Unlike Nunn, Arnow posits fluidity and the possibility—or necessity—of accommodation within that field.

Arnow's interest in portraying a community is indicated by her proposed title for the novel, "End of the Gravel," a choice which she explained by describing *Hunter's Horn* as "the story of a hill community near the end of a graveled road where the outside world was bringing change" (Arnow Introduction to *Mountain Path* 1963). She depicts the community at the moment of its passing, poised for change just as Suse is. The community emerges as a kind of character: viable, affective, pliant, and inconsistent. It is this lack of consistency which is most to the point in interpreting Nunn's final acceptance of its narrow confines. Community opinion in Little Smokey Creek is more elastic than Nunn perceives it to be, accommodating values and outlooks ranging from Sue Annie's outspoken nonconformity to

Keg Head's complacent and narrow evangelism. The visiting evangelist, Battle John, and the local preacher, Samuel, are known to differ "on many points of Scripture" (Arnow 1949, 328), but neither is repudiated. Though judgments are made of others, the community is at least loyal—or forgetful—when it is not forgiving. When Nunn decides to make extra money with a run of moonshine, he is criticized and spied on by his neighbors, but these same neighbors are there to warn him when "the law" approaches—and to buy his brew. Though the neighbors notice Suse's pregnancy before her parents do, no one speaks against her. In their reactions, troubled concern mingles with curiosity.

The community is certainly constricting: the limited options available to Suse, Lureenie's hard struggle and hasty burial, and occasional incidents of violence or ruthlessness offset the images of loyalty and supportiveness that emerge at other moments and give weight to the impulses to escape nourished by Nunn and Suse. But because Nunn poses the dilemma to himself as either escape or conformity, he fails to take advantage of the real avenues of advancement which are open: Nunn would have gained both community respect and better conditions for his family by working his farm, and education was the way up and out for Suse. Arnow asks us to consider whether Nunn is deluded in his conception of his relationship to society, first in thinking he can simply escape its prosaic confines without grave consequences, and, finally, in thinking he must wholly conform.

Fox hunting itself can be viewed as a paradigm of this community's interaction and values. Though for Nunn the activity has been an expression of individuality, undertaken in disregard of family ties and community opinion, it is normally a communal event. In a later history of the Cumberland, Arnow describes the sport:

> Most hunting . . . was done in the spontaneous, unformalized fashion in which the Cumberlander liked to do things. . . . Usually the hunter never sees fox or even hounds once the race has begun, and seldom does he ever catch a good strong-legged, sharp-witted fox. At the end of a race he has nothing more than a memory of sound. . . . The children, like the women, might never go on a fox hunt but they could share in some of the hound-dog music and never leave the porch. (Arnow *Flowering* 1963, 410-11)

Since the sounds of the hunt are carried up the hollows, participation at varying levels is widespread, and since the sport as pursued in this furrowed

terrain requires only a sharp-nosed hound, it is highly democratic. Nunn's neighbors generally "hunt" in a group on Saturday nights, starting their hounds and then drinking and talking while they listen for the bays and imaginatively reconstruct the chase which the dogs rather than themselves are making. Because the hunter's agency in bringing the fox to ground is limited, the sport enables this community to act out a pervasive fatalism—and their need to overcome isolation in the face of it.

Nunn's alterations to this practice are revealing: he introduces the less democratic advantage of pedigreed hounds, hunts more than his neighbors—who limit themselves to the Saturday night carouse—and increasingly hunts alone because he is annoyed by the chatter of the men when he is with them. He feels that his hunt has strictly personal significance, that the fox shadows forth his personal fate. Nunn substitutes individual achievement and alienation for the community model of interdependence. Arnow may indeed sympathize with Nunn's intense search for personal significance; she comments in another context that "for each of us there is a Moby Dick whom we hunt with uncontrollable compulsion, so that the long wondering begins of who is the hunter and who the hunted" (Arnow 1956, 685). But Nunn's hunting fails even to give shape to his questions, much less to answer them, and is tragically costly to his daughter.

In "Our Pursuit of Loneliness: An Alternative to this Paradigm," Langdon Elsbree finds that American writers who have diverged from the privileged monomyth of individuality have failed to be appreciated: "To the extent that they do not conform to the primary American narrative paradigm and myth, they have become writers of secondary or minor interest, at best treated defensively, at worst condescended to or largely ignored" (47). Introducing an effort to "reconstruct" the American literary canon," Paul Lauter objects to curricula which "have validated certain experiences at the expense of others," commenting: "Some of the most popular texts in United States literature present hunting—a whale or a bear—as a paradigm for 'human' exploration and coming of age, whereas menstruation, pregnancy, and birthing somehow do not serve such stereotypes" (Lauter 1983, xvi). Most likely, it is Arnow's non-canonical counterpointing of these gendered paradigms which accounts for this novel's long obscurity. But these same features, and the novel's complex treatment of interdependence, invite renewed attention at this time.

WORKS CITED

Arnow, Harriette Simpson. 1944. "The Hunter." *Atlantic Monthly* 174 (November): 79-84.

_____. 1949. *Hunter's Horn*. New York: Macmillan.

_____. 1956. "Language—The Key That Unlocks All the Boxes." *Wilson Library Bulletin* 30 (May): 683-85.

_____. 1963. *Flowering of the Cumberland*. New York: Macmillan, 1963.

_____. 1963. "Introduction." In *Mountain Path*. Berea, Kentucky: Council of the Southern Mountains.

Baer, Barbara. 1976. "Harriette Arnow's Chronicles of Destruction." *The Nation,* 31 January, 117-20.

Elsbree, Langon. 1989. "Our Pursuit of Loneliness: An Alternative to this Paradigm." Pp. 31-49 in *The Frontier Experience and the American Dream: Essays on American Literature*, eds. David Mogen, Mark Busby, and Paul Bryant. College Station: Texas A & M Press.

Farrelly, John. 1949. "Review of *Hunter's Horn*, by Harriette Simpson Arnow." *New Republic* 121 (1 August): 26-27.

Fiedler, Leslie. 1960. *Love and Death in the American Novel*. New York: Criterion.

Havighurst, Walter. 1954. "Hillbilly D. P.'s." *Saturday Review* 37 (24 April): 12.

Heller, Dana A. 1990. *The Feminization of Quest-Romance: Radical Departures*. Austin: University of Texas Press.

Hobbs, Glenda. 1979. "A Portrait of the Artist as Mother: Harriette Arnow and *The Dollmaker*." *Georgia Review* 33: 851-65.

Kazin, Alfred. 1969. "The Alone Generation: A Comment on the Fiction of the Fifties." Pp. 114-23 in *The American Novel Since World War II,* ed. Marcus Klein. New York: Fawcett.

Lauter, Paul, ed. 1983. *Reconstructing American Literature: Courses, Syllabi, Issues*. Old Westbury, N.Y.: Feminist Press.

Mogen, David. 1989. "The Frontier Archetype and the Myth of America: Patterns that Shape the American Dream. Pp. 15-49 in *The Frontier Experience and the American Dream: Essays in American Literature,* eds. David Mogen, Mark Busby, and Paul Bryant. College Station: Texas A & M Press.

Noble, David W. 1968. *The Eternal Adam and the New World Garden: The Central Myth in the American Novel Since 1830*. New York: Braziller.

"Review of *Hunter's Horn*, by Harriette Simpson Arnow." 1949. *Time* 11 July, 44.

Slotkin, Richard. 1985. *The Fatal Environment: The Myth of the Frontier in the Age of Industrialization, 1800-1890*. New York: Atheneum.

Tanner, Tony. 1972. "Ideas of Innocence in American literature." Pp. 417-39 in *The Modern World II: Realities*, eds. V. David Daiches and Anthony Thorlby. London: Aldus, 1972.

_____. 1971. *City of Words: American Fiction 1950-1970*. London: Jonathan Cape.

A PORTRAIT OF THE ARTIST AS MOTHER: HARRIETTE ARNOW AND *THE DOLLMAKER*

GLENDA HOBBS

Among the characters rarely depicted in American fiction is a woman who is both a loving, responsible mother and an accomplished, productive artist. Perhaps few novels portray such a character because few female writers in the American literary canon have the experience of motherhood on which to draw for fictional material. In her recent provocative book, *Silences*,[1] Tillie Olsen notes the predominance of women writers without children in world literature throughout the ages. In American literary history the preponderance of such notable women writers is striking. Among them are Louisa May Alcott, Willa Cather, Emily Dickinson, Mary E. Wilkins Freeman, Ellen Glasgow, Lorraine Hansberry, Lillian Hellman, Josephine Herbst, Sarah Orme Jewett, Katherine Mansfield, Carson McCullers, Marianne Moore, Flannery O'Connor, Dorothy Parker, Katherine Anne Porter, Elizabeth Madox Roberts, Agnes Smedley, Christina Stead, Eudora Welty, and Edith Wharton.

It cannot be merely an inexplicable coincidence that most of our women of letters never had children. The reasons for these writers forgoing children, and in most cases marriage, cannot be explained by the spurious theory that they somehow sublimated and channeled their maternal desires and derived complete satisfaction from producing books instead of babies. Equally foolish is the notion that those women who relinquished art for motherhood satisfied their creative urges in childbirth and rearing and no longer nourished artistic aspirations. Some of these women chose not to marry for varying complicated, individual reasons. Yet many were doubtless deterred by the likelihood of children following marriage and making

Originally published in *The Georgia Review* 33 (Winter 1979): 851-67.

demands on time and energy required for cultivating their art. Before the very recent past, when having children became for many a choice, children threatened to thwart any artistic ambitions the mother nurtured. The household responsibilities of most mothers at least partially explain the scarcity of mother-writers in our literary history.

Tillie Olsen elucidates why motherhood often produces "silences" in women writers otherwise prepared to pursue their art:

> Not because the capacities to create no longer exist, or the need (though for a while as in any fullness of life the need may be obscured), but because the circumstances for sustained creation have been almost impossible. It can have at best only part self, part time. . . . More than in any human relationship, overwhelmingly more, motherhood means being instantly interruptible, responsive, responsible. Children are one *now* (and remember, in our society, the family must often try to be the center for love and health the outside world is not). The very fact that these are real needs, that one feels them as one's own (love, not duty); *that there is no one else responsible for these needs*, gives them primacy. It is distraction, not meditation, that becomes habitual; interruption, not continuity; spasmodic, not constant toil. . . . Work interrupted, deferred, relinquished, makes blockage—at best, lesser accomplishment. Unused capacities atrophy, cease to be. (Olsen 1978, 18-19)

Olsen feels that children call upon a mother's, but not a father's total capacities, a belief shared by many male writers who use the metaphor of a mother conceiving, delivering, and raising a child to characterize the constant loving attention a writer must pay to his craft. In an early essay Olsen quotes Balzac likening a writer's creating a work of art to a mother bearing and rearing a child:

> To pass from conception to execution, to produce, to bring the idea to birth, to raise the child laboriously from infancy, to put it nightly to sleep surfeited, to kiss it in the mornings with the hungry heart of a mother, to clean it, to clothe it fifty times over in new garments which it tears and casts away, and yet not revolt against the trials of this agitated life—this unwearying maternal love, this habit of creation—this is execution and its toils. (Olsen 1978, 12)

Balzac's selecting motherhood to suggest the artist's "agitated life" is not surprising; what other continuing experience rivets one's fascination, sustains as constant an intensity, even reflects one's fundamental nature? Apart from the demands of time required by children and by art, both exert a compelling pull on one's energies and emotions. It is no wonder that few women could simultaneously mother the child of her flesh and nourish a painted canvas, a woodcarving, or a printed page regarded as a child of her mind and talent.

The idea that motherhood and art are irreconcilable is suggested in much American fiction exploring the problems of artistic women. Most often the heroine perceives a conflict between her desire to marry and her aspiration to continue cultivating her art. Kate Chopin's short story "Wiser Than a God" (1889) can serve as a paradigm for stories depicting this dilemma. Paula Van Stolz, an aspiring pianist, falls in love with a man who returns her love. The smitten young man asks her to make marriage rather than music her "calling" and labor for love alone. Believing that marriage would sabotage her plan to become a concert pianist, the tormented Paula refuses him. In time, after she has become a successful concert pianist, Chopin suggests that she may eventually give in to the persistent will of her middle-aged harmony teacher and marry him. Turning down her beloved causes Paula considerable anguish, but Chopin indicates that she could do nothing else, for the "quiet routine of domestic life" and the "serious offices of wifehood and matrimony" are incompatible with the artist's passion.

Paula and Chopin's assumption that marriage and art are mutually exclusive is nearly universally held by artistic women in American fiction. Willa Cather frequently chronicles the life choices of gifted women. Some abandon their artistic pursuits; others renounce love or marriage. Opera singer Kitty Ayrshire in "Scandal" (1920) misses never having a husband or a child, while Aunt Georgiana in "A Wagner Matinée" (1905) laments giving up her music to follow her husband to the Nebraska frontier. Kitty accepts her difficult choice with bravado; Georgiana, at hearing a concert for the first time in thirty years, weeps profusely for those other performances she never heard or gave. Occasionally novels contain a suggestion that the heroine can both marry and continue to cultivate her art. But even when an author seems to share the character's belief that the two are compatible, as Hamlin Garland does in *Rose of Dutcher's Coolly* (1895), he does not demonstrate or explain

just how the character will manage what so many could not. At novel's end it remains a hope rather than a reality.

The explanations for this dichotomy between marriage and art are more often implied than stated in literature. Husbands who cannot accept an independent, achieving wife are sometimes faulted; or blame is placed on a society that considers marriage alone a woman's career. But the primary reason for a character's feeling compelled to choose between marriage and art goes beyond other people's expectations about her proper role; it is her recognition that very likely children will follow marriage and threaten her artistic ambitions. Many heroines avoid this losing battle between motherhood and art by relinquishing their personal lives and giving themselves entirely to their art; others marry, have children, and give up hope for fulfillment outside the home. Harriette Arnow's big and brilliant *The Dollmaker*, a critically acclaimed best seller since its release in 1954, is unique in documenting the predicament of a woman who confronts the problem rather than evades it, and who is determined to have it both ways.

"What possible difference," Tillie Olsen asks, "does it make to literature whether or not a woman writer remains childless—free choice or not—especially in view of the marvels these childless women have created"? Answering her own question, Olsen supposes that there would have been "other marvels" as well, or "other dimensions" to the enduring works they have created. She suspects that there might have been present "profound aspects and understandings of human life as yet largely absent in literature" (Olsen 1978, 32).

The Dollmaker testifies to the correctness of Olsen's suspicions. Its depiction of family life—the entangled bonds between parents and children, brothers and sisters—is unparalleled in modern American fiction. Especially affecting is the loving relationship between mother and daughter shared by Arnow's heroine, Gertie, and five-year-old Cassie. Skillfully and movingly the novel depicts fictional children as original and as realistic as any child the reader has known. It also makes the joys and the pains of motherhood as heartbreakingly palpable as any vicarious account can suggest.

More than just employing fresh subject matter, *The Dollmaker* dramatizes the frequently skirted conflict between a mother's attempt to be both true to her art and watchful of her children's welfare and happiness. Gertie Nevels, a hulking Kentucky hill woman with a talent for carving in wood, grapples with the distractions and obstructions that interfere with her

sculpting a human figure out of a cherished man-sized piece of wild-cherry wood. The cherry-wood figure is more than an art object: carved during moments of hope, sorrow, regret, and then despair, it reflects the nature and the toughness of Gertie's moral fiber. The aesthetic and moral quality of the figure thus takes on singular importance in Gertie's life, for she is as much creating and discovering her destiny as she is demonstrating and assessing her talent. More than anything else, Gertie's motherhood is responsible for the cherry-wood figure's reflecting her sympathies with suffering humanity and for its remaining unfinished. Her children are the source of Gertie's sympathy and compassion—the material for her art and the cause of its doom. Thus motherhood at once inspires Gertie's creativity and condemns it to destruction.

The Dollmaker embodies, as well as dramatizes, the mother-artist's struggle to create a masterwork. The novel is Arnow's man-sized wild-cherry wood: weighty, skilled, ingenious, penetrating, and also somewhat unfinished. In some ways it is as rough and unhewed as Gertie's block of wood. However recognizable the novel is as a masterwork—Joyce Carol Oates calls it "a legitimate tragedy, our most unpretentious American masterpiece"—it lacks the streamlining and the polish that come only from sustained concentration, a luxury Harriette Arnow seldom had during its writing. For as Gertie was demanding to be written, Mrs. Arnow was responding to the more immediate demands of her own two children, both young during the early fifties, when their mother awoke at three or four o'clock in the morning to answer Gertie's "compelling pull" before her sleeping children could begin to exert theirs. Arnow's masterwork reveals the same moral probing evinced in Gertie's—the practical and spiritual conflicts that bedevil both the artist and the mother, and perhaps most unrelentingly she who is both.

The riveting story of a family's migration during World War II from the Kentucky hills to a crowded housing project in Detroit centers on Gertie's efforts to keep her family unified both before and after she joins her husband in Detroit, where the army has assigned him to a defense plant. Heaped with details of how city life befuddles and splinters the uprooted family, the novel measures Gertie's ability to help her family preserve its integrity in an alien, often hostile environment. *The Dollmaker* has that quality of greatness that Randall Jarrell attributes to another superb, unheralded novel, Christina Stead's *The Man Who Loved Children*: "It makes you a part of one family's immediate existence," so that it will

take many years to get the sound, sight, and smell of that family out of one's senses.[2]

Gertie has the artist's inventiveness and originality in abundance. When her family is still in Kentucky, she is sure she can carve in the rich, pure-grained cherry wood the Christ imbedded in her imagination since childhood. This private vision expresses Gertie's love for the common man and for nature as well as it illustrates her fecund imagination. Sharing her vision with Cassie, the daughter who is her closest spiritual kin, Gertie explains that He wears "overalls like a carpenter," makes things "like yer granpa," and carries "a big branch a red leaves." Unlike the stern Calvinistic savior her mother worships, Gertie's Christ understands human weakness and tempers justice with mercy. He's a "laughing Christ uncrowned with thorns and with the scars of the nail holes in his hands all healed away; a Christ who had loved people, had liked to mingle with them and laugh and sing the way Henley [her favorite brother, killed in the war] had liked people and singing and dancing."[3] Gertie's convivial Christ mirrors her generosity and tolerance; he also testifies to her individuality and assertiveness, for evoking such an alien savior is heretical in a community that reveres Battle John Brand's fire and brimstone savior.

When Gertie gives up her dream of buying a farm in Kentucky and follows her husband, Clovis, to Detroit, she is less certain that Christ will come laughing out of the wood. Although she had little choice but to go to Detroit, she feels that she has betrayed the two of her children who love the Kentucky hills: twelve-year-old Reuben and the younger Cassie. She begins to fear that the hidden man will be the Judas that increasingly haunts her mind. She describes her perception of him while whittling a doll for the fanciful, ever receptive Cassie:

> "Not Judas with his mouth all drooly, his hand held out fer th silver, but Judas given th thirty pieces away. I figger," she went on after blowing the shavings out of the hole, "they's many a one does meanness fer money—like Judas." Her eyes were on the poplar as she spoke, "But they's not many like him gives th money away an feels sorry onct they've got it." (23)

Discovering which man is hidden in the wood will reveal to Gertie her own moral strength or weakness.

Her family's splintering soon after their arrival in Detroit causes Gertie to weaken and Christ's laughing face to grow dim. Of Gertie's five children,

Amos (at two the youngest) is the least worrisome. Two others, fourteen-year-old Clytie and nine-year-old Enoch, cause Gertie sorrow because they gladly relinquish their hill heritage and assimilate. They urge their backward mother to purge all ruralisms from her speech, to say "kids" instead of the now embarrassing "youngens." To them, Gertie is evidence of a disgraced past; a six-feet-four-inch mountain of flesh, she seems to scream out "hillbilly." While Gertie loses Clytie and Enoch spiritually, she suffers a more terrible loss when she loses her beloved Reuben in body as well as in spirit.

Trying to envision a face for the man in the wood, Gertie sees "instead of the laughing Christ, . . . Reuben's hurt and angry eyes" (327). She first notices Reuben's half accusing, half contemptuous stare when she fails to defy her various relatives and fight to stay in their newly bought farm in Kentucky, where her family would forever be rid of the yoke of sharecropping. In Detroit the look grows more frequent as Reuben continues to carry a knife, take a short cut home from school so he can feel earth beneath his feet instead of concrete, and otherwise resist making himself over for Detroit, "like you done" he hurls at Gertie. She is constantly torn between wanting her son to maintain his individuality and pride in his roots, and wanting him to be like the other project children, so they will accept him. Guiltily, haltingly, Gertie tells Reuben to "try to run with th rest." Reuben, who views her compromises as betrayals, runs away, back to the land that nurtures rather than stunts him. Anguished over losing her son's respect and then his company, Gertie searches through the Bible for comfort, but she stops repeatedly at Judas' ignominy: "I have sinned in that I betrayed innocent blood. . . . What is that to us? . . . And he cast down the pieces of silver . . . and he went away and hanged himself" (361). Sensing her affinity with another who betrayed "innocent blood," Gertie closes the Bible and picks up a statue of Christ she is carving for a neighbor: "The knife, as if with a mind of its own, gave a tortured, furrowed face to the drooping head" (361).

As searingly real as Reuben is to readers, no character in the novel is as engaging as Gertie's favorite child, Cassie Marie. Arnow's loving portrait of this irreverent, clumsy, innocent, creative child and Gertie's mutually adoring bond with her bring readers into that "other dimension" Olsen suggested might come from writers who are also mothers. Few characters in literature are so winsomely original, so indelibly printed on the reader's consciousness; thus Gertie's betrayal of Cassie is the book's tragic heart,

because she loves the elf-child more than her other children, and because her departure is permanent. As with Reuben, Gertie is proud of Cassie's individuality but worried that she needs friends; Cassie is contented with the companion she brought from Kentucky, her imaginary playmate, Callie Lou. Back in Kentucky Gertie and Cassie had laughingly included Callie Lou in their games. Her hand forever outstretched for Callie Lou to hold, Cassie burbled joyfully during their animated conversations. But upset over the project children's calling Cassie "cuckoo" when she talks to Callie Lou, confused by her neighbors' disapproval and her family's embarrassment, and feeling that Cassie might be happier playing with other children, Gertie tells the stunned, disbelieving Cassie, "There ain't no Callie Lou." The shock of Gertie's words is debilitating because Callie Lou is more to Cassie than an imaginary friend: she betokens Cassie's individuality, her ebullient creativity, and her love for Kentucky, where Callie Lou was born. Callie Lou is as real and as important to Cassie as the laughing Christ in overalls is to Gertie. Gertie has even used that comparison to explain her private vision of Christ to Cassie: "It's kinda like you a sean Callie Lou" (76), she tells her favorite child.

The consequences of Gertie's decision to take Callie Lou from Cassie are more horrifying than the distraught mother could have imagined. Cassie's shock at her mother's words, her awful silence for a week afterward, and the alley children's apparent acceptance of Callie Lou persuade Gertie that doing away with Callie Lou was a mistake. Determined to restore her to life, Gertie finds Cassie playing with Callie Lou in the railroad yard— where Cassie can evade Gertie's rebuke. This scene, one of the most excruciatingly powerful in literature, evokes Gertie's horror and desperation as she screams for Cassie to get off the tracks. But unaware of her mother's shouts, which are drowned out by the approaching train and an overflying plane, Cassie sits cradling Callie Lou in her arms as the train, lurching ahead, severs her legs before Gertie's stricken eyes. In attempting to protect Callie Lou even from the train, Cassie expresses her unarticulated need to safeguard her private world and to resist assimilation. Sadly, ironically, Cassie dies protecting her child, as dear to her as Cassie is to Gertie.

As when she loses Reuben, Gertie turns to her art for comfort. During the following weeks, numbed, drugged, and half conscious, imagining the whole earth shaking and roaring, she believes only the man in the wood can "pull her through." But as the chips and shavings fall, revealing more and more of the man they hide, a train whistle inevitably blows, sending

the knife clattering to the floor and leaving the haunted artist rocking back and forth with hands over her ears—belatedly trying to reach Cassie in time. Gertie repeatedly galvanizes her strength and returns to the carving, trying to blur the sight of Cassie's dangling boot and to smother the sound of the train whistle.

Carving done at such times reflects Gertie's immense guilt and grief over betraying another child. One side of the block begins to emerge as "the cloth-draped shoulders of someone tired or old, more likely tired, for the shoulders, the sagging head, bespoke a weariness unto death" (438). Gertie's "own torture became instead the agony of the bowed head on the block of wood" (444). She cannot recover from losing two of her children as well as the Kentucky farm she saved for fifteen years to buy: "If she tore herself from Cassie, there was Reuben waiting, and if from Reuben, the lost land called, and then became a lost life with lost children" (459). Her art helps her to take responsibility for her sins; she perceives her kinship with Judas only when she suspects that he is the hidden man in the wood:

> There was some comfort in a hand of the block of wood, a hand cupped, but loosely holding; behind the blank wood above it she could sometimes see the face, eyes peeping through the wood, looking down upon the thing, hard won, maybe, as silver by Judas, but now to give away; the eyes were sad or maybe angry with the loss. (464)

Gertie now lacks the energy and the optimism to find a face for her laughing Christ. The shock of discovering that Clovis has killed a man over union politics nearly undoes her. No longer independent, defiant, life-giving, she does nothing. Cassie's death foreshadows, even makes inevitable the perpetual burial of Christ's face, for both He and Callie Lou owe their existences to a kindred gaiety no longer possible for the grieving mother. A neighbor sees Judas plainly in the wood. Mrs. Anderson gestures toward his cupped hand and tells Gertie that he'll give it back. "'A body cain't allus give back–things,' Gertie said, filled suddenly with a tired despair; the wood was Judas, after all" (585). Discovering the man's identity helps Gertie to decipher hers, though she is in Harriette Arnow's opinion unluckier even than the arch betrayer: he could give back the silver, Mrs. Arnow once told me, but Gertie couldn't give back Callie Lou.

Gertie shares a kinship with Judas not only because like him, she betrays "innocent blood," but because also like him, she does "meanness fer money."

In Kentucky Gertie carved only axe handles and baskets to use on the farm, and dolls for Cassie. On the train to Detroit she is surprised to learn that people would pay for her whittled figures. Unconscious of the aesthetic quality of her work, she is puzzled when an admirer in Detroit asks if she tries to create beauty in an ugly world. "I don't know nothen about things like that," she replies. "Mostly—well mostly I jist like tu whittle" (237). She learns to hate some kinds of whittling in Detroit, where she trades in share-cropping for another form of financial bondage: the installment plan. Needing money to pay for the furniture and appliances Clovis buys on credit, Gertie is faced with the artist's perennial dilemma of maintaining one's artistic integrity or prostituting one's talent in order to make a living. Weakened by the loss of her land, Reuben, and then Cassie, Gertie succumbs to Clovis' pressure and carves for money. What had been an outlet for her creativity becomes a sign of desperation and submission. Instead of creating beauty, she adds to the world's ugliness, carving a sunbonneted, barefooted figure that represents a rich city-man's picture of a folksy country woman, and a bleeding, thorny-crowned, "ribby-chested" crucifix agonizing enough even for her mother. When Clovis goes on strike, depleting their savings, the family needs money for food. Imagining her children hungry, Gertie agrees to relinquish the loving detail that distinguishes her carving and to churn out Christs and dolls formed by patterns and a jigsaw. Again the responsibilities of motherhood clash with the artist's responsibilities to her craft, and again art is neglected for one's children. The unprofitable cherry-wood man must wait until Gertie has fed her family. Finally, he is sacrificed to their bellies. In the novel's closing pages Gertie carts the faceless man to a scrap-wood lot and chops him into boards for her mass-produced dolls.

Gertie is up against so much in her struggle to finish the cherry-wood Christ that one wonders if it's possible in the novel's world both to retain one's integrity and to feed one's family. Arnow stacks the deck high against her heroine, but Gertie escapes being a victim of forces: never shirking, she assumes responsibility for her choices, refusing to blame predestination and thereby be excused. Even Judas, she reckons, was responsible for his sins, whether or not he was fulfilling a prophecy.

The Dollmaker's presumed dichotomy between mother and artist is as curious as it is disturbing. Often writers work out fictionally what they cannot manage in their lives. But in this novel Arnow depicts as impossible what she in fact achieves: reconciling motherhood with the demands of an artist. Arnow's deep involvement with Gertie's struggle is apparent

throughout the novel, indicating that she may have loaded any frustrations and resentments into her fiction, to communicate somewhere the destructiveness of the compromises demanded by both selves, and to document the cost of her achievement.

And there is a cost. *The Dollmaker* itself shares the flaws as well as the attributes of Gertie's cherry-wood masterpiece. The writing is in places as seemingly effortless and as inevitable as Gertie's whittling when the knife works its will with the shape and grain of the wood. For depictions of emotional trauma, the scenes describing Cassie's death and Gertie's progressive debility are unexcelled in literature. But just as Gertie's knife occasionally works contrary to her designs, so Arnow's pen at times shows evidence of strain in minor confusions. Gertie's puzzlement can become the reader's own as she wonders whether the cupped hand holds sandy earth from her father's fields, or gifts offered by Jonah, Esau, Lot's wife, or Job. These other possibilities distract the reader trying to discern either Judas or Christ in the wood and thinking at this point that the cupped hand holds Judas' silver. The religious symbolism related to her other carvings is in places confusing.

The reader can also get lost in the abundant detail, which solidifies Gertie's world but can obstruct the larger issues. Arnow's exuberance and thoroughness lead at times to excesses. However masterful the writing in *The Dollmaker*, occasionally the reader feels inundated with the almost daily accounting of how much money Gertie has with which to buy food, how badly bruised is the day's fruit, or exactly what goes wrong with the day's breakfast, lunch, or dinner. While repeatedly documenting these facts of Gertie's life makes vivid her daily trials and failures, the reader may crave a more structured, foreshortened vision of Gertie's world rather than a recreation of it. Hence, as the man in the wood is ultimately unfinished, so Arnow's novel is in places unfinished. Both works of art bespeak an absence of the uninterrupted, singular devotion that might have perfected them.

The aesthetic cost of being both an artist and a mother is easier to tally than the personal cost. Considering the family pressures that make many women one-book authors (usually of books written before their children are born or after they are grown), it is surprising that Arnow has published so much. Of her five novels to date, one was written before she married, two after her children left home. *Hunter's Horn* was published in 1949 when her children were three and eight; *The Dollmaker* in 1954 when they were eight and thirteen. Both took years to write: nine for *Hunter's Horn*, five for *The Dollmaker*. Both were written in the early morning hours

beginning around four, the hour Sylvia Plath, another artist-mother, called "that still blue almost eternal hour before the baby's cry." In an interview with Bernard Kalb, Mrs. Arnow recalls the strong pull Gertie exerted on her imagination: "I tried to shake her off. . . . But day in and day out Gertie awakened me at four in the morning—sometimes at three."[4]

Yet these novels, Arnow's best work, have an intensity, an urgency, a sense of life crammed into too short hours, that might have been lost if the struggle had not been waged. *Hunter's Horn*, like *The Dollmaker*, depicts family life and children with blazing, inimitable reality; the former novel also includes gripping, perspicacious dramatizations of the pain and wonder of childbirth without medical assistance. In *Mountain Path*, published three years before Arnow married, she describes authentic fictional children based on those she met teaching school in a remote corner of Kentucky while a college student. But her first novel and those published after her children were grown, *The Weedkiller's Daughter* in 1970 and *The Kentucky Trace* in 1974, though they depict credible, distinctive children, lack the conflict that makes *Hunter's Horn* and *The Dollmaker* powerful, compelling works of fiction: the almost hysterical distress felt by a parent whose energies and love are divided between children and some other passion or responsibility. Gertie's being torn between her cherry-wood Christ and her children, and Nunn, the hero of *Hunter's Horn*, being wrenched apart by guilt for neglecting his children and continuing his obsessive chase after his Moby Dick— an elusive red fox—are unsolvable dilemmas that constitute forceful, affecting fiction. These two novels, written under the greatest stress and the most uncongenial circumstances, indicate Arnow's Hemingwayesque ability to organize chaos aesthetically while under fire.

Other household duties usually befallen a wife and mother took time from Arnow's best fiction. Living on a 160-acre farm for five of these writing years (1940-1945), she grew nearly all the food she prepared, canning and preserving as well as baking. She also cared for their cattle, sheep, and pigs. An amateur botanist, she planted and tended trees, shrubs, and flowers. When she moved in 1945 to a Detroit housing project (following her husband who had gotten a job there), she spent her spare time with such organizations as the P.T.A. and the Girl Scouts, determined that her children would not be slighted just because their mother was a writer. Even more time was taken from her writing when they again moved in 1951 to a forty-acre farm on the outskirts of Ann Arbor; living in a remote area, Mrs. Arnow had to drive the children to and from school and their other activities.

During these years she was often plagued with guilt at time spent with either the children or her writing; bouts of self-pity followed the guilt.

Since time was precious, she didn't enter contests, solicit publicity, or submit some manuscripts for publication: "Typing things out and sending them off take that much time from writing," she once lamented.[5] Consequently, some unpublished manuscripts are still scattered about her Ann Arbor farm. (One wonders if she would be more known today if she had done more of the autographing and the press-junketing that can help a writer's reputation.) Some of her published books would perhaps still be in manuscript form if her husband, now a retired newspaper reporter, had not helped with typing and editing. Providing some of the services that usually fall to an artist's wife, he demonstrates the aptness of Sarah Orne Jewett's remark that she would need a wife more than a husband should she ever marry. (She never did.)

Still, Mrs. Arnow had to give up some writing she did for enjoyment:

> I especially enjoyed reviewing books. There is something about reviewing a soon-to-be-published book, then comparing your opinion with that of other published reviews, and following the career of the book, I find interesting, even exciting at times. But if I wanted to do any work of my own at all in this rather mixed up life, I could not review books so that was dropped. (Hazard 1950, 12)

More regrettably, Arnow had to give up writing short stories, for farming and children left little room for the long periods of undivided attention she required for such writing. In the mid- and late-thirties, when the young writer had to work at odd jobs to support herself, she wrote over a dozen excellent short stories.[6]

Abandoning short-story writing after her children arrived was a painful enough compromise for Arnow herself. She reasoned that only a novel was large and varied enough to allow her to delve back into it after the inevitable distractions and interruptions ceased, leaving the house quiet or empty once more. Unfortunately, the novels written during these years bespeak Arnow's absence of unwavering attention. The accommodating writer, though, never saw her situation as uncommonly burdensome: "My problems I suppose are like the problems of a great many other women who hope to carry on after marriage and discover they cannot do as they did before."[7] More than documenting the conflict between motherhood

and an artist's "agitated" life, Harriette Arnow's example illustrates the problem any writer—male or female—has in reconciling the need for creative expression and the desire for close human relations. Few writers have both the circumstances and the dedication to give their lives up entirely to their art.

Despite these limitations and the similar self-deprecations of both Gertie and her creator—that whittling is just "foolishness" and that writing novels is merely telling stories—both women have created masterful works of art embodying a woman's struggle to be a responsible, caring mother and an artist with preserved integrity. Both works—large in bulk, scope, and importance, though somewhat incomplete—are easily discerned masterpieces. The amount of "felt life" in the faceless man and in Arnow's novel is considerable. This vibrancy and Arnow's narrative skill account for *The Dollmaker*'s power as fiction.

Of all the electrifying events in *The Dollmaker*, Cassie's death generates the most voltage. Intimately acquainted with both mother and child, the reader shares Gertie's unmitigated grief over her loss. Arnow's vision of the love between Cassie and Gertie is as unique as Gertie's picture of the laughing Christ or Cassie's evocation of Callie Lou. Their mutual adoration is one of the few fictional mother-daughter relationships depicting two fully realized, captivating characters more devoted to each other than to anyone else. The relationship itself is rare in literature, and when presented it often focuses on the problems the child poses for the mother. In Tillie Olsen's short story "I Stand Here Ironing" the mother is besieged with guilt and concern over being asked to visit a school official to discuss her troubled daughter. Even Christina Stead's *The Man Who Loved Children* (which, apart from *The Dollmaker*, is modern American fiction's best portrayal of children and family life) fails to depict a mother-daughter relationship wholly. Henny, Stead's mother character, is too withdrawn from her family to be engaged in their lives (she literally does not speak to her husband). Stead, who had no children of her own, got to know children intimately as a teacher; nowhere, though, does she dramatize a mother's unconditional love for her child. A daughter like Cassie might have melted even Henny's hardened heart.

However, much sorrow pervades the man in the wood and the book in which he lives, both works are life-affirming. For all the sadness and spoiled hopes, both testify to the power of the female imagination and to the common humanity that binds us all. When searching for a title for the

book, Arnow contemplated using *Dissolution*, but she decided "it would not do. A combination of war and technology had destroyed a system of life, but the people were not all destroyed to the point of dissolution."[8] Arnow insists on the hope present at the novel's end. She once told me that Gertie might be able in a few years to buy a farm outside Detroit and thereby get closer to the land, for Clovis, she guessed, would never agree to go back to Kentucky. *The Weedkiller's Daughter* demonstrates Gertie's doing just that. A minor character dubbed "The Primitive" by the neighboring children, Gertie Nevels lives on a sprawling farm on the outskirts of Detroit, one similar, it seems, to Arnow's farm in Ann Arbor. Gertie endures, and may even prevail.

The Dollmaker* will surely do both. It is important both in what it dramatizes and in what it represents. Oddly, happily, it disproves one of the novel's most persuasive arguments: that woman cannot be both artist and mother. The richness of its subject and the skill of its execution demonstrate those "profound aspects and understandings of human life" Tilly Olsen predicted would be expressed by artist-mothers. Not surprisingly, *The Dollmaker* is one of Olsen's favorite books, for succeeding where Gertie fails, Harriette Arnow tells us what Gertie wanted so badly to tell Cassie as she sought her out in the railroad yard: "A body's got to have somethen all their own." *The Dollmaker* is Harriette Arnow's Callie Lou.

NOTES

1. Tillie Olsen, *Silences* (New York: Delacorte Press/Seymour Lawrence, 1978), 22-46.
2. Randall Jarrell, "Afterword," in Christina Stead, *The Man Who Loved Children* (New York: Avon, 1966), 493.
3. Harriette Arnow, *The Dollmaker* (New York: Avon, 1972), 64.
4. Havighurst, Walter. "Hillbilly D. P.'s." *Saturday Review* 37 (24 April 1954): 12.
5. E. P. Hazard, "Notes on a Baker's Dozen," *Saturday Review of Literature* 33 (11 February 1950): 12.
6. One of these, "Fra Lippi and Me," dramatizes in particular the artist's dilemma of simultaneously supporting oneself and cultivating one's craft.
7. Taped interview with Wilton Eckley, quoted in *Harriette Arnow* (New York: Twayne, 1974), 43.
8. Harriette Simpson Arnow, "Introduction" to *Mountain Path* (Berea, Ky: Council of the Southern Mountains, 1963).

FREE WILL AND DETERMINISM IN HARRIETTE ARNOW'S *THE DOLLMAKER*

KATHLEEN WALSH

T*he Dollmaker* (1954) completes Harriette Arnow's Kentucky trilogy, which also includes *Mountain Path* (1936) and *Hunter's Horn* (1949); the novels are linked not only by their sympathetic portrayal of rural Cumberlanders, but also by their concern with characters who feel unable to act freely in a crisis. *The Dollmaker* is the best known of Arnow's works and the one in which that concern has been the most misunderstood. Joyce Carol Oates has described *The Dollmaker* as "one of those excellent American works that have yet to be properly assessed, not only as excellent, but as very much *American*" (110). Despite a favorable reception and a small body of recent, and generally feminist, criticism, the novel has yet to receive recognition for its imposing and original treatment of a recurring American theme, the necessity of assuming individual freedom and responsibility. The dollmaker, Gertie Nevels, an uprooted Cumberland sharecropper with five children and a weak husband, encounters injustice and misfortune in the squalid industrial suburbs of World War II Detroit. Faced with bleak conditions, Gertie feels alienated, stifled, and, at critical moments, acquiescent. Through complex reference to the Judas legend, Arnow raises the question of whether acquiescence in such circumstances counts as betrayal or victimization. That Arnow probes Gertie's failures and her guilt against this backdrop of formidable determining influences accounts for the novel's peculiar force and tension—and may account as well for critical failure to come to terms with its themes.

As a native Kentuckian who moved into a Detroit housing project in 1945, Arnow writes of settings that she knows well and people she views

Originally published in *South Atlantic Review* 49 (November 1984): 92-106.

sympathetically. Reviewers of *The Dollmaker* attested to its powerful depiction of the mean life encountered by these displaced laborers, but tended to limit their treatment to this surface alone, and either admired or disparaged the novel depending on whether they found this subject compelling or depressing.[1] Later critics of the novel seem motivated by sympathy with Gertie and thus continue this emphasis on the externals which hamper her, presenting her as an oppressed woman and occasionally labeling the novel "naturalistic." One interpreter finds Gertie's helplessness the central and most admirable fact of the novel: "The excellence of Arnow's work, comparable to the best examples of literary naturalism, lies in this portrayal of the barrenness of life and the futility of the human predicament" (Rigney 1975, 85).[2] Perhaps *The Dollmaker* has remained obscure because it has been praised for the wrong reasons: the emphasis on Gertie's misfortunes strips her of the dignity and the interest that come with moral independence. The necessity of assertion despite overwhelming odds is a lesson which Gertie grasps only after great suffering, and then only partially. Readers who stress Gertie's helplessness adopt the character's own limited view of her situation and fail to appreciate Arnow's complex treatment of an absorbing and sympathetic character immobilized by self-doubt.

It is a measure of the critics' casual treatment of this novel that a figure which Gertie carves and which she ultimately identifies as Judas is frequently mistaken for Christ. In its association of acquiescence with Judas, *The Dollmaker* contrasts sharply with a novel with which it might well have been compared at the time of publication: in 1955, *The Dollmaker* was in second place to William Faulkner's *A Fable* for the National Book Award. Unlike Gertie, Faulkner's protagonist is decisive and assertive; his mutiny is treated as an elaborate allegory of the Passion of Christ. Yet V. S. Pritchett criticized Faulkner's use of the Christ motif: "The truly symbolic figure of our time is the traitor or divided man, not the mutineer; it is Judas not Christ" (558). Norman Podhoretz found Faulkner's emphasis on mutiny to be untimely, describing the emerging generation as "not 'lost' but patient, acquiescent, careful rather than reckless, submissive rather than rebellious" (250). Such testimony to the timeliness of its concerns makes all the more puzzling the failure of *The Dollmaker*'s reviewers to notice its concentration on betrayal and passivity. Certainly this underappreciated novel deserves the sort of reassessment that must finally be based, not only on its forceful drama, but on a fuller understanding of its themes.

Those who read *The Dollmaker* as a social indictment tend to exaggerate its contrast between Gertie's life in Kentucky and her trials in Detroit—without noting that Gertie acquiesces in her uprooting. In Kentucky, the Nevelses are poor tenant farmers, and Gertie is shown to have remarkable stamina, determination, and competence for such a life. In fact, the novel opens with an arresting scene in which she performs a rude tracheotomy on her choking child while a horrified Army general looks on. Gertie runs the farm while her husband, Clovis, does odd jobs and dreams of moving to the city. Unlike Clovis, Gertie is in her element: the physical labor and the closeness to the earth and to the seasons satisfy her. She yearns for her own land and when she receives a small legacy which will enable her to buy the old Tipton Place, she plans to carve a "laughing Christ" in celebration. But along with this emphasis on Gertie's strength and decency, Arnow makes clear Gertie's habits of self-doubt; these will result in her capitulation when she is pressured to forego the purchase of the Tipton Place and move to Detroit.

Gertie tends to be uncommunicative and, in critical ways, indirect. She keeps her plans for the Tipton Place secret, fearing that if Clovis knew of her savings, he would use the money for a truck. She waits to make her purchase until Clovis leaves to join the Army. This subterfuge breeds guilt and deprives her of whatever chance she might have to enlist Clovis' support. Both the silence and the guilt are patterns of response derived from Gertie's relationship to her mother, a whining and self-satisfied woman who is proud of being in poor health and of being "saved." Mrs. Kendrick has long been disappointed in her strapping daughter's failure to share her frailty and her convictions. Gertie's resistance to her mother's fundamentalist religion results in inner turmoil: she is anguished by her mother's easy weeping and her disapproval, but her own forgiving nature leads her to reject the hell-fire preaching of the hill evangelists. Gertie concentrates in her Bible reading on what she finds a more hopeful doctrine, that of the blessedness of Christian meekness. Frequent choices are Amos, who preached God's care for the poor, and Ecclesiastes, counseling submission to God's design and elevating the patient over the "proud in spirit."

That Gertie's submissiveness is tinged by her mother's fatalistic Calvinism is evident in her private legend of Judas, a figure who troubles, even obsesses, her. For Gertie, Judas' betrayal is clouded by the issue of foreordination; she wonders, "Did Judas ever ask, `Somebody has to sin to fulfill the prophecy, but why me?'" (51). She feels pity and even admira-

tion for Judas's futile repentance, and early states her desire to carve an image of Judas which would feature that moment: "Not Judas with his mouth all drooly, his hand held out fer th silver, but Judas given th thirty pieces away. I figger . . . they's many a one does meanness fer money—like Judas. . . . But they's not many like him gives th money away an feels sorry onct they've got it" (23). Although she pities Judas, she does not entirely absolve him, and her recurring sense of identification with him is a measure of her feelings of guilt. Her religious conflict with her mother is expressed in "sweaty-handed guilt and misery" and leads her to question, "Was she like Judas, foreordained to sin?" (69). Gertie chooses meekness, but she shifts between the light and the dark rationalizations for that choice.

Gertie's sense of powerlessness and her fear of being in the wrong are manifest in the meekness with which she accepts the loss of the Tipton Place. When Clovis leaves for the Army, she works cheerfully and strenuously to purchase the land and resettle her family. Refused for enlistment, Clovis goes to Detroit instead, lured by high wages and store-bought happiness. However, her mother's hysteria—and not Clovis's summons—influences Gertie to join him. Before Clovis sends for the family, Gertie's mother comes weeping and citing Scripture: "Leave all else an cleave to thy husband" (141). Gertie listens, head bowed, pulling the joints of her hands as she typically does when downcast before her mother. Without argument, Gertie bows to her loss: "It came to her that maybe she had always known those other trees would never be her own . . . just as she had always known that Christ would never come out of the cherry wood" (145). Given the owner's reluctance to sell the property over Mrs. Kendrick's opposition, given the desire of the children to be with their father, and given Clovis's limited vision, it is not certain that Gertie would have prevailed had she held to her purpose. But she did not even test those limits, and she soon looks back to term herself a "coward": "If she could have stood up to her mother and God and Clovis and Old John, she'd have been in her own house this night" (148-49). This, of course, somewhat begs the question, since one may not effectively be able to "stand up" to God; typically, Gertie feels both guilty and helpless.

Gertie soon experiences the disastrous consequences of her compliance with the removal of her family to a place where she can no longer keep them safe. The break in the narrative following her capitulation emphasizes her reversal of fortune; as the next chapter opens, Gertie and the five

children are cramped into a train heading for Detroit, and the contrast with the previous scenes of purposeful work in the outdoors is sharp. It is an uncomfortable journey toward increasing discomfort.[3] Physical unease, loss of privacy, and a sense of alienation become regular features of Gertie's life in the family's squalid quarters in "Merry Hill." Here, Gertie's strengths and skills have no outlet, and the family is no longer self-sufficient; they buy on credit, and she buys badly. Her loss of status and purpose brings "sass" from the children and increasing criticism from Clovis.

Gertie is not alone in her misery. Detroit "ain't no place for people" (159); the industrial workers and their families are literally as well as figuratively mangled by the machines and systems they encounter. The overcrowded and underequipped schools teach little besides "adjustment." Consumerism is another engine of conformity; even the children become willing adherents of a system which requires that these bewildered newcomers spend more than they have on shoddy goods they do not need. And the casualties in the factories seem to equal those of the war which has caused the industrial buildup: "Gertie had never known there were so many ways for a workingman to die: burned, crushed, skinned alive, smothered, gassed, electrocuted, chopped to bits, blown to pieces" (318). The odds are clearly against these poor and inexperienced migrants who hope to wrest a new and better life from the city. Joyce Carol Oates, discussing the novel's depiction of Detroit, asks, "How can the human imagination resist a violent assimilation into such a culture?" (101). Gertie questions the meaning of free will in such a setting in simpler terms: "Free will, free will; only your own place on your own land brought free will" (319).

Arnow challenges us to consider whether Gertie—or anyone—can be blamed for failure in such a setting. A self-contained episode which precedes Gertie's series of crises crystallizes the question of exoneration and can be seen as a demonstration of how to read *The Dollmaker*. While walking in the alley, Gertie encounters a lone, elderly, poorly dressed woman who has come to pass out Bible leaflets. Kathy Daly, the overwrought wife of the neighborhood's Irish Catholic bigot, attacks the "gospel woman," first dousing her with "Roman Cleanser" and then striking her with a broom. Gertie steps in to hold the broom while the gospel woman escapes. Overpowered, Mrs. Daly attacks Gertie with a string of shrill curses. Gertie's compassion is aroused by Mrs. Daly's worn and weary appearance and, apparently, by the extremity of her fury: "The angry, troubled eyes

made her want to say something, beg forgiveness for doing a thing she had to do" (225). Gertie feeds responsible for the scene, as if she had provoked Mrs. Daly's fury by preventing her violence. Soon after her own escape, Gertie contemplates her wood carving and remembers the laughing Christ that she once hoped to carve, but this angry scene disturbs that vision for her: "The only face she could see now was Kathy Daly's, the eyes looking at her with such hatred. A sin it was to make another sin with such hatred and such talk, but Judas had to sin" (226). Apparently, Gertie feels that she has sinned by preventing further abuse, and elliptically, she also questions whether God was just to require Judas to betray. Gertie blames herself and perhaps the gospel woman as well, but she does not blame Mrs. Daly. The sinner, or the "Judas," to use Gertie's term, has been transformed into a figure of suffering, a Christ figure.

Certainly Gertie's compassion under fire is admirable, but whether such compassion is the whole point of the episode should be considered. The episode does provide some corroboration for Gertie's reversal—or confusion—of the roles of arch-betrayer and arch-victim. Despite her poor clothing, the gospel woman, "Mrs. Bales," is only a brief visitor in the alley and is soon collected by her maid and a chauffeur. That this brief visitor goes home to safety and ease while those visited are condemned to squalor for all the time they know highlights human suffering and the unfairness of the human predicament. However, if on one level the episode invites us to consider the pained predicament of erring mortals, on a deeper level it suggests the inadequacy of any refusal based on such considerations to judge human error. Arnow's many-layered parable may at first appear to shift blame from Judas to Christ, but this appearance dissolves when one considers the convincing sympathy and wisdom displayed by the gospel woman during her brief visit. Indeed, the gospel according to Mrs. Bales counsels assertion despite the difficulties of one's predicament. Her message is one of love but not meekness, forgiveness but not acquiescence. She advises a young woman who is consumed by resentment toward her husband to "be certain" of what she feels and to take decisive action once she knows. Taken as a whole, the episode suggests that the human condition is difficult, but we are not helpless; that suffering humans are deserving of sympathy and forgiveness, but are not blameless.

Gertie undergoes three major crises of conscience in Detroit, and in each case the complexity of daily life so overshadows the crisis as it unfolds that one can easily sympathize with her errors. Her suffering is also sharply

drawn; the threnody this becomes may account for those readings of the novel which stress Gertie's helplessness. But in each event, Gertie is clearly seen to stifle an impulse which would have been more supportive, or more effective, or at all events more honest than the course which she adopts, and her anguished identification with Judas following each crisis reflects her stricken conscience. By detailing the difficult and unclear circumstances in which Gertie makes her decisions, Arnow implies that there are significant differences between Gertie's failure and Judas's far more clearcut betrayal. But despite her obvious sympathy with the character, Arnow writes a tale not only of bad luck, but of bad judgment, judgment clouded by dejection and passivity. The reader who exonerates Gertie because of her adversities looks at Gertie in the way Gertie looked at Kathy Daly.

The first of Gertie's crises involves twelve-year-old Reuben, who is sullen and withdrawn as he struggles to maintain his individuality—the outlook, skills, and interests fostered in the Cumberland—against the forces of conformity he encounters in Detroit. Gertie clearly recognizes his dilemma, but she is uncertain of the right course. She does criticize Reuben's contemptuous teacher for her treatment of him: "But he cain't hep the way he's made. It's a lot more trouble to roll out steel—an make it like you want it—than it is biscuit dough" (335). But when Reuben is then mocked by teacher and classmates for his mother's outburst, Clovis blames Gertie for the boy's difficulty in "adjusting": "You've got to git it into yer head that it's you that's as much wrong with Reuben as anything" (339). Her confidence shaken by her failure with the teacher, Gertie elects to urge conformity, but she is clearly in conflict as she counsels the troubled boy. She tells him, "Honey, try harder to be like the rest," and stifles her impulse to defiance: "She choked—she was no rabbit to beget rabbits" (340-41). Reuben now feels totally isolated, alienated, and threatened; the next day he runs away, back to Kentucky and to harsh servitude to his grandmother.

Whether or not Reuben's estrangement and flight might have been prevented, Gertie is dissatisfied with the role she has played and again her thoughts turn to Judas, suggesting both her stricken conscience and her sense of helplessness. Waiting for news of her missing son, Gertie turns to the Bible, first to read, "Why hast thou thus dealt with us? behold, thy father and I have sought thee sorrowing." But quickly dismissing the passage condemning the prodigal, she reads and then rereads compulsively (note Arnow's ellipses) Matthew's account of the repentance of Judas: "I

have sinned in that I betrayed innocent blood What is that to us? . . . And he cast down the pieces of silver . . . and he went away and hanged himself" (361). Putting aside her Bible, she gives a "tortured, furrowed" face to a crucifix she has been carving, again identifying betrayal with victimization. Yet though Gertie takes responsibility for the failure with Reuben, she does not clearly perceive the nature of her error: "Still, she knew that most of the trouble with Reuben was herself—her never kept promises, her slowness to hide her hatred of Detroit" (369). Perhaps since she does not fully recognize her failure to defend his individuality, the pattern of well-intentioned stifling of her own impulses is repeated in the ultimate tragedy of the novel.

The death of six-year-old Cassie, the personable and imaginative child most like Gertie and therefore dearest to her, is a searing loss. As the crisis unfolds, Gertie's dilemma is again whether to defend her child's individuality or to encourage adjustment. Although two of the Nevels children have been assimilated fully and quickly, Cassie, like Reuben, "seemed always a child away from home" (210). She finds solace in her imaginary friend, Callie Lou, alternately witch child and old woman, around whom she spins elaborate tales and with whom she shares confidences.[4] Callie Lou was tolerated in Kentucky, but this setting requires greater conformity. Complaints about Cassie's "talking to herself" mount after Reuben runs away, particularly from Clovis, who berates Gertie: "You've got to make her quit them foolish runnen and talken-to-herself fits. Th other youngens'ull git to thinken she's quair, an you'll have another Reuben" (367). Gertie, guilty over Reuben, decides to do as Clovis demands, thinking, "Happiness in the alley with the other children was better for Cassie than fun with Callie Lou" (368).

That this will be a loss for the child she also recognizes: "Giving up, giving up; now Cassie had to do it" (379), and she is clearly in conflict as she denies Cassie the Callie Lou who has long been a bond between them. She tells Cassie, "there ain't no Callie Lou," but is "fighting down a great hunger to seize and kiss the child and cry: 'Keep her, Cassie, Keep Callie Lou. A body's got to have somethen all their own'" (379). Gertie's attempt to force adjustment pushes the child away from her into a dangerous world. Cassie retreats with Callie Lou into "the little island of safety between the big alley and the railroad fence" (386). The child is clearly troubled and catastrophe looms, but Gertie continues to distrust those impulses which we later find would have averted the tragedy. When Gertie finally realizes that the alley children have accepted Callie Lou and include

her in their games, she decides, "All this business of doing away with
Callie Lou had been a mistake." She hunts Cassie, imagining the joyful
dialogue she will have with her: "Lady, lady, bring that black-headed child
in out a this raw cold" (401). But it is too late for reversal when Gertie
spots Cassie: she has crept through a small hole in the fence and is huddled
on the railroad tracks, apparently sheltering Callie Lou from an oncoming
train. Cassie's legs are severed by the train, and the tragedy culminates
pitilessly in the child's pain and the mother's grieving futile efforts to
undo it all. Certainly circumstances have been stacked against Gertie and
much does seem left to chance, from the ill-timed appearance of the hole
in the fence to the airplane which drowns Gertie's warning cries. Yet
though the scene is crowded with bad fortune, it is clear that Gertie had an
option. Her guilt over her failure to exercise that option in time is the
focus of the final third of the novel.

After Cassie's death, Gertie comes close to losing herself in grief, unable
to stop reliving "the losing battles—all the battles: to have the land, to make
Reuben happy, to reach Cassie, and the last big battle—to hold the blood"
(417). But it is not simply the sense of loss which makes this grief unbear-
able to her; it is "the anger, the hatred for herself who had caused it all"
(417). After this tragedy, Gertie is more fully aware of the nature of her error
than she was in her guilt over Reuben. Almost immediately after Cassie's
death, Gertie attempts to rationalize: "I didn't aim it that away I didn't
send her off to be killed. I didn't aim to kill her when Mom made me come.
It was Mom an——." But beneath this hysterical—and uncharacteristic—eva-
sion is the unspoken recognition that despite her mother's interference,
Gertie bears the blame for her acquiescence: "No, not her mother, herself,
herself only she couldn't say it. She ought to have stood up to them all"
(421-23). The idea that one bears responsibility for going along with
another's bullying, that unfought weakness may be as disastrous as unmoder-
ated force, is later expressed by Gertie to a neighbor, Mrs. Anderson. Mrs.
Anderson has contempt for her husband, Homer, who marshalls his wife to
play a part in impressing his bosses, and she complains of him to Gertie, "he
never sold his birthright—he thinks he found it. But he stole mine." Gertie
responds, "'I guess,' she said, speaking with difficulty, thinking of the
Tipton Place with Cassie, 'we all sell our own—but allus it's easier to say
somebody stole it'" (440).

If the novel ended with this recognition of the importance of assertion,
Arnow's statement of individual responsibility would be far more direct—

and simpler—than in fact it is. But the issue is extended through Gertie's carving of the wooden man, and through yet another troubling act of passivity. Clovis becomes involved in the seamier side of union politics, and after he is hurt in a fight, his anger draws him toward violent revenge. After the fight, Gertie grimly does what Clovis requires of her to cover up his participation, telling lies to the children and the neighbors. As Clovis' behavior becomes more suspicious, Gertie struggles to keep from having her suspicions confirmed, and tries instead to blame herself for her uneasiness: "There wasn't anything except her own wicked imagination" (562). When the circumstantial evidence that Clovis has murdered the man he sought is strong, Gertie is pulled two ways: wanting to know and to deny what she knows. She runs water over her whittling knife after Clovis uses and returns it, but she argues herself out of seeing what she sees: "Some red rust maybe The knife had gone deeply; some blood had got into the handle. No, no, it wasn't blood, man's blood on her knife. She turned the water on full force; it frothed and bubbled white in the basin, pure white; there was no stain—no stain at all" (568). Gertie can no longer achieve self-suppression without a struggle.

And though she does keep quiet, Gertie is conscious of the struggle. She feels herself to be sinning and identifies with Judas, thinking, "What had Judas done for his money? Whispered a little, kept still as she did now" (564). After the murder, Gertie can no longer hide her error from herself: "she heard her moans, her words, like from another's mouth; her tongue ashamed, too ashamed to use her own speech, but crying in the words of the alley, 'I stood still fer it—I kept shut—I could ha spoke up'" (584). Gertie has repeatedly recognized her error of passivity and yet has continued to err in that way. The strength and significance of this last confession must be assessed not only in light of Gertie's previous failures, but in light of the somewhat destructive, somewhat assertive action which concludes the novel.

Immediately following the death of Cassie, Gertie turns to the partially carved block of wood; the carving of it, though often interrupted by the family's increasing financial difficulties, dominates the final third of the novel. The wooden figure embodies Gertie's conflicts and doubts but remains tantalizingly incomplete when she destroys it in an enigmatic ending which is not so much a resolution as a release from the tensions which the figure embodies.

Gertie's carving is primarily motivated by her need to resolve these tensions. Glenda Hobbs argues for another view, that the drive for artistic

self-expression in the usual sense impels Gertie to carve. Hobbs interprets *The Dollmaker* in light of Tillie Olsen's *Silences*, seeing the novel as a dramatization of "the frequently skirted conflict between a mother's attempt to be both true to her art and watchful of her children's welfare and happiness" (854). In Hobbs' view, Gertie's central conflict is that she is "torn between her cherry-wood Christ and her children" (862). However, Gertie's obsessive involvement with the wooden figure comes after Cassie's death. Before that, there is no time when the desire to carve can be seen to hinder her attempt to be "watchful of her children's welfare." She is never too busy with her carving to meet Reuben's or Cassie's needs, she is simply too uncertain of herself. If the wooden figure does not distract her from the children, neither do the children pull her from the wood until the novel's concluding chapters. During the early months in Detroit, that is, during the period when her tragedy occurs, Gertie often finds time on her hands while the children are at school or at play. She is revealingly contrasted with Mrs. Anderson, who complains that as wife and mother she cannot pursue her painting. Mrs. Anderson is shamed by what Gertie accomplishes in wood—while Gertie has been relieving her of the distasteful job of laundering Homer Anderson's shirts. Arnow depicts Mrs. Anderson as a self-pitying, neurotic woman whose regrets for her lost art deserve little sympathy.

Though Hobbs finds Gertie in "the predicament of a woman who confronts the problem [art vs. motherhood] rather than evades it, and who is determined to have it both ways" (854), Gertie never seems conscious of herself as an artist. The quality of her work is suggested by admiring viewers, but she characterizes her carving as "whittlen foolishness." If this is self-deprecation, it cuts deeply enough so that she makes little resistance to the mechanization of her carving through Clovis' introduction of a jig saw. His aim is to mass-produce the dolls which Gertie has occasionally carved for cash. Although she dislikes the ugliness and cheapness of the painted dolls and cringes at hawking them as "genuine hand-made dolls," she readily takes up the scheme as the surest means of income with Clovis out of work. Hobbs perhaps rightly applies to Arnow's own life Tillie Olsen's discussion of the conflict between motherhood and concentrated attention to art. But in *The Dollmaker*, Arnow's consciousness of such a conflict seems muted; in fact, Arnow has written, "Gertie was no artist" (Arnow 1976). Gertie's choice of her family as her top priority is so consistent and unlabored as to admit no conflict. We must interpret the wooden

figure within the context of Gertie's felt needs and Gertie's priorities. Within that context, the carving is an outlet not so much for Gertie's imagination as for her guilt; it gains prominence as the means by which this reserved and confused woman examines her failure to protect her family. Through the carving, Arnow reveals the issues with which Gertie must come to terms in this examination.

Because the carving reflects contradictory impulses and because it is never finished, its identity is uncertain. Yet the carving has rather freely been termed a "figure of Christ,"[5] an assertion that gives Gertie's whittling a more pious—and more straightforward—significance than in fact it has. The carving is never identified as Christ in the novel. Generally it is "the block of wood," sometimes "the faceless man" or "the man in the wood." Gertie is consistently in doubt about the final image as if it is something that she will find rather than create. In the novel's opening scene, Gertie declares her uncertainty as to whether she will carve Christ or Judas. Later, when the wood arrives in Detroit, Gertie is asked if it is to be Christ and replies, "I've allus kind a hoped so" (226). In the novel's final scene, she is asked if the figure is Christ and shakes her head and answers, "Cherry wood" (598). The careless assertion that the faceless figure is Christ rests on the attribution to Gertie of a much greater degree of religious conviction than Arnow shows her to possess. Gertie's vision of a "laughing Christ" collapses with the loss of the Tipton Place; she continues to search in her Bible, but with little satisfaction. Soon after arriving in Detroit, she tells the gospel woman: "I've been a readen th Bible an a hunten God for a long while—off an on—but it ain't so easy as picken up a nickel off th floor" (221). Later, after Cassie's death, Gertie encounters a Bible salesman asking, "Lady, what must we do to be saved through Christ?" Automatically, "She answered, reaching for a lump of coal, 'Believe.'" But immediately she despairs, "But what if a body cain't believe?" (518). Gertie's despair—and her anger—prevent her from carving Christ.

Gertie's old enigma as to whether one who gives in is victim or betrayer lingers in her hesitation over the identity of the figure and causes her to resist declaring her subject to be Judas either. However, her carving comes to look more and more like Judas, captured at that moment which has long fascinated her—Judas contemplating repentance. Much of her work is on the hands, one empty and one holding an undefined substance. The attitude of the hands prompts observers to question, "Wot's he gonna do?" (482); "Will he keep it?" (511). The feeling is not simply remorse; hesitation is palpable.

While Gertie whittles, an array of biblical characters with something to hold on to occurs to her in reference to the hands: "Jonah with a withered leaf from the gourd vine—Easu his birthright—Lot's wife looking at some little pretty piece of house plunder she could not carry with her—Job listening to the words of Bildad and wondering what next the Lord would want" (444). That moment of decision between keeping and giving is the key to the dilemma Gertie projects onto the figure. The hands reflect her divided mind: her habitual, giving impulses toward accommodation, acceptance, and atonement are countered by her guilt and anger for having given too much.

The carving is an incarnation of Gertie's regret, regret that bites in at least two senses. There is the sense of loss and longing, and at this level the figure is Gertie's link to her past, the wood a tactile remnant of Kentucky and also a reminder of Cassie, who prized the figure and connected it to Callie Lou. The hands express the wish to keep that which is already lost. Secondly, the wooden figure expresses Gertie's regret over her role in that loss; the concentration on "a hand cupped, loosely holding . . . the thing, hard won, maybe as silver by Judas, but now to give away" reveals her desire for expiation. But there is conflict in such giving. Glimpsing the face as she contemplates that cupped hand, she thinks, "the eyes were sad or maybe angry with the loss" (464). Her remorse prompts a giving posture, but that impulse is paradoxically restrained by a growing recognition that no further giving can gain her what she wants. In fact, she lost it by giving.

These conflicts are arrested—if not resolved—at a critical moment in Gertie's final crisis, and from that moment she seems rather grimly free from doubt about the figure. Struggling against her knowledge that Clovis has murdered a man, Gertie escapes to the wood, seeking for the last time a being who will absolve her: ". . . she had only to pull the curtain of wood away, and the eyes would look down at her. They would hold no quarreling, no scolding, no questions. Even long ago, when only the top of the head was out of the wood, below it had seemed a being who understood the dancing, the never joining the church, had been less sinful than the pretending that she believed and—" (584). At this point, the passage breaks off into her pained confession of pretense, "I kept shut—I could ha spoke up." Gertie appears to recognize that atonement has been a poor substitute for action. Almost immediately following this secret confession, Mrs. Anderson appears and confidently assesses Gertie's carving: "he won't keep still and hold it. He'll give it back." Gertie's response reveals a new awareness of the necessity of following the right impulse at the right moment:

"'A body cain't allus give back . . . things,' Gertie said, filled suddenly with a tired despair." She concludes with an identification which she never retracts: "The wood was Judas after all" (585). Gertie's pained recognition that her mistakes cannot be rectified through regret,[6] that repentance does not make Judas a Christ, forces her to confront the present.

Her new awareness—or disillusionment—is soon demonstrated. Gertie has been steadily awakened to the needs of what family she has left. Clovis is indefinitely unemployed, money can be made by machine—producing dolls, and wood is needed to make them. That same evening, Gertie turns obsessively to the wooden figure, working dumbly through the night "as if time were running out and this were the one thing she must do with her time" (595). In the morning, as if in extension of the same drive, she hauls the still faceless carving to a scrapwood lot where she asks that it be sawed into small boards. When Gertie learns that she must split the wood for the saw, she hesitates but does not reconsider. After several blows, the wood splits open as if it were a living thing: "The wood . . . came apart with a crying, rendering sound . . . then slowly the face fell forward to the ground, but stopped, trembling and swaying, held up by the two hands" (599). This pathetic collapse is met by "a great shout" from the watching children, echoing an earlier passage depicting Gertie in Kentucky in all her strength, splitting firewood while her children "gave cries of encouragement, and always shouts of joy as each chunk came apart" (89). These shouts may be a tribute to Gertie's new firmness, but the sense of loss is also strong.

Gertie's final action is an equivocal one and is described in terms which deepen the ambiguity. She has turned toward the importunities of the present, away from the link with the past which the carving provided, but in the past, irrevocably in the past, lie the components of her happiness. She has finally substituted decisive and responsible action for contemplation of what the unalterable limits to action might be—or might have been—but the action she chooses is at some level destructive, even self-destructive, and arises in a climate of moral defeat. Arnow has not chosen to resolve the problem of the obstructed will through its exertion; instead, she presents the problem fully. At the novel's end, the issue of assertion is felt as complex, perplexing, and pressing.

If Arnow's subject is self-reliance, her argument for it is more guarded than that made by its great American spokesman. In "Self-Reliance," Emerson claims to have easily dismissed such a dilemma as Gertie's when he was "quite young": "if I am the Devil's child, I will live then from the

Devil." Gertie's confidence is never so strong. That her final action cannot be felt as a heroic triumph of the will is of a piece with the repetition of her error: Arnow's subject is not simply the importance of self-reliance but the difficulty of maintaining it. A heroic triumph would suggest that assertion of the will is relatively easy once the necessity is recognized. But Arnow never relaxes the tension between responsibility and inability; she suggests that circumstance will continue to pressure and perplex and that the desire to accommodate will likewise continue. Resolve must be strong and clear indeed if it is to have timely expression.

Though Arnow's vision of the power of the will to counteract the crushing weight of adversity is not optimistic, her power lies in revealing—not the exterior forces which oppose the individual—but the interior monitors which inhibit. The subject of betrayal was timely in the 1950s when various prominent figures were publicly pressured to betray by speaking up and naming names. However, Arnow treats a type of betrayal which is far more insidious, hence far more common, betrayal not of commission but of omission, not of self-interest but of self-doubt. We are frequently asked to overlook or even support some minor transgression—as when a coworker cheats on petty cash or a friend cuffs his child—and we acquiesce, we keep shut, because we are not sure of what we saw, or of whether we're right, or of whether speaking up will make any difference. One carries away from *The Dollmaker* a sense of the awful cost of such passivity.

Readings which assert the work's "naturalism" perhaps arise from the understandable temptation to explain away Gertie's errors out of admiration and compassion for this remarkable and hard-pressed woman. Arnow never depicts Gertie as so far debased that we are free from the pull of her strengths. Gertie remains unselfish, actively compassionate, and competent in providing for her family; indeed, she is their mainstay in the end as she was in the beginning. Arnow writes that she rejected "Dissolution" as a possible title for the novel: "A combination of war and technology had destroyed a system of life, but the people were not all destroyed to the point of dissolution (Arnow 1963). Although Gertie does not triumph, she retains our sympathy throughout, evoking not simply pity, but a measure of admiration. However, Gertie is admirable for something other than her victimization; Arnow would surely concur with W. H. Auden's objection to the presentation, "in novel after novel," of "heroes whose sole moral virtue is a stoic endurance of pain and disaster" (37). Gertie's acquiescence in her victimization is the trait by which her heroic qualities are reduced, betrayed.

NOTES

1. See, for example, "Review of *The Dollmaker*," *The New Yorker*, 1 May 1954, 119: "It remains a depressing picture of human defeat and bewilderment." Also, Walter Havighurst, "Hillbilly D. P.'s," *Saturday Review* 37 (24 April 1954): 12: "This long, somber, and moving novel shows Gertie Nevels struggling to save her family from a sordid and grasping world." Also Harriett T. Kane, "The Transplanted Folk," *New York Times Book Review*, 25 April 1954, 4: "It is hard to believe that anyone who opens its pages will soon forget the big woman and her sufferings."

2. Barbara Baer, "Harriette Arnow's Chronicles of Destruction," *The Nation*, 31 January 1976, 118, also discusses Arnow's "naturalistic outlook." Joyce Carol Oates argues that "The beauty of *The Dollmaker* is its author's absolute commitment to a vision of life as cyclical tragedy—as constant struggle" (102), but Oates finally withholds the label of naturalism because "a total world is suggested but not expressed" (110). Frances Malpezzi, "Silence and Captivity in Babylon: Harriette Arnow's *The Dollmaker*," *Southern Studies* 20 (1981): 90, presents Gertie's oppression in feminist rather than cosmic terms: "Gertie is every woman who has had to deny herself, her desires, her talents, for the sake of family."

3. This journey has been described as an archetypal descent into hell. See Dorothy H. Lee, "Harriette Arnow's *The Dollmaker*: A Journey to Awareness," *Critique* 20 (1978): 92-98.

4. The resemblance between Cassie's imaginative outlet in Callie Lou and Gertie's own in her carving has been noted. See Glenda Hobbs, "A Portrait of the Artist as Mother: Harriette Arnow and *The Dollmaker*," *Georgia Review* 33 (1979): 851-66.

5. See, for example, Baer, "Harriette Arnow's Chronicles of Destruction," 118: "She is constantly carving a figure of Christ, whose face, emerging and receding from a great block of cherry wood, is the central image of the novel." Also Wilton Eckley, *Harriette Arnow* (New York: Twayne, 1974), 86: "Her biggest project is the carving of a figure of Christ." Also Lee, "Harriette Arnow's *The Dollmaker*," 97: "The hidden face in the wood is that of Christ."

6. Remarking on this scene, Glenda Hobbs reports Arnow's comment to her that Gertie is "unluckier even than the arch betrayer; he could give back the silver . . . but Gertie couldn't give back Callie Lou" (859-60).

WORKS CITED

Arnow, Harriette. [1954]. 1972. *The Dollmaker*. New York: Avon.

_____. 1963. "Introduction." In *Mountain Path*. Berea, Ky: Council of the Southern Mountains.

_____. 1976. "Letter to Barbara Rigney," *Frontiers: A Journal of Women Studies* 1-2 (1976): 147.

Auden, W. H. 1948. "Henry James and the Artist in America." *Harper's Magazine* July, 37.

Baer, Barbara. 1976. "Harriette Arnow's Chronicles of Destruction." *The Nation* 31 January, 117-20.

Eckley, Wilton. 1974. *Harriette Arnow*. New York: Twayne.

Havighurst, Walter. 1954. "Hillbilly D. P.'s." *Saturday Review* 37 (24 April): 12.

Hobbs, Glenda. 1979. "A Portrait of the Artist as Mother: Harriette Arnow and *The Dollmaker*." *Georgia Review* 33: 851-66.

Kane, Harriett T. 1954. "The Transplanted Folk." *New York Times Book Review*, 25 April, 4.

Lee, Dorothy H. 1978. "Harriette Arnow's *The Dollmaker*: A Journey to Awareness." *Critique* 20: 92-98.

Malpezzi, Frances. 1981. "Silence and Captivity in Babylon: Harriette Arnow's *The Dollmaker*." *Southern Studies* 20: 90.

Oates, Joyce Carol. 1974. "The Nightmare of Naturalism: Harriette Arnow's *The Dollmaker*." Pp. 99-110 in *New Heaven, New Earth: Visionary Experience in Literature*. New York: Vanguard, 1974.

Podhoretz, Norman. 1966. "William Faulkner and the Problem of War: His Fable of Faith." *Commentary* (September 1954): 227-32. Reprinted in Robert Penn Warren, ed. *Faulkner: A Collection of Critical Essays*. Englewood Cliffs, N.J.: Prentice Hall.

Pritchett, V. S. 1954. "Time Frozen: A Fable." *Partisan Review* 21: 558.

"Review of *The Dollmaker*." 1954. *The New Yorker*, 1 May, 119.

Rigney, Barbara. 1975. "Feminine Heroism in Harriette Arnow's *The Dollmaker*." *Frontiers: A Journal of Women's Studies* 1: 85.

AMERICAN MIGRATION TABLEAU IN EXAGGERATED RELIEF: *THE DOLLMAKER*

KATHLEEN R. PARKER

Harriette Arnow's account of a Kentucky hill family's World War II migration to Detroit provides rich insight into how individual human realities were painfully recast in that transforming collective event. It is a narrative that is emotionally gripping, lavishly detailed, structurally complex, and intensely personal. It is, in short, a powerful story, and that, perhaps, is its principal value. But there is also much in this story that may be appreciated from the perspective of American literary, social, and cultural history. Its depiction of one Appalachian family's participation in the migration of rural mountain people to large northern cities imaginatively captures for a cultural historian the reality of that momentous demographic shift in our nation's past. From such a viewpoint, moreover, the drama that engulfs the Nevels in their dislocation serves as a tableau on which are played out the exaggerated pastoral/urban themes that have persisted historically in the American consciousness.

These antithetical themes—the pastoral ideal against urban reality; authentic creativity against artificial commercialism; the benefits of capitalism to the individual against the disintegrating effects of capitalism on the family; and provincialism against cosmopolitanism—are interrelated. And each is presented in the struggles of the novel's central character, Gertie Nevels, as she attempts to maintain her personal integrity in the face of radically altered circumstances. These conflicts reflect an ambivalence that has insistently replayed itself in the American psyche; as such, they are in large part responsible for the ambivalence readers feel when they come to the novel's end. There is no easy resolution to the conflicts posed by the American migration experience.

The Dollmaker's exemplification of the confrontation between pastoral values and industrial realities lends itself well to changing theories of what

constitutes the pastoral ideal. As a literary construction, this ideal has been characterized by Harold Toliver as generally reflecting the values of nature juxtaposed to those of society (125). Under Toliver's delineation of oppositions, the characteristics that present themselves most appropriately in *The Dollmaker* are freedom against constriction, democracy against hierarchy, authentic honesty against masked artificiality, and innocence and simplicity against experience and complexity. In terms that are similar to those of Toliver, Lucinda Hardwick MacKethan sees the pastoral longing expressing itself in an unsophisticated innocence, a persistent nostalgia for what is past, a belief in the superiority of rural values, and a reverence for the natural order (MacKethan 1980, 6). In keeping with these traditional notions of the pastoral mode, Arnow's greatly disparate descriptions of the hill country and the industrial world give concrete shape to the superior worth of the idealized rural life in the American imagination.

Consider, for example, her contrasting depictions of the Tipton Place, Gertie's longed-for home in the mountains, and Merry Hill, the industrial housing complex to which she is transplanted in Detroit. First, Gertie is seen smiling

> . . . on the shake-covered roof of the old log house; the white oak shakes, weathered to a soft gray brownness. . . . Now in the yellow sun the moss shown more gold than green, and all over the roof there was from the quick melting frost a faint steam rising, so that the dark curled shakes, the spots of moss, the great stone chimney, all seemed bathed in a golden halo and Cassie called that the house had golden windows. (53)

The "natural" goodness of this home must be abandoned in the course of events, to be replaced by prefabricated housing units that exaggerate in every way the "constriction," "artificiality," and "complexity" seen to embody the "societal," or antipastoral, mode. Directly adjacent to the factory and train yard, the housing units were little

> . . . shed-like buildings, their low roofs covered with snow, the walls of some strange gray-green stuff that seemed neither brick, wood, nor stone . . . a few feet away across a strip of soot-blackened snow were four steps leading to a door with a glass top, set under low, icicle-fringed eaves. There was on either side of the door a little window; in front of one was a gray coal shed; in front of the other a telephone pole, and by it

a gray short-armed cross. The door was one in a row of six, one other door between it and the railroad tracks. Gertie turned sharply away, and across the alley her glance met another door exactly like her own. (170)

Just as the images of nature are blotted out at Merry Hill, so are the images of simplicity and democracy said to characterize rural life. Contrast the mountain livelihood that encouraged family member interdependence and group support of the farm with the alleyway where there is no patch of dirt for growing anything. Gertie's meal of "shuck beans, baked sweet potatoes, cucumber pickles, and green tomato ketchup," where "everything, even the meal in the bread, was a product of her farming," is rudely replaced by her dependence for food on a company-owned vendor charging inflated prices (91). See how the world of freedom, innocence, and nostalgia, evident in Gertie's quiet times alone in expansive fields and peaceful woods, must be given over to the complexity of inescapable congestion in row-upon-row housing units, situated next to a rail yard, where trains incessantly clang and crash by. Contrast the children having intergenerational lessons with their mother on the front porch with children having to scramble alone each day across a dangerous intersection to get to a school, within whose walls "adjustment" is demanded in the face of thinly veiled prejudice. Remember, finally, the promise of land ownership, and the autonomy and spiritual harmony Gertie believed it would provide her and her children, lost forever to the prospect of a wage labor livelihood.

It is with the use of such starkly evident contrasts that Arnow fully articulates the certain betrayal of the pastoral ideal by industrial forces in *The Dollmaker*. A fuller exploration of other theories about America's pastoral consciousness yields further insight into how this novel epitomizes a struggle so fundamental to the American experience.

Probably the earliest, well-known work on pastoralism in America is Leo Marx's 1967 analysis of the "machine in the garden" (9). Offered at a time when social events had prompted Americanist scholars to self-consciously examine the American "identity," as found in literature and history, Marx distinguished between sentimental and complex pastoralism.[1] The more popular form of pastoralism was the "sentimental" one, characterized by a closeness to nature, a more harmonious lifestyle, and the idealization of rural ways. As we have seen, Arnow brings such characterizations to life in this novel. Significantly, according to Marx, such hostility to civilization puzzled Freud, who asked whether our society was so repressive that it

unnaturally deprived people of their pastoral instincts. Were people drawn to pastoral ways because of an inborn affinity for nature? Marx then suggested that, if this was so, the pastoral longing should be viewed as a sign of a collective pathological neurosis of the culture. He did not mean that to long for pastoral values is neurotic; rather, he reasoned that to subvert our natural desires for the pastoral life under a compulsory adherence to more complex societal values is to behave in a deliberately self-defeating way, which he understood to be neurotic. On the basis of this perspective, one may wonder if Gertie's resignation in the end comes to symbolize America's neurotic acquiescence to the demands of modern industrial society.

Marx's "complex" conceptualization of pastoralism is that which is expressed imaginatively in high literature as a "paradigm of high symbolic power" (16). Marx could easily have included Arnow alongside Wordsworth and Hawthorne in his exemplification of this paradigm. In his thinking, this literary mode was chiefly articulated in a conflict between rural peace and simplicity and urban conflict and sophistication, often embodied in the real and symbolic image of the "train." Hawthorne's train, a smoke-belching mechanism invading the undisturbed wilderness, is reincarnated by Arnow in a larger, more personally injurious sense than Hawthorne could have envisioned a century earlier. Arnow's foreboding train inexorably transports a heartsick and frightened woman and her children away from their beloved Kentucky hills to a brutal, urban wilderness; it violently intrudes upon their daily existence as it screeches past their front yard; and finally, it becomes the malevolent instrument of Cassie's death at the very moment she is seeking to protect her own childhood illusions from the destructive influences of the industrial world. In her portrayal of the antithetical nature of rural and urban cultures, Arnow's use of the train is both poignant and stunning; but its ultimately lethal role illustrates the great extent to which Arnow goes to depict the industrial threat to rural values.

In Annette Kolodny's theory of how the pastoral mode has infused the American experience, she argues that it was men who abused the landscape pastoralism calls to mind. Drawing on images of the wasteful and rapacious settlement of America's western prairies, Kolodny figuratively relates the receptive land to a woman who must submit to an aggressive, self-satisfying man. Here, the values of pastoralism are linked to a feminine persona embodying passivity and victimization; those of industrialism to a masculine persona embodying impersonal and deliberately destructive

force (Kolodny 1975, 3-9). Is such an analogy applicable to *The Dollmaker?* May the reader view the subversion of Gertie's values, which emanate from the pastoral values of simplicity, affinity for the land, and nature, as a rape, in the sense that Kolodny applies the term? Certainly, in the traditional sense of the pastoral mode, Gertie's longing for the mountain life was severely thwarted in the industrial milieu, and much of her subversion was due to her own passivity. Her inability to stand up to her mother, for example, and her unwillingness to tell Clovis about the money she had saved for the land allowed her to be exploited by the situation.

There is, on the other hand, another pastoral interpretation—a feminist revision of the pastoral myth based on a reconfigured view of women's experiences—that would suggest that Gertie, as exemplar of the feminine pastoral persona, was not completely subverted in her confrontation with the male-dominated industrial world. This is an interpretation that was foreshadowed when Kolodny noted that the "archetypal polarities" of masculine and feminine were "undergoing radical alteration" (158). Given such an altered perspective, it was possible, she supposed, that the "pastoral polarity" she had described might indeed "partake of that transformation" as well (158).

This feminist revision of the pastoral ideal comes out of a yeoman tradition, which is distinct from the post-Civil War patrician longing for a return to the Old South's plantation life (MacKethan 1980, 17). The older tradition arose, toward the end of the nineteenth century, from the fear that oppressed peoples, such as black freedmen and poor white farmers, were on the verge of overpowering the hitherto politically dominant group, that is, the white landed gentry (Harrison 1991, 5). The yeoman tradition did not originate with the idealized plantation myths, but rather with the idealization of life on small Southern farms; it is a tradition that does not associate political status with the pastoral longing, but rather focuses on a personal working relationship with the land (MacKethan 1980, 16). Elizabeth Harrison locates Gertie's rural values in the yeoman pastoral mode, a tradition that fostered affinity with the land and was rooted to a cooperative work ethic in the rural setting (83-92). It is this spirit of cooperation that Gertie ultimately regains, says Harrison, and it is in this sense that she enlivens the female pastoral tradition. It is Harrison's insight that, while the "husbands are competing for economic survival in factory jobs, the women learn to care for each other and each other's children and to share emotional burdens"—it is the "women of the

project who draw together," while the men "succumb to quarreling and violence" (92). The real failure of the female pastoral ideal in *The Dollmaker*, says Harrison, is found in the inability of Clovis and Gertie to cooperate with one another (91-92). This failure was a feature of their relationship that precluded them from achieving the female pastoral ideal of communication and cooperation in a rural setting, long before they journeyed to Detroit (92). In the end, it is Gertie's discovery of her connections to the women in Merry Hill that locate her in the yeoman's pastoral life tradition.

Thus, the pastoral mode is much in evidence in *The Dollmaker*, in keeping with varied and evolving definitions as to what that means. At its heart, the literary pastoral tradition is tied to the historical reality of the land, and has its roots in a deep American longing to maintain the values born of its earliest agrarian beginnings. These values have been shown to be antithetical to those of industrialism; they have also been shown to be hypocritically espoused by the very men who, in claiming America's virgin lands, exploited and destroyed them. Paradoxically, however, the cooperative spirit agrarian life requires, while shown to be at risk among the men in the industrial world, emerges for Gertie among the women—in a way she had never experienced before. Gertie Nevels is the "character" who personifies the worth of these pastoral traditions in confrontation with the depersonalizing forces unleashed by the modern age. By analogy, her struggles are integral to America's concern with the loss of its personal ties to the land, and constitute the backdrop from which emerge the remaining themes in this discussion.

The title of this novel refers to Gertie's natural ability to carve intricate dolls from pieces of wood. She calls it just "whittlen'," the visible manifestation of a creative impulse emanating uniquely from within her, resulting in an authentic artistic expression that is nearly extinguished by Clovis's eternal preoccupation with machinery. The making of dolls becomes the means by which the conflict between creative human forces and expediency is played out. Clovis insists that she stop whittling the dolls and make flat ones with a jigsaw instead; thus, the dolls could all be the same, she could make more in less time, and they could be painted with bright colors. In this way, Clovis reasons, she could put in less time and make more money. But for Gertie, the time and the money are not of serious consequence. For Gertie, the featureless flat dolls are not the expression of her indigenous craft; they are not the distinctive, three-dimensional

creations whose wood-grained texture bears the mark that is singularly hers. Gertie's carved creations are inspired by her love of what is "natural"; they come from her personal connection to a rural world.

At their first Christmas in Detroit, Clovis presents the family with a new refrigerator and several bright and costly toys. When Cassie, the child most like Gertie in her affinity for more personal, spiritual values, receives a doll from Clovis, she promptly cuts the shiny blue rayon dress off the new doll and puts it on her "little ole makeshift doll Mom whittled fer her" before they left home (287). It was a doll Gertie had made for Cassie in anticipation of owning the Tipton Place. Clovis does not understand and becomes quarrelsome about the "ravished doll." The full significance of this moment for Gertie is revealed in her response to what Cassie has done:

> Gertie saw that the fine blue cloth was draped about the little hickory doll, the "golden child" she had whittled by the Tipton Spring. She stood a moment looking, her eyes warm as if a sparrow had pecked a crumb from her hand. Both Clytie and Clovis, she realized, were looking at her with disapproval. (287-88)

Gertie's whittled dolls also become the focus of admiration among the city-folk, who had never seen such unique, "natural" figures. William J. Schafer states that "Gertie's skills with her carving knife are viewed as amiable anachronisms" (1986, 49). But it seems to me there is much more to this aspect of her encounter with the urban community than Schafer, or Clovis, certainly, recognizes. The whittled dolls, which Gertie herself refers to apologetically as "whittlen' foolishness," are the only fundamentally pastoral expression of her former life in the mountains that she is able to sustain in her new circumstance; further, they are the only manifestation of who she once was that others in this new life seem to value. In a larger sense, the urban folk who come to appreciate her whittled dolls may be demonstrating the instinctual longing for nature that, it will be remembered, puzzled Freud.

There is a spiritual aspect to this for Gertie, too. Her Christ is someone she encounters in nature, and her art is sometimes a medium for the expression of her spirituality. In the following passage, Gertie has just completed a commissioned carving of a crucifix for a Merry Hill neighbor while Clovis looks on unsympathetically:

She was silent, staring at the crucifix, and he for the first time noticed what she had done. "Aw, Gert, you've set up all night a worken on that thing," he scolded, his voice disgusted, pitying. "What a you want to take all that trouble to whittle out them logs, when you could has made the cross flat out a little boards in a third a the time. . . . You didn't haf to make him out a hard maple—an a have him bowen his head an showen his back thisaway. You'd ought to ha left him flat an a glued him on, stead a foolen around with these little wooden pins."

"You know what you need, "he said, pulling off his jacket, looking at her as she sat, lax-handed, head drooping above the Christ he had flung into her lap, "you oughta have a jig saw. With one a them things a body can cut out anything—Christ, er pieces fer a jumpen-jack doll—it's all th same to a jig saw." (362-63)

The values of industrialism do not allow for unique artistic creativity, nor do they accommodate the spiritual side of human life. What matters is expediency and efficiency. Gertie's Christ, far removed from her mother's misogynist, fundamentalist God, is the embodiment of goodness, grace, spiritual love, and suffering. This is the Christ she so artfully created. Clovis's response is emblematic, in deliberately overstated tones, of the practical strategies that the American commercial ethic demands. It is an expedient, reductive assessment that equates Gertie's unique, indigenous creativity with jumping jacks. Gertie's artistic expression, that authentic essence of her humanity, is callously dismissed in favor of painted, look-alike, jumping-jack dolls and flat, glued Jesus Christs.

Probably one of the more difficult themes that Arnow deals with in this novel is the effect of capitalism on individuals and the family. As others have done before her and since, Arnow raises the question: Who does capitalism benefit, and who does it hurt? At the risk of oversimplifying what is a complex issue, I suggest that *The Dollmaker* illustrates the view that those who in some way control the production of goods fare well under capitalism, while those who do not have control over production find themselves in the most precarious positions. Here, the latter category includes Clovis and his fellow workers, as producers, and Gertie, as a non-producer who must be dependent on a producer.

Eli Zaretsky argues that capitalism's centralized commodity production separates production from the family, thereby separating women (at home by tradition) from men (usually laboring away from the home), giving new

meaning to male supremacy and female subordination (1973, 23-34). For the Nevels, living in Detroit means that production is removed from the home, and the consumption of commodities takes its place. Those who do not profitably produce commodities are devalued.

For Gertie, moving into a capitalist setting completely changes her role as a wife and as a mother. In the mountains, she had been strong, stable, self-reliant, able to get by on resources with which she was familiar. She was, in Kentucky, a primary contributor to the family livelihood, a planner, a designer of the means for survival. In Detroit, however, the family's dependency on Clovis's wage-earning role underscores her feeling of uselessness and of being out of place in the small house cluttered with confusing appliances. The reader understands her sublimation more than do those around her; the reader remembers her exclamation upon finally owning the Tipton Place: "What more, oh Lord, could a woman ask?" (128). Notably, this is a question more usually asked by a man, but the referent of the noun "woman" here, is at that moment an independent female individual, who believes, as men always have, in her legitimate claim to self-direction and personal fulfillment. The Tipton Place would have provided a source of autonomy for her and a legacy of security for her children. In Detroit, on the other hand, there is no land for her labor and love, and the factory, as the sole source of production, is not accessible to her, since her role is now caretaker of the home. Until she later receives a substantial order for her whittled dolls, she is fully dependent on Clovis for support.

We know that Marxist and Marxist-feminist theories have criticized capitalism's deleterious effects on the family in general and women in particular. In the 1970s, anthropologist Kathleen Ghoul stated that the inclination to view women's position as subordinate to men became more apparent as societies developed greater concern for production, as opposed to sustenance. Excess production provided surplus wealth, which was usually a direct outcome of the labor of men and thus came under the control of men (62). Ghoul pointed out that the family "provided essential cooperation, creativity, purposive knowledge, love, and creativeness, but today . . . the confinement of women in homes . . . artificially limits these capacities" (76). Gertie's capacity to act as a provider, while possible in limited fashion in Kentucky, is unavoidably diminished in Detroit.

But, the capitalist system puts Clovis at risk in ways he cannot control, either. When demands for worker solidarity require that Clovis participate

in a "sympathy walk-out," Gertie does not understand his compliance in that action. She asks,

> "When them others walked off, couldn't you ha stayed? You need th money, an th war needs whatever it is you all are maken an . . ." She stopped in the face of his angry jeering glance. "You want me to come home with a busted nose? When them others walk—you gotta walk." (252)

At Christmas, when Clovis's gifts are unappreciated and he sulks over it, Gertie's thoughts consider the effect of this life on him:

> She felt sorry for Clovis. He looked so bleary-eyed and tired. He'd been getting less overtime since going on the midnight shift. But he was slow about learning to sleep in the daytime, and he'd spent a lot of his sleep time pushing his way through the hot, overcrowded, smelly depart- ment-store basements hunting Christmas for them all. (288)

Thus, as a producer and as a consumer, Clovis finds that his naive expec- tations are disappointed. His new Icy Heart refrigerator keeps the milk too cold and freezes the lettuce; the too-small oven burns the turkey. His ini- tial success as a machinist is thwarted by union protests over work speedups and unsafe working conditions, and then ended abruptly in his being laid off when the war's end brings a halt to factory production.

Arnow is true to the anticapitalist imagination in her portrayal of Clovis as a producer of commodities, a position that puts him at the mercy of the controllers, that is, potential exploiters, of his labor. It is an exploitation that, as we have seen, is double-edged, exacting labor at the same time that it necessitates an often disproportionate exchange in earnings for consumer goods. Finally, it is a system that subjects producers, as Arnow shows, to a whole complex of factors that regulate the need for commodity consump- tion. In this case, the need for production is dependent on the consumption spawned by the war, which, Arnow once acknowledged, is the "real demon" in *The Dollmaker* (Samuelson 1982, 147).

Gertie does not become a producer in the capitalist economic system until she becomes a profit-making producer of her unique, hand-carved wooden figures, initially to be taken from pieces of the large unfinished cherry wood carving she finally destroys. Somehow this particular outcome

is more acceptable to the reader than had Gertie become the profit-making producer of patterned, jigsaw-made jumping jacks Clovis wanted her to be. In this sense, Gertie's capitulation, finally, is on terms she defines. Yet, Arnow's antipathy to capitalism remains evident in her portrayal of its effects on the family. Taken as a whole, her treatment of capitalism fits well with that of other 1950s writers who questioned the 1940s' resurgence of a consumer-oriented, industrially defined, American middle-class culture that once again gave preeminence to a capitalist ethic.[2]

The final theme for discussion looks briefly at how the migration experience set the stage for inevitable confrontations between culturally distinct groups of people. In an analysis of the pivotal nature of the 1930s, Russell Nye noted that, among other things, this decade became the impetus for a reformulation of values. Nye contended that a new cultural relativism was having the effect of expanding the boundaries of tolerance, so that people who could see themselves in culture were able to free themselves from its ideological, psychological, and moral constraints (1975, 37-58). In a society characterized by ubiquitous pockets of fiercely parochial communities, this shift in consciousness was the result of the transcultural events, the Depression and the war that followed. It was a shift that forced many to modify their privately held absolute beliefs and see themselves as part of a larger picture that included people who were different. The potential controversy raised by this issue emerges, it seems to me, out of a deeply valued American tradition that people have the right to think what they will. It also comes from an equally understandable need for people to maintain their group identity in the midst of dislocation and perceived fragmentation. In a nation amassing so many diverse groups of people, each wants to preserve its own cultural heritage; conflict arises, however, when the security and sanctity of holding to private belief is based on unenlightened provincialism and a fear that others of regional, ethnic, and racial difference appear to threaten our relative position in the world.

In *The Dollmaker*, the wartime atmosphere and crowded factory conditions decidedly exacerbate preexisting rivalries and give vent to old prejudices. The Merry Hill neighborhood serves as a microcosm of an urban culture in which boundaries separating Catholics, "hillbillies," "niggers," and "commies" are tenaciously protected. As southern migrants, Gertie and Clovis are soon aware of the intolerance directed against them. One neighbor (Mrs. Miller) tells Gertie about an experience she had in the factory:

> I hadda keep shut one day while th steward told a joke about a fam'ly
> come tu Detroit, an they rented um a place an they was supposed to a
> asked, "But where's the eaten trough?" A maken out like we don't so
> much as have dishes. (540)

Such an experience was not uncommon, but such attitudes ran both
ways. One time, when Clovis questioned Enoch about a facial bruise he
had acquired in a street fight, the following conversation ensued:

> "Them Dalys an that Bomarita kid . . . called us names an started th
> snowballen. Pop, is a Protestant a heathen?" "You know better'n that,"
> Clovis cried. "It's th Catholics that's th heathen, a worshipen idols an th
> pope—an they know it. That's why they're allus a throwen off on people
> like us. That's why they hate us. . . ." (252)

There is a sense here in which Clovis and Gertie are both caught in cul-
tural absolutist modes of their own; and both are called upon to move
beyond them. One day at the children's school, Gertie is told: "This school
has many children from many places, but in the end they all—most—
adjust, and so will yours." Gertie doesn't understand the word "adjust"
and, in answer to her query, the response is: "Yes, adjust, learn to get
along, like it—be like the others—learn to want to be like the others"
(207). It is to Gertie's credit in the end, that her "adjustment" is not "to be
like the others," but to recognize that, in this context, she already is like
the others. Indeed, she comes to recognize the common human kindnesses,
vulnerabilities, hopes, and pain that many of those "others" around her
share with her, despite their varied past social connections. Clovis's ready
proclivity for working with machinery makes his adjustment to the urban
setting easy, yet his practical view of the world breeds another kind of
absolutism—one that precludes any insight into Gertie's world until it is
too late. That both of them regrettably avoided responding to Cassie's
teacher's request for a meeting eloquently attests to the tragic mispercep-
tions generated by their isolationist fear and self-protection.

As for the children, their reactions divide them into two camps: Enoch,
Clytie, and Amos seem able to assimilate well into the urban environment;
but they change dramatically in that process, and Gertie increasingly
comes to feel alienated from them. The two children who are most like
Gertie, Reuben and Cassie, are gone from her by the end, both unable to

accommodate in their own ways the demands of assimilation that were made upon them. The loss of these children becomes Gertie's most vivid punishment and her greatest source of guilt for asking them to do what she herself found so impossible; indeed, what happens to Reuben and Cassie has been described as "Arnow's most damning indictment of the city" (Samuelson 1982, 201-3). Taken together, the entire family's divided response to the move lives out the divided American response to the rural-to-urban assimilation dilemma.

Arnow poignantly tells the reader that, in the early morning hours, Gertie "felt lonesome . . . when her hands remembered the warm feel of a cow's teats or the hardness of a churn handle" (209). Months later, after Reuben's resolute abandonment of the family and return south, Cassie's atrocious mutilation and death, Gertie's descent into private anguish and eventual recovery, Clovis is laid off from his job and mutters about what might have been, had they stayed in Kentucky, a now-impossible prospect: "Law, I was jist thinken. Cain't a body think about how nice it ud be if'n you'd ha bought that Tipton Place an I'd a cleared out a this town soon as V-J Day come an put my car in on a pretty good truck. Then I'd a come rollen home in it . . ." (541).

Gertie cannot listen to him. She turns instead to the projects she has at hand: building a fence and whittling dolls. Then, in response to the fifty-dollar order for whittled figures, she takes the unfinished block of cherry wood, the unfinished Christ carving, to be sawed into the boards that will allow her to complete the order. It is, to be sure, a gesture of investment—the cherry-wood block in exchange for a promising source of income. But it is more than that; in this profoundly personal sacrifice, Gertie knows her Christ of the sunlit mountains and wooded paths lives in the urban places, too. This is the realization that ends her search for a human face to model for the cherry-wood Christ. With an air of triumph and faith, Gertie declares, "they's millions and millions a faces plenty fine enough—fer him. . . . Some of my neighbors down there in the alley—they would ha done" (599). Rightly or wrongly, assimilation prevails, but not without heartache and bitter loss; and the ambivalence with which Arnow treats this theme is the ambivalence with which the American imagination has recurringly viewed assimilation among its own regionally, ethnically, and racially iden-tified populations.

On the face of it, *The Dollmaker* is a novel about bewildering disloca-tion, inarticulate ignorance, pathetic sublimation, aching grief, and bitter-

sweet acceptance. Its major strength is that it is a moving story with characters whose dilemmas are true-to-life; they are victims caught in a turbulent moment in time, predictably unable to see themselves or reflect on their own responses. Beyond this level, however, *The Dollmaker* is surely an articulation of America's enduring, sometimes convulsive, twentieth-century dialogue with itself about who and what matters. Individual readers may position themselves variously within that dialogue, and indeed, many do: thus there is disagreement among readers over interpretation of the outcome for Gertie Nevels. Ultimately, there is no danger that readers will miss that dialogue or its magnified oppositions. Appropriately, Harriette Arnow has made sure of that.

Notes

1. This point in time marked the beginning of a period of growth in the academic field of American studies. Marx has long been well known as one of the early articulators of the "myth/symbol" school of American culture studies.
2. Interestingly, the desire to conform to corporate norms has been criticized most often during times of economic prosperity. To illustrate, Sinclair Lewis's *Babbitt* (1922), Arthur Miller's *Death of a Salesman* (1949), and J. D. Salinger's *Catcher in the Rye* (1951) all questioned, in distinct ways, the absence of individual meaning in a life that is motivated or constrained by material success. In two critical observations of career individualism, William Whyte's *The Organization Man* (1956) and David Reisman's *The Lonely Crowd: A Study of the Changing American Character* (1956) probed the validity of individualism in a society that defined success in terms of middle-class aspirations and conformity.

Works Cited

Arnow, Harriette Simpson. [1954]. 1972. *The Dollmaker*. New York: Avon.

Ghoul, Kathleen. 1975. "The Origin of the Family." Pp. 51-76 in *Toward an Anthropology of Women*, ed. Rayna R. Reiter. New York: Monthly Review Press.

Harrison, Elizabeth J. 1991. *Female Pastoral: Women Writers Re-Visioning the American South*. Knoxville: The University of Tennessee Press.

Kolodny, Annette. 1975. *The Lay of the Land: Metaphor as Experience and History in American Life and Letters*. Chapel Hill: The University of North Carolina Press.

MacKethan, Lucinda Hardwick. 1980. *The Dream of Arcady: Place and Time in Southern Literature*. Baton Rouge: Louisiana State University Press.

Marx, Leo. 1967. *The Machine in the Garden: Technology and the Pastoral Ideal in America*. New York: Oxford University Press.

Nye, Russell B. 1975. "The Thirties: The Framework of Belief." *The Centennial Review* 19 (Spring): 37-58.

Samuelson, Joan Wood. 1982. "Patterns of Survival: Four American Women Writers and the Proletarian Novel." Ph.D. diss., Ohio State University, Mansfield, Ohio.

Schafer, William J. 1986. "Carving Out a Life: The Dollmaker Revisited." *Appalachian Journal* 14 (Fall): 46-55.

Toliver, Harold E. 1984. "Pastoral Contrasts." Pp. 126-29 in *The Pastoral Mode*, ed. Bryan Loughrey. London: Macmillan.

Zaretsky, Eli. 1973. *Capitalism, the Family, and Personal Life*. New York: Harper Colophon Books.

THE WEEDKILLER'S DAUGHTER AND THE KENTUCKY TRACE: ARNOW'S EGALITARIAN VISION

CHARLOTTE HAINES

Harriette Simpson Arnow liked to tell the story of how as a child she had rewritten her grandmother's stories to suit herself. She went on to say that she was not so easily able to change the narrative that her mother imagined for Harriette's life. But rewrite it she did, for she managed to leave the respectable teaching career her mother had urged upon her and move from Kentucky to Cincinnati to begin life as a writer. Arnow's work is filled with ambivalence about her chosen profession, however. Not only was her family against it, but writing, for her, meant leaving the region she loved. Throughout her work, Arnow examines her relationship to Appalachia, the role of fiction writing, and the meaning of determining one's life.

A decade would pass after the publication of her best-received work, *The Dollmaker* (1954), before Arnow would publish another novel. Even while working on that tale of dislocation, she had been torn between her fiction writing and historical research, speaking of the fiction as an obsession to be rid of so that she could continue on the project she had envisioned since a teenager, the writing of a history of the Cumberland region that would tell more than the comings and goings of its notable people. As late as a 1984 lecture, Arnow expressed her continued identification with the Appalachian area and the need to set the record straight about its people. Complaining of the Detroit newspapers who exacerbated the anti-"hillbilly" feeling rampant during the time in which *The Dollmaker* took place, she says:

> They never said that these newcomers are doing the patriotic thing by coming to Detroit to work in a factory and help win the war. Instead, they told jokes, published jokes in the paper about ridge-runners, down-homers,

rednecks that made all of them appear stupid, lazy, generally no-good. . . .
Meanwhile, Congress was discussing and debating the Appalachian
Redevelopment Act. . . . And reporters and free-lance writers for various
newspapers would go back to some place in southern Appalachia . . . and
each find the poorest, the most ignorant community or family they could
find and then write stories about them. . . And what was written that day
would have the reader believe . . . that all Southern Appalachian[s] were
alike (Arnow 1984, 11)

Arnow's anger at the treatment of Appalachia was not only due to the
image that had been created of it and its people. During the war, Harriette
and Harold received notice that the Army Corps of Engineers was taking
36 acres of their Pulaski County, Kentucky, land by right of eminent
domain. Although a lawsuit forced the government to pay them more than
originally announced, no settlement could be fair compensation for the
lack of choice in the matter or the fact that the land would later be sold to
the wealthy few who could afford a summer cottage on the recreation lake
created by the Corp's damming of the river—a process that not only took
their land, but put under water half of Burnside, where Harriette had
grown up. Rapacious development had destroyed much that Arnow loved.
Arnow described this horror in a 1970 article for *The Nation*, ironically
titled "Progress Reached Our Valley," and her Prologue to *Old Burnside*
(1977) tells the poignant tale of her return in 1953 to visit the area, now
unrecognizable to her.

During this period, when Arnow's rural Kentucky seemed besieged, she
threw herself into her lifetime goal of writing a history of the region that
would reveal something of the life and spirit of the people who settled
there. The result was the publication of two works, *Seedtime on the
Cumberland* (1960), and its companion, *Flowering of the Cumberland* (1963).
Based on intensive research, much of it in primary sources, both works
meticulously trace the development of the region. The first begins with a
detailed geological description, moves to a discussion of Indians and
explorers, and ends by documenting the life of the pioneers. The second
begins in the 1790s, and describes the everyday life of the Cumberland set-
tlers. Although always noting the hardships involved for the white people
settling the region, Arnow repeatedly emphasizes the individualistic yet
democratic ethos among them. In a 1968 lecture to the Michigan
Historical Society, "Some Musings on the Nature of History," she discusses

the genesis of her plan and motivation to write such a history. Here Arnow reveals the extent to which she sees a sense of history as essential to a strong personal identity. "The opportunity for the general public to learn is important," she says, speaking of museums, "but equally important are the many who get some measure of self-identification," a sense of belonging (11). She recounts her disappointment as a child with traditional histories that never seemed to discuss the life of "average settlers," and tells of her vow to write one of her own: "Some time during my later college years, a dream came to haunt me: I would write the book I couldn't find" (4). When living on the farm in Pulaski County, she again felt the urge to bear witness to the tradition-determined life of the area:

> I realized that about me was a living museum. . . . These people, though literate, many highly articulate, lived largely by learnings handed down through the generation. Even the seed they saved from year to year was probably descended from some brought over the mountains. My wish to write a factual account of the first settlers grew stronger than ever, in spite of the fiction I was then trying to write. (5)

Arnow's last two novels, *The Weedkiller's Daughter* (1970) and *The Kentucky Trace* (1974) have much in common with the two histories she finally produced, and much in common with each other. Both novels demonstrate the cataloguing of those everyday details that the histories embody and, although very different from one another in setting, each reveals the intense connection to and sense of nostalgia for the Cumberland region and times past that haunt *Seedtime* and *Flowering*. Most significantly, however, *Weedkiller's Daughter* and *Kentucky Trace* demonstrate that the complexity of creating, revealing, and protecting personal identity remain as problematic for Arnow at the end of her life as at its beginning.

Arnow describes the completion of the time-consuming history project as almost traumatic in its propelling of her out of the past and into the present of rural Michigan where she now lived with her family, and from which she would draw *The Weedkiller's Daughter*. While she had been writing about a time in the distant past, and lamenting her dispossession in Kentucky, the immediate world around her was also changing. The development of the countryside of Michigan, her northern substitute for the farms of Kentucky, confronted her:

The road was now a barren, ugly place, unshaded in the summer's heat,
ice-choked in winter. Increased traffic had called for a widening; many
of the elms had already died; the widening took all the locust, most of
the maples and oaks along with other trees on the road shoulders; weed
killer had taken not only the flowers but also the wonderful assortment
of native shrubs and vines up to and beyond our fence. . . . We no longer
saw ducks, not even in the bits of deeper water remaining. They proba-
bly avoided it because of the oil scum. . . . No more wild geese resting
on migration flights; no more Great Blue Herons feeding, or little
fishes, or the cry of the loon we had used to hear from the dark recesses
of the swamp. There were no longer dark recesses. The superhighway
route was wide. (Arnow 1968, 8)

It was to this deteriorating environment that Arnow turned her writing.
The Weedkiller's Daughter, published in 1970, was not very successful, how-
ever. Critics, commenting on Arnow's seeming change of subject from the
hill people of Kentucky to affluent suburbanites, found the novel lacking in
character development, as if Arnow, still the exile, did not know her subur-
ban subjects very well. In a 1976 interview with Barbara L. Baer, Arnow
claims that she wrote the novel to avoid being labeled as a writer only con-
cerned with Kentucky (she had learned early that such an identification was
a curse in the publishing world) and because she had something to say
about the America of the 1950s and 1960s. Although she saw that both
regions—Appalachia and the industrial north—were environmentally
under siege, she also felt a contrast between the life recounted in the histo-
ries of the Cumberland, where there was a spirit of adventure and a faith in
democracy, and life in suburban Detroit where "people were afraid of a vari-
ety of things from the atom bomb to mingling with the wrong kind of peo-
ple . . . and like other people they hated the things they feared" (120). *The
Weedkiller's Daughter* is, indeed, a novel about fear and paranoia. In fact,
because it is so permeated, not just with the paranoia of the reactionary
forces Arnow mentions, but also with the progressive protagonist's fear and
secretive behavior, its point of view, its moral center, is uncomfortably
ambiguous, perhaps accounting for the reading public's uneasiness. *The
Weedkiller's Daughter* is much like *Mountain Path* in that it seems to ask the
reader to identify—not just sympathize—with a character whose moral
behavior is in question. In *The Dollmaker* there exists a tension, revealed
particularly in its ambiguous ending, between the sympathy created for a

character suffering at the hands of "progress" and the imperative of a literary structure (the novel) that uses the journey to signify spiritual and psychic growth. In *The Weedkiller's Daughter*, there is an unresolved tension between the rightness of the protagonist's alienation from the destructive and hypocritical world described, and her own almost unacknowledged flaw of compulsive prevarication; a tension between her struggle to preserve and protect her identity and her seemingly limited self-awareness. The novel does present extremes of good and evil—the materialistic, imperialistic, bigoted world of the protagonist's parents versus the ecology-minded, inclusive world of the protesting teenagers, as Baer charges. It also, and more unsettlingly because without judgment, presents the elaborate methods used to deceive the "Establishment," all in the name of self-preservation, as every bit as out of control as the environmental destruction of the ever-expanding subdivisions that symbolize that Establishment.

Susan Schnitzer, the teenage protagonist of this late novel, is to some extent typical of most adolescents in her concerns. As we go through the minute details of her days (we are even taken on a several-page journey from one class at school to the restroom and to lunch—much as we see the details of the pioneers' lives in Arnow's histories), we see her concern for academic success, for social acceptance, for parental approval. As Sandra Ballard has pointed out in comparing her to Suse of *Hunter's Horn*, Susie's parents are by now stock characters in the Arnow canon: an oppressive father and a passive mother. They are also products of the modern world, however. The father is obsessive in his desire to control all in his environment, from people to vegetation (he is, indeed, the weedkiller); and the cold mother, called the "Popsicle Queen,"—Gertie's mother in a suburban setting—becomes a nonperson in her effort to keep up with appearances. Labeled "alienated" by the school social worker (a man who strongly resembles Mr. Anderson of *The Dollmaker* in his reification of the people he studies), Susie plots to defend her identity by scrambling his interpretation of her, even as she also worries that he might be right. In the course of the novel, Susie makes some headway in connecting with others who view the world as she does. In the process, however, she never quite seems to understand that integrity means asserting, not just protecting, who you are.

Deception permeates all aspects of Susie's life. Her room is equipped with a hidden electronic device that opens the back of the closet to a secret passageway above the garage. There she keeps the mementos of a life (and identity) her parents and friends know nothing about, mementos of time

spent with her grandmother, a victim of the Communist witch-hunts, now living in Nova Scotia. She is, quite literally, "in the closet." There she also hides her cousin Ter, another alienated teenager who, wanting to gain the attention of his father, has robbed a bank. It is to help Ter, in fact, that Susie weaves many of her lies. Acknowledging that it is painful to lie to her much-loved doctor, she nevertheless creates an elaborate plan to convince him that she is sick in order to obtain antibiotics for the wounded Ter.

One of the students Susie spends much of her time with is a boy who is also, it turns out, living a life of lies. In the first chapter of the novel, she returns home from a visit to Canada to be picked up by Robert, whom she had hired to make her parents think she has gone to the school prom. In an exchange between them, which seems to foreshadow a journey towards self-integration, Robert comments on the complexity of her deceitful lifestyle:

> "You know I couldn't always tell which was Susan Schnitzer and which the actress?
>
> "I get tangled in my selves sometimes myself." She looked at him as if in his face she might find one untangled self. (22)

But that is not to happen. "You are a master hand at—prevarication" he tells her, to which she replies, "I think 'diplomacy at the personal level between the mutually unaligned' is a better term. . . . The world is a cold place" (27). It is this world view, where lies are rationalized as "diplomacy," that leads both her and Robert to continue to plot their lives in secret: the cold war permeates everything here, as the second world war did in The Dollmaker. Although Robert dates her, taking her on sailboat rides on the river, he is only making use of her as a cover for his parents, as he plans to run away with a woman they have forbidden him to see. And although the evidence mounts that such is the case, Susie has hidden enough of the reality from herself that it hurts when she can no longer avoid facing it. In response to Robert's request to keep their boat rides secret, Susie feels intensely isolated:

> More secrets, more lies by silence, and why? She wished she could go away. This keen little wind had been trying to clean her up, washing out the greasy feeling from the lies she had just told, and the lies ahead when she went back to that mud-flat life with the Schnitzers. (246)

But despite the indication that she would like to stop lying and assert her own reality, moments later, in hiding that her grandfather had been a rum-runner during prohibition—why that would matter now we do not know—she laments, "The only place for real truth was with her sand castles at the bottom of the sea" (247).

Even given the life-negating ethos of Eden Hills, Arnow's ironic name for the subdivision where Susie lives, and the trauma of her background, many of the lies Susie tells seem pointless. It is convincing that her grandmother's harassment by red-baiters and the trauma of her own ostracization and attack because of it when only very young would make her fearful of expressing the political views so many think subversive—her objection to the Vietnam War, to racial bigotry, and to the devastation of the countryside to make room for housing developments. But that does not seem to account for the fact that she lies, often about petty things, even to the people she cares about—her grandmother, for example, so that she will not know Susie has been out on the lake in a storm. And what good, one wonders, can political awareness be if there is no struggle to find courage to go with it. She goes to great effort to hide from her father the fact that there is an African American boy in her school, never considering asserting the young man's right to be there. Arnow seems to make her silence a given when the reader expects the struggle to overcome it to be the central issue of the novel. When the destruction resulting from free enterprise gone amuck is portrayed in such strong terms as it is in this novel, particularly in the vivid scenes describing the damage to the environment—the burning of ducks caught in the oil from road construction is as horrific as any of the scenes in Gertie's industrial Detroit—it is difficult to feel sympathetic to Susie's nonassertiveness, even given her youth and insecurity.

The practice of deceit for self-protection from perceived enemies reaches a climax with Susie's interview with the social worker. If Gertie is confused in the face of pressures "to adjust," Susie quite deliberately cultivates an acceptable persona. She has been preparing for the interview from early in the novel when, as if Nancy Drew, she hides a psychology book with the cover of another book and retreats to her refuge at the swamp to learn the "normal" behavior of girls her age so that she might better fool him. In the final chapter, her panic over the interview mounts. Afraid, somehow, that she might reveal to him that the "camp" she claims to go to every summer is her grandmother's house, she prepares to do battle. After she escapes, having revealed nothing of who she really is, we realize how high the

stakes were for her: "it was good . . . to know that Susan Schnitzer still belonged to Susan Schnitzer" (372). As with so many of Arnow's characters, Susie's power to possess herself had been in question.

In *The Weedkiller's Daughter*, however, what was Gertie's agony, in Susie has almost become farce. Like Gertie, Susie feels beleaguered by the fact that the world around her denies the value of what she has always held dear. Also like Gertie, she isolates herself with her secretiveness. But whereas Gertie struggles to see the truth about herself and reaches to establish a connection with others, Susie believes she knows the truth and defends it against all challenges. As in *The Dollmaker*, Arnow's belief in the causes Susie espouses and her ability to describe them so poignantly make ambiguous the novel's intention, for although we fully understand the teenager's alienation in the face of the life-denying attitudes of "The Establishment," we cannot understand her inability to begin constructing a life less reliant on lies (she does, after all, find a group of friends who view the world her way).

It is significant that Gertie Nevels makes a cameo appearance in *Weedkiller's Daughter*. Called "The Primitive" by the children who roam the acreage she owns and protects from encroaching development, *The Weedkiller's Daughter*'s Gertie is a nostalgic vestige of the world Arnow has lost. Unabashedly a "hillbilly"—she wears a bonnet and carries a shotgun—she represents defiance, however hopeless, against encroaching "progress." When Susie visits her to congratulate her for having won the latest battle with the law, the teenager finds an almost spiritual haven:

> She enjoyed giving hay to hungry sheep and cattle, as she loved the big, hip-roofed barn. Going into it, she always felt she was entering a favorite church. Now at twilight before the lights went on, you could imagine the top hayloft high under the roof was a nave hidden in shadows. (303)

Arnow's 1968 lecture to the Historical Society reflects the point of view she here ascribes to Susie. Talking about the changes that have overtaken the area between Ann Arbor and Detroit where she and her family live, she says:

> I saw it all but never quite comprehended until a barn told me. This particular barn, with its twin tile silos and cluster of smaller buildings, I

thought of as 'The brave old barn.' The last barn between us and Ann Arbor, it stood near the now-paved end of our gravel road; a research plant now stood in front of it, a subdivision with the beginnings of a shopping center on another side.

On this day, I first noticed the pile of weathered lumber. The barn appeared smaller. It took me several minutes to realize it was being torn down. A kind of panic seized me, though I had known barns in many places were either fallen into shapeless decay or torn down. There had been none destroyed in my immediate neighborhood; there even a few of the older, lower, single-gabled barns could still be seen.

Yet I knew that on the whole the great, hip-roofed barns of the south central Michigan multi-purpose family farm were disappearing, and not because they were old. Would such barns ever be built again? (9)

Although less reverent than the young Susie's, Arnow's connection to the disappearing rural Michigan landscape is as real. At this point in her career, Arnow's expository voice is clearer than her fictional one, however. Perhaps Gertie's relinquishing of art in the face of the overwhelming effects of "progress" reflected a reality for Arnow's life as well. Arnow's anger over the loss of the rural landscape and her yearning for the agrarian life of Appalachia are evident in *The Weedkiller's Daughter*, in the nostalgic figure of The Primitive, certainly, but also, perhaps, in Arnow's failure to imagine a protagonist in the arid environment of suburbia capable of risking the self-disclosure necessary for personal growth, social connection, and political activism: Susie's success is limited to foiling the voyeurism of an inept social worker, thus reducing the whole effort to the merely comical and deflating any moral passion created in the novel. If Gertie seems able to find a kind of triumph through community, we are never so sure of Susie, despite any hints to the contrary. Arnow was to publish one more novel before her death, however, although that one, like *The Weedkiller's Daughter*, would also not reveal the literary gifts found in her first three.

In her 1983 essay, "Heritage and Deracination in Four Kentucky Writers," Gwen Curry includes a discussion of Arnow's *Kentucky Trace*. Like so many critics of Arnow's work, Curry finds fault with Arnow's use of details in telling this tale of a Kentucky rebel during the Revolutionary War and contrasts Arnow's narrative with one she might have told, one that would have concentrated on the more well-known heroes and events of the period; as a result, Curry sees the novel as lacking in historicity.

Arnow's work is decidedly not lacking in historicity, however, for it is in some ways a fictional version of her own *Flowering of the Cumberland*. Like the history, *The Kentucky Trace* acquaints us with the place and period, not through a litany of battles and leaders, but through a well-documented description of the daily lives of those who lived in it. This retelling of history with a focus on the lives of ordinary people—both through exposition and through fiction—is Arnow telling the story her way, just as she had done when she first began making up her own versions of the stories her grandmother told her. In this last novel, Arnow imagines the beginning of and reaffirms her relationship with a nation built on values that she found in the social life of the Cumberland during the days of the pioneers, but that she found desperately lacking in the twentieth-century world around her. *The Kentucky Trace* is Arnow coming home to a utopian recreation of the Cumberland region she had left as a fledgling writer. In it she reaffirms her identification with the Kentucky of *Flowering*, an earlier and more humane world.

A concern for the peaceful coexistence of people of different ethnic backgrounds, including Appalachian, is evident in Arnow's writing from the world of Merry Hill in *The Dollmaker's* Detroit to the ethnic prejudice despised so by Susie in *The Weedkiller's Daughter*. For Arnow, ethnicity (read also as regional affiliation) is a central part of an individual's identity and often the battleground in the fight for self-determination. In *Flowering of the Cumberland*, Arnow tells us:

> The early Cumberland country seems to have been a world remarkably free from hatred of all kinds. Few are the expressions of hatred for any Indian, and the man who hated all Indians was non-existent. There were likewise no expressions of hatred for the Negro. One finds, instead, pity, sometime's love, and often understanding. Slave or no, the black man was to most still an individual. (92)

The description of racial harmony found in *Flowering* is echoed in the microsociety created by David Leslie Collins, Arnow's protagonist in *The Kentucky Trace*. As a troubled supporter of the revolutionary cause who is returning home after a battle in which he believes he may have committed fratricide, at the start of the novel he is as lost and as alienated as his more contemporary counterpart, Susie. Finding his wife, child, slaves, and goods gone, he sets out to find them, ambivalent about the project because he has

discovered his wife has tricked him into marriage to give a name to her already conceived child. In this half-hearted search, he finds another group of people to replace the one that entrapped him, one more truly reflecting the diversity of the infant country. The encampment he encounters on his travels holds an unlikely group of pioneers whose needs give Leslie a reason to abandon his search: an infant, child to a yellow-haired, loud, eastern lady (she is from Philadelphia and speaks in the clipped tongue of a New Englander, Arnow frequently reminds us), an abused black slave, Rachael, and an Indian from an unidentified tribe, speaking an unknown language, to whom Leslie gives the gentle name "Little Brother." The group is complete when they are joined by the escaped slave, Jethro.

Curry's claim that Arnow is advocating deracination, denial of one's heritage, is based on the fact that Leslie seems to have cut all biological ties as he creates of the group a new family. In fact, over the course of the novel, Leslie establishes control of his life, disentangling himself from a life he feels trapped into, and ultimately reaffirms—choice is important here—his association with his family of origin, with the region, and with the emerging nation.

The yellow-haired woman, left on the trail by her guide to bear her illegitimate child, wants to abandon the infant and go on to Detroit. Like the neglectful and judgmental Popsicle Queen of *Weedkiller's Daughter*, she is totally self-concerned, carrying with her supplies and paraphernalia—silver spoons and fancy clothes—which are completely inappropriate in the wilderness setting, and is repulsed and frightened by the natural world about her. As such, she represents the opposite of the hardworking pioneer wives for which the region is known; she is a vacuous and demanding lady of the more "civilized" world.

Leslie, by contrast, is captivated by the child, who bears an uncanny resemblance to himself. He pours attention on him, and bands together with the others to care for and protect him. In this role, Leslie, as the best mother in the novel (and perhaps in all of Arnow's work) also steps out of the pages of *Flowering*. There, Arnow describes an egalitarian pioneer attitude toward gender identity as open as that toward Indians and African-Americans:

> . . . [T]here seems to have been on the whole little glorification of mere maleness; The ability to take responsibility, to put others ahead of self . . . was more truly a mark of manhood than mere maleness as evidenced by

a man's abilities in bed. . . . Judging from tradition and family life in the hills, small boys not infrequently played with dolls. Willingness to protect the weak and watch over children were, at least for those Cumberlanders who elected Bailey Peyton to Congress because he carried a stranger woman's baby on horseback many miles through the woods, more truly a mark of manhood than fighting duels. (70-71)

Even Leslie's name, of course, suggests an androgynous nature.

One of the pivotal scenes of the novel is the baptism of the infant. Under pressure from his companions, Leslie participates in a ceremony to christen the child after himself. It is a comic scene in many ways—we do not know how seriously Arnow intends it. Despite his uneasiness, which is great, at the seemingly inauthenticity of the ritual and his role in it, Leslie sheds his backwoods clothes and dons his fancy gentleman's attire to play the minister; his self-styled family spiffs up one of the rockhouses where they are camped and turns it into a church, complete with alter and candles. Leslie both immerses the child in water somebody has thought to warm and dribbles some from a mug on the baby's head, so as to satisfy everyone's sense of how the ceremony should go. And yet, in the context of the plot, it is all very serious indeed. The narrator links the scene to a larger world:

> Leslie looked out and up at the rockhouse roof. He was reminded of a church he'd been in sometime, somewhere; a country church of stone, big, but plain; maybe in England, not Wales, the stone would be gray; could be Scotland or France. The nave high and all red-brown stone like this, and past it a great sweep of world, but different; no trees like the ones he could see here, and beyond, the hill against the creek with the pines on top, black-seeming against the blue sky. And while he looked a great bird, too big for a hawk, had to be a golden eagle, cut a trail across the sky with never a wing beat. (255)

The scene is notably the same as, but different from, the home the colonists left behind. Arnow calls our attention to the eagle again after the ceremony as Little Brother, now the godfather of the child, and the ex-slave Jethro emerge from the church. It seems clear that Arnow means to associate this rebirth of Leslie in the form of his namesake with the creation of the new nation (the novel, after all, takes place in the midst of the

Revolutionary War). But it is the form this rebirth takes that is most interesting. In *Beyond Ethnicity: Consent and Descent in American Culture*, Werner Sollors discusses the use of Biblical typology and imagery by ethnic, minority, and regional peoples in the United States to affirm an American identity, a solidarity with the country's mythic mission of creating a "City on the Hill," the new utopia. Citing the work of Sacvan Bercovitch in *The American Jeremiad*, Sollars details the historic use of such symbols as the eagle:

> The eagle that was finally used for the [Great] seal is not just the classical emblem of the republics but also the biblical eagle of Exodus (9:1) and Revelation (12:14), an image of escape and immigration. . . . The typological elevation of the migration experience to a new exodus was and continues to be a dominant mode of conceptualizing immigration and ethnicity. . . . (44-46)

Further, the use of such typology can serve both to identify a group and to establish its relationship to the nation as a whole. Sollors asserts: "Typological rhetoric may indicate the Americanization of people who use it. Yet it can, alternatively or at the same time, serve to define a new ethnic peoplehood in contradistinction to a general American identity" (49).

What Arnow seems to be doing here is no less than associating the rebirth of Leslie Collins with the region's claim to authorship of the American Dream. The Biblical rhetoric of the Puritans is here co-opted to define Collins and his community as the real beginning of the new society, elevating Appalachia with its diverse inhabitants from the status of "peculiar" region established by the local colorists to that of model for a noble way of life. Significantly, *The Kentucky Trace* follows *Flowering of the Cumberland* in emphasizing a distinction between the Cumberland and the North, that region usually claiming to have given birth to a democracy: we are frequently reminded that the yellow-haired lady, the symbol of degeneration, comes from Philadelphia. She is associated with the crassness and materialism, the regional chauvinism and the will to exploit that Arnow, and Appalachia, have come to see as typical of the Northeast. The Appalachia region, on the other hand, and the motley crew who here represent it, are more clearly in tune with the egalitarian ideals of the new nation. In *Flowering*, in language distinctly different from the more balanced realism of her earlier work, Arnow presents the Appalachian region as nearly ideal:

Middle Tennessee, thus, looks around 1800 like a dream of democracy come true. . . . The region, up river as well as down, was undoubtedly for some years after the end of the Indian troubles about the closest thing to paradise the world has ever known. (110-11)

In contrast to this world, the North is frequently described as cold. "The travelers of later years wrote of the 'morose' habits of the sad Americans found in Philadelphia and other eastern centers, but no visitors ever accused the Cumberlanders of cold reserve," Arnow reports (123); and: "Compared to the New England child, the Southern baby was reared with great tenderness" (69); in fact, the infant death rate was significantly lower in Appalachia than in the North (68), a fact whose irony would not have escaped Arnow. Clearly, Leslie Collins, by saving young William David from the callousness of his Philadelphian mother, contributes to that statistic.

Sollors is further useful in his discussion of ethnogenesis, a process whereby generations reaffirm their connection with an ethnic or regional and American identity through consent rather than by descent, by choice rather than by birth. Leslie Collins is the son of a Virginia planter, a Loyalist turned rebel. In the beginning of the novel we find Leslie alienated from his parents. He had run away from home several times as a child, and at the beginning of his trek believes his father to be Loyalist. Only after he has chosen his new family and consecrated his association with the ideals of the new nation can he make peace with them. This is not deracination, it is the process of creating one's identity; it is, Arnow asserts, the American, and the Appalachian, way.

It was also Arnow's way, for she, too, after having left home to assert her right to a career and life of her choice, frequently returned to reaffirm her connection with the Cumberland region. The similarity between Arnow's own experience and her protagonist's is highlighted most significantly by the fact that Leslie Collins becomes a writer. His decision to name William David after himself and to claim him as his own is followed by the careful, almost tedious composition of a letter to his mother, in which he creates a fictional past to explain the baby to his family in hopes of gaining acceptance for it, and by extension, for himself.

The composition of the letter home to reconcile himself with his mother takes place over three chapters and many narrative interruptions. While he is writing it, Leslie must stop to take care of the needs of his new family, reminding us of the many interruptions Arnow faced as she tried to

write her fiction and meet her parenting responsibilities. The process of writing the letter involves drafts and rewrites. Leslie weaves a tale that dramatizes the death of his first wife, the meeting of a second, fictional and idealized wife, the birth of William David, and the death in the war of the baby's mother. So effective is the piece of writing that Leslie—as in the now-famous scene of Nathaniel Hawthorne reading *The Scarlet Letter* to Sophia—finds himself moved to tears by the story. When he shares it with Rachael, who is entirely familiar with the truth of the baby's parentage, she, too, weeps. The narrator, reflecting Leslie's thoughts, tells us:

> It could be he had written an exceptionally fine tale. Rachael's tears didn't mean anything. Some women could get so wrapped up in a novel they'd cry and carry on as bad as Rachael and all the time they knew the tale was a lie from one end to the other. Men could be just as bad. Two or three years back, he'd taken a copy of Robinson Crusoe with him on a surveying trip. One of his chain carriers had got so wrapped up in the tale, he'd look for the print of a big bare foot whenever he happened upon a bit of bare sandy creek. (284)

That Arnow associates Leslie's self-created past and identity with writing novels is obvious here. So, also, is a self-reflective doubt about the reliability of that process. Hadn't the local colorists, in fact, influenced generations with their distorted tales of the very people Arnow was now offering as the nation's noble founders? Arnow seems to invite questioning of her revisionist history even as she writes it. Leslie's narrative is powerful—he himself is moved by it—and it is associated with the prototype of the novel; but it is also more than a little foolish, sentimental, and a lie. During the whole process—from the christening to the writing of the letter—Leslie, not unlike Susie Schnitzer, is obsessed with guilt for the fiction he is creating. But we do not entirely join in that judgment of him: he is a loving man with the welfare of his chosen family at heart, and the emotional truth of the letter is clearly valid, as is the significance of the christening ceremony, no matter how "sacrilegious" it may seem; also, he is weary of traveling, as he tells us, and wants to go home. It is never made clear why he must create this false past, however. His mother is concerned with propriety (not unlike Arnow's mother, or any mothers appearing in her work), but why such an elaborate tale? Like the deceptions Susie creates, Leslie's lies seem to exist for themselves. So implausible, then, is the

letter-writing sequence in terms of the realistic plot that it resonates with psychological implications, suggesting Arnow's doubt and justification for her own life as an artist.

The series of events that interrupt Leslie while he is working on the letter add to the rumination about truth and fiction, for they all contain small narratives that involve the telling of lies for greater truth. Jethro counterfeits some papers to get supplies for the rebels, for example, and Leslie signs a note agreeing to kill the baby in exchange for Rachael's freedom, all the while planning for the infant's escape. Arnow seems to be commenting on the efficacious nature of writing, for she draws a distinction between such "lies" and those told by his wife, Sadie, when she falsifies Leslie's Bible to conceal the illegitimacy of her son. One is reminded of the self-doubts revealed in Arnow's letters responding to criticism of her first novel in which she struggles with the nature of realism and her need to tell the truth through fiction, and of the increasingly political nature of that fiction as she moved from Appalachia to Detroit.

The incredibility of Arnow's narrative as she traces Leslie's writing—he is, after all, in the middle of the wilderness—calls attention to the tensions produced in the text over the issue of truth and fiction and the creation of tales. Entirely unnecessary to the plot, yet inviting the most interpretation, the letter scenes reflect Arnow's need to explore the nature of writing and its ambiguous connection to a "real" world: in *The Weedkiller's Daughter*, Susie's fictional life is created to protect her real one; here, Collins' fictional identity is more real than the one it replaces. Throughout the novel, a pull is created between the detailed description of Collins' daily activities—just as with Susie Schnitzer—and the forward movement of the developing psychological drama. It seems clear that Arnow associates details with the everyday lives of ordinary people, as she tells us when talking about the writing of her histories, and experiences her need to write fiction as conflicted with, pulling her away from those lives. At the same time, however, the writing of fiction is essential to a sense of identity: Leslie creates himself through it. In all of Arnow's novels, there appears a conflict between her historian's desire to bear witness to the struggles of people in coping with the forces of history and her embodiment of psychic power in the creation of individual fictional lives, the unresolved pain and ambivalence, one suspects, over having to leave Kentucky in order to be able to write about it. It is echoed in the theme of obsessive pursuit of individual creative activity versus attention to practical responsibilities, as seen in *Hunter's Horn*. It is

this tension that causes most critics to call Arnow's use of details excessive. Although Arnow is most frequently called a realist, this self-consciousness, particularly as revealed in *The Kentucky Trace*, would seem to place her later work with more contemporary expression, as would her reflection of the fragmentation and alienation of the twentieth century despite her effort to recreate an earlier period in history.

At the end of *The Kentucky Trace*, Leslie's chosen and multicultural family reemerges from the wilderness with the child's life—and a reborn Leslie—intact. This family represents Arnow's fictional version of the society she found in her research on the early days of the Cumberland region. The ethnic strife in the housing complex of *The Dollmaker*, and the racism and intolerance of Susie Schnitzer's world are here replaced with a vision of a multicultural family. Through his letter home, Leslie has announced, if imperfectly, its rightful claim in the nation.

The Kentucky Trace is Arnow's letter home. Coming at the end of her life and career, it contains as much resolution as is to be found in her work about her relationship to Appalachia, to her family, and to her creativity. It claims for the region a central place in the creation of the American dream and in the process asserts the connection between Appalachians and others marginalized in American history. The novel has an aura of nostalgia about it, however. It contains several scenes in which Leslie laments the passing of the pristine environment as the pioneers forge west. Destruction is born with the nation. And Arnow's exploration of the nature of her art is fraught with conflict and tension. In its struggle, the novel reveals that resolution was as yet incomplete.

Arnow's growing awareness that the marginalization of those from the Appalachian region was only a part of a larger system is apparent as we move through her work, from her early stories to *The Kentucky Trace*. Her experience in a northern industrial city created a context within which she could view her earlier perceptions about the characterization and treatment of Appalachian people. But, although Arnow's fiction reveals an intense concern for race and gender issues and a passionate rejection of social injustice, her representations often seem less than fully informed. Susan Schnitzer's continual reference to her African-American friend as "the Negro" despite the fact that he has a name, for example, or the stereotypical characterization of Jethro and Rachael in *The Kentucky Trace*, as John Weston has pointed out, undermine these works' obvious intention to espouse the cause of racial equality. And despite the fact that

Arnow creates complex women characters such as Suse and Gertie while clearly bemoaning their lack of opportunity, and exposes as cruel and destructive the collaboration with patriarchy of characters such as Milly of *Hunter's Horn* and Gertie's mother, stereotypes such as "the popsicle queen" and "the yellow-haired lady" are disappointing. She herself refuses the title of feminist: "I don't know, I think the feminists went overboard in some things. . . . I don't see the sense of it all," she said in one of her last interviews (Kotlowitz 1983, 24).

Arnow's last novels do fall short of demonstrating a sensitivity commensurate with contemporary expectations. It must be recognized, however, that her canon is powerful in its revelation of her expanding awareness of the interconnectedness of social and personal issues and in its rendering of one writer's struggle to understand the contradictions of regional identification in American life. Given the nature of our pluralistic culture, that struggle, however unresolved, in itself—above and beyond her other merits—gives Arnow a significant place in American letters. Arnow's own determination to free herself of limiting categories, whether imposed by her family or the larger community, earned her the epitaph she requested: "She wrote the song she sang."

WORKS CITED

Arnow, Harriette Simpson. [1960]. 1983. *Seedtime on the Cumberland*. Lexington: The University Press of Kentucky.

_____. [1963]. 1983. *Flowering of the Cumberland*. Lexington: The University Press of Kentucky.

_____. 1968. *Some Musings on the Nature of History*, The Clarence M. Burton Memorial Lecture. Kalamazoo: Historical Society of Michigan Publications.

_____. 1970. *The Weedkiller's Daughter*. New York: Knopf.

_____. 1970. "Progress Reached Our Valley." *The Nation* 211 (3 August): 71-77.

_____. 1974. *The Kentucky Trace: A Novel of the American Revolution*. New York: Knopf.

_____. 1977. *Old Burnside*. Lexington: The University Press of Kentucky.

_____. 1984. "Writing and Region." Address to the Stokely Institute, University of Tennessee-Knoxville, 19 July. Transcribed by Sandra L. Ballard.

_____. 1985. "Help and Hindrances in Writing." Address to Appalachian Writers Association. Morehead State University, Morehead, Kentucky. 29 June. In this collection pages 281-91. Transcribed by Sandra L. Ballard.

Baer, Barbara. 1976. "Harriette Arnow's Chronicles of Destruction." *The Nation,* 31 January, 117-20.

Curry, Gwen. 1983. "Heritage and Deracination in Four Kentucky Writers." *Border States* 4: 73-83.

Eckley, Wilton. 1974. *Harriette Arnow.* New York: Twayne.

Kotlowitz, Alex. 1983. "A View from the End of the Road." *Detroit News,* 4 December, 14+.

Shapiro, Henry D. 1978. *Appalachia On Our Minds: The Southern Mountains and Mountaineers in the American Consciousness, 1870-1900.* Chapel Hill: The University of North Carolina Press.

Sollors, Werner. 1986. *Beyond Ethnicity: Consent and Descent in American Culture.* New York: Oxford University Press.

Weston, John. 1989. Letter to Charlotte Haines, 1 July.

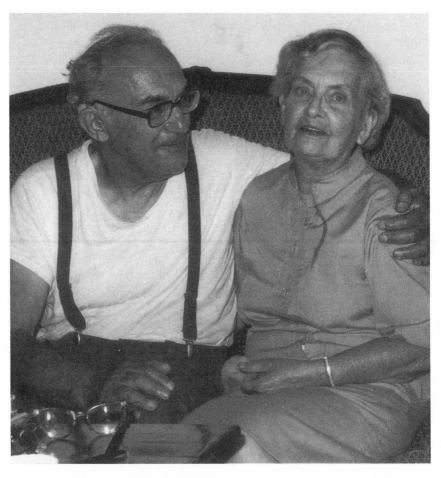

Harold and Harriette Simpson Arnow in 1983, photograph by
Kisuck Chung.

AUTHORIAL VIEWS

INTRODUCTION TO *MOUNTAIN PATH*, FIRST APPALACHIAN HERITAGE EDITION

O ne wonders on the wisdom of bringing out again a first book written close to thirty years ago. *Mountain Path* is to all practical purposes lost and dead. The original publisher, Covici-Friede, went out of business not long after the summer of 1936 when one small printing was made.

I like to think that now if writing it, I could do better. How good it is I do not know, for like the rest of my work, I have not read it since the last galleys, and anyway I would be unable to judge. There are doubtless some or even many things I would change, hoping for improvement, but because of the method of reproduction nothing is changed.

Rather than a finished work, the book were better looked upon as the beginnings of a long story that stirred in me at times when I was a small girl hunting the family cows on Tyree's Knob above Burnside on the Cumberland, for it was then I saw the other world. This lay in the rows and rows of hills to the east; I wondered on the life there, where few people whom I knew had ever visited. True, Burnside was in the hills, and all my people had lived more or less in the hills of another county. Still, though not living in the small town below me on the river, family life was shaped by town life—the graded school we attended, the Southern Railway with most of its passenger trains then stopping in the town, the lumber mills, and the steamboats. I had grown up within hearing of train and steamboat whistles, and most of the time I looked toward the world of which they spoke—Nashville, Cincinnati, Detroit, Louisville, Chicago. That world had taken most of my people and would I knew in time take me; it offered most.

Still the hills beyond the sound of train whistles were a first love. Almost before I knew it, I was teaching a one-room school in a shut away

valley near the Cumberland above Burnside. I cannot say this was the realization of a dream; quite the opposite; poverty had forced me to stop college after only two years and start teaching at eighteen. I finished that school, taught another, took a bachelor's degree, taught two years in a small rural high school, then briefly in a city. I then quit teaching and began trying to write.

Thus, to the question I have many times been asked—where is the scene of *Mountain Path*—I can only answer it is a composite of places known in Pulaski County with possibly touches of the hill counties visited or lived in for a time. The characters are of course fictitious. They came like characters to other works from where I do not exactly know.

When I went out to teach in 1926 there were hundreds of roadless creek valleys all through the Southern Appalachians, and almost no roads at all in Eastern Kentucky. The Depression had not yet come, and the Cumberland National Forest and WPA, building roads and schoolhouses, were still ahead. TVA was at yet undreamed of, and hence no REA to light the back hills. There was electricity only in the towns; even the more prosperous farmers in such counties as Pulaski and Wayne had none. Country schools like the churches and the homes had to depend on kerosene and carbide lights.

Life in the hills was on the whole worse than it had been for decades. The big timber was gone, the oil, and the soil washed from the hillsides and ridge tops; game was scarce. There was little left but scrub timber, worn out soil, and people—many people, for though there had always been emigration from the hills the Great Migration had not yet begun.

The contrast between the often prosperous and sometimes wealthy dweller in the county-seat towns of the hills and the rural family had sharpened; while the late twenties brought booming times to much of the rest of the United States, the roadless back hill communities knew only an all-encompassing poverty of environment. Mail in such communities continued to come twice or thrice weekly by mule-back. The institution now known as county health was in its infancy; hospitals were practically nonexistent in Eastern Kentucky; many were born, lived, and died with no help from that man seldom found in impoverished communities—the physician. The average school was a one-room frame building, a miscellaneous collection of seats its sole equipment, no toilets of any kind, water from the closest spring, hogs sleeping under the floor, and almost no help from the State of Kentucky. Education was on the whole considered a local

problem. The back hill child if he wanted any beyond the eighth grade had to come from a family affluent enough to pay the expenses of studying away from home.

Few of the women and children in the back hills had by 1930 heard a radio, for with no electricity all had to be the battery-powered type. Many in the more shut away communities had never seen a car. Meanwhile Somerset, not a great many miles from any community in Pulaski County, was like many county-seat towns, a busy, up-to-the-minute place with excellent grade schools, an outstanding high school, a public library, physicians, roads to the north, automobiles on its paved streets, and nearby a roundhouse of the Southern Railway.

Yet, for all the influence such centers of education and modern conveniences had on the life in the roadless hills, they might have been hundreds of miles away instead of twenty or less. One could go by train, and soon by automobile from Somerset to Cincinnati—180 miles away—more quickly and with far greater ease than from Somerset to many one-room schools in the county. Many of the men often took the time-consuming trip to the county seat; sometimes it meant a walk or mule ride of many miles to the nearest railroad station where the northbound local stopped; other times from places where the Cumberland had to be crossed by skiff, the whole of a fifteen or twenty-mile trip was done on foot. Few of the women and children had ever been in the county-seat town, separated from them not only by distance, but also, one could quite truthfully say, by two hundred years of time.

Many of the men had also been gone for varying periods at "public works." This usually meant the mines to the east in the neighborhood of Harlan, but as the union had not yet come and mining was still seasonal in nature, fitting in with their off-season in the corn crop, they stayed only during the fall and winter, saved a bit of money, and came home again in time to put in the corn.

Worn-out soil and other depleted natural resources, lack of state aid for roads and education made for a poverty of environment that in turn impoverished the family. The best homes were usually the older log houses, and at this date the tar paper shanty was uncommon. There were around these log houses many pleasant things including much that was beautiful; for those who like open fires, hounds, children, human talk, and song instead of TV and radio, the wisdom of the old who had seen all of life from birth to death, none of it hidden behind institutional walls, there

was a richness of human life and dignity seldom found in the United States today.

No hill community is or ever was a homogeneous unit of society. Families with enough good land for corn to fatten hogs, cattle and sheep on the open range, might, and on the whole did, live with a fair degree of comfort. It was almost invariably with such families or at least among the more prosperous in the community that I and other teachers boarded. The very poor we seldom saw. Their children did not come to school. Even among these the poverty of our great cities was not there: a man did not need money to keep his family warm when all around was wooded land; a good diet that meant biscuit bread for breakfast with meat and milk the year around was often lacking. Yet, in spite of poor nutrition, hunger to the point of starvation was not for the small hill farmer.

There are other kinds of poverty. Bare feet on the school paths in November often accompanied a full lunch pail; nor did the complete lack of children fitted with glasses mean that all had perfect or even good vision. Food they could grow; shoes and optical fees they could not. They could not even dream over shoes in a mail-order catalog, for even then in the booming twenties mail-order companies wasted few catalogs on back hill people with no cash.

Self sufficient as the average, hard-working hill family was, it could not live entirely without "cash money." The big problem was getting it. Even a farmer with corn to fatten hogs still had to drive them many rocky miles to market, the animals losing pounds on the way. All the sources of petty cash open to families such as my own around Burnside—the sale of eggs and poultry, dairy products, vegetables, the shipping of cream—were not to be found in the roadless, marketless hill community. Industry was nonexistent; saw and stave mills had long since gone with the timber as had the tanbark industry. Even the hewing and selling of cross-ties, a part time occupation for many more fortunately located small hill farmers, was out of the question in the roadless community; this was a world of one-horse or more accurately one-mule farmers with sleds.

There was a way to turn corn into cash, through a product easily transported by mule-back—one good mule load would put shoes on the children, pay the taxes, and buy a trinket for the baby. Knowledge of how to change corn into this product had been handed down from father to son for generations. Long ago the ancestors of hill men had made from other grains this same product in Scotland and northern Ireland; other ancestors

had made it on the borders of the colonies. This easily carried, nonperishable, always-in-demand product was whiskey.

Stills had come into the hills with the first settlers, and save for a few years before the administration of Jefferson, stilling was just as legal as making soap or weaving cloth. It was only a way for the farmer to change a raw product into a manufactured article and so make a little extra money with his work. The old ones had looked upon whiskey as a necessity, not a sinful luxury. The soldier of 1812 had a ration of a half pint daily; whiskey in the average hill home was for more than a hundred years the most common drug, used for everything from snake bite to breaking out the measles.

Gradually because of heavy taxes on the mere ownership of a still, which the small distiller producing at most only a few hundred gallons a year could not afford to pay, the distilling of whiskey as a legitimate occupation began to disappear from the hills, and in Kentucky the making of whiskey centered more and more among the great distillers in the Bluegrass. The long fight to be rid of the little distiller in the hills did not, however, begin in earnest until late in the last century, and even then it was not always wholehearted. Local opinion changed slowly. Most for many years considered the whiskey taxes unjust, and more than one moonshiner from a rural Kentucky community was elected to public office while serving time.

Local sentiment slowly changed, and well before Prohibition many hill counties were officially dry. The fight to do away with the moonshiner was intensified, grew bitter, sometimes bloody. Too often the hill man could see nothing morally wrong in making and selling a product his grandsires had made—provided the whiskey were good. The arms of the Federal Government, even after Prohibition, were not then so long and strong. This meant that enforcement of the law continued in the hands of local men—the county sheriff and his deputies. These men, the upholders of law and order in much of the rural United States, even now should not be thought of as trained law enforcement officers, objectively going about their work.

The high sheriff to begin with was an elective official; his deputies were appointed; none in the 1920s and 1930s trained, many unpaid, often serving because of some personal interest, sometimes a grudge, in catching the distiller. Thus, the apprehension of suspected moonshiners in many regions degenerated into a lawless manhunt, blackened by hatreds. How many

murders were committed in the name of law enforcement in the whole of the United States is a question. The answer has interested few. The difference between rural East Kentucky and the rest of the United States was one of degree, not of kind; for, different from the law enforcement officer in England, for example, the American officer, trained or untrained, elective or appointive, is armed.

Seas of poisonous whiskey, an increase in drunkenness, and other developments, usually not the fault of the small illegal distiller, stiffened public opinion against him, and by the late twenties he was being hunted down with unusual bitterness. Yet, whatever happened to him, the hill moonshiner was ever an individual, never organized as were the rumrunners and set-distillers in and near the cities. Unorganized, poor, remote, the back hill distiller-farmer never had his way smoothed by expensive lawyers, paid police protection, or the influence of politicians in high places.

He went it alone and it was a hard road, usually with death or imprisonment or both at the end. *Mountain Path* was not an apology for a moonshining family; it tried to be only a story, but in writing it I often wondered why the small moonshiner making honest whiskey from his own corn was so mercilessly hounded while the city gangster dealing in a thousand times as much so often went free. Possibly, if writing the work now, I might choose less violent action. I don't know. In a way I am glad I wrote of the old fashioned moonshiner. He was part of the world of the backhills I could see from Tyree's Knob.

The hills are still there—that is most of them—though strip mining and super highways have taken their toll. Yet the rich life of the twenties and thirties that revolved about the communities in the shut away valleys is gone. One can walk for miles and miles through the upper reaches of the creek valleys above Smith Shoals on the Cumberland—or rather where Smith Shoals used to be for the old river like the lower reaches of the creeks is now deep under Lake Cumberland—and find only tumble-down houses, often the chimney alone, a rusted post-office sign wind-lodged in a young pine tree, or a leaf-choked spring, around it scattered blocks of stone to remind the passerby that once a springhouse stood there.

This is the hill community after the Great Migration that began with World War II and continues still. Population in the United States as a whole has in the last two decades shown a prodigious increase; that of most counties in Eastern Kentucky has shown an even greater rate of decrease. There have been other changes, the beginnings of which one could see by

1933 when *Mountain Path* was begun—the Cumberland National Forest, ·
WPA roads, more federal funds for county health and agriculture, hope of
electricity. The things of which I had dreamed for the hills were coming to
pass. There were other changes. These more or less paralleled those in all
rural regions of the United States; improved roads and increased use of the
automobile tended more and more to destroy the rural community, still
too backward to attract industry of its own and so stay alive. The one-room
school was consolidated, and the little church when compared to that in
the town now easily reached by automobile seemed a poor thing. The
needs of the people were being met, but they were no longer there, for the
most pressing need of all—some means of earning cash—never came to the
back hill community.

This one great need was already destroying the world I saw when I
taught my first school. Not all those who went away to work came home
again. Well before *Mountain Path* was written I knew in Louisville and
later in Cincinnati a good many of the transplanted people. Some were the
sons and daughters of little farmers in the hills; with no land to farm they
had turned to industry during the booming twenties, and stayed on
through the depression chiefly because back home there was nothing for
them. Most, however, during the thirties did come back to the hills, so
that school enrollments in many eastern counties increased during the
depression.

The going out during and after World War II was different; the average
man did not stay a few months and come home again. Instead, the wife
and children followed. The Great Migration twisted, and possibly
wrecked, my old dream. At a very early age I saw much of life in terms of
roads. Possibly this was because of the very poor road to the family home
on the hill above Burnside. *Mountain Path* I originally called "Path"; edito-
rial opinion insisted on the other title. My next work on the hills, roughly
planned at the time, but never finished until many years later when I was
settled again in the city—this time Detroit—was the story of a hill com-
munity near the end of a graveled road where the outside world was bring-
ing change to the home community and at the same time taking men and
families away. This manuscript known as *End of the Gravel* was by editorial
opinion changed to *Hunter's Horn*—and many were the disappointed read-
ers; they had envisioned from the title red coats and high life with a saddle
leather smell only to find the central family with one old mare and not one
good saddle.

The last fiction centered on a hill family began where the graveled road led onto the highway, and ended in a wartime housing development in Detroit. The title, *The Dollmaker*, was of my choosing. The hill community near the highway was gone. Thus, *Highway* seemed no fit title. *Dissolution* would not do. A combination of war and technology had destroyed a system of life, but the people were not all destroyed to the point of dissolution.

Thus, the world I first saw in the summer of 1926 is gone; more completely vanished than ancient Greece and Rome. Different from Pompeii under the ashes, it cannot be excavated and recreated. Pine and sassafras roots destroy, instead of preserve, as do ashes; and anyway, who can excavate a fiddle tune, the coolness of a cave now choked with the water of Lake Cumberland, or the creakings and sighings of an old log house?

HISTORICAL SOCIETY OF MICHIGAN, THE CLARENCE M. BURTON MEMORIAL LECTURE, "SOME MUSINGS ON THE NATURE OF HISTORY"

This article, which is the substance of the 1966 Clarence Burton Memorial Lecture, was delivered by Harriettete Simpson Arnow at the 94th Annual Meeting of the Historical Society of Michigan held in conjunction with the Michigan Museums Conference at Kalamazoo, Michigan, on Friday, October 18, 1968.

The occasion was a memorable one, heightened by Mrs. Arnow's marvelously evocative account of the changing scene in Michigan over the last few decades. A novelist of note, she brought a delightfully different perception to the acute problem of the encroachment of the urban sprawl upon the virgin land.

A native of Kentucky, but transplanted Michigander, Mrs. Arnow is probably best known for her *The Dollmaker* but *Hunter's Horn*, an earlier novel of her native region, is a favorite of many.

Maurice F. Cole
President, 1968-1969

I am not exactly a historian. I have at times pondered on: "What is history?" Such answers as I have came late in life.

Beginning somewhere behind memory, stories of the "old days" as my people called them, were a taken-for-granted part of childhood. They were of all kinds and ages, some going behind the French and Indian War. Yet, I never thought of them as a form of history; history was in the books I would read when I was old enough. I remember no consciousness of learning as I listened; rather, I recall emotions, a sense of belonging, and curiosity. Still, those old stories have lived with me all my life.

I also, beginning before school age, quite often visited a museum. I did not recognize the place as a museum. Neither did anyone else. It was the home of two elderly ladies, cousins of my then dead maternal grandfather. If yet alive, the women would be many years past a hundred.

Built in the days when people wanted plenty of room, the home was large with window shutters, gingerbread, a great variety of gables and verandahs. The interior was still more fascinating, crowded as it was with all manner of furniture and bric-a-brac. Much of this was the accumulation of generations; the rest was what the present owners felt was necessary to a truly Victorian atmosphere.

The ladies worshipped good Queen Victoria. They knew but did not quite comprehend she was long since dead. These cousins were for me the most interesting parts of the museum. Human beings, for example—I am uncertain of horses and cattle—never had legs, only limbs, that is for well brought up females such as they, who also always used the proper title in referring or speaking to husbands; in that household, Reverend and Mister.

On this particular day I was invited to sit on a sofa in "the little side room" where children, close relatives, and neighbors were received. I had never before sat on that particular sofa; and as I was wearing the customary dress-up clothing of that time and neighborhood—socks and a short, full-skirted dress of some thin material such as organdy or dotted swiss—I at once began to feel a most unpleasant, scratching prickle wherever my skin touched the sofa. Particularly bad on some old chigger bites, I had great trouble in sitting still. I tried with one hand a cautious exploration of the sofa to learn what ailed it.

Cousin Mollie saw the motion, mistook it for a love pat of the sofa, and, being a kindly soul, began on its history. The covering was horsehair; her father had bought it while on a business trip to New Orleans, around 1840; he had brought it home by steamboat—after changing boats at Nashville.

And while I tried to sit still on the sofa, she talked on of the Cumberland; told of how if there were no good fall rains, and hence no "Christmas tide," holiday fare would suffer. There would be neither bought candy nor sugar for home made; no oranges or other treats, and of course no dolls or toys. The Southern Railway had not reached our part of the world until 1876. Through all those years, and for many after, the Cumberland had been the main route to the wider world—this meant we would not look north into Central Kentucky, but south to Nashville, Memphis, and New Orleans.

I listened, not too interested. I was wanting to ask how horsehair was made; were the horses shaved or was only hair from manes and tails used? My mind was always going off to such questions, but seldom could I learn the answers, especially for those dim times before our people had fought in the Revolution then crossed the mountains.

I comforted myself with thoughts that when I studied history in school I would learn how ordinary people such as my own had lived. That day never came. I studied a good deal of required history, including that of my state, Kentucky, but found no answers to my wonderings on the day to day lives of the average early settlers. I knew, at least for my forebears, there had been more to life than Indian battles and nettle bark petticoats—but considerably less than mansions and blooded horses. There seemed no middle ground.

I told myself that in later years when I lived near large libraries I would learn what I wanted to know. In time, I found many good books but never the one to answer my questions which had multiplied as I grew older. One reason for the added interest was the visiting of family graveyards and the sites in an adjoining county where great-great-great grandparents had lived.

Sometime during my later college years, a dream began to haunt me: I would write the book I couldn't find. I don't know when research began; I do remember that while at the University of Louisville I now and then took time from work and studies to see what I could find.

It was also during college that my world broadened. It is now getting on to forty years since I took a summer's job in a small resort near Petoskey, Michigan. I found myself in a delightful world of blue water, blue skies, white birches, stump fences, swamps, and with leisure to enjoy it all.

Guests, not then referred to as tourists, came usually by train for a stay of one to several weeks to swim, fish, go boating, walk in the woods, and in general soak up the atmosphere of the place. There was canoeing by moonlight, an artesian well, lake trout and white fish bought fresh daily in Petoskey, and, what for me was a great wonder, a display of northern lights now and then. I also saw my first Indians; they brought to the inn for sale beautiful handiwork, especially baskets and moccasins; they also picked and sold the little wild red raspberries.

Best of all were the people I got to know—owners, workers, and guests, many of whom were from Michigan and through them I learned something of the many ways of life in the state.

I enjoyed the place so much that three years later after having taught two years in a small high school, I again asked for a job. This time after the resort season was ended, the owner very kindly offered me, rent-free for some weeks, one of her cottages. There, I could write in peace and quiet. The urge to write had grown ever stronger; I had decided to quit teaching, at least for a while, and give the most of myself to trying to write. So, there in a cottage among the birches by a lake, I worked on what was to be my first book, a novel of life in the Kentucky hills.

My old dream of writing of the first settlers in our region was not dead, but at that time research was out of the question.

In the meantime I had, beginning with my first trip to Michigan, visited a close relative living near Detroit; and so became acquainted with the city and the surrounding country. An especial attraction was Ann Arbor. My awe of the University of which I had heard so much was almost matched by delight in the tree-filled town with its stately homes; and all around it the farmers' fields in which cattle grazed almost to the city limits.

Better yet were the farms out from the town. They appeared prosperous, happy, stable, their many buildings stood like small villages separated by broad fields. The silos rose highest, but the great hip-roofed barns were the dominant feature. I could read the dates on many—1908, 1914, 1927; nice to know they were not old, and so would be there a long, long time as would the older stone or brick smokehouses.

Years passed. I published. I married. My husband and I were caught up in what now seems stupid nonsense, the craze of "getting away from it all" that affected many during the depression. We were going to write and subsistence farm.

Thus, 1939 found us living in an ancient log house in the sheltered valley of Little Indian Creek of the Big South Fork of the Cumberland. World War II was raging in Europe; but as there was yet no great upswing in manpower needs of the United States, the remote community remained unchanged.

Much older than when I first sat on a horsehair sofa, I realized that about me was a living museum; a very different one from that of the elderly cousins, but with even more to learn. These people, though literate, many highly articulate, lived largely by learnings handed down through the generations. Even the seed they saved from year to year was probably descended from some brought over the mountains. My wish to write a factual account

of the first settlers grew stronger than ever, in spite of the fiction I was then trying to write.

Yet, I wanted the work to be as honest as I could make it. This meant that such facts as I put down would have to come from sources contemporary with the pioneer. I could not then even think of research. And without authentication, I could not say the herbs some gathered, the roof boards others rived, their farming methods, and many other facets of their life patterns had any kinship with those of the pioneer.

World War II took the world by the hair of the head. One small hair was that shut-away, farming community. There had been in that long valley eight families with more on the ridges above. Early 1945 found the valley deserted; the armed forces and jobs had taken the people.

My husband returned to his former work of newspaperman, though in a different city—Detroit. There, I could look forward to research—when the children were older, when the fiction in which a publisher was interested was finished, when, when? I only, for several years, managed to get in some background reading.

I also tried to learn something of my new homeland, both by reading and looking. We as a family explored Detroit, and acquainted ourselves with some of her institutions, including libraries and museums. The end of gas rationing permitted us to spend weekends, and sometimes longer periods, getting acquainted with the State of Michigan.

One of our favorite short drives was into Ann Arbor and the surrounding country. In spite of time and war, that world had changed but little, or so it seemed. The University was bigger, more traffic in the town, but blind-folded justice still held her scales above the old courthouse with its worn stone steps and elm-shaded lawn. Ann Arbor yet had her trees, though farmers' fields no longer ringed the town. I noticed, too, especially on Plymouth Road that several barns appeared deserted and neighboring silos roofless.

Yet, only a few miles away from Ann Arbor the world of big barns, well-kept homes and fields still spoke of abundance and peace, but above all stability. The only real change noticed was the displacement of work horses by tractors.

In spite of working in Detroit, my husband again wanted a place in the country. Early 1950 found us buying a forty-acre plot a few miles north of Ann Arbor on a gravel road. The land had once been a small farm with a number of outbuildings; all, save for a chicken house, marked only by fallen down boards and bricks.

Yet, much remained: ancient fruit trees and a large grape arbor with flowers and shrubs all over. Many of these, especially lilacs and bush honeysuckle, had escaped to grow along the road shoulders with the wild grapes and raspberries, alders, swamp dogwoods, and other native shrubs and vines. Also flourishing in the never-plowed earth of the road shoulders was a succession of wild flowers beginning with marsh marigolds and ending with purple asters. Sometimes equally beautiful were the field flowers in the fence rows and scattered among the grass and clover of the pastures that adjoined our place.

The country roads with little traffic were a walker's or biker's delight. Shaded in summer by great trees, with the heavy undergrowth to serve as snow fence in winter, the gravel roads seemed particularly beloved by wild things. Seldom did we go on them, even driving, without seeing pheasants, quail, many smaller birds, and squirrels, an opossum, or a muskrat.

Our fields, woods, swamps, and ponds were, like those around us, a reservoir of animal and plant life native to south central Michigan. It was in our woods I learned the beauty of a hawk's flight, and their troubled cries when danger came near; a family nested in a tall, broken topped maple. One morning at first light a buck, doe, and fawn sprang up in the lower lawn and went racing away. Often at dawn I would see a Great Blue Heron flying low above the tree tops on his way to feed in some nearby swamp.

Surrounding us were the farm communities, real worlds built through the generations by people for people. Inhabited chiefly by prosperous, up-to-date farmers, they seemed as secure, as stable as the big granite boulders along our back fence.

Our younger child came of school age at about the same time as I got the manuscript of a third novel in shape to show an editor. These events meant that such time as I could steal would go to research on the work I had thought on so long it had worn tracks in my brain. I had already done enough preliminary research to get at least some idea of the job ahead. In time, the story of the horsehair sofa had made it clear the Cumberland River had tied the first settlements in my part of the country together. No one of them, not even Nashville, had stood alone.

I was more than fortunate in being close to exceptionally fine libraries. Better, I was permitted to use them, even allowed to take all manner of books home. I was happy in the hunting, always hunting the little things: what texts had the school children used; how was gun powder made; how

did they drill for salt; how had they spoken; what drugs were frontier doctors prescribing around 1800?

Often the answer was found in the microfilmed Draper Manuscripts in the Burton Historical Collections of the Detroit Public Library; sometimes in the North Carolina Colonial or State Records, or some other document available in the University of Michigan libraries.

Other answers had to be searched out in county records, letters, store accounts, court proceedings found only in Nashville or some Kentucky county courthouse. Museums were also of vast help; all kinds in Tennessee, Kentucky, Virginia, the Carolinas, Maryland, Pennsylvania, Washington, D.C., Quebec, Ontario, Nova Scotia—and of course Michigan. In the early years, for example, flax was grown and made into cloth as far south as Nashville; yet, the only display of the various steps in the early manufacture of linen was found in the Detroit Historical Museum.

And so the years went: research, typing up notes, background reading, correspondence of all kinds, cogitation on the arrangement of the whole, plus the usual housewifery along with gardening, chauffeuring, and this and that. Much of the time I was buried in the past; even when gardening I was not so much setting onions or tomatoes as an archaeologist digging up Michigan artifacts—if a shard of blue crockery, the twisted copper of what has been a silver plated spoon, or pieces of a heavy iron cook stove can be called artifacts. The deed on the land went back to the eighteen forties, and the garden was a rich storehouse of reminders of the years between.

There were also rusted bits of farming tools. I could make out the remains of axes, hoes, plow points, and rings that might have been parts of saddle or harness gear. Other pieces, often crumbling when dug up, remained unsolved mysteries. Through the years the turning plows of the big borrowed tractor brought up six long, pointed pieces of iron. I thought for a long time all were bayonets, but as I studied them I grew less certain.

A trip to the Detroit Historical Museum, plus the knowledge, time, and trouble of people there, revealed that only one was a Civil War bayonet; another could have been a pike head, though there was no certainty—understand the pieces were not only badly rusted but bent in the plowing up—of another there was no idea what it had been; the remaining three were thought to have been tent stakes, ice spikes, or surveyors' stakes. That was for me an excellent lesson in the danger of jumping to conclusions.

This mistake didn't keep me from thinking that if I had a real Michigan background in history, agriculture, and several other disciplines, I would

do a social history of a piece of land and the people who had settled it; or, given sufficient talent and knowledge, some author could make a wonderful novel of the building of a Michigan farm.

My own work covered with some degree of intensity a period of less than twenty years, but required two large, tedious, benoted tomes. By the time the manuscript of the second was ready for the editor, our older child was in college, the younger in high school. I had been so lost in family and the past that coming out of them was like walking into a different world. There was a great change in the seemingly unchangeable world of Ann Arbor and the surrounding farm lands. Yet, for the most part I had known these changes as purely intellectual learnings, though they had touched my life in many ways.

We no longer, for example, biked or walked on our gravel road. It was now only something to take you and the car where you had to go. The road was also a place where I went at intervals to pick up the trash, chiefly empty beer bottles and cans, the speeding public threw in front of our fence. The road was now a barren, ugly place, unshaded in the summer's heat, ice-choked in winter. Increased traffic had called for a widening; many of the elms had already died; the widening took all the locust, most of the maples and oaks along with other trees on the road shoulders; weed killer had taken not only the flowers but also the wonderful assortment of native shrubs and vines up to and beyond our fence. Two or three years later poison ivy, coarse grass, and a tough variety of goldenrod began to take over the barren spots.

Drouth plus strains on the water level caused by nearby industrial use, along with city drains, now less than a quarter mile away, had more or less dried up most of the ponds. We no longer saw ducks, not even in the bits of deeper water remaining. They probably avoided it because of the oil scum. The business route of U.S. 23 now ran through the swamp; though the throughway was some distance from our land, the swamps connected, so that even before the road was ready for traffic, oil seepage from the construction machinery spread all over. No more wild geese resting on migration flights; no more Great Blue Herons feeding, or little fishes, or the cry of the loon we had used to hear from the dark recesses of the swamp. There were no longer dark recesses. The superhighway route was wide.

The hawks were gone; killed or moved we did not know. I realized it was a long time since I had heard the screech owl who had used to give nightly serenades. And when had I heard quail, or the calls of the cock

pheasants in the spring dawns, or seen an opossum, or skunk, or deer? Instead of wild life we had stray dogs and cats from the subdivision, now only one farm away.

I never knew the sequence of events. One morning in spring there were tractors in an adjoining field instead of cows. The dairy farmer who had rented the field for pasture had sold his farm and moved away. The local school district, like many around, in order to assure its children of a high school education had been forced to become part of the Ann Arbor School System. This meant the end of the one-room country school as well as most of the field flowers.

School taxes were raised to the same rate as those in Ann Arbor that went higher and higher. At about the same time Ann Arbor went into a population and building boom. Land values had so risen, reevaluation of township properties was called for. Farmers living miles away from the high-priced land gone into the town, had their land evaluated, not on its worth as crop land, but on what it might possibly bring when and if it were wanted for a subdivision or a factory site.

Taxes climbed, not by hundreds, but by thousands of percent. The land owners, and all around us were long-time farmers, some heirs, could no longer afford to rent for pasture; with taxes running at twenty dollars per acre per year, they had to get all they could from the land. They rented their fields for crops, usually to men with a great deal of equipment, and who lived elsewhere. These men with all that expensive machinery, also had to earn what they could. Herbicides were cheaper and more efficient than cultivation; like those on the road sides, their chemicals left the tougher, coarser plants, but the variety was gone.

Yet, I saw all this—for years—only in fragments. I knew the township was growing smaller, the city larger, more choked with traffic, trees cut as streets were widened; many buildings had been demolished including a beautiful church, and the courthouse. This had been replaced by a huge, shiny box of a "county building"; and, alas, with no justice on the roof. By Ann Arbor's streets, along the country roads and fence rows, the bleached skeletons of dead elms stood to remind one that, though modern man might get to the moon, he could not save his elms.

I saw it all, but never quite comprehended until a barn told me. This particular barn with its twin tile silos and cluster of smaller buildings, I thought of as "The brave old barn." The last barn between us and Ann Arbor, it stood near the now-paved end of our gravel road; a research plant

now stood in front of it, a subdivision with the beginnings of a shopping center on another side.

On this day I first noticed the pile of weathered lumber. The barn appeared smaller. It took me several minutes to realize it was being torn down. A kind of panic seized me, though I had known barns in many places were either fallen into shapeless decay or torn down. There had been none destroyed in my immediate neighborhood; there, even a few of the older, lower, single-gabled barns could still be seen.

Yet, I knew that on the whole the great, hip-roofed barns of the south central Michigan multipurpose family farm were disappearing, and not because they were old. Would such barns ever be built again? Was there in this age of specialization any need for such barns? Certainly, the new barns would not have foundations of hand-hewn granite field stone, or be framed with notched and pegged timbers, many of which had been hewed with a broadax. And above all were there men left who could plan and build such barns? And from where and what had they taken their patterns? The neighbors' barns I had visited, though showing kinship, had each a person-ality all its own. As a group they were reminiscent of, yet very different from, barns seen in Pennsylvania, New England, Ohio, parts of Canada, and other places.

Later, I went down the road to pester with questions, as I had done so many times, the Ormond Kapps. Though younger than I, they had lived on their nearby farm all their married lives, and were descended from early settlers. They knew the local history.

History? And what was history? Something not for people as blind as I had been to change. This immediate Michigan world was only part of it. The small town I had known as a child was now mostly buried under an artificial lake; once familiar hill communities were now vanished along with their one room schools and post offices; the main building of the summer resort near Petoskey I had so enjoyed was still there, but so changed by different owners to meet new demands of the public, I scarcely recognized it. Cities I had known well were like Ann Arbor—strange places in which I could scarcely find my way without a map.

And through it all I had not been the complete intellectual hermit. I had through the years read a good deal about our dwindling farm popula-tion, but had confused change with empty dwellings. Around us there were no deserted homes as I had seen in Kentucky, other states, Mexico, Nova Scotia, Scotland, and Wales—farm homes of people who left the land

because they could no longer get a living from it. And the land lay there with the buildings open to the sky. Various United States publications had given much space to poor subsistence farmers, especially of the South, who, forced to leave the land, choked our inner cities as they hunted jobs.

The disappeared farmers around us in Michigan were anything but subsistence types. When their children left the farms, as they often did, they went first to college and or university, then into some profession. Their children could never know the kind of farms their fathers had known as boys. That farm would be a part of history.

I at long last had learned that history, whatever she is, does not always make headlines; nor does she tap one on the shoulder and say: "I am history. Look at me as I pass by." Changes in agricultural patterns, plus the ever-increasing demand for farm lands both for public and private use are probably affecting more lives than the headlined stories of riots, invasions, earthquakes, floods, and tornadoes. The revolution in farm life came quietly with no violence, no hint of evil. All from the laws on dairying to the trillium dead from weed killer went with the wheels of progress.

I tried to comfort myself with thoughts: the Michigan farms around me were by no means extinct; and should they be, the memories of many would keep them alive. But people died as had my own, and took their memories with them. Did we need memories? Michigan, more so than most any state, gives attention to agriculture and the farm family, with goodly representations of its past both in publications and museums.

Still, I had lived surrounded by a living museum and in the midst of what for a few years amounted to a wild life preserve. I had enjoyed that world, but my awareness of its destruction had not penetrated.

I could never comprehend the really big things. I had not even been aware of all the little changes, the little things—only those I had literally felt as I had the horsehair sofa, or emotionally like the sight of a barn being torn down. Why? I had never been in that particular barn. Yet, it had become part of my life, a landmark to admire and love.

And so another partial answer came of: "What is history, at least to me?" Study and appreciation of the past are not always purely intellectual processes. History for some of us is a shy girl, not coming close unless she can be certain of some kinship, some common bond, some self-identification with her.

Take, for example, a Middle Westerner of non-English ancestry with some facet of the lumbering industry in his background. He will at the

restoration of Colonial Williamsburg learn a great deal, more if he has not forgotten early colonial history. Much of his learning, however, will be purely intellectual, a gleaning of facts. He can identify neither himself nor his people with any of it. A walk among the Hartwick Pines, followed by a trip to the museum of logging equipment may yield few facts he does not already know; he may not even remember to take notes. More important he has found a kinship with the past. The great trees and the machinery were part of the past of his people, and so become part of himself.

Another, with a military background, might be more interested in Fort Wayne. Most any urbanite and many from the country will find much to awaken memories of their own past or the stories of older ones in a series of three films called "When Detroit Was Young," or another, "A Guest in Detroit," made up of selections from the first three. Made possible by the Burton Abstract Company, the work was done by James Babcock, John Creecy, and Al Jacoby with material from the Burton Historical Collections.

All kinds of people find themselves or imagine themselves in the world of a good book. Such a one is *White Pine Days on the Taquamenon* by William D. Hulbert. Published by the Historical Society of Michigan, it is in one sense a collection of stories concerned with different aspects of lumbering in the early years. Yet, for me at least, the stories created people, places, woods, an especial pine tree. Information was by no means all I got from the work. One wishes our Michigan school children had in their texts excerpts from this book, and others telling of the people who literally built Michigan.

This, to me, is one of the more amazing feats of Michigan's historical organizations, museums, and libraries. They have made it possible for the public to learn that famous generals and statesmen alone did not make Michigan. This was done in many places by all kinds of people. Your publications, films, lectures, museums, and bibliographies have place for the miner, the lumberman, fisherman, sailor, farmer, industrialist, shopkeeper, religious leader, soldier, professional, and many others. The opportunity for the general public to learn is important, but equally important are the many who get some measure of self identification.

My experiences as a child, mother, and teacher indicate that children in particular need to identify a place or person with the past; the more familiar the place or person, the close, I think, the past becomes. I am not certain the average young one saluting the flag of the United States, can

comprehend his country. Is it for him Washington, D.C.? He may have many facts in his head, but when he speaks or is spoken to of patriotism and love of country, what thoughts, if any, come to him?

The bigness of his world needs to be whittled down. As a beginning he should have something smaller, more intimate: the closest museum of history, a film or story of the old days in an industry of his neighborhood, or any other means of making him aware his particular place has a history; and that the trigger-happy men he sees on commercial TV Westerns were not the only ones to make history.

I wish the history of Michigan were a required subject in all our schools as is United States history. I also wish children could learn of their cities, towns, county seats, townships or of whatever place in which they happen to live. Let their first geographies be a map of their town or a plat book of their county. I wish we could see more state flags, state mottoes, state flowers, and wall maps of Michigan. I would like to see Historic Michigan, the map published, as you know, by the Historical Society of Michigan, in every elementary school room and in many classrooms of our secondary schools. An early awareness of local history would, I believe foster, not only interest, but also a sense of belonging, of being part of an important place—the child's neighborhood. I think this is one of the first steps toward good citizenship.

The child, and often the adult, needs a bit of orientation on who does what. With the national flag flying from the school, the post office, the recruiting station, as well as the county courthouse, some, particularly children, get the idea the federal government supports and supervises the school as it does the army. State flags on state and local institutions could help the child understand his nation rests on the states. He is part of a state. He belongs.

I feel one way to give many of us a sense of belonging would be a living, working museum of some general purpose Michigan farm as it was fifty, or even only thirty, years ago. We in Michigan represent different regions, nationalities, religions, races, and economic backgrounds; yet at one time or another a great many of us or some ancestor knew the problems and pleasures of making the earth produce. This is probably our most common heritage.

I apologize for wishing for a living museum when Michigan has among many other reminders of our farming past the Waterloo Area Farm Museum. Thanks to the Michigan Historical Commission and the

Historical Society of Michigan, well over two thousand Centennial Farms are now marked.

I have spent too much time bemoaning what is gone and going. Rather, I should thank the many historical associations in Michigan and all those who have helped preserve the past through their work and donations. I am familiar with only a part of what they have accomplished, but that part has meant much to me.

FICTIONAL CHARACTERS COME TO LIFE:
AN INTERVIEW

CONDUCTED AND TRANSCRIBED
BY HAEJA K. CHUNG

I talked to Harriettete Simpson Arnow at her farmhouse on Nixon Road in Ann Arbor, Michigan, on 27 August 1983. Her husband, Harold, was present. The interview lasted about two hours and basically concerned her novels. Mrs. Arnow was 75, hard of hearing, and occasionally apologetic for digressing. But her sincere and patient answers to my questions provided great insights, not only into her books and writing process, but also into the personality of this author who genuinely respected her readers. The interview gave me the tantalizing pleasure of being shamelessly nosy and gossipy about people who were fictional, but more real than my next-door neighbors. I was so mesmerized by the reality of the fictional world that the end of the interview came as a rude awakening.

I often referred to a telephone interview I had with Jane Fonda on 7 July 1983 about her television film based on *The Dollmaker*. The Arnows had just come back from their yearly trip to Kentucky, and so the conversation began with the trip.

CHUNG: When you go to Kentucky every summer, how long do you stay in Kentucky? About two weeks?

ARNOW: Yes, about that.

CHUNG: What do you do?

ARNOW: In Kentucky, I teach in a writers' workshop. I also visit relatives and the little town I grew up in, Burnside. The business section, the lower town, was destroyed by a lake the army engineers built; it's kind of pitiful. There are not many people left now who knew me or who might know . . . there are not many left. It was on the Cumberland River, and I loved the

river, but the river's gone; there's just a still lake, dead. Sad. Well, I suppose you could call it "progress," but it did destroy all the industry. So they did make a farm into an island. The town was Burnside . . . Burnside Island I call it now. But not too many tourists come to that particular place.

I enjoy going back, yes. My husband and I have talked about spending the rest of our old age down there, at some place in the deeper South. In the winter of 1982-83, do you remember all that, with all the snow and the ice? We could not decide whether we wanted to go to North or South Carolina; we didn't think we'd like Florida, Texas, or California. Then this last winter, we had no winter, so [we stopped] our talk about our moving to North Carolina or South Carolina, which would be close to my relatives in Burnside. I have a brother and a sister. The sister is retired; she worked as a librarian for many years in Cincinnati and the brother is a great deal younger than I am, but he is not yet retired.[1]

CHUNG: On the phone, your husband told me you don't care what they do with the movie.

ARNOW: I have nothing to do with it, you know. I don't even give advice or anything. They never asked. In the last letter I had from Jane Fonda—came this week I guess—they are finished with everything except maybe some polishing. They hope to show it in the early autumn, but because of these Olympics—wherever they are, I don't know anything about them—it may have to be held over until later.

CHUNG: Somewhere I read that you don't understand why *The Dollmaker* became so popular.

ARNOW: No, I don't. Well, look at it. Have you read the book?

CHUNG: I've read all your novels, but I haven't quite finished *The Weedkiller's Daughter*.

ARNOW: I wouldn't read that. It was less well-reviewed than any of my other novels.

CHUNG: What about *The Kentucky Trace?*

ARNOW: That had excellent reviews. I wouldn't waste any time on *The Weedkiller's Daughter*. Well, I thought it was as good as any of my other books. In fact, when it was published I had more hope for it than I had for *The Dollmaker*. Who wants to read a book about a big ugly woman [deliberately thumping the top of the coffee table emphasizing each adjective]

who is almost inarticulate, so she drove me crazy when I was writing about her? I wondered why I ever thought up such a creature, because she couldn't express herself except through thinking of passages from the Bible, and I had to rely on the Bible and the stars and all manner of things, and she was also secretive; she wouldn't tell her husband about the money she saved and so on and so forth. I wasn't sure anyone would want to read the book. I still don't know why.

CHUNG: But how did you create such a person? She is so real.

ARNOW: It was a tremendous task. Time and again I would want to throw Gertie away and think up another character. The other things like coming to Detroit or any industrial center from the hills, I would have kept that. Why I dreamed up a woman like Gertie I never knew. And I thought the reader would get as impatient with her as I did at times. And also I had already been criticized by one or two reviewers who said I was afraid of sex and there was no sex in Gertie. But I figured that any woman who had had five children must have had some sex life, so why discuss it?

CHUNG: But have you ever met a woman like Gertie?

ARNOW: No, I often look for a woman like Gertie. I can see her, part of her with that straight pulled-back hair, and big and raw-boned, and not beautiful. I think I mentioned somewhere that she had grey eyes and that she was sunburned at the beginning of the story and her hands showed a sign of work. But in a way very much alive, except she was a coward. When it came to her mother and opinions of the neighbors, she would never talk to anyone of her image of Christ because it didn't go with the fundamentalist—I guess that's the right name—the religion her mother and most of her neighbors had.

I don't think I could write about real people because I don't know what's going on in their minds or how they feel about certain things or their least actions. You have to follow them for years with a camera and then you would know as much as you know about an imaginary character when everything's in your head. So I never tried it, though I have known women from out of places like back hills and around.

CHUNG: When I asked Jane Fonda why she wanted to make a movie out of the book, she said, "Because of Gertie . . . I admire her so much."

ARNOW: I don't know. I begged Jane Fonda not to do that scene with the mule at the beginning. I'll show you, I have photographs of Jane Fonda in

the film. I told her it's very dangerous; a mule bucks at anything; a mule is not as predictable as a horse. But she said no, she wanted very much to play the scene. She liked it. I'll get the photographs. [At this point, her husband changed the batteries in her hearing aid, and she said she could hear much more clearly.]

CHUNG: Is there any incident and time that inspired the story of Gertie?

ARNOW: Well, as a teacher in a one-room school in the back hills, I knew many women—I don't like the word "back hills"—but they were more than rural people; they lived shut off from the outside world—I knew many women. I often thought about them—well, in my first book, I wrote a bit about women in the hills, but it wasn't until World War II and I found myself living in a Detroit housing development [that] I began to wonder.

You see, at that time, all through the sixties and into the seventies, there were heavy migrations from the South and the southern part of the Appalachians, and many rural regions. Because of the Manpower Act, partly, they needed men, and women, too, in the factories to turn out war material of all kinds almost as much as they needed soldiers. And I knew that many of those women, all of them eventually, had followed their husbands to war jobs and I wondered how women, who had never used a telephone or seen or used any appliance run by electricity—-in the housing development, everything was electric; oh, I think the hot water heater was power or gas, I'm not sure—and I began to wonder how they would—I use that word I don't like—"adjust"—in many ways. At that time, most small farmers or farming families tried to produce all the food they possibly could, and this job of gardening and canning and preserving and drying fell largely on the women, and most of the women had had little experience in buying food because men did what they called a "trade in." Men got out more than the women. Many went to the county town on court days; they liked to see the court, the trial, so forth. Women seldom did that.

And the job of living with electricity or gas—when you had never used anything but wood for cooking or coal for fuel, and carried your water from the spring—some had a well—buying the family food, and sending children to a strange school where they couldn't understand the teachers— you see there was at that time a vast gulf between the South and the hills and the American language as it was spoken in Detroit—teachers couldn't

understand the pupils and the pupils couldn't always understand the teachers, and there were many rural women, so on and so forth. And out of all this wondering and thinking, Gertie for some reason was the one I chose. Though I'm sure there were thousands and thousands of women who were happy to go with their husbands and have all the gadgets they could get and get away from the drudgery of living in an electricity-less community, but for some reason I kept thinking of Gertie, who couldn't learn, partly because she didn't really want to. She kept hoping to go back. And what was there to go back to? They had no land.

CHUNG: What about the names?

ARNOW: I don't always know. . . . Did we ever know a Clovis anywhere? [She asked her husband, Harold.] You wouldn't; Harold spent most of his life in . . . Chicago as a newspaperman. Clovis and Gertie too, Gertrude, are common names you will find anywhere, not just in the hills. And for most of the children, I chose Bible names, really well-known names like Amos and Reuben, but where Callie Lou came from I don't know. It just popped into my head one day, so there she was.

CHUNG: Jane Fonda said that she had to show "a more rounded and fulfilling ending" in the film because you always thought that chopping the block of wood was a positive ending. But many people feel sad about the ending. I feel sorry for Gertie because she could not bring out the head.

ARNOW: Well, I felt it was a sad ending, a part almost sad, leaving out Cassie's. . . . Oh, Cassie is the nickname for Keziah, I believe, Job's very beautiful daughter, the fairest in the land, as I remember, and I called her Cassie. Gertie and Clovis would have liked it, and perhaps Gertie's mother chose the names and they would have come from the Bible, and most did. Now, I got off the track there, I'm sorry.

Well, when Gertie didn't say no, she didn't say yes, but you have the idea that she would yield when Clovis talked to her about getting a jigsaw, and cutting the major portion of the figures, and then she could take a knife and do a little whittling, and they would look handmade and hand-carved. At the same time, you may recall a scene in the book—it's when Reuben ran away; oh, it's when his father slapped him and he [Clovis] told Gertie it's all her fault, and Gertie thought to herself that once Clovis wouldn't have talked to her that way back home where she had helped almost as much as he, by the big garden she made, the winter's meat she

had, and the eggs she sold to buy sugar or flour, and things like that. So I think, in spite of all her sorrow and hatred for splitting the wood, she felt that once again she would be helping her family. She'd be getting money to buy them something better than—she was feeding them beef hearts, can you imagine? They were cheap then.

In the film, I understand, Gertie gets so much money from the things she's made she is able to exchange her car for a truck, I think, and they all go home, looking happy. That's supposed to be a happy ending. I don't know how Clovis will feel; he knew the strike would be over sometime because in general whatever company he worked for would want to go back to work. And Clytie and Enoch both of them are so well "adjusted"; they don't want to go back to the hills.[2] Clytie by then would have been somewhere in high school, possibly close to finishing, and what would they have gone back to?

CHUNG: Fonda said she read someplace that you wanted Gertie to buy a piece of land in Michigan.

ARNOW: That's a story in my own imagination, except part of it comes out in *The Weedkiller's Daughter*. Have you reached the point where the children visit the pond and see the Primitive? This is just my private imagining—how she got the money is the part I'm getting at.

You know in Detroit and other cities, I suppose, and elsewhere, there are lawyers who are ambulance chasers—whoever is hurt in an accident or killed is a good case for a lawsuit—that's one kind, and others read little notices in the newspapers about accidental deaths and automobile deaths, hunting for a possible case. So there was a little or maybe a big one—they love human interest stories—about Cassie's being killed on the railway tracks, when there was a hole in the fence she could get through that was supposed to be fenced to keep the children away from the tracks. Well, the lawyer read that and thought he would try the parents of this child; he saw a case where the railway should be sued for not having a childproof fence. He went to Clovis and Gertie. Clovis accepted. Gertie didn't want to; she said it was blood money made with poor Cassie. But Clovis was the head of the house and wanted to sign, and by then he knew that she wanted land above everything else.

And this was shortly after the war, before the land values north of and all around Detroit grew so very high; I heard of lots selling for $50,000 an acre. The great migration from Detroit to suburbia was just beginning and

there was plenty of vacant land. But now suburbia is miles and miles from Detroit. So Gertie, with Clovis driving, looked around until they found an abandoned farm with an old nice brick home, partially burned and fallen down. Gertie jumped at it; she knew she could build the home back up with help from Clovis and children. It wasn't so far out, so Clovis could drive to work and Clytie could go to high school. *The Weedkiller's Daughter* was written either during the time of the Vietnamese War or when we went to Korea to help the country, I've forgotten which; anyway there was several years' lapse long enough for them to rebuild the house and Gertie to get the cattle and have a big garden and do all the things she used to do at home. Of course it wasn't like home; the seasons were shorter. All this was in my imagination.

CHUNG: None of this is in *The Weedkiller's Daughter*?

ARNOW: In *The Weedkiller's Daughter*, the children meet the Primitive. And the girl tells her father about how cheaply she got the old farm and all that land. She did say, as I remember, a relative was accidentally killed. That's in the book, but everything else I told you before that was in my head— how she got the money and how she got out to northern Detroit.

CHUNG: Which ending do you like better, Gertie's going home or buying land?

ARNOW: I won't quarrel with Jane Fonda or the film. Though I can't help but wonder—see, this was very soon after the war and there were no consolidated high schools that Clytie and her young brother could've gone to, and I wondered what they would go back to in the hills; they didn't have land. And also Clovis, he had liked his job in the factory. There was something he didn't like, but he received a good salary. With all that training and fixing all kinds of machines and keeping up the old cars, he had earned a lot scarcely without knowing. So he did get a good job, helping take care of mending machines when they went bad. He was Somebody in Detroit. A man with a good job in Detroit in a factory, a steady job, was and still is a somebody. And they made good wages. You've heard what's happening to men: they've lost their jobs. The union was on strike and Clovis couldn't work. But strikes after the war were soon settled.

CHUNG: But didn't he kill a man?

ARNOW: I never did come straight out. Clovis was afraid to show himself and I only tell what Gertie feared. This boy who had been acting as a man

who tried to break up a strike—what do you call him? (She asked her husband.)

MR. ARNOW: A stoolpigeon? A strikebreaker or a scab is the best word.

ARNOW: Anyway, Gertie could only surmise or imagine that Clovis had killed the man. She wasn't certain. This boy who worked on the vegetable truck, he must have known some Mafia who lived there—well, we shouldn't call them Mafias, they were gangsters. And this boy knew about them in Grosse Pointe. The only way he could have known was through the Mafia. . . . So it could've been this boy was trying to pick up a little extra money, either trying to kill a union leader, or hurting him, or acting as a scab. See, Gertie didn't know a great deal about Clovis's life.

CHUNG: Did the idea of Gertie's buying land come after the book's publication?

ARNOW: Yes, after I published it, I think. I was so sick of Gertie and so tired of it, and then I began. . . . The publicist at Macmillan sent me all the reviews. They were so good that I was shocked. And I still get letters from readers praising the book and asking questions and so on and so forth. The only trouble is some readers, judging from their letters, they never give me credit for imagination. They think all these are real people, and that I was Gertie. Well, nothing I can do about it. Now I talked too long again. I'll leave off everything except what you want to know.

CHUNG: What about Cassie? Her accident breaks everybody's heart. Was it all your imagination too?

ARNOW: I think a great many children have imagination and talk to themselves as playmates. Somehow when they start school and get older, the world becomes factual. I don't think children read or are read to as many fairy tales, Mother Goose rhymes, and this and that as they used to . . . Looking at children's books in the library some weeks ago right here in Ann Arbor, I saw rows and rows of books, fictional about wars among the planets and satellites, and journeys into space, and all that, and not too many about *Poohs*, or *Alice in Wonderland*, or fairy tales, French or American, or English or any kind. And that's a poor way to judge, I'm not certain. Our children, of course, they are grown and long since gone, but we read poems like *A Child's Garden of Verses*; they enjoyed *Poohs* and certainly *Alice in Wonderland*. My daughter was crazy about Heidi, and our son did read *20,000 Leagues under the Sea*. Of course, that's been several

years ago before outer space became next-door, if you know what I mean. And I didn't think Cassie was unusual in her imaginings, like sticking yellow leaves on her shoes and saying she had gold shoes, and things like that.

Gertie once more showed her cowardice, not that she wanted Cassie to get rid of Callie Lou, but because Clytie—that's her older daughter, isn't it?—wanted it done and she was afraid that the children and everybody would make fun of her.

CHUNG: Just one more thing about Gertie. You don't seem to like Gertie very much, but Fonda said that she likes "values Gertie represents" that place quality of life, such as art, before material possessions.

ARNOW: Well, I won't dispute Jane Fonda. But Gertie didn't think of her whittling as art. She scarcely knew—"art" and "creative" are overworked words now, aren't they? Do you remember when she said to her neighbor who had to give up painting—Homer's wife, do you remember Homer and his wife, who'd hoped to paint? But in this new life with demands on her time, so on and so forth? Anyway, Gertie said to this woman who thought of her painting as art, "Everybody has to have a little foolishness." And Gertie felt guilty about her work, spending time on it except after she lost Cassie. And she may have had then, I don't know, a premonition, that with Cassie gone she would also lose the block of wood. She worked very hard for several days or weeks.

CHUNG: Why do you think she did that?

ARNOW: Well, she was half-in and half-out, sick. And it's possible that working on the block of wood was the only thing she could do in her state or it's possible that working on it—remember how Cassie loved the block of wood, always asking when you are going to bring him out, the man in the wood—that she seemed closer . . . or she was doing it because the dead Cassie had wanted it done. I didn't go into that. I wasn't certain. But sometimes most any human being can get a bit of not exactly comfort— sanity, perhaps—after a great loss or a great upset, in doing or making something they enjoy making. I don't know. Not just standing around and looking.

CHUNG: When she chopped the block of wood, I thought she had realized that she herself had to let her wood go as Cassie had done with her Callie Lou.

ARNOW: I don't know, but I felt she was doing it in trying to help. No money was coming in and Clovis was deeply in debt. Do you remember when she was up paying the rent and she saw a woman who couldn't pay the rent and told her she had so many days to get out? Gertie, well she could imagine things, saw that happening to her own children and I think that helped, and then having to feed them beef hearts. And Clovis was unable to work even an odd job because of his scar and beat-up face. And I think all that was the push. The ending, I suppose I wanted it that way to leave something for the reader.

But I've been trying to read a paper—I am not finished—written by a professor of English who teaches in a community college; he received his doctorate here at the University of Michigan. And he called Gertie a Judas, because she had betrayed herself and her art by splitting up the wood. It's interesting, different opinions. A college girl—I was speaking at Bellarmine College, and after speaking there was a question and answer period. One of the questions was "Why did you kill Christ?" She was certain that Christ was the block of wood; Gertie had more or less changed her mind and thought it was Judas giving back the money, the 30 pieces of silver or that was the idea I wanted to give. I told the girl that no one can kill Christ. I tried and failed. But this Judas theme—there was someone else who thought Gertie was a Judas and I can't see that at all in her splitting. . . .

Had she thought of it as a great art . . . but think of the artists who didn't make sales, who had suffered. Well, Van Gogh, I don't think he burned any of his paintings, but some possibly did. But he no longer cared, cut off his ear, and shot himself because [he thought] he was a failure. He and other painters of that period thought of themselves as artists or workmen; earlier I think Cellini thought of himself as a workman— remember he couldn't get enough metal when he was making his beautiful horse, enough metal to pour into the mold and had to use something else. And the world betrayed their art, but they themselves did not. And Gertie, she put her whittling on handles—remember when she talked to the general or whatever he was in the car? She first told him she whittled a lot on hoe handles, ax handles, churn handles—she put that before the block of wood. She didn't mention the block of wood as if she considered it art, although she didn't call it "foolishness" at that time.

CHUNG: But she became more articulate at the end. She could talk and relate with other people better in Detroit, don't you think?

ARNOW: Well, I think she did, I don't know. Gertie, though it's hard to realize, found more kindness to her in other people in the alley than she had ever known at home. She always felt a stranger at home, especially with her mother. Not with her father.

And she also began to realize that she was only one among the many women who had their troubles and suffered. Her boys and the Murphy [Daly] boys may have fought every time that they looked at each other, but she did have great sympathy for Mrs. Murphy [Mrs. Daly] having to put up with her husband and fighting boys. And the last touch was her daughter, the kind and good and beautiful daughter for whom she'd been collecting the trousseau for years, you know, and who had gone off to be a nun. And Gertie I suppose—that was one of my troubles, you see. Gertie was so incoherent [that] she couldn't always think in words. Gertie may have compared the woman's loss of her daughter—if you could call it a loss, and the woman thought it was, although she was extremely religious—to [her own] loss of Reuben. Gertie did lose Reuben. She lost him after she accepted the return of the money for the land [the Tipton Place]. Reuben hated and despised and looked down upon her and realized for the first time she was a coward. And so it went.

It worried me when a Macmillan editor came out to see me and [said] that they had accepted Gertie, it was a wonderful book. He met me on the steps and said, "Oh, I thought you would be a big woman." He apparently thought that I was Gertie. The next thing he said worried me even more: "Oh, Gertie was a saint, wasn't she?" And I saw her as anything but a saint. She was secretive; she was cowardly in the face of public opinions. And she didn't have the ability or whatever was needed, the desire to adjust to the place where they had to live. And so it went.

CHUNG: I have so much to talk about *The Dollmaker*, but we should talk about something else.

MR. ARNOW: That's a great idea.

CHUNG: You wrote about the Cumberland. Why?

ARNOW: Well, I have written *The Kentucky Trace*. And the time there is about 1780, I guess, the American Revolution, the year of the Battle of King's Mountain. But I did write a great deal. I have three nonfiction books, two about the pioneers to the Middle Cumberland. Most of it was about Tennessee, but a part of Kentucky that was settled at a very early

date, and that covered the period from about 1780 to 1803. I enjoyed especially the research. *Seedtime on the Cumberland* and *Flowering of the Cumberland* are long, long, heavily denoted books; so I had letters from readers wanting more notes, and they have been just recently brought out by the University of Kentucky, in paperback. Why the University of Kentucky wanted to publish them, I don't know, because there is very little in them about Kentucky; the major part of the work belongs to central Tennessee.

CHUNG: Did you enjoy writing nonfiction books as much as fiction?

ARNOW: Yes, it was quite a chore. But I enjoyed the research more than anything. I spent days and weeks in the Tennessee State archives and library.

CHUNG: You love history.

ARNOW: I do. I only wish we were teaching more history now in school. I don't know why exactly, but I think sometimes we need to know more not only about our own past, but that of other people. More geography with the history because geographies change. Perhaps there is a better understanding of present-day America, I don't know. Maybe I'm just an old fuddy[-duddy]. Our study of history began in the fifth grade with a book called *Myths of Greece and Rome*.

MR. ARNOW: There are biting flies around here. One I think is picking on your leg. (He was pointing to my leg.) I'll get you a fly swatter.

ARNOW: How did they get in here, Harold? Why don't you fix the hole?

MR. ARNOW: They went in with this nice young lady. They like a nice young lady.[3]

ARNOW: The last book, a very small book, *Old Burnside*, was published by the University Press of Kentucky a few years ago. It's the only book in which I write about some of my sisters and my family at home. They asked me to do that. I don't like to write about my relatives at all. But I wrote about my young school days and I cut out a lot of the history, so it's almost an "I . . . I . . . I . . . " book. I don't like it too well. Yes, partly [autobiographical]. I did manage to leave in a great deal about the Cumberland River, and the steamboats, and the coming of the railway. We didn't have the railway until 1880, I guess. That was before I was born. But it was late; the country was settled. The early settlers were there before 1800, so they went almost a hundred years with the river, first rafts and dugouts, and steamboats

by 1833 and all the way up. And the steamboat went, and the stagecoach went, and now there is no passenger train, and I don't think any bus service. It's amazing—the changes in my lifetime; of course I'm not young anymore.

CHUNG: In the introduction to *Mountain Path*, you said, "I saw much of life in terms of roads." How do *The Weedkillers' Daughter* and *The Kentucky Trace* fit in?

ARNOW: *The Weedkiller's Daughter* doesn't fit in any place. You mean because I saw those first three books as a trilogy? In the first book, *Mountain Path*, there was practically no road to the community, and no roads in the neighborhood, mostly just trails; there was no electricity in that community, and the mail came twice a week by mule-back, as it did to most communities or many with one room schools. I started to call the book *Path* because most people follow up a path, a path to school, a path to the post office, a path to the river, a path to the church, or even a path to get to the place, walking.

My second book. . . .

CHUNG: *Hunter's Horn*. Oh, I like that book a lot, but your trilogy, those three books are very sad stories to me.

ARNOW: Yes. I should have thought up a happy book with a lot of sex and violence, but with always evil people the ones that are suffering. I try to be a realist and most things do happen.

Anyway, I wanted to call that book *End of the Gravel* because the gravel road came to the post office on top of the ridge. Nunn Ballew and his family lived in the valley below the ridge and below the end of the gravel. But editors, or someone, possibly the sales department, changed the name to *Hunter's Horn*. Pretty sound, as they said. But only one or two of the hunters in the book blew a horn to call the hounds and usually they didn't call the hounds home ever. Others were blowing gun barrels and cupped their hands, I don't know how they did it, to blow. And they also gave the reading public the picture of the brush, the fox's brush on the cover. The idea was that the book was of this great life where men rode horseback, in red coats with all the trappings to hunt, and the fox's brush was greatly prized.

And it wasn't that at all. I don't think they do that in England or in any other countries, certainly not in the Kentucky bluegrass country. In many places in the South, beginning with Kentucky, men sit and listen to their hounds run; each man knows the voices of his hounds. He doesn't have to

see them to know whether they are doing well or poorly or have lost the scent. He can tell by listening. But the book did sell quite well and was on the best-seller list for a while. I did get some good letters from fox hunters, telling me it was a great fox-hunting book.

CHUNG: How could you know all that? Do you know a lot about hunting?

ARNOW: I first heard foxhounds when I was five or six years old. Not too far from my house. They scared me to death. They make an awful sound if you don't know what it is. So I had fox hunting explained to me. Then Harold and I lived in a place for a while where fox hunting took the place of baseball, football, tennis, gambling, and every other sport and pastime known to man. The children talked about it at school, and [about] the hounds. The women baked unsalted bread, because salt was supposed to ruin the fox's smell. And it wasn't only that neighborhood. This was before the days of super-highways. I don't think even a good hound could follow the trail across a road where many cars, coming and going, passed. If they tried, they probably got killed, I don't know. One day I was in the kitchen putting a lunch on the table and two big hounds burst through the screen door, jumped on the table and started eating. They were starved to death. Well, we knew it would be an unthinkable crime to hurt those hounds. So, how did you get in touch with the owner? Put an ad in the paper, or what? [She asked Harold.]

MR. ARNOW: I'm trying to remember. I remember the hounds but I don't remember how I got the owner. I think somebody told him I had them. That was quite well-known, for the hounds were missing for a couple of weeks or so.

ARNOW: The owner lived miles away. They got away from him, or got lost, or something happened. You see, a hound, after an all-day and all-night and part of the next-day chase, he just lies oblivious to everything; he doesn't get up and bark. He doesn't do anything but sleep and rest; he might have eaten. We finally found the owner and he thanked us.

MR. ARNOW: I think most of them were directly descended from the English fox-hunting packs. This was part of English gentry, English kings. . . .

ARNOW: Oh, I disagree there.

MR. ARNOW: Oh, you might be right.

ARNOW: What was the breed of Sam and Vinie? I had it in my book. Macmillan was afraid for me to use it and they cut it out.

MR. ARNOW: Walker hounds, weren't they?

ARNOW: Walker hounds from the bluegrass.

MR. ARNOW: I thought that the Walkers came from England.

ARNOW: Maybe they did. The best bluegrass horses all come from England; some are Arabian. I've not heard of anybody in the Middle East using hounds.

CHUNG: Did you have a firsthand experience with fox hunting?

ARNOW: No, I just listened.

MR. ARNOW: I am the one who went.

ARNOW: Did you ever go?

MR. ARNOW: Yes, I sat on top of those mountains and drank that stinking, lousy hard liquor and listened to foxhounds, a few times, anyway. Eventually I decided she was better company than the drunkard who I was sitting with.

ARNOW: Well, we had what they called a cur dog, and people warned us that if [the hounds] got on his scent, they'd chase him like a fox and kill him. . . . Do you remember the scene where the no-good hounds were chasing the teacher's cur dog, and Sam and Vinie did not? Oh no, they knew [that the cur dog was not a fox].

CHUNG: Life in the trilogy is very hard on some of the characters. For instance, Suse in *Hunter's Horn* broke my heart. She is going to have a living death.

ARNOW: But the Calvinistic faith is still strong in the hills and they do suffer, especially the women. Milly, I didn't come out and say she had a Calvinistic faith and anything like that, but the idea was "suffer here on earth, do the best you can, all will be different in heaven." The songs, some of them indicated like—I wish I could remember, I remember the one I used to say only two lines: "Far away beyond the starlit sky, where the love life never, never dies." That love life, I suppose their husbands loved them of course, but most of the pastimes and the pleasures were for men. They could stop working and go to town on court days. Well, the woman had a young child or two or three to watch until she passed the childbearing age.

Now family planning has come to the hills. And what they didn't learn at home, they learned in the cities they went to, and the size of a family—13 or 14, so forth—has dropped radically.

CHUNG: Your women characters are more fully developed than men. Women characters are stronger than men, I should say. Are you aware of that?

ARNOW: Women are stronger than men?

MR. ARNOW: She is stronger than her husband, anyway.

ARNOW: They don't always get their way. In what way do you mean that they are stronger?

CHUNG: Your major characters are women.

ARNOW: I see what you mean. Yes, but oh it hurt my feelings. One woman who read *Hunter's Horn* wrote to tell me, "if I had a husband like you've got, wasting all that time hunting, I would take a skillet to his head." And here's poor old Harold who never owned a foxhound in his life. She thought I was Milly and Harold was Nunn. I could stand the Milly part, but to think my poor husband was Nunn. . . .

And *The Dollmaker*, I wanted to call that *Dissolution*, but they already changed the names of the other two books, so I called it *The Dollmaker*, not knowing what else. And that was the third part of the trilogy. And then I wrote two nonfiction books on the Cumberland country, the early settling of the Middle Cumberland, and then after the two Cumberland books I came out with *The Weedkiller's Daughter*, which is the only book I've had that is remaindered, gone. They sent me several copies—they are in the chicken house.

CHUNG: You said someplace you don't have any favorite books.

ARNOW: No, not while I'm writing one, even. . . . Well, *The Dollmaker* when I was writing it grew to be my unfavorite. Gertie, she was so inarticulate either in her thoughts or talk, she was difficult to work with. But she seems so real, and it looked like she had grabbed me and wouldn't let me go. So I stayed with her.

CHUNG: Then do you have any favorite characters?

ARNOW: Let me see now. Suse in *Hunter's Horn* was one of my favorite characters.

CHUNG: Why is that?

ARNOW: I have the most sympathy with her. She was trapped and there was no way to get out of the trap. She went into the worst trap, working herself to death, having many children. I also liked the man—what was his name?—in *The Kentucky Trace*, who was free; he felt at home in the woods. And I had much sympathy for Nunn Ballew.

CHUNG: But I didn't like him at the end because he sent Suse away. He was honorable as a hunter, but. . . .

ARNOW: He was an honorable, honest hunter, but he didn't worry what the country would think of him when he went on a bender, drank too much, remember? Danced, went off with strange women, and all that. But when Suse did wrong, he once thought of his newly made friends and how awful it would be to tell them that this child that wasn't even yet born was Suse's. . . .

CHUNG: Did you still like him?

ARNOW: I didn't like him after that. I had sympathy with his obsession for fox hunting that tore him all into pieces. I used to think that would make a fragment of a ballet; so danced, that the observer couldn't tell whether Nunn was chasing the fox or the fox was chasing Nunn. Each had to; they were doing what they had to. But the fox was chasing him, bringing on that obsession, just as much as Nunn chased him.

CHUNG: Do you often think about your characters?

ARNOW: Not after I am finished. I never read my books after I read the last of the proofs. I look at them, but I never call them books. The real work is in the writing and the revision; sometimes it's great. I don't know why I write. I enjoy it. At the same time it's hard work. I am not a great writer; I revise and work and read. . . .

I have been working on a manuscript for years, but last year I took on more engagements than I realized. I'm not long home now from teaching in a writers' workshop. And when you run around and play the literary lady the way I have been this summer, writing, I'm ashamed of myself, goes by the boards.

CHUNG: What kind of manuscript are you working on?

ARNOW: Well, the most I can say about it is it's about people. It's a fiction. But I don't know that anything will come of it. I hear conversations. I have to see [scenes] in images before I write.

CHUNG: I understand you read a lot as a child. But did you read other writers even after you became a published writer?

ARNOW: Lately I've been reading selections from the diary of the Rev. Francis Kilvert. I don't read very much fiction. I've been intending to. I'm trying to think of the last book I read, it was for a review; it's about the usual mother-daughter conflict except the daughter is fully grown, and another book [*Them*] by Joyce Carol Oates. Since then I did read *The Sounds of Waves* but before that *Snow Country* by the Japanese writer who won the Nobel prize—very short books.[4] I wish I could turn out short books. I don't seem able to. It gets longer and longer. I start out with a character, and there's a family, or friends, and a community, and they all talk, and this happens . . . and oh God. I'd have to write about a person living alone in a cave, I think, to get a short book.

CHUNG: You once said, "I don't think of myself as a writer, but as a housewife, writing in my spare time." Do you still feel that way?

ARNOW: I still feel that way. Housewifery, cooking, letters, and many other things. I don't know, I don't seem to have much more time than when our two children were home. I guess it takes longer to get a given amount of something done, I don't know. On ordinary days, when I'm not getting ready for some kind of an engagement or something, I work on my writing and letters from six in the morning until eleven, eleven thirty. Then what's left of me and the afternoon goes to housework. Haven't you looked at all the weeds?[5] I've talked myself hoarse. It's my fault; I spent too much time answering questions.

NOTES

1. Both Elizabeth and Jim are deceased now. Jim was thirteen years younger than Arnow.
2. I tried to retain the style of her dialogue as closely as possible. I think Arnow's occasional slips into the present tense are indicative of the characters' immediate presence in her mind, rather than of grammatical errors.
3. A discussion ensued on which fly swatter, rubber or plastic, would be good to kill the fly without ruining my hose.
4. Both books are by Japanese writers: the first by Yukio Mishma, the second by Yasunari Kawabata.
5. She was referring to her own yard.

HELP AND HINDRANCES IN WRITING: A LECTURE

TRANSCRIBED BY SANDRA L. BALLARD

Harriette Simpson Arnow gave this address to the Appalachian Writers Association, at Morehead State University in Morehead, Kentucky, on 29 June 1985. I recorded this lecture and completed my transcription after Professor Parks Lanier Jr., of the Department of English at Radford University, provided me with a clearer copy of the tape.

I will speak on help and hindrances in writing. A good many of those hindrances were my own fault. . . . In considering my talk here, I thought most of students and others who are writing, publishing, or those who are learning to write, and not of readers. It would be a sad world if all of us spent so much time in writing there would be no time left for reading because writers can learn much from reading—especially the lives of other writers. [Reading] keeps you from getting discouraged.

One of the happiest memories during early childhood was listening to our father tell stories just before bedtime. Many of his stories were handed-down stories of ancestors who had fought in the French and Indian War, the Revolution, the War of 1812, after it was finished, and other wars. They [the stories] were all right; they weren't bloody or grisly or too sad. But what I liked best were what we today call folktales, such as "Old Granddaddy Grumble," which I have heard in different names and different versions and read in a French book of stories for children. The story, however, which I liked best was our father's version of "Jack and the Beanstalk." Father had a good voice; he sang bass in the choir, but he could somehow, without ruining his vocal cords, scream out in a high voice of the deceitful harp when it told the giant that Jack was running away with her. Better yet, in our father's natural voice, though louder than common, was "Fi fie fo fam! I smell the blood of an Englishman. Be he alive or be he

dead, I'll grind his bones and make my bread!" Even after I'd heard the story enough that I knew the giant couldn't get Jack when he started down the beanstalk, I still shivered, but Jack really had to hurry to get down the beanstalk and cut it down just as the giant had one leg out to get on it. So there was nothing bloody in the story.

My sister, only two years older than I, . . .could read most anything; [she] read stories to me. My favorites were "The Nuremburg Stove" and "King of the Golden River." They had sad places but happy endings, which I always wanted, though I've not always written happy endings.

Our maternal grandmother came to visit us for several weeks or months each year. She told stories, such horrible tales, ghost tales, and other stories that sent me to bed crying and shivering.

However, I didn't cry or shiver in bed for long. I did away with the ghost tales and the worst stories, just as I did away with the deceitful harp and kept the remainder of "Jack and the Beanstalk."

Now I was plagiarizing, which is a bad beginning for a writer; it's against the law. But I'd never seen the word or heard the word "plagiarizing," so I was happy in being able to change it [the unhappy ending] in my imagination. Even worse for me, for a beginning writer, I couldn't think too well in words. My vocabulary was limited at five or six years of age and later. So I had to see and hear the giant as our father gave him to us, the deceitful harp, and the stories my sister read. And that seeing and hearing—whatever I'm writing—if two characters are talking, I have to be able to hear them in my mind before I can record the conversation. I still do it, though I have a vocabulary of sorts.

I was eager to go to school. Sister Elizabeth had been taught to read both at home and at school when she was four years old. I had to wait until the September after I was six years old to attend Burnside Graded [School] and [Burnside] High School. I enjoyed school. We studied; we did all manner of things, from learning the numbers to a hundred, to learning to read, and spent much time on phonetics, so that if we chanced upon strange words in our readers in first grade, we could sound them out.

Better than anything were the stories our teacher read or told us. And there were also stories in the first reader. But I did have to change one story in that book: it was when Foxy Loxy told Chicken Little and his relatives that the sky was falling, and the only way they could keep their heads or bodies from being crushed by the falling sky was to follow him

into his den. So the foolish fowls did, and Foxy Loxy ate them all up while he was in the den.

I continued to enjoy school. And I suppose I learned something. That didn't leave as much time for reading as I would have liked at home. But I was sorry to have to drop out of school at the end of the fourth grade. I would have been upstairs in the fifth grade; my sister was ready for high school. The flu epidemic during 1918 was raging. Scarcely a day passed but what we at home could hear the tolling of a church bell. Our mother was afraid we'd catch the flu, so she kept us at home, as did many other parents.

I had quite a good time that summer. I could read. I lived with the characters of Dickens, Cooper, and others, struggled through *Idylls of the King*, . . . I didn't know enough either legend or history of England to know what it was, so I admired some characters. I disliked Guinevere and hated Mordred, and Lancelot seemed almost too good for life.

However, poetry came from our father, from his head mostly, and he recited "The Raven" to me until I could memorize all of it, until I knew it. Then in one of his old books, I found another poem by Poe which I liked even better: "Annabelle Lee." I had decided after reading *Oliver Twist* there were worse things in this world than the flu. At last, my father introduced me to *The Rime of the Ancient Mariner*. I didn't understand it all, but I liked the lilt . . . of the poem and also what happened. I had not, at that time, read *Moby Dick*, but when I think of *Rime of the Ancient Mariner* I think it was possibly a forerunner in a way, not that the author of *Moby Dick* plagiarized, as I had tried, but one killed an albatross and lived through it, and the other, . . .is a story really of good and evil.

September of 1919 was close. And I was torn from *Nicholas Nickleby* by our mother telling sister Elizabeth and myself to come; she wanted to have a serious talk with us. She told us she was soon sending us to a different school, where she hoped and thought if we studied hard enough we could make up for all the time that previous year and still add another year to our studies. She never called it a "cram school," but some of my classmates did and gave it worse names.

Mornings were spent on arithmetic problems, that is all morning. . . . I had to square two numbers, add them together, and extract the square root of the sum. I learned to do that from some of the older girls, but I never knew why or understood the problems until I was studying plane geometry in high school.

Worse were the afternoons, three or four hours spent in hard, new sentences, new to us, and we could never know by counting down or counting up to us which word we would get. The teacher skipped around in the class, so the word was always unexpected. And that went on all afternoon.

Nights were given up to working my difficult problems in arithmetic. And still worse for me was diagramming sentences, which I first didn't understand . . . and once more I got help from the pupils, not the teacher. During the year out of school, our mother had given me several lessons on grammar. The one thing I remembered was gerunds. . . . Some of the girls were tangled on that; . . . but they had to know to diagram [sentences]. So I was able to give a bit of help to some.

Next morning, first thing, we turned in our arithmetic papers from the evening before and the diagram sheets to the teachers for grading. I never saw a book in that school, except texts. It didn't matter; there was no time for reading, and soon, I couldn't read. In studying arithmetic problems, I'd have to read it more than once or ask sometimes because each time I started to read it, my sentence would fly off—parsing was so ground in that I had no idea of what the problem said.

The end came at last in the following June. I was there more than nine months. And I learned that in that time, I'd finished the fifth, sixth, seventh, and eighth grade, and was now ready for high school, though I'd had no history, geography, or English. . . . I tried to write letters home, but they were hard, scarcely could be understood. But our mother was pleased. I would be twelve years old during the summer after that school. I'd be sixteen before I entered college. That meant I could have a teaching certificate by the time I was eighteen years old, the lowest age which, by Kentucky law, anyone could teach school, and that was too young, in my opinion.

Back home, I slowly recovered and was able to write school papers on a variety of subjects and read again. And it was during my junior year in high school that I wrote my first story. The anemones, the hepaticas, the creeping iris, and other wild flowers in the woods served as my characters and gave the action, though some of that action came from a thunderstorm. Our mother subscribed to many magazines, but I sent it to [the] only one for children—she subscribed to *Child Life*—that is after I had sneaked out some of mother's writing paper, typed it single-spaced on that paper, using an old Oliver, folded the thing up as it shouldn't have been, and sent it to *Child Life*. It was gone so long I was certain that magazine had taken it.

Well, the mail came one day, and with it was the story in a big envelop, typed double-spaced on paper this size [standard-sized typing paper— Arnow held up a page of the manuscript from which she was reading]. There was a letter saying they had liked the story but couldn't use it now; would I please try them again? They had retyped the story because someone, in handling it, had torn it. Years later, I wondered if the story had been torn because what *Child Life* had done, in addition to writing a letter asking to see more material, they had shown me how to prepare a manuscript for submission to an editor and how it should be mailed. At that time, I didn't have sense enough to know that a letter was a great deal better than a rejection slip.

I was cast down because of their rejection and not particularly by our mother's words; the casting down hurt even worse. But our mother was furious, and I had a great lecture: here I was wasting my time, her writing paper, and money for postage on scribbling, which would never bring me, anybody, anything except disappointment and sorrow. She was telling me this, she explained, only for my own good, because it would be far better to have a steady job like teaching school, as she had done for ten years before her marriage, than wasting time on scribbling. I continued to want to scribble.

When high school finished, I was supposed to go to Normal School, but instead of going to Normal School, and there were many, I chose to go to Berea College, the one place I could find where I could still take the required "education courses" I had to have in order to teach as our mother had said and at the same time take several courses and subjects I wanted to study and that would also lead to a college degree.

I put in two years at Berea, but found no one who cared [about] writing. In fact, some of the students, girls, wept when they had to write another paper. They hated it. I got so tired of their complaining I offered to write their papers for free. I wanted to write, and I did write. We were off in a small building called Gilbert Cottage, all girls. And I know there were six or eight of us sleeping in one room, so I remember one paper I wrote at that college.

Well, certificate in hand, at last, the required age almost, I learned I could find no trustee who was interested in a young teacher with no experience. However, it wasn't long before school, in early July, until I heard from the Pulaski County superintendent of schools. He told me he had one vacancy in the county, and I could have that school if I wanted it. He gave

the school a pretty name which I have forgotten, but I soon found myself in what was locally known as Possum Trot school district. Only nineteen students were enrolled in the school. Older ones often had to stay home to help in some way. They were the sons and daughters of small or subsistence farmers. Young ones couldn't walk four or five miles to school in bad weather, especially [since] some didn't get shoes until late November and early December. Mail came twice weekly, as I had come, by mule-back.

Now remember, this was in the late twenties, long before I think anyone had thought of Appalachian redevelopment or helping Appalachia, what they call "Appalachia," in any way, though I was teaching and living, not in Southern Appalachia, but what we today call south central Kentucky . . . north of Knoxville.

But this place, shut away from the world as it was, had no contact, almost no contact, certainly not for women, with the outside world. At that time, before the coming of REA, no utility corporation would sell electricity, or you couldn't get a telephone, and of course, [you had] to have your own well or spring. It's a wonder not everybody died with typhoid because they'd never heard of water testing, and so shut away from the world, their customs, things, and most especially their speech, [reflected] no Americanisms.

And their speech interested me though it gave me trouble at first, but I remembered parts of Shakespeare. They talked more as Shakespeare did than many people in Kentucky towns—I mean as Shakespeare's characters did. I don't know how Shakespeare talked. But I think much like his characters. And I soon realized that my landlady was perfectly correct in telling me that her husband was "carrying" her mule and the wagon to town— that meant the county [seat] town many miles away—because, by then, after hearing "carrying" used in such ways, I had looked it up in the dictionary. It meant, "to take with," as Falstaff was "carried." Nobody picked him up; he went with someone or a man took him. And I began to learn more about our language: myself and most people gave only one meaning to a word, unless they could find a synonym. And I began to realize that most words had more than one meaning, that a perfect synonym for a word was almost impossible to find; there are a few. And I realized how rich our language was.

I taught one more year, in a less interesting school. The trustee of that school wouldn't have me again because he expected me to board with him. He lived two or three miles from school. And in those days, the fifteen or

sixteen dollars a teacher paid, monthly not weekly, meant a lot to several families. And I had a good landlord and landlady close to the school. And my pay per month was $65.

I went to the University of Louisville for various reasons. Sister Elizabeth now had a degree, and she could go back to teaching. It looked as if we'd have to take a turn [alternating between working and going to college] forever. At the University of Louisville, I met many who were writing, and one girl had published poetry. I decided instead of a mere writer of short stories, I would be a poet. We were studying Browning, so I decided to write a dramatic monologue, same as he wrote, except my material would be different. There was plenty of material around me.

The Depression. We had promises from Roosevelt (he hadn't been in office long); many people were living in hope, even though unemployment kept rising. Many people, adults and children, lived with hunger. Nights, coming out of a restaurant, we'd hear the rattle and crash of garbage cans, and we knew that men, and sometimes women, were going through the garbage cans. They could find any food from the other restaurants that would serve to take home to their wives and children. There were also many evictions.

And I don't know [if] the closed bank I watched was [observing] a bank holiday or [if] the bank was closed. I saw the crowd of sad-eyed people standing around; a few women had tears running down their faces. But all was quiet. There were no outcries. Louisville policemen on horseback were riding round and round the crowd or going through it, and I thought of my dramatic monologue. I'd read of evictions, and I knew there were many. Mine would be a wife and mother, begging whatever came to evict her—I don't know whether it was a policeman or a landlord—but he didn't say anything. It was all her talk, telling him there's barely enough money for food to feed the children and keep them in school. And she also said that the eviction could at least wait until the wild flowers on one side of the yard—she hadn't put them there—[she wanted to wait until] the grassless yard would bloom and smell so sweetly.

I worked and I worked and I worked on that, but got no place. It never did sound like Browning's "My Last Duchess," nor "Fra Lippi Lippo," or anything else. I came to my senses after neglecting calculus and physics and realized I was not Browning. I was only Harriettete Simpson and was no poet. I don't know how a poet got to be a poet. When I had time, I read different lives of writers.

Well, with my degree, I returned to Pulaski County, where right off I was offered a job teaching in a rural high school, a new one. I liked it very much, and there was much more pay, about a hundred dollars more the month than when I'd started teaching. But like an idiot, I quit at the end of my third semester or second year in the school and accepted an offer to teach in Louisville.

I thought mostly of how great it would be to be close to the Louisville Library, where you could get most anything you wanted to read. I asked no questions, but when I reached the school, the principal wanted to see me. I learned, alas, I was to teach social studies. I not only knew nothing about them; I'd never studied them—or should you say IT when you speak of social studies? I not only didn't know about teaching them, I disapproved of them; I didn't like to see history shoved off in one corner. There were children going through good schools with only one year of history.

Had I stayed in Burnside's school, instead of going to cram school, I would have had eight years of some kind of history, beginning in the fifth grade and ending in the twelfth. In high school after I got back to Burnside, we had history each year.

I left that school the last day without going to the conference the principal had with the teachers. I didn't know whether she would fire me—it was plain she didn't care for my work—or bawl me out in front of everyone. So, instead of going to the conference, I packed for a move.

It was a short move from Louisville to Cincinnati, but a long, long one in my life. I had made up my mind that I would stop teaching and give all my time and mind to reading the great European novels I had missed, at home mostly, and the books of English literature and high school and writing. I would write. I'd only stop when I had to take some kind of odd job to pay for food and rent and of course, paper, typewriter ribbons, and postage.

It was a great life. I met a great many writers of fiction. At that time, more fiction was being published than nonfiction, even in some magazines. The reverse is true today. I heard much talk of writers and writing, read the reviews in the *New York Times*. I only had to go down to the library; I couldn't afford the book page or anything, and [I] read reviews in other papers.

Many of the reviews were given over to what was called "proletarian writing," usually highly praised. Well, I eventually, with the help of dictionaries, learned what was the "proletariat," and I thought of the poor I

had met in the hills and I couldn't consider them as members of the prole-
tariat, proletarians; they were all individuals to me, as were characters in
my imagination.

Also, I heard of *Tobacco Road*, and that sickened me. I tried to read it and
couldn't. I felt in spite of what critics had said about it—it'd been out
some time and had great sales—I felt it was a disgrace not only to the
South but to humankind and authors in general. So I concentrated on the
great novels that I had to read mostly in translation, things such as *War
and Peace*, or Sigrid Undset's work, never a smile in that, or Dostoyevski,
and you wanted to wring your hands and cry. And that was a bad begin-
ning because all those books or most of the ones I liked best were long,
long novels with detail, and my novels, later, were much too long. Then in
the midst of proletarianism and grim realism . . . I read Thomas Wolfe.
Everybody seemed to love Thomas Wolfe. They enjoyed his work. And I
read at that time only *Of Time and the River*, *Look Homeward Angel*, and
loved the sometimes very richly worded rhetoric. But better than anything
after all the grim realism coupled with proletariat, I liked what seemed on
his part a joyous feeling for life. It was a great change, and I loved it. I
thought briefly of trying to write as Thomas Wolfe wrote, but that
attempt to be a Browning had cured me, so I didn't try.

I had more short stories placed and in 1936 had my first novel pub-
lished. It's a wonder I didn't burst open like the frog in the fable. I was so
puffed with pride and glory when I read the reviews, especially the one in
the *New York Times*. All the reviews were surprisingly good for the first
novel, but the book didn't sell a great many copies.

Then . . . it was thirteen years before I could submit to another com-
pany—the one that had published my first book had gone out of busi-
ness—and John Steinbeck and myself both had to find other publishers.
But that book was *Hunter's Horn*. I sent it to a publisher; the first one I
sent it to accepted it, and it did quite well. It was on a bestseller list. It
was written while the family and myself and two young children were liv-
ing in wartime housing in Detroit. Husband, who for several years before
marriage, worked as a newspaper reporter in Chicago, during the gangster
era, got a job on the *Detroit Times*. And as soon as he could find a place for
us to live, we followed.

While we were living in the housing development, I began to think, as
I often did, of housewives I had known in shut-away communities when I
was teaching. How could a woman who had never talked on the telephone,

seen an electric light, never heard the word "traffic," and had gone by sun time, instead of clock time—how could she manage in noisy, busy, wartime Detroit? She couldn't understand the people, and all the people around her, they couldn't understand her. Worse, she had to feed the family, and do the buying by paper poke. At home she had—with her garden, her canning, her eggs and everything—grown most of the food the family had saved. How could she "shop" in the city when she couldn't even find the food she wanted?

They usually, for example, had what they called biscuit bread—they were good biscuits—for breakfast. But the noon meal, except on Sunday, and the evening meal were cornbread. There was no [corn] meal in Detroit at that time except what came in cardboard boxes, small cardboard boxes. It had been degerminated and dehydrated, was expensive, compared to the twenty-five pound sack they could buy, or when they took their own meal to mill, it came back soft, undegerminated, un-kiln-dried; it made excellent cornbread. And Gertie had her troubles when she'd always been at home on the land and often did man's work.

Ordinarily, I don't wonder when I'm writing something if anybody will read it . . . but I did wonder if there were any editor in the world who would read ten pages about this big, ugly, secretive woman, one to whom Clovis had said she always looked as if she wanted to fight.

But I sent it off to what I'd heard was a good publishing house. Much to my surprise, it was gone but a short time until I received a letter from an editor, praising it, and a contract which meant, I was told as soon as I signed it and returned it, [that] I could receive an advance on the novel.

About two weeks later, an editor from the publishing house came to our home, then in Ann Arbor township. He began by praising the novel. He made a few suggestions—one of them was the novel could have more reader appeal. Well, I thought, dear man, if you could write novels with reader appeal, you'd have them all on the bestseller's list, and earn more money, and have more fun than working for a publishing house. However, I kept silent.

He left on the evening of the third day, so late I had to start dinner immediately, else it would be too late for husband and children. Dinner finished, dishes washed, and the kitchen in some semblance of order, I opened the manuscript.

I glanced at a few pages and wished I could faint or just lose consciousness. However, I spent most of the night going over the manuscript. He

had changed every word and thought, except those passages from the Bible, that Gertie had ever had. She would look at the sky and think, "Well, it's kinda cloudy, looks like maybe we'll have rain soon." I knew that language was ungrammatical, but how could Gertie speak grammatically when most of the people around her spoke ungrammatically? She hadn't spent much time in school, though she did read. She had said that, and it was changed to "The sky appeared cloudy or clouds appear in the sky. Perhaps it will rain soon." In all the time I'd been in these shut-away places, I'd never heard the word "perhaps." I'd heard "happenchance," but mostly "maybe." I looked up "perhaps" in the dictionary—big one—it did say that "perhaps" could sometimes, but not always, mean "maybe." I'd forgotten so much of my grammar, but I couldn't see why it didn't mean "maybe" there.

I went over that manuscript for most of the night, finally tried to go to sleep, and thought I could surely do something. Here I'd signed a contract; maybe they'd change their minds and nobody would publish it. If they tried to, I'd get a lawyer, which broke the family budget, and sue if they tried to use my name on something I hadn't written. [Arnow accidentally turned two pages of her speech at once.]

I hadn't plagiarized since "Chicken Little," but I came up again—this time by adding something—I only added to a well-known phrase: be true to thyself and to thy parish.

Thank you for your patient listening. I've talked too long.

NOTES ON CONTRIBUTORS

SANDRA L. BALLARD is Associate Professor of English at Carson-Newman College in Jefferson City, Tennessee. She published the most comprehensive bibliography on Arnow in *Appalachian Journal* (1987), and her continued research on the life and works of Arnow has been supported by a James Still Fellowship at the University of Kentucky, a Summer Stipend from the National Endowment for the Humanities, and Mellon Fellowships from the Kentucky Faculty Scholars Program, and the Appalachian College Association. She is currently writing a critical biography of Arnow.

BARBARA L. BAER is a writer of many talents. She has been a college teacher, a journalist, and a fiction writer. Her article "Women of the Boycott" in *The Nation* won many prizes and has recently been reprinted in *125 Years of Writing from THE NATION*. Her fiction has been published in a number of magazines from *Redbook* to *Confrontation*. She is currently working on bilingual media and education projects.

HAEJA K. CHUNG teaches interdisciplinary humanities courses and Asian American literature at Michigan State University. A former *Lansing State Journal* correspondent, she wrote a feature article on Arnow, and her new essay on Arnow has appeared in *Critique: Studies in Modern Fiction*. With Sandra Ballard, she is editing a volume of Arnow's published and unpublished short stories.

WILTON ECKLEY is Head of the Humanities and Social Sciences Department and Director of the McBride Honors Program in Publiic Affairs for Engineers at the Colorado School of Mines. He was Chair of the English Department at Drake University, a John Hay Fellow in the

Humanities at Yale University, a Senior Fulbright Professsor at the University Ljubljana (Yugoslavia) and at Cyril and Methodius University in Bulgaria. Dr. Eckley's publications include books on E.E. Cummings, Harriettete Arnow, Herbert Hoover, T.S. Stribling as well as articles on Bret Harte, Rudyard Kipling, Robert Louis Stevenson, and many others.

JOAN R. GRIFFIN is an associate professor of twentieth-century American literature and writing at Metropolitan State College in Denver, Colorado. Completing the final revisions on a book-length study of Arnow's Kentucky novels and the editing of a series of interviews with the author are her major projects at the moment. Dr. Griffin's other research interest extends to the fiction of a number of contemporary women writers to include Bobbie Ann Mason, Barbara Kingsolver, Marilynne Robinson, Louise Erdrich, and others.

CHARLOTTE HAINES teaches at Delaware County Community College in Media, Pennsylvania. She received her Ph.D. in Enlgish at the University of Massachusetts, Amherst, in 1993. Her dissertation focuses on Harriettete Arnow's work, examining her regionalism as a form of ethnicity. Her other areas of interest include radical American writers of the 1930s and African-American literature, particularly novels by African-American women.

BETH HARRISON is author of *Female Pastoral: Women Writers Re-Visioning the American South* (1991). Her areas of research include southern women authors, autobiography, and American regionalism. She is a reviewer for *The Women's Review of Books* and has published articles in *South Atlantic Review, MELUS, and The Southern Quarterly*. She is currently Director of the Charleston Center for Women, a non-profit organization offering support services and enrichment programs for women.

GLENDA HOBBS is a writer based in San Francisco. She completed her Ph.D. dissertation, "Harriettete Arnow's Literary Journey: From the Parish to the World," at Harvard (1975). She has taught at Harvard, Boston College, and Holy Name College in Oakland, California. She has written several essays on Arnow and Sarah Orne Jewett. She also wrote a four-part adaptation of Jewett's *Country of the Pointed Firs* for WGBH radio, starring Julie Harris. She is the former Arts Editor for *The San Francisco Examiner*.

DANNY L. MILLER is Associate Professor at Northern Kentucky University. He interviewed Harriettete Arnow in 1982 and published "A *MELUS* Interview: Harriettete Arnow" in *MELUS* (1982). He has also written several articles on urban Appalachian literature and with Maureen Sullivan wrote "Cincinnati's Urban Appalachian Council and Appalachian Identity" in *Harvard Educational Review* (1990). Dr. Miller has been active in the Appalachian Studies Conference since its founding.

KATHLEEN R. PARKER teaches in the Department of History and Social Sciences at Waynesburg College in Waynesburg, Pennsylvania. In 1988-89, she served for nine months as a Congressional fellow for the Women's Research and Education Institute in Washington, D.C. She has presented numerous papers at conferences on issues affecting American women. Her finished dissertation (1993) is a study of the sex-crime prosecutions conducted by the Circuit Court of Ingham County, Michigan, from 1850-1950.

LINDA WAGNER-MARTIN is Hanes Professor of English and Comparative Literature at University of North Carolina, Chapel Hill. She has published widely on modern American authors—Hemingway, Faulkner, Williams, Frost, Plath, Sexton, Glasgow—and has been working recently as a biographer (Sylvia Plath, Gertrude Stein, others). Currently president of the Hemingway Foundation/Society, she has been the recipient of awards from NEH, the Guggenheim Foundation, the Rockefeller Foundation, ACLS., and others. She is co-editor of *The Oxford Companion to Women's Writing in the U.S.*, and is editor of the contemporary section for the *D.C. Heath Anthology of American Literature*.

KATHLEEN WALSH is Associate Professor in the Humanities Department at Central Oregon Community College. Recipient of awards from NEH, she has published articles on Henry James, Mark Twain, and Harriettete Arnow. Her next project, which is an outgrowth of her work on Arnow, will be an examination of hunting tales as a peculiarly American sub-genre.

INDEX

297